DREAM A WORLD ANEW

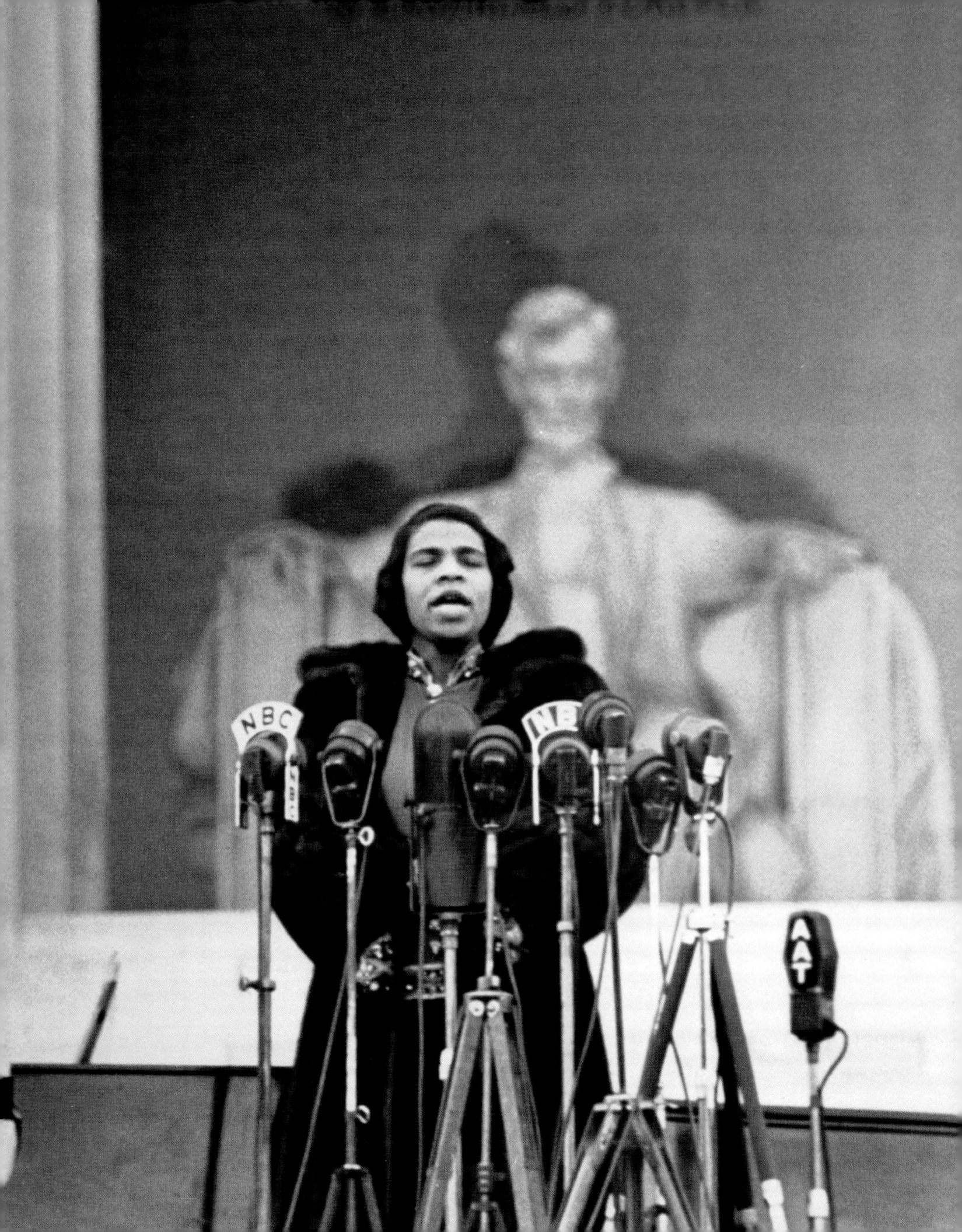

DREAM A WORLD ANEW

The African American Experience and the Shaping of America

Introduction by Lonnie G. Bunch III
Edited by Kinshasha Holman Conwill

*In Association with the National Museum of
African American History and Culture*

Smithsonian Books
Washington, DC

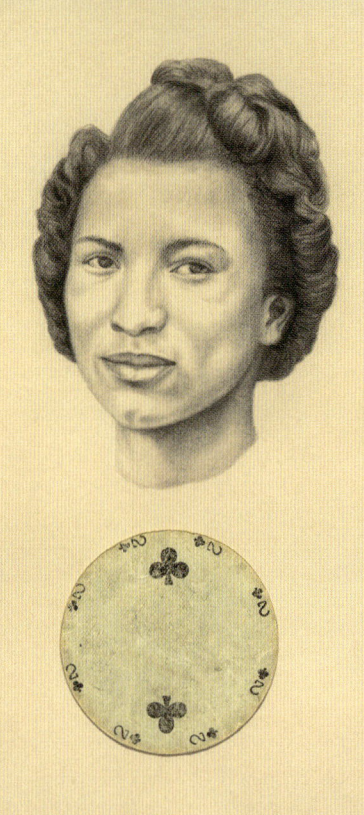

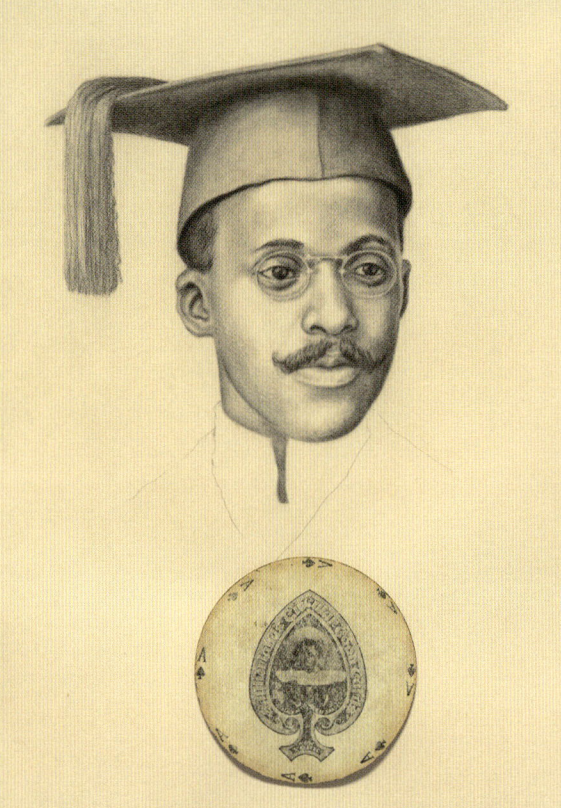

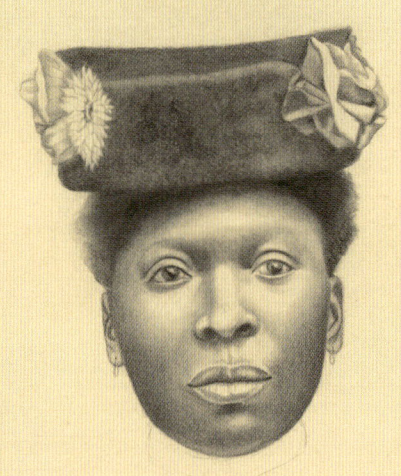

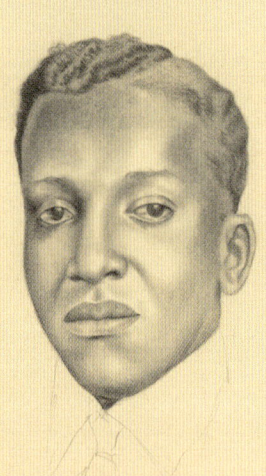

For John Hope Franklin and all those who kept the flame of black history alive.

CONTENTS

"MY COUNTRY, 'TIS OF THEE" Contralto Marian Anderson (*preceding page*) sang "America" at an Easter Sunday concert at the Lincoln Memorial in 1939 after the Daughters of the American Revolution denied her a performance at Constitution Hall because of her race.

EXTENDED FAMILY
Contemporary artist Whitfield Lovell's *The Card Series II, The Rounds* (*opposite*), charcoal drawings based on found vintage portraits of unknown African Americans, bridges the gaps in African American genealogy by claiming a host of historic black ancestors.

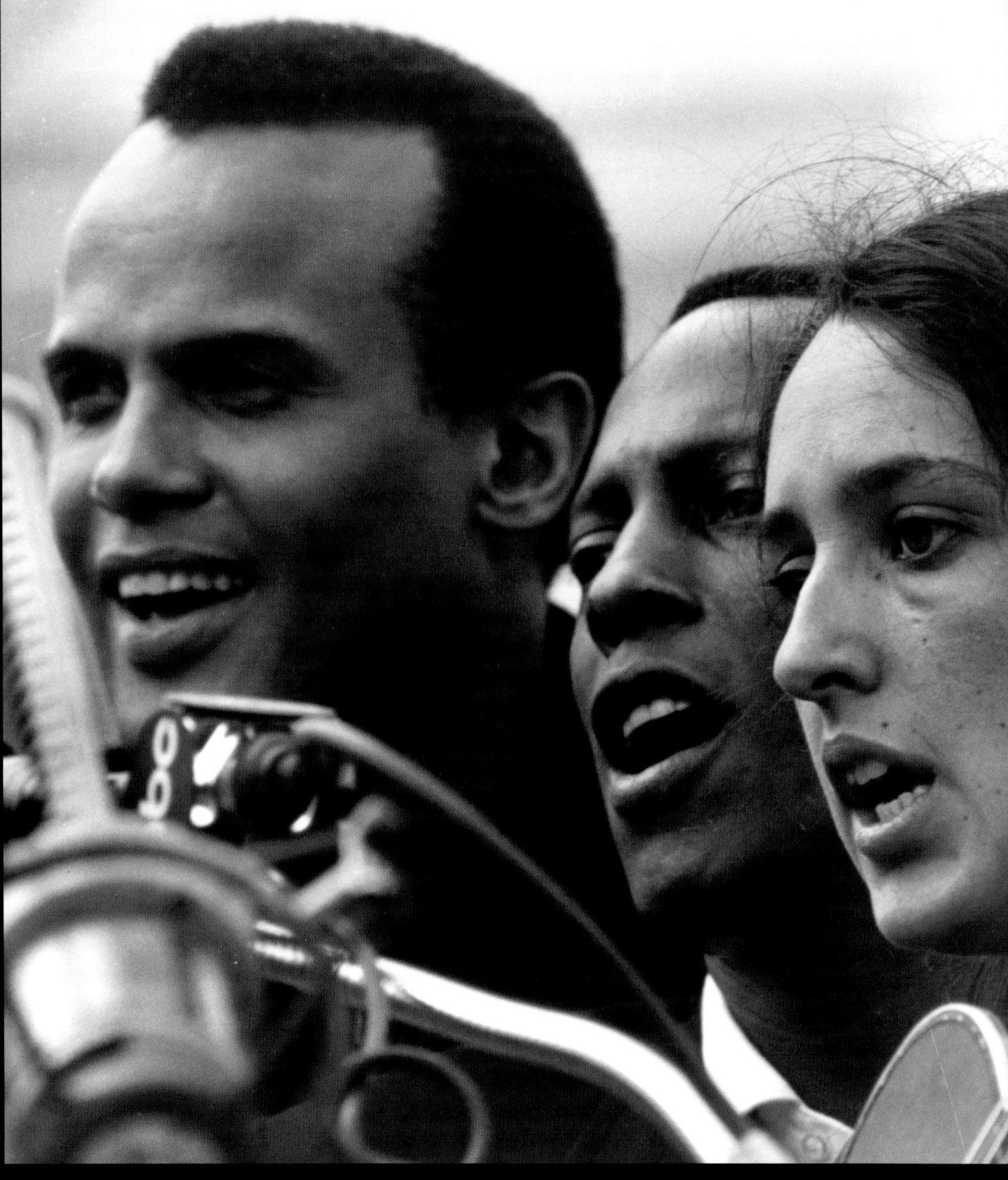

FREEDOM SONGS Singers (*left to right*) Harry Belafonte, Leon Bibb, and Joan Baez inspire

I Dream a World, 1945

Langston Hughes

I dream a world where man
No other man will scorn,
Where love will bless the earth
And peace its paths adorn.
I dream a world where all
Will know sweet freedom's way,
Where greed no longer saps the soul
Nor avarice blights our day.
A world I dream where black or white,
Whatever race you be,
Will share the bounties of the earth
And every man is free,
Where wretchedness will hang its head
And joy, like a pearl,
Attends the needs of all mankind—
Of such I dream, my world!

> "*The past is all that makes the present coherent.*"
> —JAMES BALDWIN, *Notes of a Native Son*, 1955

> "*They [Americans] are in effect still trapped in a history which they do not understand and until they understand it, they cannot be released from it.*"
> —JAMES BALDWIN, "A Letter to My Nephew," 1962

INTRODUCTION

Lonnie G. Bunch III
Founding Director, National Museum of African American History and Culture

The creation of the National Museum of African American History and Culture, the newest museum within the Smithsonian Institution, will enable the millions who visit the site on the National Mall or encounter the museum virtually to understand, as James Baldwin has written, both the power and the contemporary resonance of the past. America's political and educational institutions, its economic development and cultural evolution, and its foreign policy and global interactions have all been shaped by the intersection of history and race from the nation's founding to the present day. Unearthing the richness, complexity, challenges, and nuances of African American history not only reveals the story of a people, but, equally important, reveals much about America's identity.

Dream a World Anew celebrates and commemorates the opening of the National Museum of African American History and Culture, an institution whose formation was first proposed more than a century ago when African American veterans of the Civil War refused to allow their important participation in that conflict to be erased from history as the nation marked the fiftieth anniversary of the Battle of Gettysburg by celebrating the reunion of North and South without acknowledging the unresolved racial legacies of that conflict. *Dream a World Anew*, like the national museum, seeks to reframe our understanding of black history by centralizing the African American experience. Rather than see this history as an ancillary story with limited appeal and impact, this publication demonstrates that in many ways African American history *is* the quintessential American story. So many moments when American notions of liberty and freedom were enlarged or made manifest, when the definition of citizenship was rethought, and when America was challenged to live up to its stated ideals were embedded within and profoundly shaped by the African American

community. Far too frequently, it was the African American experience that demanded, in the words of poet Langston Hughes, that "America be the dream the dreamers dreamed."

It is quite fitting that this work of history be one of the ways the National Museum of African American History and Culture is launched. During the one-hundred-year struggle to open the museum, the historical profession was also wrestling with the place, the importance, and the interpretation of African American history within the academic canons. Often the earlier scholarship reflected the condescending and bigoted racial attitudes of the era. These scholars frequently saw "Negroes" as an inferior people whose presence was a problem—a drag on American greatness—or, at best, a sideshow in the great pageant of American history. Fortunately, the work of an array of gifted scholars, especially since the end of World War II, has reshaped our understanding of both the African American experience and the American past. Historians as diverse as W. E. B. Du Bois, Gerda Lerner, Carter G. Woodson, Letitia Woods Brown, August Meier, Kenneth Stampp, Benjamin Quarles, John Blassingame, and the former head of the museum's Scholarly Advisory Committee, John Hope Franklin, laid the foundation that has helped to make African American history one of the most active and important fields of historical study. There would be no national museum without the scholarly insights that have reshaped our understanding of enslavement, migration, work, gender, global connectivity, and culture. *Dream a World Anew* builds upon this legacy and reflects the best of current historical scholarship.

It is this scholarship that defines and undergirds the organization of this publication. While no book or museum can be encyclopedic, *Dream a World Anew* offers an account that provides a sense of clarity and accessibility to the complicated narrative of the African American experience. One of the key ways to understand this history is to use both chronological and thematic lenses. So the overarching framework, like that of the museum, offers a chronological sweep that takes one from fifteenth-century West Africa and Europe into the United States of the twenty-first century. This chronology is

CROWNING ACHIEVEMENT
The National Museum of African American History and Culture sits adjacent to the Washington Monument and the White House.

SAGE ADVISER Historian and scholar John Hope Franklin, best known for his authoritative history *From Slavery to Freedom*, first published in 1947, headed the museum's Scholarly Advisory Committee.

divided into three periods: from slavery to freedom, from the era of the institutionalization of segregation through the Civil Rights Movement, and the struggle to redefine the recent American past since 1968. The initial discussion of the period from slavery to freedom explores how the economic and social system of slavery shaped so much of the European and American colonial and antebellum experience, and how the tensions and contradictions of a nation created out of the need for freedom while denying that liberty to so many of its inhabitants based on race and gender unfolded throughout the eighteenth and nineteenth centuries. The section addressing the period from segregation through the Civil Rights Movement explores how the struggle for the soul of America led to the creation of laws, institutions, and violent extra-legal organizations such as the Ku Klux Klan that upheld segregation while equally determined African Americans and their allies created organizations and strategies to force America to uphold its stated ideals of equality and fairness. The final section examines the successes and failures of a recent America grappling with changing racial expectations at a time of diminishing resources and unrealized possibilities, although it has also been a time of prosperity and promise for some. This chronology is leavened by the thematic explorations of the roles of diverse African American communities, based on region, gender, education, and the impact of evolving cultural productivity, consumption, and appropriation.

LAST DAYS OF SLAVERY
In a photo taken by Civil War Union officer James E. Larkin ca. early 1862, two enslaved women, Lucinda Hughes (*left*) and Frances Hughes (*right*), gather their children at Volusia plantation, near Alexandria, Virginia. A year later, Lincoln issued the Emancipation Proclamation, freeing the enslaved in rebellious states.

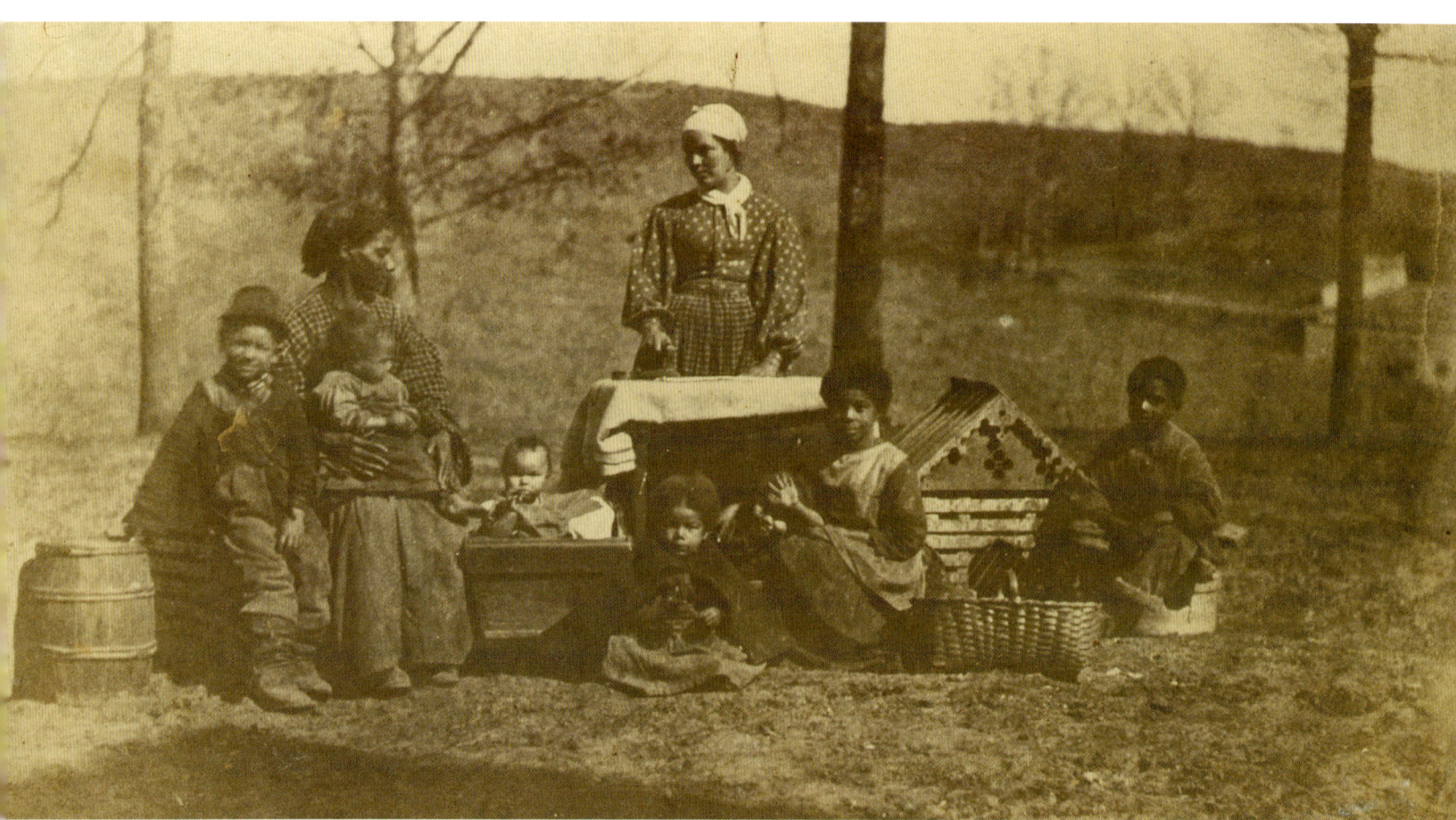

Dream a World Anew also seeks to broaden our notion of scholarship by including and assessing the material that composes the collections of the National Museum of African American History and Culture. These artifacts and images not only provide new evidence and insights into the past; they are also concrete manifestations of the past that allow audiences to engage history through these collections. In many ways, the collections help the museum make history accessible and meaningful. These history-infused objects encourage audiences to define their own relationship to the collections, to perhaps see their families or themselves in the artifacts, which, in turn, helps them find a useful and usable past that gives history meaning.

Helping the public discover a meaningful past, one that gives the visitors the tools that enable them to better understand the contemporary world, has been at the heart of the museum's vision. The goal has been to encourage the public to remember—to remember the history of black America so that America can confront its tortured racial past. While the museum, and this publication, will help our audiences to rethink, in new ways, the names and the history they have been taught, it will also introduce an array of historical actors who were traditionally left out of our understanding of the past. By remembering, museum visitors and readers will find moments to ponder the pain of slavery and segregation, but they will also comprehend the resilience and joy that are at the heart of the African American experience. Remembering, however, is not enough. The National Museum of African American History and Culture crafts exhibitions and publications that use African American history and culture as lenses to better understand and confront what it means to be an American. As *Dream a World Anew* demonstrates, the sweep, import, and impact of black history transcend a single community. This history unpacks the best and the worst of the American past and shows the broad impact and reach of this story. In essence, the African American past contains the moments that have shaped all who call themselves Americans.

Creating a national museum that illuminates all the dark corners of the American experience was not without significant challenges. This endeavor began in earnest in July 2005. The museum had a "staff" of two; no real idea of where the museum would eventually be located; no benefactors; no architect or even an architectural vision; no collections; and the challenge of raising hundreds of millions of dollars. Yet of the many hurdles that needed to be overcome, building a nationally significant collection from scratch was the most daunting.

One of the strengths of the Smithsonian Institution is its vast holdings. The collections run the gamut from iconic objects, such as the 1903 Wright Flyer, Hope Diamond, and Greensboro Lunch Counter, to the thousands of animal and plant specimens housed within the National Museum of Natural History. This new museum needed to acquire artifacts that would be as engaging and important as the collections of its sister museums. But was that possible? So much of the African American cultural patrimony seemed lost to history or already in the hands of private collectors. Should the museum even try to collect objects, or would the public be better served by an educational institution driven mainly by virtual technologies? Ultimately, the national museum decided that it must

develop its own collection and that the process for obtaining these artifacts should also stimulate a national conversation about preserving African American material culture.

The museum believed that most of these materials were still located in the homes, basements, attics, and trunks of black America. I remember, as a child, the joy of discovering the treasures hidden in my grandfather's trunk. And as a curator, I have spent hours rummaging through dusty rooms in search of the stuff of history. So the museum needed to find ways to encourage the public to open their homes and share their artifacts and stories with the Smithsonian. With a signature program, "Saving Our African American Treasures," the museum sought to stimulate a national conversation about the importance of these artifacts and the methods needed to ensure that future generations would have access to them. The museum brought conservators from throughout the Smithsonian and from across the country to more than fifteen cities, where instruction in preserving textiles and protecting photographic material was coupled with an effort to help individuals determine the historical importance of the artifacts presented—whether they were a grandmother's dress or a farmer's tool—and the best ways to preserve them. The museum has been humbled by the way that people have trusted us to preserve their histories and to share their stories through the artifacts they possessed.

I remember receiving a call in 2009 from Charles Blockson, one of the most important black bibliophiles in the United States. He said that he had obtained material relating to the abolitionist Harriet Tubman that the museum had to see. I was skeptical because nineteenth-century material associated with people such as Tubman is rare. Nevertheless, along with a few museum colleagues, I met Mr. Blockson in a library on the campus of Temple University. He quickly dispelled any skepticism when he reached into a box and withdrew little-known images of Harriet Tubman's funeral. Repeatedly he extracted objects from the carton that were equally startling and impressive. Then he unveiled a shawl given to Harriet Tubman by Queen Victoria (see page 62) that took our breath away. Finally he showed us Tubman's personal hymnal, which left us all in tears. Every time Mr. Blockson revealed a treasure, his excitement led him to punch me in the arm.

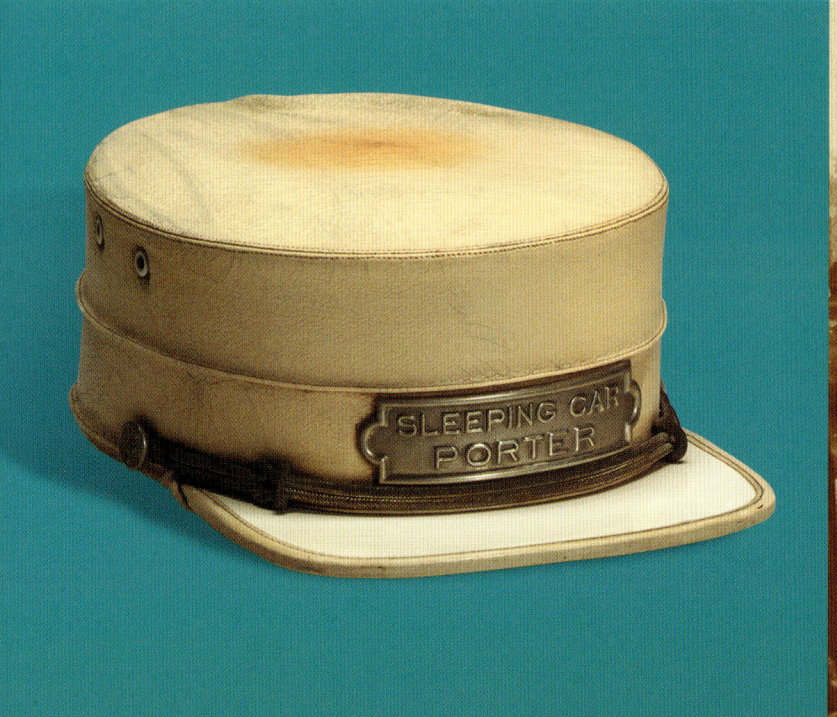
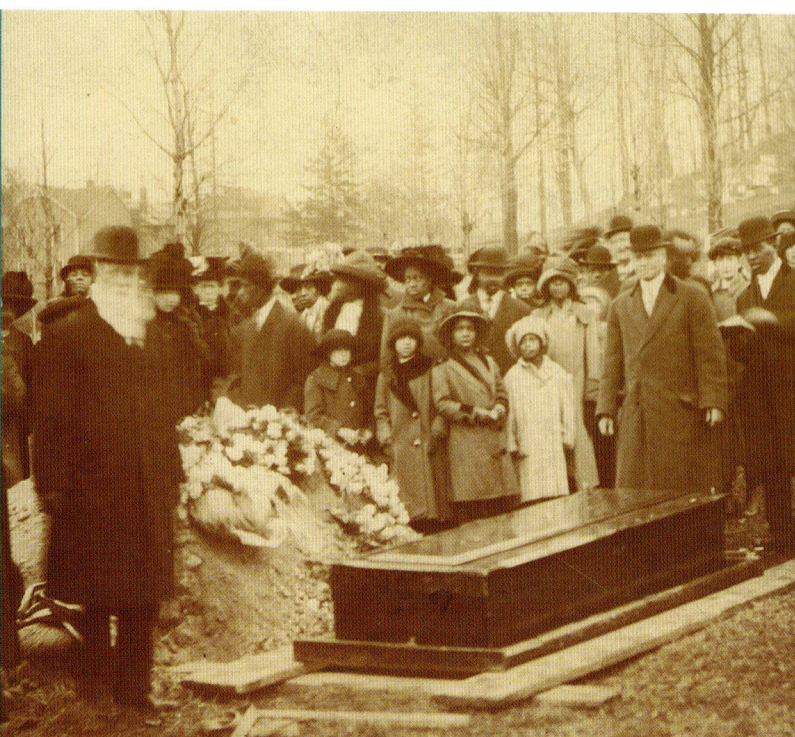

I soon realized that being privy to this collection made the pain worthwhile. Also moving me to tears was Mr. Blockson's insistence that he donate the collection to the museum so that millions would have the chance to engage with the story of Harriet Tubman. That generosity spoke volumes about Mr. Blockson and about the impact that this museum could have.

And that spirit of generosity continued to touch all who were associated with the museum as hundreds, then thousands, of objects became part of the museum's holdings. We were moved when Gina McVey visited the museum with material that was associated with her grandfather, an African American veteran of World War I. During the visit, it became clear that Lawrence McVey had been a member of the 369th Regiment, known as the Harlem Hellfighters, a unit of black soldiers that the U.S. military detached to the French army. While unappreciated by the American military, their courage was rewarded by the French with their highest military award, the Croix de Guerre. Sitting on my table was McVey's medal from 1919, which his granddaughter donated to the museum (see page 80). We were saddened to silence when Joan Trumpauer-Mulholland, a veteran of the civil rights struggle since her time as a member of the Student Non-Violent Coordinating Committee in Alabama, brought to the museum some materials that she had held for more than three decades. Ms. Trumpauer-Mulholland was in Birmingham in September 1963 when the 16th Street Baptist Church was bombed and four children were killed. She came to the museum and donated shards from the stained-glass windows that were damaged in the bombing. Those simple pieces of glass allow the museum to explore that tragedy in a way that is poignant and personal: These silent shards speak volumes about loss and resilience and remind our audiences that change is not without sacrifice.

Dream a World Anew, as a manifestation of the National Museum of African American History and Culture, seeks to introduce new audiences to the impact of black history and culture, strives to centralize the African American experience as a history that has shaped the identity of all Americans, and reveals a world of complexity, nuance, unmet expectations, fortitude, and a belief in the better angels of a nation that often did not reciprocate that loyalty or love.

CREATING THE COLLECTION
The National Museum of African American History and Culture's major collection of artifacts includes objects discovered during its national signature program, *Save Our African American Treasures*, designed to encourage Americans to preserve historic objects. The items include (*opposite, left to right*) the cap of a sleeping car porter and a photographic postcard of the 1913 burial of Harriet Tubman. Joan Trumpauer-Mulholland, a former member of SNCC (*below, right*), in a 1961 mug shot after being arrested in Mississippi during the Freedom Rides, contributed shards of stained glass and a shotgun shell (*second from right*) from the 1963 bombing of the 16th Street Baptist Church in Birmingham that killed four young girls.

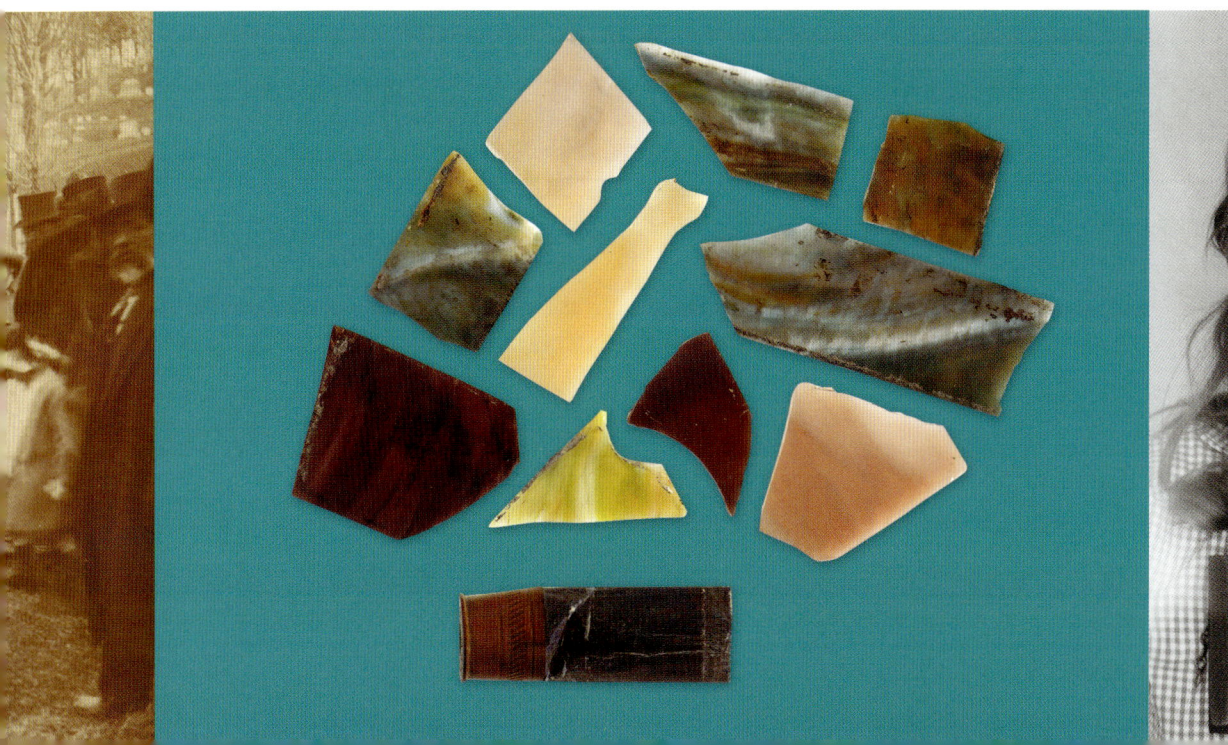

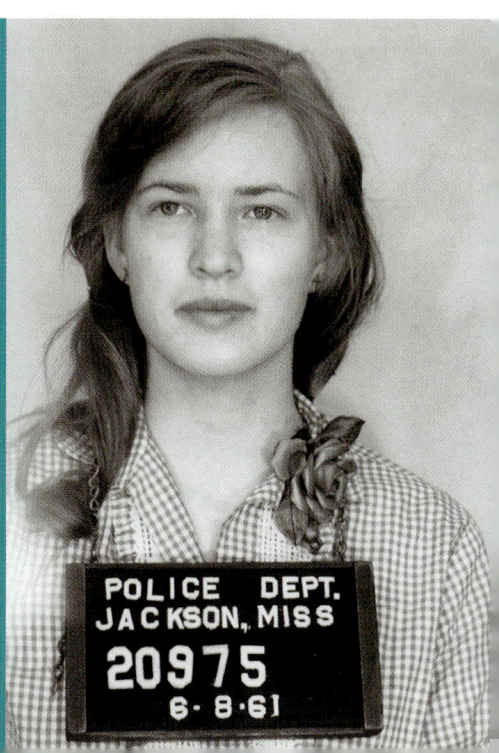

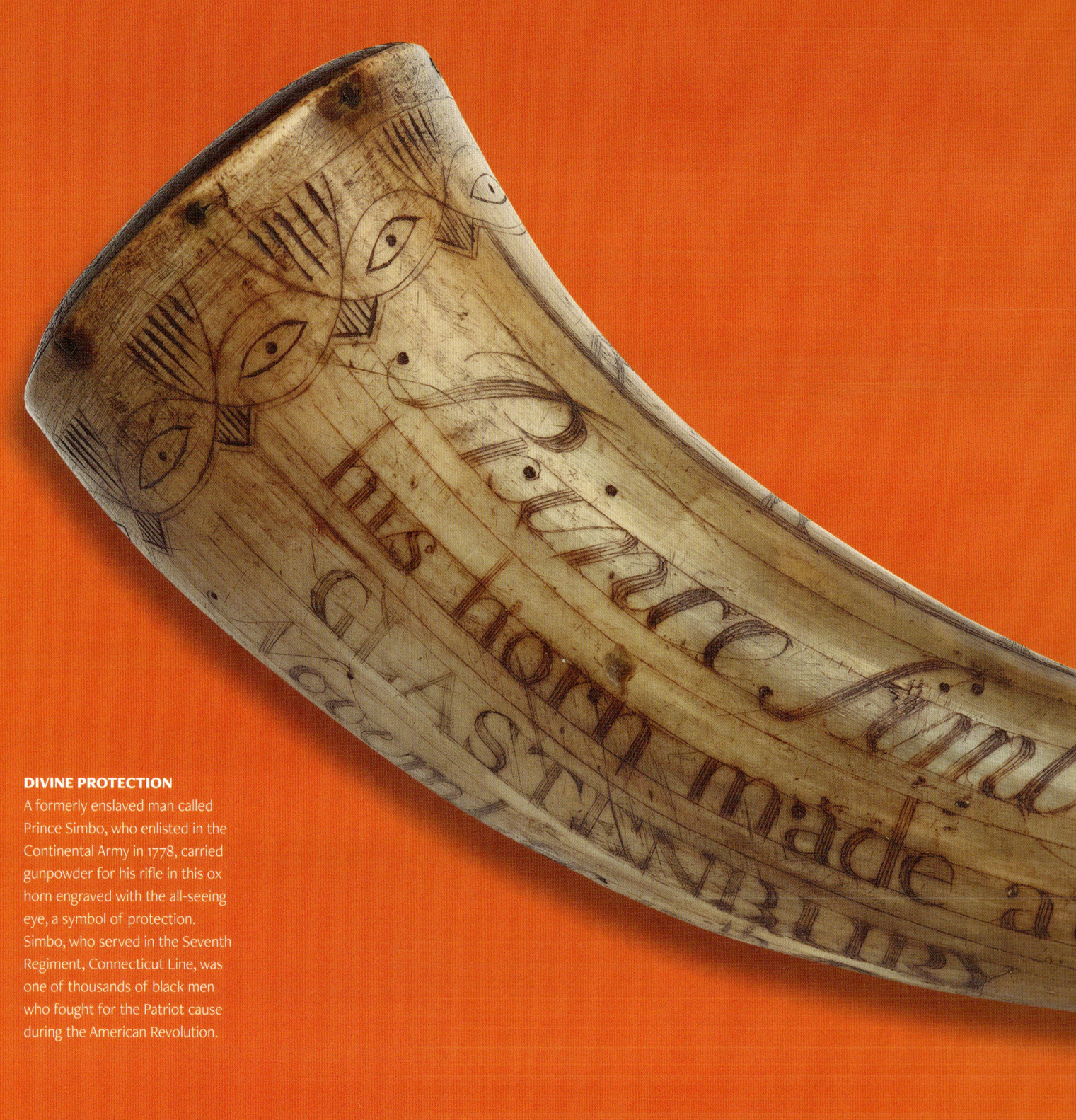

DIVINE PROTECTION

A formerly enslaved man called Prince Simbo, who enlisted in the Continental Army in 1778, carried gunpowder for his rifle in this ox horn engraved with the all-seeing eye, a symbol of protection. Simbo, who served in the Seventh Regiment, Connecticut Line, was one of thousands of black men who fought for the Patriot cause during the American Revolution.

SLAVERY
&
FREEDOM

David W. Blight

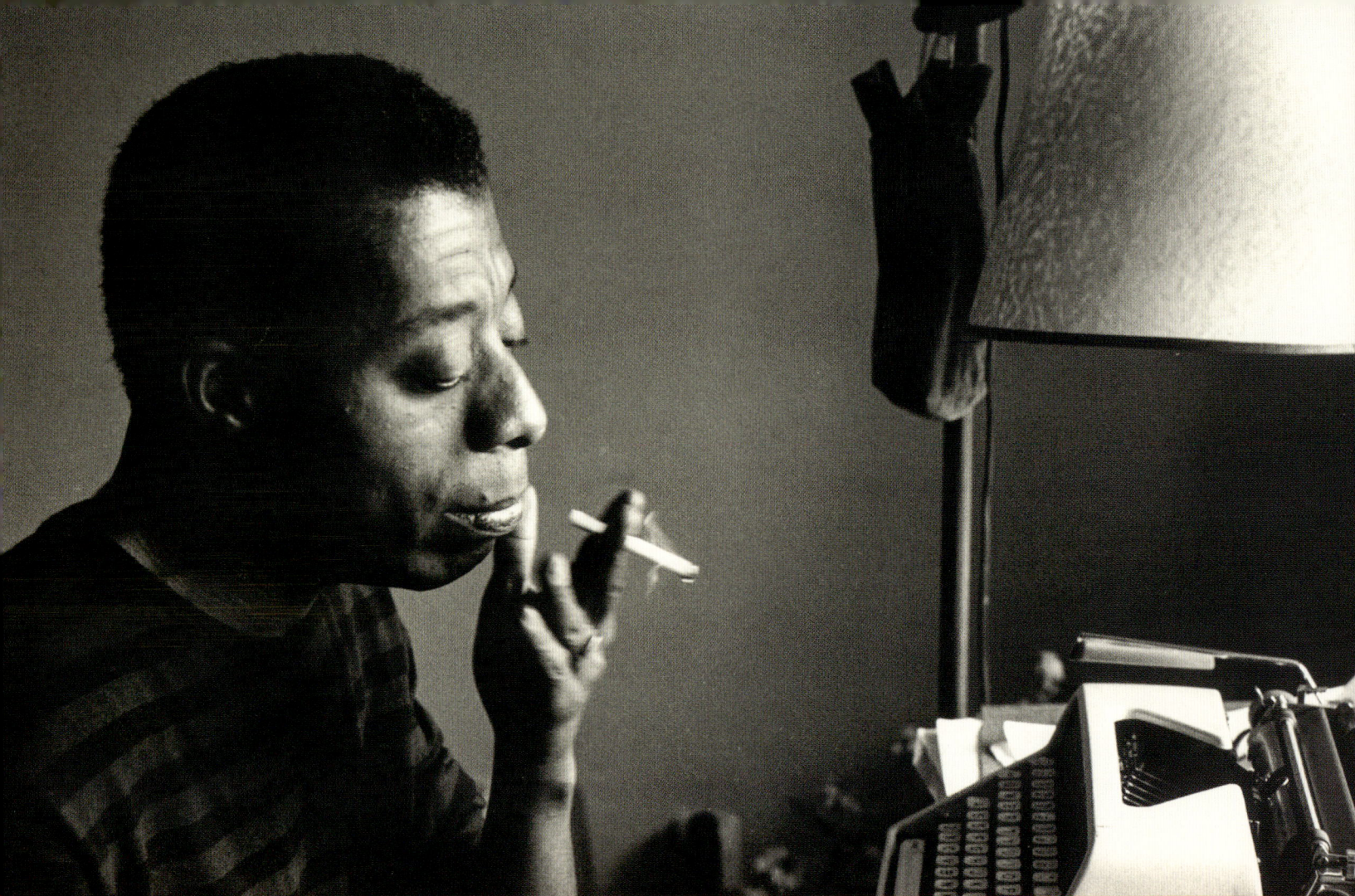

STUDS TERKEL: What do you mean by a "sense of history"?

JAMES BALDWIN: Well, you read something that you thought only happened to you, and you discovered it happened a hundred years ago to Dostoyevsky. This is a … great liberation for the suffering, struggling person, who always thinks that he is alone.

TERKEL: What do you mean by a "sense of tragedy"?

BALDWIN: People think that a sense of tragedy is a kind of … embroidery, something irrelevant, that you can take or leave. But, in fact, it is a necessity. That's what the blues and spirituals are all about. It is the ability to look on things as they are and survive your losses, or even not survive them—to know that your losses are coming. To know they are coming is the only possible insurance you have, a faint insurance, that you will survive them.

—Studs Terkel interviewing James Baldwin, WFMT radio station, Chicago, 1961

African American history has never been a story for the faint-hearted or for those who seek a past that will merely please or entertain them, although it sometimes does both. The African American past comes to us laden with both enlightenment and terror, encompassing equal parts of slavery and freedom, racism and humanity, unspeakable oppression and unfathomable courage, guilt and responsibility, and travail and triumph. It was created by human beings who died for the American flag and by those who fought against every vestige of American hypocrisy. It is a turbulent, fascinating history that reflects all shades of color and was made by all manner of heroes and villains. It is a history, like all others, as James Baldwin might insist, of enormous and recurring loss, but also of exhilarating victories. In 1962, six months after giving the radio interview to Studs Terkel quoted at left, Baldwin wrote an article in the *New York Times* entitled "As Much Truth as One Can Bear." He lamented that as Americans reflect on their history, too often "words are mostly used to cover the sleeper, not to wake him up." The African American experience should always awaken the sleeper.

WISE WORDS The grandson of an enslaved man, the writer James Baldwin articulated the subtleties of the African American experience, even though he spent long periods of his life in Europe. "Once you find yourself in another civilization," he said, "you are forced to examine your own."

A Sense of Place and Loss

The story begins in countless villages and cities along coasts and rivers in Africa. Along a coastline of some 3,500 miles, from the Senegambia river basin in West Africa to Angola in southwest Africa, at least 12.5 million Africans of enormous cultural diversity were deported to the Americas over a period of nearly four centuries. It was the largest forced transoceanic migration of human beings in history. By 1650, Africans formed the majority of all settlers in the Americas, and by the Age of Revolution, in the late eighteenth century, more Africans had migrated to the Americas than Europeans. In the 1770s, African- and American-born black people formed 20 percent of the population of the new United States.

There are 140 known ports of embarkation for the slave trade in Africa. Some are now teeming cities, and others are not much more than a collection of stone relics from a haunted past. They include Luanda, the capital of Angola (where almost 3 million Africans embarked); Ouidah, Benin (1.4 million); and, with hundreds of thousands of enslaved people in each of their counts, coastal sites such as Benguela and Cabinda in Angola; Bonny, Lagos, and Old Calabar in Nigeria; Cape Coast Castle and Elmina Castle in Ghana; Saint-Louis in Senegal; and the Sierra Leone Estuary.

THE TRANSATLANTIC TRADE At least 12.5 million people were trafficked from Africa to the Americas between the 1400s and the 1800s. It was the largest forced migration in human history. They boarded ships along the coast of West Africa: 750,000 people were taken from Senegambia, 389,000 from Sierra Leone, 337,000 from the Windward Coast, 1,209,000 from the Gold Coast, 1,999,000 from the Bight of Benin, 1,595,000 from the Bight of Biafra, 5,695,000 from West Central Africa, and 543,000 from Southeast Africa and Madagascar.

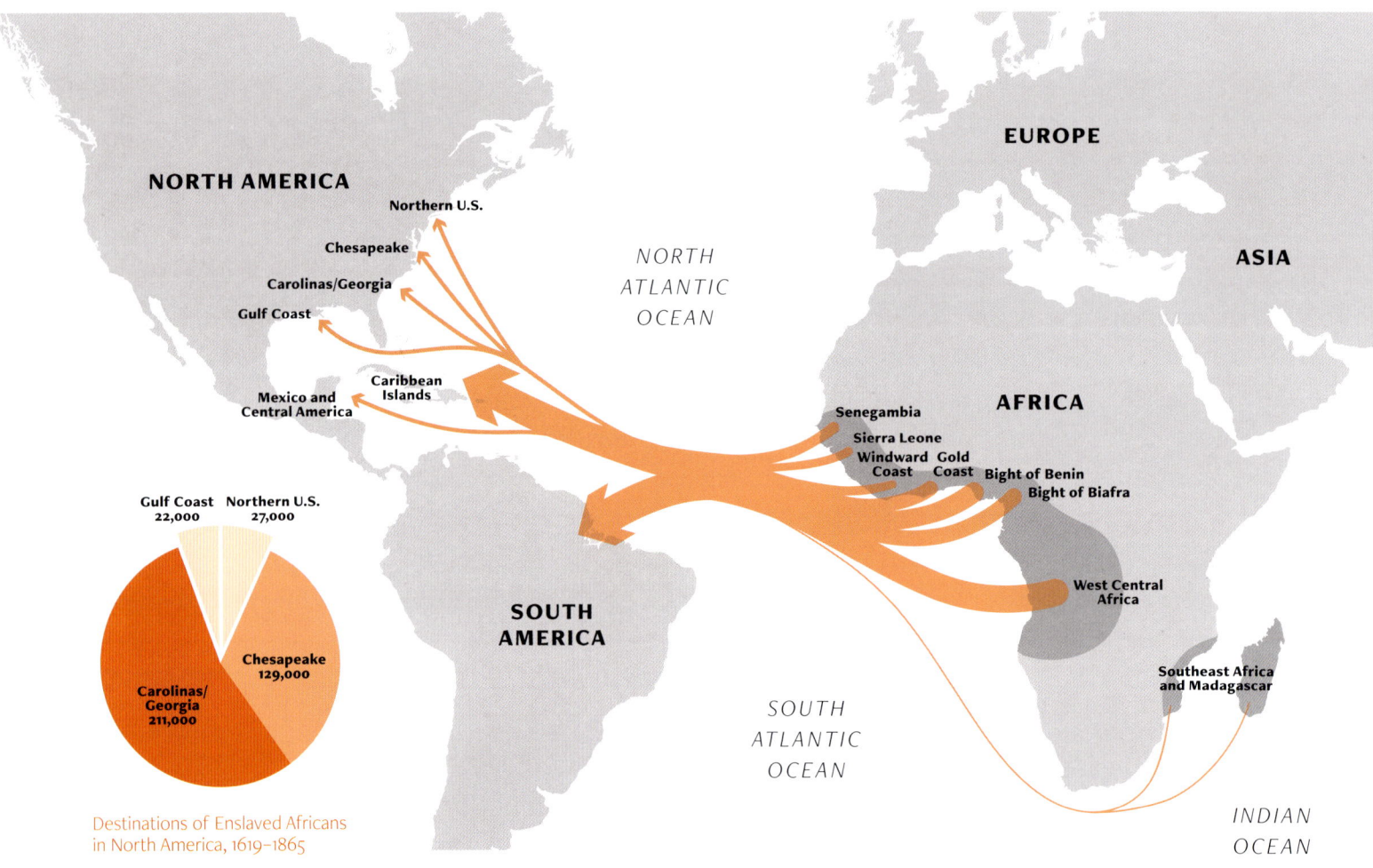

Destinations of Enslaved Africans in North America, 1619–1865

Visions hoodoo holler here; landscapes,
the march, Almina Castle, Gold Coast,
the sea, churning voices; landscapes,
twisted with little hollow places
estuaries where spirits linger;
our eyes press against the red glow of horizons.

—Larry Neal, from "Libations for Olorun," 1974

ELMINA CASTLE Enslaved people were housed in the cells of Elmina Castle, in Ghana, before being transported by ship to various ports along the transatlantic slave trade route.

The Portuguese first landed slave-seeking expeditions along the northwest coast of Africa in the 1440s. With time, they moved south and then east all the way to the Bight of Benin. At Elmina, on the coast of Ghana, in the region Europeans came to know as the Gold Coast, they initially sought to establish a trading base near the gold mines of the interior before their attention turned to slaves. Other European nations—Spain, France, Holland, and England—did the same from the fifteenth through the eighteenth centuries, creating some fifty slave-trading forts and many other outposts.

The oldest surviving edifice among the slave stations built to process the African captives is Elmina Castle. Built by the Portuguese in 1482, it was designed to face the sea while its rear walls looked inland, toward vast rainforests, trade roads, and river systems. The presence of the large, square structure, then called São Jorge da Mina (St. George of the Mine), declared that Europeans had come to the coasts of Africa to stay and do

business. Described by one ship captain as "justly famous for its beauty and strength, having no equal in all the coasts of Guinea," Elmina became a model for many similar fortresses built over the next two centuries. Like all the slave ports, it was a crossroads of commerce, culture, and human bondage.

As gold supplies dwindled in the 1600s, the slave trade began to boom. In 1637, Elmina and the Gold Coast came under the control of the Dutch, who continued in the lucrative trade. By 1710, Elmina alone shipped thirty thousand slaves a year across the Atlantic to the Americas. Beneath the base of the castle, a large cistern supplied ships with fresh water, and from its waiting rooms thousands of African slaves filled ships bound for the Americas. Its vaulted cellars, wrote one captain in 1732, could "easily hold a thousand slaves." African captives, who had often been brought to Elmina on foot from hundreds of miles inland, entered the imposing structure across a drawbridge spanning a moat. In a large, open courtyard, they were inspected, branded, and forced to exercise. Often they waited weeks while the ships were fitted out in the harbor, wracked with fear and agony as they faced a strange and unknown fate. When the ships were ready, the captives entered a hell in motion, a savage commerce in flesh.

Vastness and Villages

Africa is the second-largest continent on Earth; the whole of the continental United States would fit inside North Africa alone. Africa's 11,635,000 square miles straddle the four hemispheres and are part of three broad cultural worlds: the Middle East, the Mediterranean, and the sub-Sahara. In the fifteenth and sixteenth centuries, most West Africans lived in agricultural communities; their villages, whether rooted in farming or coastal fishing, were the centers of their lives. They drew their identities from their language groups and from mores and practices that for generations had shaped their

"I had never heard of white men or Europeans, nor of the sea."

—OLAUDAH EQUIANO, *The Life of Olaudah Equiano,* **1789**

exploitation of land, livestock, and water trade routes. Life and aspiration were determined by the natural environment and village institutions. An estimated eight hundred languages and dialects were spoken (most were oral traditions and not written), giving Africa the greatest linguistic diversity in the world.

Olaudah Equiano, whose memoir recounts his kidnapping from the Niger River Valley village of Essake (today Esseke) as an eleven-year-old boy in the 1750s, described the isolation of such a community: "The manners and government of a people who have little commerce with other countries are generally very simple; and the history of what passes in one family or village may serve as a specimen of the nation." Yet many African

OLAUDAH EQUIANO (ca. 1745–97)

The Life of Olaudah Equiano, or Gustavus Vassa, the African, Written by Himself, published in 1789, was the first full-length autobiography of an enslaved African. Beginning with an account of an idyllic childhood in West Africa, it goes on to describe the writer's brutal abduction, the horrors of the Middle Passage, and life as a slave in the West Indies and the American colonies.

In 1766, Equiano bought his liberty for seventy pounds. He spent the next ten years as a sailor, merchant, and explorer, traveling to the Mediterranean and to the Arctic. At one point, he managed a plantation on the Mosquito Coast that relied on slave labor. Equiano had become an abolitionist by the time he wrote his book, which became a testimony for the abolitionist movement. In 1999, historian Vincent Carretta found evidence that Equiano was born enslaved in South Carolina rather than in Africa and that much of the book is suggestive of African traditions of oral histories passed between generations.

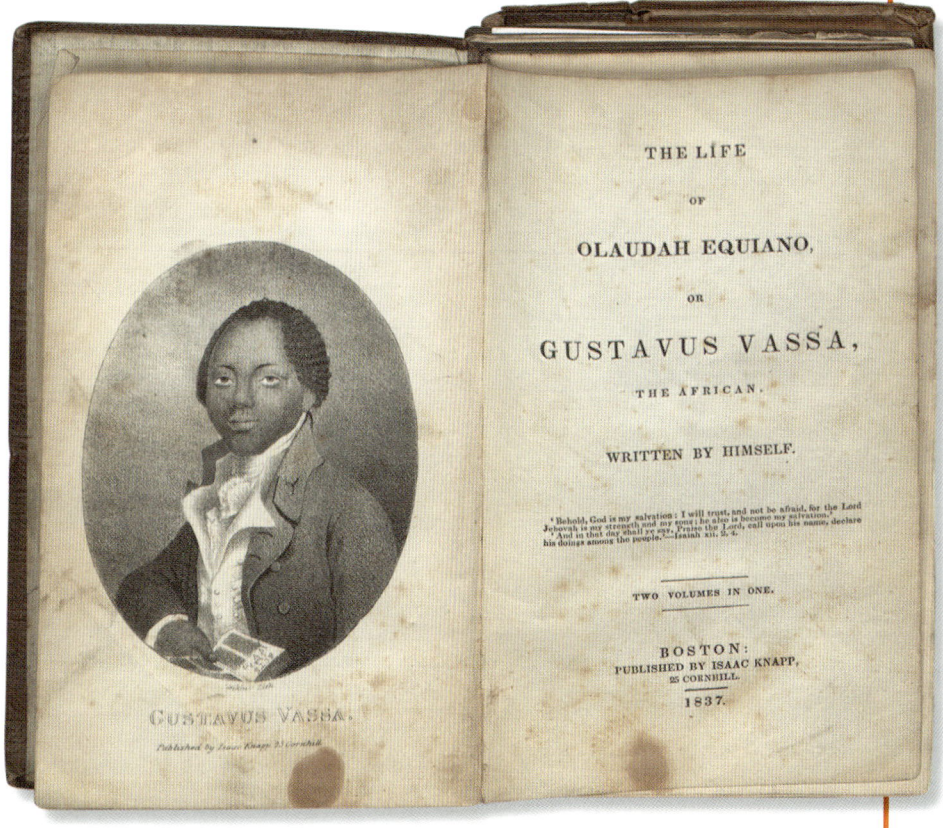

peoples and their leaders were experienced traders, connected to far-reaching markets. From the latitude of the Gambia River all the way south to the Congo, most of the African coast was densely populated, heavily forested, and laced with waterways that produced rich interregional trade. Trade networks, plied by large fleets of canoes carrying all manner of agricultural products, hardwoods, palm oil, spices, kola nuts, fish, and slaves, had existed long before the Portuguese mariners landed.

The Portuguese engaged in cultural interaction and intermarriage as well as trade with the Africans, establishing unique communities. This new group of Luso-Africans—people of Portuguese and African descent, often converts to Catholicism who still practiced some elements of indigenous African religions—formed a powerful merchant elite and were some of the first African-born people to travel freely to the Americas. Known as the Tangomaos to the Portuguese, they spoke a syncretic language sometimes called Guinea speech or Negro speech.

By the early 1700s, Luso-Africans numbered several hundred at Elmina, and there were hundreds more at similar forts down the coast to the Congo and Angola. As the African trade boomed, these creoles, as they were known, swelled the population of major

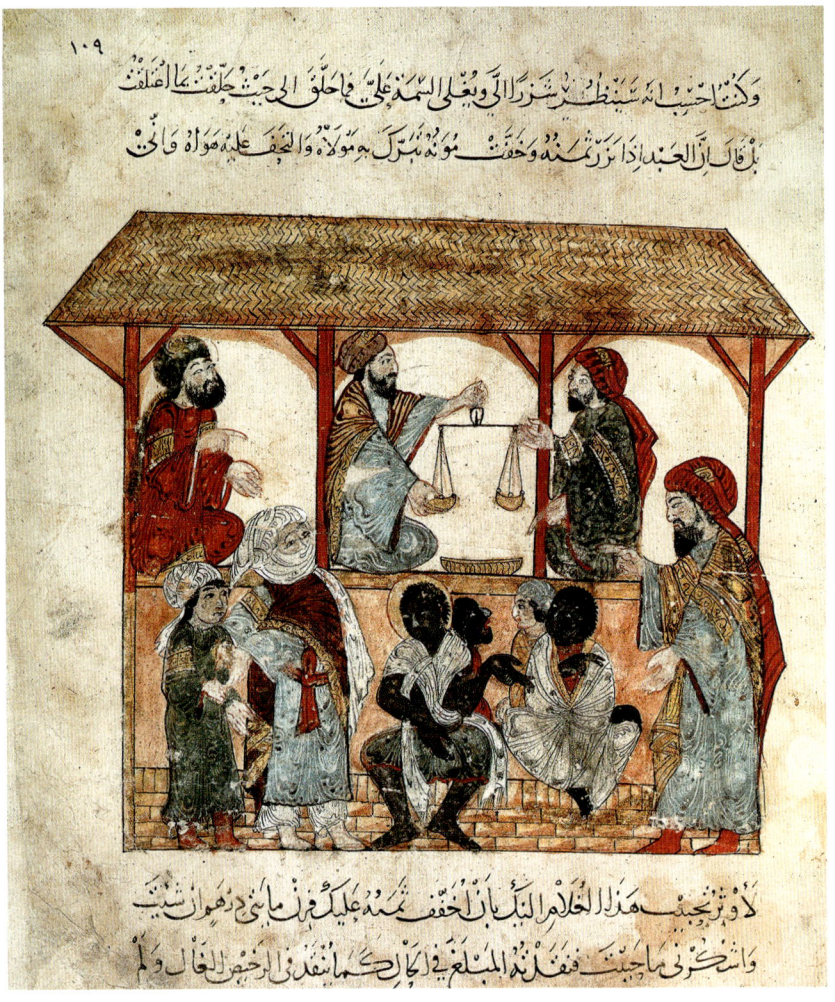

European capitals; approximately ten thousand black people, both slave and free, of differing hues (10 percent of the population) resided in Lisbon in the 1550s. This was the start of a cultural and genetic fusion that spread all over the Atlantic world for four centuries.

As trade developed, outsiders moved south through Africa. In the north, at the edges of the Sahara, the drylands sustained societies of herdsmen who traveled almost constantly in search of fresh pasture for their cattle. In the savannas, settled agriculture flourished alongside trade with Islamic peoples from the Sahara and farther east. In these regions, Muslim and traditional African cultures had collided, made war, and mixed since the ninth century.

As Islam filtered down through West Africa via merchants and a military class tasked with carving out routes, it facilitated greater trade, introducing the African elite to useful tools such as a written means of record keeping. West African kings traded gold, ivory, and slaves, often captured in battle, in return for salt, metal goods, and weapons. Most northbound trans-Saharan caravans included some slaves—sometimes as many as several hundred—generally destined for

THE SLAVE SOUK In the Middle Ages, Arab slave traders sold captives from sub-Saharan Africa at markets in Morocco, Tunis, Algiers, Cairo, the Arabian Peninsula, and India. This illustration from around 1300 depicts a slave market in Yemen.

domestic or military service in North Africa or the Mediterranean. Islamic principles forbade only the enslavement of other free-born Muslims, not those of other faiths.

Highly developed, polytheistic religions among Africans encouraged a belief in spirits and gods who governed everything from the arrival of the rains and the fertility of women to the outcomes of wars and the fortunes of daily commerce. Traditional African religions tended to place faith in society; a divining priest might bless a harvest, a wedding, a trading arrangement, a fleet of fishing boats, and diseased cattle all in one day. Gods lived in people's everyday lives. Ceremonial dance and music were almost universal practices in family and village life. Such strong beliefs and mores helped sustain the millions who were enslaved and transported to the Americas as they struggled to survive.

Modern ethnographers have divided West African peoples into numerous ethnic and linguistic groups, including the Yoruba of modern southern Nigeria; the Igbo, Akan, and Asante of Ghana; the Fulani, who were spread throughout West Africa; the Ejagham of eastern Nigeria and Cameroon; the Mende and Mandinka of Senegal and Gambia; and the Fon and Ewe of the Bight of Benin region. These and many other ethnic groups were swept up in the crucible of the Atlantic slave trade. Yet most Africans would not

IGBO SHRINE FIGURE

(*opposite*) Many enslaved people were brought from Igbo villages in West Africa. Igbo called on their gods to protect them.

have considered themselves part of such ethnic groups, nor would they have identified as African any more than the Portuguese or Spanish traders who captured them would have called themselves European.

Origins and Nature of the Atlantic Slave Trade

Slavery has ancient roots. Forms of bond labor have existed in all world civilizations, including Africa in the fifteenth and sixteenth centuries. The well-worn notion that slavery is "America's original sin" is a historical idea. America's sins have been shared by societies wherever mines were to be worked, wherever great agricultural innovations have occurred, wherever land was plentiful and labor scarce, and wherever power was defined as the ownership and control of people. The stranger and the captive of war have been fated for bondage throughout history. All of this was as true in Africa as elsewhere.

As historians have shown, Africans were not merely "exploited junior partners" in the slave trade. Most African states were fragmented political units, often no larger than an American county. Competition over resources and trade was rampant among states. Moreover, while land in Africa was rarely privately owned, slaves were. Slaves were essential, productive property in the domestic economy. Wars of conquest, therefore, tended to be about people, cattle, tribute, and loot, and not about territory. With only a few exceptions, during the entire age of the slave trade, Europeans did not "conquer" any African societies. They built a trade in slaves for the world market in partnership with Africans.

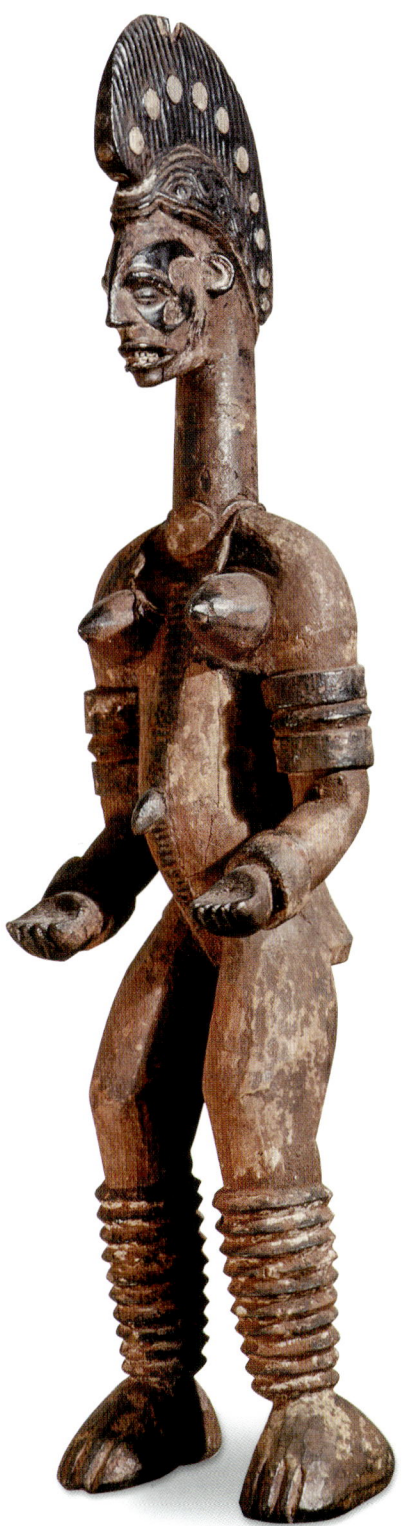

By 1472, Portuguese sea captains had reached the Bight of Benin, and the commerce in slaves began to boom. In 1492, Christopher Columbus sailed for the Spanish crown and reached the West Indies, encountering New World lands that would soon transform the lives of millions of Africans. The Portuguese made landfall on the coast of Brazil in 1500 and the Spanish on Cuba in 1511; when the Spanish explorer Vasco Núñez de Balboa, whose crew included at least one African slave (named Nuflo de Olano), reached the Pacific Ocean by traveling through the Isthmus of Panama in 1513, the scramble for the Americas and the labor to exploit them was on. A slow but certain commodification of people took place on both sides of the Atlantic.

The British and the French were not officially interested in slave trading in the fifteenth and sixteenth centuries: they had not yet established their Caribbean colonies. In 1562, however, an English pirate, John Hawkins, did manage to break the Portuguese and Spanish monopoly of the slave trade. On a voyage with three ships, he secured two hundred slaves along the Guinea coast and transported them to Hispaniola in the West Indies, returning to England laden with goods and raw materials. This "Great Circuit" trade, sometimes called the Triangular Trade, was a precursor of things to come a century and a half later, when the British would dominate the slaving business.

Africa consisted of deeply stratified, feudal societies with many forms of slavery, including chattel—personal property. Most West African societies from the fifteenth through the eighteenth centuries were small states ruled by monarchs, who gained prestige and power by controlling people and developing extensive kinship networks of wives, children, and dependents, including slaves. African rulers commanded their slaves'

labor or service, as well as their bodies, in exchange for security and protection. As a Yoruba (Niger River Valley) proverb says, "A man cannot sit alone and be a chief." These political systems required such dependents to be continually replenished. Rulers often owned hundreds of people who would serve as wives, agricultural workers, porters, soldiers, oarsmen, servants at court, trading agents, and retainers. Political and social power in a region rested with those who could command the largest numbers of kinsmen and dependents. "The slaves and masters in this country," wrote Samuel Crowther, an African bishop and former slave freed by an anti-slavery patrol during his passage to the Americas and then educated in Britain, "live together as a family; they eat out of the same bowl, use the same dress in common and in many instances are intimate companions."

At best, African slaves might be a ruler's kinsmen, who over time would rise to full freedom and status in this occasionally fluid social structure, but under commercial pressure they could also be sold as disposable assets. While Europeans came from production economies where business was calculated in currency prices and items were worth more or less money, Africans lived in exchange economies where things were valued for their usefulness. A certain quantity of grain would equal so much cloth, or one slave, or three horses. The African economic world was a barter system, and it was largely on this basis that the slave trade evolved in its deadly but mutually exploitative ways.

European pressure met with African response. African rulers sought new ways of getting and selling people to the slave traders, and in greater numbers, in order to acquire manufactured goods and technology. The regularization of African demand for European products, especially firearms, created competition among African kingdoms and systematic efforts within Africa to increase the supply of slaves through raiding and warfare.

With the exception of the Portuguese in Angola, Europeans and their middlemen seldom ventured inland or actively participated in the raids that seized slaves. They stayed on offshore islands or in coastal fortresses, where they set up shop as managers. Some kingdoms made increasingly aggressive war upon their neighbors in order to obtain slaves for the ocean trade, and some captives emerged from a variety of judicial procedures in which the punishment for certain crimes was sale into slavery and transport to the coast.

The slave trade and its markets grew exponentially between the sixteenth and eighteenth centuries. African traders, conducting caravans of dozens, even hundreds of

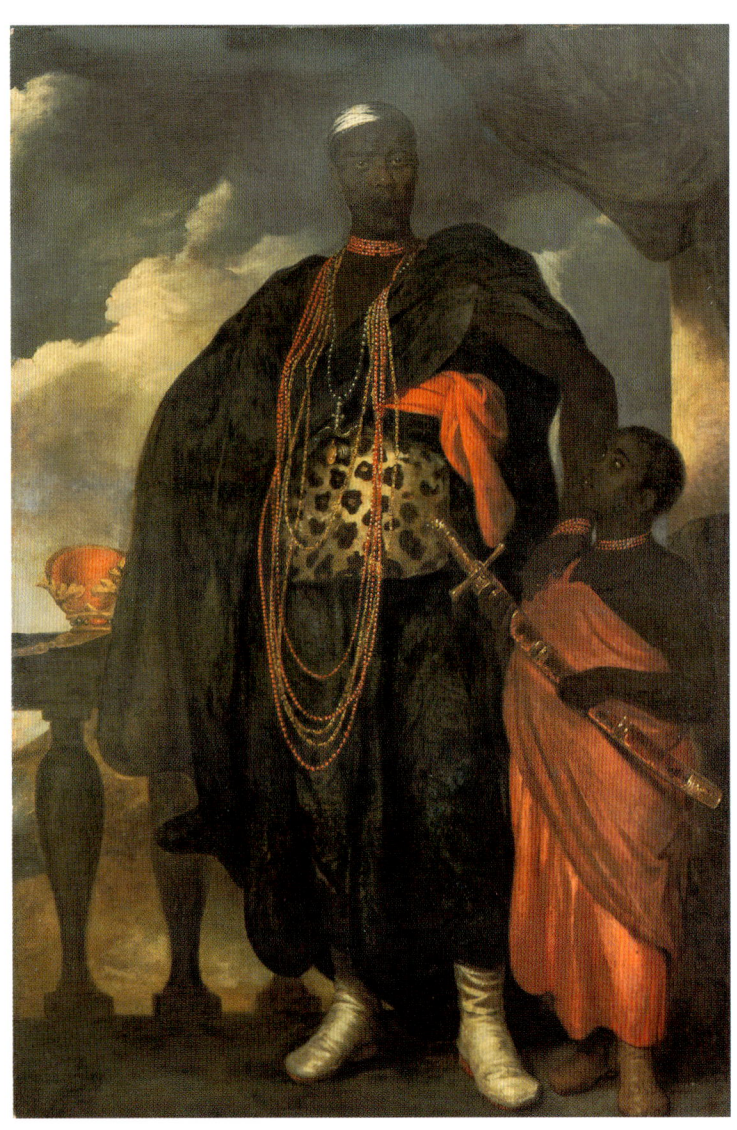

COMPLEX TRADE This portrait of an African chief is attributed to the Dutch artist Albert Eeckhout (1610–66). Numerous African rulers facilitated the trade in slaves.

captives in coffles—chained lines—trekked great distances toward the coasts as early as the 1600s. It was in this process that Olaudah Equiano (see page 21) said he became ensnared. Later, as a free man living in London, he described his capture in his autobiography: "One day, when all our people were gone out to their works as usual, and only I and my sister were left to mind the house, two men and a woman got over the walls, and in a moment seized us both, and without giving us time to cry out … they stopped our mouths, and ran off with us to the nearest wood." On the second day of his ordeal, bound and placed in a sack, Equiano was separated from his sister. Sold from one master to another, he contemplated escape but concluded in despair: "If I possibly could escape all animals, I could not those of the human kind; and that, not knowing the way, I must perish in the woods. Thus was I like the hunted deer."

Such violence and kidnapping might last a generation or so in one region and then move on to another. Some agricultural villages grew into slave market towns, such as one at the confluence of the Niger and Benué rivers near Igala in what is now Nigeria, where an estimated eleven thousand slaves were being sold each year by 1700. In 1795–96, Mungo Park, a Scottish explorer, traveled from the interior to the coast with a coffle of slaves captured in war. The slaves Park joined journeyed from the upper Niger River Valley westward to the mouth of the Gambia River. Park witnessed the full cruelty of these caravans and conversed freely with the slaves. They asked him if the European traders at the coast were cannibals. "They were very desirous to know," wrote Park, "what became of the slaves after they crossed the salt water. I told them they were employed in cultivating the land; but they would not believe me; and one of them, putting his hand on the ground, said to me … 'have you really got such ground as this to set your foot upon?'" The French Huguenot trader Jean Barbot described the slaves arriving in his midst at the coast in Senegal as "barbarously treated by their masters," their bodies covered with "scabs and wounds."

In such conditions of exposure, sickness, and psychological terror, and after weeks of travel, African slaves found themselves in "barracoons" at the coast, large pens or forts where they might spend months more awaiting sale. Equiano's autobiography describes a six-month ordeal of forced transport on land and on rivers to the port at Old Calabar in what is now southeastern Nigeria. He tells how he peered out at the harbor and beheld a terrifying fate: "The first object which saluted my eyes when I arrived on the coast was the sea, and a slave ship, which was then riding at anchor, and waiting for its cargo. These filled me with astonishment, which was soon converted into terror when I was carried on board. I was immediately handled and tossed up to see if I were sound by some of the crew." Thus dehumanized, rendered a piece of commerce, Equiano would have been one of approximately fifty-three thousand Africans enslaved and transported to the New World each year in the 1750s.

The actual sale of slaves was the result of negotiation and bargaining. It was common for a slave ship to sail down the African coast, stopping at several estuaries, trading

FAVORED CURRENCY Glass beads were in high demand in Africa, where they were sometimes used as currency to buy slaves. Cheap to produce, they were made according to local preference and came in many different colors and styles.

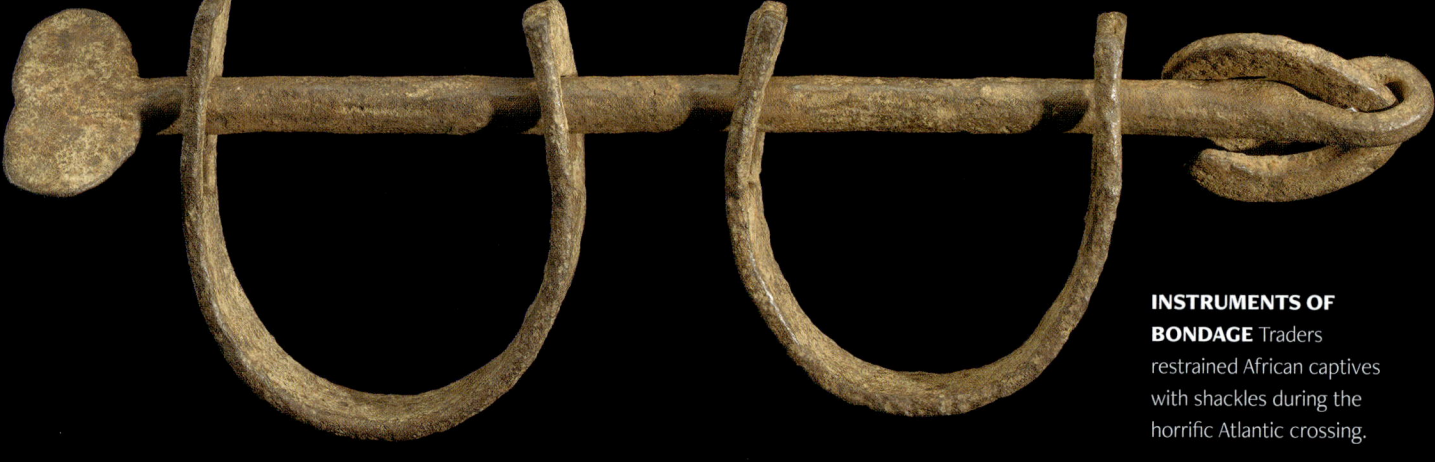

ENSLAVED MARCH Victims captured in the interior of Africa were marched to the coast in a coffle connected by chains and iron collars. Those who died on the way were left where they fell, as shown in this American engraving of 1868.

INSTRUMENTS OF BONDAGE Traders restrained African captives with shackles during the horrific Atlantic crossing.

for a dozen slaves here or twenty more there until its captain could declare his hold full for the Atlantic voyage. Sometimes the act of sale was conducted on the deck of the ship itself. One enslaved man who lived to write of his experience, Venture Smith, recollected boarding his ship of fate at Anomabu, on the Gold Coast, in the 1740s. "All of us were then put into the castle and kept for market," he wrote later as a resident of Connecticut. "At a certain time I and other prisoners were put on board a canoe … and rowed away to the vessel belonging to Rhode Island.… While we were going to the vessel, our master told us all to appear to the best possible advantage for sale. I was bought on board by one Robert Mumford, a steward of said vessel, for four gallons of rum, and a piece of calico, and called Venture, on account of his having purchased me with his own private venture. Thus I came by my name."

In ships with names such as *Esperanza*, *Jesus*, *Mercy*, and *Liberty*, Africans journeyed through horror as unwilling immigrants to build the economies and cultures of the Americas. They watered the ground of Africa for the last time with their blood, sweat, and

"Rudely forced, they were, nevertheless, destined to help create a new world, to become the founding fathers and mothers of a new people."
—NATHAN HUGGINS, historian, *Black Odyssey*, 1977

tears, dying or living through a massive historical upheaval. The historian Nathan Huggins lyrically captured the catastrophe of being pushed outside the orbit of one's known universe. "None would have willed it so," wrote Huggins. "None, beforehand, could have imagined the awful agony to be endured—the separation from all that they were, the voyage into empty space, the trials of adjustment to a new life."

The Middle Passage

Slave ships were the creations of cold, capitalist calculations, the reeking, white-sailed messengers of European ambitions. They fed the American colonies with labor and then brought the lucre of the Indies back to Europe. But they were also dungeons bobbing on the water, torture chambers with the power to destroy or corrupt everyone and everything they touched. In the age of sail, nothing fueled the capitalist revolutions in the Atlantic quite like the slave ships.

The "Middle Passage" was the name given to the second leg of the triangular journey among Europe, Africa, and the Americas. It was the most dangerous section of these epic voyages; the slaves' survival depended on the journey's success and duration, as did the profits of investors. Slave ship companies were state-sponsored enterprises as well as private businesses. Crown-sanctioned monopolies were granted to certain companies, and great houses and fortunes were amassed in the major slave-trading ports of Liverpool,

London, and Bristol in England; Nantes in France; Lisbon in Portugal; Seville in Spain; Middelburg in Holland; and Charleston and Providence in North America.

The typical slave trader might undertake many types of commerce—whaling, banking, and the China trade as well as slaves—and sometimes owned plantations in the West Indies or Brazil. Often partnerships of venture capitalists financed slave ships, and many owner-merchants started as ship captains. So crucial was the slave trade to the economy of the city of Liverpool in the 1700s that sculpted heads of slaves still decorate a frieze on the facade of its town hall, built in 1754 during the height of the trade. On the American side of the Atlantic, many prominent families, including the Brown family of Rhode Island (founders of Brown University), accumulated their wealth in the slave trade. All European religions were involved in human commerce, and many slave traders or financiers were members of the British Parliament or the U.S. Congress or were deputies of the National Assembly in post-Revolutionary France, which required labor for its sugar-producing islands in the Caribbean.

As the trade became regularized, shipbuilders designed vessels to carry larger cargoes of captives. A French critic of the slave trade, Guillaume-Thomas Raynal (1713–96), known by his clerical title Abbé Raynal, wrote satirically in 1782 about the builders of the ships. "Look at that shipbuilder," said Raynal, "who, bent over his desk, determines, his pen in hand, how many crimes he can make occur on the coast of Guinea; who examines at leisure the number of guns he will have need to obtain a black, how many chains he will need to have him garroted on his ship, how many strokes of the whip to make him work." Most slave ships did not last very long; the sea was a cruel master, and a single vessel rarely made more than six or seven full voyages.

The full triangular voyage typically took fifteen to eighteen months, and the average ship captain usually completed no more than three or four full Atlantic circuits in a lifetime. British ships on the Middle Passage averaged forty-four days from the African coast to Barbados in the seventeenth century. Some fast or lucky ships crossed in twenty-five to thirty days, but many more unlucky ones endured ghastly voyages that took several months due to storms, unfavorable winds, or incompetent captains.

Over time a debate developed among captains and companies over the relative benefits of "tight-packing" or "loose-packing" slaves. Small ships carried as few as 150 slaves, but large eighteenth-century ships embarked with as many as 600 to 700 people in their holds. By the 1780s, the peak years of the slave trade, when nearly 89,000 Africans were

MARKERS OF ENSLAVEMENT

Dating from the 1820s, these pewter and copper buttons were worn by the enslaved and engraved with the name or initials of slave trader Thomas Porter, suggesting that Porter trafficked slaves after the 1808 ban in the United States.

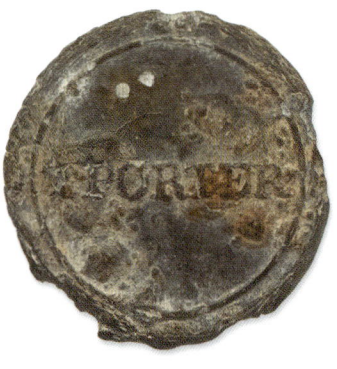
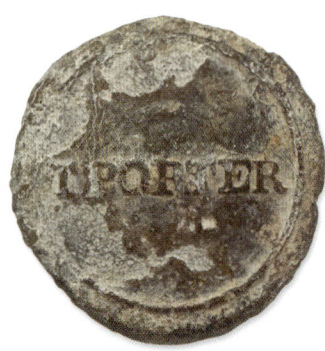
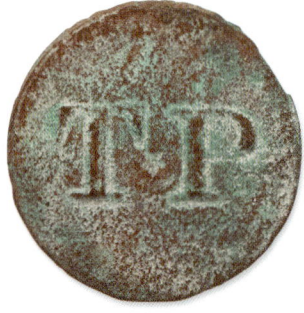
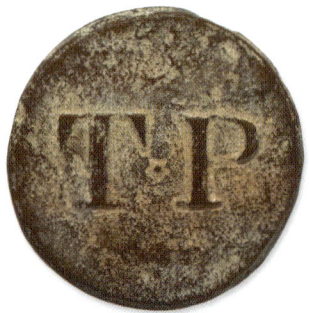

A MOST CRYING EVIL

Rex M. Ellis

During the last quarter of the eighteenth century, nearly 750,000 enslaved men, women, and children left Africa on British ships. About 90,000 Africans were captured and brought to the Americas each year, 42,000 of them on vessels from Great Britain, the leader in transporting human cargo.

The Atlantic crossing was dangerous for both the ship's crew and the captives, but shackled Africans packed tightly in the hold were particularly vulnerable. Congestion, contagions, terrible sanitation and ventilation, and poor nutrition made the slave ships floating dungeons of disease. The Africans suffered from dysentery, elephantiasis, friction sores from lying on wood, hookworm, leprosy, malaria, measles, scurvy, smallpox, sleeping sickness, tapeworm, typhoid fever, ulcers, yellow fever, and extensive injuries from accidents, fights, and abuse.

Enter Sir William Dolben, an Oxford-educated member of the House of Commons and an abolitionist. After visiting a slave ship docked at the Port of London in 1788, he was so horrified by the conditions that he pressed for immediate action against what he termed a "most crying evil." Dolben argued that at least ten thousand lives would be lost if Parliament did not act to improve conditions on the ships before the end of its legislative session. In a matter of months, he pushed through the first British legislation to regulate the treatment of captives on slave ships.

Under the Slave Trade Regulation Act of 1788, the ship's cargo capacity governed the number of enslaved Africans whom British ships could transport. Moreover, the act required a ship physician to certify the number of captives onboard and the vessel's compliance with regulations. It also established a bonus system for the crew if fewer than 3 percent of captives died during the voyage. The act reflected the growing abolitionist movement in England and relieved some of the overcrowding, but it was too little, too late. Some shipping companies flouted the law, and others made little effort to improve the treatment of their human cargo. It was not until Britain abolished the slave trade in 1807 that this "most crying evil" came to an end.

SHIP OF SORROW A diagram of the lower deck of a transatlantic slave ship illustrates the traders' method of cramming the maximum number of human beings into the hold. Often shackled together in the cramped, unsanitary conditions, the captives suffered disease, injuries, and death.

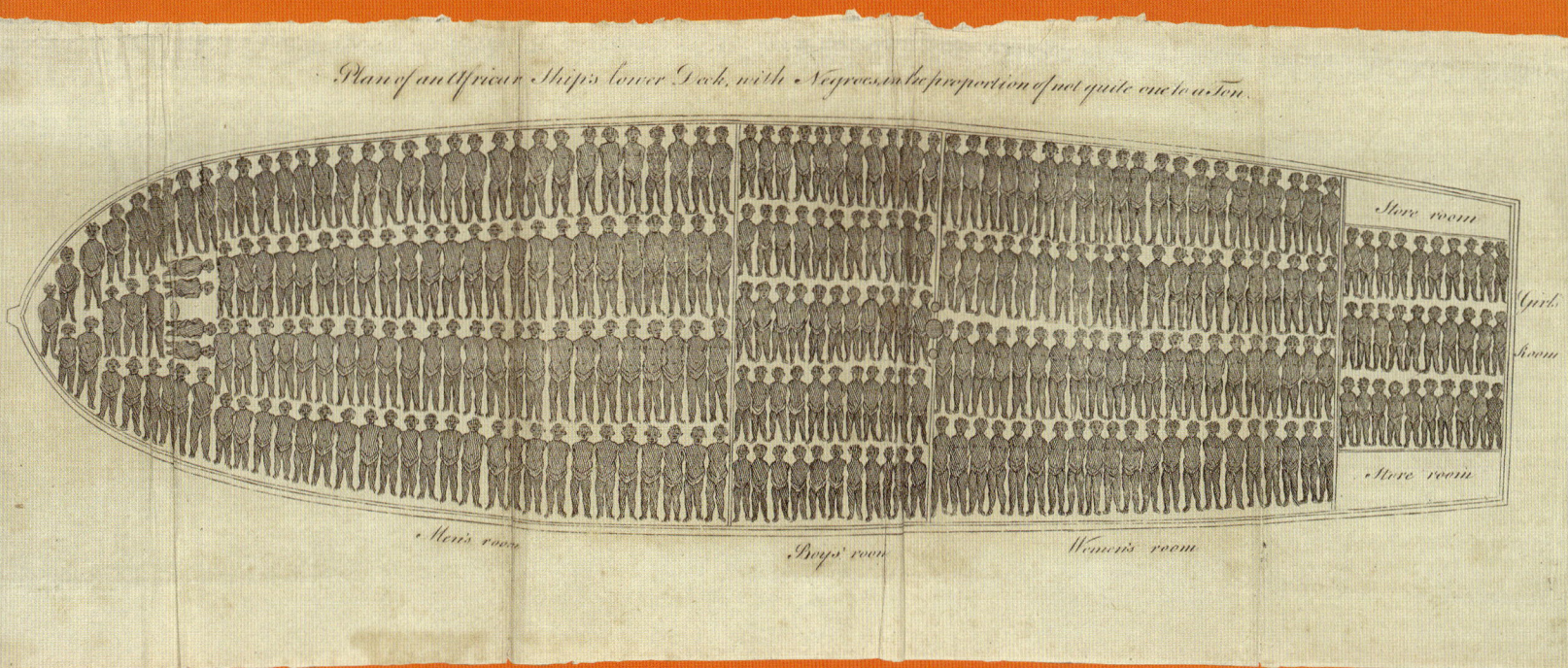

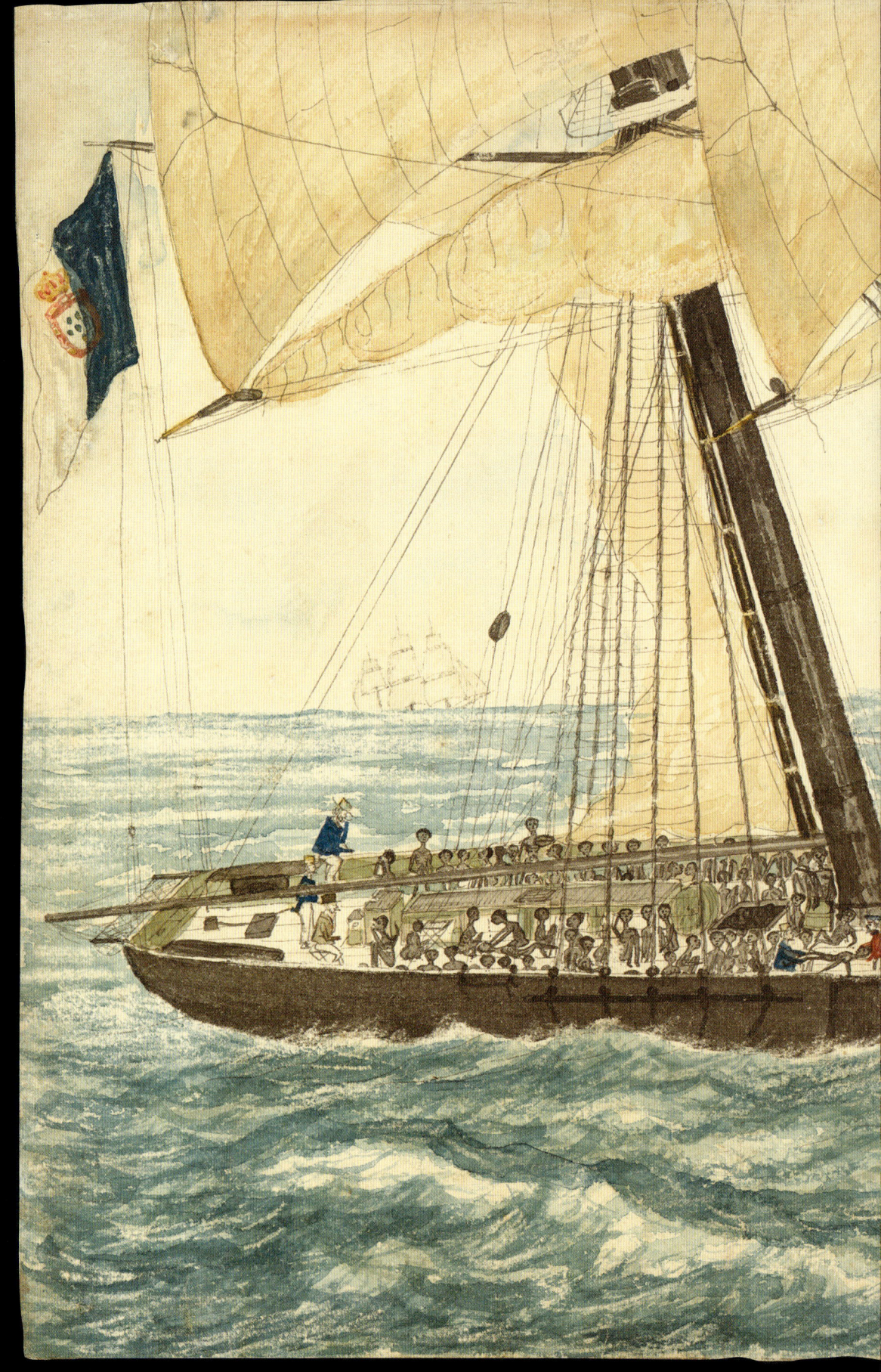

ILLEGAL TRADE The slave trade continued after its official abolition. In 1838, the British Navy intercepted the illegal Portuguese slaver *Diligente* and freed the enslaved people onboard. This watercolor was painted from direct observation by Lieutenant Henry Samuel Hawker, a British officer.

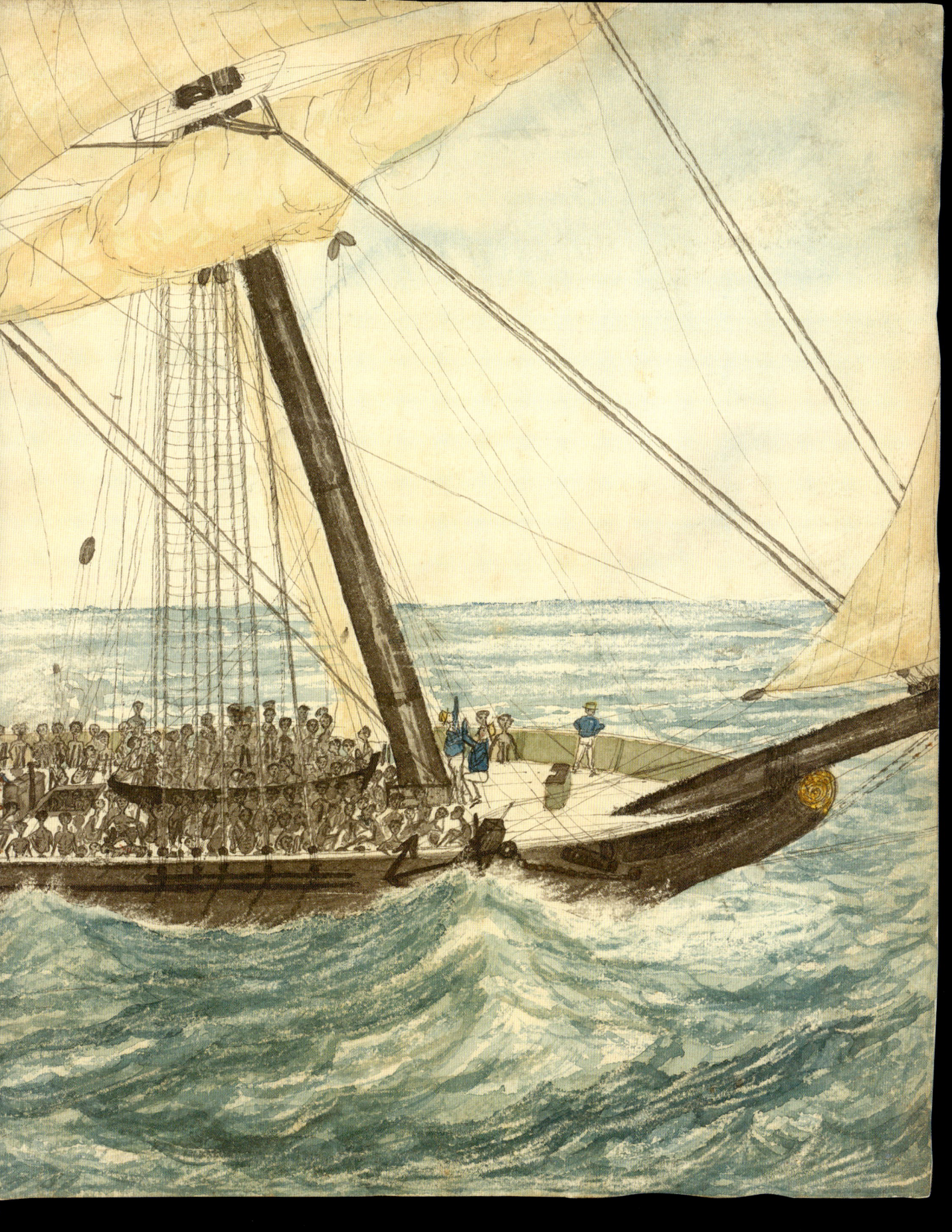

transported to American ports each year, the tight-packers had won the argument. Ever more elaborate chains were used to fasten men, women, and children in place in the holds. Forced exercise and singing on deck, as well as punishments and forced feeding for the despondent, were routine. The vessels became incubators of diseases, especially dysentery.

The large majority of enslaved Africans survived to set foot in the Americas, but death rates on the ships were high. In one nine-year period, 1680–88, the Royal Africa Company reported 24 percent mortality. By the early 1700s, the rate had fallen to an average of 10 percent. The French reported their highest annual death rate, 32 percent, in 1732 and their lowest, 5 percent, in 1746. The average mortality rate over nearly four centuries of the Atlantic slave trade was probably 12 to 15 percent on the sea voyage alone. The thirty-five thousand or more slave ships that made the Atlantic crossing to bring black labor to the Americas left the bones of at least 1.5 million Africans on the ocean floor. While many died from disease, others succumbed to suicidal despair. As historian Stephanie Smallwood has shown, African slaves were denied not only life, but also their conception of a "fully realized death," in which they could be laid in the ground of their villages, properly mourned, and connected to "the realm of the ancestors."

DESTROYED FAMILIES

An illustration from British writer Amelia Opie's 1826 anti-slavery poem "The Black Man's Lament" depicts the violent separation of an African man from his family and homeland.

Although burdened with confusion, fear, and physical debility, Africans did not easily acquiesce to their enslavement. Evidence from 1650 to 1860 shows that shipboard revolts may have occurred on about 10 percent of all slave ships. (Although the United States prohibited international slave trading in 1808, the Atlantic trade continued illegally through the mid-1800s to countries such as Brazil and Cuba.) A large database encompassing 27,000 ships' records for the British, French, and Dutch slavers lists 485 acts of violence by Africans against slave ships or the long boats used on the coast, and 392 cases of actual shipboard revolt. From such data, historians have concluded that approximately 1 percent of the slaves in the Atlantic trade died as a result of revolt—exceeding 100,000 in total. Most of the recorded revolts occurred while ships were moored off the African coast during the process of purchase and loading, when captives could still imagine finding their way back to their homelands.

To deal with potential insurrection, slave ships increasingly carried many more crewmen than other vessels did. They were equipped with cannon, swivel guns, elaborate netting, and a variety of barricades and constraints. Such measures drove up operating costs by an estimated 18 percent; historians have calculated that because of this, the number of slaves transported to the Americas was reduced by as many as one million over the entire history of the trade.

Historical evidence of revolt begins to help us understand the long, complex history of slave resistance. Words and imagination are sometimes all we have to enter this maritime world of human suffering. John Newton, a British slaving captain in the early 1750s who

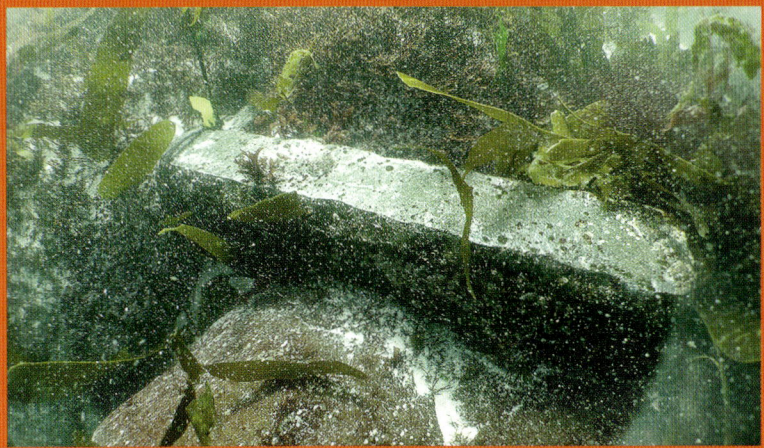

THE *SÃO JOSÉ* SLAVE SHIP WRECK Archaeologists study the remnants of the *São José* slave ship (*top*), which sank near South Africa's Cape of Good Hope in 1794, losing more than half of the four hundred enslaved people onboard. Copper nails and sheathing dated the ship to the late 1700s, while the discovery of iron ballast (*above left and right*), used to stabilize ships with unsteady human loads, identified it as a slave ship. The East African mangrove timber (*left*) was likely from the hull of the vessel.

Middle Passage (excerpt), 1962
Robert Hayden

Shuttles in the rocking loom of history,
the dark ships move, the dark ships move,
their bright ironical names
like jests of kindness on a murderer's mouth ...
weave toward New World littorals that are
mirage and myth and actual shore.

Voyage through death,
* voyage whose chartings are unlove.*

A charnel stench, effluvium of living death
spreads outward from the hold,
where the living and the dead, the horribly dying,
lie interlocked, lie foul with blood and excrement ...

But oh, the living look at you
with human eyes whose suffering accuses you,
whose hatred reaches through the swill of dark
to strike you like a leper's claw.

You cannot stare that hatred down
or chain the fear that stalks the watches
and breathes on you its fetid scorching breath;
cannot kill the deep immortal human wish,
the timeless will.

years later repented his past and became a minister and composer of the famous hymn "Amazing Grace," published a pamphlet that described conditions in the holds of a slave ship: "The cargo of a vessel of a hundred tons … is calculated to purchase from 220 to 250 slaves. Their lodging rooms below deck … are sometimes more than five feet high and sometimes less … the slaves lie in two rows, one above the other like books upon a shelf. … The poor creatures … are likewise in irons for the most part which makes it difficult for them to turn or move … without hurting themselves or each other." The slave trade could render everyone "blind," as Newton described in his famous lyrics. His experience as a slaver gave him good reason to exclaim, "Amazing grace! How sweet the sound that saved a wretch like me!"

"Every morning, perhaps, more instances than one are found of the living and the dead fastened together."
—JOHN NEWTON, slaving captain

Sometimes only through art and poetry can we gain access to the full agony of this story. In his poem "Middle Passage" (opposite), the modern American poet Robert Hayden captured the meaning of slave ships. The slave trade was a massive economic enterprise, rooted to the modern mind in enormous immorality and amorality, a story of vast human cruelty and exploitation that forged one of the foundations of capitalism and a tale of migration that brought African peoples and folkways to America. Hayden offered a poet's simple and timeless definition, stripped of any adornment, of the slave trade: a "voyage through death to life upon these shores."

The Charter Generations in Colonial America

The earliest recorded instance of Africans arriving in a permanent English settlement in North America comes from Jamestown, Virginia, in 1619. In a long letter recording the travails of the fledgling Virginia colony, John Rolfe, one of the settlement's leaders, offhandedly remarked: "About the last of August [1619] came in a dutch man of warre that sold us twenty negars." This momentous statement is a "first" of a kind, but other blacks had accompanied Spanish conquistadors almost a century earlier to the American South, and a muster roll in Jamestown from March 1619 recorded that approximately thirty-two enslaved Africans already lived in the colony. "How is it, *why* is it," asked historian Thomas Holt, "that when that Dutch warship laid anchor in Jamestown harbor, Africans were in the hold and Europeans were on the deck?" The answers, of course, were part of complex world economic forces, but in America it was also a *racial* story.

These first blacks were part of a slowly growing population that historian Ira Berlin called the "charter generations." By the early 1600s, mainland North America was on the periphery of the great mercantile European empires of the Atlantic. Many of the people of

PROTECTIVE AMULET In the seventeenth and eighteenth centuries, the Lobi people of West Africa hung miniature shackles barely an inch in size on their weapons to provide extra strength to resist slave traders.

color, mostly slaves, who arrived in North America were Atlantic creoles—people whose identities and skills with language and commerce made them especially useful in these frontier societies.

More than any other mainland colony, New Netherland (later New York) depended on slave labor. The Dutch West India Company, desperate for laborers, recruited people from all around the Atlantic world. By 1640, some one hundred blacks lived in New Amsterdam, composing 30 percent of the fledgling port's population. Many of them, though actually owned by the West India Company, identified with Dutch Reform Christianity, married and raised families, sued in Dutch courts, served in the militia, spoke Dutch, and were crucial to the colony's economy. The transatlantic character of these black New Amsterdamers is evident in many of their names, which reflect mixed racial and cultural heritage: Paulo d'Angola, Anthony Portuguese, Simon Congo, Jan Guinea, Van St. Thomas, Francisco van Capo Verde, and Palesa van Angola. The communal integration of New Netherland's first blacks gave them a unique degree of autonomy; in 1635, a group of them even traveled to Holland to petition the monarch for wages. By the time of the British conquest of New Amsterdam in 1664, one in five blacks had achieved freedom by manumission, purchase, or other negotiation.

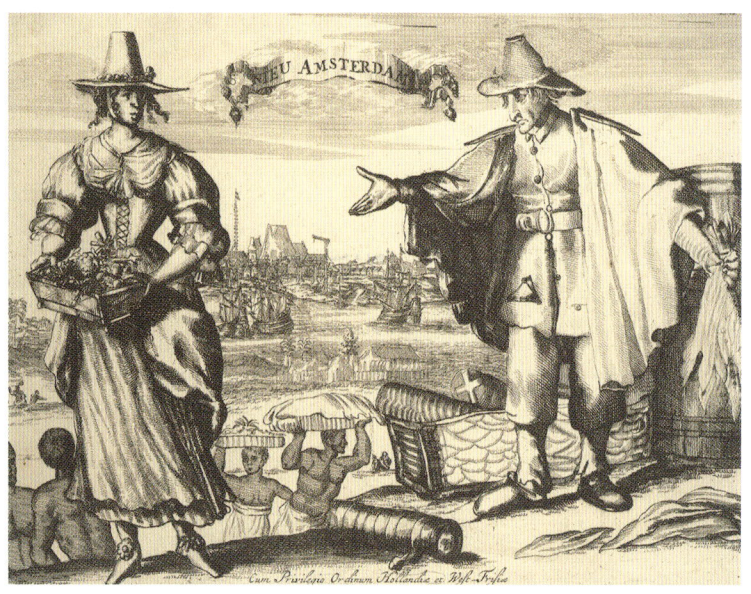

ENSLAVED LABOR The Dutch were active in the slave trade from the early 1600s. Enslaved labor was put to work in New Amsterdam on the southern tip of Manhattan Island, the seat of their trading colony in North America.

Charter-generation blacks helped to forge other colonial societies in North America. By 1665, in the Chesapeake colonies of Virginia and Maryland, before white indentured servitude declined, the black population was around 1,700. Like New Amsterdam to the north, this frontier population was fluid; a considerable amount of intermarriage occurred between servants and slaves. Moreover, this charter generation also included at least a few dozen free blacks, usually Atlantic creoles.

One member of the charter generations, "Anthony a Negro," who eventually became Anthony Johnson in his struggle to assimilate, made quite a name for himself. Sold at Jamestown in 1621, Johnson labored at the Bennett family plantation with such skill and determination that he was allowed to have his own farm and then his personal freedom. Johnson married, had children who were baptized as Christians, and eventually, by the 1650s, owned a substantial 250-acre estate as well as a few slaves to help him work it. One of those slaves, John Casar, fled, and Johnson successfully sued two neighboring white planters, the Parkers, for harboring or abetting his escape. In the early frontier setting of the Chesapeake, such a fluid social, legal, and racial system existed because the need for labor was so great that it trumped all other issues. Within a few decades, when tobacco emerged as Virginia's staple export crop and the British slave trade delivered African- or Caribbean-born slaves in large numbers, the Chesapeake charter generation, with its potential for status and property, ceased to exist.

In the lower Mississippi Valley, settled by the French but fought over by the English, Spanish, and various Native American groups, the charter generations enjoyed similar but longer patterns of fluidity. Indeed, by the early 1700s, New Orleans was known not only as a marketplace for Atlantic goods of all kinds, but also as a mecca for a mix of peoples and cultures. From the arrival of the charter generations, some Native Americans mixed with Africans, to the extent that in modern times large numbers of Americans claim both black and Native American ancestry.

From the 1680s to the 1780s, Louisiana remained under French colonial control, but it did not develop a staple-crop economy dependent on slaves until after the Haitian Revolution in Saint-Domingue in the 1790s, an event that led to the decline of that sugar-growing colony. Until then, some Africans had enjoyed relative freedom in Louisiana. Samba Bambara, an African who had originally worked and traveled freely as an interpreter

"We grant to freed slaves the same rights, privileges and immunities that are enjoyed by freeborn persons."
—LOUISIANA'S CODE NOIR, 1724

for French slave traders along the river and around St. Louis, Galam, and Fort d'Arguin in West Africa, was enslaved and exiled to Louisiana in 1722 after he was accused by the French of conspiring with African captives in a revolt at Fort d'Arguin. Samba Bambara adapted well to his new environment; his skill in French and many African languages led to work as an interpreter for the Compagnie des Indes as well as the Louisiana Superior Council. Samba Bambara never escaped slave status, but he enjoyed relative autonomy.

As a free black population slowly grew in Louisiana, many took advantage of the French Code Noir, a series of laws first conceived in 1685 and put in place in 1724, which allowed free people of color numerous rights, especially the right to petition and the right to sue white colonists over land and various kinds of discrimination. An alliance of Natchez Indians and African slaves rebelled in the 1720s and thwarted for an extended time French dreams of a plantation colony in Louisiana's rich soils. (Louisiana didn't become known for its sugar and cotton plantations until well after the American Revolution.)

As early as 1693, the Spanish crown in Florida adopted the approach of "the enemy of my enemy may be my friend." Catholic Spain and Protestant England were bitter imperial foes throughout the Americas. Spain offered a qualified kind of freedom to any fugitive slaves who escaped into Florida if they converted to Catholicism. For decades, St. Augustine was a magnet for Africans and African creoles escaping the harsh regime of South Carolina slavery. Many among the enslaved Africans arriving in Charlestown (Charleston) were from Angola and the Congo, where Portuguese Catholicism had deep roots; some slaves in South Carolina practiced a kind of Congolese Catholicism. When Carolina fugitives succeeded in escaping into Florida, Spanish officials quickly enlisted them into black militia units to defend the colony.

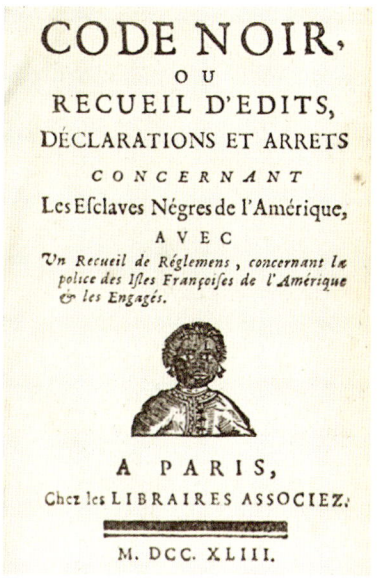

REGULATIONS The French instituted the Code Noir in colonial Louisiana in 1724 to codify the legal status of enslaved people. It covered every aspect of life, including marriage, religion, and manumission.

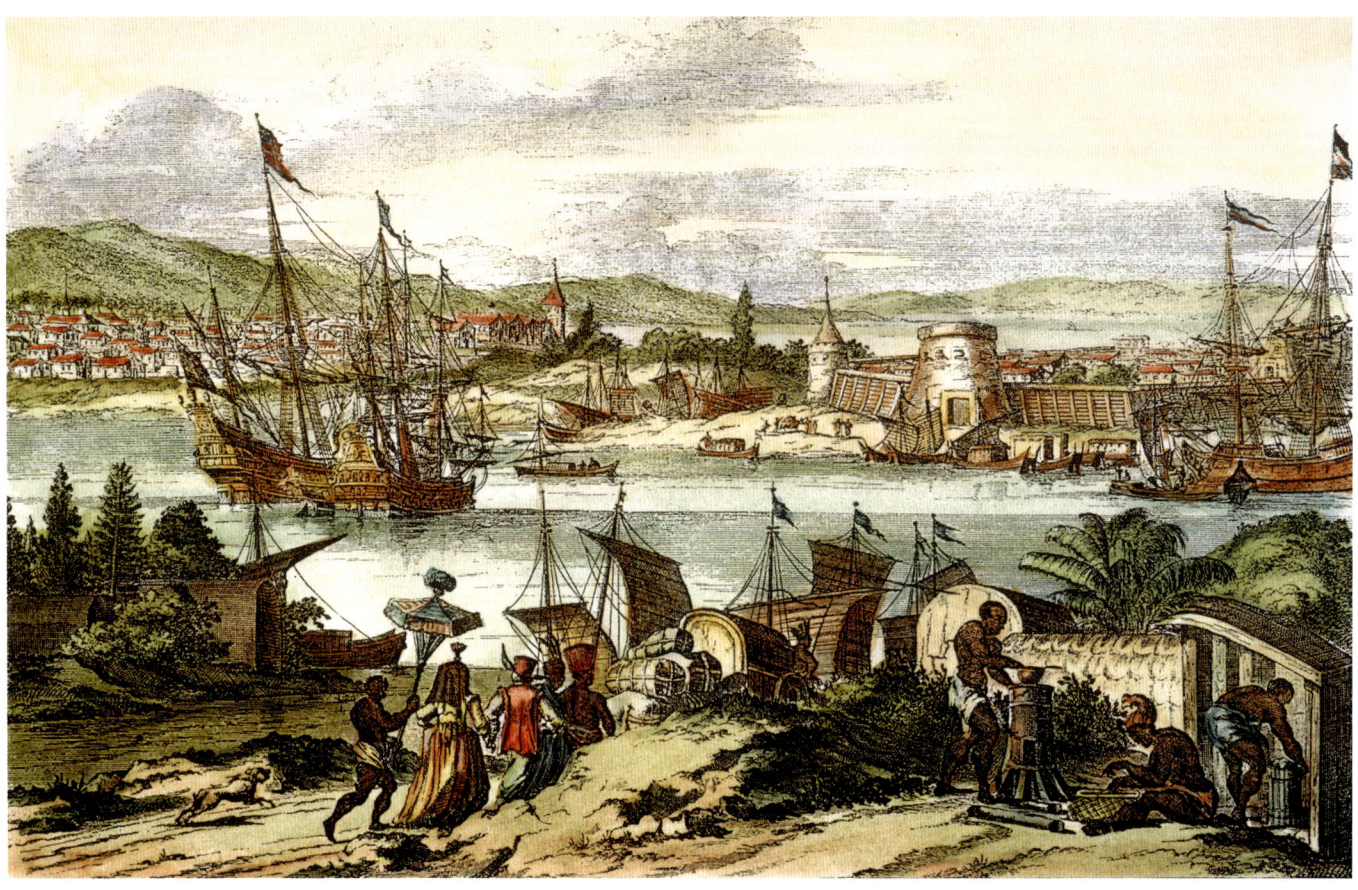

CONDITIONAL FREEDOM

Some slaves in Britain's American colonies managed to escape to the Spanish colony of Florida, where the first free black town in North America, Fort Mose, was established near St. Augustine in 1738.

In September 1739, a group of Africans led by a figure called Jemmy rebelled along the Stono River, twenty miles south of Charleston, raiding a firearms store and killing more than twenty white people. As they marched with drums south toward Florida, recruiting others along the way, the Carolina militia descended upon them. By the end of the day, most of the sixty or so rebels had been captured or killed, but some made it across the border. The Stono Rebellion left a terrible legacy in Carolina and led to the acceleration of the Negro Act, ushering in much harsher conditions for enslaved Africans in the colony. St. Augustine, however, became a growing multicultural society, where Africans, Indians, Mexicans, and Spaniards mixed racially and culturally in an uneasy tension. North of St. Augustine, the Spanish governor established Fort Mose (see page 42), an agricultural community and a black military bulwark against English invasion. Under the leadership of the black militia captain Francisco Menendez, Fort Mose became a relatively autonomous settlement of more than one hundred people.

English attacks followed with great vengeance after Stono. Menendez heroically defended the fort but had to evacuate as the Florida–Carolina colonial border remained in constant warfare. St. Augustine, however, thrived. By 1746, a quarter of its population was black, and they accounted for a large number of the artisans, laborers, and sailors who made the colony viable. Many of those blacks who became integral members of Spanish Florida were genuinely creolized Catholics and crown subjects. Although the promises

made by the Spanish crown were not always fulfilled, the black populace learned the arts of cultural negotiation and patronage. However, the Florida charter generations ended in bloodshed and loss in 1763, when the British seized the colony from the Spanish. To survive, much of the black population evacuated to Cuba.

The Colonial Plantation Generations

It was evident early on that the opportunities open to the charter generations would not last long in the Carolinas. English proprietors moved from Virginia into what became the colony of North Carolina in 1653 and from Barbados into South Carolina by 1670. Enslaved Africans migrating with their owners soon composed one-third of South Carolina's population. With dreams of land-based wealth, the colonists ignited a plantation revolution.

Native Americans up and down the Atlantic seaboard challenged this process of converting hunting, fishing, and agricultural lands into plantations. Although they often traded openly with the Europeans, they also waged war on them, sometimes with great success. The native peoples involved in this epic and disastrous encounter with Europeans included the Algonquin of New England; the Iroquoian groups of New York and Canada; the Delaware, Nanticoke, and Powhatan of the Chesapeake region; and the Tuscarora, Pamlico, Pedee, Waccamaw, Santee, Cusabo, and Yamasee of the Carolinas.

The English, now deeply involved in the Atlantic and Caribbean slave trade, also exploited the slave potential of Native Americans in their trading deals. (Southeast Indians had engaged in slave raiding and trading as part of warfare long before Europeans arrived.) By 1715, some 1,500 enslaved Indians labored on Carolina plantations, and the colony had exported an estimated 30,000 Indian slaves to the West Indies. But Indian enslavement was never a permanent answer to the commercial dreams of Carolinians, although they surely tried to make it so; Native Americans were fiercely resistant to enslavement as field

GENERATIONS OF ENSLAVEMENT This unadorned baby's bed from the late 1700s or early 1800s was crafted by an enslaved person. By the laws of slavery, enslaved mothers gave birth to enslaved children.

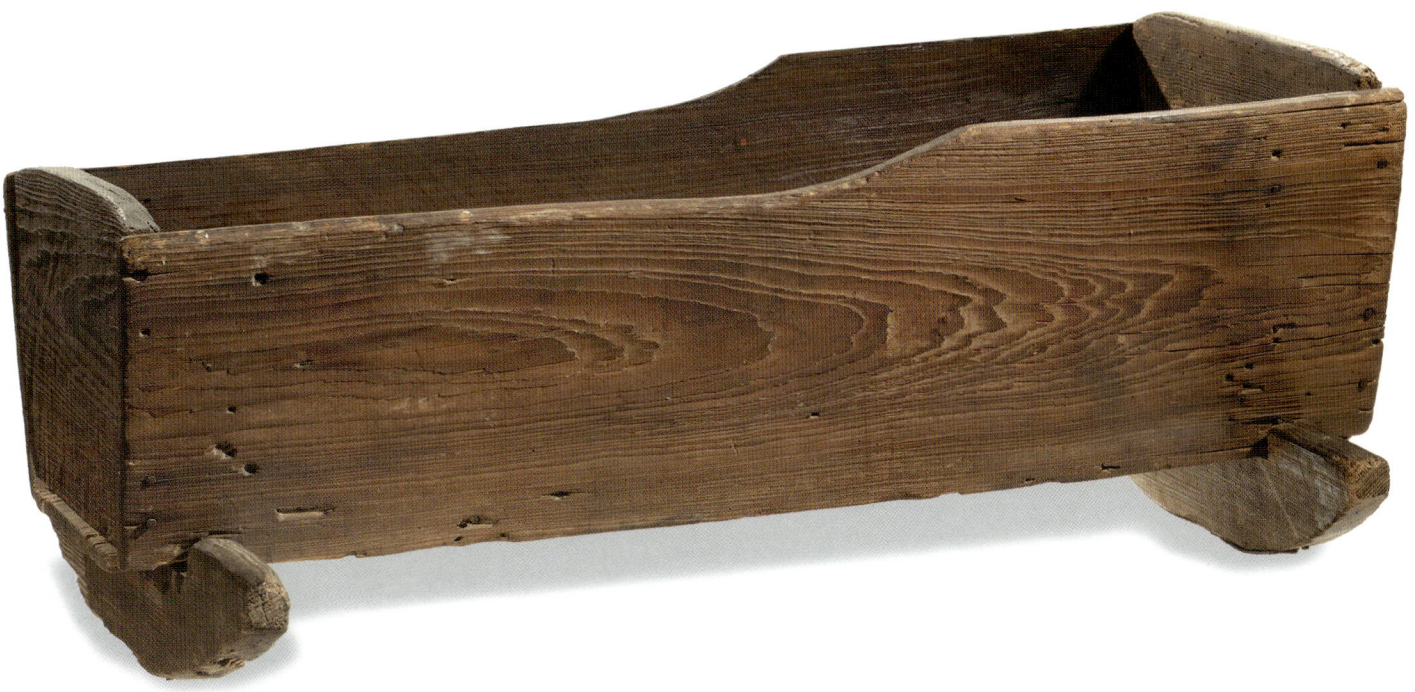

laborers, and their numbers were never sufficient to meet European demand. The English sought to build a plantation slave society, rooted in the production and export of rice and indigo, with the labor of Africans as well as Indians. The colony started importing slaves directly from Africa in 1710. Soon Africans were a majority not only of the enslaved labor force, but also of the entire colony.

That black majority, from many parts of West Africa, encountered terrain not unlike the semitropical regions of their lost homelands; they also brought skills in making and using dugout canoes, fishing nets, and baskets. They possessed knowledge of rice cultivation and cattle herding, contributing mightily to the prosperity of South Carolina. African women played a crucial role in cultivating and processing rice and became the primary market traders in all sorts of wares. African men, on the other hand, conducted the body-breaking labor of clearing swamps and fields, removing alligators, and harvesting rice.

Because of the rapid growth and density of America's first major plantation society, African culture, including naming practices, survived longer and more completely than anywhere else on the continent. A common West African practice was to name children after the day on which they were born, so names such as Cudjo (Monday) or Quashie (Sunday) persisted. But so did other traditional African names. Those listed among the slaves of an eighteenth-century South Carolina planter at his death included, in anglicized spellings, Allahay, Benyky, Bungey, Cumbo, Jehu, Jeminah, Minto, Quamino, Sambo, Satirah, Tehu Yeabow, and Yeachney. The modus operandi of plantations was to reduce people to labor, to the means of production of the cash crop, and planters tried to achieve this by inflicting suffering. But Africans resisted by preserving aspects of their own naming practices, gods, music, dance, concepts, and storytelling. When low-country enslaved workers relaxed around a fire and told folktales about "Br'er Rabbit" and other animals competing for food and sexual prowess, they were engaging in an African tradition while imaginatively reversing the power roles of master and slave.

An early plantation system evolved in the tobacco fields of the Chesapeake area. In Maryland and Virginia, particularly after the suppression of Nathaniel Bacon's rebellion in 1676 (an uprising of black and white indentured servants and small farmers against the colonial elite), planters turned decisively to slavery as their way to wealth. They imported large numbers of slaves, many directly from Africa, and the concept of labor and the stratification of Virginia society became rigidly racial. Some eight thousand enslaved Africans arrived in Virginia in the decade 1700–10 alone, and the numbers multiplied as the British came to dominate the slave trade. As early as 1640, a Virginia court ruled that three runaway indentured servants should receive lashes and extended service as punishment, but the one black among them, John Punch, was ordered to "serve his said master or his assigns for the time of his natural life." Similarly, a 1662 law determined that "all children borne in this country shall be held bond or free only according to the condition of the mother." Hence, with time, slavery had become permanently racial and inheritable—"from the cradle to the grave and beyond," as the saying went.

The plantation boom transformed some regions, as one historian has put it, from "societies with slaves to slave societies." People—white, black, Indian, or mixed—would

grow up conditioned in all essential values and habits of life by a world of white privilege and freedom contrasting with black degradation and enslavement. The plantation revolution narrowed black life markedly, rigidly restricting the possibilities of economic autonomy and social mobility enjoyed by the charter generations. With huge shiploads of new slave laborers quickly moved from the coast to plantations in the interior, family life declined. The male-to-female ratio reached two to one in the early 1700s. Many planters stripped their "new Negroes" of their African names and gave them new names that reflected their commodification. In 1727, the planter Robert "King" Carter proudly stated that he gave new ones to his slaves so that he could "always know what sizes they are," and he reported that they would "readily answer to them."

The Virginia and South Carolina plantations of the 1700s, as well as the even bigger cotton operations that spread across the South in the following century, grew into autonomous economic and social worlds. The Virginia planters developed what they believed was a genuine aristocracy of "grandees," on the model of the English landed gentry. As the planters' raw power grew, the punishments for slaves became even more severe and inhumane; mutilation and even the killing of rebellious slaves were codified in South Carolina. Slaves were valued for work, but also as commodities for purchase, speculation, and sale. Above all, the daily labor of slaves, whether working in tobacco, rice, or the production of all the goods and services that made a great plantation function, became regimented and brutal.

The fluid world of the Atlantic creoles had largely disappeared by the 1760s. As political revolution brewed between the thirteen American colonies and the English crown, this new world of planter sovereignty and prosperity, built on black slave labor in the wealthiest realm of the British empire, was very much at stake on estates such as Shirley and Stafford Hall on the James River, George Washington's Mount Vernon on the Potomac, and Thomas Jefferson's Monticello on a mountaintop in Virginia. "Self-evident truths" abounded in this thriving, contradictory world of freedom and slavery, which was soon in turmoil over the "right of revolution" proclaimed in the Declaration of Independence.

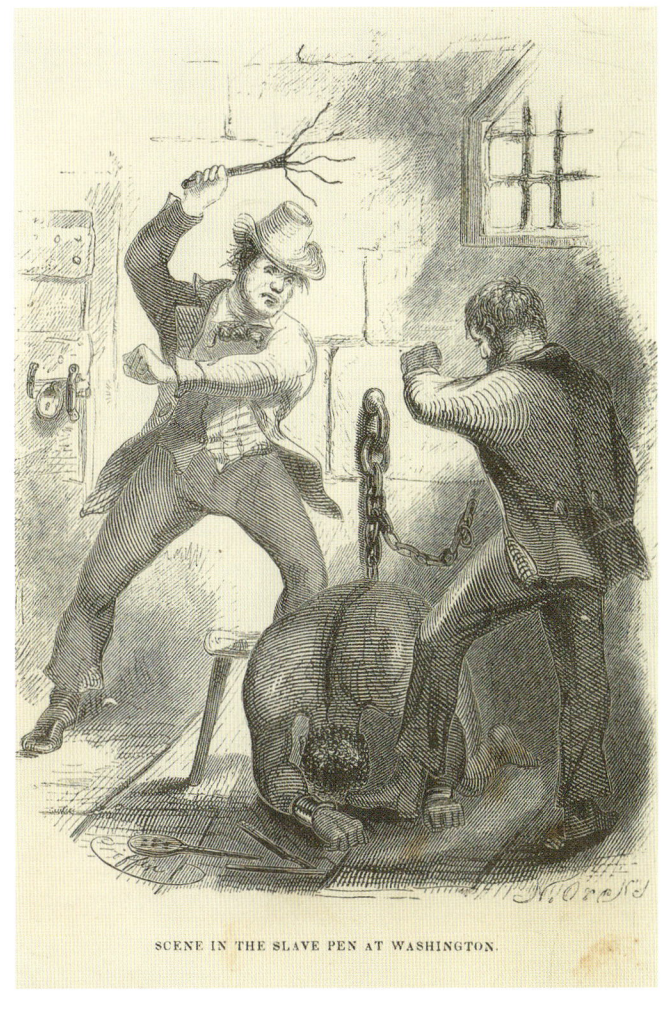

SCENE IN THE SLAVE PEN AT WASHINGTON.

FIRSTHAND ACCOUNT
Solomon Northup's 1853 memoir *Twelve Years a Slave*, from which this engraving is taken, described what happened after his kidnap and illegal sale into slavery. Such narratives galvanized the abolitionist cause.

SLAVE BADGE Enslaved workers hired out by their masters in eighteenth-century Charleston, South Carolina, had to wear or carry metal badges identifying their trade or the slave owner.

COMMUNITIES OF FREEDOM
Paul Gardullo

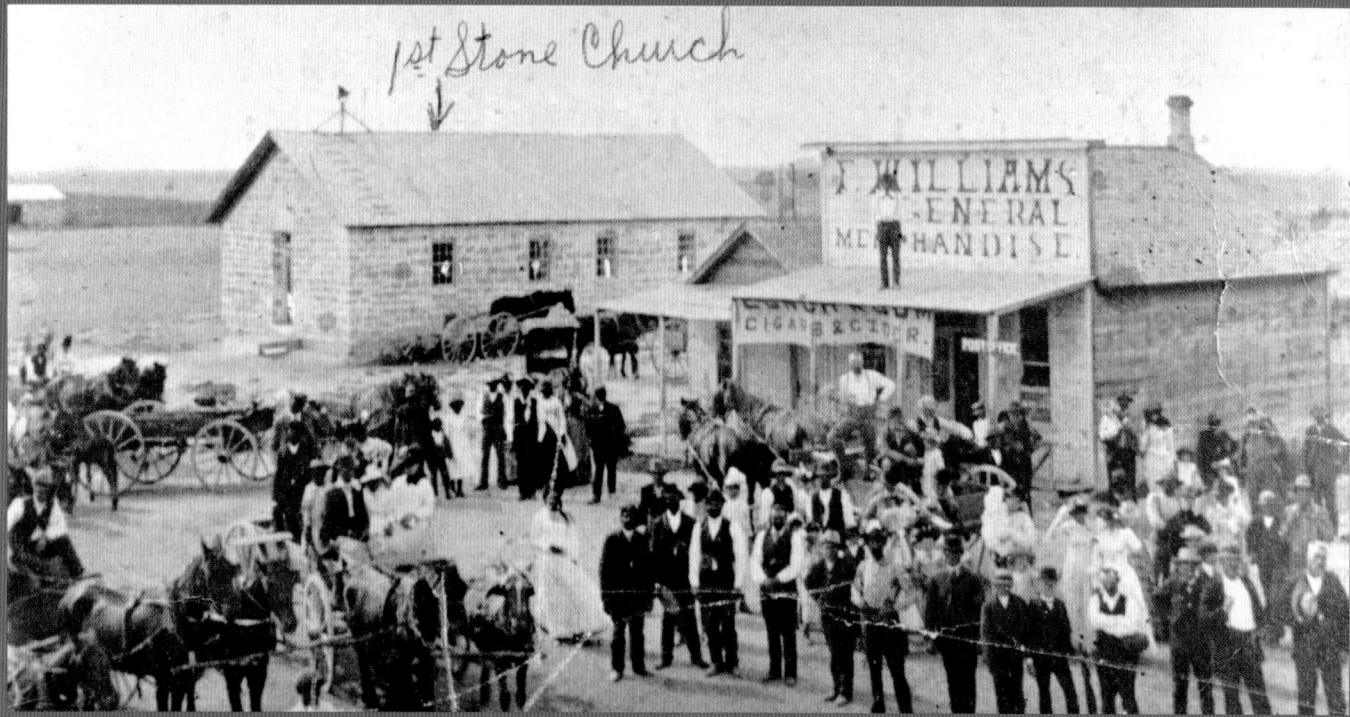

1st Stone Church

For much of American history, land was a potent symbol of freedom and self-determination. For free and enslaved Africans and African Americans, land held the same significance as it did for the white population, as well as the potential for strong community. Demonstrating the desire to live, work, and worship freely despite racism and inequality, black people organized towns and communities in all parts of the country—rural and urban, northern and southern, hidden away from all eyes or among interracial neighbors.

The first free black settlement in North America was Gracia Real de Santa Teresa de Mose, established in 1738 just outside St. Augustine in the colony of Florida. The community, known as Fort Mose, served as a Spanish fortification against the British and was populated with black fugitives who had escaped from slavery in the Carolinas. The Spanish king promised the runaways freedom and citizenship if they converted to Catholicism. Captain Francisco Menendez, a free black creole who years earlier had fled slavery in South Carolina and had distinguished himself in the militia, was appointed leader of the community. By 1760, Fort Mose had developed beyond a military outpost. It became a self-governing and self-sustaining town with skilled workers, fishermen, and farmers, who built homes and churches. The inhabitants formed alliances with European and Indian neighbors and defended their settlement until 1763, when the British took control of Florida.

BUILDING A TOWN Nicodemus, Kansas, was founded in 1877 by freed people migrating west at the end of Reconstruction. In less than a decade, the community had churches, schoolhouses, and businesses.

After the American Revolution, African Americans sought sanctuary and sovereignty in a growing nation that would not give them full rights and liberties. Some built distinct communities amid the cities of the early republic; others moved toward the promise of freedom on the western frontier or in the isolated marshes of the Great Dismal Swamp of Virginia and North Carolina. Some left the United States in search of freedom in Canada or relocated to Liberia in West Africa—a country set up by abolitionists, freed slaves, and even slaveholders who feared the destabilizing influence of freed slaves at home.

The legacy of these communities varies. Places such as the Tremé district in New Orleans continue to be distinct neighborhoods that have imprinted on popular culture. Others, such as Seneca Village in Central Manhattan, have long since disappeared. Yet a sampling of these African American towns, present or vanished, conjures up pride and resilience. Nicodemus, Kansas; Boley, Oklahoma; Rosewood, Florida; Weeksville, New York; New Philadelphia, Illinois; Mound Bayou, Mississippi; and Blackdom, New Mexico, testify to histories of hard-won freedom that was perpetually imperiled, always contingent, and often lost.

African Americans in the Age of Revolution

In the age of revolution that swept through the Atlantic world in the late 1700s, the American War of Independence was an extraordinary event. It rejected the British monarchy and established the thirteen British colonies in North America as a republic. Yet while asserting freedom, natural rights, popular sovereignty, and equality for the white population, it reinforced human bondage and racial inequality. In some quarters, the American Revolution challenged slavery and led to a wave of emancipations, but in the long run it also caused a fiercer commitment to slaveholding in the South. In Virginia, slavery and racism became the ideological basis of liberty and equality for whites.

Many among the Revolutionary War generations of African Americans exploited this paradox of the American founding. Their liberties were severely restricted, but their numbers were strong. Blacks composed approximately 20 percent of the 2.6 million people living in the North American colonies during the Revolution. Over time, no group did as much as black abolitionists, argued historian Benjamin Quarles, to prevent the United States from "de-revolutionizing its revolution." Abolitionist H. Ford Douglas claimed that the reason the Liberty Bell cracked was that it simply didn't contain enough brass to sustain "the lie" in its biblical inscription: "Proclaim liberty throughout the land and to all the inhabitants thereof."

The bookish, stargazing, Maryland-born grandson of an indentured Englishwoman and an African slave, Benjamin Banneker became a mathematician and astronomer and the author of his own almanac. In 1791, Banneker matched his wits against Thomas Jefferson in a famous letter about the American paradox. He asked the Founding Father to recall the time when the British had tried to "reduce you to a state of servitude." "You were then impressed with proper ideas of the great violation of liberty," said Banneker, "and the free possession of those blessings, to which you were entitled by nature." How is it, then, the black intellectual asked the Sage of Monticello, "that you should counteract" God's mercies "in detaining by fraud and violence … my brethren under groaning captivity and cruel oppression, that you should at the same time be found guilty of that most criminal act, which you professedly detested in others"? Jefferson rarely said a public word on this contradiction between slavery and freedom, but in 1820 he acknowledged it privately: "We have the wolf by the ears; and we can neither hold him, nor safely let him go. Justice is in one scale, and self-preservation in the other."

BANNEKER'S ALMANAC

A scientist and city planner, abolitionist Benjamin Banneker published his first almanac in 1791. He sent a copy to Thomas Jefferson along with a letter urging the abolition of slavery.

The Account of Supplies Did to the Officer & Soldiers families that belong to the Town of Glastenbury; doing duty in the Continental line; from the first Day of Jan.y 1781, to the first Day of Jan.y 1782: with each Sum against their Names as it was Charged to them by the Committe of Paytable and an Acc.t of the monies loged by said Officers or Soldiers

Mens Names and Office Sustained	Amount of Supplies			Sums of Money Loged		
	L	s	d	L	s	d
Serj.t Francis Nicholson	10	10	0	0	0	0
Serj.t John Warren	11	18	2	0	0	0
Soldier Thomas Loveland	11	16	6	0	0	0
D.o Timothy Stevens	11	11	8	0	0	0
Syfax Mosley	11	11	8	0	0	0
Prince Simbo	11	12	0	0	0	0
Isaac Tryon	5	0	4	0	0	0
John Holding	11	13	5	0	0	0
Asa Fox	11	16	6	0	0	0
Alexander Macculping	9	0	0	0	0	0
Cromwell Price	5	11	8	0	0	0

Certified p.r Isaac Goodrich Committee of Supplies for the Town of Glastenbury for the year 1781

NB. the Family Supplies of Cromwell Price must be paid to Isaac Tryon whose Substitute S. Price is

LEDGER OF SUPPLY COSTS

This 1782 document listing the annual cost of supplies for eleven black Revolutionary War soldiers from Glastonbury, Connecticut, includes the name of Prince Simbo, who was formerly enslaved.

During the Revolutionary War, the contest between both sides for the loyalty of black soldiers illuminated these ironies. There were black men among the Patriot soldiers at the battles of Lexington and Concord and Bunker Hill, near Boston, in 1775. In May 1775, the Continental Congress decided that only "free blacks" should be enlisted as soldiers; but two months later, as he took command in New England, General George Washington issued an order not to enlist any black men. The Americans would shift in and out of this policy at both the federal and state levels during the war. All states except South Carolina and Georgia recruited African Americans for the Army, both slave and free. New York had a substitution law, allowing a white man to replace himself with a black when drafted.

Despite resistance by Washington and other slave-holding officers, of the three hundred thousand men who served in the American armed forces during the Revolution, five thousand were black (two thousand of them in the Navy); they came primarily from the North and served in all campaigns. Connecticut and Rhode Island produced their own fully black companies of infantry, although most blacks served in integrated units. One Hessian officer, observing the Continental Army, saw "no regiment … in which there are not Negroes in abundance and among them are able-bodied, strong, and brave fellows."

In late 1775, Lord Dunmore, the British governor of Virginia, threw the Southern countryside into turmoil by issuing a proclamation offering freedom to all "indentured servants, Negroes … or others … that are able and willing to bear arms." Both sides in an enveloping revolutionary struggle that resembled a civil war, especially in the South, competed for the black man's service. On the last day of 1775, Washington reversed his policy and ordered the recruitment of free blacks. Fears of slave insurrection spread in Virginia and beyond. Dunmore's aim was to weaken the Americans' capacity to fight, and for a while it worked. Virginians in particular, as one account put it,

"were struck with horror." In the *Virginia Gazette*, some white planters fought a propaganda war for the loyalty of their own slaves, warning that if they fled to Dunmore's ships or his regiments, the British would eventually sell them to the West Indies. They argued that only American masters had the fate of their slaves at heart and that they could expect a "better condition in the next world."

Many blacks served the British as effective boat pilots along coastal rivers they knew well, and still others acted as foragers to supply the ship-bound Redcoats. In the end, disease, especially smallpox, killed most of Dunmore's recruits, known as the Ethiopian Regiment. But the British promise of liberty caused widespread slave escapes across the South when the main theater of war moved to the region after 1780. Jefferson estimated that thirty thousand slaves had run away in Virginia alone, including many of his own. South Carolina experienced approximately twenty-five thousand runaways before the war's end in 1783, and Georgia fifteen thousand (75 percent of its enslaved population).

The chaos of war and the inherent principles at stake made the Revolutionary War the source of the First American Emancipation and what historian Gary Nash called "the largest slave uprising in our history." As Benjamin Quarles maintained, wherever possible blacks "reserved their allegiance for whoever made them the best and most concrete offer in terms of man's inalienable rights." This wave of wartime self-emancipation, as well as manumission extended for service to the Patriot cause, led to an explosion of the free black population in the new United States; by 1790, some sixty thousand African Americans were free, yet seven hundred thousand of their cousins remained enslaved.

This First Emancipation took many institutional strides forward. During the Revolution and its aftermath, dozens of petitions drafted by blacks appeared in the press or arrived in state legislatures and the federal Congress, demanding the same liberties that their white neighbors had sought to obtain. Caesar Sarter, a former slave who had attained his freedom in Massachusetts, made an eloquent appeal to whites for reason and morality and to the Golden Rule in order to end slavery and extend to all "the natural rights and privileges of freeborn men." A Boston petition to the British governor of Massachusetts, signed on behalf of the group by "Felix," exuded deference as it also stated the plight of the enslaved: "We have no property! We have no wives! No children! We have no city! No country! But we have a father in heaven." Felix ended his appeal with "one thing more," praying that their "relief" from bondage would in no way cause "injury to our masters; but to us will be as life from the dead."

The petitions boldly employed the two great traditions that fueled revolutionary ideology: the Bible and the Enlightenment. In 1779, a petition from slaves in Fairfield County, Connecticut, bluntly stated: "Altho our skins are different in colour, from those whom we serve, yet Reason & Revelation join to declare, that we are the creatures of that God, who made of one blood … all the Nations of the Earth." They staked their claims to freedom in the "Laws of Nature," the "Christian Religion," and the "Race of Adam."

In 1797, in the earliest extant petition to Congress by African Americans, four former slaves from North Carolina, who had been manumitted by their masters under the sway of revolutionary ideology, reported being "hunted day and night." As "citizens of the United

States," they raised their grievances with U.S. congressmen. The North Carolina petitioners called slavery "unconstitutional bondage" and sought "public justice," which they called "the great object of Government." Through these actions, the petitioners expressed their new identity as "African American."

But that identity had to be forged *against* the letter and spirit of the new U.S. Constitution, instead of *with* its protection. At the 1787 Constitutional Convention in Philadelphia, the North and the South hammered out numerous compromises, many over slavery. Three pivotal provisions, none of them actually employing the word *slave*, had everything to do with slavery and its future. The obligation to return fugitive slaves to their owners had already been codified in several Indian treaties between 1781 and 1786,

"We beg leave to submit ... whether it is consistent with the present claims of the United States to hold so many thousands of the Race of Adam ... in perpetual slavery."
—SLAVE PETITION, Connecticut, 1779

as well as in the Northwest Ordinance of 1787. Against only meager Northern objection, a federal fugitive slave law entered the Constitution, requiring that any "person held to Service or Labour" escaping from one state to another be "delivered up on Claim of the Party to whom such Service or Labour may be due." Slaveholders, especially from the states of South Carolina and Georgia, all but held the convention hostage to their wishes.

A second agreement emerged from a fierce debate over the potential end to the foreign importation of slaves. Many Northerners had hoped for a complete ban of the slave trade. But facing a threatened rupture in the convention led by South Carolina, upper South and northern states compromised on a deal to postpone any prohibition of the external trade in "such persons" for twenty years, until 1808. And finally, most telling of all, the convention enacted the Three-Fifths Compromise, or "federal ratio," as a means of counting slaves for congressional representation and taxation. Fiery speeches ensued on both sides of the issue of how to count "persons … bound to service" in addition to "free persons." Many Northerners argued that slaves were "property" and should not be taken into consideration when determining representation; Southerners, on the other hand, demanded that their bondsmen be among the people counted equally, a move that would have given the South a larger representation in Congress. The Three-Fifths Compromise (in debate since 1783) was a bone thrown to the North to garner its support for this embittered compromise; thus, black Americans and indentured servants would be politically valued in the new republic as three-fifths of a person.

The three-fifths law had enormous implications for the political and material future of slavery. In the pivotal presidential election of 1800, Republican Thomas Jefferson

garnered eight more electoral votes than the Federalist John Adams. Historians estimate that between twelve and sixteen electoral votes derived from this "slave count" in the Southern states. The Federalists never let Jefferson forget his advantage or his fathering of children by his slave Sally Hemings, as indicated in the following ditty:

> *Great men can never lack*
> *Supporters*
> *Who manufacture their own*
> *Voters.*

With these extra votes, Southerners held the Speaker of the House position 79 percent of the time from 1788 to 1824. The three-fifths count gave the slave states forty-seven instead of thirty-three seats in Congress in 1793, seventy-six instead of fifty-nine in 1812, and ninety-eight instead of seventy-three in 1833. In the sixty-two years from Washington's election in 1788 to 1850, slaveholders held the presidency for fifty years, and eighteen of thirty-one Supreme Court justices were slaveholders.

In this revolutionary and nationalizing ferment, the northern states all passed varieties of emancipation acts, mostly by gradual means. Vermont led the way in 1777 by an act of its legislature, followed by Massachusetts in 1783 as a result of a court case brought by the slave Quork Walker, who sued based on the "promise" of his master. Walker's attorneys rooted the case squarely on "natural rights." New Hampshire also liberated its few slaves in 1783. In 1784, Rhode Island adopted gradual emancipation, liberating all children of slave mothers born after March 1 of that year, while also protecting all property of slaveholders, including those involved in the foreign slave trade. Also in 1784, Connecticut passed a longer-term gradual emancipation, freeing all children born after March 1 upon their twenty-first birthday. New York enacted a gradual abolition plan that freed its last slaves in 1827, and in 1804 New Jersey did the same, with the last vestiges of its enslaved population freed in 1830.

Pennsylvanians vigorously debated gradual abolition schemes throughout the Revolution; in 1780, their divided legislature voted 34 to 21 to enact a plan whereby all slaves had to serve as indentured servants until their twenty-eighth birthday. Staunch pro-slavery forces in the former Quaker stronghold waned only in the 1790s; the 1820 census recorded only 211 slaves remaining. Well into the 1800s, across the North, the "free" states harbored a preferred anti-slavery heritage, despite the fact that gradual emancipation left initially thousands and then hundreds of blacks enslaved until well into the 1820s and 1830s.

Leadership, Christianization, and Resistance

Constitutional and structural forms of racism did not prevent the emergence of a remarkable generation of leaders in the new free black communities of the early republic. Phillis Wheatley, a survivor of the Middle Passage born in Gambia,

PUBLISHED POET While enslaved, Phillis Wheatley became a celebrated poet and the first African American woman to be published. Scipio Moorhead, an enslaved artist, drew this portrait for her 1773 book of poetry.

WOMEN HELD IN SLAVERY

Nancy Bercaw

Just before Christmas 1836, Gerd and Ann Riecke sold "Mary about Seventeen years of age" to Charles Seignious in South Carolina. Seignious paid $625 (an estimated $17,100 in today's dollars) for "Girl Mary with her future issue and Increase." The transaction was unremarkable. Buyer and seller recorded it in their ledger books and in the county court house. Mary was one of more than six hundred thousand people sold in the United States between 1800 and 1861. Like Mary, many were under eighteen years old, and one-third of them were girls.

As the phrase "her future issue and Increase" states, slave owners and slave traders valued girls and women because of their sexual and reproductive potential. As property, enslaved women were the sexual prey of slave owners and other whites. "Fancies," young women and girls, often with light complexions, brought extremely high prices, four to five times more than other women. They were, in effect, sex slaves. Young mothers also drew higher prices for their proven ability to give birth. While the slaveholder who bought Mary made a sizable investment, if she gave birth, he could expand his holdings without more expenditures.

As property herself, Mary's mother could not protect her child from sale and separation. As historian Jennifer Morgan has observed, enslaved mothers reinforced slavery every time they gave birth. One mother, Margaret Garner, caught the attention of the national press in 1856. Running from slavery, Garner managed to cross the Ohio River with her husband and children before they were caught by slave catchers. Before being captured, Garner took her daughter's life in order to spare her child from enslavement. Her wrenching choice is evidence of the trauma of enslavement.

What enslaved women experienced was in many ways unspeakable but is not forgotten. Their stories reach down through the generations. The Galloway

skirt in the collections of the National Museum of African American History and Culture survives as such a reminder. In a letter to the museum, Janet Galloway recounted how she learned of her grandmother's skirt: "While I was growing up in Macon, Georgia, my grandmother would always get moved to anger if anyone would go anywhere near this old treasure chest.... On her deathbed she told me why. In that old trunk was a ... skirt worn by slaves and she wanted me to care for it and she wanted me to assure her that I would treasure it and respect its authenticity always."

When telling her story, Mrs. Galloway's grandmother held up her hand and pointed to each of her five fingers. Each finger, she told her granddaughter, represented a generation—a woman who had held onto the skirt, and its story, before passing it to a daughter.

Seven generations had treasured the Galloway skirt and, in keeping it safe, they held onto the humanity of the woman who wore it. Despite the forces gathered against them, enslaved women refused to be "property." Denied the legal right to have families— the authority of parenthood, the lessons of childhood, and the love that binds— enslaved African Americans cast the net wider. They raised and loved children regardless of kinship, gave respect to elders regardless of bloodlines, and used their communities to instill a sense of self beyond slavery. These actions, passed down through generations, shaped African American women's activism—a definition of rights, of worth, and of belonging based on the claims of community.

A FAMILY TREASURE Now in the National Museum of African American History and Culture, this simple cotton skirt was passed down through generations of the Galloway family in memory of the family member who wore it during slavery.

West Africa, around 1753, made her mark in society with her pen. Her Boston owners, who ultimately freed her, saw Wheatley's intelligence and helped her attain an education. At the age of nineteen, in words both delicate and politically charged, she addressed a poem to King George III's Secretary of State in America, the Earl of Dartmouth:

> *Should you, my lord, while you peruse my song,*
> *Wonder from whence my love of Freedom sprung,*
> *Whence flow these wishes for the common good,*
> *By feeling hearts alone best understood,*
> *I, young in life, by seeming cruel fate*
> *Was snatch'd from Afric's fancy'd happy seat;*
> *What pangs excruciatingly must molest,*
> *What sorrows labour in my parent's breast?*
> *Steel'd was that soul and by no misery mov'd*
> *That from a father seized his babe belov'd;*
> *Such, such my case. And can I then but pray*
> *Others may never feel tyrannic sway?*

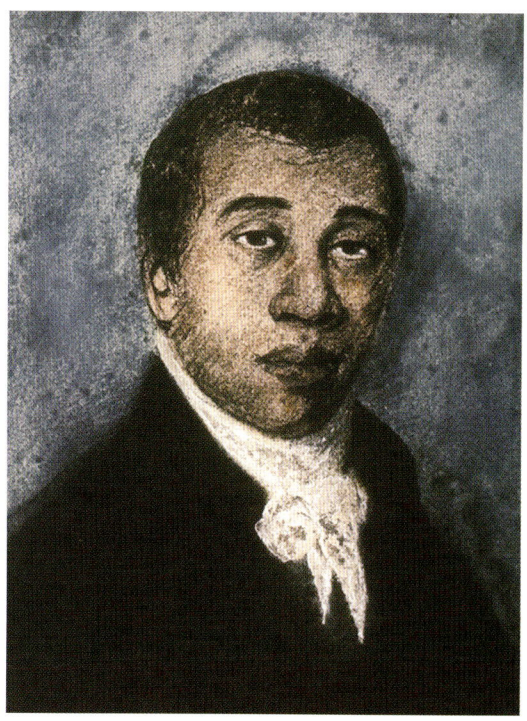

A year later, Wheatley wrote of her belief that "civil and religious liberty" were "inseparably united" and thus the "Israelites" were so determined to gain "their freedom from Egyptian slavery." The young poet, who died in childbirth at the age of thirty-one, spoke for her emergent people in claiming the Exodus story as her own.

Free black communities sprouted in every sizable town from Maine to Maryland and even in Southern seaport cities. They often united around religious leaders, and churches became the heart of black life. Thus African Americans became what one scholar has called a "nation within a nation," clutching parts of their African identities as they embraced American society.

Like Olaudah Equiano in literature and Benjamin Banneker in science, other African Americans laid their claims as black "founding fathers and mothers." Born enslaved in 1760, on a wealthy planter's estate in Delaware, Richard Allen was sold with his family at age eight to the owner of a smaller farm. In his teens, he witnessed the sale of his mother and three siblings. To cope with the trauma and under the influence of itinerant Methodist preachers, Allen embraced the Christian faith. By vigorous manual labor, he raised enough money to purchase his freedom by 1783. Three years later, he moved to Philadelphia, where he conducted prayer meetings among blacks and began to preach at St. George's Methodist Church. When the white church officials tried to segregate blacks and even yanked Allen and his associate, Absalom Jones, from their knees during prayer, the black men bolted and established the Free African Society.

By 1794, Allen had organized his own congregation and been ordained as a deacon. He soon founded the African Methodist Episcopal Church (AME) in a converted blacksmith shop. Between 1799 and 1816, the AME Church grew as a movement of spiritual and social

FOUNDING FATHER As a young man, Richard Allen embraced the Methodist faith, but he broke with the church in 1787 because of its racist treatment of black parishioners. Allen later founded the African Methodist Episcopal Church (AME).

RICHARD ALLEN'S MONEY BOX This box belonging to religious leader Richard Allen may have secured church funds or documents. Allen was an astute businessman as well as a churchman, who donated substantial funds to his AME Church.

autonomy. By 1820, there were four thousand black Methodists in Philadelphia and another two thousand in Baltimore—building their own churches, ordaining their own ministers, and educating their own children. The movement spread to other, more distant cities such as Charleston, South Carolina. Allen was a brilliant organizer as well as a prolific writer and theological leader. He made "Mother Bethel" into an important refuge for runaway slaves as well as a self-help and protest center. Before he died in 1831, Allen presided as chair over the first national Negro Convention, which convened in Philadelphia in 1830.

James Forten was born free in Philadelphia in 1766; many of the events of the American founding took place in his own neighborhood. As a teenager, Forten served as a powder boy on a Patriot privateer, fighting the British; captured, he spent the final year of the Revolutionary War on a British prison ship. Returning to Philadelphia after the war, he went to work in a sail-making business to provide for his widowed mother and three siblings. He soon took over the business, inheriting two dozen white laborers. In the next two decades, Forten turned the business into a highly successful enterprise. He became a scion of black business acumen and a pillar of St. Thomas African Episcopal Church, pastored by Absalom Jones. Forten and the extended family he produced became the energetic hub, along with Robert Purvis and others, of a thriving, autonomous black anti-slavery community in Philadelphia.

People such as Forten and Allen were institution builders; they forged collective hope as they also fostered real-world mutual aid networks, especially through churches. As historians Sylvia Frey and Betty Wood have argued in their book *Come Shouting to Zion: African American Protestantism in the American South*, "The passage from African traditional religions to Christianity was arguably the single most significant event in African American history." This bold claim holds up if we consider how much of the values, artistic creation, leadership, institutional life, and worldviews of blacks has been rooted in the stories of the Old and New Testaments. From the Hebrew prophets, African Americans drew on the stories of the Exodus, the Babylonian Captivity, the liberation from Egyptian bondage, and the search for a new Israel and the Promised Land—both real and spiritual. Enslavement and the horrifying transport to foreign lands required a counter-story of meaning, "chosenness," or salvation. The slave ship, the auction block, and the plantation needed nighttime redemption from daytime oppression. The "days of Jubilee" promised in the Bible, when the slaves and laborers would be released, resonated deeply with the enslaved.

The Bible offered a wealth of wisdom through which to process slaveholders' hypocrisy and brutality. In the long, crooked paths of Christian conversion, Africans in the West Indies and blacks in North America found a God who chimed with their own needs and experiences. From all over the Psalms, they heard the Christian God portrayed as their "rock … fortress … deliverer" and even their "buckler." From missionaries with many motives, including those who intended to use the Gospels to forge more obedient slaves,

black people learned about Jesus standing up in a synagogue in Nazareth, preaching the passage from the prophet Isaiah about his mission "to proclaim liberty to the captives, and the opening of the prison to them that are bound." Many revivalist preachers, white and black, could only glimpse the power they offered to slaves when they enticed them with the old biblical plea to the lowly: "Come unto me all ye who labor and are heavy laden and I will give you rest."

Christian conversions of various kinds began early on the African coasts, emerged in the Caribbean in spurts and waves, expanded significantly in the Great Awakening of the 1730s, and exploded in institutional and evangelical forms in the Revolutionary era as well as in the Second Great Awakening revivals of the 1820s. Forced to attend Methodist or Baptist camp meetings, many slaves scoffed at their masters' rousing confessions of faith as they themselves became enthralled with a personal God evoked within "the circle" they could not enter. The mysteries of conversion captured African Americans. A distinct cosmology, unique modes of spirit worship born in Africa and remade on plantations in the American South, as well as a magical musical creation called the Negro spiritual, poured forth from people determined to fathom "a better day a-comin'."

A people "is always more than the sum of its brutalization," wrote the novelist Ralph Ellison. Although it is impossible to measure, the resource that enabled slaves to defy a potentially dehumanizing repression was their culture: a body of beliefs and practices born of their past and reimagined in the present. As the cotton boom and the burgeoning system of chattel slavery spread like wildfire across the South from 1810 to 1860, the increasingly American-born slave population, torn from any sense of place and forced westward, tried to knit themselves together by stories, music, community, and religion. Survival was at stake; some made it through psychologically and some did not. But "the values expressed in folklore," wrote the poet Sterling Brown, provided a "wellspring to which slaves … could return in times of doubt to be refreshed."

African influences remained strong, despite lack of firsthand memory, especially in appearance and expression. Some enslaved men plaited their hair into rows and fancy designs; slave women often wore their hair "in string"—tied in bunches and secured by a piece of cloth. Men and women wrapped their heads in kerchiefs in the styles and colors of West Africa.

American slaves developed what scholars have called a "sacred worldview," which affected all aspects of work and leisure. They fashioned musical instruments with carved motifs drawn from Africa. Their drumming and dancing followed African patterns that made whites marvel. One visitor to Georgia in the 1850s described a ritual dance: "A ring of singers is formed.… They then utter a kind of melodious chant, which gradually increases in strength, and in noise, until it fairly shakes the house." This observer of the "ring shout" also noted an African-derived call-and-response in the chanting. These cultural survivals were not static "Africanisms"; they were cultural adaptations re-formed in the Americas.

For many enslaved black Americans, Christianity became a matter of everyday worship wherever they could find privacy. They nurtured a belief, drawn from numerous

AFRICAN RETENTION
This drum belonged to a nineteenth-century African American secret society in the Sea Islands, South Carolina. It is nearly identical to drums illustrated in a popular print of an Asante festival in West Africa.

prophecies, that God would intercede and end their bondage. In collective ways, they called, sometimes in prayerful tones, on God to come to bring them a "balm in Gilead." Other times they caught the "holy spirit" and shouted their appeals. "The old meeting house caught fire," recalled one ex-slave preacher. "The spirit was there.… God saw our need and came to us.… There is a joy on the inside and it wells up so strong that we can't keep it still. It is fire in the bones. Any time that fire touches a man, he will jump."

Rhythm and physical movement were crucial to enslaved African Americans' religious experience. Some black preachers delivered their sermons in a rhythmic, songlike cadence, mesmerizing parishioners with a narrative of meaning and emotion. Such a sermon conveyed a message from the scripture and provided a collective experience of worship punctuated by the congregation's "Yes, Lords" and "Amens!"

As unique as the preaching style was and continues to be today, it was the songs of enslaved black Americans that would become a sublime gift to American and world culture alike. Through spirituals, slaves tried to impose a storytelling order on the chaos of their uncertain lives. Many themes run through the lyrics of the songs. Frequently referred to as the "sorrow songs," they often anticipate imminent rebirth. Sadness could suddenly give way to joy: "Did you ever stan' on a mountain, wash yo hands in a cloud?" Rebirth infused the famous hymn "Oh, Freedom": "Oh, Oh Freedom/Oh, Oh Freedom/Oh, Oh

RING SHOUT An illustration from an 1872 book depicts enslaved people in the United States performing a religious circle dance. Researchers theorize that the dance has roots in sacred West African rituals.

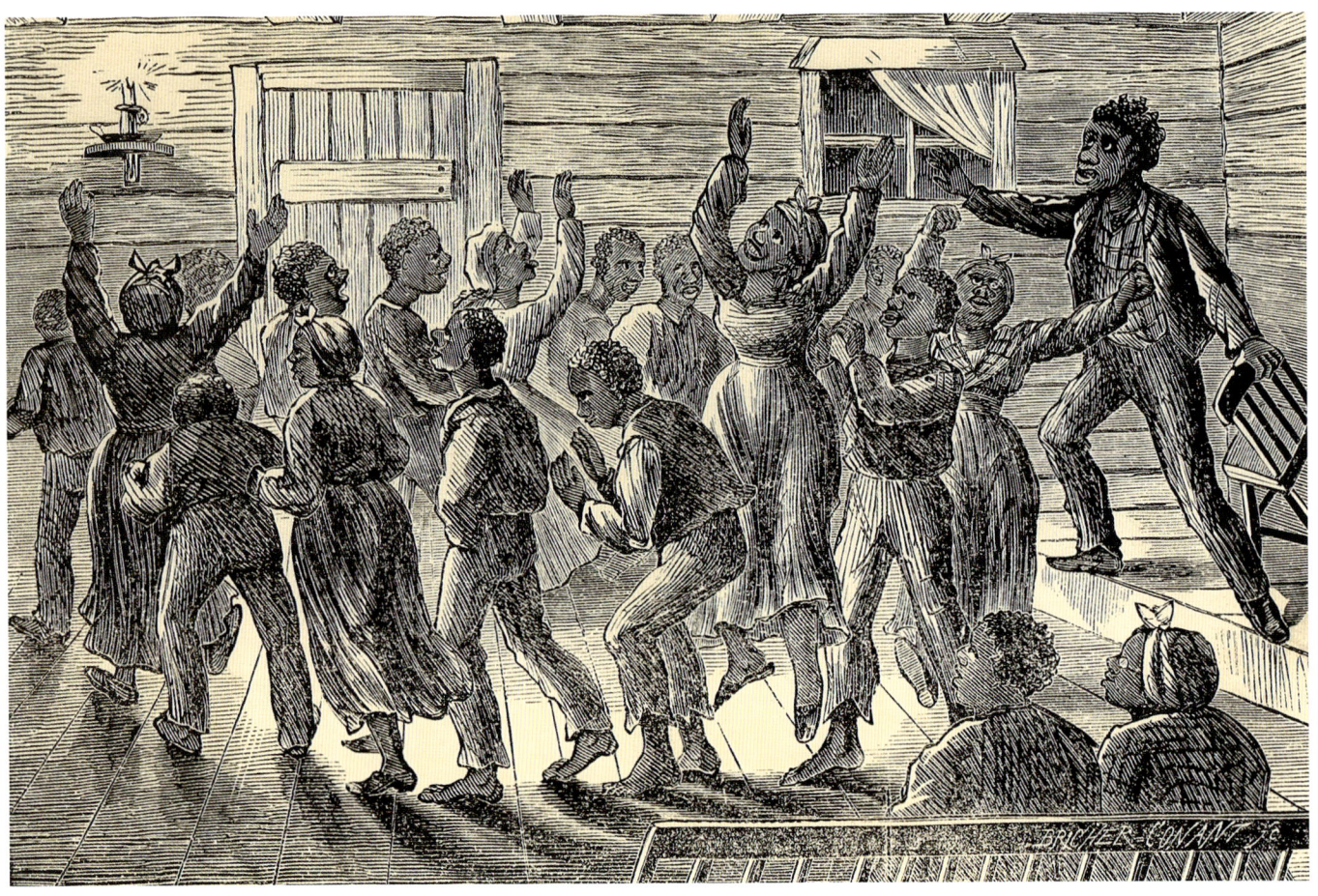

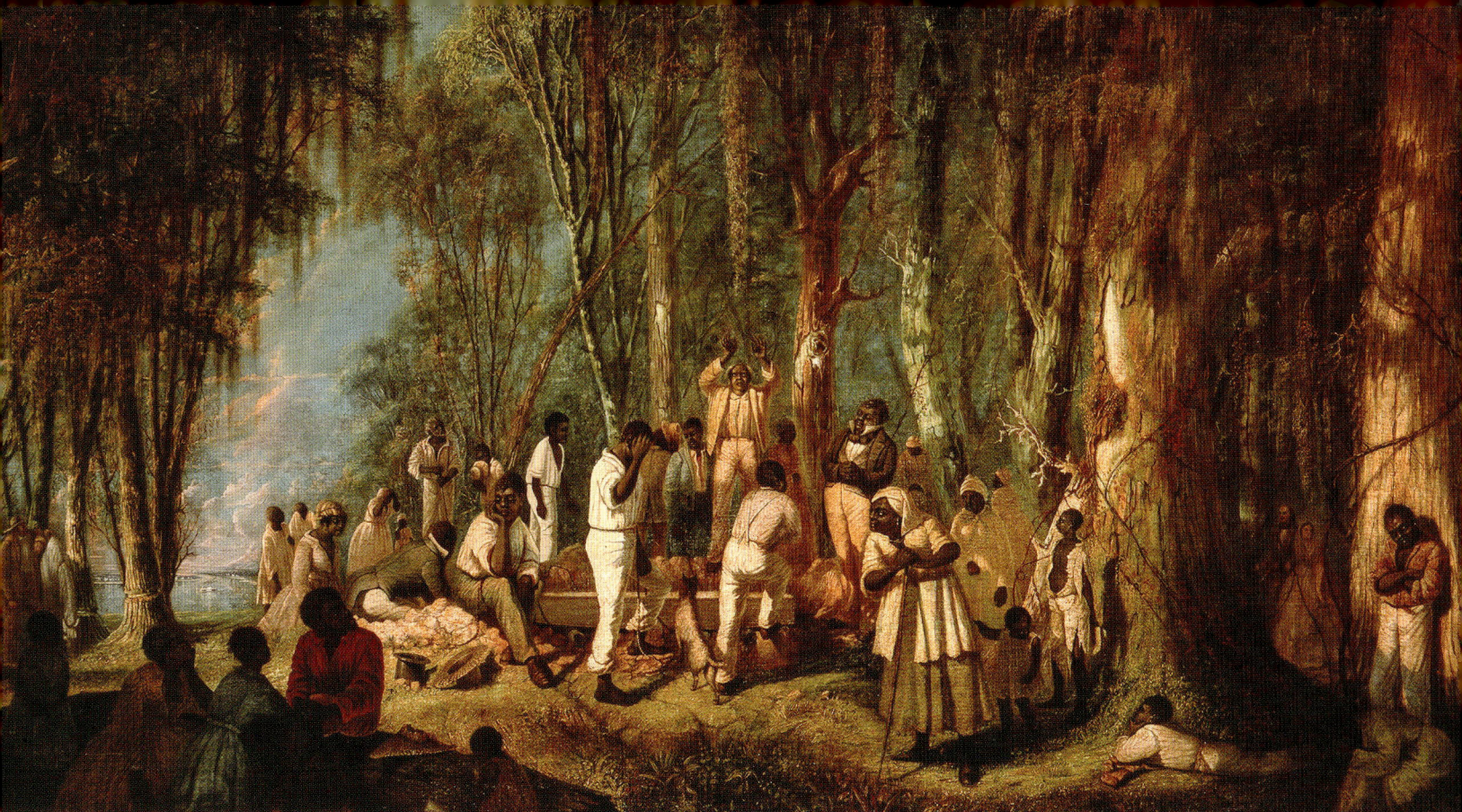

Freedom over me/But before I'll be a slave/I'll be buried in my grave/And go home to my Lord/And Be Free!"

This tension between sorrow and joy animates many songs: "Sometimes I feel like a motherless chile. . . ./Sometimes I feel like an eagle in the air. . . ./Spread my wings and fly, fly, fly!" Many spirituals also express an intimacy with God. Some display an unmistakable rebelliousness, as expressed in the enduring lyrics "He said, and if I had my way/If I had my way, if I had my way/I'd tear this building down!" And sometimes great biblical stories—such as those of Lazarus and Noah—combine in stirring appeals for salvation and justice:

> I got a home in that rock, well, don't you see?
> Way between the earth and sky
> I thought I heard my Savior cry
> Well—a poor Lazarus poor as I
> When he died he had a home on high
> He had a home in that rock, don't you see?
> The rich man died and lived so well
> When he died he had a home in Hell
> He had no home in that rock, well, don't you see?
> God gave Noah the rainbow sign
> No more water but the fire next time
> He had a home in that rock, well, don't you see?
> You better get a home in that rock, don't you see?

A PLANTATION BURIAL

A black preacher conducts an evening burial on a Louisiana plantation while a white overseer and slaveholders watch from the sidelines in this 1860 oil painting by John Antrobus.

Cultural and religious expression was just one way enslaved blacks survived cruel bondage. The oppressive system also produced some fearless rebels. Gabriel Prosser's plot to overthrow slavery in Richmond, Virginia, in 1800 involved as many as one thousand slaves. An enslaved blacksmith, Prosser took inspiration from both the Haitian and American revolutions, recruiting black artisans and field hands. A huge thunderstorm and betrayal by another slave conspired to thwart the plan to burn the Virginia capital and capture Governor James Monroe; Prosser and twenty-five other rebels were hanged. According to disputed court testimony, a similar slave rebellion was uncovered in Charleston, South Carolina, in 1822. It was led by Denmark Vesey, a slave from the Caribbean who had purchased his freedom and become a charismatic religious leader in an AME church. When the plot unraveled, Vesey and dozens of other alleged black conspirators were executed.

CRIME AND PUNISHMENT

Nat Turner's 1831 revolt, in which more than fifty white people were killed, led to an aftermath of fear and violence, resulting in stricter laws for blacks and the deaths of scores of innocent black people.

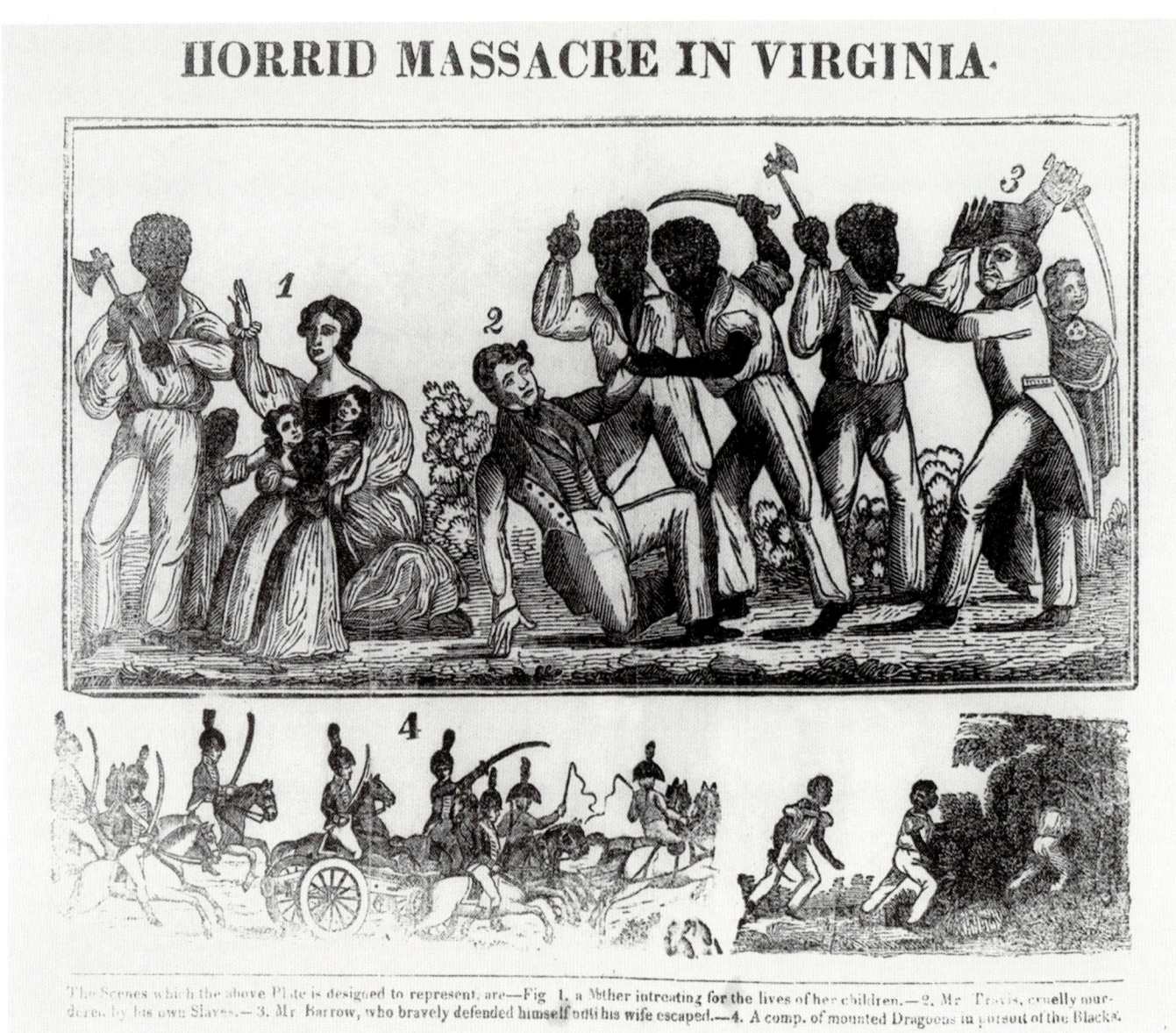

NAT TURNER (1800–31)

In August 1831, Nat Turner, a literate slave and self-proclaimed preacher, masterminded the bloodiest slave revolt in American history. Believing he had received divine instructions to raise a guerrilla army to overthrow slavery, Turner and six conspirators launched a series of attacks on slaveholders in Southampton County, Virginia. As the men went from house to house murdering entire families, they procured guns, ammunition, horses, and recruits for more attacks, with the goal of seizing the armory in the nearby town of Jerusalem. During a thirty-six-hour period, the marauding band grew to forty rebels, who killed an estimated fifty-five whites before the uprising collapsed under a white counterattack. Turner and seventeen other rebels were tried and hanged. In the wake of the rebellion, slaveholders redoubled their efforts to control black people. Southern states tightened restrictions on African Americans, prohibiting education and assembly and limiting access to weapons.

Nat Turner's Bible

The most famous rebel of all, Nat Turner, struck for freedom in Southampton County, Virginia, in 1831. Turner, a local preacher with a reputation for eloquence and mysticism, and a small band of rebels attacked several farms, slaughtering scores of white victims in a two-day rampage before being captured, quickly tried, and hanged. However, he lived long enough to be interviewed in his cell by a white Virginia lawyer, Thomas R. Gray, who went on to write *The Confessions of Nat Turner*, a bestseller at the time and one of the most remarkable documents in the annals of America's racial history.

STAPLE CROP Enslaved African Americans used this early-nineteenth-century woven basket when harvesting cotton. The enormously profitable crop produced more than half of the nation's wealth and accelerated the domestic slave trade.

Cotton and the Domestic Slave Trade

The slave revolt that successfully drove Napoleon Bonaparte's French troops out of Saint-Domingue and led to the founding of the independent nation of Haiti forced the French to sell their North American territory to the United States in 1803. The huge swath of land gained in the Louisiana Purchase galvanized American planters, who turned their eyes and dreams westward. With the help of Eli Whitney's 1793 invention of the cotton gin, a device for cleaning the staple variety of the crop, American cotton production doubled each decade after 1800 and provided three-fourths of the world's supply by the 1840s. Southern staple crops composed three-fifths of American exports by 1850, and the jobs of one in every seven workers in England depended on American cotton.

As the cotton boom spread westward into the Southwest, it made slaves the single most valuable financial asset in the United States—greater than all banks, railroads, and manufacturing combined. In 1860, the total worth of slaves as property came to an estimated $3.5 billion (about $80 billion today). Southern planters and politicians began to boast of the supremacy of "King Cotton" in world markets. "Our cotton is the most wonderful talisman

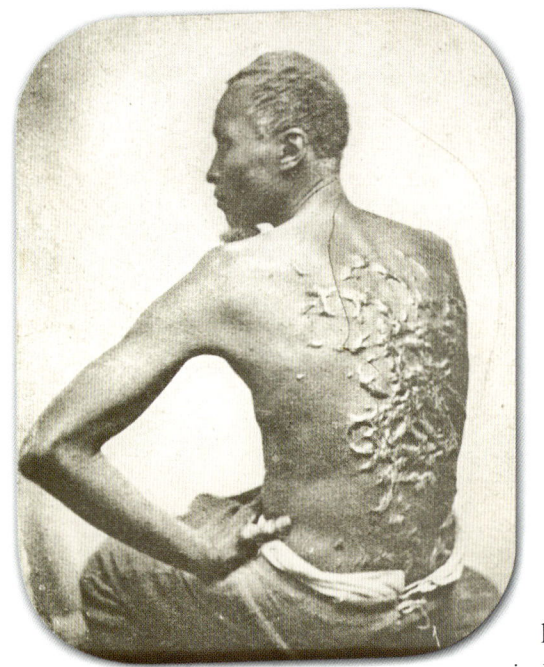

HAUNTING EVIDENCE When Gordon, a fugitive from slavery, enlisted in the Union Army in Louisiana in 1863, military doctors discovered extensive scarring on his back from beatings. The widely circulated photograph stoked the abolitionist cause.

in the world," announced one proud planter in 1853. "By its power we are transmuting whatever we choose into whatever we want." Cotton production made slavery a primary force in American economic development. By tracing slavery's supply networks and its monetary and credit systems, scholars have shown how the ownership of people as property fueled American capitalism. As slavery spread westward, slaveholders became not only richer and more politically powerful, but also more violent in their treatment of slaves. In the Cotton Kingdom, increasing use of the lash and other forms of punishment accompanied the quest for greater productivity and profits. Born enslaved on the Eastern Shore of Maryland in 1818, Frederick Douglass, who went on to become the most important black leader of the century, witnessed brutal whippings as a young child and endured them in his teens. Ownership of slaves, said Douglass, gave masters the "fatal poison of irresponsible power." Hiding behind a door, he watched in shock as his owner, Aaron Anthony, tied his Aunt Hester "to a joist" and whipped her until she "was literally covered in blood." Such a "terrible spectacle," wrote Douglass, was for many black youths "the blood-stained gate, the entrance to the hell of slavery, through which" they must pass.

Too often, the master's control over slave women resulted in sexual exploitation. Enslaved women had to negotiate a confused world of desire, threat, and shame. Harriet Jacobs, who spent much of her youth and early adulthood in North Carolina dodging her owner's relentless sexual molestation, described this circumstance in her autobiography as "the war of my life." In recollecting her effort to protect her children, Jacobs asked a haunting question that many enslaved mothers carried with them to their graves: "Why

"The gang walked slowly, fastened together by a chain of iron about a hundred feet long and handcuffed in pairs."

—CHARLES BALL, *The Life and Adventures of Charles Ball,* **1837**

does the slave ever love? Why allow the tendrils of the heart to twine around objects which may at any moment be wrenched away by the hand of violence?"

Separation following their sale into the burgeoning domestic slave trade is what African Americans dreaded most. Among the migration generations, those coming of age from 1820 to 1860, an estimated one million were moved by outright sale into the region extending from western Georgia to eastern Texas. Hundreds of thousands of black families were forcibly separated to serve the needs of the expanding slave economy.

The internal slave trade became an enormous business in which thousands of white Southerners, as well as northern merchants and bankers, made their living. South Carolina

alone had more than one hundred slave-trading firms selling an annual average of 6,500 slaves to the southwestern states in the 1850s. Outright sale was common for a young slave, as was migration with his or her owner. A typical trader's advertisement read: "NEGROES WANTED. I am paying the highest cash prices for young and likely NEGROES, those having good front teeth and being otherwise sound." One estimate from 1858 indicated that sales of enslaved people in Richmond, Virginia, netted $4 million that year alone. A market guide to slave sales that same year in Richmond listed average prices for "likely plough-boys," aged twelve to fourteen, at $850 to $1,050; "extra number 1 fieldgirls" at $1,300 to $1,350; and "extra number 1 men" at $1,500.

Market forces drove the trade. At slave "pens" in cities such as New Orleans, traders did their utmost to make the slaves appear young, healthy, and happy, cutting gray whiskers off men, disciplining them with paddles to avoid scarring, and forcing them to dance and sing as customers arrived to gawk and buy. When transported overland, slaves trudged five hundred miles or more on foot, often chained together in coffles. Charles Ball, who eventually escaped to write of his experience, recalled being in a coffle of fifty souls. The women were "tied together with a rope, about the size of a bed cord, which was tied like a halter round the neck of each; but the men ... were very differently caparisoned ... [an] iron collar ... round each of our necks." Ball captured the inhumanity of this system. "The poor man to whom I was ironed," he wrote, "wept like an infant when the blacksmith ... fastened the ends of the bolts that kept the staples from slipping from our arms."

The toxic mixture of racism and venality among traders is evident in their language. "I refused a girl twenty years old at 700 yesterday," one trader wrote to another in 1853. "If you think best to take her at 700 I can still get her. She is very badly whipped but good

"THE SALE" Eyes downcast, the black man portrayed on an 1863 *carte-de-visite* awaits his fate (*below, left*). Small cards bearing an image or photograph were often disseminated during the Civil War to sway political opinion.

PROFIT AND POWER A business card advertises an 1860s slave yard in Memphis, Tennessee, that sold black people on commission.

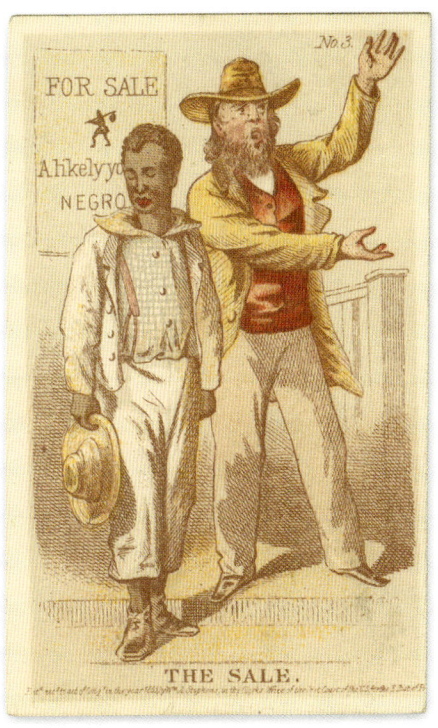

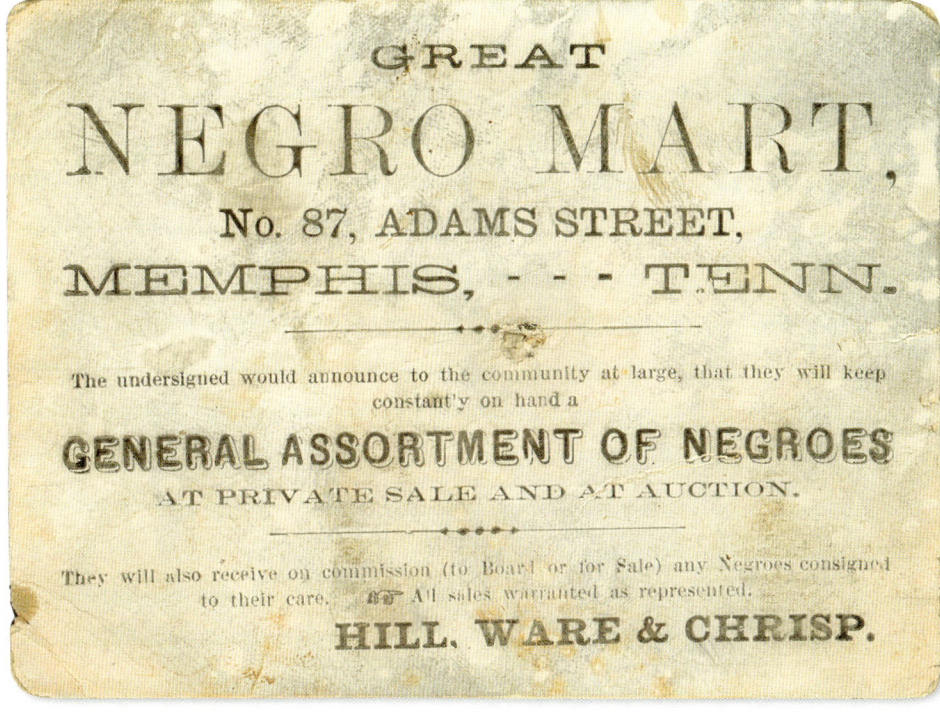

56 VERY CHOICE
Cotton Plantation SLAVES,
MECHANICS,
SEAMSTRESSES, COOKS, &C.

By J. A. BEARD & MAY. J. A. BEARD, Auctioneer.

WILL BE SOLD AT AUCTION,
ON MONDAY, JANUARY 29, 1855,
At 12 o'Clock, at Banks' Arcade,
WITHOUT RESERVE,

The following list of Choice and Valuable SLAVES, from the Plantation of Gen. W. BAILEY, Lake Providence, La., viz:

ONE FAMILY.
1.—BIG HENRY, aged about 21 years, a superior field hand, fine servant, and first rate cotton picker; and his wife—
2.—AMY, aged about 18, superior cotton picker and fine servant.
3.—LITTLE HENRY, aged about 16, slightly near-sighted, a superior cotton picker and fine servant.

ONE FAMILY.
4.—BOSTON, aged about 26 years, a complete ostler and field hand, and superior cotton picker, and an invaluable servant.
5.—LITTLE MILLY, his wife, aged about 19, a superior cotton picker, and a most valuable hand.

ONE FAMILY.
6.—STEPHEN, aged about 24 years, a fine ox driver and superior cotton picker, etc.
7.—BIG FANNY, aged about 24, his wife, a good seamstress, and superior cotton picker and field hand; his child—
8.—WIRT HENRY, aged about 20 months.

ONE FAMILY.
9.—CASWELL, ox driver, aged about 30, very slightly ruptured, a fine field hand, and an invaluable servant.
10.—AGGY, his wife, aged about 30, a superior cook, washer and ironer, a most valuable woman, and superior field hand and cotton picker.
11.—FAYETTE HENRY, her child, aged about 5 years.
12.—STANHOPE McLANHAN, aged about 2 years.

ONE FAMILY.
13.—BIG JIM, a rough carpenter, a superior field hand and cotton picker, aged about 25 or 26 years—invaluable.
14.—ANN RANDOLPH, his wife, aged about 22 years, can pick cotton with any negro, and is invaluable.

ONE FAMILY.
15.—GEORGE, aged about 26 years, plain but useful plantation smith, a fine driver, and one of the best cotton pickers and field hands in the State, without exception.
16.—LITTLE FANNY, his wife, aged about 23 years, a most valuable cotton picker and field hand.
17.—RODERICK DHU, her child, aged about 4 years. This man and wife can pick more cotton than any two hands in the State.

ONE FAMILY.
18.—PETER, aged about 47, carpenter and cooper, a trusty and valuable servant, (formerly servant of Thomas Jefferson); can build a house out and out.
19.—HARRIET, his wife, aged about 22 years, a most superior cotton picker, and invaluable.
20.—THOMAS JEFFERSON, their child, aged about 3 yrs.

ONE FAMILY.
21.—JACK, aged about 49 or 50, one of the best drivers in the State, and invaluable.

22.—DOLLY, his wife, aged about 21 years; can pick from 420 to 500 lbs. of cotton per day; a superior field hand, sews well.

23.—NELSON, aged about 28, slightly ruptured; a most valuable field hand and superior cotton picker; has never lost an hour's work from his rupture.
24.—JORDEN, aged about 19, a very valuable field hand, a fine cotton picker and ginner.
25.—ADDISON, aged about 18, an invaluable field hand and cotton picker, one of the best.
26.—SAM, aged about 18, a fine cotton picker, and as valuable a boy as can be found.
27.—WASHINGTON, aged about 15 or 16, a fine cotton picker and valuable boy.
28.—DICK, aged about 20, a fine cotton picker and superior gin hand.
29.—CHARLES, aged about 19, field hand, a good boy.
30.—JOHN, aged about 23 years, fine cotton picker and field hand.

ONE FAMILY.
31.—EDWARD, aged about 19, one amongst the best cotton pickers and field hands in the State.
32.—MARGARET, his wife, aged 18, a valuable cotton picker; and her two children—
33 and 34.—JENNY LIND, aged 2 years, and Infant 3 mos.

35.—BIG WILLIAM, aged about 20, a fine cotton picker and good servant—a strong and valuable man.
36.—JIM HENRY, aged about 19 years, a fine field hand and cotton picker.
37.—HOYT, aged about 11 or 12 years, cotton picker, etc.
38.—WILLIAM NELSON, aged about 14 years, fine cotton picker, etc.

ONE FAMILY.
39.—JESSEE, aged about 20 years, fine field hand; can pick 500 lbs. cotton; invaluable boy.
40.—CAROLINE, his wife, aged 17 years, can pick as much as Jessee.

41.—AMANDA, aged about 18, fine field hand, etc.
42.—MARY PATE, aged about 18, field hand and cotton picker, etc.
43.—YELLOW MARY, aged about 18, a good seamstress, can pick 500 lbs. cotton per day.
44.—DINAH, aged about 45, a good field hand, strong and valuable; can pick 350 lbs. cotton; good midwife.
45.—PHILLIS, aged 20, field hand and cotton picker.
46.—NANCY, aged 17, do. do.
47.—MARY CASWELL, aged 12, field h'd and cotton picker.
48.—SUCKEY, aged about 11 or 12, do. do.
49.—BETSY, aged 11, do. do.
50.—SALLY, aged 11, orphan, do. do.
51.—NELLY, aged 52, midwife, etc., good hand to give medicine, and take care of children.
52.—JANE, aged 18, fine cotton picker, and invaluable.

TERMS OF SALE, CASH, or on a credit, for approved notes or drafts, with such interest as may be agreed on between vendor and purchaser. *Acts of Sale before T. O. Stark, Not. Pub., at the expense of the purchasers*

teeth." Some traders admitted the self-evident contradictions in their commodification of human beings. "I have bought the boy Isaac for 1100," wrote a trader in 1854. "I think him very prime.… He is a … house servant … first rate cook … and splendid carriage driver. He is also a fine painter and varnisher.… Also he performs well on the violin.… He is a genius and it's strange to say I think he is smarter than I am." With such sickening irony, American slavery thrived even as it threatened the nation that gave it legal comfort.

Abolitionism

Although anti-slavery activity was almost as old as slavery itself, with its roots in Quaker Pennsylvania, it gained momentum with African American petition drives during the American Revolution. In the 1820s, the movement against slavery took several important turns. The American Colonization Society (ACS), launched in 1816 and supported by prominent upper South slaveholding politicians such as Thomas Jefferson and Henry Clay, campaigned to relocate blacks to foreign lands. The ACS always maintained a philosophy of "voluntary" and not forcible deportation of free African Americans to foreign lands, particularly the nation of Liberia, which it founded in 1822. The ACS and the myriad supporters it attracted over time believed that blacks and whites could not coexist peacefully and successfully in America. Some blacks embraced the colonizationist idea, including Paul Cuffe, a New England sea captain, and John Russwurm, a Bowdoin College graduate and newspaper editor. But most found the schemes put forth by colonizationists an insult to their fondest hopes and a denial of their birthright as Americans.

By the late 1820s, many black spokesmen vehemently rejected the paternalism and racism inherent in colonization and other forms of gradualism. In 1829, David Walker, a free black who migrated northward from the South, published a stunningly radical attack on the essential hypocrisy of America's official complicity with slavery. His *Appeal to the Colored Citizens of the World* called for overt resistance and employed Enlightenment philosophy and the Bible to condemn American "tyranny." Walker addressed white Americans directly with a classic jeremiad, warning that blacks "must and shall be free … in spite of you. You may do your best to keep us in wretchedness and misery, to enrich you and your children, but God will deliver us from under you. And wo, wo, will be to you if we have to obtain our freedom by fighting." Walker was found dead by mysterious means near his clothing shop in Boston in 1830.

On this foundation built by black abolitionists, the white journalist William Lloyd Garrison founded a newspaper called the *Liberator* in Boston in 1831. From deep Christian faith, a radical temperament, and his hatred of slavery, Garrison forged a movement and created the American Anti-Slavery Society. His paper and that organization were the longest-lasting abolitionist institutions of their kind. Garrisonians, who included many loyal black

NOTICE OF AUCTION African American families were often permanently separated in sales, but this auction in Louisiana in 1855 (*opposite*) offers family units for sale. Details include mention that Peter, a carpenter and cooper, once belonged to Thomas Jefferson.

EMBLEM OF ABOLITION
An image of a kneeling man in chains decorates an early nineteenth-century cast-iron desk box. The English potter Josiah Wedgwood created the design to support the anti-slavery campaign.

abolitionists by the 1840s, such as northern free-born Sarah and Charles Remond and William Cooper Nell, as well as former slaves such as Douglass, embraced several principles and strategies: moral suasion (the belief in converting the heart of the individual); pacifism; anti-clericalism (attacking religious hypocrisy); anti-voting (participating in politics was viewed as complicity with evil); women's rights; and black civil rights. Above all, Garrison and his followers brought a new disposition to anti-slavery known as immediatism, the urgency that slavery must be attacked by the most radical means necessary short of violence.

By the end of the 1830s, the abolitionist movement, even as it split into different ideological factions, had mastered the art of propaganda by printing and distributing posters and petitions, had created nearly 1,500 local associations, and had about one hundred thousand members. At the same time, blacks in northern communities built their own annual convention movement, published their own newspapers (as Douglass did in breaking with Garrison and editing the *North Star* in 1847), and created self-improvement strategies in order to thwart the worst elements of racism.

Black abolitionism also underwent significant changes as former slaves—among them Douglass, William Wells Brown, Henry Bibb, Harriet Jacobs, Sojourner Truth, Henry Highland Garnet, and Solomon Northup, all of whom possessed the experience of

FREEDOM PAPERS Free African Americans were in danger of being sold into slavery if they did not carry legal documents certifying their free status at all times. Loudoun County, Virginia, issued this 1852 certificate to Joseph Trammell, who was born enslaved in 1831. Trammell protected his papers in a pocket-sized handmade tin box.

WILLIAM LLOYD GARRISON (1805–79)

"I will not equivocate—I will not excuse—I will not retreat a single inch—AND I WILL BE HEARD," William Lloyd Garrison declared in the first issue of the *Liberator*, his weekly newspaper advocating the immediate abolition of slavery. From that issue in January 1831 until the December 1865 ratification of the Thirteenth Amendment, which abolished slavery, Garrison, a white Massachusetts-born journalist, maintained a relentless call for freeing enslaved African Americans. He traveled around the country and overseas to gain support for the cause, cofounded the New England and American anti-slavery societies, and joined forces with Frederick Douglass and other black and white abolitionists.

Fearlessly outspoken, Garrison burned a copy of the U.S. Constitution in 1854, denouncing it as a pro-slavery "covenant with death." For years, Garrison's newspaper gave a voice to the anti-slavery movement, influencing many New Englanders, but his rigid views on certain strategies eventually led to rifts with other abolitionists, including Douglass and Wendell Phillips.

Garrison's gold pocket watch

enslavement in their souls—moved beyond the abstractions of their white comrades. They wrote their life stories as witnesses to enslavement as well as living embodiments of survival and black intellect. They liberated themselves by the written and spoken word. When Northup told his harrowing tale of being kidnapped and transported to the worst of Louisiana slavery for twelve years, he exhibited a "broken spirit" and "unutterable agony" like few others. He also, by nearly miraculous means, lived to rejoin his family in the North, "arisen" to a physical and emotional redemption.

Douglass, in his autobiography *My Bondage and My Freedom*, published in 1855, may have spoken for all fugitive slaves when remembering his slave youth: "The thought of only being a creature of the present and the past

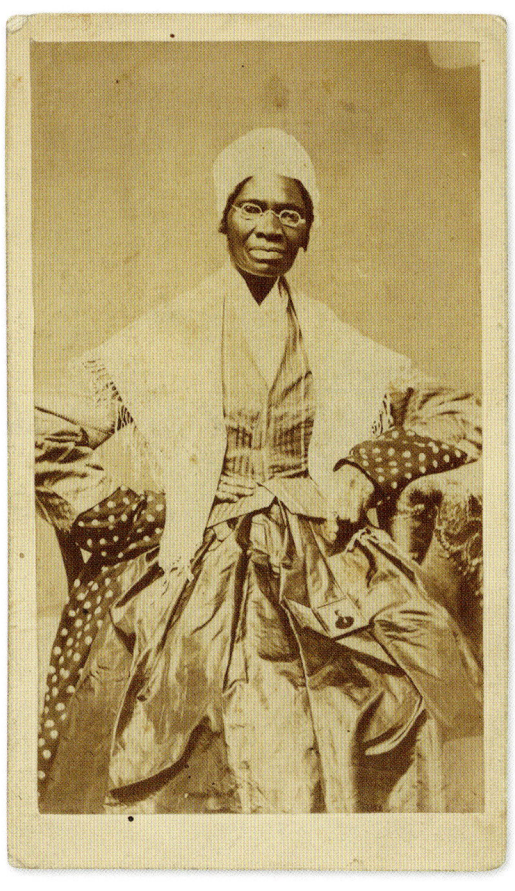

"I feel safe in the midst of my enemies for the truth ... will prevail."
—SOJOURNER TRUTH, abolitionist, 1850

troubled me, and I longed to have a future—a future with hope in it. To be shut up entirely to the past and present is abhorrent to the human mind; it is to the soul—whose life and happiness is unceasing progress—what the prison is to the body."

By 1850, most black abolitionists were looking for all possible means to destroy slavery, which was expanding westward and threatening to tear apart the nation's political institutions. Many became impatient with moral suasion, embraced political action, and considered the uses of violence.

CRUSADER Abolitionist Sojourner Truth escaped enslavement in 1826. She became the first black woman to win a legal case against a white man after she went to court to recover her son. This photograph of Truth with an image of her grandson resting in her lap (ca. 1866) was one of many that she sold to support her lectures.

The Road to War

After the United States' war with Mexico in 1846-48, the American anti-slavery movement became highly politicized. With the passage of the Fugitive Slave Act of 1850, enforcing the return of escaped slaves even in free states, thousands of former slaves living in the North fled to Canada. There they found thousands of others who had arrived by various routes and methods in what became known as the Underground Railroad. Through the brave rescues conducted by the intrepid Harriet Tubman, the clandestine assistance of hundreds of sympathizers, black and white, and their own courage, some slaves had escaped by land and sea into insecure fates. Indeed, so many slaves had absconded that slaveholders were demanding in Congress a stronger federal enforcement of the return of their "property." By the mid-1850s, Tubman had made her base of operations St. Catherines in Canada. A network of "vigilance" committees in northern cities, which harbored and aided fugitives in their escapes, caused consternation among white Southerners. These local activists included Lewis Hayden in Boston, David Ruggles in New York (the only black activist in the group), William Still in Philadelphia, and John Parker in Ripley, Ohio.

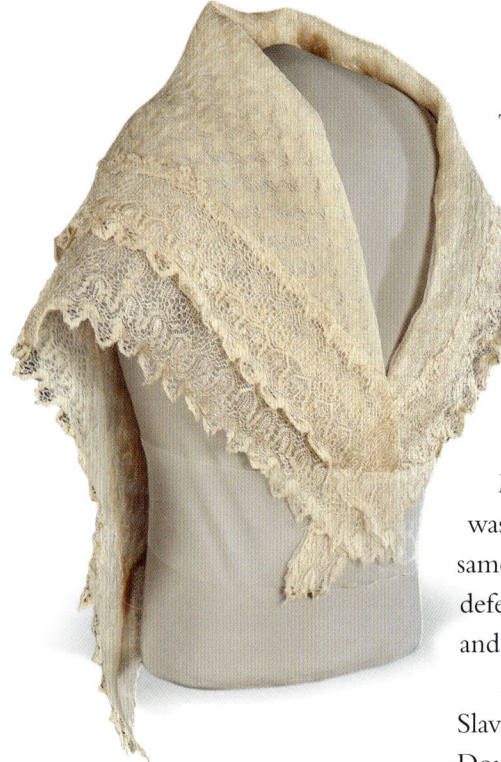

The Fugitive Slave Act of 1850 radicalized many white Northerners and caused terror and outrage among blacks. Specially appointed federal commissioners adjudicated on the identity of alleged fugitives and were paid fees that favored slaveholders: $10 if they found the person to be a fugitive and $5 if not. The law also made it a felony to harbor runaways. Anti-slavery supporters were most angry at the law's lack of due process of law for former slaves.

Between 1850 and 1854, violent resistance to slave catchers occurred across the North. Sometimes a captured fugitive was broken out of jail or freed from the clutches of slave agents by abolitionists, as in the 1851 Boston case of Shadrach Minkins, who was spirited to Canada. Also in 1851, a fugitive named Jerry McHenry was liberated by an abolitionist mob in Syracuse, New York, and hurried to Canada. That same year, the small black community in Lancaster County, Pennsylvania, took up arms to defend four escaped slaves from a federal posse. At this "Christiana riot," the fugitives shot and killed Edward Gorsuch, their owner, who was seeking to re-enslave them.

Many black abolitionists embraced potentially violent means of resisting the Fugitive Slave Act. In an 1854 column, "Is It Right and Wise to Kill a Kidnapper?" Frederick Douglass concluded that the only way to make the Fugitive Slave Law "dead letter" was to make a "few dead slave catchers." He also said that the reason slave catchers feared having their "throats cut" was because "they deserved to have them cut."

In 1854, the Kansas–Nebraska Act demonstrated how the expansion of slavery had divided American politics. It opened up the vast territories of the old Louisiana Purchase

HARRIET TUBMAN (ca. 1822–1913)

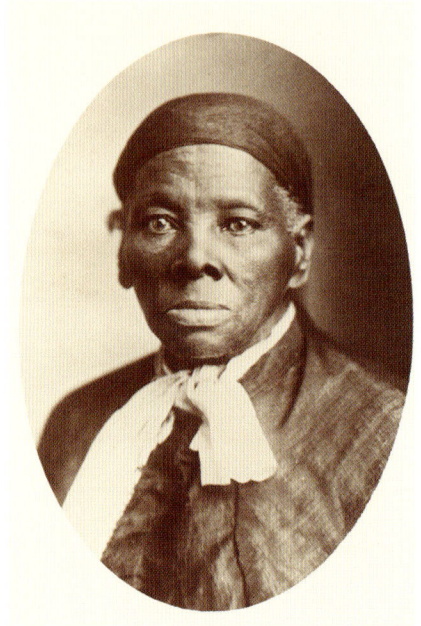

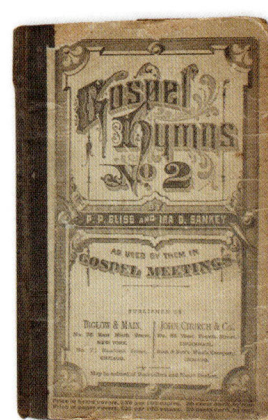

Harriet Tubman's family hymnal

After her escape from slavery in Dorchester, Maryland, in 1849, Harriet Tubman returned to the South more than a dozen times in the 1850s to escort some eighty family members and friends out of bondage, earning her the nickname Moses. Despite suffering seizures caused by a childhood head injury inflicted by an overseer, she was arguably the Underground Railroad's most remarkable "conductor." Incomparably shrewd, she often used disguises to elude slave catchers and never lost a passenger, she claimed. During the Civil War, Tubman was equally effective as a nurse, spy, and scout for the Union Army. Her intelligence gathering on a Confederate stronghold in coastal South Carolina helped liberate more than seven hundred black people. After the war, Tubman was active in women's suffrage and black women's club movements. She also established a home for elderly and indigent black people in Auburn, New York, her home from the late 1850s until her death in 1913. An estimated one thousand people attended her funeral.

SLAVERY AND CAPITALISM

Nancy Bercaw

At first glance, the U.S. economy today appears to bear no relation to legal slavery. After all, how could a thriving twenty-first-century national economy be based upon slavery, something defined as backward, regional, and peculiar?

Yet slavery is the story of American capitalism. Interwoven into the economy in expected and unexpected ways, slavery created wealth for the North and the South. The average slave-trading voyage returned more than 20 percent of the capital invested. In 1860, the value assigned to four million enslaved people stood at $3.5 billion and represented one-fifth of the nation's wealth. The cotton, rice, sugar, and tobacco produced by enslaved workers were valued at more than half of the nation's gross national product.

However, slavery did not just create wealth. Slavery sparked financial innovation and stimulated new capital markets. Investors could buy shares in the domestic slave trade, the Bank of the United States sold bonds in slaves, and insurance companies sold policies to guarantee the "product"—an enslaved human being. "People used as collateral, not just as laborers, lubricated the flow of capital and thus cotton, around the globe," historian Sven Beckert has written in *Empire of Cotton*. These financial innovations, triggered by slavery, laid the foundations for capital markets. Slaveholders' business deals often involved mortgaging their enslaved laborers, using them as collateral to buy land and more slaves. Enslaved Africans became the foundation of global credit and investments in New York, Liverpool, and Le Havre.

Slavery also galvanized American industrialization. The enslavement of four million people on plantations led to the mass manufacture of hats, shoes, and shirts. Some of the first factories established in the United States made such goods for the enslaved population. Cotton grown in the South was shipped to New England or to Britain, woven into cheap "Negro cloth," then sold back to slaveholders. The earliest factory-produced shoes, hoes, shovels, restraints, and whips were produced for sale to slave owners.

Until slavery was abolished in 1865, it drove the national and international economy, creating in large part the world in which we live today. It created great wealth and enduring poverty. It triggered westward migration in the United States as planters bought land and sought to expand the enslavement of people. It was critical to the development of capitalism and in establishing the United States as a global economic power. The history of slavery, therefore, is not "black" history or "southern" history but the nation's history.

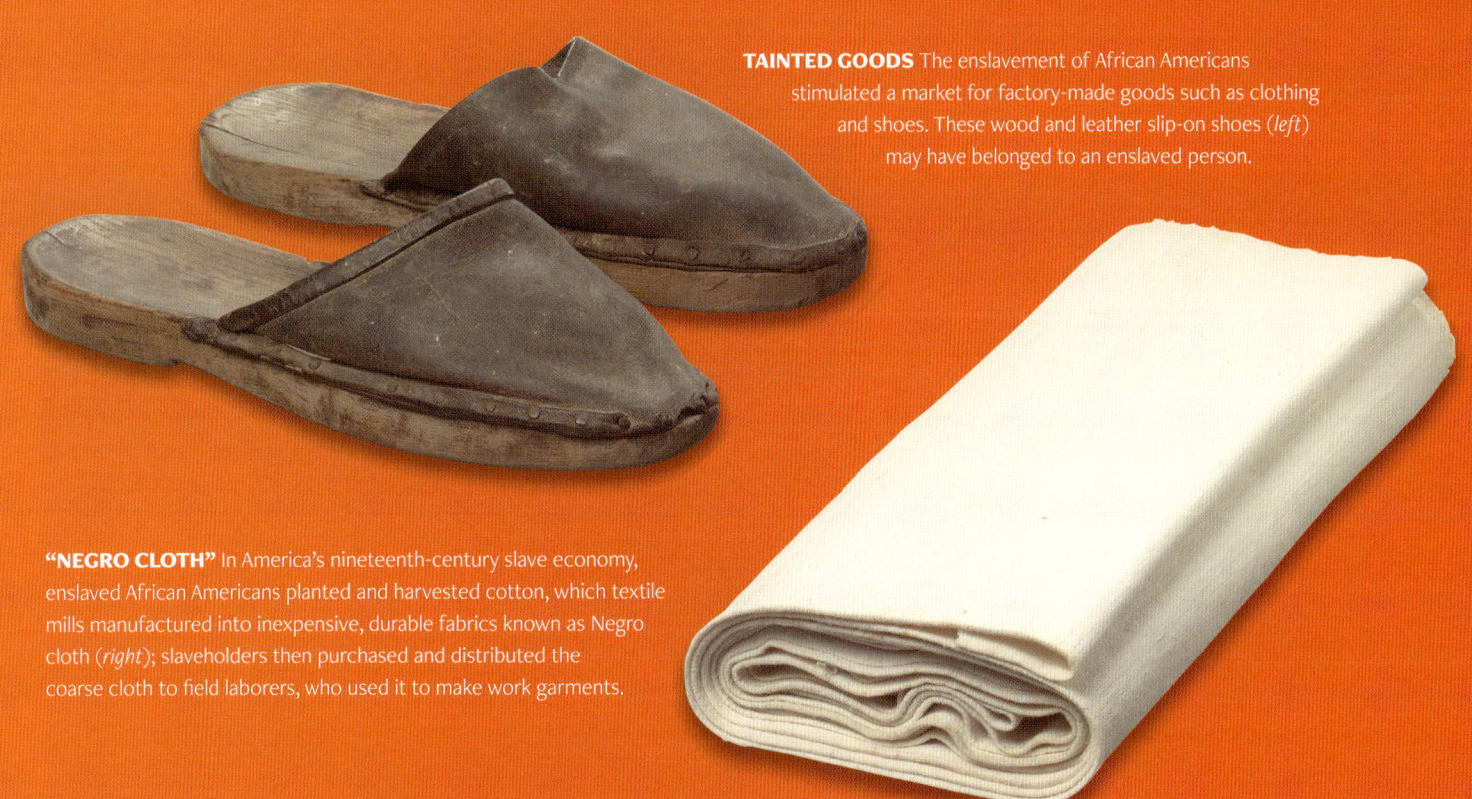

TAINTED GOODS The enslavement of African Americans stimulated a market for factory-made goods such as clothing and shoes. These wood and leather slip-on shoes (*left*) may have belonged to an enslaved person.

"NEGRO CLOTH" In America's nineteenth-century slave economy, enslaved African Americans planted and harvested cotton, which textile mills manufactured into inexpensive, durable fabrics known as Negro cloth (*right*); slaveholders then purchased and distributed the coarse cloth to field laborers, who used it to make work garments.

to the potential spread of slavery and threatened millions of white Northerners who, infused with a faith in free labor ideology, feared the competition of a "slave power" oligarchy in the West. As a border war broke out between these Free Soilers and pro-slavery advocates in "Bleeding Kansas" in 1855–56, a new political coalition called the Republican Party took hold across the North. Republicans threatened the slaveholders' dreams of extending their economic system by introducing a platform that would cordon off slavery, stop its spread westward, and, as Abraham Lincoln declared in 1858, put it on "a course of ultimate extinction."

In 1857, the Supreme Court entered the fray and likely created the point of no return on the road to disunion. Dred and Harriet Scott, two slaves who had married and had two daughters during a stay with their army physician–owner in the free territory of Minnesota in the 1830s, sued for their freedom in Missouri courts upon return to that state. Scott won his freedom in a local court with help from abolitionists, but the verdict was overturned on appeal to the state Supreme Court. Scott's case was then appealed to the federal Supreme Court. After long delays, Chief Justice Roger B. Taney announced the 7–2 *Dred Scott* decision in March 1857. The court declared that Scott was not a citizen of the United States, that residence in free territory did not make him free, and that Congress had no power to bar slavery from any territory.

The decision, coupled with the Kansas–Nebraska Act of 1854, not only overturned the sectional agreement (the 1820 Missouri Compromise had prohibited slavery north of

POETIC POTTER

This jar (ca. 1852) was made by Dave, a talented enslaved African American potter who lived in Edgefield County, South Carolina. Born around 1801, he had multiple owners associated with commercial pottery manufacturing. Dave, who was literate, began signing, dating, and writing short poems on some of his vessels by 1834.

HUNTED SLAVES Fear and peril are palpable in Richard Ansdell's 1862 painting of an enslaved man and woman cornered by snarling dogs as they escape through North Carolina's Great Dismal Swamp. Despite the danger and uncertainty, thousands of African Americans fled the cruelty of slavery in a bid for freedom.

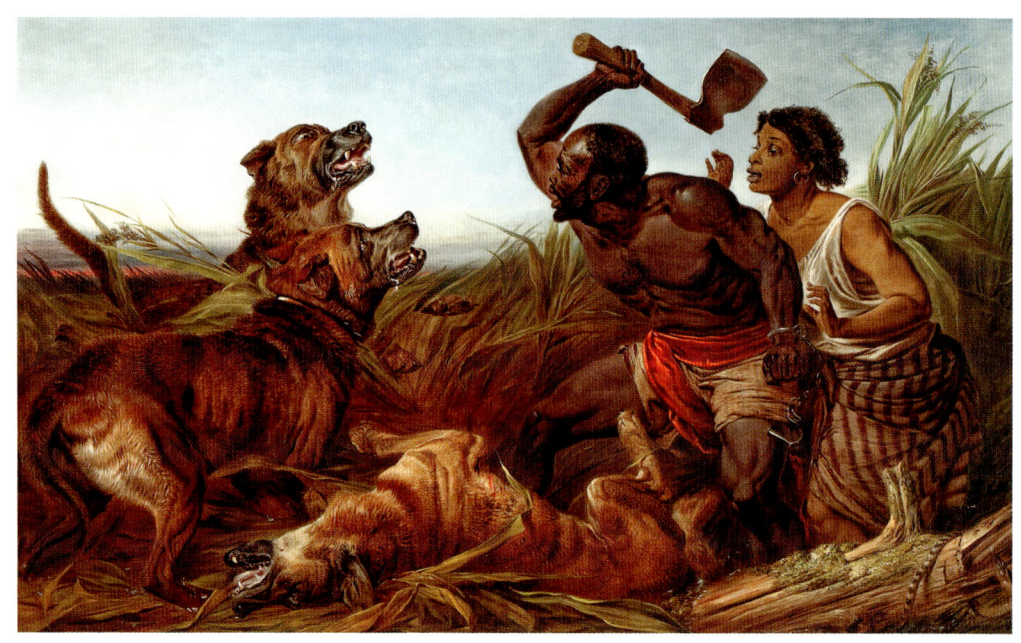

the 36°30' parallel) that had been honored for thirty-seven years, but also sent a blunt message to African Americans. From the nation's founding, Taney argued, blacks had been regarded "as beings of an inferior order" with "no rights which the white man was bound to respect." The ruling seemed to shut the door on black people's hopes of gaining justice. After 1857, African Americans lived in the land of the *Dred Scott* decision. Many who were fugitive slaves sought refuge in Canada. In this state of fear and disillusionment, some black leaders, including abolitionists Henry Highland Garnet and Martin Delany, explored the possibility of blacks emigrating from the United States to the Caribbean or West Africa.

The tension surrounding the slavery issue intensified on October 16, 1859, when John Brown, a radical white abolitionist steeped in the Old Testament concept of justice, led a band of twenty-one whites and blacks in an attack on the federal arsenal at Harpers Ferry, Virginia. Hoping to trigger a slave rebellion, Brown, who had previously engineered the murder of four pro-slavery men in Kansas, failed miserably; he was captured and most of the twenty or so men who had joined him were killed. After a celebrated trial in November and a widely publicized hanging in December, Brown became for African Americans an enduring martyr of abolition.

Brown had tried to recruit prominent abolitionists to his ill-fated crusade, especially Frederick Douglass. Many raised money for Brown; few joined his band. During Brown's trial, Douglass fled the country, fearful that previous collaboration with the old warrior could implicate him. The gallows made Brown sacred in death, and Douglass contributed mightily to his martyrdom, calling him a "glorious martyr of liberty," a "Gideon" of "self-forgetful heroism." White southerners labeled Brown's raid an act of terrorism by the long-dreaded "abolition emissaries" who would infiltrate the region and incite slave rebellion. As the bearded old Brown went eagerly to the gallows on December 3, 1859, he handed a note to his jailer with this famous prediction: "I John Brown am quite certain that the crimes of this guilty land will never be purged away, but with blood."

The War for Emancipation

Few events in American history can match the drama and the social significance of emancipation in the midst of the Civil War. Black abolitionists, fugitive slaves seeking their way to an uncertain freedom somewhere in the "Canaan" of the North, and the millions of slaves cunningly surviving on cotton or sugar plantations in the South were all actors in

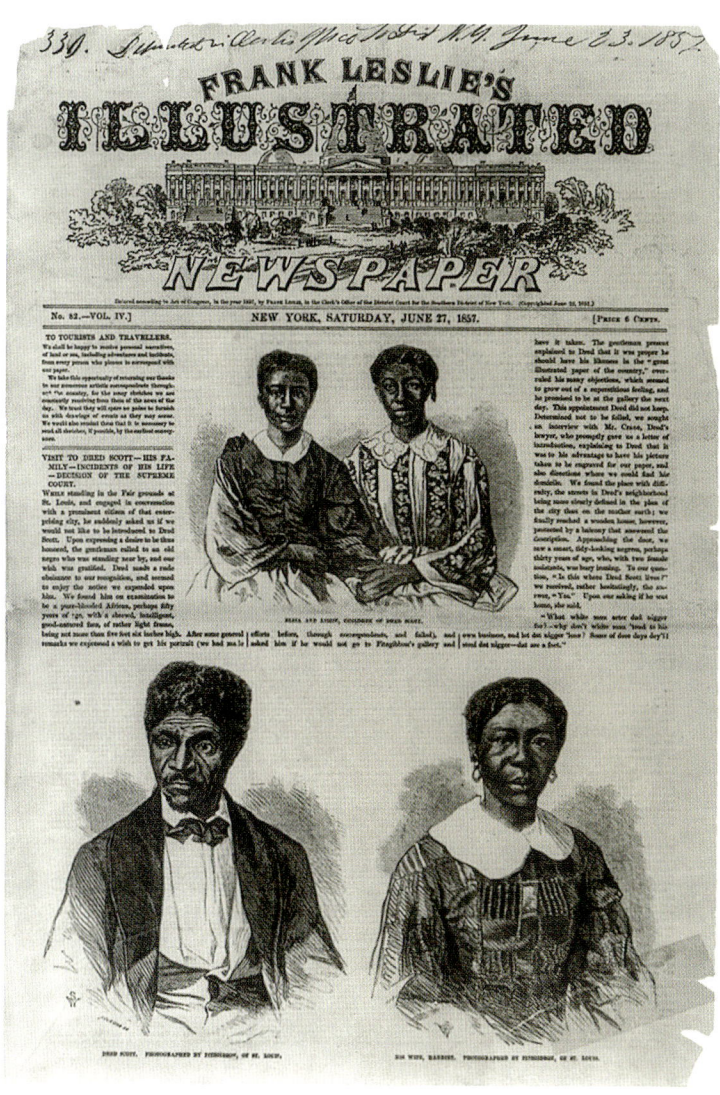

THE SCOTT FAMILY These pictures of Dred Scott, his wife, Harriet, and their daughters, Eliza and Lizzie, were printed on the front page of the *Illustrated Newspaper* on June 27, 1857. They accompanied an article about the lives of the family after the Supreme Court decision that declared Dred Scott was not a citizen of the United States.

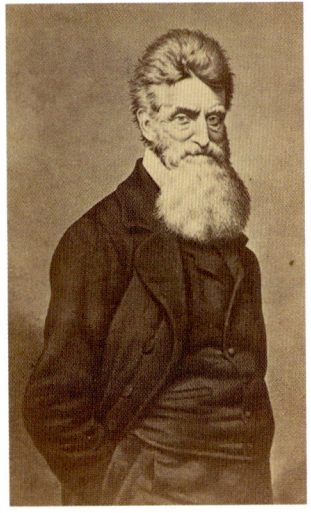

MARTYR TO THE CAUSE

Although John Brown failed to spark a rebellion with his raid on Harpers Ferry in 1859, the white abolitionist became a martyr in the eyes of many African Americans.

this long drama. The agony and the hope embedded in the story of emancipation are what black poet Frances Ellen Watkins captured in her simple verse written in the wake of John Brown's execution:

Make me a grave where'er you will,
In a lowly plain, or a lofty hill,
Make it among earth's humblest graves,
But not in a land where men are slaves.

As the war between North and South increased in scale, it spawned the freedom generation of African Americans in all their complexity. After the election of Republican Abraham Lincoln in 1860, followed by the secession of several southern states, and in April 1861 the outbreak of war, African Americans believed that a struggle over their future had begun. Although they could not yet know the scale of impending bloodshed, most would have agreed with the words of one of Douglass's editorials: "The contest must now be decided, and decided forever," he wrote, "which of the two, Freedom or Slavery, shall give law to this Republic. Let the conflict come."

Black Americans' responses to the war ranged from an ecstatic willingness to serve to caution and resistance. In the North, black communities organized militia companies and wrote to the secretary of war offering their services. In the immediate wake of President Lincoln's call for volunteers, African Americans in Boston gathered at a meeting, declaring themselves "ready to stand by and defend the Government with our lives, our fortunes, and our sacred honor." From Pittsburgh came the offer of a militia company called the Hannibal Guards, who insisted on being considered American citizens. The large free black population in Philadelphia pledged to raise two full regiments. In Albany, Ohio, a militia

BRIDGET "BIDDY" MASON (1818–91)

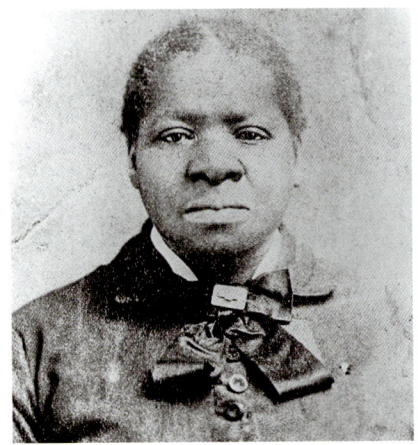

In 1856, Bridget "Biddy" Mason, an enslaved woman, sued for her freedom and won. Mason's owner, a Mormon named Robert Smith, had transported her from Mississippi two thousand miles west, eventually arriving in Los Angeles. Aware that Smith planned to relocate his family to Texas, a slave state, Mason's friends urged her to take him to court while still in the free state of California. After her legal success, in *Mason v. Smith*, Mason worked as a nurse and midwife to support herself and her three daughters. In 1866, she began buying property in what is today's downtown Los Angeles, becoming one of the first black women to own real estate in the city. A wise investor and astute money manager, she became one of the wealthiest women in the city. Mason's philanthropic work included donations of food and goods to prisoners and poor people. In 1872, she cofounded and funded the First African Methodist Episcopal Church, Los Angeles's first and oldest black church. When she died, her net worth was upward of $250,000, equivalent to more than $5 million today.

company calling itself the Attucks Guards—after the black Revolutionary War hero Crispus Attucks, the first casualty of the Boston Massacre in 1770—presented a flag made by the black women of the town. In Detroit, a full black military band sought to enlist. Such refrains sounded from all corners of the free states.

However, as promptly as blacks volunteered, their services were denied during the first year of the war. The initial policy of the federal government reflected widespread white public opinion: The war meant the restoration of the Union and not the destruction of slavery. This stance provoked fear, confusion, and anger in 1861–62, and a vigorous debate about support of the war ensued among blacks. An African American man in Troy, New York, announced: "We of the North must have all the rights which white men enjoy; until then we are in no condition to fight under the flag which gives us no protection." Another New Yorker was even more explicit. "No regiments of black troops," he said, "should leave their bodies to rot upon the battlefield beneath a Southern sun, to conquer a peace based upon the perpetuity of human bondage."

In his newspaper, Frederick Douglass demanded black enlistment from the first sounds of war. The exclusion policy greatly frustrated him, and in September 1861, he attacked the Lincoln administration's "spectacle of blind, unreasoning prejudice" and accused it of fighting with its "white hand" while allowing its "black hand to remain tied." The war was not yet the social revolution it would become within a year.

Personal inclinations as well as powerful political considerations dictated Lincoln's reticence. He personally hated slavery, but he made decisions cautiously and gradually. In a short war, slavery may hardly have been harmed. But as the struggle continued, the destruction of slavery turned into a major goal of the Union forces—by moral impulse and "military necessity." Early on, the president had tried unsuccessfully to convince the border states that had not seceded, particularly Delaware and Kentucky, to adopt their

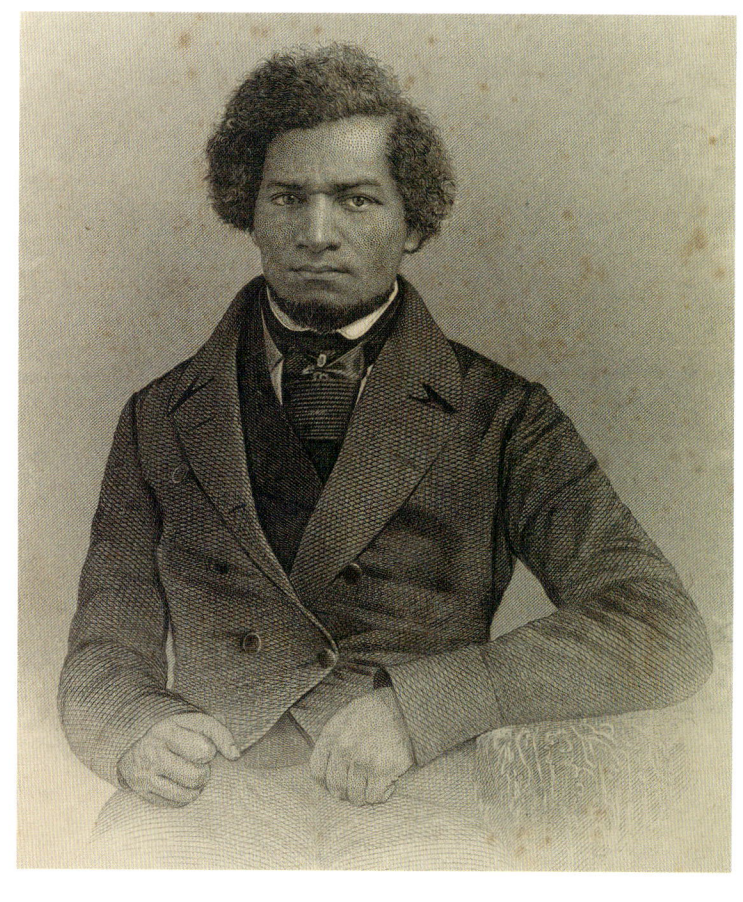

FREEDOM'S ORATOR

In 1841, three years after escaping slavery, Frederick Douglass delivered a stirring speech on Nantucket about his experience of slavery. The speech set him on a path to become an impressive orator.

"The contest must now be decided, and decided forever ... which of the two, Freedom or Slavery, shall give law to this Republic. Let the conflict come."

—FREDERICK DOUGLASS, *Douglass Monthly,* **1861**

own gradual, compensated plans of emancipation. His administration also initiated a series of schemes to colonize free blacks outside the United States, machinations that encountered great hostility from most black leaders. Lincoln lectured a small delegation of black ministers meeting with him at the White House in August 1862, urging them to volunteer to lead colonization in Liberia and saying that the presence of blacks in America had caused the war: "But for your race among us there could not be war." He concluded that "it is better for us both [the two races] … to be separated." Yet at the very time Lincoln was making this plea—his worst racial moment—he was also drafting an executive order for emancipation.

Lincoln came to view emancipation as an essential weapon to crush the Confederacy. A Union victory at the Battle of Antietam in Maryland provided the morale boost Lincoln needed to issue the Preliminary Emancipation Proclamation on September 22, 1862, and change the perception of the war. A few months earlier, approximately 3,100 slaves in the District of Columbia had been freed with compensation to owners. Moreover, the Second Confiscation Act, passed by Congress in July, had freed slaves as enemy "property" anywhere in the Confederacy. The Preliminary Proclamation was, in effect, a warning to the South to put down its arms and return to the Union or their slaves would be liberated in one hundred days. On January 1, 1863, Lincoln issued the final Proclamation. Its primary differences from the first were that it did not mention colonization, which was prominent in the Preliminary, and it authorized the recruitment of black soldiers into the Union Army and Navy.

BENJAMIN BUTLER (1818–93)

A month into the Civil War, in May 1861, General Benjamin Butler, commander of Union-held Fort Monroe in Hampton, Virginia, granted three enslaved black men asylum, a decision that would significantly impact the emancipation of black Americans. Butler, a lawyer before enlisting, flouted the 1850 Fugitive Slave Law and designated the fugitives "contraband" of war—confiscated enemy property that had been used against the Union. The men had been forced to construct Confederate fortifications. When other enslaved blacks learned of Butler's action, hundreds flocked to Fort Monroe. A few months later, the

Butler Medal for valor

U.S. Congress passed legislation that codified Butler's initiative, a measure long urged by abolitionists. A year later, Congress passed a stronger confiscation act, declaring that human "contraband" would be "forever free of their servitude and not again held as slaves." That statute formed the basis of Lincoln's Emancipation Proclamation. In 1864, Butler commissioned and paid for a silver medal to honor the valor of black troops under his command during the Battle of New Market Heights in Virginia. The Butler Medal (also known as the Colored Troops Medal or Army of the James Medal) was never officially recognized by the federal government.

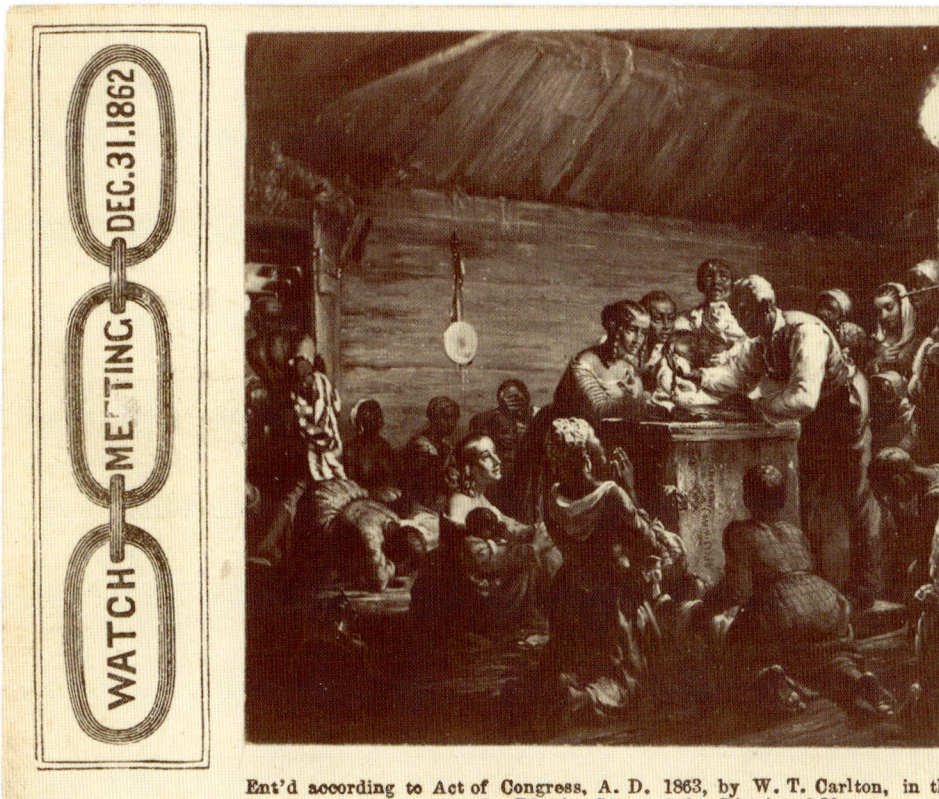

Ent'd according to Act of Congress, A. D. 1863, by W. T. Carlton, in the Clerk's Office of the District Court of the District of Mass.

Initially crafted as a legal document based on the president's war-making powers, the Emancipation Proclamation became a moral and political document of profound significance. It declared that "all persons held as slaves" in areas in rebellion "shall be then, thenceforward, and forever free." For constitutional reasons, Lincoln excepted the border states that had not seceded and all counties under Union occupation from his order. Significantly, though, Lincoln had ordered the armed forces to free slaves wherever the war penetrated the Confederacy. From that day forward, every advancing step of the Union Army was a liberating step.

On December 31, 1862, "jubilee meetings" occurred all over black America. At Tremont Temple in Boston, a huge gathering met from morning through the night, awaiting the news that Lincoln had signed the fateful document. Many attending the "watch night" were concerned that something might go awry. Numerous black leaders spoke during the day: the attorney John Rock, the minister and former slave John Sella Martin, the orator and women's suffragist Anna Dickinson, the author William Wells Brown, and the Boston Garrisonian William Cooper Nell. Douglass was front and center in the oratory as always. Genuine worry set in by evening, as no news had yet come over the telegraph wires.

Then, at about 9 p.m., a runner arrived, shouting: "It is coming … it is on the wires!" An attempt was made to read the legal language of the proclamation, but great jubilation engulfed the crowd. Amid unrestrained shouting and singing, Douglass gained the throng's attention and led them in a chorus of a favorite hymn, "Blow Ye the Trumpet, Blow." Then

WATCH NIGHT African Americans gathered in churches and homes to await the moment the Emancipation Proclamation went into effect on January 1, 1863. The tradition continues in many communities today.

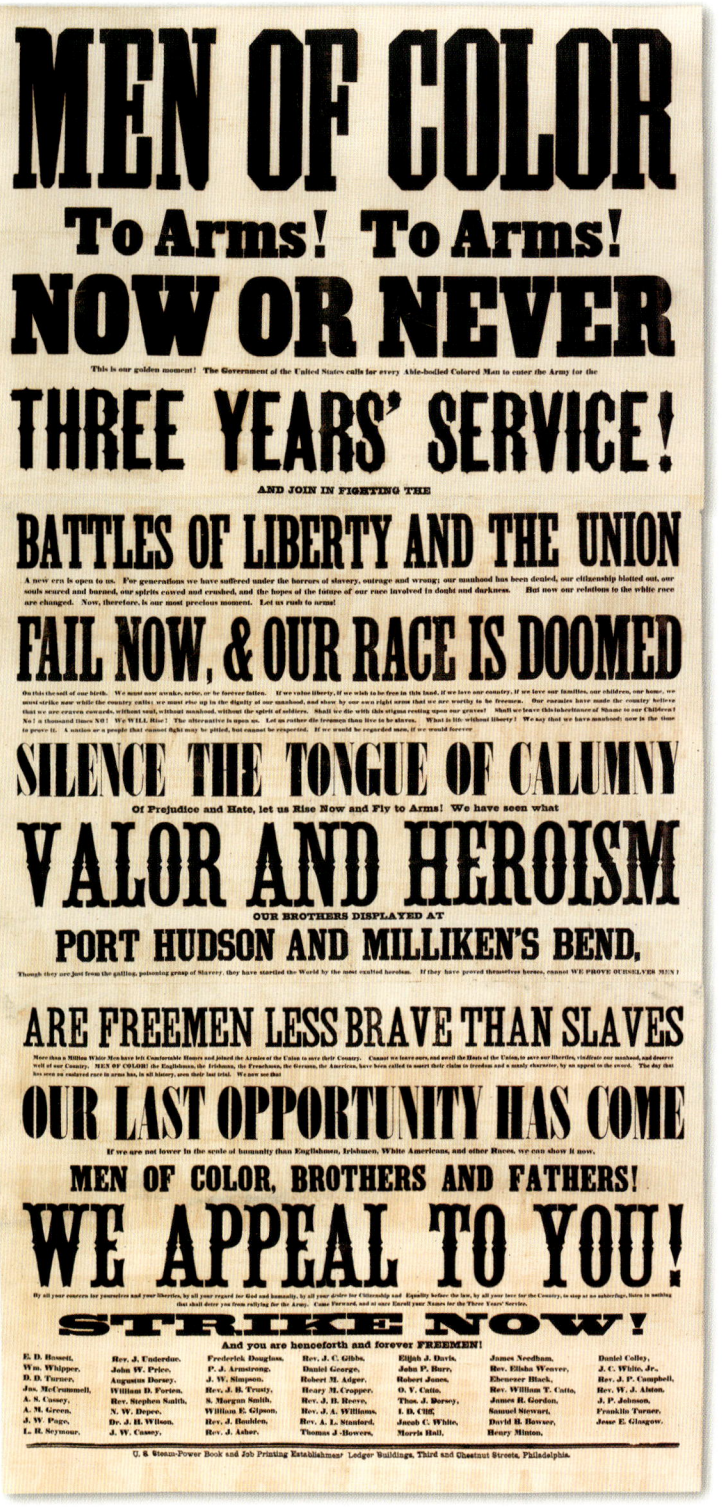

RALLYING CRY When the Union Army authorized the enlistment of African American men in 1863, a group of Philadelphians, among them Frederick Douglass, issued this call to arms. Measuring nearly eight feet by four feet, the notice could not be missed.

an old preacher named Rue led the group in "Sound the loud timbrel o'er Egypt's dark sea, Jehovah has triumphed, his people are free!" The celebration lasted all night.

At a large "contraband camp" (a center for refugee ex-slaves) in Washington, D.C., some six hundred black men, women, and children gathered at the superintendent's headquarters on New Year's Eve and sang through the night. In chorus after chorus of "Go Down Moses," they announced the magnitude of their exodus. One newly supplied verse concluded with "Go down Abraham, away down in Dixie's land, tell Jeff Davis to let my people go!"

Between 1863 and 1865, emancipation evolved as a grinding social process, alternately exhilarating and tragic. The timing and circumstance of liberation for enslaved black people depended on several interrelated factors: the character and density of the slave population in a given region, the course of the war itself, the policies enforced by the Union and Confederate forces at any given time, and the remarkable volition and bravery of the slaves themselves. Southern geography, the chronology of military campaigns, the character of total war, with its massive forced movement of people, the personal dispositions of slaveholders and Union commanders, and the advent of widespread recruitment of black soldiers all combined in determining when, where, and how freedom was achieved.

Often freedom emerged alongside the worst elements of social revolution—displacement, disease, and death in refugee camps. The author and former slave Harriet Jacobs worked in the contraband camp in Washington, D.C. She observed "men, women, and children all huddled together … in the most pitiable condition … sick with measles, diphtheria, scarlet and typhoid fever." For a period, she recorded ten deaths every day among freedmen. Scrambling about in "filthy rags," wrote Jacobs, "the little children pine like prison birds for their native element." So moved was Jacobs that she could only conclude: "What but the love of freedom could bring these … people hither?"

One Georgia Confederate planter, John Jones, watched the disintegration of slavery with "hopeless despair." To him, it was an unbearable revolution, observing "the dark, dissolving, disquieting wave of emancipation."

By the spring of 1865, approximately 474,000 former slaves and free blacks had participated in some form of labor for the Union cause in the South. Of the approximately

186,000 black men who served in the Union Army and Navy—10 percent of total federal forces—nearly 80 percent were former slaves recruited in the South. Of that number, thirty thousand gave their lives, the vast majority from disease, in the war for their freedom and that of their kinfolk. The black soldier embodied the revolutionary character of the war. At war's end, some six hundred thousand to seven hundred thousand enslaved Americans had achieved emancipation. The remaining three-quarters or more of the enslaved population found their fledgling freedom during the summer of 1865, when the war was over and all former Confederate territory was under Union occupation.

A perennial question never seems to lose its resonance in American history: Who freed the slaves? Lincoln and the Army, or the slaves themselves? Despite much heat on both sides of this argument, the answer is and always has been *both*.

A single case in point from 1864 illustrates this reality. Slave pens were the dark and ugly crossroads of American history. To see, hear, and smell one was to understand why the Civil War happened. Wallace Turnage, a seventeen-year-old slave from a cotton plantation in Pickens County, Alabama, entered wartime Mobile in December 1862 through the slave trader's yard; he would leave Mobile from that same yard a year and eight months later. His history was typical. Born on a remote tobacco farm near Snow Hill, North Carolina, in 1846, he was sold to a slave trader named Hector Davis from Richmond, Virginia, in 1860, as the nation teetered on the brink of disunion. In early 1861, Davis sold him for $1,000 to an Alabama cotton planter. Frequently whipped and longing to escape, the desperate teenager tried unsuccessfully four times over the next two years to run away to the Union lines in wartime Mississippi.

In frustration, his owner took Turnage to the Mobile slave traders' yard, where the youth was sold for $2,000 to a wealthy merchant. Mobile was increasingly under military siege. One day in August 1864, Turnage crashed his owner's carriage. In anger, his master

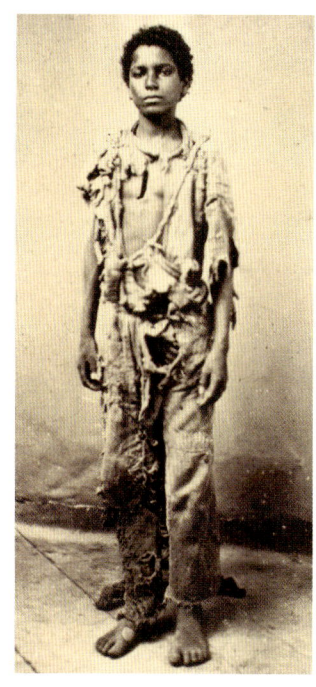

ESCAPE TO FREEDOM

Jackson, a runaway in rags, found refuge with the Union forces in Baton Rouge, Louisiana, in 1863 and later became a drummer boy. This image was used with one of Jackson in military uniform to inspire black men to enlist.

ROBERT SMALLS (1839–1915)

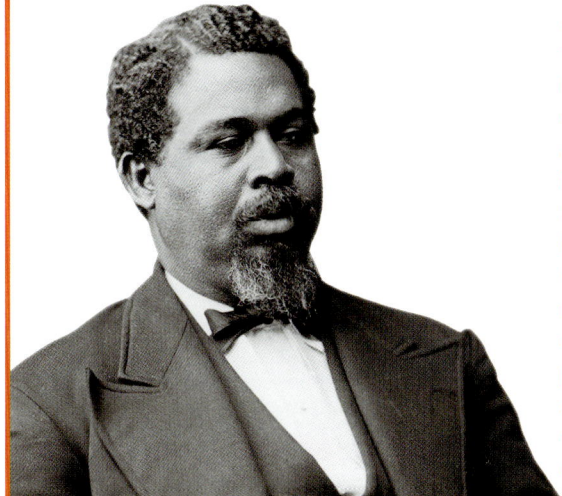

A year into the Civil War, during the early hours of May 13, 1862, Robert Smalls sailed to freedom by commandeering the Confederate arms transport ship *Planter* while its white officers were ashore. Smalls, aged twenty-three, had been hired out by his master to serve as the ship's crew with seven other enslaved men. After slipping the ship out of dock in Charleston, Smalls picked up his wife and children and several other black people waiting at a wharf. Dressed like the captain and giving the secret signals, Smalls piloted *Planter* past several Confederate checkpoints. By dawn he was out to sea. Flying a makeshift white truce flag, *Planter* approached a ship in the Union's naval blockade. Later, as a free man and much-heralded hero, Smalls went on to pilot several vessels for the Union Navy, then became captain of *Planter*. After the war, Smalls settled in his hometown, Beaufort, South Carolina, served in the South Carolina legislature, and was elected to four terms in the U.S. House of Representatives.

took him to the slave pen and hired the jailer to administer a severe beating. Stripped naked, his hands tied together with ropes, Turnage was hoisted up on a hook on the wall and whipped. At the end of the gruesome ritual, his owner instructed the battered young man to walk home. Instead, Turnage "took courage," as he wrote in his postwar narrative, "prayed faithfully," and walked steadfastly southwest, right through a large Confederate encampment and trench works. The soldiers who glanced at the bloodied and tattered black teenager took him for just another camp hand.

"It was death to go back and it was death to stay there and freedom was before me."

—WALLACE TURNAGE, remembering Mobile Bay, Alabama, 1864

EMANCIPATION PROCLAMATION Abolitionist John Murray Forbes published copies of the proclamation as pocket-sized booklets for Union soldiers to bring word of emancipation to African Americans.

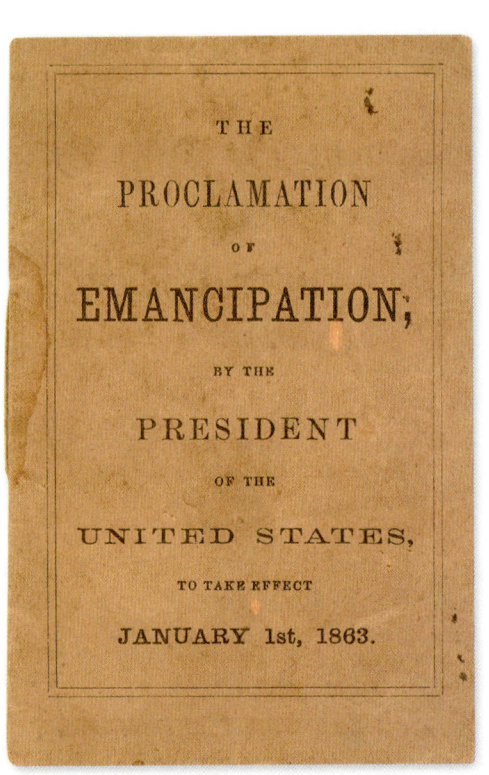

THE

PROCLAMATION

OF

EMANCIPATION;

BY THE

PRESIDENT

OF THE

UNITED STATES,

TO TAKE EFFECT

JANUARY 1st, 1863.

For the next three weeks, Turnage crawled and waded for twenty-five miles through the snake-infested swamps of the Foul River estuary, down the west edge of Mobile Bay. Narrowly avoiding Confederate patrols, Turnage made it all the way to Cedar Point, where he could look out at the forbidding mouth of Mobile Bay to Dauphin Island, now occupied by Union forces. Alligators swam in their wallows, delta grass swayed waist high in the hot breezes, and the gulls squawked around Turnage as he hid in a swampy den.

One day at the water's edge, he noticed an old rowboat that had rolled in with the tide. The runaway took a "piece of board" and began to row out into the bay. As a squall with "water like a hill coming" nearly swamped him, he suddenly "heard the crash of oars and behold there were eight Yankees in a boat." Following the rhythm of the oars, Turnage jumped into the Union gunboat. For a few moments, he remembered, the oarsmen in blue "were struck with silence" as they contemplated the frail young black man crouched in front of them. Turnage turned his head and looked back at Confederate soldiers on the shore and measured the distance of his bravery at sea. Then he took his first breaths of freedom.

In this single, extraordinary act of remembering by an individual, Turnage showed for all time that emancipation, the greatest turning point of American history, was both the result of Lincoln's Emancipation Proclamation and the actions of the Army and Navy; but he also demonstrated that he would never have achieved his liberation without his own unfathomable courage.

The Civil War transformed American history like no other event. It destroyed the first American republic and gave violent birth to the second in the emancipation of both African Americans and the nation to a redefined future. It remained to be seen how what Douglass called this "stupendous sweep of events" would or would not be sustained in the postwar era.

THE ROCKY ROAD TO CITIZENSHIP

William S. Pretzer

After Civil War hostilities ended in 1865, Americans—black and white, in the North and the South—were uncertain about the consequences of abolishing slavery. While Congress debated in Washington, African Americans across the nation gathered in mass meetings, conducted political conventions, and drafted petitions demanding the same political and social rights as white males. What did "freedom" mean, not just for former slaves, but for all citizens of the United States? Who, in fact, were citizens and what were their rights? The response came in three Constitutional amendments, known as the "Reconstruction Amendments," enacted between 1865 and 1870.

Congress had abolished slavery in the District of Columbia in 1862, and President Lincoln's Emancipation Proclamation, authorized by his constitutional power as commander of the armed forces, ended slavery in the rebellious Confederate states in 1863. Nothing, however, prevented individual states from reinstituting slavery at some future date. The December 1865 ratification of the Thirteenth Amendment, forbidding slavery "within the United States, or any place subject to their jurisdiction," put the issue beyond the legislative whim of both state governments and Congress.

In 1866, as formerly enslaved people continued to be subjected to violence, economic exploitation, and political injustice, President Andrew Johnson, a southern sympathizer, vetoed the Civil Rights Act designed to protect the rights of African Americans. Led by Republicans (the liberal party of the time), Congress overrode the veto but realized that only a constitutional amendment could protect the rights of African Americans. The Republican-dominated Congress passed the Fourteenth Amendment, which defined citizens as all persons "born or naturalized in the United States."

The amendment reversed the U.S. Supreme Court's infamous 1857 *Dred Scott* decision, which ruled that no person of African ancestry could claim U.S. citizenship. It also revoked the Three-Fifths Compromise of the Constitution, under which an enslaved person counted as three-fifths of a free person for the purpose of calculating congressional representation and property taxes. When most of the southern states initially refused to ratify the Fourteenth Amendment, Congress passed legislation requiring ratification as a condition of rejoining the Union. It was added to the Constitution in July 1868.

The Fourteenth Amendment fundamentally redefined American legal and political standards. It provided all citizens with "equal protection under the laws," thus establishing the principle of legal equality and entrusting protection of that principle to the national government. It provided further protection for individual rights by prohibiting state governments from depriving "any person of life, liberty, or property without due process of law." The principles of equal protection and due process helped establish the federal government as "the custodian of freedom," in the words

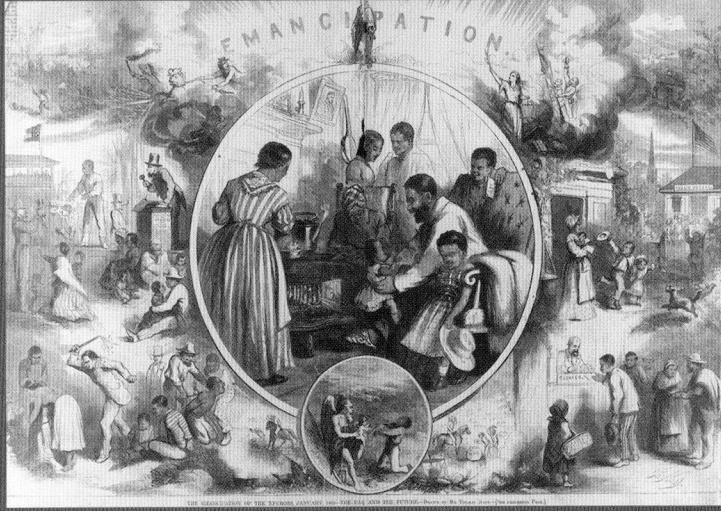

NEW YEAR, NEW DAWN Thomas Nast produced a commemorative drawing of the Emancipation Proclamation for *Harper's Weekly*. In the picture below the central image, a New Year baby unlocks the shackles of a slave. This image was later changed to one of Abraham Lincoln.

of abolitionist senator Charles Sumner. For example, the equal protection clause was the basis for the Supreme Court decision reversing the principle of "separate but equal" in the 1954 school desegregation case *Brown v. Board of Education*. Significantly, the Fourteenth Amendment granted Congress the power to enforce its provisions through legislation, which became the basis for enacting the Civil Rights Act of 1964 and the Voting Rights Act of 1965.

African Americans had long demanded the vote as fundamental to their freedom and citizenship. In January 1867, Congress overrode President Johnson's veto of legislation enfranchising African Americans in the District of Columbia. Soon afterward, Congress extended the vote to all adult males in the western territories regardless of race, religion, income, property, or other restriction. However, the presidential election of 1868 revealed that many black people in the South and North were still banned from the ballot box. To rectify this inequality, Congress passed the Fifteenth Amendment, which prohibited the federal and state governments from denying citizens the right to vote based on "race, color or previous conditions of servitude" (but not on the basis of gender: women did not get the vote until the Nineteenth Amendment in 1920). The states ratified the Fifteenth Amendment in February 1870.

The new right did not prohibit states from applying qualification tests or using other means to limit suffrage. By implementing poll taxes, literacy tests, and other restrictions in addition to employing violence and intimidation, the former Confederate states effectively disenfranchised African Americans for the next hundred years.

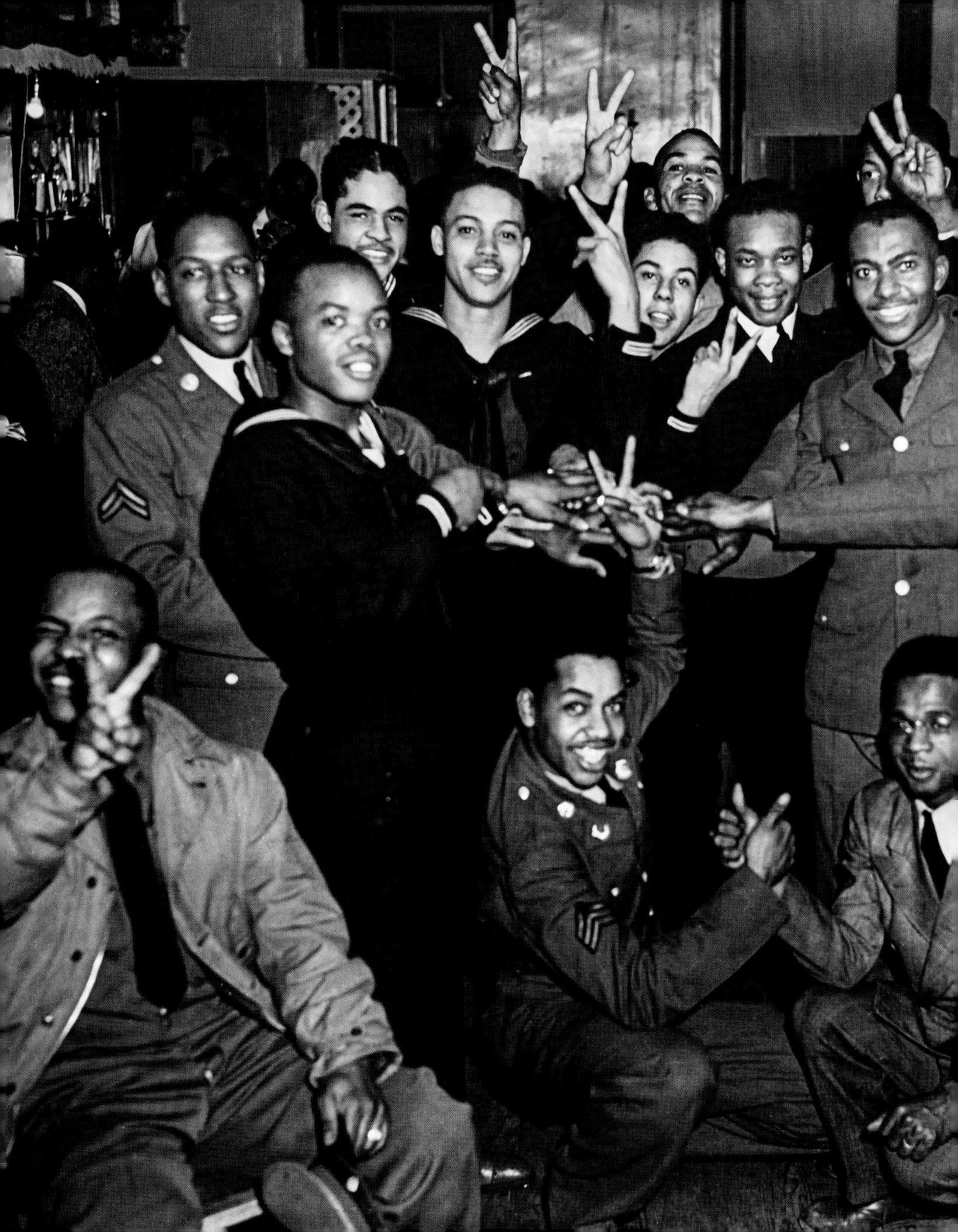

DOUBLE VICTORY

THE HISTORY OF AFRICAN AMERICANS IN THE MILITARY, FROM THE AMERICAN REVOLUTION TO THE WAR ON TERROR

KREWASKY A. SALTER

Throughout its history, America has engaged in wars to preserve freedom and democracy while paradoxically neglecting to grant or secure the rights of its black populace. Despite the clear hypocrisy, African Americans have willingly served in the military in the hope that it would lead to their gaining personal freedom and social justice. During World War II, black soldiers faced a two-front battle: fascism overseas and discrimination at home. The *Pittsburgh Courier*, a black weekly newspaper, launched Double V (Double Victory), a campaign promoting victory against prejudice at home as well as victory for the nation. Although created in the 1940s, Double V also encapsulated the aims of African American service personnel at other times in history, from the American Revolution through the desegregation of the military in the 1950s.

DUAL FRONTS World War II servicemen in Brooklyn, New York, flash the Double V, a symbol of the campaign to end fascism abroad and racism at home. Supporters showed their solidarity by displaying items such as this linen handkerchief (*right*) emblazoned with the Double V emblem.

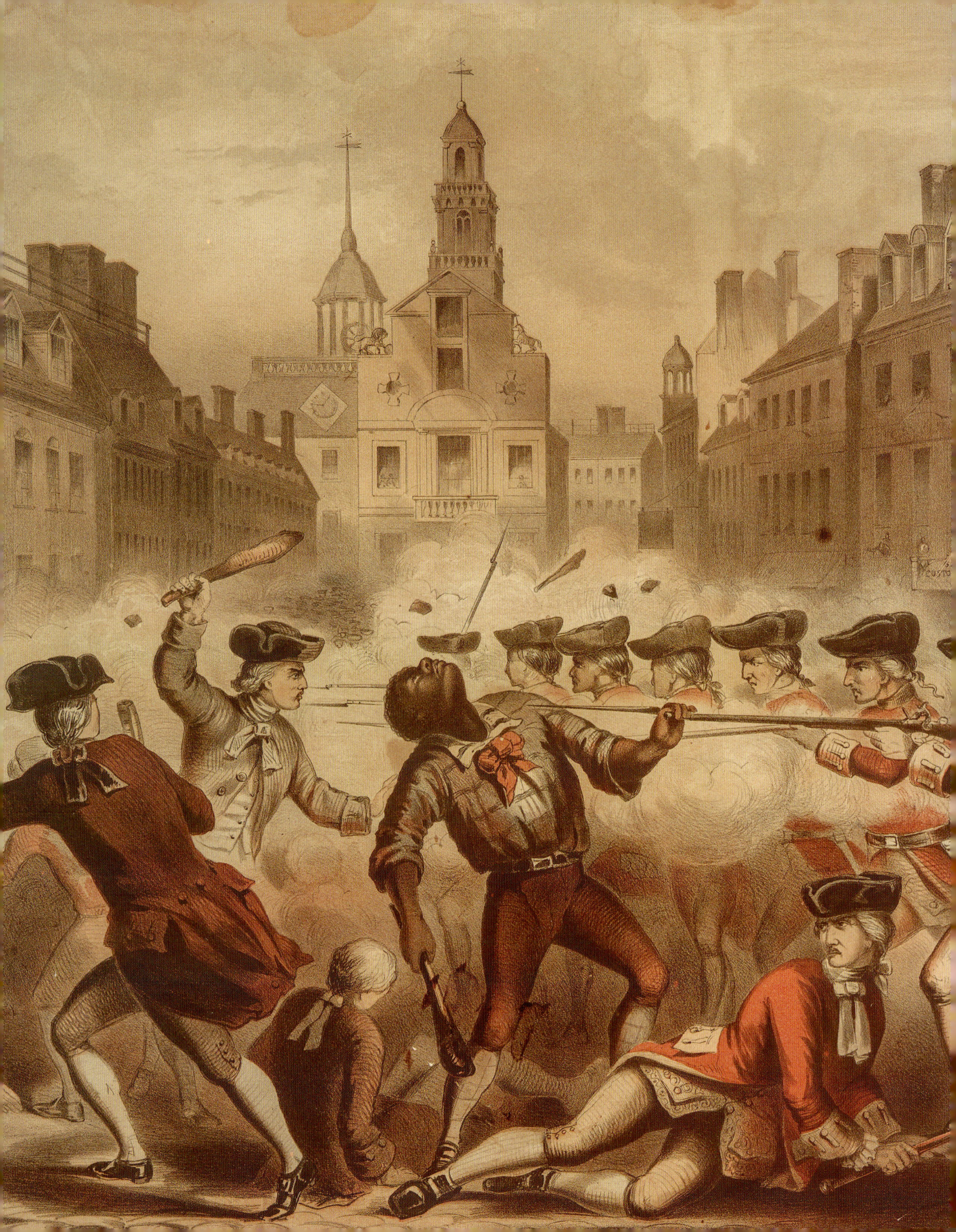

African Americans have a long history of going into harm's way in defense of the United States, a loyalty that began before the American Revolution. In 1770, black seaman Crispus Attucks died in a street confrontation with British soldiers; by the end of the war, up to six thousand African Americans had joined the Patriots in the struggle for independence. Significantly, thousands more joined the British, who offered enslaved men independence of a different sort: In return for military service, they would be set free.

During the American Revolution (1775–83), enslaved African Americans enlisted on the side that offered them the best chance of freedom. Early in the war, the British dangled an irresistible incentive in front of enslaved men. John Murray, Earl of Dunmore and royal governor of the Virginia colony, issued a proclamation in November 1775 that promised freedom to "all indentured servants, Negroes, or others" if they joined "His Majesty's Troops." Dunmore's proclamation led to the formation of Lord Dunmore's Ethiopian Regiment, a unit of about three hundred former slaves whose uniforms were embroidered with the slogan "Liberty to slaves." Over the course of the war, Britain attracted some twenty thousand black recruits. They mostly served as soldiers, sailors, laborers, and spies; some two hundred fought as infantrymen in the Battle of Savannah in October 1779.

Although the British made laudable efforts at the end of the war to keep their promise to free black soldiers in their service, fewer than five thousand African Americans were resettled. By 1783, a few hundred had arrived in England, the West Indies, and the Bahamas; about one thousand went to East Florida, where Britain still had interests, even though it had been ceded to Spain; and some three thousand to Nova Scotia in Canada.

By the end of 1775, the colonists had also begun enlisting black volunteers in larger numbers.

BLACK PATRIOTS Seaman Crispus Attucks was one of five colonists shot dead by British soldiers in the Boston Massacre (*left*). This Revolutionary War pay certificate (*right*) granted African American soldier Jack Little thirteen pounds, eight shillings, and eight pence.

They served in mixed as well as all-black units. An all-black Connecticut company was integrated into the state's white regiment and participated in the Siege of Yorktown in 1781, playing a significant role in the assault and capture of Redoubt No. 10, a key victory in the battle. Notable individuals such as Prince Hall, Paul Cuffe, and Seventh Virginia Regiment soldier Isaac Brown fought in key engagements from Lexington and Bunker Hill to Cowpens and Yorktown. Prince Hall went on to establish African American Freemasonry. Isaac Brown began a long tradition of family service in the military; his great-great-great grandson, Sergeant John Edward James Jr., served in World War II.

When wars erupted in the early years of the new nation and during its westward expansion, enslaved African Americans continued to serve in the military, in the hope of creating pathways to freedom. During the War of 1812, the British, again promising freedom, recruited slaves from Maryland, Virginia, and Georgia and trained them as marines. Serving from May 1814 through August 1816, they were among the British forces that attacked Washington, D.C., in August 1814. Fighting on the side of the United States, between three hundred fifty and five hundred free men of color in Louisiana, including Vincent Populus, who was promoted to major, helped General Andrew Jackson defeat the British at the Battle of New Orleans in January 1815. However, many of these soldiers never received the bounty, land, and pensions due them. The marines who fought for the British were settled in Trinidad.

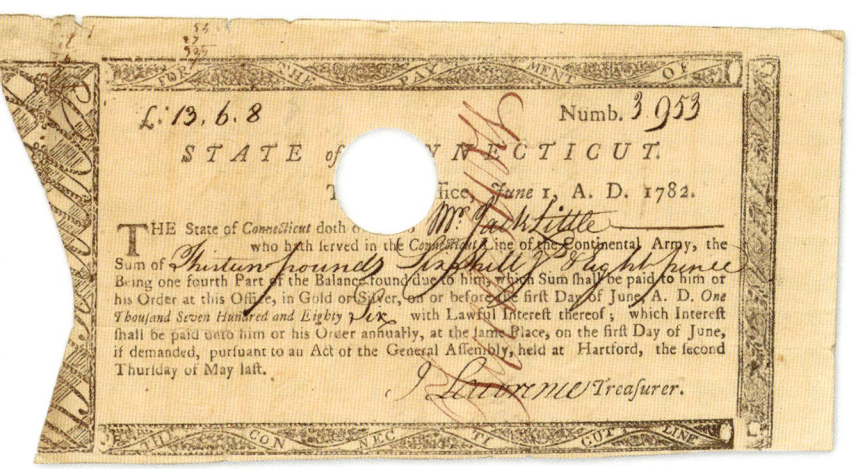

When the Civil War broke out in 1861, the prominent black abolitionist Frederick Douglass prophetically stated: "The side which first summons the Negro to its aid will conquer." Between 1861 and 1865, the Union enlisted nearly 180,000 African American soldiers into the United States Colored Troops (USCT). Another twenty thousand to thirty thousand black men served as sailors. Recognizing the benefits of military service to the cause of abolition, Douglass urged African Americans to volunteer: "Let the black man get ... a musket on his shoulder and bullets in his pocket, there is no power on earth that can deny that he has earned the right to citizenship."

CIVIL WAR BRAVERY This veteran's pin (*above*) belonged to Alexander Hill of the Fifty-fourth Massachusetts Infantry. Hill was wounded in 1863 when the African American unit launched an assault on the Confederacy at Fort Wagner, South Carolina. The Fifty-fourth and another black unit, the Fifty-fifth Massachusetts Infantry (*below*), demonstrated the courage of African American soldiers.

Although all-black units were usually assigned noncombat roles, such as constructing fortifications and guarding supply trains, many of the regiments distinguished themselves on the battlefield. The Fifty-fourth Massachusetts, depicted in the 1989 movie *Glory*, fought valiantly at Battery Wagner, South Carolina, again putting to rest the notion that African Americans would not or could not fight. Three Native Guards regiments from Louisiana served, including one that fought at the Battle of Port Hudson in 1863. While a tactical defeat for the Union, the battle contributed to the fall of Vicksburg two months later. Of the twenty-six Medals of Honor awarded to African Americans during the Civil War, thirteen were for actions at the Battle of New Market Heights in September 1864 during the Siege of Petersburg, Virginia.

A military victory for Union forces was an unequivocal win for African Americans as well. They had helped free

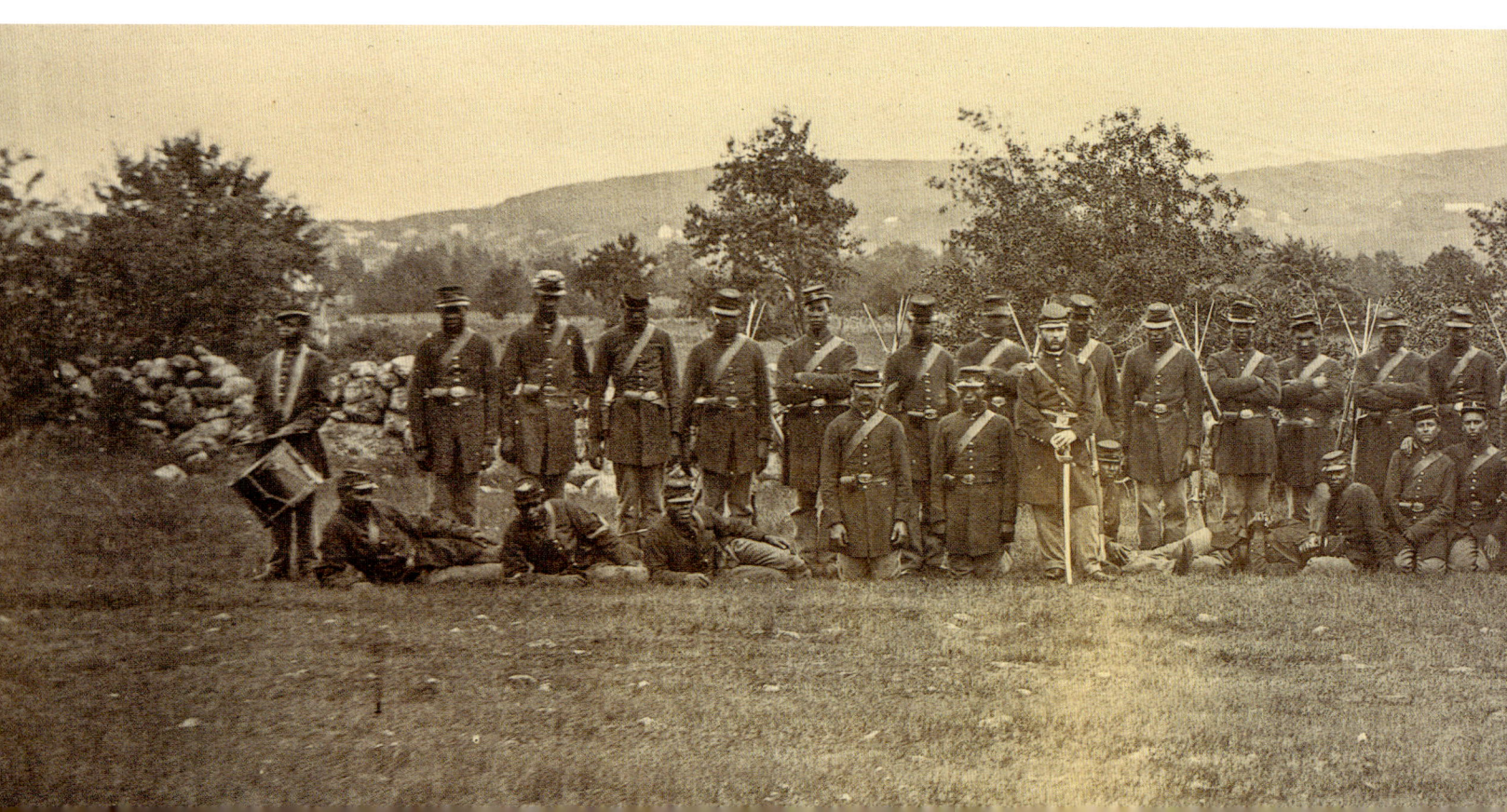

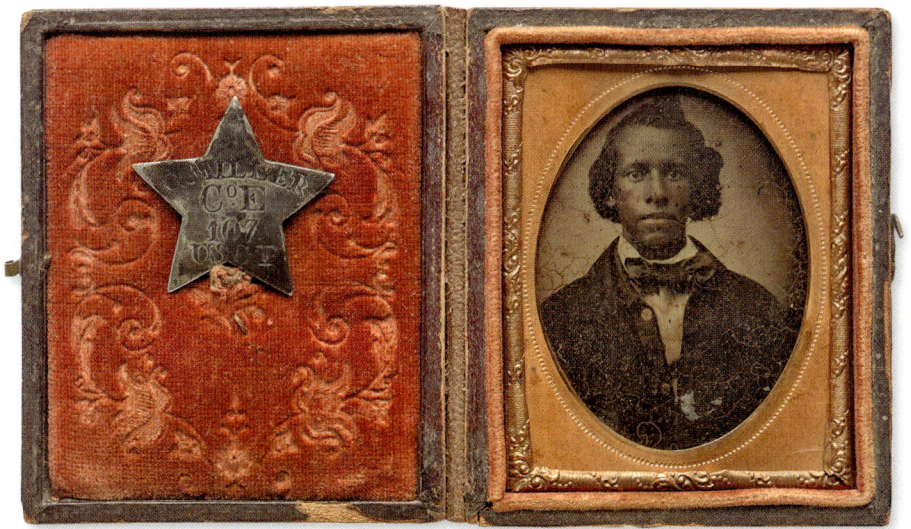
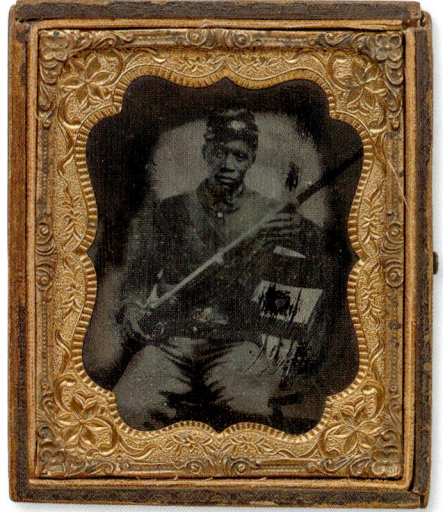

themselves from bondage. Three constitutional amendments followed to extend and protect their rights. The Thirteenth Amendment abolished slavery in 1865, the Fourteenth granted citizenship to African Americans in 1868, and the Fifteenth extended the vote to African American men in 1870.

Although codified in the U.S. Constitution, the newly won rights of African Americans were curtailed by 1877, when Reconstruction ended and an era of segregation arose. As the country transitioned to a peacetime army, the Army Reorganization Act of 1866 established six "colored" regiments—four infantry and two cavalry, marking the first time black soldiers were included in the

MEMENTOS As photographic techniques improved in the mid-1800s, thousands of Civil War soldiers commissioned itinerant photographers to take their portraits. They included Creed Miller, whose identification badge accompanies his portrait (*left*), and Qualls Tibbs, who posed with his rifle (*right*).

regular army. Eventually consolidated into the Twenty-fourth and Twenty-fifth Infantry Regiments and the Ninth and Tenth Cavalry Regiments, the men were critical to the opening of the American West. During the Indian Wars from 1866 to 1891, they built forts and roads and escorted wagon trains. Their fierce fighting against the American Indians who resisted U.S. expansion earned them the nickname Buffalo Soldiers and several Medals of Honor.

At the start of the Spanish-American War in 1898, Buffalo Soldiers and several African American volunteer and National Guard units deployed to Cuba. Were it not for the Tenth and Twenty-fourth regiments' courageous charge up San Juan Hill in the heat of battle, Colonel Theodore Roosevelt and his Rough Riders might have been defeated. Five African American soldiers and one sailor were awarded Medals of Honor during the Spanish-American War. Buffalo Soldiers also served during the Philippine Insurrection (1899–1902) and the Punitive Expedition (1916–17), a retaliatory operation against Mexican revolutionary Pancho Villa.

In 1917, when the United States could no longer maintain neutrality in World War I, two African American divisions, the Ninety-second and Ninety-third, deployed to France. While most black soldiers provided labor and manned supply lines, the eight African American infantry regiments within the two divisions saw combat. The most famous was the 369th Infantry Regiment, which fought under French command and was dubbed the Harlem Hellfighters. The 369th amassed a stellar record while defending a sector along the Aisne River in northeastern France, repelling German attacks and playing a key role in the Meuse-Argonne offensive.

For soldiers who had tasted equality in Europe, the racism awaiting them at home was a particularly bitter pill. Serving in World War I did little to end Jim Crow practices in the U.S. military or in society in general, but it did heighten the consciousness and readiness of African Americans to fight for equality at home.

PROUD TO SERVE *Counterclockwise from left:* African American troops joined whites in a valiant charge up Cuba's San Juan Hill during the Spanish-American War in 1898; a veterans' reunion flag commemorates the Spanish-American War service of the Ninth Ohio Volunteer Infantry; the Croix de Guerre medal bestowed on World War I soldier Lawrence McVey by the French; McVey (in uniform) in 1918; McVey's 369th Infantry, nicknamed the Harlem Hellfighters, parades up Fifth Avenue in New York City at the war's end (*opposite*).

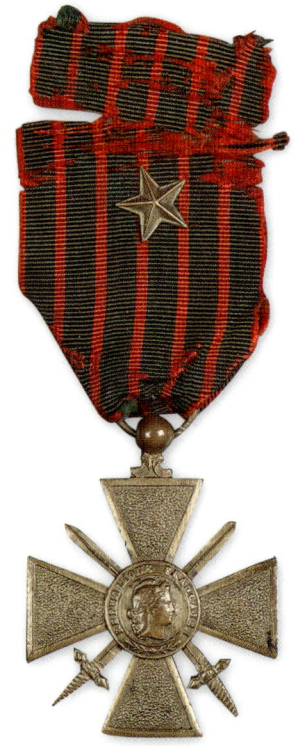

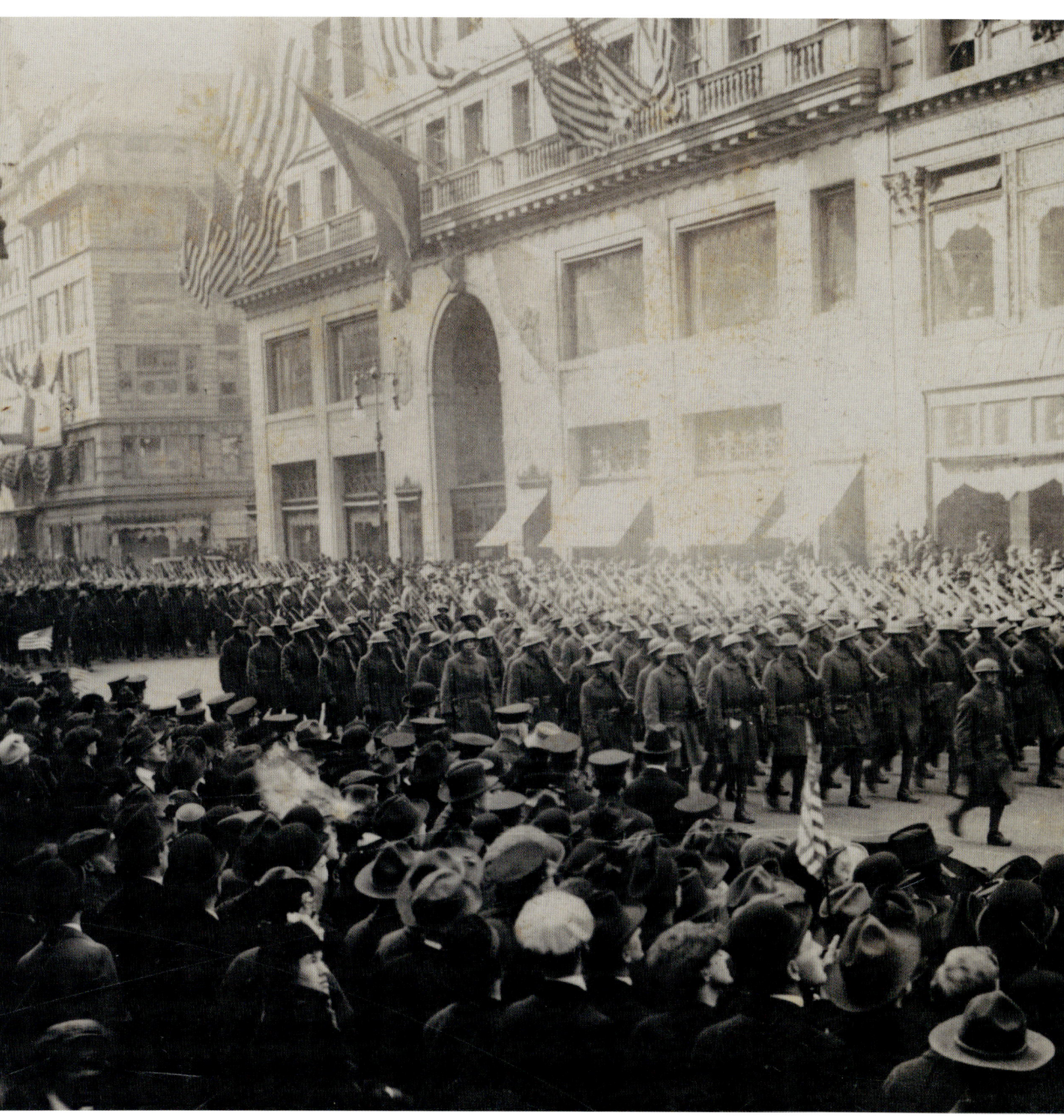

Twenty-three years later, when America entered World War II, the hardened racial barriers in the segregated military slowly began to erode as the country faced the enormous challenges of a global conflict and pressure from the black press and civil rights advocates. In 1941, after black labor leader A. Philip Randolph threatened a massive march on Washington, D.C., President Franklin Roosevelt issued Executive Order 8802, prohibiting discrimination in hiring for war-related jobs and increasing opportunities in the military. Nearly 1.2 million African American men and women answered the call to duty over the course of the war, serving in both Europe and the Pacific. About 99,200 African Americans were in the U.S. Army in 1941, but none served in the Army Air Corps, the Marine Corps, or specialty branches. The few African Americans in the U.S. Navy and Coast Guard worked mainly in service jobs, and fewer than fifty black nurses were in military service. But by 1943, African Americans had been assigned to nearly every specialty, including the Women's Army Corps (WAC), and hundreds more women were inducted as nurses.

African Americans contributed measurably to victory in Europe and Japan. On D-Day, June 6, 1944, the African American 320th Barrage Balloon Battalion came ashore at Normandy and installed gigantic balloons to prevent enemy aircraft from strafing Allied soldiers. In the months following the invasion, black tank and field artillery battalions fought fiercely and continuously in and around the site of the Battle of the Bulge. Many African Americans were assigned to the Red Ball Express, a truck convoy that required them to drive deep into occupied Europe to supply the frontline. Fighter pilots known as the Tuskegee Airmen distinguished themselves overseas, flying thousands of sorties and destroying scores of enemy aircraft, locomotives, and vessels. In the Pacific, African American Marines, initially in support jobs, proved their prowess in combat during D-Day landings on Saipan, Iwo Jima, and Okinawa.

The success of World War II's Double V campaign was mixed. Although African Americans had proved critical in vanquishing the enemy abroad, they still grappled with discrimination at home. Because of racism, only a small percentage of eligible African American veterans benefited from the G.I. Bill of Rights, created in 1944 to aid veterans economically and educationally. One of the few who did was WAC veteran Dovey Johnson Roundtree, who used her assistance to attend Howard University Law School and later won a landmark bus discrimination case.

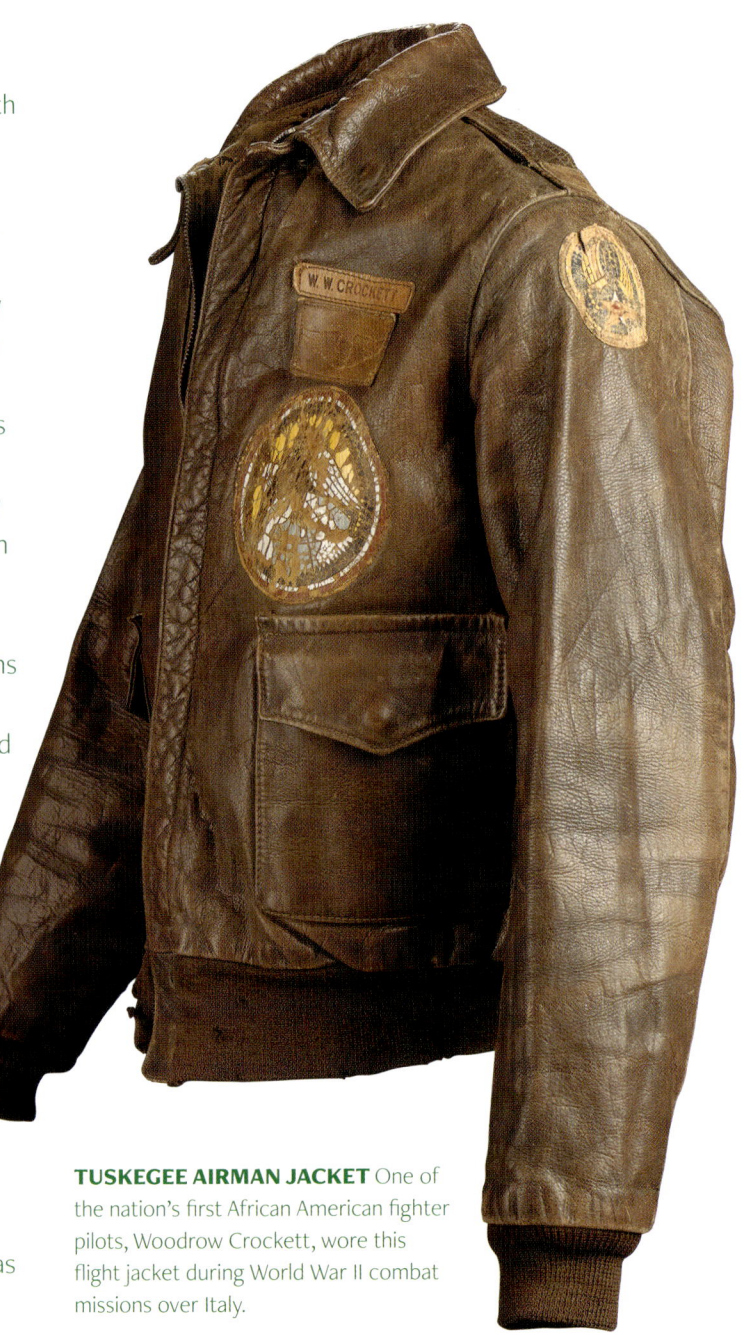

TUSKEGEE AIRMAN JACKET One of the nation's first African American fighter pilots, Woodrow Crockett, wore this flight jacket during World War II combat missions over Italy.

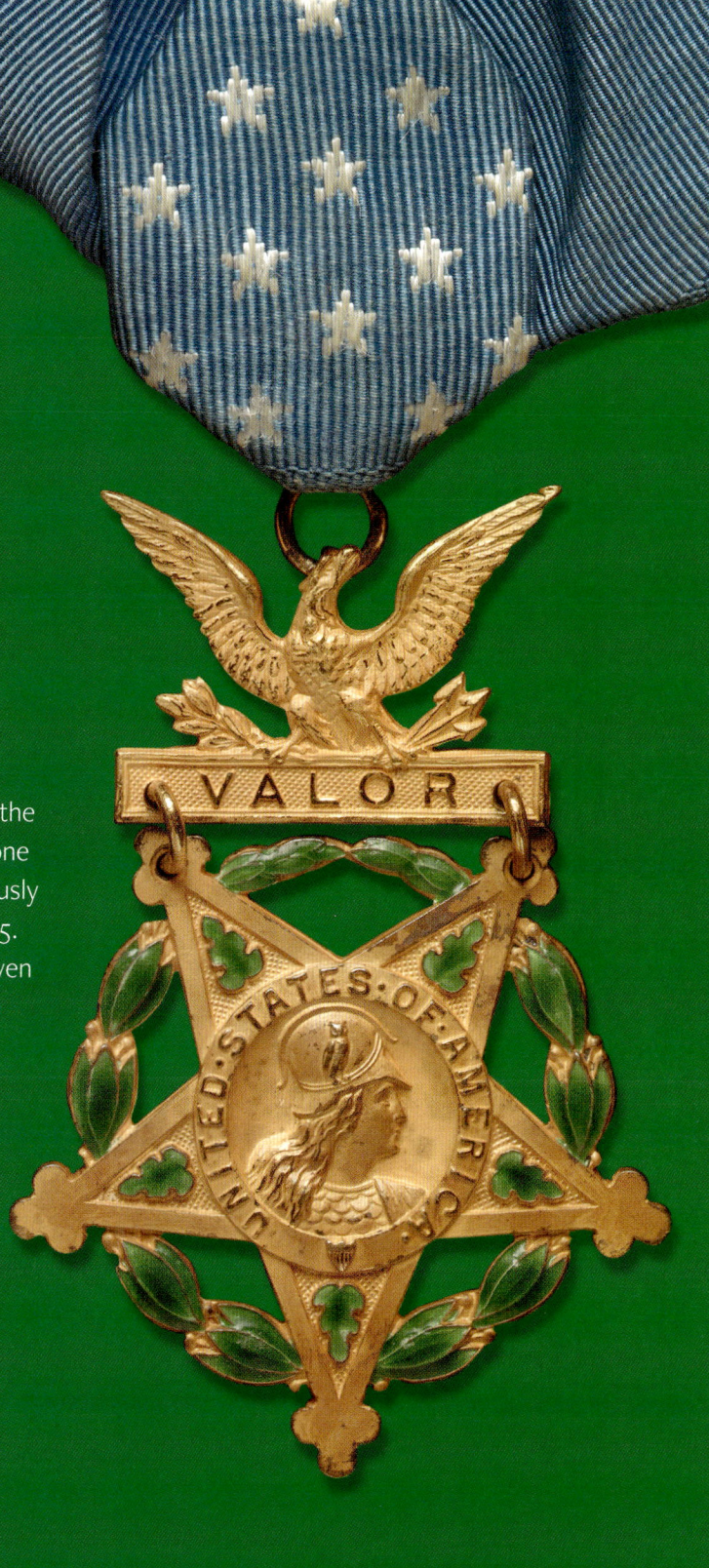

The Medal of Honor

During the world wars, no African Americans received the military's highest award, the Medal of Honor. In 1991, one soldier from World War I was belatedly and posthumously awarded the medal, and another was awarded it in 2015. In 1997, following a Department of Defense review, seven from World War II received it (six posthumously). Two African Americans gained the medal for service in the Korean War, both posthumously.

VALOR IN ACTION Mortally wounded while carrying out a heroic assault during the Korean War, Sergeant Cornelius H. Charlton was posthumously awarded this Medal of Honor for his actions on June 2, 1951.

With the exception of the U.S. Air Force, the armed forces remained largely segregated when the Korean War began in 1950. The Twenty-fourth Infantry Regiment, the last of the Buffalo Soldier regiments, deployed to Korea segregated, yet it secured one of the first American victories at Yechon. Meanwhile, pilots in the Air Force and members of the Marine Corps and Navy completed successful air combat missions with integrated squadrons. It was not until President Harry S. Truman replaced General Douglas MacArthur with General Matthew B. Ridgway that the integration of the Army truly got underway in 1951. Officials found that integrating units improved morale and fighting skills.

The Vietnam War (1955–75) was the first American war conducted with a fully integrated military. The long conflict became the training ground for many future military leaders, including African Americans, other minorities, and women. Former Secretary of State Colin Powell, who once held the highest-ranking office in the U.S. military as the Chairman of the Joint Chiefs of Staff, rose to captain and major during the Vietnam era.

The all-volunteer force policy instituted in 1973 helped transform the military, making it more professional and integrated at all levels and extending opportunities to women and all ethnicities. In 2012, the percentage of African Americans in the Army, Navy, Marine Corps, and Air Force was 17.25 percent, well above the 13.2 percent within the American population. High-ranking African Americans are scattered throughout the services.

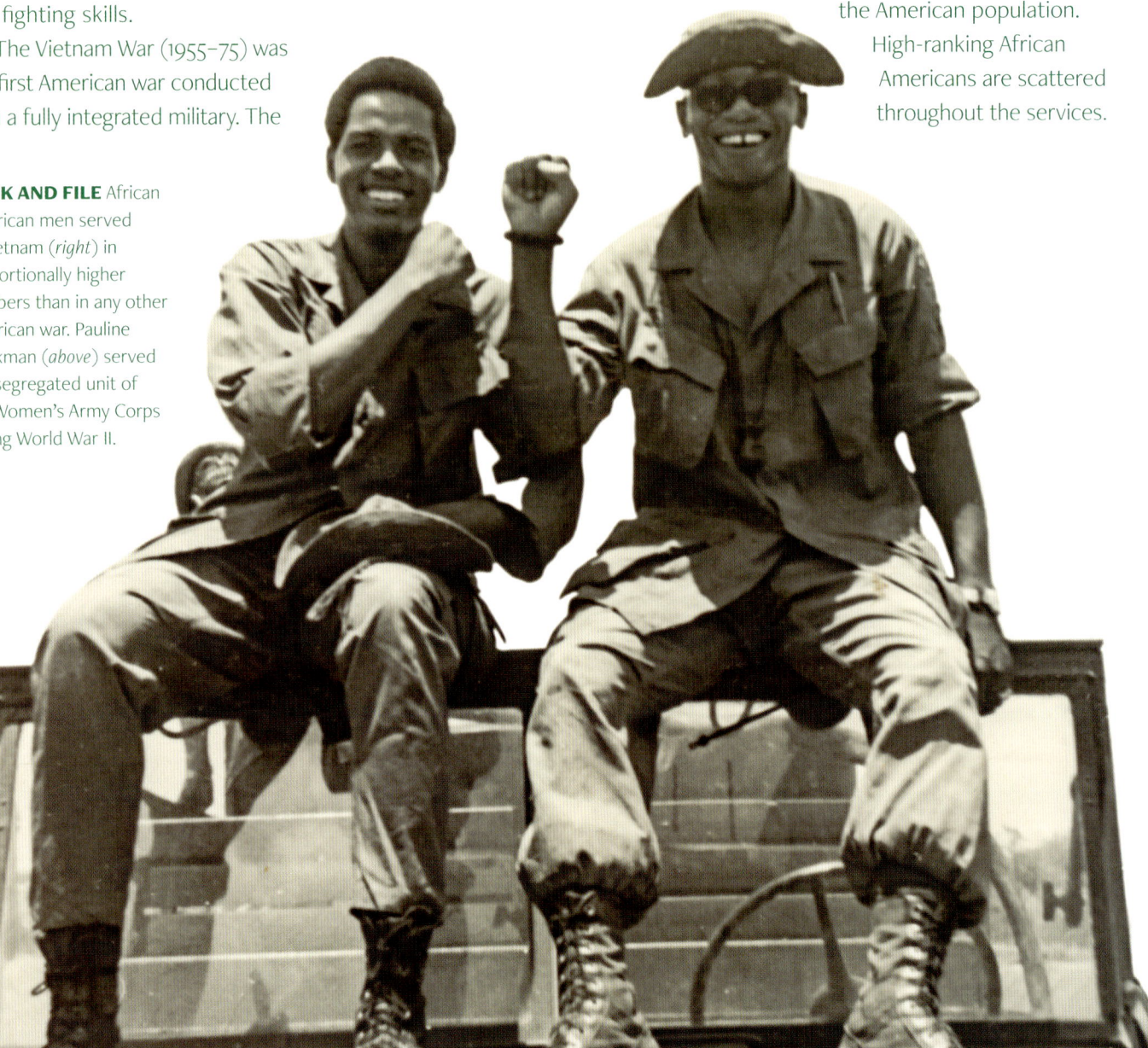

RANK AND FILE African American men served in Vietnam (*right*) in proportionally higher numbers than in any other American war. Pauline Cookman (*above*) served in a segregated unit of the Women's Army Corps during World War II.

TOP BRASS The pilot flight suit (*left*) of Major General Charles F. Bolden Jr. represents one of several roles in which he has excelled, including U.S. Marine Corps officer, space shuttle astronaut, and administrator at NASA. General Colin Powell (*above, left*) served as Chairman of the Joint Chiefs of Staff (1989–93), advising the president on military matters. Admiral Michelle J. Howard (*above, right*) became the first four-star female officer in the U.S. Navy.

By 2013, four-star African American Army generals Lloyd J. Austin III and Vincent K. Brooks headed Department of Defense combatant commands. When General Austin retired in 2016, the Chief of Staff of the Army stated: "He is the only general or flag officer in the United States military of any service who has commanded in combat at every rank as a general or flag officer for the last fifteen years."

African American women who have scaled the ranks include 1998 Air Force Academy graduate Shawna Rochelle Kimbrell, now a lieutenant colonel, who became the first female African American jet fighter pilot. African American soldiers such as Specialist Toccara R. Green, killed in Iraq when her convoy was ambushed in 2005, continue to make the ultimate sacrifice.

Because of courageous and pioneering African Americans who have served in the armed forces over the past two centuries, fighting for their country and for racial equality, the face and principles of the military have forever changed.

a lie is not a shelter

discrimination
is not protection

isolation is not a remedy

a promise is not a prophylactic

THE STRUGGLE FOR FREEDOM

Spencer R. Crew & Peniel E. Joseph

A LIE IS NOT A SHELTER
In *Untitled (A lie is not a shelter)*,
artist Lorna Simpson eloquently
challenges prejudices and
preconceptions.

FROM RECONSTRUCTION TO THE CIVIL RIGHTS MOVEMENT

Spencer R. Crew

ROAD TO FREEDOM In 1965, weeks after Bloody Sunday, advocates for African American voting rights marched fifty-four miles from Selma, Alabama, to the state capitol in Montgomery, protected by federal troops.

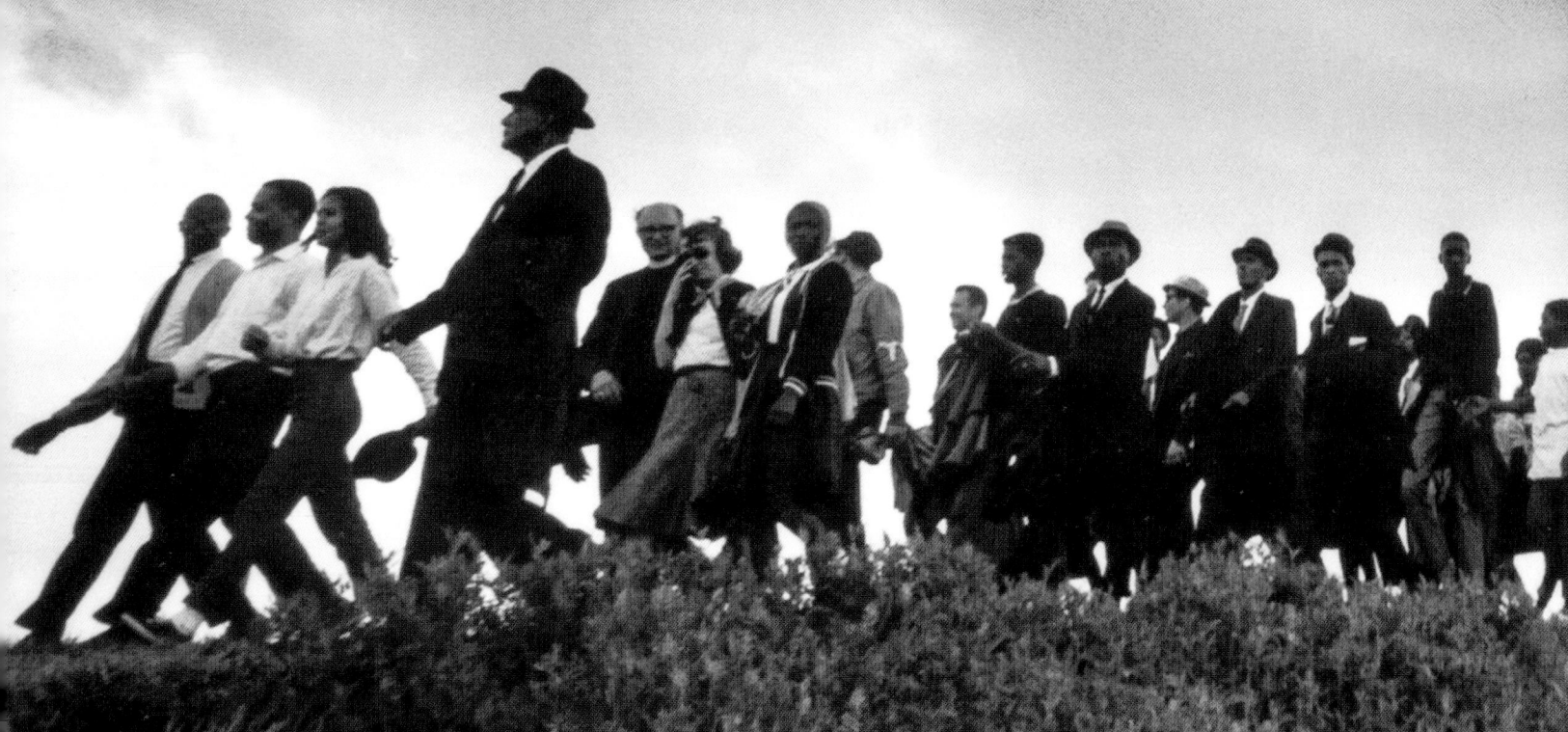

"**M**y race needs no special defense, for the past history of them in this country proves them to be equal of any people anywhere. All they need is an equal chance in the battle of life," Robert Smalls said in 1895. A formerly enslaved black man who became a Civil War hero (see page 71), he had spent many years as a U.S. congressman struggling to protect the rights of African Americans. The new chapter of his life that began at the end of the Civil War was like that of many African Americans at that time: They sought to build a life for themselves as free citizens. Smalls and his family joined four million freed people who scrambled to carve out a place for themselves in a war-weary nation. In the process, they confronted white southerners trying to regain their footing after a stinging defeat on the battlefield and an upending of their social and economic lives.

Reconstruction Era

The years after the Civil War, in which the country tried to address the readmission of southern states and the economic and political inequities of the black population, is known as the Reconstruction era. Traditionally, the dates of Reconstruction extend from 1865 to 1877, but there is now some historical debate over this time frame. Alternative interpretations date it from as early as 1863, ending as late as the 1883 Supreme Court decision that invalidated the 1875 Civil Rights Act. During these Reconstruction years, Radical Republicans in Congress employed a variety of strategies to ease black people's transition to freedom, including deploying federal troops to the South and proposing amendments to protect the citizenship and voting rights of African Americans.

Even with the protection of the U.S. Army, African Americans living in the former Confederate states faced major obstacles to fully experiencing their newly won freedom. In 1865, just months after the Civil War ended, Mississippi and South Carolina enacted the first Black Codes. These laws, similar to the old slave codes that had restricted enslaved people, were designed to intimidate and obstruct the rights of African Americans and to turn them into second-class, low-wage workers for southern landowners. Mississippi, for instance, created strict vagrancy laws that required black people to show written proof

"The rebels here threatened to burn down the school and house in which I board before the first month ... passed."

—EDMONIA HIGHGATE, African American schoolteacher, 1866

of employment and residence or risk going to jail and paying a fine. In an insidious scheme reminiscent of slavery, a white landowner or businessman might pay the fine and then bond the released prisoner to work off his debt. Black Codes regulated where African Americans could buy or rent property, prevented them from testifying in court, and imposed fines if they were found owning guns or violating curfews. These laws were intended to thwart the economic and personal independence of blacks and, in effect, nullify the Thirteenth Amendment, which had ended slavery.

As jurisdictions openly instituted Black Codes, white supremacists hatched virulent secret organizations such as the Ku Klux Klan and the Knights of the White Camelia that did not hesitate to use violence against African Americans. The Ku Klux Klan originated in Pulaski, Tennessee, in 1865, under the leadership of former Confederate general Nathan Bedford Forrest and quickly spread its terror tactics to other parts of the South. White hate groups often masterminded violent clashes between the races, such as the riots that erupted in New Orleans and Memphis in May 1866, when black residents in Memphis attempted to prevent a white policeman from arresting a black soldier. In retaliation, white rioters attacked black residents in their neighborhood, burning scores of homes, schools, and churches, while local white officials looked on or joined the fray. Three days of unrest

left forty-six black people dead and hundreds injured. A few months later, when Radical Republicans convened in New Orleans with African American supporters to pressure the state legislature to give black people the vote and overturn Louisiana's Black Codes, a white mob attacked the meeting. Local police opened fire on participants as they fled, killing thirty-four black and four white supporters. Federal troops eventually regained control, but it was clear that local southern governments would not protect the political or civil rights of African Americans. Congress proposed the Fourteenth and Fifteenth amendments, which were ratified in 1868 and 1870 respectively, to try to protect African Americans' status as citizens and guarantee black men's right to vote. Even so, getting equal treatment according to the nation's laws would remain an ongoing struggle.

Congress also established the Freedmen's Bureau in 1865 to help African Americans move from slavery to freedom. The bureau provided the formerly enslaved with medical help, established schools, and negotiated contracts between black workers and white employers. Freedmen's schools were one of the bureau's greatest successes. More than 9,000

FIFTEENTH AMENDMENT
An 1870 lithograph depicts a Baltimore parade celebrating the passage of the Fifteenth Amendment, which protects voting rights. Images of African American leaders, such as Frederick Douglass and Hiram Revels, and presidents Abraham Lincoln and Ulysses S. Grant decorate the print.

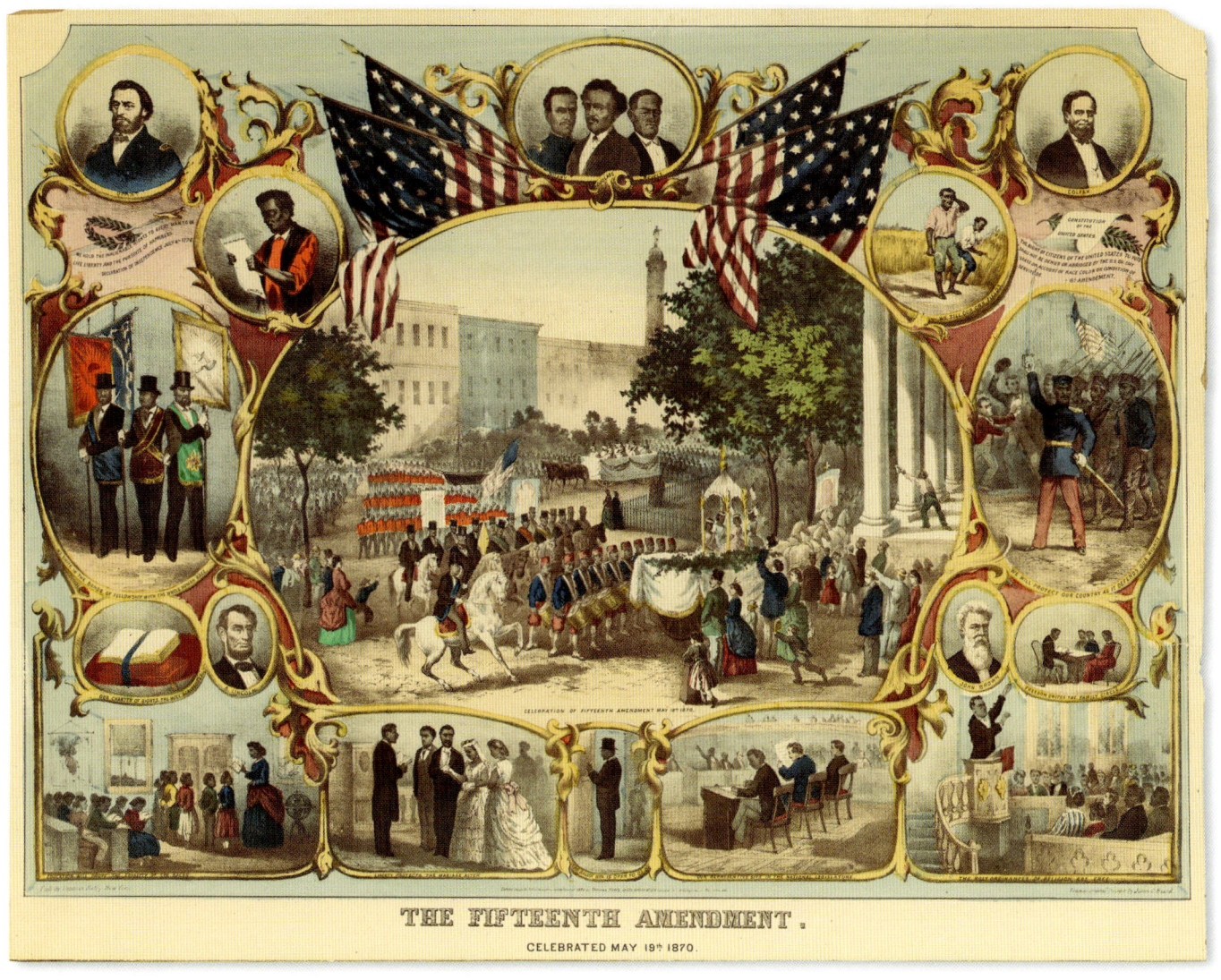

THE FIFTEENTH AMENDMENT.

CELEBRATED MAY 19TH 1870.

"THEY ARE DETERMINED TO BE SELF-TAUGHT"

Michèle Gates Moresi

Enslaved and free African Americans alike recognized the power of literacy and learning. African Americans pursued education by any means they could find, whether self-taught in secret or encouraged by an owner. Indeed, learning to read and write while enslaved was a form of defiance and ultimately a potential path to freedom. After Emancipation, the Freedmen's Bureau was an initial source of teachers, buildings, and supplies for the newly freed to enable them to acquire formal education. However, to meet the demand for schooling, philanthropy and individual community efforts supplemented federal and state resources. The story of educator Elijah P. Marrs and the efforts of support organizations illustrate African Americans' determination to teach themselves despite numerous obstacles.

Marrs, who had learned to read and write in secret while enslaved in Kentucky, escaped during the Civil War and sought out the Union Army to enlist as a soldier. Because he was literate, fellow soldiers asked him to write letters home, read the news aloud, and even provide rudimentary reading lessons. When officers learned of Marrs's skills, he was promoted to sergeant; through his military service, Marrs honed the leadership skills that would eventually serve him well as an educator.

After the Civil War, Marrs returned to Shelby County, Kentucky, where his community solicited him to teach, paying him directly for the black students' tuition. In his memoir, Marrs recounts how whites saw him as a curiosity, questioning his abilities, and describes fearing for his life due to threats and intimidation by the Ku Klux Klan. Marrs persevered and in 1879 cofounded the first college in Kentucky for African Americans, the Normal and Theological School. While not formerly trained as an educator, Marrs had felt compelled to serve his community, and his community had sought his help in educating themselves. African American teachers boldly challenged former slaveholders' insistence on illiteracy as necessary for blacks and defied whites' assumptions that African Americans were not capable of learning.

After Emancipation, the Freedmen's Bureau, in combination with philanthropic efforts, assisted and expanded the efforts of recently freed slaves to gain an education. Hundreds of schools, including a school in La Grange, Kentucky, where Marrs taught in 1867, received monetary support in combination with contributions from its pupils. What made the bureau's efforts effective during its short tenure was the sheer willpower of its participants and

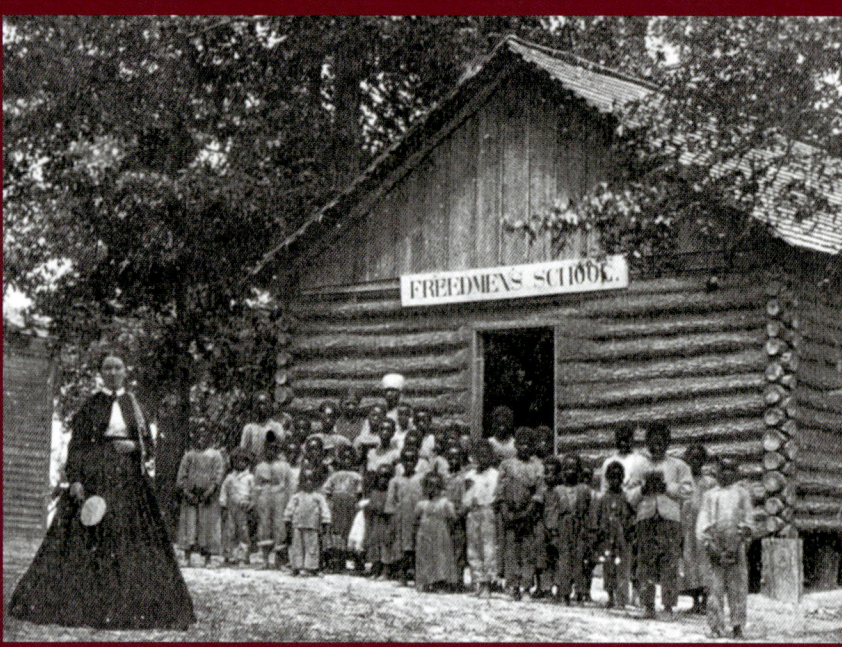

ANSWERING A NEED A teacher, one of many who traveled to the South to teach African American children who had been denied an education while enslaved, poses with her students in front of a Freedmen's school in North Carolina, ca. 1867.

the African Americans who made the most of the government's support. "Throughout the entire South an effort is being made by the colored people to educate themselves," John W. Alvord, general superintendent of schools for the Freedmen's Bureau, reported in 1866. "In the absence of other teaching, they are determined to be self-taught."

Even the poorest African Americans continued a tradition of self-help despite a consistent lack of adequate support from the state. An organization that helped to fill the gap was the Julius Rosenwald Building Fund, the brainchild of Booker T. Washington. The Hope School in Pomaria, South Carolina, demonstrated the cooperative effort of the Rosenwald Fund with local white and black residents. The Hope family sold two acres of their estate to the local school district for the nominal price of $5 to build a school.

The community ultimately raised $2,200—more than half coming from private black contributions—to match the Rosenwald and public funds. Operating as a two-room, two-teacher school from 1925 to 1954, the Hope School, along with numerous other Rosenwald schools in the rural county, provided the sole means of primary education for black students. Such schools would not have been possible without African American contributions to supplement public funds.

educators, mainly black and white women from the North, came to work in facilities that educated nearly 250,000 students of all ages. The teachers were dedicated to their mission even though white residents threatened them and set fire to their buildings. Edmonia Highgate, an African American educator from Massachusetts, described the challenges of teaching in a school near New Orleans in an 1866 letter to a friend: "Twice I have been shot at in my room. Some of my night-school scholars have been shot but none killed. A week ago an aged freedman was shot so badly as to break his arm and leg—just across the way."

Despite the danger, and with the support of U.S. troops, some of whom were African American Civil War veterans, the Freedmen's Bureau intervened in negotiations between black workers or farmers and white employers. Because Congress was not willing to confiscate land from former slave owners and distribute it to the people who had worked it as slaves, many black farmers had to rent land. As sharecroppers, they surrendered a portion of their crop for the right to use the land. The bureau supervised contracts in an effort to protect black workers from dishonest landowners, but the limited number of agents spread across the South found it impossible to oversee all contracts or the day-to-day relations between sharecroppers and their landlords. Some white landowners used the agreements to manipulate black tenants and sharecroppers, forcing them into a cycle of debt that tied them to the land and a new form of enslavement.

African American churches provided spiritual and tangible assistance. Congregations grew rapidly after declaring independence from white denominations, and some, in particular the African Methodist Episcopal (AME) and Baptist churches, flourished. In 1787, Richard Allen, a black preacher, and other black parishioners walked out of a Philadelphia Methodist church after a trustee tried to force them to sit in segregated pews; the incident eventually led Allen and his cohorts to establish the AME Church, independent of the white Methodist church. The formation in 1895 of the National Baptist Convention of the United States of America was also a key milestone because it brought together black clergy in the South and the North. As part of its broad mission, the new organization sought to create its own publications and support the education of African Americans.

Whatever the need in the black community, black churches frequently lent their support. Joining forces with pioneering heart surgeon Daniel Hale Williams and others in 1891, African American churches in Chicago helped create Provident Hospital and Training School Association, one of the first African American–operated hospitals in the nation. Black churches in Philadelphia also donated funds to establish the Frederick Douglass Memorial Hospital and Nursing Training School, run by Dr. Nathan F. Mossell, the first black graduate of the Medical School of the University of Pennsylvania.

Some church leaders, such as AME Bishop Richard Harvey Cain, entered southern politics. He held office in the South Carolina State Senate and later served two terms in Congress as the representative from South Carolina. In Washington, he lobbied unsuccessfully for the passage of a civil rights bill in 1870. Churches in the South also collaborated with their northern counterparts to set up schools such as Atlanta's Augusta Institute (now Morehouse College) and Paul Quinn College in Austin, Texas, to train black students.

Cain and Robert Smalls, who served in elected offices in South Carolina and the U.S. Congress, were among more than 2,000 African American politicians holding positions at the state and national levels during Reconstruction. They gained political support from conventions such as the 1866 North Carolina meeting where black citizens demanded their rights, fair wages, access to education for their children, and the repeal of discriminatory laws. Recognizing that electing black people to office offered the best opportunity to attain their goals, African Americans voted in large numbers when not obstructed by white officials.

The progress of African Americans was dependent on the presence of U.S. troops in the southern states. That safeguard disappeared in the election of 1876, when in a close presidential contest, winner Rutherford B. Hayes agreed to remove troops from the South in exchange for the votes needed to ensure his election, a deal consummated, ironically, at the black-owned Wormley's Hotel, located within the shadow of the White House. The aftermath proved calamitous for blacks abandoned into the hands of white southerners, who rapidly took steps to deprive them of political, social, and economic rights. The removal of troops led to thousands of black politicians losing their positions at the local and national levels. By passing discriminatory voting requirements and using terror and intimidation, southern whites denied black people voting rights and quickly regained political power. In 1875, the U.S. House of Representatives had seven black members and the U.S. Senate had one. By 1902, no African Americans held congressional office. George H. White, the last black politician to leave the U.S. Congress, captured the feelings of many African Americans when he declared, "This, Mr. Chairman, is perhaps the Negroes' temporary farewell to the American Congress. But let me say, phoenixlike, he will rise up someday and come again."

The Birth of Modern Civil Rights

As white officials again gained control of the South, they passed legislation and established practices that separated the activities of black and white people. Referred to as Jim Crow laws, the racial segregation applied to restaurants, restrooms, schools, public transportation, social engagements, and almost every other aspect of life. The name was based on a white actor's negative caricature of an African American he called Jim Crow. Portrayed as buffoonish and slow-witted, the character became a minstrel-show staple in the mid-1800s. As segregation spread after the Civil War, the Jim Crow moniker was adapted as a descriptor of the hateful laws and customs.

In 1883, the U.S. Supreme Court reinforced the South's codification of segregation by striking down critical aspects of the Civil Rights Act of 1875, which had guaranteed black citizens equal access to public transportation and accommodations. Accordingly, southern

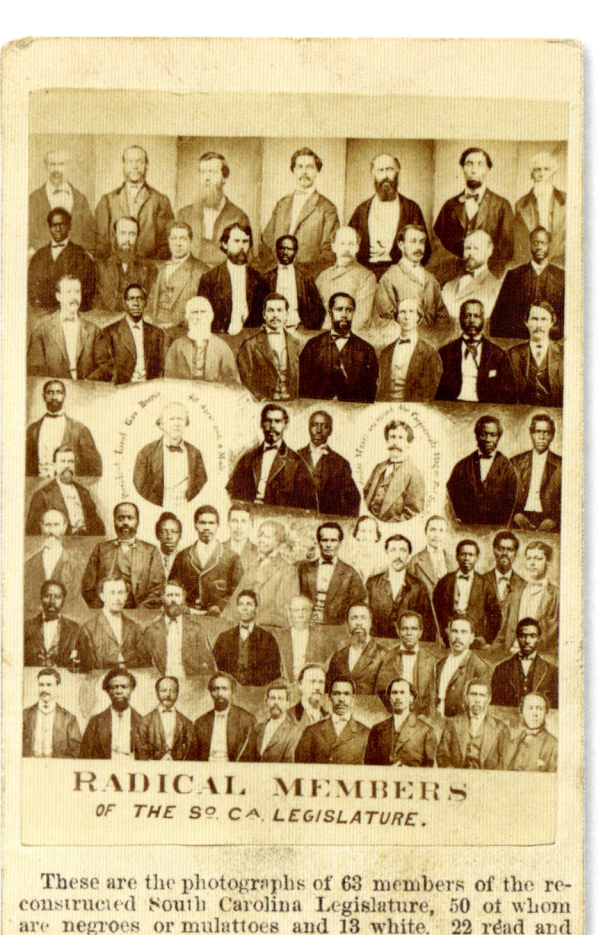

RADICAL MEMBERS OF THE S° CA. LEGISLATURE.

These are the photographs of 63 members of the reconstructed South Carolina Legislature, 50 of whom are negroes or mulattoes and 13 white. 22 read and write (8 grammatically), the remainder (41) make their mark with the aid of an amanuensis. Nineteen (19) are tax-payers to an aggregate amount of $146.10. the rest (44) pay no taxes, and the body levies on the white people of the State for $4.000.000.

EARLY BACKLASH An 1868 card displaying portraits of South Carolina legislators ridicules black members in the text below the pictures. Many whites resented the Reconstruction government's inclusion of African Americans.

GREAT PROMISES AND UNFULFILLED HOPES: THE LEGACY OF BENJAMIN FRANKLIN RANDOLPH

Elaine Nichols

From 1865 to 1877, Reconstruction was a time of expectancy and hopefulness based on the promises of freedom and citizenship associated with the ratification of the Thirteenth, Fourteenth, and Fifteenth amendments to the Constitution. It was a time when African Americans in the South were able to serve with distinction in politics, government, and the military.

Many of these individuals, although little known today, such as the Reverend Benjamin Franklin Randolph (1820–68), held influential local, state, and national positions. Born free in Kentucky, Randolph attended Oberlin College—a critical institution in the abolitionist movement—between 1854 and 1862. He joined the Twenty-sixth U.S. Colored Troops at Rikers Island, New York, in 1864 and was one of the few African American chaplains during the Civil War. In 1865, Randolph was mustered out of the army and lived in South Carolina, where he became active in the religious, social, and political life of the state.

Although trained as a Presbyterian minister, Randolph joined the Methodist faith in South Carolina, seeing it as more progressive and socially conscious. Additionally, he sought work with the Freedmen's Bureau, established by the U.S. Congress in 1865 to aid the transition from enslavement to freedom for millions of African Americans as well as to provide assistance to destitute whites in the South. Writing to the bureau, Randolph explained, "I am desirous of obtaining a position among the freedmen where my qualifications and experience will admit of the most usefulness. I don't ask for position or money. But I ask a place where I can be most useful to my race. My learning and long experience as a teacher [in the] North, and my faithful service as chaplain demand that I seek such a place." As a result, the bureau hired Randolph to serve as an assistant superintendent for education in South Carolina.

From 1864 to 1868, Randolph was a major political figure, not only in South Carolina but nationally as well. In the first nine

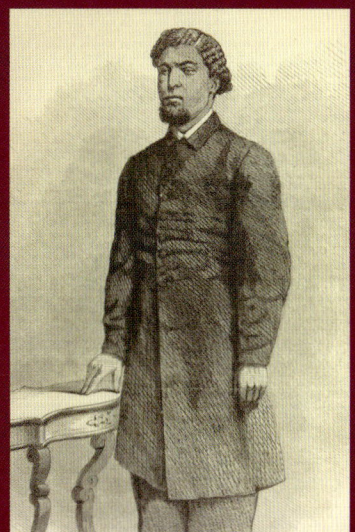

SEEKING TO SERVE A man of noble ambitions, Benjamin Franklin Randolph played a crucial role in politics and activism in South Carolina during Reconstruction. He was especially supportive of voting rights and public schools.

months of 1868, he served as a delegate/elector to the Republican National Convention (which nominated General Ulysses S. Grant for president), chaired the Republican Central Committee for South Carolina, was elected to the state Senate, and played a critical role as a delegate to the South Carolina Constitutional Convention—where he wrote provisions to create South Carolina's first universal public school system and grant non–property holders and black men the right to vote. Seeking new opportunities to help African Americans during the early years of Reconstruction, Randolph became active in journalism. In 1867, he cofounded, with Reverend E. J. Adams, the *Charleston Journal* and coedited the *Charleston Advocate;* both newspapers emphasized issues of social justice and equality.

Unfortunately, Randolph's successful political activism attracted the attention of resentful southern whites. In October 1868, three white men, identified as members of the Ku Klux Klan, assassinated Randolph in Abbeville, South Carolina, while he was on a speaking tour.

In 1872, as a way of honoring his life and work for the people of South Carolina, nineteen African American leaders in the state established the Randolph Cemetery. It would become one of the most prominent historic cemeteries in South Carolina.

Randolph's life and death represent both the great promises and the unfulfilled hopes of African Americans. As Randolph himself observed, "We are laying the foundation of a new structure here, and the time has come when we shall have to meet things squarely, and we must meet them now or never. The day is coming when we must decide whether the two races shall live together or not."

states revised their constitutions to incorporate discrimination in public places and established literacy tests, poll taxes, and grandfather clauses to prevent African Americans from voting. After 1890, Mississippi citizens had to read and explain a passage of the state constitution to the satisfaction of white registrars who consistently failed African Americans. A grandfather clause, however, exempted descendants of prior voters—white citizens, in most cases—from the literacy tests, thereby protecting white voting rights. The tactic was a treacherous subterfuge employed to disenfranchise black people.

The Supreme Court reinforced its segregationist stance in 1896 with its landmark ruling in *Plessy v. Ferguson*. After Louisiana had passed its Separate Car Act in 1890 requiring "equal but separate" accommodations for black and white travelers, African American Homer Plessy refused to sit in the Jim Crow train car and was arrested. He lost in the local and state courts and on appeal to the Supreme Court. In a 7–1 decision, the Supreme Court ruled "separate but equal" accommodation constitutional, and in doing so set a legal precedent for segregation for the next half century.

Brutal repercussions often awaited African Americans who breached the South's racial barriers. Lynchings proliferated during the last quarter of the nineteenth century, with 1,100 black people murdered between 1889 and 1898. Large crowds of white people, including women and children, frequently gathered to watch the grisly illegal executions. Some even hoped to take home souvenirs of the crime. In 1899, about two thousand people in Georgia attended the lynching of Sam Holt, who was accused of killing his white employer. "Sam Holt … was burned at the stake in a public road," according to the *Atlanta Constitution*. "Before the torch was applied to the pyre, the Negro was deprived of his ears, fingers, and other portions of his body."

Black journalist Ida B. Wells was one of the intrepid activists who publicly took a stand against the racism of mob justice. When three of her friends were lynched in 1889, she became a prominent anti-lynching crusader. After conducting investigative research on the lynching of blacks in the South, Wells lectured extensively and published many articles and pamphlets.

Mob lynching in the South was designed to terrorize black people, but less spectacular incidents also intimidated them and reinforced conformity to racist customs. Deference toward white people was a standard expectation to which many African Americans begrudgingly adhered. Stepping off the sidewalk to allow whites to pass and passively accepting swindling were parts of a black person's daily life in the South. African American Minnie Whitney, born in 1902 and raised in Virginia, noted, "You speak out, you get hurt."

In such a hostile environment, it was critical for black people to develop tactics that allowed them not only to survive, but also to thrive. Wanting to raise families and build homes and institutions, they often created separate communities that would be safe havens, far away from white rancor. Moving west was a rational option, especially

LYNCH MOB Lynching is a form of extrajudicial mob killing, most frequently meted out against African American men in the South, chiefly in the years 1890 to 1920, reaching a peak in 1892. Such was the fate of Allen Brooks (*shown lynched below*), who was attacked and brutally murdered by a mob of several thousand people in Dallas, Texas, in 1910. As was often the case, the details leading up to Brooks's death remain murky. But we know this: Each of the thousands of people lynched was a human being, a person with a family, a person with a right to equal justice.

Old Lem, 1980

Sterling Allen Brown

I talked to old Lem
and old Lem said:
 "They weigh the cotton
 They store the corn
 We only good enough
 To work the rows;
 They run the commissary
 They keep the books
 We gotta be grateful
 For being cheated;
 Whippersnapper clerks
 Call us out of our name
 We got to say mister
 To spindling boys
 They make our figgers
 Turn somersets
 We buck in the middle
 Say, 'Thankyuh, sah.'
 They don't come by ones
 They don't come by twos
 But they come by tens.

"They got the judges
They got the lawyers
They got the jury-rolls
They got the law
 They don't come by ones
They got the sheriffs
They got the deputies
 They don't come by twos
They got the shotguns
They got the rope
 We git the justice
 In the end
 And they come by tens.

"Their fists stay closed
Their eyes look straight
 Our hands stay open
 Our eyes must fall
 They don't come by ones
They got the manhood
They got the courage
 They don't come by twos
 We got to slink around
 Hangtailed hounds.
They burn us when we dogs
They burn us when we men
 They come by tens ...

"I had a buddy
 Six foot of man
 Muscled up perfect
 Game to the heart
 They don't come by ones
 Outworked and outfought
 Any man or two men
 They don't come by twos
 He spoke out of turn
 At the commissary
 They gave him a day
 To git out the county
 He didn't take it.
 He said 'Come and get me.'
 They came and got him
 And they came by tens.
 He stayed in the county—
 He lays there dead.

 They don't come by ones
 They don't come by twos
 But they come by tens."

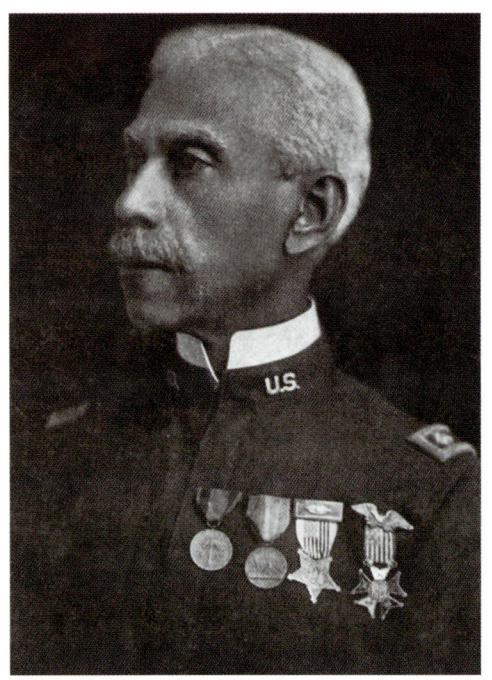

after the removal of federal troops from the South. As land opportunities and possibilities emerged in Oklahoma, Kansas, California, and other western states or territories, African Americans migrated from the South in hopes of a better life. One of the largest movements was the Exodus of 1879 to Kansas, encouraged by Benjamin "Pap" Singleton of Tennessee and Henry Adams of Louisiana. Singleton believed that salvation for blacks lay in farm ownership and saw the homestead land available out west as an alternative to sharecropping in the South. It is estimated that some six thousand people, mainly from Tennessee, Louisiana, and Texas, relocated to Kansas that year and created all-black towns such as Nicodemus, named in honor of an African slave who had bought his freedom. The founders of Nicodemus sought to create a place where African Americans could have economic opportunity and political freedom. Other all-black towns followed, including Langston, Oklahoma, in 1890, and Allensworth, California, in 1908.

With a strong desire for independence and land ownership, African Americans started similar towns in some former Confederate states. Mound Bayou was founded in the undeveloped frontier land of northwest Mississippi by twelve black men, led by Isaiah Montgomery, who purchased land from the Louisville, New Orleans and Texas Railway. Early settlers paid $8 per acre for plots of forty acres. The town suffered economic challenges but was a respite from racism when it was first established in 1887. If the creation of a separate town was not possible, black citizens tended to settle in specific neighborhoods, either by choice or due to exclusion from others. The South Side of Chicago, Southwest Raleigh in North Carolina, Auburn Avenue in Atlanta, and Freetown in Houston are examples of African American communities within larger cities.

SETTLING THE WEST

Allen Allensworth, the first black man to attain the rank of lieutenant colonel, founded the only all-black town in California in 1908, promoting it as a community for African Americans eager to farm and build businesses.

IDA B. WELLS (1862–1931)

"One had better die fighting against injustice than to die like a dog or a rat in a trap," fiery activist Ida B. Wells proclaimed. When Wells was a young teacher in Tennessee, she once bit the hand of a railroad agent who forcibly ejected her from a first-class train car. She later sued the railroad company and won, but the state supreme court overturned the decision. The incident propelled her into a career as a crusading journalist and publisher who concentrated on issues of racial justice and women's suffrage. Incensed by the lynching of her friend Thomas Moss in 1892, Wells campaigned against lynching. After months of research in the South, she concluded that lynching was a systematic practice of racial intimidation and oppression. In 1898, Wells led an anti-lynching demonstration in Washington and called on the White House for reform. As part of a coalition of activists responding to racial violence, she helped to found the National Association for the Advancement of Colored People (NAACP) in 1909.

As freed people headed north and west, they established religious institutions, businesses, and fraternal organizations. The Grand Fountain of the United Order of True Reformers, one of the early black fraternal groups, began as a mutual aid society in Richmond, Virginia. Initially focused on providing life insurance for its members, it became, under William Washington Browne's leadership, one of the largest African American–operated businesses in the country. By the 1890s, the order had created a bank and invested in land. With a company-owned hotel and meeting hall, members operated without interference from the white community. For many years, True Reformers was a model for other enterprising African Americans.

Budding entrepreneur Annie Turnbo Malone built a very successful hair-care and cosmetics company in 1902 in answer to the particular needs of black women. Based in St. Louis, which in 1900 had the fourth-largest African American population in the country, Malone's Poro products made her one of the nation's wealthiest black women and enabled her female employees to prosper as well. Madam C. J. Walker, whose hair-care product line eventually surpassed Malone's, started as a Poro agent. Both Malone and Walker recognized the challenges facing the African American community and used their wealth and influence to support organizations that strengthened it and advocated change.

Through clubs and philanthropic groups, women became a force in the African American community. Two national women's organizations merged in 1896 to form the National Association of Colored Women, with the motto "Lifting as We Climb." The organization focused on job training, wage equity, and childcare and on ending lynching, peonage, and segregation in transportation.

In the early 1900s, the deepening entrenchment of segregation and injustice toward African Americans prompted a group of black intellectuals to take action. Black sociologist W. E. B. Du Bois called for a meeting to renounce the principles of Booker T. Washington, the prominent black educator who encouraged African Americans to accept second-class, segregated status as they pulled themselves up economically, a position Washington thought realistic based on the racial attitudes of nineteenth-century America. In 1905, some thirty men attended the inaugural meeting of the Niagara Movement, named for their convening site near Niagara Falls. Proclaiming their belief that "persistent manly agitation is the way to liberty," they planned to protest the denial of rights for African Americans and lobby politicians for change. The all-male group also quickly moved to include women and welcomed alliances with white people sympathetic to its cause.

Booker T. Washington's opposition to the philosophy and strategies of the Niagara Movement prevented it from gaining much momentum in its early years. With his focus on economics and interracial goodwill rather than political agitation, Washington

ELEVATING THE RACE
The motto on the banner of the Oklahoma Federation of Colored Women's Clubs expresses the goal shared by many such clubs to aid the poor and in doing so strengthen the black community.

LANDMARK MEETING
Frustrated by the lack of opportunity and continuing injustice toward African Americans, W. E. B. Du Bois (*below, middle row, second from right*) and other black professionals founded the Niagara Movement in 1905 to protest racism. The organization led to the creation of the NAACP.

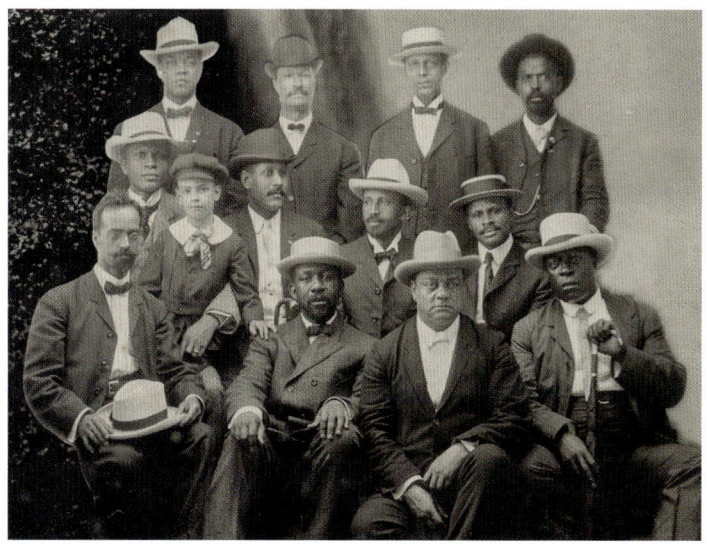

Elegy for the Native Guards, 2006

Natasha Trethewey

> Now that the salt of their blood
> Stiffens the saltier oblivion of the sea ...
> —Allen Tate

We leave Gulfport at noon; gulls overhead
trailing the boat—streamers, noisy fanfare—
all the way to Ship Island. What we see
first is the fort, its roof of grass, a lee—
half reminder of the men who served there—
a weathered monument to some of the dead.

Inside we follow the ranger, hurried
though we are to get to the beach. He tells
of graves lost in the Gulf, the island split
in half when Hurricane Camille hit,
shows us casemates, cannons, the store that sells
souvenirs, tokens of history long buried.

The Daughters of the Confederacy
has placed a plaque here, at the fort's entrance—
each Confederate soldier's name raised hard
in bronze; no names carved for the Native Guards—
2nd Regiment, Union men, black phalanx.
What is monument to their legacy?

All the grave markers, all the crude headstones—
water-lost. Now fish dart among their bones,
and we listen for what the waves intone.
Only the fort remains, near forty feet high,
round, unfinished, half open to the sky,
the elements—wind, rain—God's deliberate eye.

REOPENED SEPTEMBER 25th, 1908.

WHITE DENTAL PARLORS

SELF-SERVING QUICK LUNCH

REGULAR MEALS and A LA CARTE

LOPERS PLACE AFTER RIOT AUG 08
AUTO BURNED SPRINGFIELD

223-225 SOUTH FIFTH STREET.

VIOLENCE AND RETRIBUTION After white restaurateur Harry Loper used his car to drive two black prisoners out of harm's way and prevent them from being lynched during the 1908 riots in Springfield, Illinois, a vengeful mob set fire to his car and destroyed his restaurant.

won favor with powerful politicians, including Theodore Roosevelt, white philanthropists, and southern-born African Americans. As the founder and president of Tuskegee Institute in Alabama, Washington was a strong proponent of education and over the years amassed more than a million-dollar endowment for the school. He used this network to create the "Tuskegee Machine," which solicited money and controlled black education. Perhaps the most powerful black man of his time, he funneled resources to causes he championed and nimbly undermined his enemies. His opposition to the ideas of the Niagara Movement crippled its chances for success.

A race riot in Springfield, Illinois, in 1908 reignited the discussion of racial injustice. When two African American men were arrested for attacking white residents, a vengeful lynch mob gathered. After police spirited the prisoners out of town (in the car of a local restaurateur), the crowd unleashed its fury on black neighborhoods. Seven people died, including an elderly black cobbler, William Donnegan, who was dragged from his home and hanged. The town sustained hundreds of thousands of dollars' worth of damage, primarily in black communities. The ferocity of the violence against black people, especially in the home state of Abraham Lincoln, alarmed black and white social reformers. White progressives, including Mary White Ovington and Oswald Garrison Villard, met with African Americans, among them Du Bois, Ida B. Wells, and Mary Church Terrell, past president of the National Association of Colored Women, and founded the National Association for the Advancement of Colored People (NAACP) in 1909. Building on the principles of the Niagara Movement, the new organization sought to change laws that discriminated against African Americans and to secure for everyone the rights guaranteed under the Thirteenth, Fourteenth, and Fifteenth amendments. Headquartered in New York, the organization worked to create a network of local offices around the country. A publication, *The Crisis,* under the direction of Du Bois, publicized civil rights activism around the nation.

THE MIGRATION EXPERIENCE

Paul Gardullo

HOPE UP NORTH The first panel of Jacob Lawrence's *The Migration of the Negro* (1940), a series of sixty paintings, depicts a throng of African Americans leaving the South for the promise of more equality and better economic opportunities in northern cities.

The Great Migration was a vast movement between 1910 and 1970 of more than six million African Americans, mainly from the South, to urban areas in the North, Midwest, and West. At the beginning of the twentieth century, 90 percent of African Americans lived in the rural South. By the end of this massive relocation, only about 60 percent of the black population remained in the South. This movement was one of the largest and fastest migrations in the history of the nation.

The *Chicago Defender*, founded in 1905 by Robert S. Abbott and eventually the nation's largest black newspaper, motivated tens of thousands of African Americans to move to Chicago and other northern cities. A southern migrant himself, Abbott actively promoted African American relocation by publishing graphic accounts of lynchings and other racial atrocities in the South alongside stories detailing opportunities in northern cities. When white southerners barred official distribution of the *Defender*, a network of Pullman train porters stepped in to deliver the paper secretly. Upon reading the newspaper, black southerners often wrote letters to the *Defender* and Abbott seeking additional information, aid, and practical advice. The paper shaped and gave voice to the Great Migration of black southerners. Reading letters written to the newspaper provides a window into the hearts and minds of individuals and families who sought refuge from the harsh environment of the Jim Crow South. The following excerpts from migrants' letters written in 1917 were compiled by the *Journal of Negro History*.

"I have been taking *Defender* for sevel months and I have seen that there is lots of good work in that section and I want to say as you are the editor of that paper I wish that you would let me know if there is any wheare up there that I can get in…. I will go to pennsylvania or n y state or N. J. or Ill. Or any wheare."—Jacksonville, Florida

"I am a young man 25 years of age. I desire to get in some place where I can earn more for my labor than I do now, which is $1.25 per day…. I have finished a correspondence course with the practical auto school of New York City and with a little experience I would make a competent automobile man."—Atlanta

"I has heard so much talk about the north and how much better the colard people are treated up there than they are down here and I has ben striveing so hard in my coming up and now I see that I cannot get up there without the ade of some one…. Our southern white people are so cruel we collord people are almost afraid to walke the streets after night."—Texas

Uprooting their lives out of fear, necessity, and hope, black migrants reimagined their futures when they left the South. Their migration would alter their personal lives and the social and cultural fabric of the nation as they put down new roots across the country.

The NAACP initiated court cases with the goal of overturning discriminatory laws. In 1915, it scored a U.S. Supreme Court win in an Oklahoma case, *Guinn v. United States,* which outlawed the use of a grandfather clause as a device to exclude black residents from voting. The NAACP also threw its support behind anti-lynching legislation after conducting an investigation of the 1916 torture and lynching of teenager Jesse Washington in Waco, Texas. Elisabeth Freeman, a white woman, carried out the investigation and issued a report, which was printed in *The Crisis.* She also went on a speaking tour for the NAACP, denouncing the crime. NAACP supporters further dramatized their abhorrence to racial violence with a silent protest march in New York City in 1917. Approximately eight thousand people marched to muffled drums and issued flyers stating why they marched: "Because we deem it a crime to remain silent in the face of such barbaric acts."

By 1920, New York City had the largest African American population of any city in the United States. The availability of jobs for African Americans during World War I provided a powerful incentive for black people in the South to head to New York and many other cities. African American newspapers such as the *Chicago Defender* and the *Richmond Planet* published articles about opportunities in the North and encouraged African Americans to leave the South rather than accept poverty and racial discrimination. Many prospective migrants wrote newspapers requesting further assistance. One letter from New Orleans stated: "Sirs: Noticing an ad in *Chicago Defender* of your assistance to those desiring employment there I thought mayhaps you could help me secure work in your Windy City."

Letters from relatives who had already made the journey north also urged thousands of African Americans to uproot from the South. Rube White was ten years old and living in Mississippi in 1917 when her father learned of jobs in Beloit, Wisconsin, from their cousin. Not long afterward, the family boarded a train to Beloit, where her father quickly

SILENT STRENGTH A month after white rioters killed dozens of African Americans in East St. Louis, Illinois, the NAACP led thousands of protesters in a silent march down New York's Fifth Avenue, accompanied only by muffled drums.

found work at a factory. Between 1910 and 1920, the black population in New York City grew from 91,000 to 152,000, while Chicago's African American residents increased from 40,000 to nearly 110,000. The sudden influx of migrants created large enclaves of black residents in these cities. Many of the areas were overcrowded, with poor sanitary conditions and minimal municipal services, because most cities were unprepared for the flood of people who settled in black communities such as Harlem in New York, South Street in Philadelphia, and the Near East Side in Detroit.

Concern about the challenges facing migrants spurred the creation of the National League on Urban Conditions among Negroes in 1910 under the guidance of Ruth Standish Baldwin, a white philanthropist, and Dr. George Edmund Haynes, the first black PhD in economics from Columbia University. The Urban League, as it was later known, provided counseling to the newcomers and helped them find employment and housing. The agency also tried to protect newly arrived young women from criminal exploitation. The NAACP and Urban League, both interracial organizations, employed different strategies: The NAACP utilized litigation and political lobbying, while the Urban League focused on improving economic and social conditions. Local communities mirrored these national tactics. For example, Los Angeles created the Men's Forum, which aided new migrants to the city and organized to combat racial discrimination.

Renaissance and Resistance

African Americans hoped they might advance their demands for full citizenship by supporting and participating in World War I. President Woodrow Wilson labeled it a war to make the world safe for democracy, and African Americans hoped to make democracy function better for them in the United States. Though large numbers of African Americans

SERVING WITH DISTINCTION
World War I's most decorated black regiment, the 369th Infantry, dubbed the Harlem Hellfighters, trains in trenches in France in 1918. The French awarded the unit 171 medals, including the Croix de Guerre.

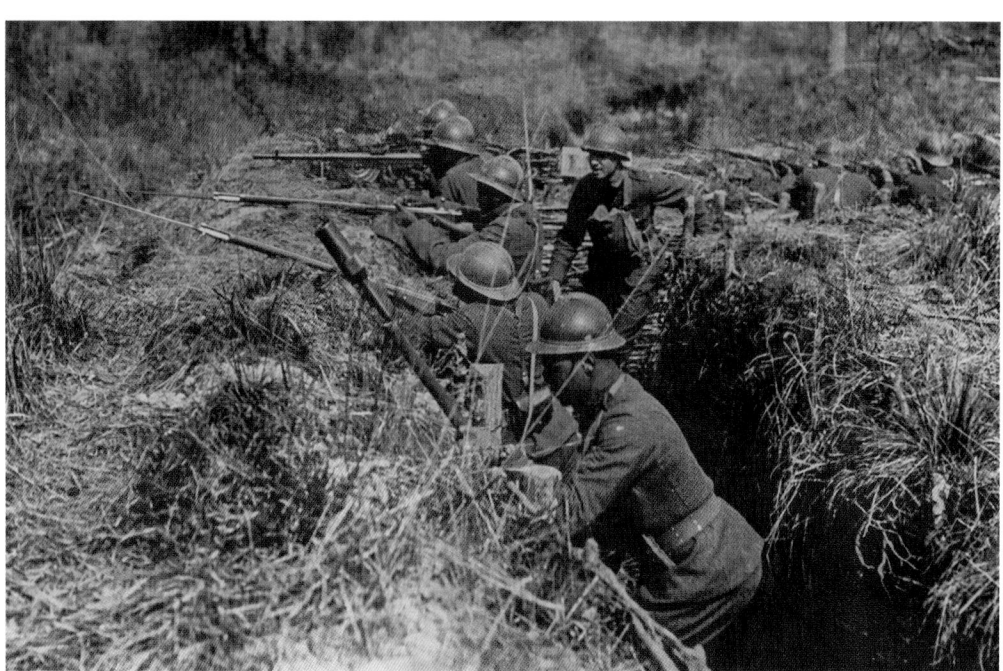

volunteered for military duty, most of them wound up in labor and support units and never saw combat. Protests against this policy finally pushed the army to create two black combat units, the Ninety-second and Ninety-third divisions. The participation of the 369th, a regiment of the Ninety-third nicknamed the Harlem Hellfighters, illustrated the experiences of black combat soldiers. The discrimination and hostility that the unit encountered from white locals during training in Spartanburg, South Carolina, nearly caused a riot. When the 369th reached Europe, the soldiers operated under the command of the French, wearing French uniforms and using French weapons in order to separate them from white American combat troops. The French eventually awarded the unit their highest military honor, the Croix de Guerre, for bravery in combat. In contrast, no black soldier received a medal from the U.S. military in the years immediately following World War I. The white press and army officials more often sought to denigrate the performance of black troops.

Most important, the experiences gained by African American troops while in Europe impacted how they saw themselves and their status back home. Returning soldiers were more likely to resist acts of mistreatment. Their emboldened postwar attitude, combined with the growing numbers of African Americans living in urban areas, triggered animosity from whites who resented the economic and housing competition and tried to intimidate and drive out black residents. Consequently, the summer of 1919 was a violent one for the nation. Three dozen riots erupted in cities around the country. The largest ones took place in Chicago, Washington, D.C., and Elaine, Arkansas. What was different about these riots was that African Americans, especially veterans, resisted the assaults and fought back. African American newspaper accounts of the outbreaks described the sense of black people's growing determination to protect themselves and their communities.

African Americans' invigorated spirit spawned a cultural component in the 1920s. Called the Negro or Harlem Renaissance, it was a time when black writers, musicians, and artists approached their work with a new sensibility. They embraced their African heritage, the rhythms of their communities, and the unique contributions that people of African descent had made to American culture. In 1925, *The New Negro,* edited by Alain Locke, the first African American Rhodes Scholar, published essays by leading black intellectuals as well as works by emerging writers. One of the young writers, anthropologist

"Colored men are simply defending their lives and their homes. We say to them—continue defending them until the last man falls and then let the women take up the fight!"

—CLEVELAND GAZETTE, African American newspaper, 1919

IN SEARCH OF SELF An anthropologist as well as a Harlem Renaissance novelist, Zora Neale Hurston endeavored to preserve the folk culture and speech of African Americans in the rural South. Her research and storytelling talents are reflected in her best-known novel, *Their Eyes Were Watching God*, written in 1937 and still popular today.

Zora Neale Hurston, stood out for her devotion to African American folk culture and vernacular. The many bright literati showcased in the anthology included poets such as Countee Cullen and Langston Hughes, who are now well known. The overall goal of the Harlem Renaissance was to focus on the African American community: its history, culture, and distinctions. For instance, Archibald Motley's colorful Jazz Age canvases depicted African Americans in a variety of skin tones, and Meta Vaux Warrick Fuller and Augusta Savage rendered sculptures with genuine African American physiognomy. The poetry of Jamaican American Claude McKay boldly confronted society's racism, while the music of Louis Armstrong and Duke Ellington embellished European styles that evolved into new genres. Such artists promoted the history and culture of people of African descent as essential aspects of American culture.

The New Negro also spoke out against injustice toward African Americans. One of the most strident voices was that of Jamaican-born Marcus Garvey. An orator and political leader, Garvey roused his audiences with impassioned "Up, You Mighty Race" appeals and promoted a Pan-African philosophy that encouraged economic and political solidarity among African peoples around the world. He also urged blacks to return to Africa. Garvey's black pride message inspired thousands of African American followers.

When the Great Depression hit the United States and the world, African Americans, in particular, felt the blow. Black unemployment reached 50 percent by 1931, which was much higher than the 31 percent unemployment rate among whites. When President Franklin D. Roosevelt took office, he created an array of programs designed to mitigate the impact of the Depression. Unfortunately, they had mixed results for African Americans. While some programs hired black people in the segregated units of the Works Progress Administration (WPA), other programs penalized them. For instance, subsidies paid to large landowners encouraged them to consolidate their holdings and throw sharecroppers and other renters off their land. This proved disastrous for black farmers, who frequently did not own the land they farmed. In addition, numerous private agencies refused to help African Americans or gave them less assistance than white citizens.

Black churches intervened when they could to help ease the impact of the Depression by providing food, clothing, and housing for the needy. Spruce Street Baptist Church in Nashville, Tennessee, found shelters for the homeless, and both Mother Bethel AME in Philadelphia and Bethel AME in Kansas City, Missouri, set up nurseries. Other, less traditional, and sometimes controversial religious organizations also emerged to support those in need, including the Nation of Islam, under the leadership of Elijah Muhammad and Sister Clara Muhammad; Daddy Grace's United House of Prayer of All People; and Father Divine's Peace Mission. In the 1930s and 1940s, the International Peace Mission Movement opened more than a hundred residential hotels, called the Divine Hotels. Members received food, shelter, job opportunities, and spiritual guidance at the residences, which were located in Harlem and later around the world. Father Divine also established restaurants, grocery stores, and clothing shops that sold good-quality, low-cost goods to patrons. Movement members were not allowed to smoke, drink, or swear. They also vowed to remain celibate. Despite these strict rules, Father Divine recruited tens of thousands of

SHARECROPPING

Elaine Nichols

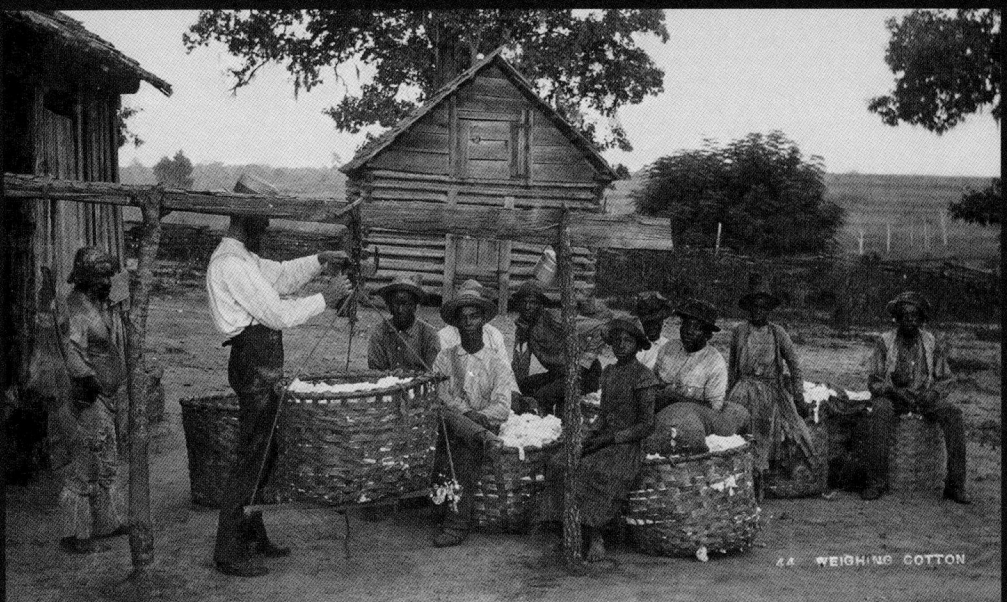

A NEW BONDAGE Without land to farm, freedmen resorted to sharecropping, an exploitive system that dominated agriculture in the post–Civil War South. This scene in Thomasville, Georgia, in 1895 shows black workers weighing cotton.

During the last months of the Civil War, thousands of formerly enslaved people followed the Union Army through Georgia and South Carolina. In January 1865, as a practical response to the growing numbers of refugees and a proposal from several African American ministers, General William T. Sherman ordered that 400,000 acres of coastal land confiscated from Confederate landowners in those states should be temporarily redistributed to black freedmen. A later order allowed Army mules that were not being used in battle to be loaned to these families.

African Americans erroneously believed that they were now landowners who would be able to earn a living and profit from their land. After Lincoln's assassination in April 1865, one of Andrew Johnson's first acts as president was to return land under federal control in the South to previous white owners. The Army enforced the policy, removing anyone who resisted.

With their path to landownership and economic self-sufficiency blocked, African Americans had few options. Of the four million African Americans in the South, only about thirty thousand owned land, and most had little money or resources to find employment. Even though African Americans had earned their freedom and citizenship during Reconstruction, the federal and state governments did little to help them secure land or to protect them from the cruel economic system that replaced slavery—sharecropping. This economic arrangement—in which landowners rented parcels of land to laborers on credit to grow crops in exchange for a share of the harvest—became the only recourse for thousands of newly freed people and some poor whites.

White landowners extended credit to sharecroppers so that they could acquire farm equipment, seeds, fertilizer, work animals, food, housing, and other essentials, but they also routinely exploited them with unscrupulous contracts and high interest rates or even falsified records. At the end of the harvest season, the sharecroppers were usually deeper in debt and locked into a vicious cycle of financial obligations that forced them to stay on the land to work off their mounting liabilities. By the 1870s, sharecropping had become the dominant form of southern agriculture, guaranteeing that African Americans in the South would remain destitute and landless, trapped in a new form of bondage.

At the turn of the twentieth century, sharecropping began to decline as agricultural mechanization spread in the South and African Americans migrated north and west to escape the brutal racism and economic hardship. In their new homes, they still faced racism and other challenges but found increased opportunities for better-paying jobs and some measure of equality.

followers during the Depression. They were drawn to his support of racial equality and his belief in creating an interracial heaven on earth. His "Righteous Government Platform" called for an end to segregation, lynching, and capital punishment. It also demanded "equal opportunity for every individual without regard to race, creed or color."

Calls for fair treatment came from other organizations as well. The National Council of Negro Women formed an association of women's groups under the leadership of Mary McLeod Bethune. It focused on improving racial and economic conditions for black women and children by researching problems and publicizing information exposing the challenges facing black families. The council also lobbied the White House and Congress for new initiatives and laws.

"Don't Buy Where You Can't Work" campaigns and a series of protests were held in thirty cities, including Washington, D.C., Chicago, New York, Los Angeles, and Cleveland. Aiming to increase job opportunities, activists mobilized African Americans to use their economic clout. Through boycotts and picketing, they pressured neighborhood business owners who had a sizable black clientele to hire African Americans. In 1930, fiery editorials in the *Chicago Whip*, a black newspaper, encouraged black shoppers to boycott Woolworth stores in black communities, eventually winning three hundred jobs for African Americans.

The success of the Chicago protest spurred other cities to try similar tactics. Charismatic Reverend Adam Clayton Powell Jr. led New York campaigns that resulted in more equitable hiring practices at a Harlem department store in 1934, the New York's World's Fair in 1939, and the local bus company in 1941. Powell steered protests against the telephone and local utility companies in 1938. Picketing, tying up telephone lines, and disrupting

POWER OF THE PURSE

Protesters in Brooklyn, New York, in 1940 boycott local businesses as part of a nationwide effort opposing discrimination in hiring.

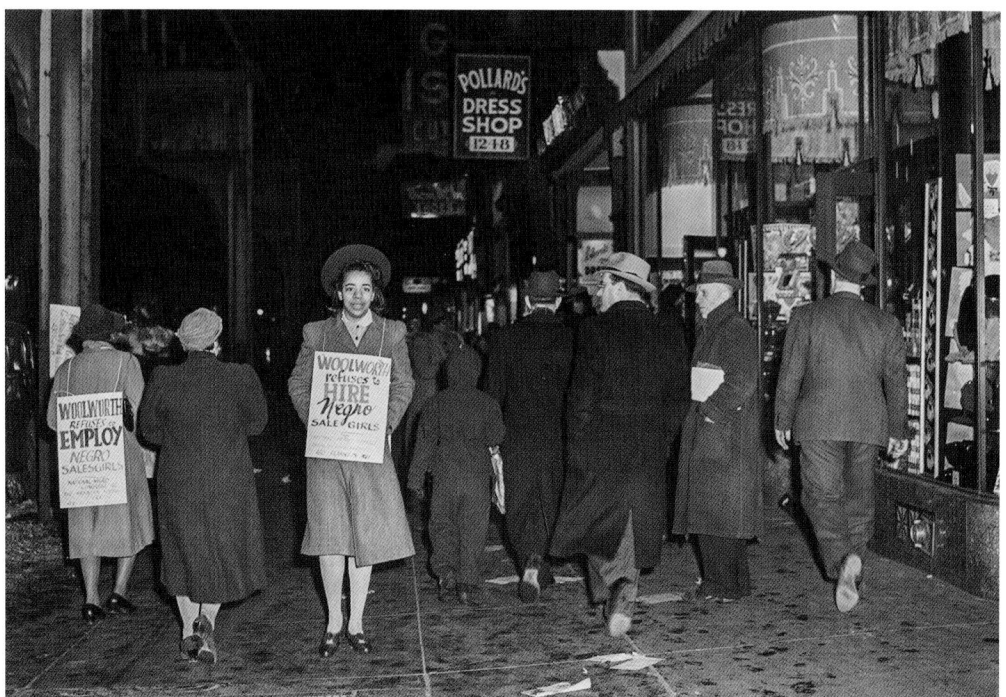

businesses by paying bills with pennies were strategies used to force companies to hire black cashiers and clerks. Powell's activism propelled him to a seat in the U.S. Congress in 1945.

In Washington, D.C., three young African American men created the New Negro Alliance in 1933 to organize "Don't Buy" campaigns against white businesses in black neighborhoods. In 1938, the alliance's boycott and picketing of a chain of grocery stores in the black community led to a Supreme Court decision that upheld protesters' rights to boycott a business that refused to employ African Americans. The ruling strengthened other black consumer boycotts across the country.

The start of World War II created more points of contention for African Americans concerning fair employment opportunities. As the U.S. government distributed contracts to companies to produce goods for the war effort, African Americans were shut out of the better-paying jobs in most businesses. When black citizens demanded equal treatment, President Roosevelt was slow to respond to their entreaties. Black labor leader A. Philip Randolph and his colleague Bayard Rustin then proposed a massive protest march in Washington, D.C., in 1941. Their goal was to embarrass the president and the nation at the start of a war which they claimed was being waged for freedom and democracy. Randolph and Rustin traveled across the country, giving speeches and building support for the march, predicted to bring more than one hundred thousand people to Washington.

ACTIVIST VOICE Mayor Fiorello La Guardia (*right*) swears in Adam Clayton Powell Jr. (*center*) as New York City's first black councilman in 1941. Powell's mother, Mattie (*far left*), his wife, Isabel, and his father, Adam Sr. (*second from right*) witnessed the event.

"It is time to wake up Washington as it has never been shocked before."

—A. PHILIP RANDOLPH, labor leader, 1941

A week before the scheduled protest, the president finally signed Executive Order 8802, which created the Fair Employment Practices Committee to oversee future hiring practices of companies receiving government contracts. Randolph canceled the march but kept the organization in place to continue lobbying for desegregation of the military and stronger civil rights laws. Randolph and Rustin would later revive and adapt their plan for the 1963 March on Washington.

Randolph was not alone in the desire to keep pressure on the president. Other groups also refused to set aside their demands for equal treatment just because the nation was at war. Instead, they saw it as a time to push even harder to make the nation live up to its claims concerning democracy and freedom. This was epitomized in the Double V Campaign, spearheaded by the *Pittsburgh Courier* (see page 75). The newspaper demanded

POSTWAR PROTEST Predating 1960s sit-ins, civil rights activists Bayard Rustin (*left*) and George Houser (*right*), a white minister and a founder of the Congress of Racial Equality, staged a sit-in at a segregated restaurant in Toledo, Ohio, in 1945.

JUSTICE TRIUMPHS NAACP attorneys (*below, left to right*) George E. C. Hayes, Thurgood Marshall, and James Nabrit congratulate one another outside the Supreme Court after the 1954 ruling declaring separate-but-equal schools unconstitutional.

that African Americans commit themselves to victory in the war and victory at home in the fight against discrimination. The campaign became a popular concept as other African American newspapers and readers embraced the idea. Rallies and other public events were held in support of the campaign, with the hope of influencing lawmakers and other political leaders. Among the national organizations that supported Double V were the Urban League and the NAACP. The Urban League focused on pressuring labor unions and companies to provide greater opportunities for black workers. White political and business leaders in Birmingham, Detroit, Portland, Oregon, and other cities across the country sought the league's guidance on how to improve race relations in cities and workplaces.

The NAACP concentrated on litigation in its battle against discrimination. One of its most important cases involved Irene Morgan, a woman arrested for refusing to move to segregated seating on a bus from Maryland to Virginia in 1944. With the assistance of the NAACP legal team, she challenged a local court's guilty verdict and appealed to the Supreme Court. The high court ruled in 1946 that segregated seating violated the Interstate Commerce clause of the U.S. Constitution by forcing passengers to change seats when the bus crossed into different states, but the court did not set a time schedule for implementation of the decision or rule against intrastate bus segregation. Another civil rights group, the Congress of Racial Equality (CORE), formed in Chicago in 1942, tested the decision by sending an interracial group of sixteen men south by bus. The riders were arrested several times during their two-week trip. In practice, the ruling had no teeth, but it inspired lawyers and activists and laid the groundwork for the 1960s Freedom Rides.

The 1946 *Morgan* decision and earlier 1938 *Gaines* decision, which ruled against the segregated University of Missouri law school, along with ongoing racial discrimination and violence, prompted President Harry S. Truman to act. Seeking to encourage more civil rights progress, he created the Presidential Committee on Civil Rights in 1947, proposed significant civil rights legislation, and in 1948 issued Executive Order 9981, which desegregated the military. While Congress was slow to act on Truman's legislation, his efforts and the recent Supreme Court rulings marked an important shift in key parts of the federal government with regard to civil rights. It appeared that wholesale acceptance of discriminatory practices was weakening, which encouraged civil rights advocates to redouble their efforts to achieve change.

The NAACP's successful court cases involving schools and education in the 1930s and 1940s inspired the organization to reach higher. Most cases had not sought to overturn the idea of "separate but equal" established in the 1896 *Plessy v. Ferguson* case, but instead had looked to ensure that separate facilities were indeed equal. Emboldened by success, the NAACP began legal strategies designed to overturn the *Plessy* case and render the concept of segregation illegal.

In 1951, the NAACP's legal division began litigation of several class-action cases, including a lawsuit Oliver Brown filed against the Topeka, Kansas, school

board. Activist Oliver Brown's daughter Linda, a third-grader who attended a segregated school in Topeka, had to walk past a nearby white school to catch a bus to attend her school several miles away. The lead counsel on the case, Thurgood Marshall, who in 1967 would become the first African American Supreme Court justice, argued that "separate but equal" was inherently unequal because of its negative emotional and psychological impact on students. Segregation, the NAACP asserted, implied that black children were inferior to their white counterparts and damaged their self-esteem. The Supreme Court, led by Chief Justice Earl Warren, agreed, ruling in May 1954 that racial segregation was unconstitutional and violated the Fourteenth Amendment's equal protection clause. *Brown v. Board of Education of Topeka* was a landmark case that set in motion a new wave of civil rights activism that would begin the eradication of legal segregation in the United States.

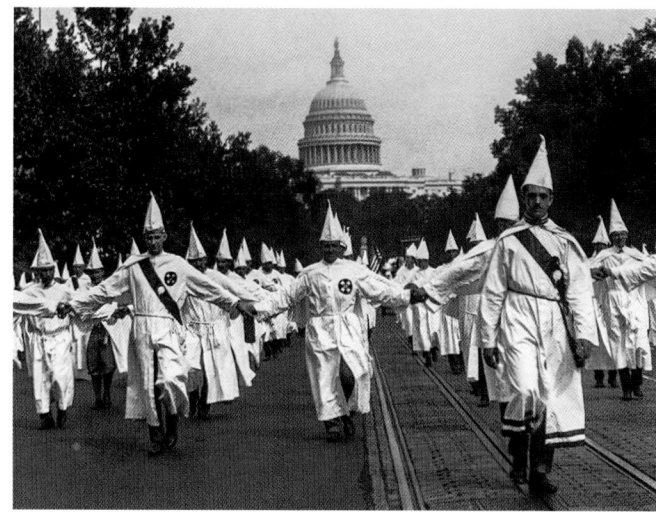

TERROR TACTICS In 1925, some fifty thousand white-robed members of the Ku Klux Klan, a white supremacist organization that targeted African Americans, Jews, Catholics, and immigrants, paraded openly in front of the Capitol in Washington, D.C.

Eyes of the World

There was also a new aggressiveness on the part of human rights activists. Many understood the influence of the post–World War II ideological struggle between the United States and Russia for influence over new nations emerging around the world, which put U.S. domestic policies in the spotlight. Civil rights activists recognized the impact that international news coverage might have on the nation's foreign policy and used this to their advantage. In the decade after the *Brown* decision, African Americans faced intractable racism and horrific calculated violence, not just from bigoted individuals and Ku Klux Klansmen, but also from southern law enforcement officials and authorities. And now the whole world was watching. Musician Louis Armstrong cancelled a goodwill tour of the Soviet Union for the State Department out of frustration and embarrassment over the treatment of African Americans in the United States. "The people over there ask me 'what's wrong with my country' and what am I supposed to say?" he lamented.

The vicious murder of fourteen-year-old Emmett Till was a tragedy that captured world attention. While visiting relatives in Mississippi in 1955, Till was kidnapped and murdered for allegedly whistling at the wife of a local store owner. The subsequent acquittal of the boy's murderers by an all-white jury strengthened African Americans' determination to fight racial oppression. Opposition to segregated public transportation flared throughout the South as African Americans boycotted buses in Tallahassee, Florida; Baton Rouge, Louisiana; and Montgomery, Alabama. Worldwide attention, however, focused on Montgomery on December 1, 1955, when Rosa Parks, a seamstress and civil rights activist, defied local segregation laws by refusing to give up her seat to a white man when the front of the bus was full. Emmett Till's death motivated her, she said later: "I thought about Emmett Till, and I

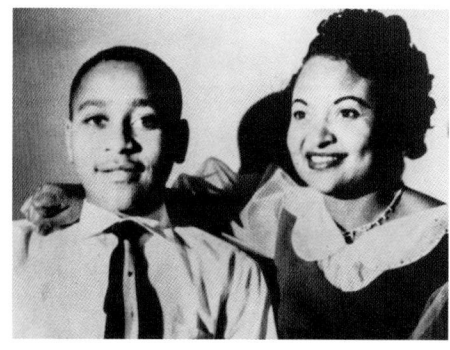

MOTHER AND SON Mamie Till Mobley drapes her arm around her son, Emmett, as both smile for a photograph taken in the early 1950s. A few years later, he was brutally murdered in Money, Mississippi.

could not go back." Although Parks, aged forty-two at the time, acted spontaneously that day, she was trained in civil disobedience and as a long-time member of the local NAACP was aware of its plan to challenge discrimination on local buses.

After the arrest of Parks, African American residents and civil rights leaders broadened her cause, refusing to ride the city's public buses until officials desegregated them. Local black leaders elected the Reverend Martin Luther King Jr., the recently arrived minister of the Dexter Avenue Baptist Church, president of their new organization, the Montgomery Improvement Association, which spearheaded the boycott. For more than a year, black residents carpooled, hitched rides, and frequently walked several miles rather than ride city buses. When asked if she would keep walking, one elderly woman declared, "My feets is tired, but my soul is rested." The highly effective boycott hurt the bus company's finances and made international heroes of Parks and King. African Americans demonstrated a new resolve to stand up for their rights. Despite arrests, bombings, and other threats, black people stayed off the buses until the Supreme Court ruled against city officials, who finally capitulated. "We came to see, that in the long run, it was more honorable to walk in dignity than to ride in humiliation," King said of the triumph.

A similar spirit and fortitude pervaded the 1957 effort to desegregate Central High School in Little Rock, Arkansas. Daisy Bates, president of the local NAACP, handpicked nine high school students for their intelligence and temperament to enroll in the school. Counseled and prepped on how to respond to hostile situations, they endured a crowd of hate-spewing whites on opening day. Elizabeth Eckford, a stoic sixteen-year-old black student, recalled that one woman spat on her as she approached the entrance. The Arkansas National Guard, on orders from Governor Orval Faubus, prevented her and other black students from entering the school. His actions forced a reluctant President Dwight D. Eisenhower to send one thousand members of the 101st Airborne Division and ten

MAMIE TILL MOBLEY (1921–2003)

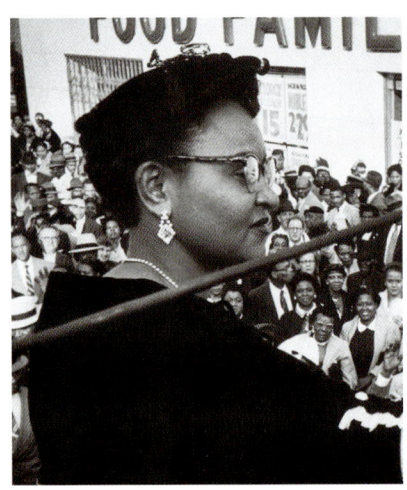

When two white men brutally murdered Mamie Till Mobley's fourteen-year-old son, Emmett Till, in Money, Mississippi, in 1955, she insisted on an open-coffin funeral, forcing the world to "see what they did to my boy." She allowed the media, most prominently John Johnson's black weekly magazine *Jet*, to publish photographs of Till's tortured and mutilated body, hoping to raise awareness of racial hatred and intolerance. The crime sparked national outrage. Till, her only child, had left Chicago to visit relatives in Mississippi when he was kidnapped and killed for allegedly whistling at a white woman. Roy Bryant and J. W. Milam were acquitted shortly after Emmett's body was pulled from the Tallahatchie River. Months later, the men confessed to killing the boy in a *Look* magazine article detailing their crimes, but they remained free for the rest of their lives. Mobley pressed for justice in her son's death and became a crusader for poor children. She worked to keep her son's memory alive by writing, teaching, speaking out, and organizing Emmett Till tributes. "If I don't talk," Mobley once said, "it stays in and worries me."

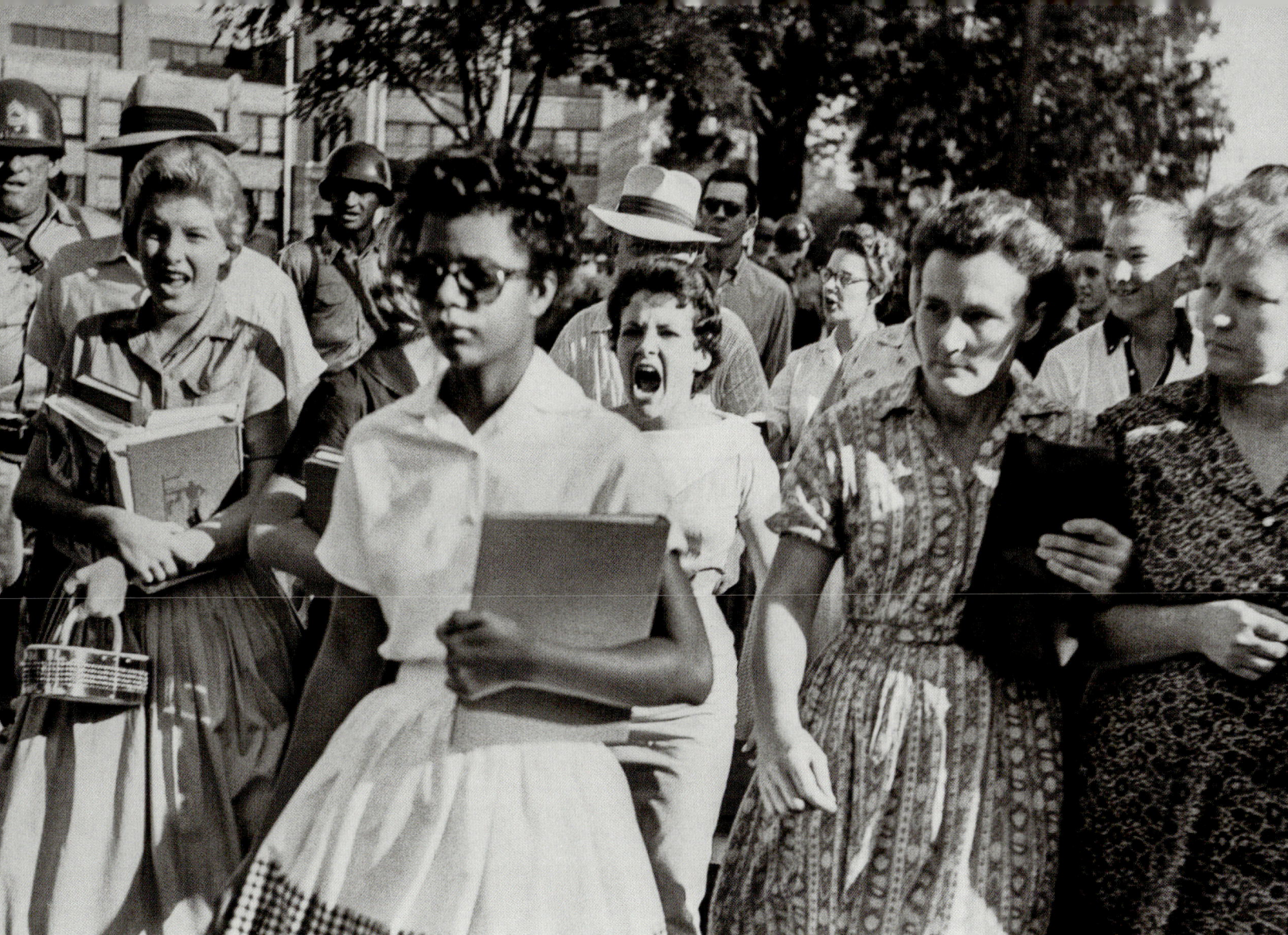

thousand federalized Arkansas National Guard soldiers to Little Rock to protect the students. After the African American students were finally enrolled, white students continued to harass them, hoping to have them expelled. Ernest Green, who would one day serve in the Carter administration and later join an investment bank, became the first African American to graduate from Central High School in 1958.

A much younger student, six-year-old Ruby Bridges, desegregated an all-white elementary school near New Orleans in 1960. When local officials claimed they could not protect her from jeering crowds, U.S. marshals escorted her to class and back home every day. Norman Rockwell created a now-famous painting depicting her courage. Ruby spent the entire year as the only student in her class because white parents refused to allow their children to join her. Remarkably composed, she never cried, the marshals reported. Her family, however, suffered the backlash: Her father lost his job and her grandparents were thrown off the farm they rented. Nonetheless, they kept her in the school until she progressed to junior high.

Hoping to maintain the momentum demonstrated by the Montgomery bus boycott, dozens of black ministers and civil rights leaders had met in Atlanta in early 1957

DESEGREGATION BATTLEGROUND One of nine black students to integrate Central High School in Little Rock, Arkansas, in 1957, sixteen-year-old Elizabeth Eckford (*center, in glasses*) tries to ignore the hostile taunts of a mob of students on her first day of school.

to create an organization to bring about social change through the use of nonviolent resistance. Martin Luther King Jr., the Reverend Ralph Abernathy, and Fred Shuttlesworth, all ministers and proven civil rights activists, were among the founders of the Southern Christian Leadership Conference (SCLC). The organization, which aimed to coordinate civil rights groups throughout the South and train protesters in nonviolent tactics, chose King as its president.

Not yet thirty years old, King had earned his PhD at Boston University in 1955 after graduating from Morehouse College in Atlanta and Crozer Theological Seminary in Chester, Pennsylvania. His father and grandfather were respected ministers, and his family members were among the most prominent activists in Atlanta. Young and energetic,

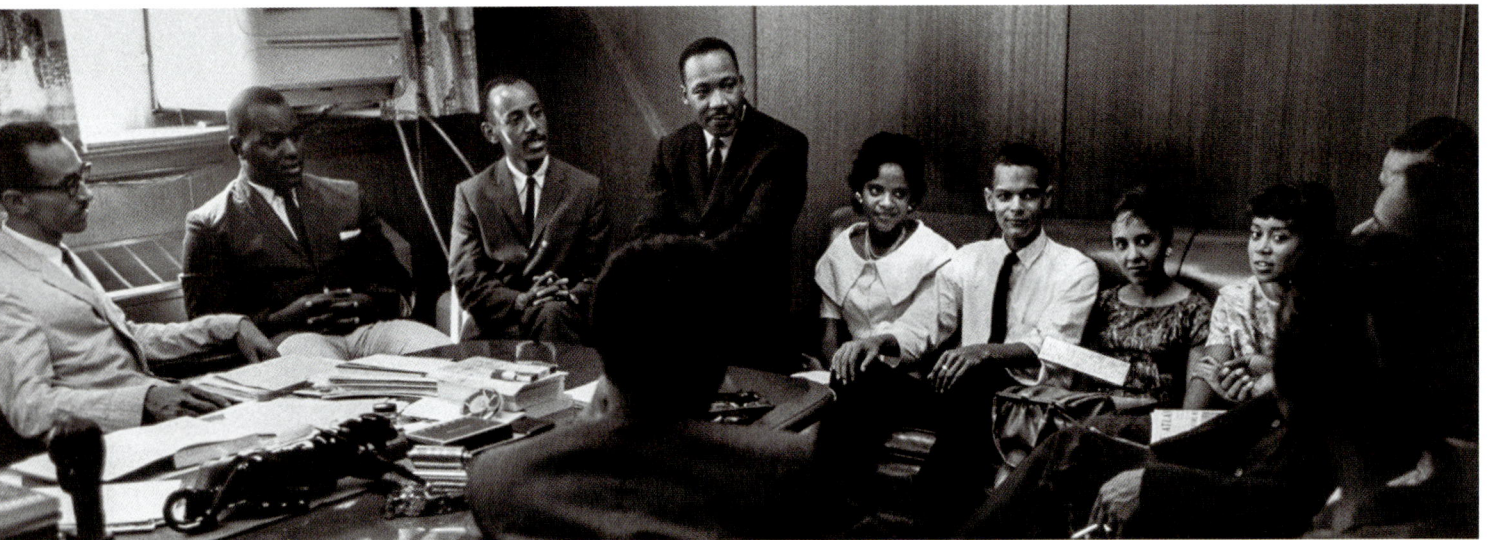

THE ATLANTA STUDENT MOVEMENT The Reverend Martin Luther King Jr. (*center*) discusses strategy with colleagues Wyatt T. Walker (*left*) and Lonnie King (*second from left*) and the student organizers of sit-ins to protest lunch counter segregation in Atlanta, Georgia. The students include (*left to right from King*) Carolyn Long Banks, Julian Bond, and (*right, facing camera*) Alice Clopton Bond.

King quickly gained national attention with his powerful and eloquent speaking style. As a student, he had studied many theologians and philosophers, but he was particularly inspired by the teachings of Mohandas K. Gandhi, whose campaign of civil disobedience helped India win independence from Great Britain in 1947. "It was in this Gandhian emphasis on love and nonviolence that I discovered the method for social reform," King wrote in 1957. He would devote his life to preaching and practicing nonviolence as a strategy to win rights for African Americans.

One of the first major SCLC actions occurred in 1961 in Albany, Georgia, where local black citizens had initiated a broad campaign to desegregate the entire city, starting with voter registration rights. Their protests had resulted in mass arrests but little change. SCLC joined the fight, hoping to direct national attention to the city and pressure local officials to relent. White city officials did not abuse arrested protesters in the presence of the media but broke promises to end segregation as soon as King and the news organizations left town. The stalled process strained relationships between SCLC and a new organization, the Student Non-Violent Coordinating Committee (SNCC), created to attract young people to the movement.

The catalyst for the creation of SNCC was the sit-in at a Woolworth lunch counter in Greensboro, North Carolina, in 1960. When four students from North Carolina Agricultural and Technical State College (A&T) refused to leave the store's lunch counter after waitresses declined to serve them, the movement spread to other segregated stores around the city. Students in other states quickly adopted similar tactics, which proved highly effective. When Woolworth and other stores relented, King called it an "electrifying movement of Negro students [that] shattered the placid surface of campuses and communities across the South."

Hoping to take advantage of the energy and success of the students, SCLC encouraged them to create a youth wing of the organization. Under the mentorship of Ella Baker, a veteran civil rights activist and SCLC member, the students created SNCC, a separate, independent interracial organization. While not opposed to working with SCLC, the members of SNCC created their own strategies and projects. More aggressive in their demands for change than the parent organization, SNCC sought to destabilize segregation more rapidly.

Although they shared the philosophy of nonviolence, SNCC and SCLC did not always work together harmoniously. Some young activists complained that they were the ground troops doing the tough work, only to have SCLC show up later to receive the media coverage and credit. When King and SCLC arrived in Albany, SNCC felt its efforts were overshadowed and undervalued.

On at least one occasion, an SNCC member rescued a fledgling protest and helped turn it into a juggernaut of success for the Civil Rights Movement. Diane Nash, a Fisk University student and founding member of SNCC, reinvigorated the Freedom Rides, the strategy that had eventually helped topple segregated travel barriers but was nearly derailed early on. In 1961, CORE recruited black and white passengers to ride on interstate buses to challenge segregation laws in southern states. The 1960 Supreme Court ruling in *Boynton v. Virginia* that declared segregation in facilities used by interstate travelers unconstitutional provided the legal authority for integration, and CORE set out to test it. On May 4, 1961, thirteen young activists left Washington, D.C., on two Greyhound buses bound for New Orleans. Courageous but unsure of their fate, several wrote letters to loved ones in the event of their deaths. The group rode the buses through several southern states without much confrontation. John Lewis and white activist Albert Bigelow were attacked in Rock Hill, South Carolina, but their injuries did not prevent them from continuing the journey.

However, violence escalated in Alabama, when angry white mobs attacked the buses, slashing the tires, setting fire to one bus, and assaulting the passengers as they fled. A second bus arrived in Birmingham only to be met by another crowd of whites who savagely beat many of the riders. Alarmed at the violence and unable to find a bus driver willing to transport riders, CORE considered ending the Freedom Rides. Nash, however, stepped in and organized an SNCC contingent of eight students to travel from Nashville to Birmingham to increase the number of riders and ensure that the Freedom Rides continued. "If the Freedom Riders had been stopped as a result of violence ... the

THE SIT-IN MOVEMENT

William S. Pretzer

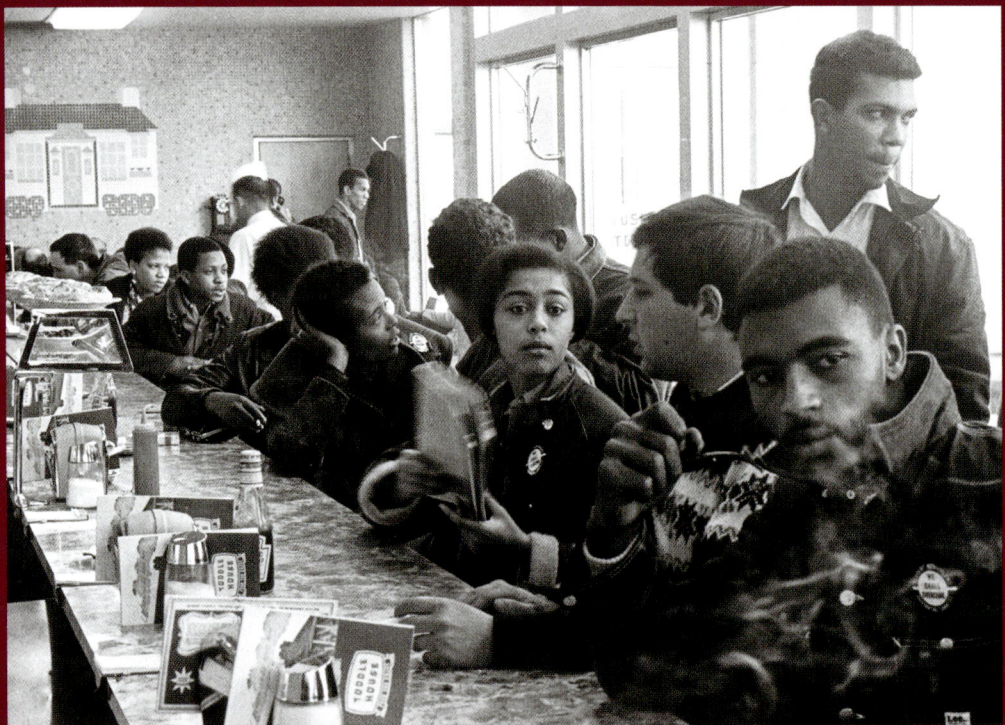

STUDENT PROTEST When four black North Carolina college freshmen staged a sit-in at a lunch counter in an F. W. Woolworth store in Greensboro in 1960, they sparked a movement that pressured restaurants across the South to serve African Americans. Sit-ins occurred in Atlanta, where students lined the counter of Toddle House (*left*). Among those shown in this photograph are Ivanhoe Donaldson (*in background, by coat hook*), Joyce Ladner (*with elbow on counter*), Judy Richardson (*looking at camera*), George Grieve (*standing, right*), and Chris Neblett (*lower right*). Hundreds of students demonstrated at Greensboro stores, including coeds (*below*) at Woolworth.

On February 1, 1960, four North Carolina Agricultural and Technical State College (A&T) freshmen walked into the F. W. Woolworth store in Greensboro, North Carolina, bought some school supplies, sat down at the lunch counter, and ordered coffee. Because they were black and the lunch counter segregated, they knew they would not be served. But they refused to move when the store manager ordered them to leave. At 5 p.m., the store closed early, and the students went back to their college dorm. The next day, they returned to the store, along with several friends, to continue their "sit down." That night, with college officials and local citizens, they formed the Student Executive Committee for Justice and sent a letter to the president of Woolworth requesting that he "take a firm stand to eliminate discrimination."

On February 3, more than sixty black students from A&T, Bennett College for Women, and Dudley High School occupied Woolworth's lunch counter seats for the entire day. The next day, nearly three hundred black students, along with three white female students from the Woman's College of the University of North Carolina in Greensboro, did the same in the S. H. Kress store. The local press picked up the story, and soon afterward national newspapers arrived to cover it, too. A Congress of Racial Equality (CORE) representative came from New York City to support what was now being called a "sit-in" as word of the demonstration spread and students at other colleges staged similar protests.

After six days of sit-ins, the Woolworth store closed its lunch counter, and a mass rally of students voted to suspend the sit-ins while they negotiated with city officials, college administrators, and store representatives. On February 22, the lunch counters reopened but remained segregated. Throughout the month of March, a citizens' advisory council established by the Greensboro mayor received numerous letters and resolutions from local white residents and organizations advocating desegregation. The stores, however, refused. On April 1, the students resumed the sit-ins at Woolworth and Kress and the stores again closed their lunch counters the next day. The students picketed in front of the stores while an economic boycott organized by local civil rights

leaders increased pressure on the store managers. These efforts continued, as did negotiations, throughout May and June. Finally, in late July, Woolworth and Kress desegregated their lunch counters, agreeing to serve "all properly dressed and well-behaved people."

Ezell Blair Jr., Franklin McCain, Joseph McNeil, and David Richmond—the four young black men who started the sit-in at Woolworth—did not invent this particular protest strategy. Five years earlier, on January 20, 1955, members of Baltimore's CORE and students from Morgan State College held sit-ins that lasted only a few minutes at two Read's drugstores. Within two days, the local chain of more than three dozen stores agreed to "serve all customers throughout our entire stores." In July 1958, members of the Wichita, Kansas, NAACP Youth Council embarked on a three-week sit-in at the local Dockum drugstore that resulted in the store's manager agreeing to serve black patrons, saying, "I'm losing too much money." On August 19, 1958, thirteen high school student members of the Oklahoma City NAACP Youth Council sat down at the lunch counter of Katz's drugstore and ordered Cokes. They continued this tactic for just a few days before the store desegregated its lunch counter.

In July of that year, the annual convention of the NAACP National Youth Work Committee recognized youth groups in five cities—Oklahoma City, Wichita, Louisville, Indianapolis, and Maywood, Illinois—for conducting "sit-down protests" against segregated public accommodations such as restaurants, soda fountains, and drug and department stores. The Oklahoma City group received high praise for desegregating fifty-one stores in the city. In September 1959, black and white students attending the CORE Interracial Action Institute in Miami began sit-ins at the lunch counters of two local department stores.

After two weeks of sit-ins, both stores closed their lunch counters. A few days later, the counters reopened, and the students returned, only to be attacked by local racists and arrested by the police. The stores maintained their segregated lunch counters until another wave of sit-ins resulted in their desegregation in August 1960. Utilizing advice from the Oklahoma City protesters, the women of Bennett College's chapter of the NAACP began discussing direct-action tactics to protest segregated facilities in Greensboro; news of these discussions may have reached the men at North Carolina A&T, two miles away. By the time they entered the Woolworth store on February 1, 1960, the four young men were acting on ideas widely disseminated among black students.

Their firm but nonviolent actions in Greensboro energized African American students in a way that earlier events had not. According to historian Taylor Branch, sit-ins had taken place in seventy-one cities by the end of March 1960. Within two years, tens of thousands of African Americans had participated in sit-ins at lunch counters, theaters, and other public facilities in more than one hundred twenty cities in thirteen states. Authorities arrested some three thousand participants, clogging local jails and courtrooms. Media coverage highlighted the demonstrators' nonviolent actions in the face of racist attacks and police brutality.

The proliferation of sit-ins unleashed a new generation of local civil rights leaders in communities across the South. Reverend Douglas Moore led a movement in Durham, North Carolina, and in Nashville, Reverend James Lawson launched protest campaigns and ramped up his training of young activists such as Marion Barry, Diane Nash, and John Lewis. Many black southerners eagerly endorsed strategies that produced tangible improvements in their daily lives. Sit-ins shifted attention from distant courts, city councils, and state legislatures to local businesses by focusing on chain stores and franchises. The tactic attracted moral and financial support from around the country. In solidarity, students in northern cities picketed local branches of national chains that maintained segregated facilities in the South. As a Columbia University student explained, "Injustice anywhere is everybody's concern."

INSPIRED TO LEAD Activists C. T. Vivian, Diane Nash, and Bernard Lafayette (*from left to right*) lead a march to City Hall in Nashville to confront Mayor Ben West about violence surrounding attempts to desegregate lunch counters. After days of negotiation in May 1960, they prevailed.

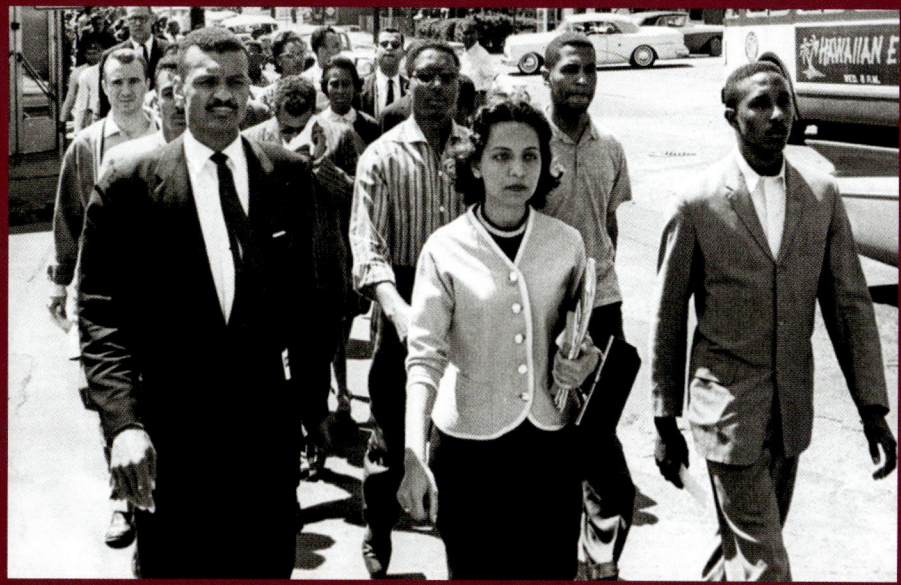

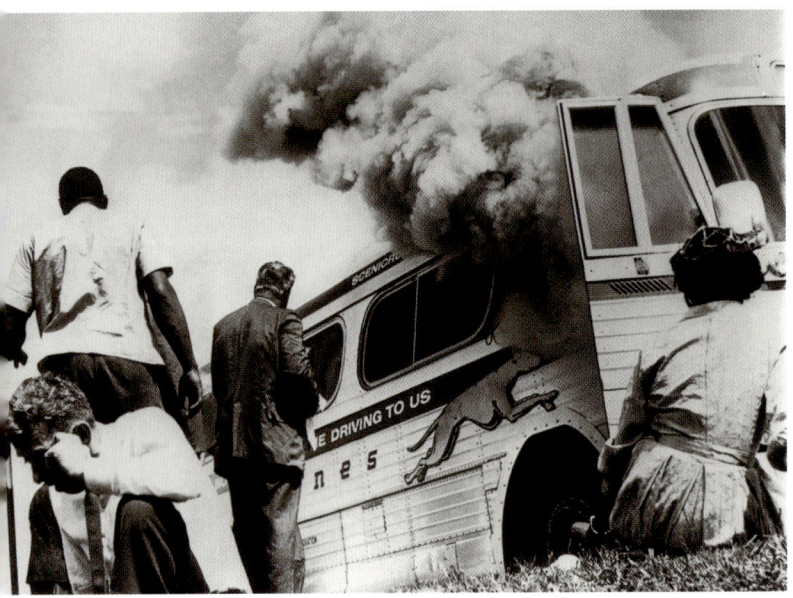

future of the movement was going to be cut short," Nash said. A week later in Montgomery, a hostile white group, armed with baseball bats and lead pipes, set upon a busload of SNCC riders. This time John Lewis, along with white rider Jim Zwerg, suffered serious injuries, and an observer sent by the White House was knocked unconscious when he tried to protect two female riders.

The vicious attacks only inspired more young people to join the protest. Scores rode to Jackson, Mississippi, where they were arrested and sent to Hinds County jail or Parchman Farm, the infamous state penitentiary known for its brutal treatment of inmates. Eventually more than three hundred Freedom Riders clogged the prison, stirring national and international outrage. At the urging of Attorney General Robert F. Kennedy, the Interstate Commerce Commission outlawed segregation in interstate travel in November 1961 and began actively enforcing the new law's violation. In a matter of months, the bravery of the Freedom Riders and the leadership of people such as Nash had helped bring down a decades-old practice of segregation.

College students also challenged segregationist policies at all-white universities. The year of the Freedom Rides, lawyers at the NAACP Legal Defense and Educational Fund, led by Constance Baker Motley, sued the University of Mississippi to admit James H. Meredith, a black Air Force veteran. Motley, who had worked on the *Brown v. Board of Education* case, successfully argued Meredith's case before the Supreme Court. Although other southern universities had admitted black undergraduates, tensions escalated at the

ON THE FRONT LINE Freedom Riders were attacked as they fled their bus when a white mob firebombed it in Alabama. Despite the dangers, the integrated bus trips increased and helped end Jim Crow practices for interstate travelers.

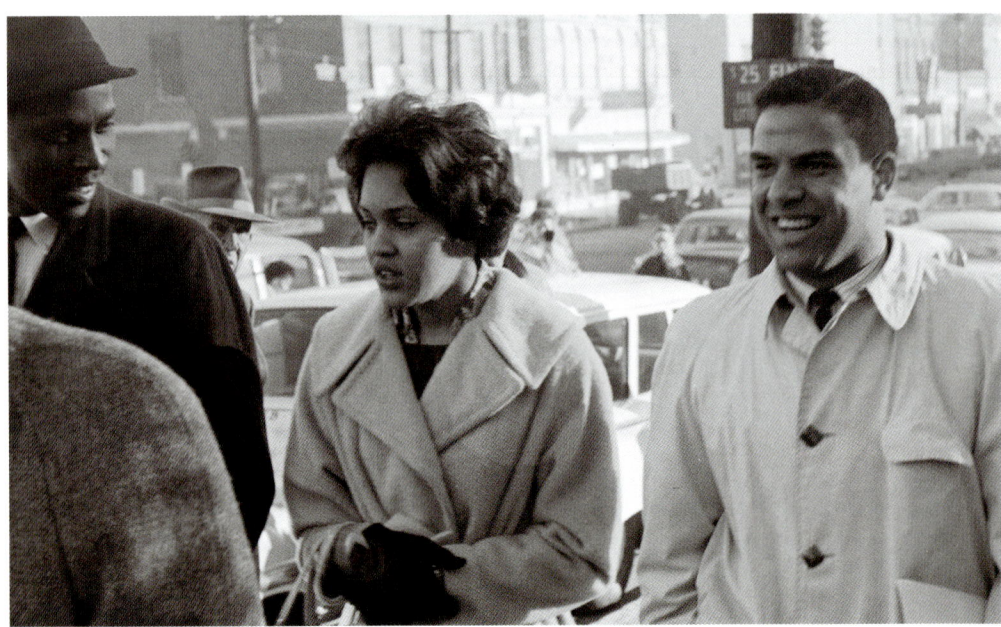

CROSSING THE COLOR LINE The first African Americans to attend the University of Georgia, Charlayne Hunter-Gault (*center*) and Hamilton Holmes (*far right*) enrolled in 1961. Vernon Jordan (*left*) was on the legal team, headed by NAACP lawyer Constance Baker Motley.

CONSTANCE BAKER MOTLEY (1921–2005)

As a lawyer for the NAACP Legal Defense and Educational Fund (LDF), Constance Baker Motley took part in nearly every major desegregation case of the civil rights era. Earning her law degree from Columbia University in 1946 while working at LDF with Chief Counsel Thurgood Marshall, Motley built a career handling high-profile school desegregation cases. She argued ten cases before the U.S. Supreme Court, winning all but one, and assisted in the landmark 1954 *Brown v. Board of Education* case. She famously won James H. Meredith the right to attend the University of Mississippi in 1962 as its first black student. Her legal work also helped end racial segregation at Clemson College in South Carolina and at universities in Florida, Georgia, and Alabama. In 1964, she became the first black woman to be elected to the New York State Senate, and in 1966 President Lyndon B. Johnson appointed her to the U.S. District Court for the Southern District of New York, making her the first black woman in the federal judiciary. In 1982, she became the first woman to serve as chief judge of the Southern District of New York.

university when the state's defiant governor, Ross Barnett, refused to allow Meredith to enroll. After pressure from the Kennedy administration and campus riots that left two people dead, Meredith was admitted, accompanied by U.S. marshals and hundreds of federal troops. It was not an easy time for Meredith, who was harassed and ostracized by the other students throughout the school year. Despite these obstacles, he graduated on schedule in 1963.

The South remained a hotbed of protest as activists worked to root out entrenched discrimination. A long and difficult campaign in Birmingham, Alabama, to desegregate downtown businesses received a boost in April 1963 when King joined local minister Fred Shuttlesworth and others to disrupt the Easter buying season and pressure local business leaders to negotiate an end to segregated lunch counters and other racist practices. The protesters picketed businesses, held sit-ins, and conducted a prayer march through downtown streets to thwart business as usual. When King and supporters disobeyed a local court order to halt the marches, they were arrested and jailed without bond. From jail, King wrote a response to local white clergy who criticized him for disrupting activities in the city. In his famous "Letter from Birmingham Jail," King eloquently explained why people of good conscience must not obey unjust laws and elucidated the logic behind civil disobedience. "Nonviolent direct action seeks to create such a crisis and foster such tension that a community which has constantly refused to negotiate is forced to confront the issue," King wrote in the margins of a copy of the *Birmingham News,* which had published the clergyman's letter. King's friends smuggled out his reply, which was reprinted in numerous publications and hailed for its thoughtful repudiation of the clergy's criticism.

A month later, in May 1963, Birmingham organizers tried a new tactic to break the grip of segregation. Recruiting schoolchildren aged six to eighteen to join the protest, they launched the Children's Crusade. Although many parents were reluctant to expose their

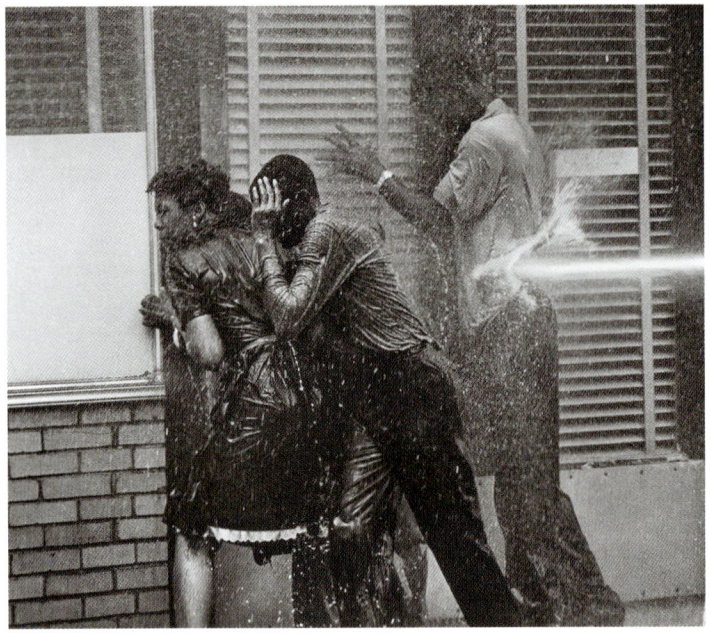

CHILDREN'S CRUSADE Blasts of water from high-pressure fire hoses (*above*) batter young demonstrators in May 1963 in Birmingham, Alabama, where brutal police tactics prompted President Kennedy to send a negotiator and federal troops to restore calm.

children to danger, they were ultimately convinced of the importance of the plan because it would attract media attention. On May 2, more than a thousand children marched to downtown Birmingham, where many were arrested. The next day, when more children joined the protest, the commissioner of public safety, Eugene "Bull" Connor, ordered police to use dogs and clubs on the marchers and instructed firemen to direct high-powered water hoses on them. The images of snarling dogs attacking children and jets of water knocking them to the ground sparked outrage and condemnation from countries around the world. Although hundreds of students packed the jails and demonstrators clogged the streets, Birmingham merchants and businessmen clung to their Jim Crow practices. President Kennedy called the impasse a local matter but dispatched Assistant Attorney General Burke Marshall to help mediate a settlement. When the campaign ended on May 10, protesters had not achieved all their demands, but they accepted a compromise. Disgruntled segregationists responded by bombing the hotel where King had stayed and the home of his brother. Because of the violence, President Kennedy stationed three thousand federal troops nearby to discourage more attacks.

From Washington, D.C., to Selma

Disorder and bloodshed were predicted in August 1963, when more than two hundred thousand people gathered in the capital for the March on Washington for Jobs and

Freedom. The culmination of months of planning by A. Philip Randolph, Bayard Rustin, Whitney Young, and Dorothy Height, the president of the National Council of Negro Women, the march rallied black and white activists to pressure Congress and the Kennedy administration to pass comprehensive civil rights legislation to end segregation and protect voting rights. The stated goals also included a demand for a federal jobs program for unemployed workers. Supporters arrived on "freedom" buses and marched to the Lincoln Memorial to listen to music, prayers, and speeches by an array of speakers, including NAACP head Roy Wilkins and Rabbi Uri Miller, president of the Synagogue Council of America. There was some controversy behind the scenes when march organizers told John Lewis, the chair of the SNCC, to remove criticism of President Kennedy from his speech, which he did reluctantly. Critics also complained that the march failed to feature a woman speaker. Overall, however, the event was a resounding success. The day went smoothly despite the fears of Kennedy and law officials. The high point of the day was Martin Luther King Jr.'s "I Have a Dream" speech, which expressed the hopes and dreams of the assembled crowd that one day Americans "will not be judged by the color of their skin but by the content of their character." It was a moment of great optimism for the Civil Rights Movement.

However, within a month, trouble was escalating again in Birmingham. The city endured two bomb blasts in early September after a federal court mandated the desegregation of Alabama schools. A third attack, on September 15, targeted Birmingham's 16th Street Baptist Church, the launching point for many of the city's marches and protests. On that Sunday morning, the bomb destroyed portions of the church, injured twenty people, and killed four young girls attending Sunday school. As news of their deaths spread, an

POWER BROKER In 1962, National Urban League (NUL) executive director Whitney Young (*center*) and NUL president Henry Steeger III (*right*) met President Kennedy to advise him on civil rights and urban issues.

MARCH ON WASHINGTON FOR JOBS AND FREEDOM
Martin Luther King Jr. (*center*) with other civil rights activists during the March on Washington in August 1963. Walter Reuther (*fourth from right*), president of the United Auto Workers, was a leading advocate of the critical role of unions in the Civil Rights Movement.

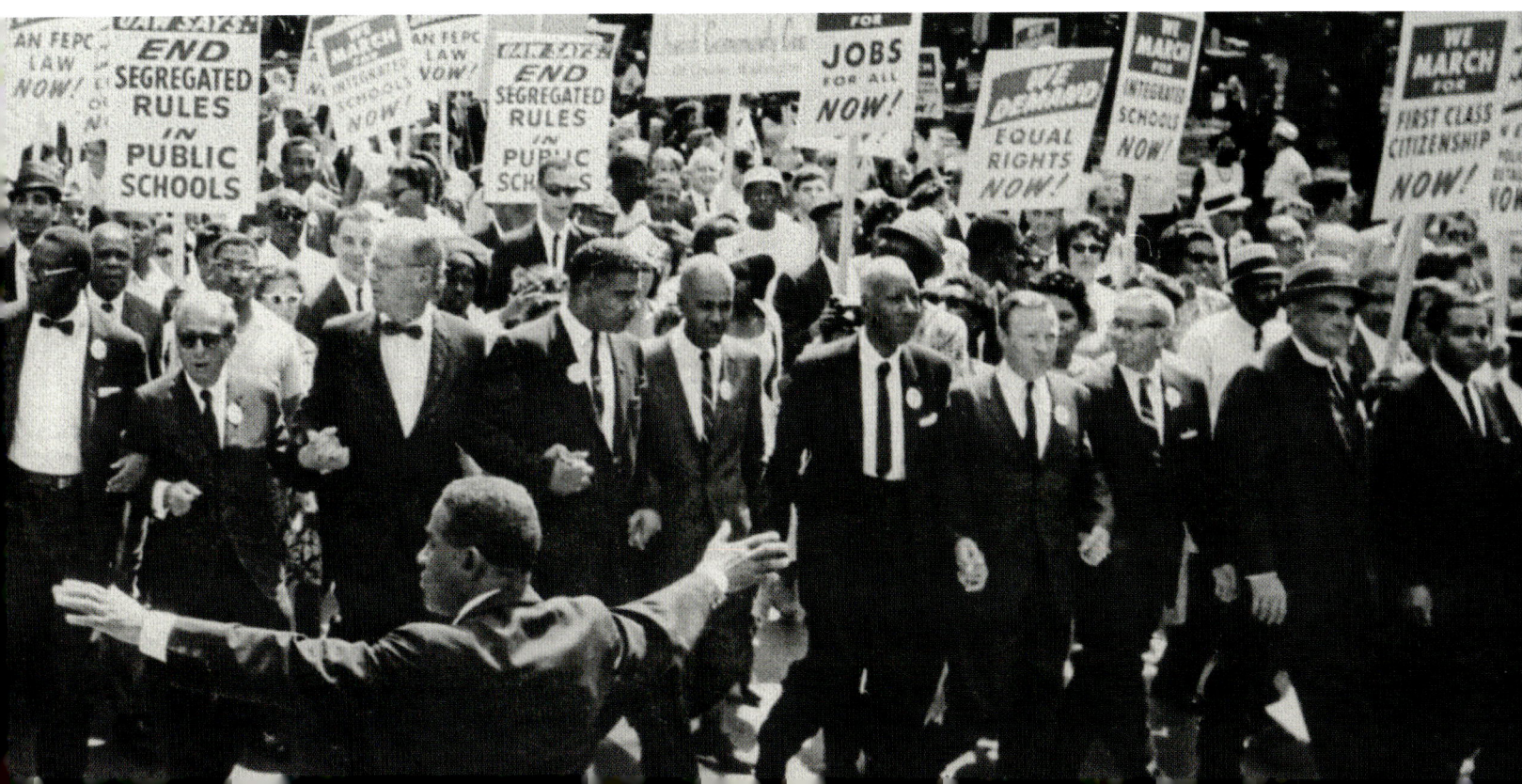

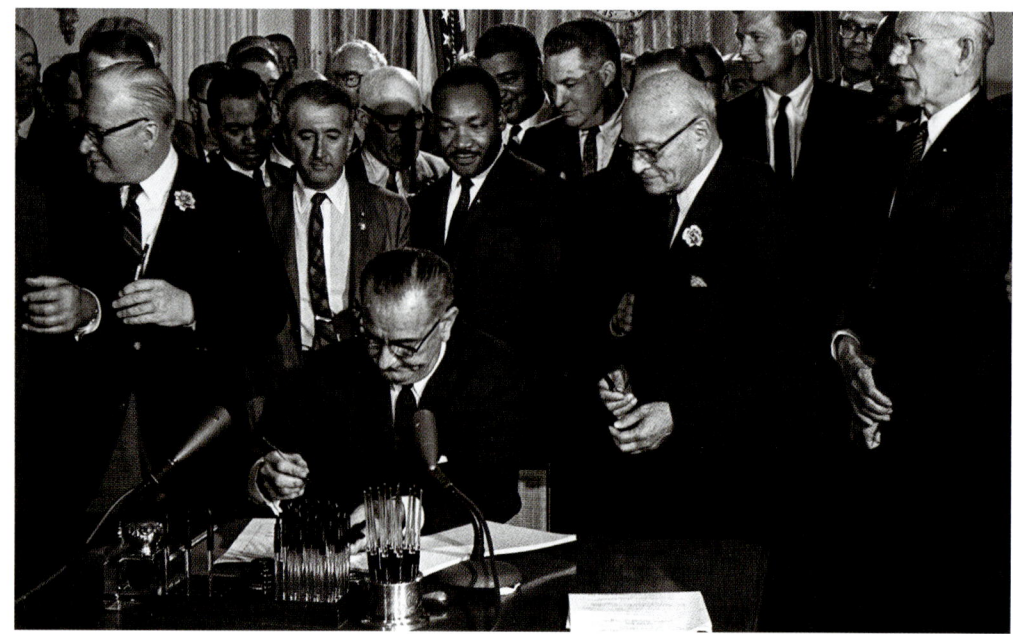

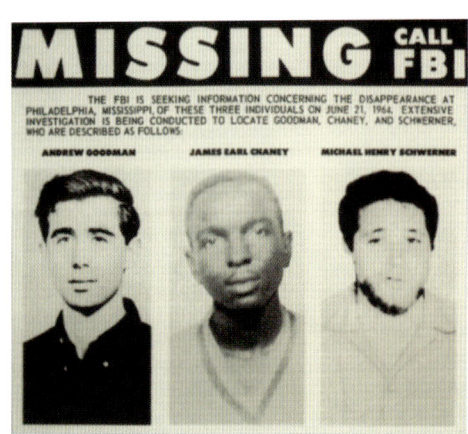

angry crowd gathered near the church. When Governor George Wallace sent state troopers to disperse it, fighting broke out, and the National Guard was called to the scene.

Rather than discouraging activists, the church bombing provoked outrage and increased national support for legislation to end segregation. With the assassination of President Kennedy in November, support grew for passage of his civil rights bill. Despite a filibuster by southern senators, his successor, Lyndon B. Johnson, was able to garner enough congressional votes to pass the Civil Rights Act. On July 2, 1964, President Johnson, in the presence of Martin Luther King Jr., Rosa Parks, and other civil rights leaders, signed the bill into law. It was landmark legislation that outlawed segregation in all public places and prohibited discrimination based on race, color, sex, or religion when hiring.

While the passage of the Civil Rights Act was a moment of triumph, the glow soon faded. A month later, authorities found the bodies of three civil rights workers who had disappeared six weeks earlier in Mississippi while participating in "Freedom Summer," a program headed by SNCC activist Robert Moses to register black voters and set up freedom schools to teach literacy and civics. James Chaney, a black Mississippian, and white New Yorkers Michael Schwerner and Andrew Goodman had been beaten, shot, and buried outside the town of Philadelphia. The crime horrified the public but did not slow the flow of volunteers into Mississippi. Nearly one thousand students volunteered and spread out across the state, encouraging black residents to register and vote in the mock election for the Mississippi Freedom Democratic Party (MFDP) and establishing health clinics and legal aid centers to provide services frequently denied African Americans in Mississippi. The workers encountered many episodes of violence and intimidation, as segregationists bombed homes and churches, beat workers, and murdered six more people.

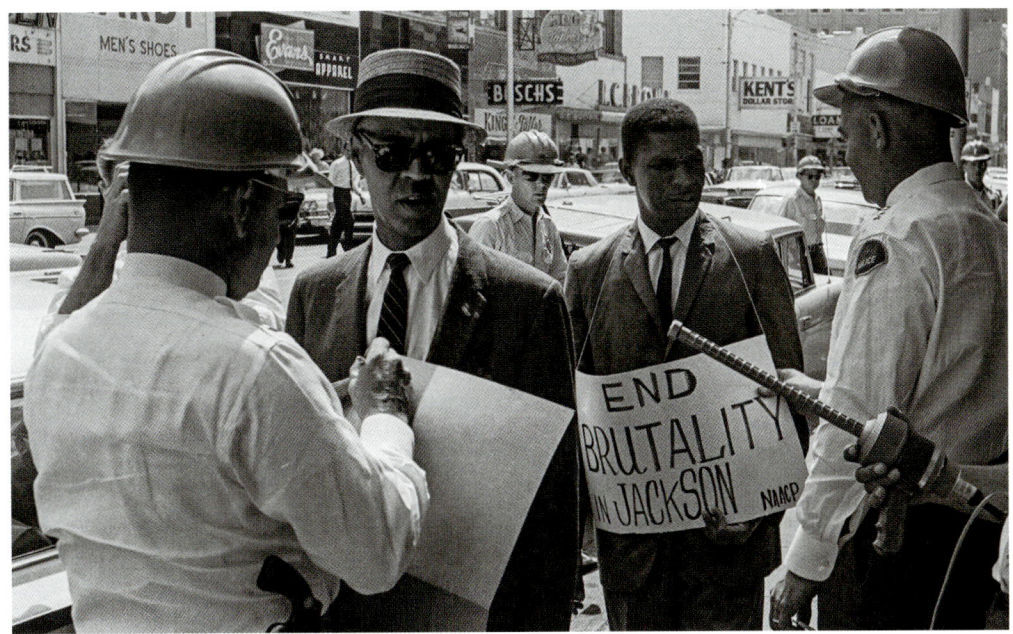

JACKSON PROTEST Mississippi police arrest NAACP officials Roy Wilkins (*center left*) and Medgar Evers (*center right*) for picketing a Woolworth store in 1963.
BIRMINGHAM GRIEVES SNCC member Dorie Ann Ladner (*below, with flag*) and other activists stand outside the 16th Street Baptist Church during the funeral of the four girls killed in the 1963 bombing.
DEMANDING A SEAT AT THE TABLE Delegates of the Mississippi Freedom Democratic Party sing outside the Democratic Convention in 1964. (*Bottom, left to right*) Emory Harris, Stokely Carmichael, Sam Block, Fannie Lou Hamer, Eleanor Holmes, and Ella Baker.

One of the goals of Freedom Summer was to elect MFDP members who would contest the seating of white Mississippi Democrats at the Democratic convention in August because African Americans had been excluded from the election process. Among the MFDP hopefuls was Fannie Lou Hamer, an activist and longtime Mississippi resident. Hamer delivered a powerful convention speech describing the brutality she and other black Mississippi residents faced for seeking their civil rights. Even though MFDP was not successful at the convention, the 1964 summer program invigorated similar endeavors in other states. However, the continued virulent racism in the South embittered many SNCC members, who began to lose faith in King's commitment to nonviolence and inter-racial cooperation.

Meanwhile SNCC, SCLC, and local activists had launched a renewed campaign to register African Americans to vote in Alabama. Although the Fifteenth Amendment granted voting rights to blacks, southern states rigorously denied that right through literacy tests, poll taxes, complicated registration requirements, and outright intimidation. In a peaceful protest against voter injustice in the town of Marion, Alabama, in February 1965, police and state troopers beat and shot twenty-six-year-old Jimmie Lee Jackson, who was trying to protect his mother as officers

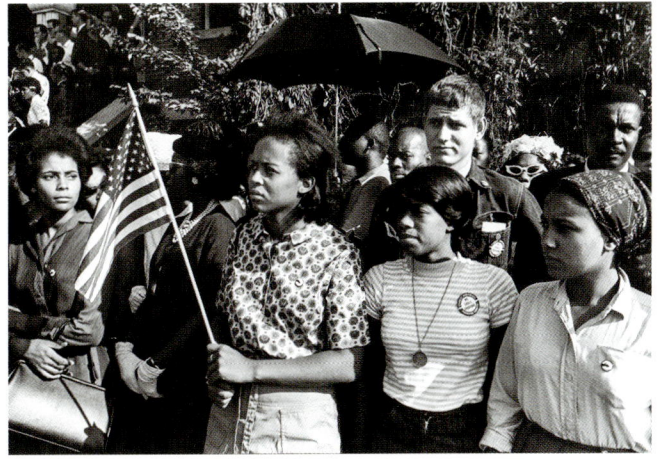

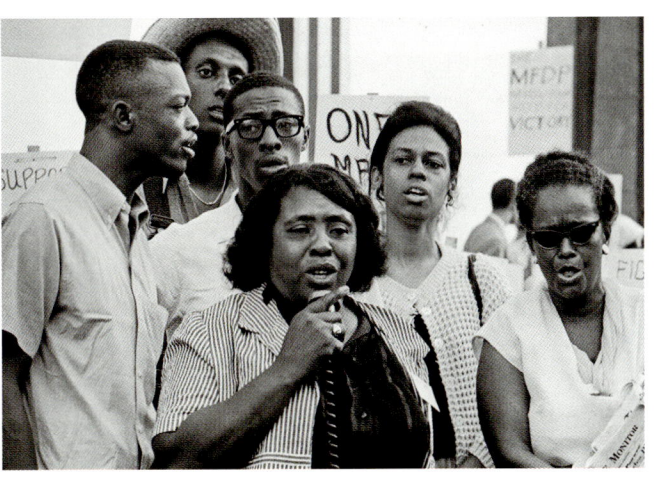

CONFRONTATION Alabama troopers order Selma marchers to disperse just before rushing them with nightsticks and bullwhips. John Lewis (*in light-colored coat*) suffered injuries. Hosea Williams stands to his right.

MEN OF RESOLVE Martin Luther King Jr. (*left*), Ralph Bunch (*center*), and Rabbi Abraham Joshua Heschel (*right*) walk together during the final march to Selma.

routed the marchers. His subsequent death prompted civil rights leaders to stage a march from Selma, Alabama, to the state capitol in Montgomery, fifty miles away, to demand voting rights. Alabama Governor George Wallace announced that he would not permit the march because "it would tie up traffic," but six hundred people gathered on Sunday, March 7. Led by SNCC's John Lewis and SCLC's Hosea Williams, the group crossed the Edmund Pettus Bridge, spanning the Alabama River. Just short of the other side of the bridge, local officers and state troopers, some mounted on horses, descended on the marchers, firing tear gas and viciously beating them with billy clubs when they refused to turn back.

"As I stepped aside from a trooper's club, I felt a blow on my arm," marcher Amelia Boynton recalled. "Another blow by a trooper, as I was gasping for breath, knocked me to the ground and there I lay, unconscious." Bloody and bruised, the marchers retreated back across the bridge, carrying the wounded with them. National and international media's films of the brutal attack prompted outrage around the world, and the assault became known as Bloody Sunday.

Refusing to bow to segregationists, civil rights leaders rallied for another march. King sent telegrams to religious leaders asking them to join him for a ministers' march. The response was overwhelming as hundreds of clergy converged on Selma. James Reeb, a white Unitarian Universalist minister from Boston, was fatally beaten on a Selma street by white supremacists. When King eulogized Reeb at a memorial service, religious leaders of diverse faiths stood by his side, including Greek Orthodox Archbishop Iakovos. At the third and successful march to

Montgomery, leading Jewish theologian Rabbi Abraham Joshua Heschel was on the front line. A federal judge limited that march, which began on March 21, to three hundred participants, but when they reached Montgomery four days later, twenty-five thousand people joined them for a triumphant rally at the state capitol.

Hardcore racists, however, orchestrated a bloody epilogue to the victory. That evening, Viola Liuzzo, a white housewife from Michigan, was shot and killed as she drove march-ers back to Selma. Three members of the Ku Klux Klan were eventually tried in 1966 and convicted for the murder. The deaths of Jackson, Liuzzo, Reeb, and others influenced the president and Congress to pass the Voting Rights Act of 1965 within months. When President Johnson signed the law in August, he called it "the most powerful instrument ever devised by man for breaking down injustice and destroying the terrible walls which imprison men because they are different from other men."

The passage of the Voting Rights Act was another significant milestone for the nonviolent Civil Rights Movement. But it did not end the struggle for justice for African Americans. Segregationists continued to resist the future that King optimistically had imagined two years earlier in his "I Have a Dream" speech, when one's char-acter would matter more than the color of his or her skin. African Americans persevered in their fight for change, but the philosophy of nonviolence and passive resistance would face increasing challenges from activists drawn to a new radical concept called Black Power under the leader-ship of longtime SNCC activist Stokely Carmichael.

HONORING THE FALLEN

Ralph Abernathy, Martin Luther King Jr. (*both lower left*), and Archbishop Iakovos (*lower right*) join clerics of many faiths at the funeral of Reverend James Reeb, who was murdered by Alabama segregationists.

JAMES REEB (1927–65)

The Reverend James Reeb was gentle and soft-spoken, but he possessed a steely commitment to social justice. A young, white Unitarian Universalist minister, in 1965 he was living and working in a poor black neighborhood in Boston when he saw a TV broadcast of police attacking peaceful demonstrators during a voting rights march on the Edmund Pettus Bridge in Selma, Alabama. In the aftermath of the incident, which became known as Bloody Sunday, Reeb answered Martin Luther King Jr.'s call for clergy to join him for another Selma-to-Montgomery march across the bridge. Reeb, age thirty-eight, joined thousands of others in Selma. But shortly after his arrival, club-wielding white segregationists viciously attacked him and two other white ministers as they left an integrated restaurant. Reeb died two days later from severe head injuries. King eulogized him as "a shining example of manhood at its best." Reeb's death and the violence of the Selma march stirred the nation's conscience and influenced President Lyndon B. Johnson to propose and push passage of the landmark Voting Rights Act of 1965, which expanded and protected the enfranchisement of racial minorities across the country.

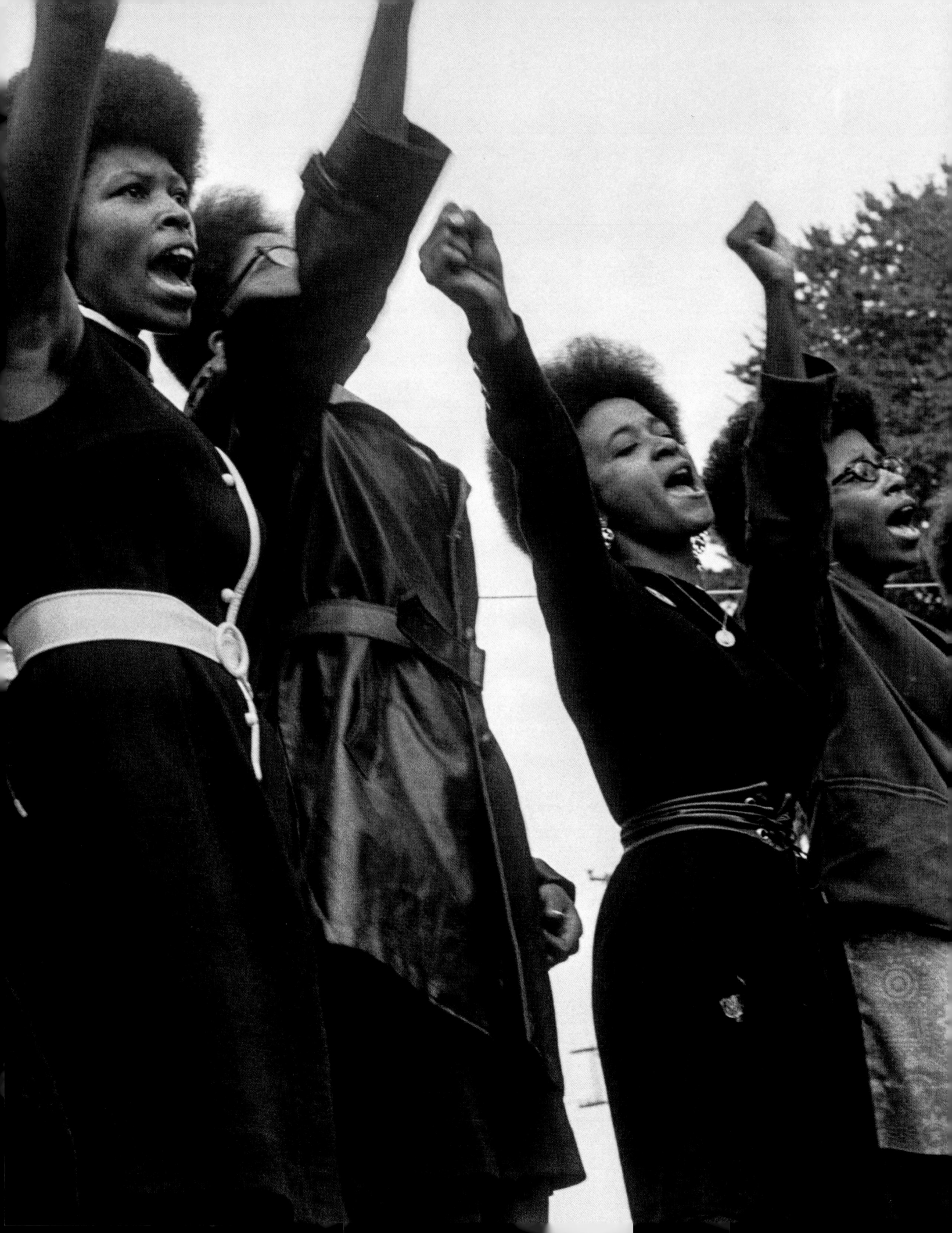

THE MODERN BLACK FREEDOM STRUGGLE: FROM BLACK POWER TO BLACK LIVES MATTER

Peniel E. Joseph

The years between 1954 and 1965 were the heroic era of the Civil Rights Movement. From the Supreme Court's historic *Brown v. Board of Education of Topeka* desegregation decision to the passage of the Voting Rights Act in 1965, this period stands out as an extraordinary decade of political activism, with its achievements unfolding in spectacularly cinematic fashion. The events of this period continue to fascinate, inspire, and sometimes confound generations of Americans and people around the world. The Civil Rights Movement has been enshrined in public memory as a moral and political good, making it difficult for many people to fully comprehend how controversial and violent the era really was. Some Americans, particularly southerners, repudiated the movement, refusing to spurn a tradition and history that allowed political power and national prosperity to rest on the exploitation and dehumanization of black people.

POWER TO THE PEOPLE

Women from the Sacramento, California, chapter of the Black Panther Party raise their fists and demand the release of Huey Newton at a Free Huey rally in Oakland in 1968. Newton, jailed for killing a police officer, became a symbol of black defiance. (*Left to right*): Delores Henderson, Joyce Lee, Joyce Means, and Paula Hill.

When African Americans rose up to fight for their own rights after helping make the world free for democracy in World War II, a sizable segment of the population recoiled and found it easier to blame communist conspiracies and outside agitators for the racial unrest sweeping the country. The movement to end racial segregation in America involved local and national activism, touching politicians and prisoners, sharecroppers and senators, rich and poor. Through nonviolent protest, African Americans and their supporters began to uproot entrenched injustice and racism. But the mid-1960s marked a change in the Civil Rights Movement, as protesters grew weary of humbling themselves for another violent clash with racist authorities.

Historians typically identify 1966 to 1975 as the Black Power era. In 1966, Stokely Carmichael, the twenty-five-year-old president of the Student Nonviolent Coordinating Committee (SNCC) began popularizing and defining the slogan. Already an activist for several years, the Howard University graduate had participated in the Freedom Rides, conducted voter registration drives in the Mississippi Delta, and helped independent black candidates run for office in Lowndes County, Alabama. Carmichael unleashed the phrase "black power" during a demonstration in Greenwood, Mississippi, on June 16, 1966, days after James H. Meredith, the first African American to enter the University of Mississippi, was shot and wounded. Carmichael's call for black power came soon after his own arrest, the twenty-seventh by his count, for trying to raise a tent on public school property where marchers could sleep overnight.

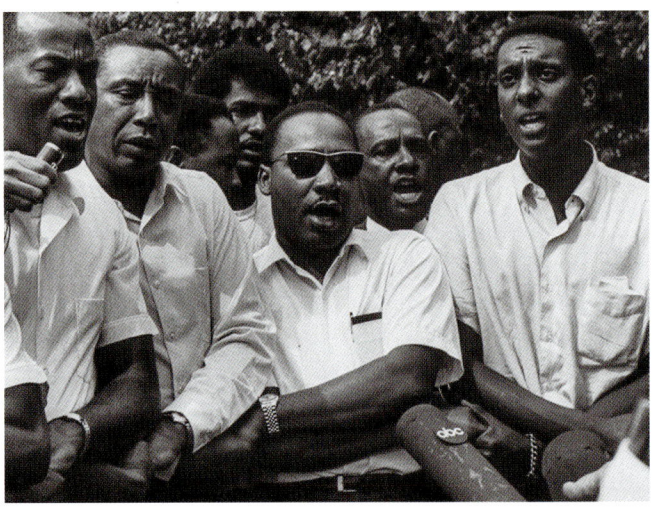

COMMON CAUSE Civil rights leaders lock arms at a voter registration march in 1966. *Left to right*: Unidentified, Floyd McKissick, unidentified, Cleveland Sellers, Martin Luther King Jr., unidentified, and Stokely Carmichael.

Released on a warm Mississippi evening, Carmichael addressed a crowd of six hundred and challenged them to embrace radical political self-determination as part of a larger vision of political transformation. "All we've been doing is begging the federal government," Carmichael told the protesters. "The only thing we can do is take over." Rallying the crowd, he shouted, "We want Black Power!"

Carmichael's black power cry reverberated from the Mississippi Delta to the big cities on both coasts. The concept roiled the nation, ratcheting up a new race controversy from which mainstream civil rights leaders tried to distance themselves. Critics

"When you talk about black power you talk about bringing this country to its knees any time it messes with the black man."
—STOKELY CARMICHAEL, civil rights leader, 1966

portrayed black power as the Civil Rights Movement's evil side that threatened to destroy years of painstaking social and political reform. Younger militants, however, gravitated toward the philosophy, which imagined a new American and global political and cultural landscape, in which black people would define themselves through their own art, politics, and culture.

Martin Luther King Jr. disagreed with the use of the term *black power,* but not with the advocacy of black pride and self-determination. King and Carmichael became unlikely personal friends even as they sharply diverged on the role of violence in the movement. They found common ground in a shared critique of the Vietnam War. In fact, Carmichael's energetic and controversial antiwar posture, including popularizing the slogan "Hell No, We Won't Go!" later influenced King's own decision to speak out against the war.

Carmichael became the Black Power Movement's rock star: handsome, charismatic, intelligent, and brash. Throughout 1966, he toured college campuses, made frequent national television and radio appearances, and became the subject of endless newspaper and magazine stories that debated the black power controversy. Carmichael delivered perhaps his most important speech on October 29 of that year at the University of California, Berkeley. Speaking to more than ten thousand predominantly white students, Carmichael presented black power as a call to reimagine American democracy, calling out white privilege and white supremacy as the nation's primary stumbling blocks to achieving racial and economic justice. The speech knitted together black power and antiwar activism as part of a larger struggle against American imperialism. "A new society must be born," Carmichael proclaimed. "Racism must die."

SINGULAR VOICE In the 1960s, H. Rap Brown served as chairman of SNCC and acted as a liaison to the Black Panther Party.

His radical activism drew the attention of local and national intelligence agencies. He soon found himself, like King, under round-the-clock surveillance from the FBI, White House, State Department, and a web of law enforcement agencies. He joined forces with King on April 15, 1967, in New York City to headline a massive antiwar rally that attracted some four hundred thousand protesters. King's participation, on the heels of his controversial antiwar speech at New York City's Riverside Church, led some critics to argue that he was now following Carmichael's lead. Reverberations of the Black Power Movement became global in scope, with hundreds of politicians and poets, scholars and students, and prisoners and preachers advocating radical political self-determination.

A few months after Carmichael's 1966 speech, California college students Huey P. Newton and Bobby Seale founded the Black Panther Party for Self-Defense (BPP). Drawing inspiration from the concept of black power and Carmichael's grassroots activism in Alabama, they adopted the panther symbol of Alabama's Lowndes County Freedom Organization, which ran independent candidates in local elections that November. The Black Panther Party and black power philosophy radicalized the American political landscape, hastening calls for radical change and progressive politics. The Panthers drafted a ten-point program that

POWER COUPLE With a poster of Huey P. Newton behind them, Kathleen and Eldridge Cleaver pose in 1970 while living in exile in Algeria. They had been prominent leaders in the Black Panther Party.

WOMEN UNITE Protesting the imprisonment of six Black Panther women, including Elaine Brown, this poster was jointly issued by the Black Panther Party of Connecticut and the N.E. Women's Liberation group.

called for ending police brutality, freeing black prisoners, institutionalizing black history, and providing "land, peace, bread, and justice" for African Americans, a platform influenced by the teachings of Carmichael, Malcolm X, and radical intellectual Frantz Fanon. The group's call for a socialist revolution was underscored by its paramilitary style, which featured black men and women wearing leather jackets and berets and brandishing guns.

The BPP was arguably the most intrepid and revolutionary of the groups espousing the black power philosophy. Although controversial and feared by many, it attracted thousands of supporters, especially in the aftermath of cofounder Newton's arrest for murdering a police officer. Newton, who was shot and injured in the encounter with two police officers in October 1967, proclaimed his innocence, as did his supporters, which included ex-prisoner-turned-writer Eldridge Cleaver and his wife, former SNCC activist Kathleen Cleaver. By 1968, thousands of black Americans flocked to join the Panthers, attracted by both its symbolism and substance. The group was daring, at times reckless, displaying bravado and courage by patrolling the police in Oakland, California, and surrounding neighborhoods while legally armed. Supporters discovered truth and meaning in the group's expansive critique of racial and economic oppression.

Although radical politics defined the Black Panthers, the organization was committed to immediately improving the lives of African Americans through a raft of social initiatives. Members organized community programs that offered free breakfasts, healthcare, and legal aid in poor black communities. Black women such as Erika Huggins and Kathleen Cleaver played major roles in developing Panther programs. Huggins organized and led the New Haven, Connecticut, chapter of the BPP and later served as director of the Oakland Community School, the Panthers' liberation school for African American children. By the early 1970s, the number of women Panthers exceeded that of men, and issues such as birth control, childcare, health clinics, and education became key components of the organization's platform, which elevated the image of the BPP in the African American community. Kathleen Cleaver, probably the most prominent woman in the organization, helped her husband write and edit the *Black Panther* newspaper and officially held the position of communications secretary and spokesperson.

As the Black Power Movement led to an increased commitment to the welfare of fellow African Americans, it also inspired a cultural movement that heightened black people's sense of their own aesthetic. Carmichael's assertion that "black is beautiful" became the hallmark of a national black pride movement that influenced popular culture, music, television, movies, and journalism. In this

climate, the Black Arts Movement was born. Its primary promoter, poet and playwright Amiri Baraka (formerly LeRoi Jones), encouraged African Americans to look to their own culture, not that of whites, for beauty and validation. Baraka pointed to Malcolm X, who was assassinated in 1965, as an example of a black man who had found his African identity through his odyssey of prison, politics, and religion. Malcolm's quest became a generational touchstone for the poets, writers, artists, and activists of the Black Arts Movement. Baraka helped spark a national and global Pan-Africanism Movement not seen since the heyday of Marcus Garvey. Maulana Karenga, head of the Los Angeles–based Organization Us, developed Kawaida, a philosophy that offered black Americans a way to reclaim their African identity while living in America. The group's most lasting contribution would be Kwanzaa, a holiday celebration that connects black Americans to African traditions and values. Black power often rejected western conceptions of art, beauty, and politics. The movement shifted educational curricula, inspired African-centered independent schools and think tanks, and promoted images of black strength and intelligence.

Seeking a middle ground between black power stridency and "timid supplication for justice," King began what would be his last crusade, the Poor People's Campaign, in 1968. He called for a massive demonstration to "confront the power structure" in Washington and demand national antipoverty legislation that guaranteed income, affordable housing, and decent healthcare, not only for blacks but for all Americans mired in poverty. When King was assassinated on April 4, 1968, a few weeks before the planned march, civil unrest and riots broke out in more than a hundred cities in twenty-nine states, resulting in more than $45 million in damages. The upheavals came on the heels of devastating riots in Newark and Detroit in the summer of 1967 and marked the sixth consecutive summer of unrest since Birmingham, Alabama, in 1963. The Kerner Report, commissioned by President Lyndon B. Johnson and published just weeks before King's death, blamed institutional racism and economic inequality as the root causes of the 1967 riots. King's death seemed to quicken the pulse of black power activists. Talk of racial confrontation and violence increased alongside efforts to bring political and social self-determination to African American communities.

NEW CONSCIOUSNESS By emphasizing self-determination, self-respect, and self-defense, Malcolm X embodied the essence of a modern black revolutionary strategist. His ideas continued to influence activists for decades after his assassination in 1965.

"When and Where I Enter"

Another political phenomenon that evolved during the black activism of the 1970s was black feminism. The Third World Women's Alliance (TWWA) combined black power rhetoric with radical feminist and socialist politics to combat the triple oppression of race, class, and gender. Frances Beal, a former SNCC activist and TWWA leader, emerged as a key black feminist activist and thinker. Her 1970 essay "Double Jeopardy: To Be Black and Female" became a theoretical pivot, linking nineteenth-century

SHANTYTOWN During Martin Luther King Jr.'s Poor People's Campaign in 1968, protesters petitioned federal agencies while living in a tent and shack settlement erected on the National Mall in view of the Washington Monument (*left*).

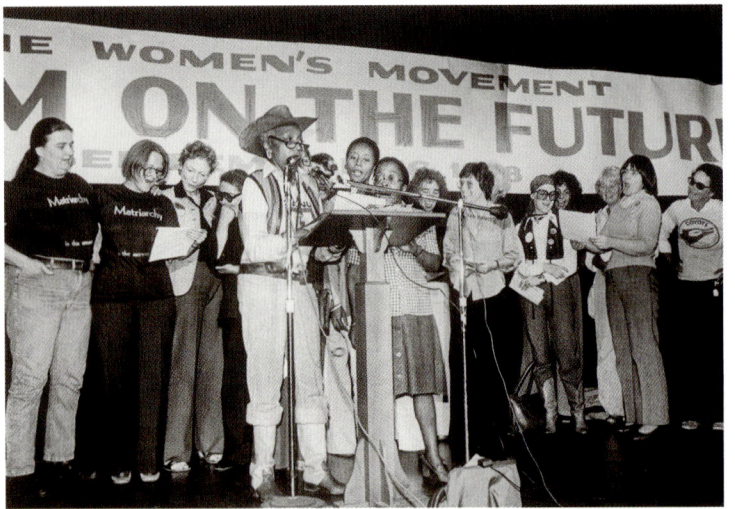

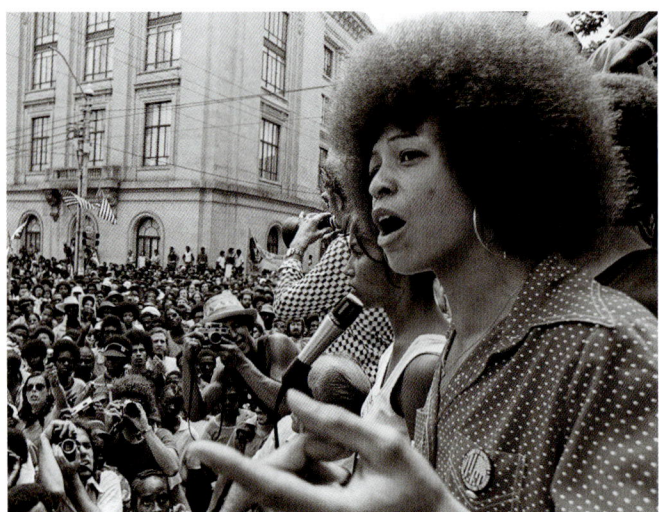

SOLIDARITY Lawyer-activist Florynce Kennedy (*above, left, in hat*), here at a feminist rally with Barbara Love, Ti-Grace Atkinson, and Kate Millet to her right, merged the struggles of feminism and black power in the 1970s. Angela Davis (*above, right*) speaks at a rally in North Carolina in 1974.

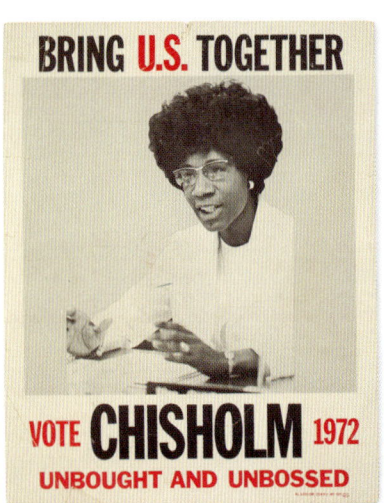

LEADING THE WAY A 1972 poster marks Shirley Chisholm's historic run for the Democratic Party's presidential nomination. She was also the first black woman elected to Congress.

black women activists such as Ida B. Wells and Anna Julia Cooper with the activism of modern-day women such as Angela Davis. Writer Toni Cade Bambara's anthology *The Black Woman,* a 1970s collection of scholarly essays and stories by Alice Walker, Nikki Giovanni, and others, signaled the rise of black feminism as a serious academic field. Through dramatic poems and plays, Ntozake Shange also added her voice to the discussion of black feminism.

The literal face of radical black power and radical feminism was Angela Davis, a black scholar and Communist active in the prisoner rights movement in California. She appeared on ubiquitous posters, her huge Afro hairstyle framing her face like a halo. Davis was jailed for nearly two years on charges of conspiracy, kidnapping, and murder in connection with a shootout before eventually being acquitted. Many white feminists refused to connect Davis's radicalism with their own quest for gender equality, but black feminists viewed her as a kindred spirit. Meanwhile, with a very different style, Congresswoman Shirley Chisholm was in the vanguard of the gender equality movement. Her 1972 run for the Democratic Party's nomination for president—the first African American to seek the office—reflected the bold political ambitions of black women.

Black feminist groups often reached out to black women who were marginalized by white liberals or black organizations. Radical groups such as the Combahee River Collective and Third World Women's Alliance aimed to place women as leaders, strategists, and architects of a new America liberated from sexism and racism. The National Black Feminist Organization pushed organizations such as the National Organization for Women and the Democratic Party to be more inclusive of issues that impacted black women. Even black women who may have rejected the label "feminist" manifested black power by organizing anti-poverty and tenants' rights groups in cities across the country.

The Rise of Electoral Politics

By 1975, revolutionary groups, most notably the Black Panthers, declined in an atmosphere of political infighting and FBI surveillance and harassment. Local and national law

enforcement's pressures on black militants in the first half of the 1970s contributed to the Black Panthers' evolution from overt radical revolution to community political reform. Many key black power activists found themselves imprisoned or living in exile. Eldridge Cleaver fled to Cuba in 1968 to avoid jail. After an honorary position with the Black Panthers, Stokely Carmichael left the United States in 1969 and spent the rest of his life in Guinea. There he formed the All-African People's Revolutionary Party and took the name Kwame Ture in honor of the president of Ghana, Kwame Nkrumah, and Sékou Touré, president of Guinea. FBI scrutiny and assassinations stifled the growth and spread of the black radicalism of groups such as BPP, but some wounds were self-inflicted. The ideological diversity of the 1960s, broad enough to allow moderates and militants to work together at times, atrophied into a search for a magical cure to racial and economic oppression. The search for the "correct" ideology capable of dismantling capitalism and racial oppression often blinded militants from more practical grassroots strategies. Black nationalists, Pan-Africanists, Marxists, liberals, and conservatives all vied for influence at the expense of a larger political solidarity. National crises, such as the Vietnam War and industrial decline, dimmed the prospects for massive domestic spending on urban renewal, anti-poverty, and employment programs.

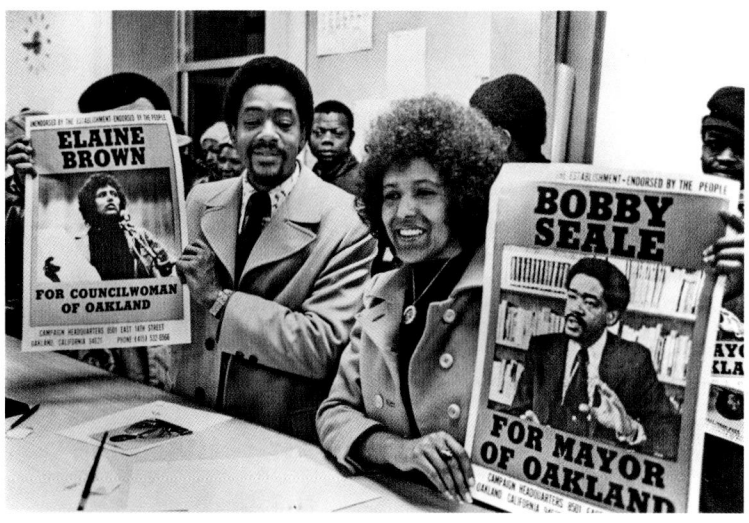

POLITICAL CONTESTS Black Panthers Bobby Seale (*above, left*) and Elaine Brown (*right*) ran unsuccessfully for mayor and city council of Oakland, California, in 1973. Mayor Richard Hatcher (*below*) is shown in 1972 with the Reverend Jesse Jackson and Amiri Baraka (*at left*) at the Gary Convention.

Even though some African Americans had become impatient with King's nonviolent strategy by the mid-1960s, they could not deny that black people had made tremendous progress in the previous decade and continued an upward course on several fronts. For instance, the effectiveness of the Voting Rights Act of 1965 could be seen in the dramatic growth of black elected officials by the early 1970s. The number of African Americans in Congress increased from seven in 1967 to ten in 1969, fourteen in 1971, and eighteen in 1975.

The 1960s also heralded the era of African Americans being elected mayors of several prominent cities, albeit just as these once-proud industrial cities were crumbling. Richard Hatcher, who was elected the first black mayor of Gary, Indiana, in 1967, became one of the era's most charismatic and progressive African American political leaders. Hatcher embraced black nationalism and progressive politics, welcoming the National Black Political Convention (dubbed the Gary Convention) in March 1972 with a city festooned in the Pan-African colors of red, black, and green. In contrast to Hatcher, Carl Stokes, who was elected mayor of Cleveland the same year that Hatcher won Gary, adopted a more cautious

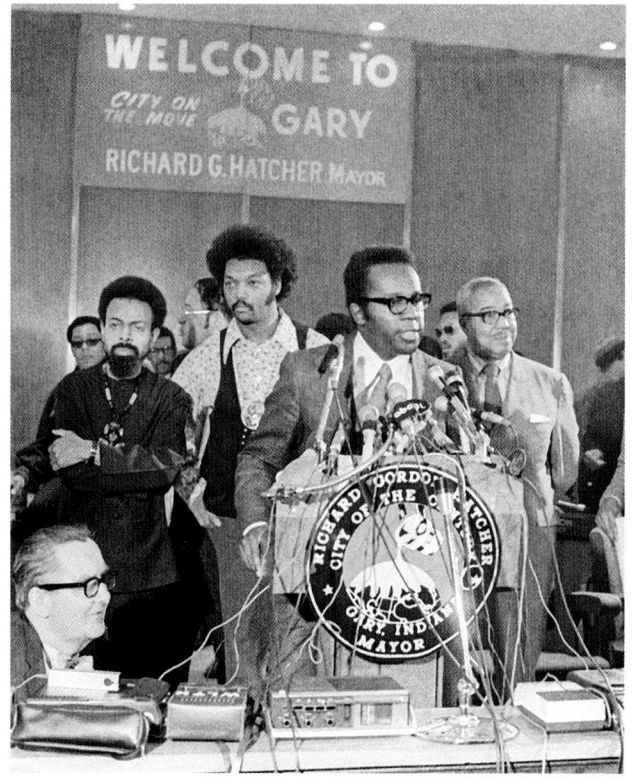

approach. In Stokes's effort to maintain white support while including African Americans in Cleveland's political infrastructure, he even refused to appear with Martin Luther King Jr., who had campaigned for him, wary that some whites considered the civil rights leader a subversive race-baiter.

Newark, New Jersey's Kenneth Gibson rode a wave of black militancy, including support from Amiri Baraka, into office in 1970 before breaking with radical supporters to join the Democratic Party's political machine. Atlanta's Maynard Jackson took strong steps to include African Americans in the political structure of Atlanta even as he angered many by dismissing striking black garbage workers during his first term.

Marion Barry, a former activist and SNCC chairman elected mayor of Washington, D.C., in 1978, proved to be the most controversial black mayor in America. Barry's unabashed progressive politics, flamboyant personal style, and unapologetic black nationalism made him a hero to African American residents of the nation's capital. Politically, Barry opened the door of the city hall to black businesses and entrepreneurs through an aggressive affirmative action program that white critics interpreted as reverse racism. Barry's personal demons, absenteeism, and drug abuse culminated in his being arrested in an FBI sting operation that secretly videotaped him smoking crack cocaine. Miraculously, after serving a prison sentence, Barry was elected to a fourth term in 1994.

Although militant revolutionary activism declined in the 1980s, African Americans continued to make steady political progress at the local and national levels. Harold Washington's successful 1983 election as Chicago's first black mayor updated organizing strategies honed in the 1960s. Washington's campaign took a page from the Civil Rights Movement by building a grassroots voting registration movement. Speaking openly about how his victory would specifically help poor black people in the city, he solidified the

MAYNARD JACKSON (1938–2003)

A large man with an outsized personality to match his build, Maynard Jackson Jr. was the first African American mayor of Atlanta, and at thirty-five, the youngest mayor of a major American city. A lawyer, he quickly rose to national prominence while serving three terms, from 1974 through 1994. Under his leadership, the city's multiracial urban core came to exemplify an enlightened "New South" and proof of the power of the southern black vote. Although a descendant of generations of Baptist ministers, Jackson symbolized an emerging class of black leaders rooted in political and corporate worlds. Chief among his accomplishments is the modernization of Atlanta's airport in the 1970s, a $500 million project that included minority contractors for major public works projects, signifying a new kind of economic black power. After Jackson's death, the airport was renamed Hartsfield-Jackson Atlanta International Airport in his honor.

Atlanta became a gleaming city of progress under Jackson and a beacon for a stream of aspiring African Americans seeking business opportunities that Jackson created. After leaving office, he established several civil and business organizations and founded a black investment banking firm.

black vote and, with support from white liberals, bested his two white opponents in the Democratic primary. Winning the primary was tantamount to winning the mayoral race. A few years later, New York City elected its first and only black mayor. David N. Dinkins, a longtime Democratic political operative, was elected to the office in 1990. His single term was marked by racial tensions in Brooklyn, vocal police dissatisfaction that bordered on racism, and disappointment among the city's African American community. Dinkins lost reelection to Republican Rudy Giuliani in a city where Democrats outnumbered Republicans five to one.

Promise and Peril

As legal segregation died a slow death, numerous cities, including many headed by black mayors, slid further into poverty and decay. Most whites—and some blacks—fled to the suburbs, creating a dramatic gulf in life opportunities between blacks and whites. During the second half of the 1970s, black Americans found themselves increasingly on the defensive, trying to preserve policy victories such as affirmative action practices, which encountered a variety of legal challenges and racial backlash. The 1980 presidential election of former California Governor Ronald Reagan signaled the ascendancy of a conservative counterrevolution to the dreams of black activists from the civil rights and black power eras. Reagan's appointment of black conservatives to the Justice Department, federal courts, and the Supreme Court made the enforcement of civil rights laws more difficult. The new president's ambitious tax cuts shortchanged the federal government's anti-poverty efforts and funds to aid urban centers with increasingly large black populations. Finally, the Reagan administration's anticrime policies helped further the criminalization of black men and contributed to the rise of mass incarceration.

Among the presidential hopefuls who challenged Reagan after his first term in office was black civil rights activist Jesse Jackson, who mounted a historic campaign for the Democratic Party presidential nomination in 1984 and again in 1988. Jackson, perhaps more than any single civil rights leader of his era, claimed King's mantle as the most significant black leader of his generation. Jackson's Rainbow Coalition sought to use a diverse progressive coalition that included black, white, rich, and poor, Hispanic, women, gay, young, old, and others to launch his bid to become the nation's first black president. Jackson garnered 18 and 21 percent of Democratic Party primary votes in 1984 and 1988, respectively, by injecting a spirit of radical democracy, anti-poverty, and hope into an often exclusionary political process. Most important, Jackson's campaigns helped change Democratic Party primary rules from winner-take-all to proportional representation, which years later helped black Illinois Senator Barack Obama become president. Jackson's alliance with Ron Brown, a savvy negotiator who managed Jackson's campaign at the 1988 Democratic Convention, led to Brown's becoming the first black chairman of the Democratic National Committee.

While Jackson reinvigorated black activism through two audacious presidential campaigns, a black legal scholar and veteran civil rights lawyer introduced groundbreaking concepts that illuminated the racial contours of American law. During the 1980s, Derrick

HISTORIC RUN A campaign poster encourages voters to support activist Jesse Jackson for the 1984 Democratic Party's presidential nomination. Jackson, the second African American to run for the presidency, won about 20 percent of the primary vote.

CRITICAL RACE THEORY Law professor Kimberlé Crenshaw is a leading scholar in this progressive school of legal thought that examines the links between race and law to better understand racial injustice.

Bell, a civil rights lawyer, professor, and author, helped pioneer the development of Critical Race Theory (CRT), a new interdisciplinary school of legal theory that argued that race and racism were integral, even if largely unrecognized, aspects of American jurisprudence. Espoused by several legal scholars, most notably Patricia Williams, Kimberlé Crenshaw, Richard Delgado, and Ian Hanley-López, CRT challenged the conventional principles of law schools and legal experts, prodding them to acknowledge racism's intrinsic impact on American law, which marginalized African Americans and people of color. The study and debate of the theory and the publication of books and articles on the issue helped transform legal thinking in the United States. By the twenty-first century, CRT was being taught in major law schools, revealing to a new generation of legal scholars what black civil rights activists already knew: Race shapes America's legal systems in a manner that disadvantages communities of color in terms of sentencing, parole, probation, arrests, and access to legal counsel.

Even as experts applied CRT to the legal system and black politicians won more elections, some black communities continued devolving to a new nadir of crises. A crack cocaine epidemic ravaged many black neighborhoods that were already suffering from police brutality, dilapidated housing, declining schools, and incarceration. From the cauldron of racial and economic woes emerged voices of the disaffected youth of the hip-hop culture. What had begun as party music in the 1970s turned into political and social commentary on the poverty and violence of American society. Millions of white consumers eagerly embraced the beats and narratives of inner-city African American life, which were often defiant and nihilistic.

Black life in the 1990s ran along parallel lines of triumph and tragedy, as was exemplified in the presidency of Bill Clinton. After twelve years of Republican presidents, Clinton's 1992 election offered hope to African Americans, who robustly supported him at the polls. Clinton increased the number of senior and midlevel black cabinet and administration appointees and cultivated strong relationships with the Congressional Black Caucus and venerated civil rights icons such as Congressman John Lewis and the historian John Hope Franklin. However, Clinton's ease around black people and his admiration of civil rights leaders were juxtaposed with policy measures that significantly harmed poor blacks. His 1996 Welfare Reform Act, bipartisan legislation passed in a Republican-controlled Congress, disproportionately hurt single black mothers heading poor households by cutting off guaranteed welfare benefits without providing the employment opportunities, education, and childcare resources necessary to combat poverty successfully.

If welfare reform injured the poor, the 1994 Omnibus Crime Bill helped engineer a catastrophe by dramatically increasing the mass incarceration of black men. The bill's harsh sentencing of nonviolent drug offenders and zero tolerance toward drug users helped usher in a new era of unequal imprisonment that legal scholar Michelle Alexander has characterized as the "New Jim Crow."

The crime and welfare bills worked in tandem to marginalize poor African Americans. Even nonviolent drug offenders found themselves cut off from welfare benefits for ever, curtailing their efforts to find employment, housing, and healthcare and to reunite with

families. Meanwhile, a scourge of antiblack police violence brought national attention to issues of race and police brutality, especially during the aftermath of New York City police officers' assault and sadistic torture of Haitian immigrant Abner Louima in 1997 and the death by multiple shooting of Guinean immigrant Amadou Diallo in 1999. Both cases clearly demonstrate that police brutality against unarmed black suspects had a long history before recent twenty-first-century incidents caught on video helped incite a national movement.

Although the 1990s wreaked tragedy and chaos on the lives of many black people, others prospered substantially. Increasingly, more African Americans had joined the ranks of the middle class through economic advancement, improved housing, and college educations. The percentage of black males who had completed college rose from 11.1 percent in 1990 to 13.2 percent in 2000, and to 15.8 percent in 2010. African American unemployment rates fell from 14.2 percent in 1992 to 7.6 percent in 2000. By 2007, there were seven black CEOs of Fortune 500 companies, the most in American history.

A FAMILY'S GRIEF The parents of Guinean Amadou Diallo, killed by forty-one police bullets in 1999, arrive at Albany County Courthouse, New York, with Reverend Al Sharpton (*far left*). The officers charged with the murder were acquitted.

The Struggle Continues

Topping off black achievements during the early years of the new millennium was Barack Obama's meteoric rise from community organizer to Illinois state senator to U.S. senator to the White House—a watershed in African American progress in U.S. history. Obama's improbable 2008 presidential election faced extraordinary obstacles that included upstaging seasoned and well-known Democratic Party primary frontrunner Hillary Clinton, doubts about whether Obama's upbringing (as a biracial child reared by his white family) would hamper his ability to relate to the historic African American experience, and questions regarding the American electorate's willingness to vote for a black candidate. Obama's insurgent presidential campaign, which touted ideals of hope and change as its mantra, built upon and amplified Jesse Jackson's Rainbow Coalition of the 1980s. As Obama told cheering crowds during the presidential campaign in 2008: "Change will not come if we wait for some other person, or if we wait for some other time. We are the ones we've been waiting for."

Obama's life story resonated with many Americans striving for a better life. He is a strong family man with two daughters, yet grew up without his father and managed to attend Ivy League schools and earn a law degree. His candid best-selling memoirs *Dreams from My Father* and *The Audacity of Hope,* which laid out his political vision of the American dream, revealed great depth and freshness of thought on issues of racial equality, identity, and citizenship. Aided by the telegenic presence of his wife, Michelle (a graduate of Princeton and Harvard), and their daughters, Sasha and Malia, Obama's platform and charisma captured the attention of millions of Americans, especially African Americans. During the primary and election season, Obama inspired not just a campaign but a movement. Americans projected onto the young, energetic candidate their hopes and

YES WE CAN *Hope,* Shepard Fairey's 2008 portrait of Barack Obama, captured the optimism inspired by his campaign. Obama won more votes than any candidate in America's history.

dreams for another New Deal in American politics, one that included calls for racial and economic justice, echoing the civil rights era. His election marked the first time a Democratic presidential candidate had won more than half of the popular vote since Lyndon B. Johnson in 1964.

The victory, which was celebrated around the world as a sign of human progress, triggered enthusiasm and racial rapprochement that bordered on hysteria. Journalists and media pundits interpreted Obama's win as the beginning of a "postracial" America, in which individual excellence had finally defeated ancient prejudice. Both liberals and conservatives basked in the victory over institutional racism that Obama's election seemed to represent.

As Obama neared the end of his two-term presidency, there were many accomplishments to note. These included creating the Affordable Care Act, winding down wars in Iraq and Afghanistan, signing executive orders to protect millions of undocumented workers and families, normalizing relations between the United States and Cuba, negotiating a historic nuclear deal with Iran, steering the nation out of an economic recession, and ending high unemployment, all the while sparring with an adversarial Republican majority in Congress.

Like most presidents, Obama polled high or low depending on the issues of the day, but the numbers associated with his reelection in 2012 were significant, especially among African Americans. For the first time in American history, black voter turnout, according to census data, surpassed that of whites, 66 percent to 64 percent. In addition, nearly two million more African Americans voted in the 2012 election than in 2008. The exit polls illustrated the enduring nature of the multiracial coalition that had catapulted Obama to the presidency in 2008, with racial minorities making up 28 percent of voters, the largest such turnout in American history.

BLACK LIVES MATTER

Demonstrators march in 2012 in memory of Trayvon Martin, the unarmed teenager shot to death in Florida by a neighborhood watch coordinator. The killing sparked a national outcry against racial profiling. Demonstrators, joined by Trayvon's parents, Sybrina Fulton and Tracy Martin (*bottom, center*), march in New York.

Some months before his reelection, a high-profile shooting prompted the creation of a national movement and motivated Obama to address specific racial issues, areas some critics say he often avoided during his administration. In 2012, after a neighborhood watch coordinator shot and killed seventeen-year-old Trayvon Martin, the president told reporters, "If I had a son, he'd look like Trayvon." The comment underscored Obama's connection to the black community but ultimately did not prevent a not-guilty verdict for the boy's killer. Two years later, a police officer in Ferguson, Missouri, shot and killed eighteen-year-old Michael Brown. When a grand jury failed to indict the officer, violence erupted in Ferguson and triggered nonviolent demonstrations nationwide. Eight days later, a New York City grand jury declined to indict a police officer in the videotaped illegal chokehold death of Eric Garner, an African American man suspected of selling single cigarettes from packs without tax stamps.

The impact of those decisions escalated the activism of the Black Lives Matter (BLM) movement, a group established in the wake of the Trayvon Martin killing. Using social

"You have a duty in this moment in history to take action and stand on the side of people who have been oppressed for generations."
—OPAL TOMETI, cofounder of Black Lives Matter, 2015

media and grassroots organizing, supporters took to the streets to protest, paralyzing major highways, intersections, and public transportation in New York, Boston, Oakland, Washington, D.C., and other cities. It was the first time since 1992 (in response to the Rodney King verdict in Los Angeles, in which LAPD officers filmed beating King were acquitted) that the treatment of African Americans triggered such massive street protests. The recent racial events unequivocally demonstrate to a new generation of activists that despite the gains of the Civil Rights Movement and the election of a black president, racism remains pervasive in our society.

Although still an emergent organization, BLM has some parallels to the Civil Rights Movement of the 1960s, especially its multiracial makeup and large number of young leaders and activists. The cofounders of BLM, three black women—Alicia Garza, Opal Tometi, and Patrisse Cullors—connect citizens, mainly online, who want to abolish systemic racism. Its three queer-identifying founders have remained determined to resist efforts to rewrite the movement's history in a manner that devalues and ignores the critical role of women and the black Lesbian, Gay, Bisexual, Transgender (LGBT) movements in shaping contemporary and historic black activism. The proliferation of police killings of black men and women sparked a national conversation about race and the mass incarceration of black men, issues that Black Lives Matter protests helped galvanize.

LINEAGE OF ACTIVISM Veteran civil rights leader Julian Bond joins youth activists Dream Defenders during a sit-in demonstration at Florida's statehouse in 2013. The group demanded hearings on the state's Stand Your Ground laws.

The Dream Defenders, a group of young activists dedicated to expanding Martin Luther King Jr.'s legacy, has targeted the criminal justice system's treatment of African Americans. Rasheen Aldridge and Phillip Agnew of the Dream Defenders and Missouri activists Ashley Yates, T-Dubb-O, and Brittany Packnett, among others, met with President Obama in the White House in late 2014 for a candid dialogue about the criminal justice system in particular and racial and economic injustice in general. "Straight talk" was how Agnew characterized the activists' conversation with the president. " We told him that we had no faith in anything, church or state. We told him that the country was on the brink," Agnew said. "We asked for the president to utilize his pulpit … to end federal funding to police departments with histories of discrimination, harassment, and murder. We beseeched President Obama to invest in community-based alternatives to policing and incarceration." The president responded "passionately," Agnew said, and agreed with many of their points. He expressed admiration for their political courage but stressed that change happens gradually. The White House meeting with the grassroots protesters was the first of its kind in two generations. The fruits of this meeting would be realized over the course of the next year.

Demonstrations against police brutality in 2014 and 2015 have renewed a broader public interest in African Americans' struggle for equality. People of all ages and ethnicities flocked to movie theaters to see *Selma,* a dramatization of the 1965 efforts to win voting rights for black citizens in Alabama. Directed by the highly acclaimed African American filmmaker Ava DuVernay, the movie offered an unvarnished look at the brutal violence that peaceful protesters suffered at the hands of law enforcement.

At the fiftieth-anniversary commemoration of the Selma march, in March 2015, President Obama noted, "At the time of the marches, many in power condemned rather than praised them.… Back then they were called Communists or half-breeds or outside agitators, sexual and moral degenerates, and worse." Obama placed the black freedom struggle's quest for racial and economic justice at the center of a tapestry of social movements for equality that included workers, women, Latinos, Native Americans, and the LGBT community.

As his two terms drew to a close, the president seemed eager to support special initiatives to assist African Americans. My Brother's Keeper Initiative, a White House program started in 2014, is designed to bolster education opportunities and achievements for young men of color. At the 2015 NAACP national convention, Obama noted that thousands of black men were trapped in the criminal justice system. "If you're a low-level drug dealer, or you violate your parole, you owe some debt to society," the president said. "You have to be held accountable and make amends. But you don't owe twenty years. You don't owe a life sentence." When Obama took office, black men were incarcerated at six times the rate

First Fight, Then Fiddle, 1949

Gwendolyn Brooks

First fight. Then fiddle. Ply the slipping string
With feathery sorcery; muzzle the note
With hurting love; the music that they wrote
Bewitch, bewilder. Qualify to sing
Threadwise. Devise no salt, no hempen thing
For the dear instrument to bear. Devote
The bow to silks and honey. Be remote
A while from malice and from murdering.
But first to arms, to armor. Carry hate
In front of you and harmony behind.
Be deaf to music and to beauty blind.
Win war. Rise bloody, maybe not too late
For having first to civilize a space
Wherein to play your violin with grace.

of white men, and black women at nearly triple the rate of white women. A few days after the NAACP speech, Obama became the first president to visit a federal prison—in Oklahoma—as part of his reform efforts to shorten prison sentences for nonviolent drug offenders. He also commuted the sentences of nearly a hundred drug offenders, granted clemency to dozens of others, and banned solitary confinement of juveniles in federal prisons.

Young activists from organizations such as Dream Defenders and Black Lives Matter are beginning to have an impact, much as activists did more than fifty years ago. From civil rights protesters Fannie Lou Hamer, Rosa Parks, and Martin Luther King Jr. to black power radicals Stokely Carmichael, Angela Davis, and the Black Panthers, African Americans have sought to fundamentally reimagine American democracy. Civil rights activism in the 1960s and 1970s promoted a vision of justice that confronted social evils plaguing society. Although segregated bathrooms and trains have been relegated to the dustbin of American history, whole communities are still trapped in generational poverty.

Many poor black people continue to experience mass incarceration, high unemployment, failing public schools, and police brutality.

A year after African Americans voted in record numbers and helped send the first black president to a second term, the U.S. Supreme Court gutted the enforcement powers of the 1965 Voting Rights Act in *Shelby v. Holder*. By invalidating the section of the act that requires federal approval before certain states—mainly southern, with a history of discrimination—can change their voting procedures, the decision increases the possibility that some states will make it difficult for certain groups, such as poor African Americans and other minorities, to exercise their voting rights. A year after the ruling, North Carolina and Texas implemented stricter, more onerous ID requirements; North Carolina also restricted early voting and same-day voter registration. The Supreme Court "stuck a dagger into the heart of the Voting Rights Act," wrote Congressman John Lewis, a frontline fighter for voting rights in the 1960s. "More than a century ago, this fight for equality and justice under the law began," black Congresswoman Marcia Fudge commented, "and today it's clear it is far from over."

Black Americans remain underrepresented in almost every positive social economic indicator measuring health, wealth, employment, and life chances and overrepresented among the poor, racially segregated, unhealthy, incarcerated, unemployed, and those on death row. Even as black elites enjoy unprecedented wealth, access, and corporate, political,

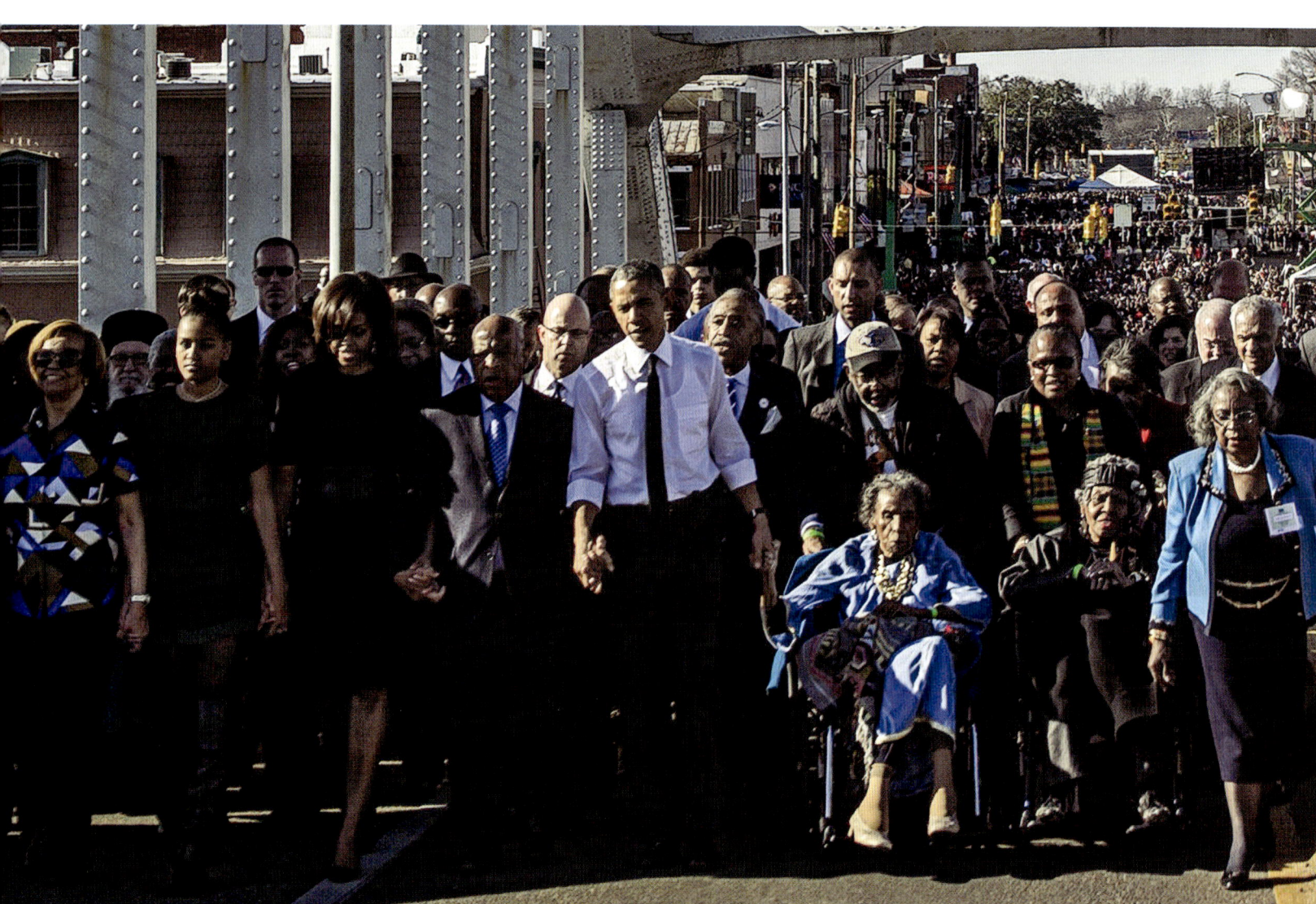

business, and cultural power, the faces at the bottom of America's economic and political well remain obsidian, to paraphrase scholar Derrick Bell. This stark reality, however, has inspired new movements of racial consciousness that result in creative mash-ups of art, culture, and politics. With works such as hip-hop artist Kendrick Lamar's "The Blacker the Berry," soul singer D'Angelo's "Black Messiah," Ava DuVernay's *Selma,* and writer Ta-Nehisi Coates's *Between the World and Me,* black America is once again reasserting its collective voice.

Dreams of freedom persist in the era of Obama and Black Lives Matter, which are in many ways the latest chapters in the continuing saga that is our national Civil Rights Movement. Racial fatigue has—since the Civil War—inspired some people to prematurely write an ending to racism, regardless of the nation's political reality and circumstances. The latest wishful thinking occurred after Obama's election, with some journalists promoting the notion that America had become a "postracial" nation. A black president symbolized, according to this logic, that race mattered less in American society than at any other point in our history. This proved untrue, as systemic racism seems inexorable. But there is now, more than ever, good reason to continue the struggle for equality and economic justice that for centuries has been African Americans' North Star. No matter how long the fight, how treacherous the journey, or how dangerous the terrain, African Americans are determined to change the face of American democracy and perhaps, in the process, redeem the nation's soul.

COMMEMORATING SELMA

Fifty years after the bloody assault on voting rights advocates at the Edmund Pettus Bridge in Selma, Alabama, President Barack Obama and others commemorate the event. Obama (*opposite*) holds the hands of John Lewis and Amelia Boynton Robinson, both injured at the 1965 march. First Lady Michelle Obama (*third from left*) joins hands with Lewis. Former President George W. Bush (*this page, below*) walks with his wife, Laura. Juanita Abernathy holds the hand of her son, the Reverend D. Ralph Abernathy III (*center*).

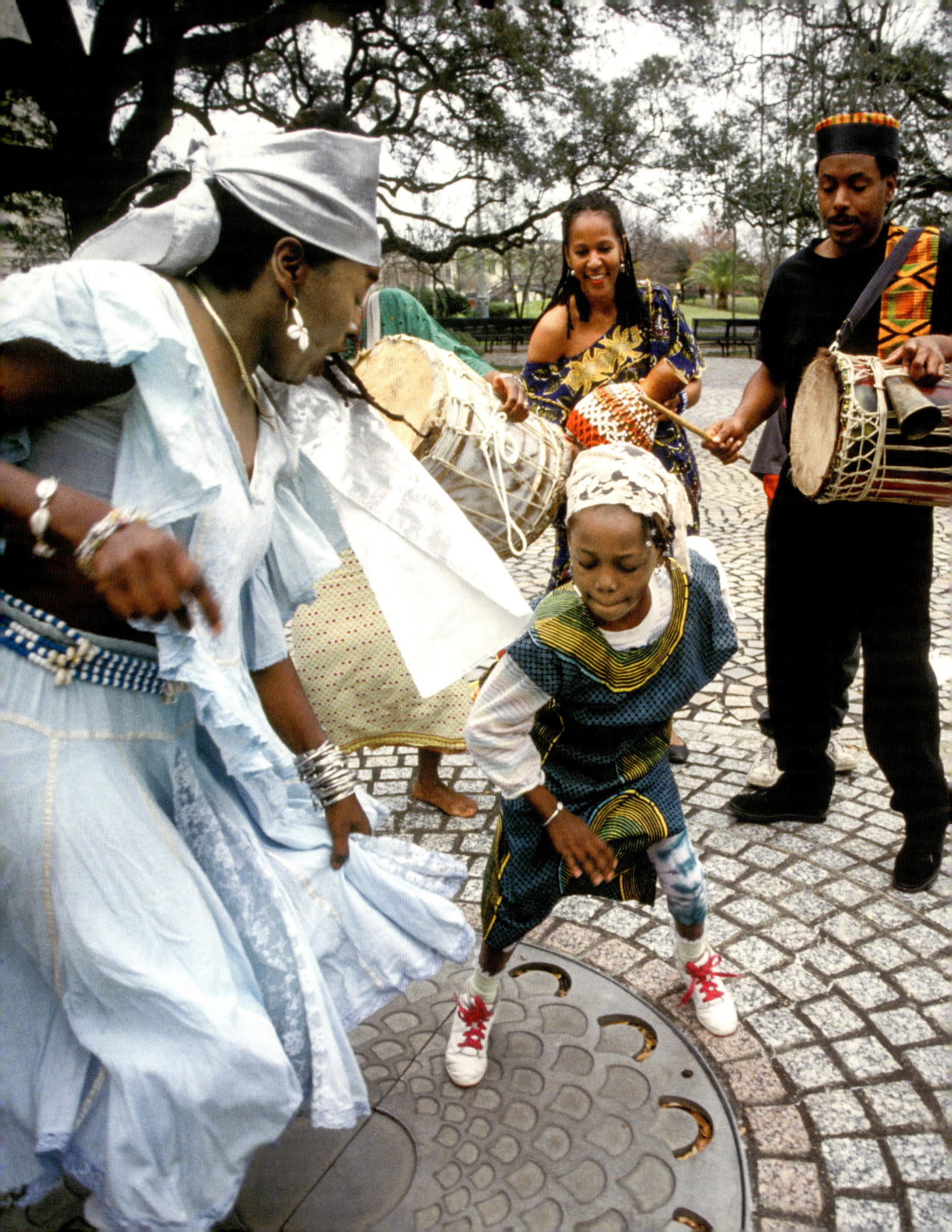

A SENSE OF PLACE

CENTURIES OF RESTRICTION HAVE SHAPED THE AFRICAN AMERICAN RELATIONSHIP WITH PLACES

FARAH JASMINE GRIFFIN

Down home. Uptown. The bottom. The hill. Round the way. On the block. By naming, we lay claim to a place, shaping and defining it according to our needs and aspirations, our hunger, and our dreams. African Americans were forged in an act of dispossession and displacement; consequently, their relationships to places have been both precarious and precious. For much of their history, most have lived under legal or de facto segregation. Forced to inhabit spaces prescribed by others, black people have generated their sense of place by creating and sustaining tradition, history, and identity. In the process, they have created a powerful political vision, dynamic artistic forms, and distinct culinary and religious traditions.

SITES OF MEANING A girl in Congo Square in New Orleans (*opposite*) dances to Percussion Inc., an African group, reflecting a centuries-old tradition of enslaved Africans gathering on Sundays to drum, sing, and sell their wares. This pineapple quilt from the late 1800s (*right*) belonged to a woman in Lyles Station, Indiana, an African American community established in the late 1840s.

n 1718, enslaved Africans in New Orleans, a multiethnic city with a history rich in influences from Europe, the Caribbean, and Africa, turned Place des Nègres into Congo Square. There, they would gather on Sundays to beat drums, market goods, sing, dance, and lay the foundation for one of the richest musical traditions the world has known. Congo Square was a major site for the continuation of African religious and musical practices, giving birth to Africanized forms of Christianity, to jazz, and even contributing to the spread of voodoo. Reflecting the

African diaspora, the square brought together influences from Africa, Haiti, and the American South to create a distinctive set of aesthetic and spiritual practices that over time spread far beyond their places of origin.

A little farther north, on the fertile land of the Mississippi Delta, in the northwest corner of Mississippi, a large population of black people first worked as slaves on gang-labor plantations and then later as oppressed sharecroppers. With that injurious past, the Delta became the site of some of the country's most profound racial

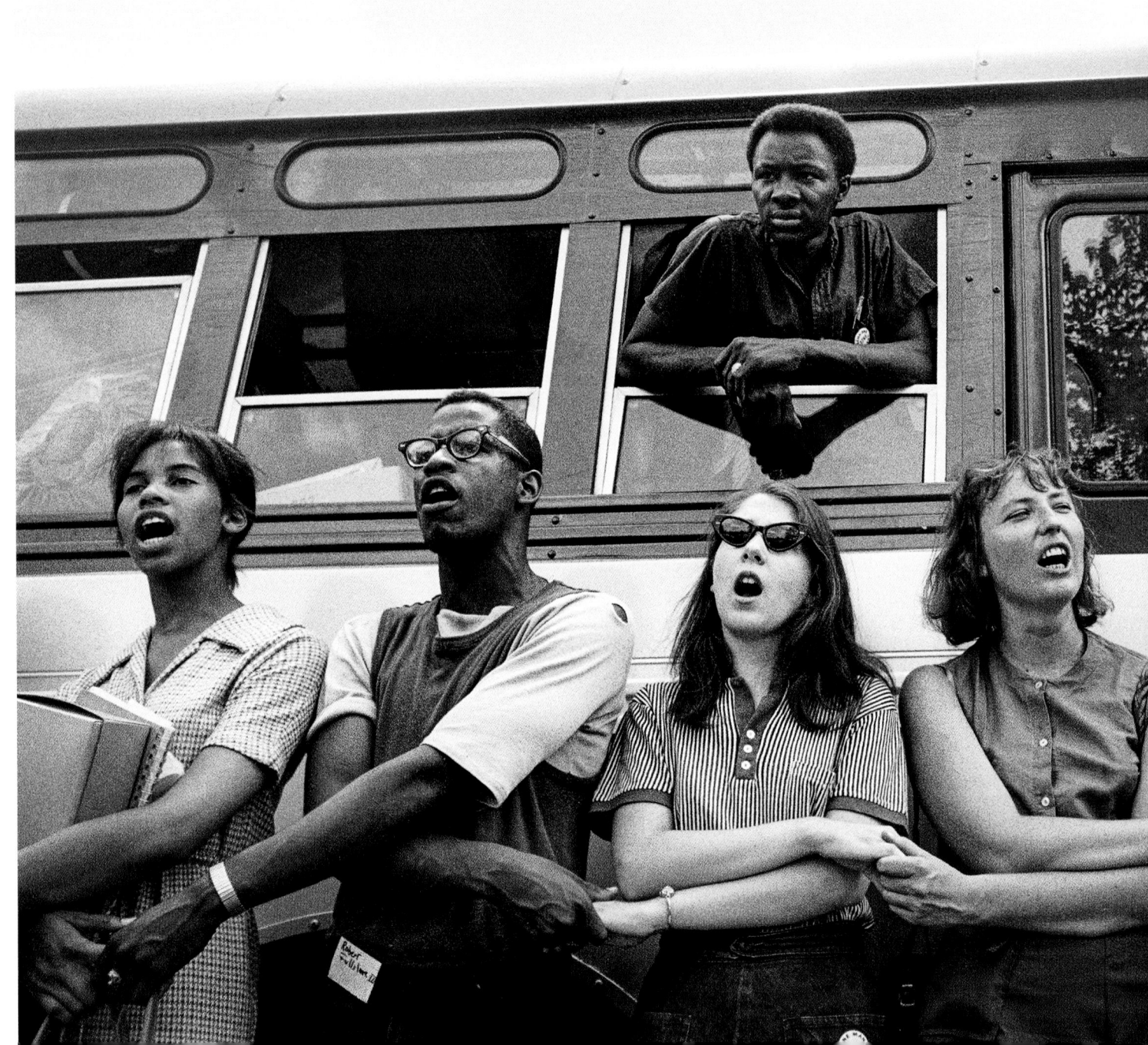

terror, a space of degradation. Yet the Delta was also a place of creativity and inspiration that produced some of the richest expressions of black humanity. It is the birthplace of blues pioneers Eddie James "Son" House Jr., Robert Johnson, and Charley Patton, of freedom fighter Fannie Lou Hamer, and of literary great Richard Wright.

The Delta is a land watered with the blood of thousands of African American men and women who were tyrannized by white supremacy, and in particular of

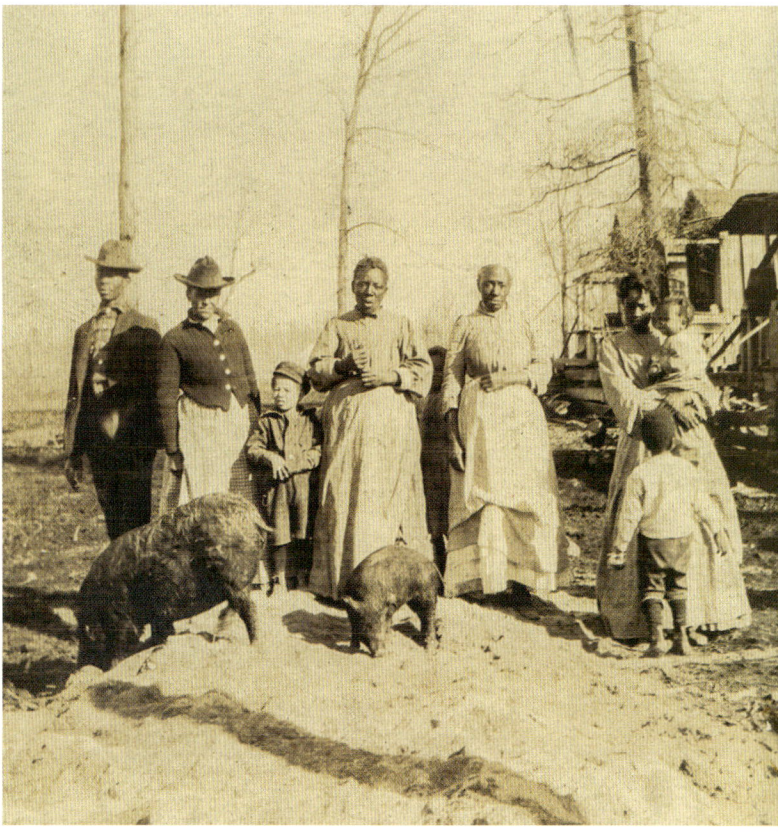

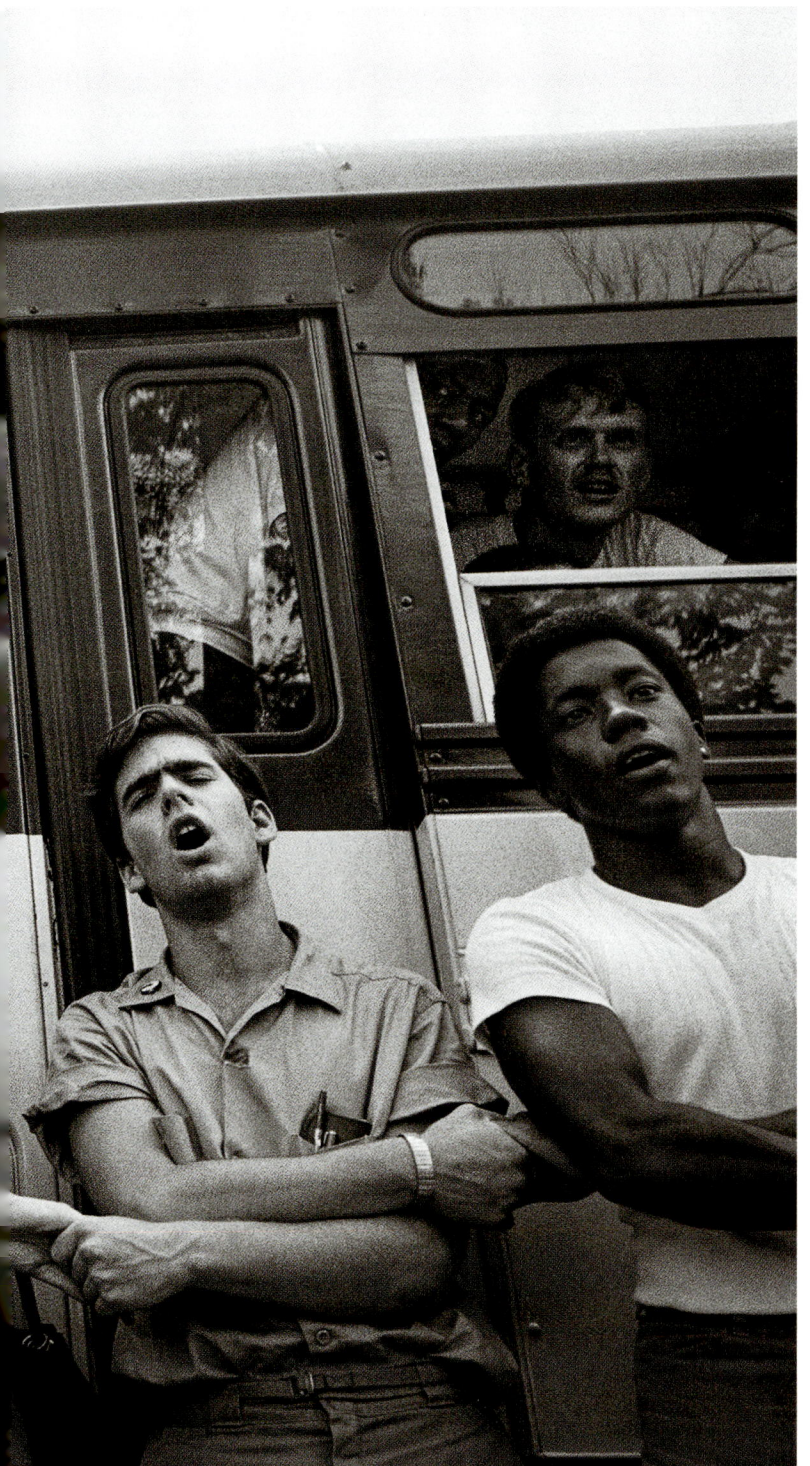

SOUTHERN STRUGGLE College students (*left*) attending a training session in Oxford, Ohio, in 1964, before boarding a bus to Mississippi during Freedom Summer. The African Americans outside a shanty in this photograph from the 1880s (*above*) would have struggled to make a living after Emancipation.

Emmett Till, whose brutal murder at the age of fourteen helped spark the modern Civil Rights Movement.

Mississippi was also the site of Freedom Summer in 1964, when hundreds of students from all over the country converged on the state to help register African Americans to vote. The Student Non-Violent Coordinating Committee, the National Association for the Advancement of Colored People, the Southern Christian Leadership Conference, and the Congress for Racial Equality organized the campaign. In a further effort to represent disenfranchised blacks, civil rights workers established the Mississippi Freedom Democratic Party, which challenged the seating of delegates of the state's all-white Democratic Party at the 1964 Democratic National Convention.

In Mississippi, the studio of African American photographer Henry Clay Anderson was a place of dignity and pride. From the late 1940s through the 1970s, he documented the lives of generations of middle-class African Americans who came to his studio in Greenville. Capturing their daily lives—at weddings and proms, sports and entertainment events, lodge meetings and funerals—Anderson offered black people a vision of themselves beyond the stereotypes that pervaded American media. Like the photography studios of Richard Samuel Roberts of Columbia, South Carolina; James Van Der Zee of Harlem; Charles "Teenie" Harris of Pittsburgh; the Scurlocks of Washington, D.C.; and Ernest Withers of Memphis, Anderson's studio affirmed black humanity and created a visual record of African Americans as they wanted the world to see them.

About the time Anderson opened his photographic studio, a few hundred miles east, two African American brothers, Robert and James Paschal, opened a restaurant in west Atlanta that evolved into a nerve center for the Civil Rights Movement. Serving chicken and yams and other foods traditionally enjoyed by African Americans, particularly those from the South, Paschal's Restaurant became a hub for like-minded, freedom-seeking folks who wanted to eat good food while discussing politics and planning strategy. Customers such as Martin Luther King Jr. and Ralph Abernathy rose to national prominence, but many unsung restaurant regulars, including students from nearby black colleges, also rallied to the cause here. From Paschal's, they branched out, recruiting others and managing civil rights campaigns throughout the nation.

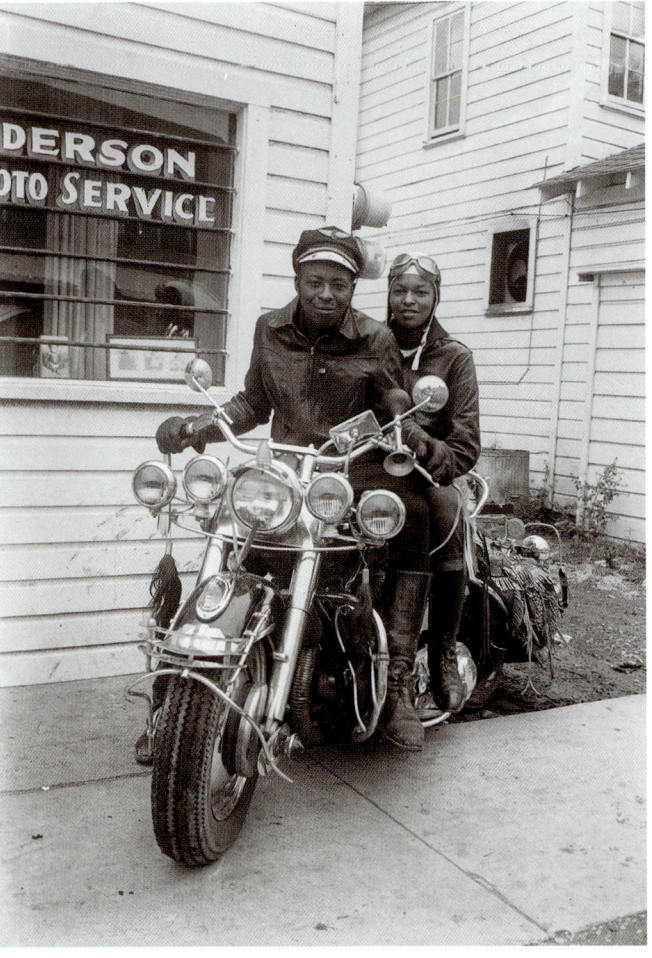

BEHIND THE LENS Black photographer Henry Clay Anderson used this large-format camera (*above*) to chronicle the lives of the middle-class African American community of segregated Greenville, Mississippi, in the 1950s, 1960s, and 1970s. He photographed this couple (*right*) riding a Harley-Davidson motorcycle outside his studio in the 1960s.

BLACK MECCAS Children jump rope in 1941 on the South Side of Chicago (*right*), an African American community that attracted black southerners during the Great Migration. Civil rights leaders often convened at Paschal's Restaurant in Atlanta, including at this 1962 gathering. (*Below, left to right*) Fred Bennett, Isaac Farris Sr., Christine King Farris, Ralph Abernathy, Roy C. Bell, Clarice Wyatt Bell, Martin Luther King Jr., and Coretta Scott King.

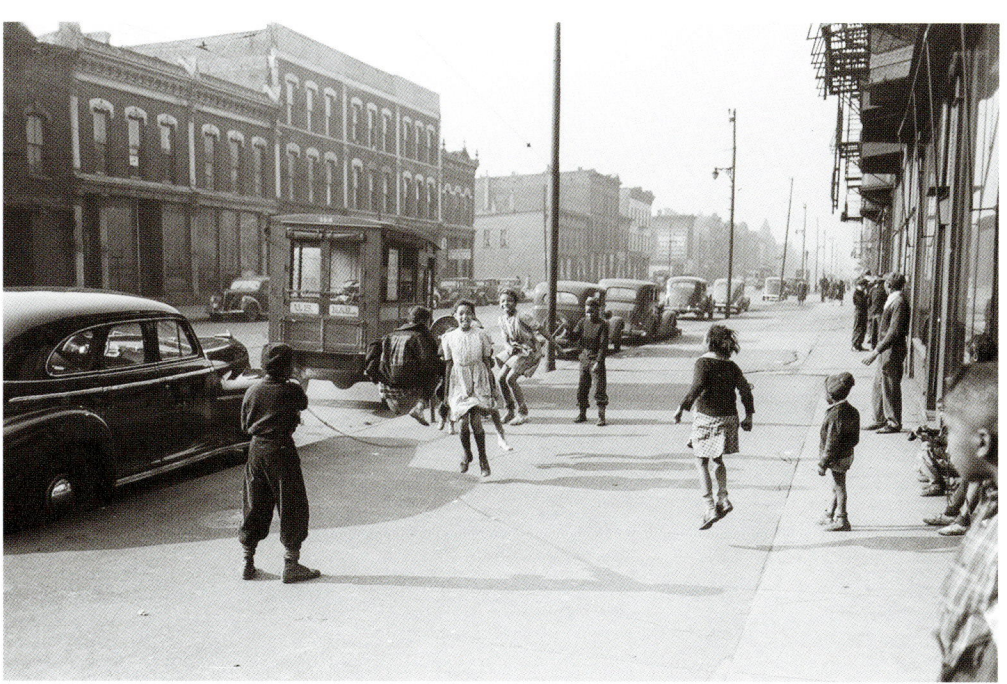

A string of entertainment venues sprang up in the 1920s and 1930s to cater to a pool of talented African American performers, especially in the eastern part of the United States. Black musicians, singers, and comedians traveled a circuit of venues to reach black audiences. Theaters such as the Royal Peacock in Atlanta, the Apollo in Harlem, the Regal in Chicago, the Lincoln in Los Angeles, the Howard in Washington, D.C., the Uptown in Philadelphia, the Ritz in Jacksonville, Florida, and the Madam C. J. Walker in Indianapolis acquired iconic status among black Americans. They flocked to these theaters to be entertained by luminaries such as Billie Holiday, James Brown, Sammy Davis Jr., and a multitude of Motown singers.

Young black performers would start out on the black circuit, honing the talents that would catapult them to worldwide fame. The theaters were places where novice artists were mentored, challenged, and nurtured. Michael Jackson recalled that at age six, "after studying James Brown from the wings, I knew every step, every grunt, every spin and turn."

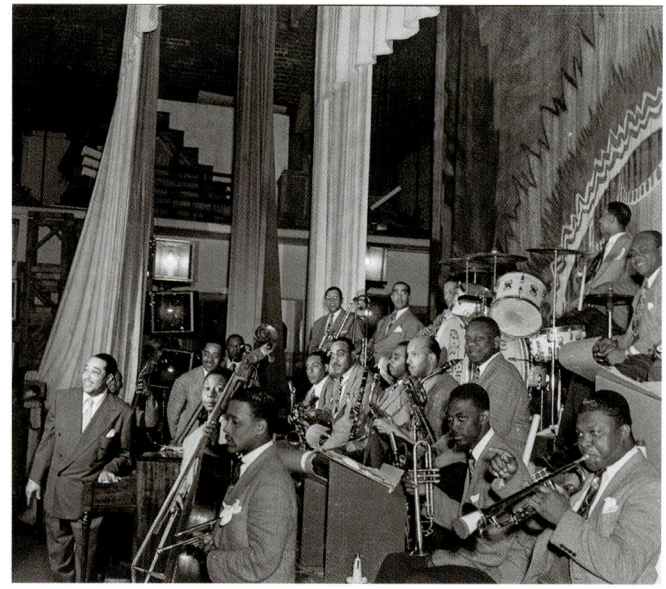

SOUL CIRCUIT In the twentieth century, a host of theaters and nightclubs drew black entertainers and patrons. Duke Ellington and his band (*above*) perform at the Howard Theatre in Washington, D.C., in 1940; the marquee of the Regal Theater in Chicago announces a star-studded Motortown Revue in 1962 (*below*); the Apollo in Harlem (*opposite*) kickstarted the careers of many African American singers and entertainers.

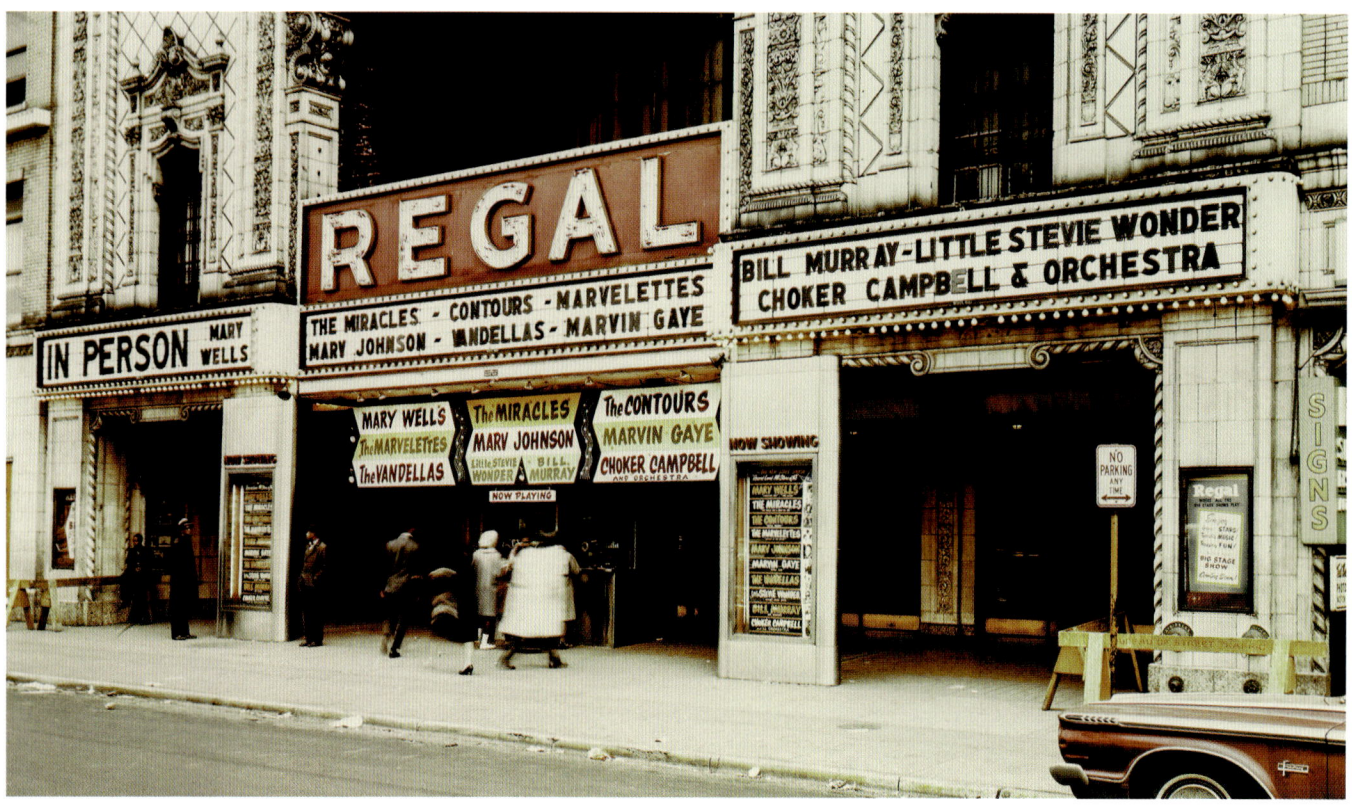

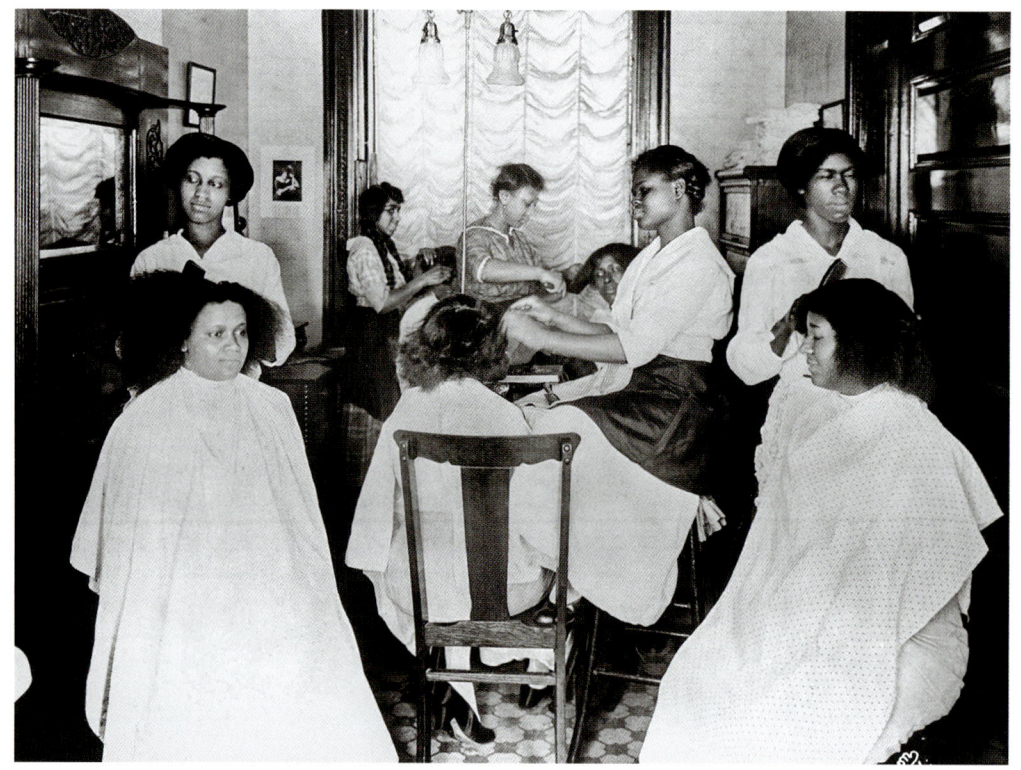

Beauty parlors such as Mrs. Robinson's in New York City (*left*), ca. 1915, have long been special places for black women. Sanctuaries for grooming and pampering, they also served as meeting places where women could share their views and forge support groups. Hair care also represented a business opportunity for black women. Madam C. J. Walker's hair products (*below*) helped make her a millionaire in the 1910s.

When millions of African Americans left the South for cities in the Northeast, Midwest, and West during the Great Migration, they took with them their worship practices, music, ways of preparing food, and other customs. They also created new places and artistic forms to nurture and sustain them in their new surroundings.

Consider, for instance, black beauty salons. Created by female entrepreneurs, they were institutions of economic empowerment. Instilling confidence in black women by validating their unique beauty, they mitigated (and still do) the perception of white supremacy. Privy to the gossip and neighborhood news of salon clients, African American girls were absorbed into black womanhood through the intimate act of having their hair styled. In his classic novel *Invisible Man*, Ralph Ellison declares that places like black beauty salons are public spheres for African Americans, places where political stances are debated and black humanity affirmed. He writes of "the barber shops and the juke joints and the churches ... and the beauty parlors on Saturdays when they're frying hair. A whole unrecorded history is spoken there."

It would not be unusual for a young woman leaving a Harlem hair salon ninety years ago to encounter a fiery orator on a street corner, most famously at Speaker's Corner at 135th Street and Lenox Avenue. Common fixtures in African American urban communities, street orators stirred debate on a range of issues, including black history, politics, unions, and religion. Black socialist Hubert Harrison was a radical voice in Harlem, as was black nationalist Marcus Garvey. Speaker's Corner was a place where black people could acquire knowledge and perspective. Among the audiences may have been the little girl who became the writer and documentary maker Toni Cade Bambara, who often spoke of the influence Harlem's street orators had on her writing and politics, or a young hustler, just beginning his political awakening, who would eventually join the tradition of speakers when he transitioned from Malcolm Little to Malcolm X.

A HEAD FOR HATS Mae Reeves and her husband, Joel Reeves, stand in her Philadelphia shop in the 1950s (*below*). Reeves created many unique styles (*above*), specializing in turbans and feathered hats. Her customers included Lena Horne and Ella Fitzgerald.

MAE'S MILLINERY SHOP

"You're not fully dressed unless you wear a hat," Mae Reeves often said. A hat designer and entrepreneur in the 1940s, Reeves built a thriving business in Philadelphia that kept women stylishly adorned. After growing up in Georgia, Reeves migrated north, attending millinery school in Chicago in 1930. At age twenty-eight, she secured a loan of $500 and opened Mae's Millinery in an African American community in Philadelphia. In 1953, she moved her shop to 60th Street, a white commercial corridor, becoming the first black woman to own a business in that area.

ROOM AT THE INN

Visitors to Martha's Vineyard, ca. 1931, gather outside Shearer Cottage (*above*), a guesthouse established by an African American family in 1903, when black visitors were barred from white-owned lodging. Gingerbread cottages line a street in Oak Bluffs (*right*), Martha's Vineyard, a historic African American enclave on the Massachusetts island.

For centuries, the places black people could venture and inhabit were limited, regardless of their status or wealth. Unwelcome at fine resorts and most beaches, the black elite established their own places of leisure that not only provided respite and recreation, but also generated political and social networks. From Idlewild, Michigan, to the Oak Bluffs section of Martha's Vineyard, Massachusetts; American Beach, Florida; Sag Harbor, New York; Highland Beach, Maryland; and Bruce's Beach in Southern California, privileged African Americans escaped the challenges confronting their race and carved out a space to affirm themselves, their leaders, and their children in an often hostile world.

Oak Bluffs is the most famous and enduring black beach resort. Activist and Harlem Congressman Adam Clayton Powell Jr. vacationed there in the 1940s, and in recent years President Barack Obama has frequented the town's restaurants during visits to the Vineyard. In the intervening decades, Oak Bluffs welcomed generations of African American artists, intellectuals, and families seeking a black enclave and safe space.

The creation of place is not the prerogative of elites only. Poor and working-class black people have also created and sustained places of joy, resilience, beauty, and self-determination in spaces as diverse as storefront churches and neighborhood bars. Urban renewal often demolishes such sites, so their names and locations are lost to history but live on in the memories of those who frequented them. Plantations and public squares, restaurants and churches, theaters and street corners, beaches and beauty shops— all these places contribute to a people's sense of themselves as a culture.

Over the years, gentrification and urban renewal have altered many black neighborhoods, forcing out residents who cannot afford the rising rents or real estate taxes that ensue. Some black institutions and spaces have disappeared in the wake of integration, and in extreme cases, whole neighborhoods have been razed. New structures often bear the names of important black historical figures, such as The Douglass, luxury condominiums in Harlem. Here, history is a marketing tool that lends a sense of heritage to areas that otherwise bear little evidence of the past.

Yet place remains in other traces—in an elder's reminiscences or the lyrics of a song. The art, history, and politics inspired by many sites will help maintain a sense of these places for generations yet unborn. As if imagining a new world into being, African Americans, though forced to inhabit certain spaces because of their race, transformed those places to reflect the full dimension of their humanity and creativity.

HEART OF HARLEM In the 1920s, black entrepreneurs built and operated the Renaissance Theater and Casino in the center of Harlem (*right*). A place for society balls, political meetings, basketball games, and more, it was a hub of African American social activity. The building was demolished in 2015.

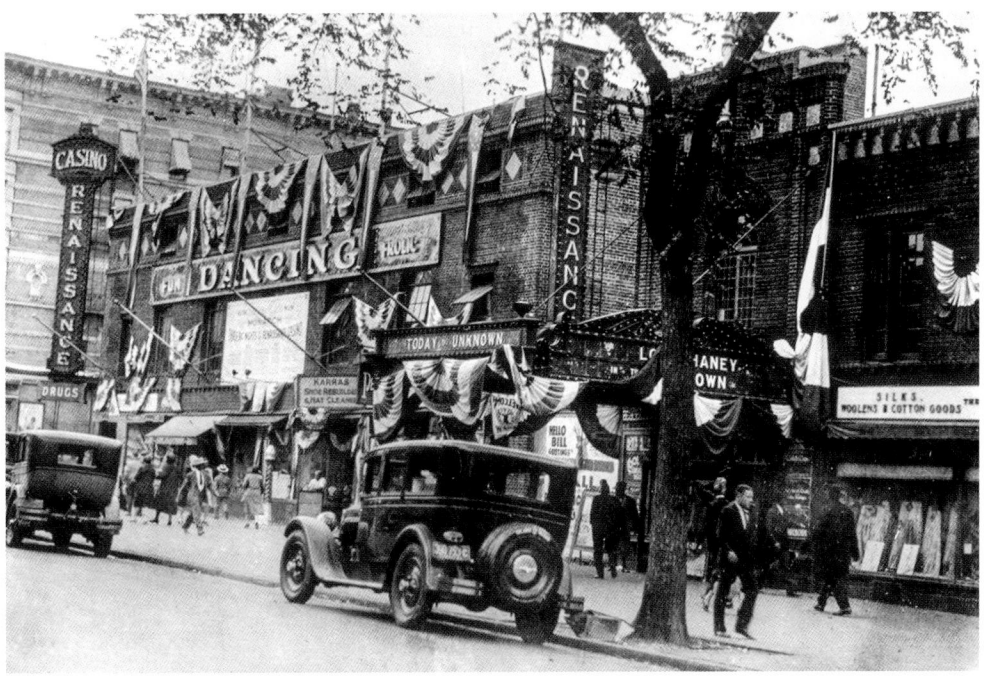

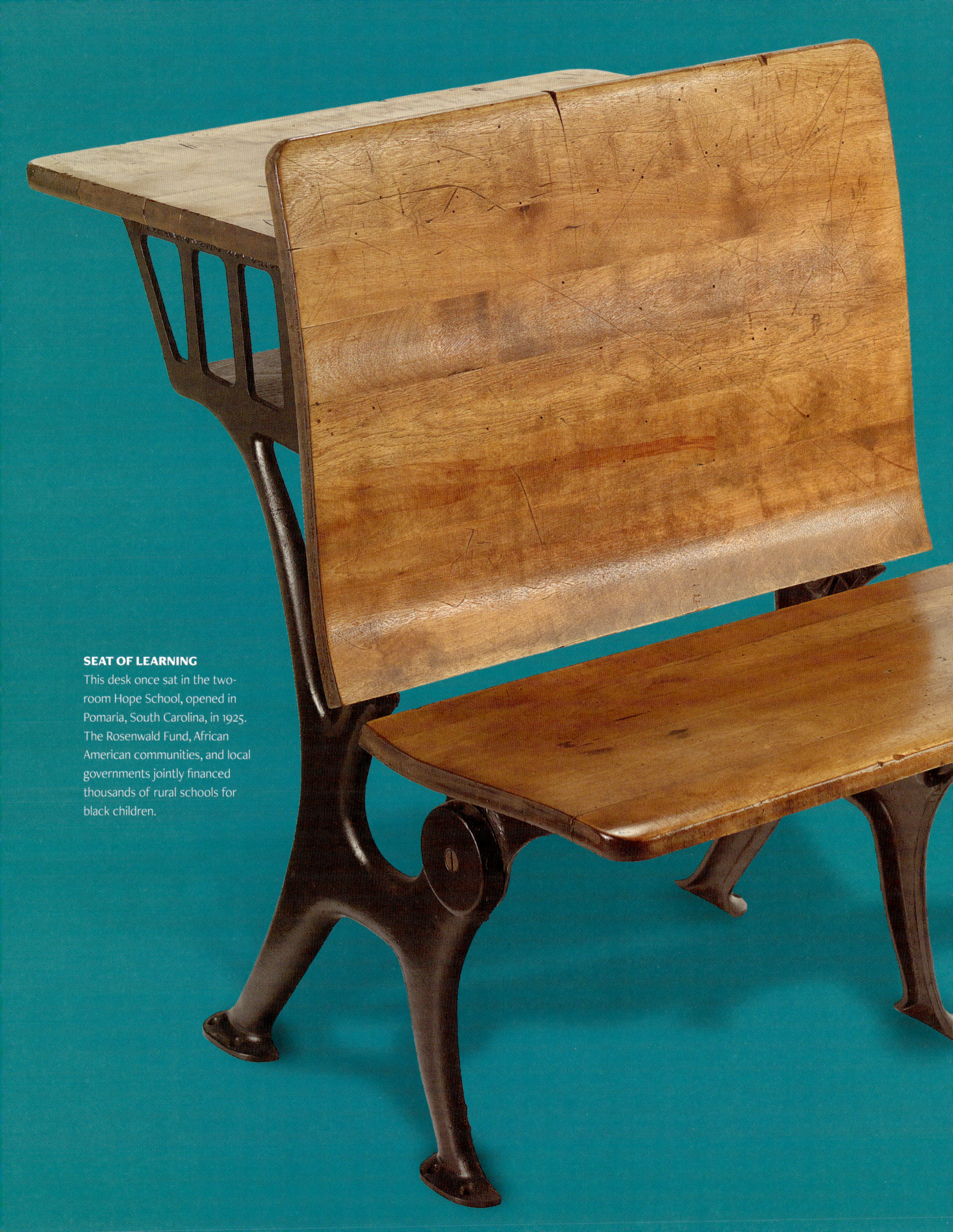

SEAT OF LEARNING

This desk once sat in the two-room Hope School, opened in Pomaria, South Carolina, in 1925. The Rosenwald Fund, African American communities, and local governments jointly financed thousands of rural schools for black children.

MAKING A WAY OUT OF NO WAY

Alfred A. Moss Jr.

Throughout the history of the United States, African Americans have faced seemingly overwhelming challenges. How they built institutions that enabled them to survive and overcome prejudice and expand possibilities for freedom and opportunity is one of the great sagas in the nation's history. The committed work of educational, religious, and community organizations and the role of the press reflect African Americans' will to endure and achieve. Such organizations are the embodiment of the Latin proverb *Aut viam inveniam aut faciam* (I'll either find a way or make one). Working collectively for their common good, African Americans were able to make a way out of no way.

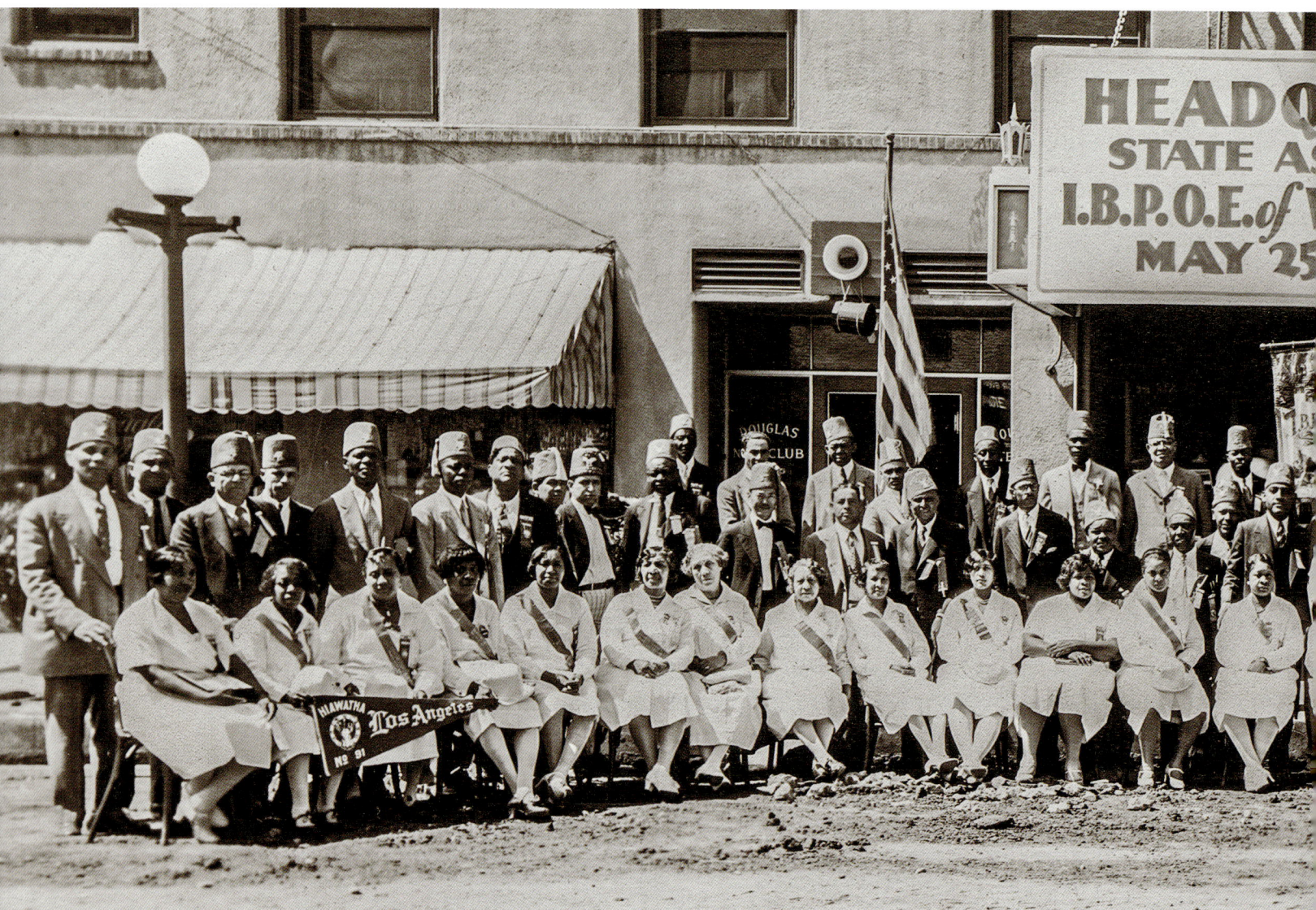

Educational Institutions

One of the most important paths to advancement was education. Before Emancipation, educating enslaved people was against the law in southern states, and the education of free black people in the North was erratic and controversial. "For colored people to acquire learning in this country makes tyrants quake and tremble," radical abolitionist David Walker observed in 1829. Aware of the power of knowledge, African Americans, free and slave, exhibited a fierce drive to learn to read, write, and do basic math. Those who secured a rudimentary education often gained it through the aid of a sympathetic employer, Quaker schoolteachers, or a slave master's wife or children or by their own self-instruction.

African Americans living in northern states, where slavery was abolished in the three decades after independence, benefited from the trend to establish and improve schools in

FRATERNAL GATHERING
Wearing their distinctive sashes and fezzes, members of the Improved Benevolent and Protective Order of Elks of the World (IBPOEW), founded in Cincinnati in 1898, gather in the 1940s with members of the women's auxiliary group.

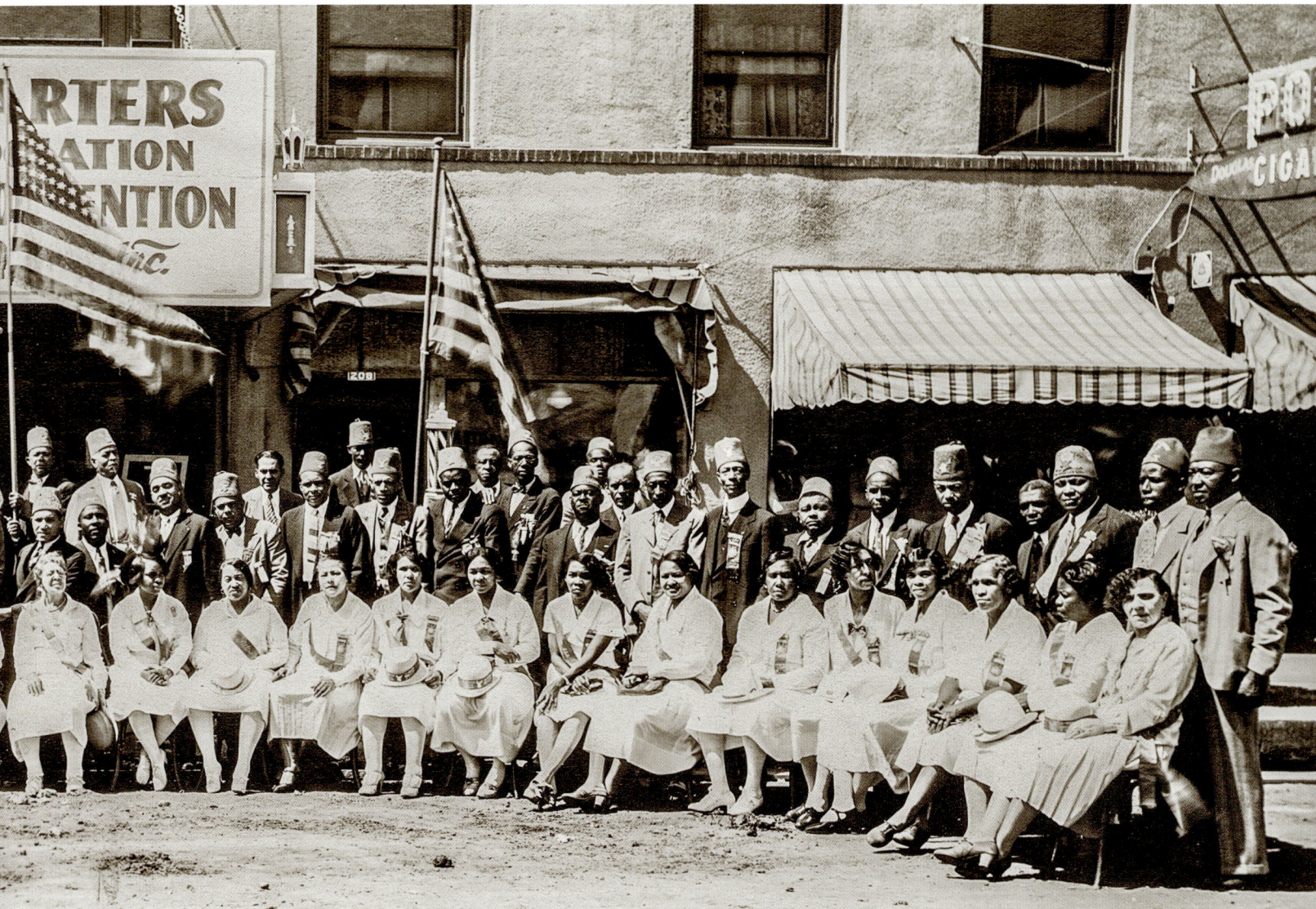

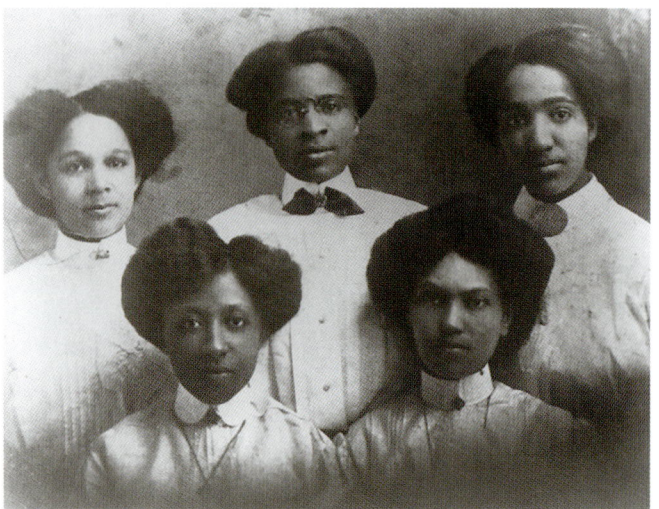

CALLED TO TEACH Charlotte Hawkins Brown (*top, center*), photographed here with fellow teachers, opened the Palmer Memorial Institute in North Carolina in 1902. An 1866 *Harper's Weekly* illustration depicts a Mississippi freedmen's school (*above*).

the new republic. In the early nineteenth century, educational opportunities for African Americans expanded, particularly in New England, New York, and New Jersey, often because of initiatives by Quakers and other religious and humanitarian groups. Some of these schools were segregated and others were not.

As the country expanded, the new western states banned slavery upon their admission to the Union. They also offered public education, but African Americans in the North and West were not educated in large numbers in public schools until after the Civil War, due to white resistance to integrated schools and a widespread refusal to fund separate schools for blacks.

The end of the Civil War and of slavery brought significant advances in public and private educational opportunities for African Americans in the South. The U.S. Bureau of Refugees, Freedmen, and Abandoned Lands, known as the Freedmen's Bureau, made the founding of schools for formerly enslaved people a priority, creating and funding more than one thousand schools for African Americans in the South. Partnering with northern philanthropic and religious organizations, the Freedmen's Bureau established a range of institutions, from elementary-level to industrial schools and colleges, and provided night and Sunday classes to accommodate adults eager to learn. The American Missionary Association, a Protestant and predominantly white organization, founded more than five hundred schools for black students, among them Howard University in Washington, D.C., and Fisk University in Nashville, Tennessee. Meanwhile, independent African American religious groups, such as the African Methodist Episcopal Church, the African Methodist Episcopal Zion Church, the Christian Methodist Episcopal Church, and black Baptists also donated resources to educate their own. White Americans came from northern states in significant numbers to teach in the new schools, often joining forces with black teachers and even some southern white educators. As more African Americans trained to be teachers, they began to take charge of many of the schools.

Yearning for an education, African American students of all ages poured into the newly established schools. While visiting a school in Atlanta in 1865, the head of the Freedmen's Bureau, General Oliver Otis Howard, for whom Howard University would be named, asked students what message they wanted to send to northerners. "Tell them we are rising!" an enthusiastic ten-year-old boy replied. However, ascendancy would not be easy. With the dissolution of the Freedmen's Bureau and the end of Reconstruction policies in the late 1870s, southern racists abruptly halted improvements in the economic prospects and political rights of African Americans. Yet African Americans were undeterred and continued to make education a major goal.

In many cases, as soon as a young African American woman acquired sufficient qualifications, she became a teacher herself, often in a one-room schoolhouse in a rural community. In 1902, for example, Charlotte Hawkins Brown founded the Palmer Memorial Institute in tiny Sedalia, North Carolina, shortly after completing a college education in Massachusetts made possible by a benefactor. Aiming to educate students beyond basic skills, Brown built a liberal arts and college preparatory curriculum with an emphasis on decorum and social graces. The elite school flourished for sixty years and transformed the lives of hundreds of children, testament to the words of African American scientist George Washington Carver: "Education is the key to unlock the golden door of freedom."

Large educational foundations, most established by wealthy white Americans in the late nineteenth and early twentieth centuries, further enabled the slow but steady

"For colored people to acquire learning in this country makes tyrants quake and tremble on their sandy foundation."

—DAVID WALKER, abolitionist, *Walker's Appeal*, 1829

HOWARD UNIVERSITY
Chartered by the U.S. Congress in 1867, Howard now ranks among the nation's top historically black colleges and universities (HBCUs). This detail of a stereographic postcard shows Howard in the late nineteenth century.

increase in the number of schools for African Americans. Gifts from the George Peabody Education Fund, the John F. Slater Fund, the Rockefeller Family's General Education Board, the Anna T. Jeanes Fund, the Phelps-Stokes Fund, the Rosenwald Fund, and other foundations poured in, often stimulating additional contributions from local communities and individual donors, black and white. In an effort to address many southern states' meager funding of African American schools, the Rosenwald Fund developed a model that provided start-up capital for local schools and encouraged the communities to donate and raise matching or additional funds. In this manner, African Americans raised millions of dollars for the foundation of thousands of Rosenwald schools.

While most African Americans agreed that education was key to economic, social, and political advancement, philosophical differences in the approach to education erupted in the early 1900s, when Booker T. Washington and W. E. B. Du Bois, two prominent black intellectuals and educators, sharply disagreed on the best strategy to advance the race.

In 1881, Washington, with seed money from a group of black and white Alabama legislators and the support of a group of enterprising African Americans, created a new vocational school in central Alabama, known today as Tuskegee University. An articulate, persuasive spokesperson, he became an ardent apostle of the school, which trained African Americans to become skilled farmers, mechanics, carpenters, and domestic

"The problem of the twentieth century is the problem of the color line."

—W. E. B. DU BOIS, 1903

FULL PARITY W. E. B. Du Bois, a preeminent scholar and advocate of higher education for African Americans, was an outspoken critic of racial injustice and second-class citizenship. He later became a founding member of the NAACP and a leading Pan-Africanist.

servants. Such occupations, he contended, were most likely to strengthen the majority of black Americans economically and create a basis for future political and social progress. Washington accepted segregation and disenfranchisement, declaring "in all things purely social," blacks and whites "can be as separate as the five fingers, yet one as the hand in all things essential to mutual progress." White citizens across the country hailed Washington's conciliatory approach, which generated substantial donations and White House approval. Washington, who was born into slavery, became the most influential African American educator of his time.

In 1903, Du Bois, an African American professor at Atlanta University who had grown up in a racially tolerant Massachusetts environment, launched a stinging attack on Washington's educational policy, accusing him of preaching a "gospel of Work and Money to such an extent as to … almost completely … overshadow the higher aims of life." In books, essays, and speeches, Du Bois and other black

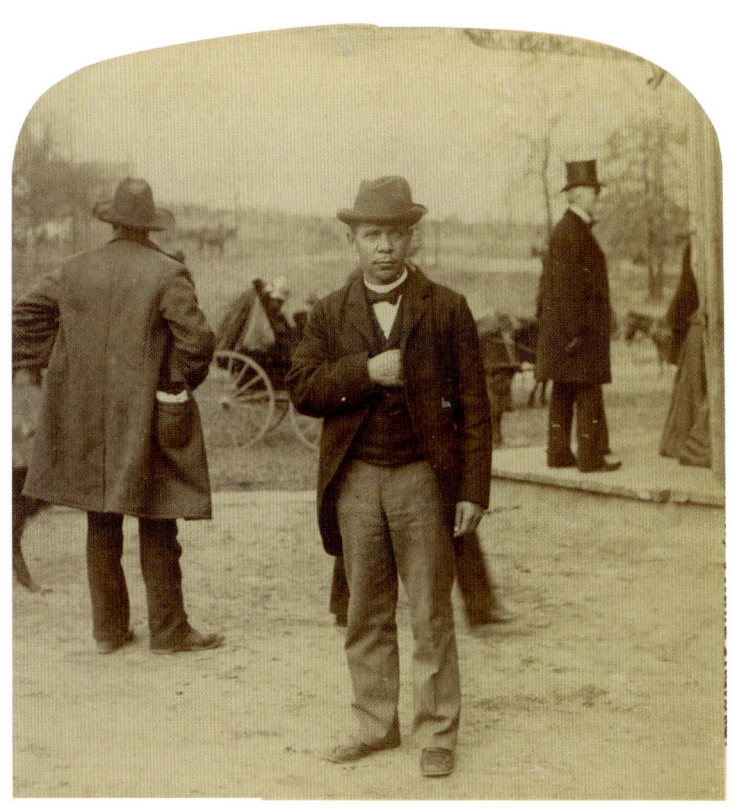

"You may fill your heads with knowledge or skillfully train your hands, but unless it is based upon high, upright character, upon a true heart, it will amount to nothing."
—BOOKER T. WASHINGTON, 1901

intellectuals argued that in order for African Americans to gain full political and social rights and be competitive in the larger world, their institutions had to produce graduates schooled in academic subjects and liberal arts, not just vocational skills. Furthermore, Du Bois maintained, Washington's counsel of silent submission to racism, advice that motivated whites to give him the money and influence to wear the mantle of leadership of his people, was in reality damaging the spirit of African Americans. Washington, however, remained the dominant voice in the public life of African Americans until his death in 1915.

By the 1920s, public governmental agencies had begun replacing philanthropic and private donors as primary funders of most African American educational institutions, but systemic racism and segregation prevented black students from sharing fully in educational opportunities. For the first half of the twentieth century, the bulk of African American students in elementary and secondary schools attended small, impoverished, short-term schools with pronounced inadequacies in every phase of the educational program.

UP FROM SLAVERY

Booker T. Washington, who founded Tuskegee Institute, recommended the acquisition of training and skills for the economic advancement of African Americans. He was an author, orator, and trusted presidential adviser.

EMPOWERING OURSELVES

Michèle Gates Moresi

African American professional organizations served as platforms to advocate fairness and equality and created a support network for black Americans who had been denied employment or opportunities for career development. When African Americans entered the field of medicine, for example, black medical students experienced obstacles in their bids to secure clinical training and staff positions in quality hospitals. Concerned about the lack of opportunities for African American interns, nurses, and physicians in white-run hospitals, Dr. Daniel Hale Williams, a successful surgeon in a private practice in Chicago, cofounded Provident Hospital and Training School Association in 1891. The first hospital in the nation to train African American nurses, it employed both white and black medical professionals with the express goal of serving the sick and poor. "A people who don't make provision for their own sick and suffering are not worthy of civilization," Williams once said.

When African American medical practitioners were refused membership to the American Medical Association, Williams joined forces with Robert F. Boyd, Miles V. Link, and other like-minded African American physicians to establish the National Medical Association (NMA) in 1895, a forum for African American health professionals on medical policies and standards of expertise. Throughout the twentieth century, the NMA led healthcare reform efforts, advocated for minority patients' rights, worked to expand access to medical education, and actively participated in efforts to pass civil rights legislation. The organization's publication, the *Journal of the National Medical Association*, first published in 1909, supported professional standards through its articles and provided updates on the numbers and types of African American health professionals.

Like medical professionals, African American lawyers were also held back, excluded from the mainstream American Bar Association and most local bar associations. In 1925, African American attorneys from several states established the National Bar Association (NBA), motivated by a desire to honor the legal profession and to work to protect civil and political rights of all citizens. Indeed, many members of the NBA, such as Charles Hamilton Houston and Thurgood Marshall, were active in the National Association for the Advancement of Colored People (NAACP) and at the forefront of discrimination cases that changed the nation.

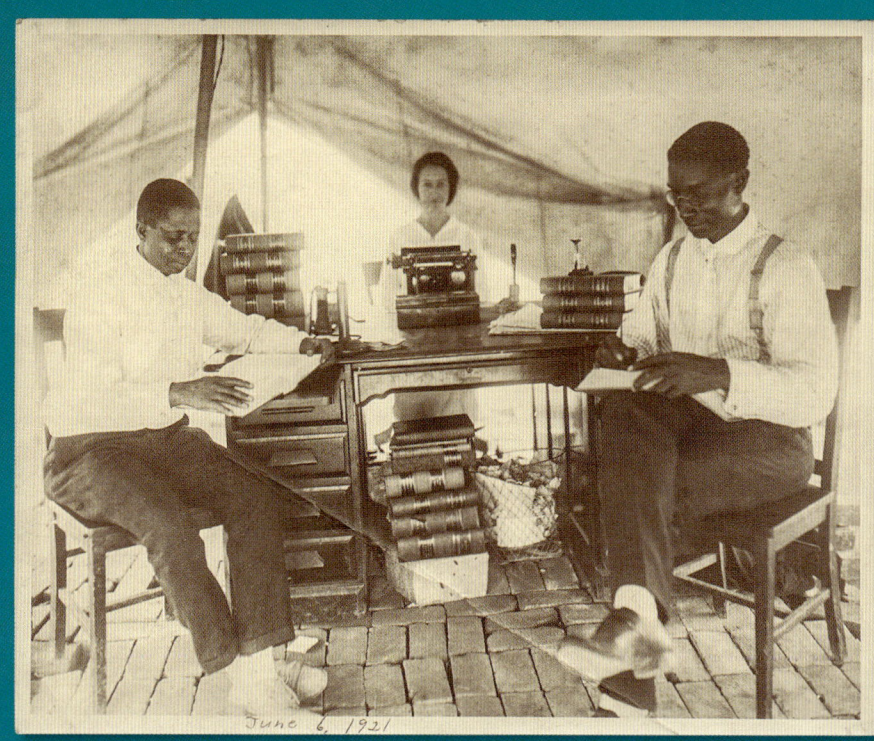

TULSA DEFENSE Attorneys B. C. Franklin (*right*) and I. H. Spears (*left*), with secretary Effie Thompson, set up practice in a tent in 1921 to provide legal assistance to black residents after the city's race riots.

The solidarity of the African American community motivated black professionals to collaborate in the face of unrelenting discrimination. B. C. Franklin, who attended Roger Williams University in Nashville, Tennessee, and Atlanta Baptist College, trained as a lawyer through correspondence and apprenticeship. He passed the oral bar examination in 1907, and subsequently worked throughout the state of Oklahoma. He and other African American lawyers established law firms in direct competition with white firms to serve African Americans in burgeoning towns and cities in the West.

After the Tulsa race riot of 1921, in which whites killed as many as three hundred people, injured hundreds more, and burned the homes and businesses of the local African American community, Franklin and his partners set about addressing the immediate needs of the victims. In particular, the lawyers challenged insurance companies that refused to pay claims filed by African Americans and preempted city ordinances that would have prevented black residents from rebuilding homes and businesses. African Americans' ability to organize for mutual interest and support has been essential to surviving and thriving in the midst of oppression.

Such shortcomings were especially acute in the South. By 1900, every southern state had enacted laws that provided for separate schools for blacks and whites, resulting in a grossly inequitable share of funding for African American schools. *Plessy v. Ferguson*, the 1896 U.S. Supreme Court case that legitimized separate facilities for the races, also specified that the facilities be equal, but southern officials assiduously disregarded the court's directive on equality. During the first half of the twentieth century, the disparity between funding increased significantly. In 1900, for every $2 disbursed for the education of African Americans in the South, $3 was spent on whites; by 1930, $7 was spent on whites to every $2 allocated for blacks.

While the Great Depression of the 1930s hurt education in every part of the United States, it exacted a special hardship on African American schools in the South. In 1935, the expenditures in ten southern states averaged $37.87 for each white student, compared to an average $13.09 for every black student. In educational services, such as transportation, visual aids, laboratory equipment, and modern buildings, the differentials were even greater. In 1929–30, for example, North Carolina spent more money on school buses to transport white students than it did on constructing sorely needed schools for black students. During the 1930s and early 1940s, the slightest cut in resources to African American schools often had the effect of taking away the barest essentials, including the teachers.

As the black population moved from rural to urban areas during and after World War I, access to better schools increased. Greater taxable wealth in the cities meant more funding for public schools, which were integrated and open to all children. However,

ARTIFACT OF HOPE This stove heated a classroom in the Rosenwald-funded Hope School in Pomaria, South Carolina.

GEORGE WASHINGTON CARVER (ca.1864–1943)

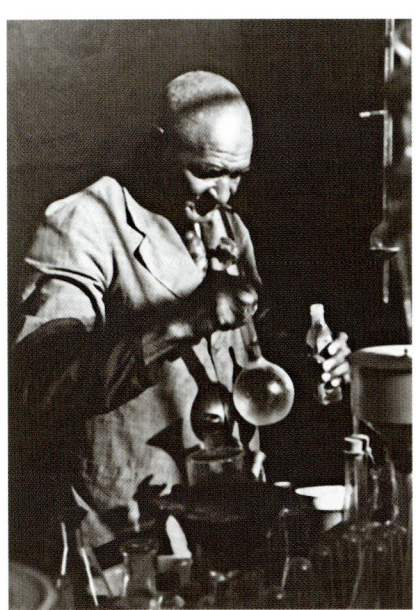

George Washington Carver, born into slavery and orphaned as a baby, was a leading botanist, environmentalist, and chemurgist who promoted recycling, composting, and the efficacy of agricultural products such as soy beans over fossil fuels. For nearly fifty years, Carver was based at Booker T. Washington's Tuskegee Normal and Industrial Institute (now University) in Tuskegee, Alabama, having joined its faculty in 1896 after earning his master's degree at Iowa Agricultural College and Model Farm (now Iowa State University). Carver built Tuskegee's agricultural department and ran its agricultural Experiment Station. He spearheaded outreach programs for local farmers, even introducing a classroom on wheels known as the Jesup Agricultural Wagon. To renew soil depleted by decades of growing cotton, Carver advocated crop rotation with soil-enriching plants such as peanuts, sweet potatoes, and black-eyed peas. His development of peanut-derived products, from coffee to cosmetics, led to him being known as "the Peanut Man." The NAACP's Spingarn Medal and the Theodore Roosevelt Medal for Outstanding Contribution to Southern Agriculture are among his many accolades. After his death, the George Washington Carver National Monument, a 210-acre park near Diamond Grove, Missouri, where Carver was born, became the first national monument dedicated to a black American and a nonpresident.

"Education is our passport to the future, for tomorrow belongs to the people who prepare for it today."

—MALCOLM X, 1964

many African American children in northern cities still landed in schools far inferior to those of their white counterparts because the new migrants lived in poor, de facto segregated communities.

Despite such handicaps, African American illiteracy continued to decline. By the mid-1950s, the number of predominantly black colleges had increased from the twelve listed in Freedmen's Bureau reports soon after the Civil War to almost a hundred. Enrollment of African American students in these institutions rose from 1,643 to more than 225,000. Presidents who were skillful fundraisers boosted the success of their institutions. They included Rufus E. Clement at Atlanta University; Mary McLeod Bethune at Bethune-Cookman College, Daytona Beach, Florida; Albert Dent at Dillard University, New Orleans, Louisiana; and Mordecai Johnson at Howard University, Washington, D.C.

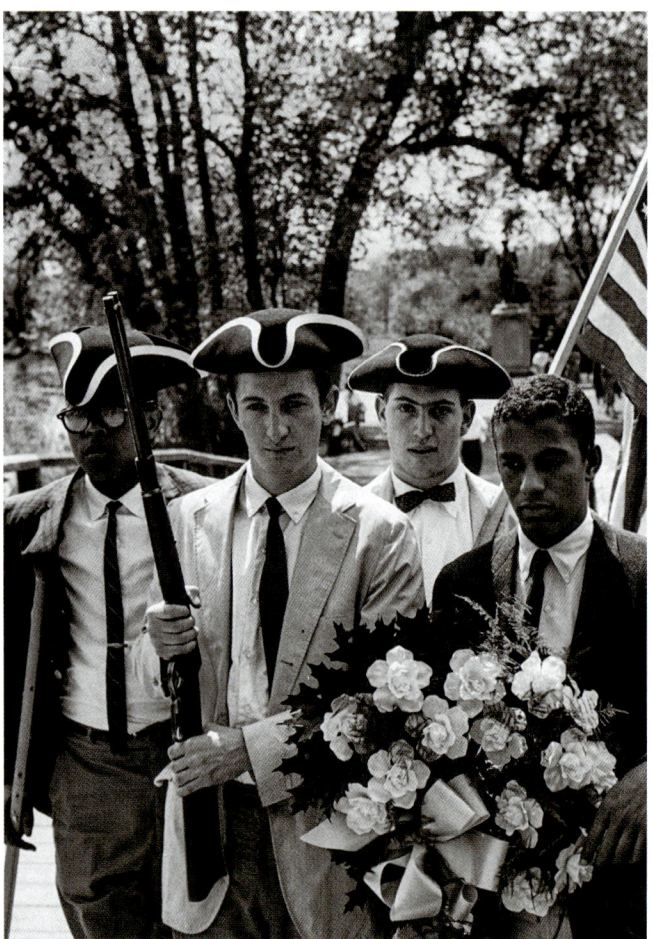

By 1944, however, the challenge of meeting operating expenses at African American colleges prompted the heads of thirty-three historically black colleges and universities (HBCUs) to pool their solicitation budgets and establish the United Negro College Fund (UNCF), which wealthy Americans supported with multimillion-dollar campaigns.

In the mid-twentieth century, the unanimous decision of the U.S. Supreme Court in *Brown v. Board of Education of Topeka*, delivered May 17, 1954, outlawed segregated public schools. Southern jurisdictions resisted vehemently, and the struggle that ensued not only desegregated schools, but also fueled the Civil Rights Movement and the Black Power Movement of the 1960s and 1970s. Nevertheless, the process of completely integrating public education remains a challenge some sixty years later, mainly due to housing patterns and wealth disparities.

HARVARD REMEMBERS

To celebrate the sixth anniversary of the Supreme Court's 1954 desegregation decision in *Brown v. Board of Education of Topeka*, Harvard University students (*left*) dress up as Revolutionary War Minutemen to symbolize a revolt against racial discrimination.

FUNDING OPPORTUNITY

A poster (*right*) promotes the United Negro College Fund scholarship program. Since 1944, the UNCF has raised $4.5 billion for thirty-seven historically black colleges and universities, providing funds for more than four hundred thousand students.

A Mind is a Terrible Thing to Waste

We are born with limitless potential. Help us make sure that we all have the chance to achieve. Please visit uncf.org or call 1-800-332 8623. Give to the **United Negro College Fund**

MORDECAI JOHNSON (1890–1976)

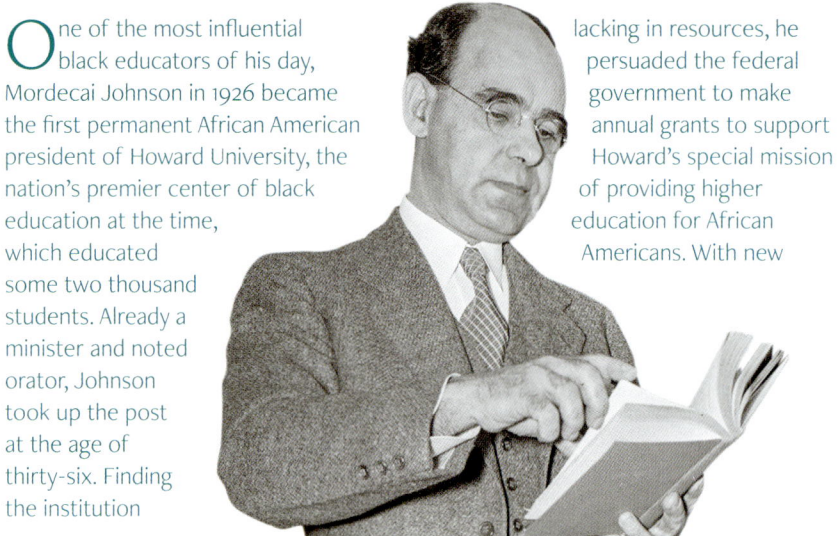

One of the most influential black educators of his day, Mordecai Johnson in 1926 became the first permanent African American president of Howard University, the nation's premier center of black education at the time, which educated some two thousand students. Already a minister and noted orator, Johnson took up the post at the age of thirty-six. Finding the institution lacking in resources, he persuaded the federal government to make annual grants to support Howard's special mission of providing higher education for African Americans. With new public funds and private donations, which he also raised, Johnson expanded the university's faculty. He attracted luminary black scholars, including Charles R. Drew in medicine, future Nobel Prize–winner Ralph Bunche in political science, and E. Franklin Frazier in sociology. Perhaps his greatest contribution to the university was the development of its law school. Its dean, Charles Hamilton Houston, laid the legal foundation that enabled Thurgood Marshall, a Howard graduate, to win the 1954 Supreme Court case *Brown v. Board of Education of Topeka*, outlawing segregation in public schools.

After the Brown decision there was a dramatic increase in the enrollment of African Americans in predominantly white colleges and universities, with a big surge in the 1960s and a steady increase since then. At the same time, colleges across the nation have hired increasing numbers of African American administrators and faculty. Of the almost one million African American students enrolled in colleges or universities at the dawn of the twenty-first century, just under one-third attended historically black institutions. Such a shift challenges HBCUs to find the necessary funds to expand their educational programs and build state-of-the-art campuses that can compete with predominantly white institutions and attract the most talented African American students as well as gifted faculty and administrators.

The history of African American educational institutions clearly illustrates their key role in educating generations of black women and men who were and are teachers, leaders, professionals, advocates, and more. From one-room schoolhouses to ivy-covered universities, black schools have played a pivotal role in the progress of African Americans. Today, the struggle continues as the nation tries to address poverty and other inequities that prevent African Americans and other minorities from taking full advantage of educational opportunities. Activist Malcolm X's 1964 admonition still resonates today: "Without education, you are not going anywhere in this world."

Religious Institutions

From the time of slavery, African Americans have embraced religion and spirituality to affirm their identity, uplift their community, and engage in the struggle for civil rights. The Africans who arrived in North America as captives were able to maintain some African spiritual traditions. However, vestiges of African worship fused with Christianity

to create distinctly African American churches. Weary of segregation and discrimination in predominantly white congregations, African Americans founded their own denominations, such as the African Methodist Episcopal (AME) Church and the National Baptist Convention, which developed their own styles of singing hymns and preaching. Such churches have preserved vibrant worship traditions, including dramatic preaching, gospel choirs, call-and-response-style liturgy and music, and Holy Ghost dancing. They also engaged in political and social activism against racism and promoted education.

During the antebellum era, slaveholders often used Christianity as a means of controlling enslaved black workers. Quoting selective Christian scriptures, masters proselytized that black slavery was the will of God, who would punish defiant slaves on Earth and in hell after death. Most enslaved people recognized such sermons as a subterfuge to justify their subjugation and exploitation. In fact, as enslaved converts learned more about genuine Christian principles, they came to believe that God would one day deliver them from cruel bondage. Such convictions inspired revolts and resistance, as in the case of Denmark Vesey, who, after purchasing his freedom, helped found a congregation of the AME Church in Charleston, South Carolina. Vesey frequently read biblical passages to his enslaved brethren, likening them to the Israelites whom God set free. Such preaching

LEMUEL HAYNES The black minister depicted on this lacquered tray (ca. 1835–40) is thought to be Lemuel Haynes. Ordained in 1785 after fighting for the Patriots in the American Revolution, Haynes pastored white churches in Connecticut and Vermont.

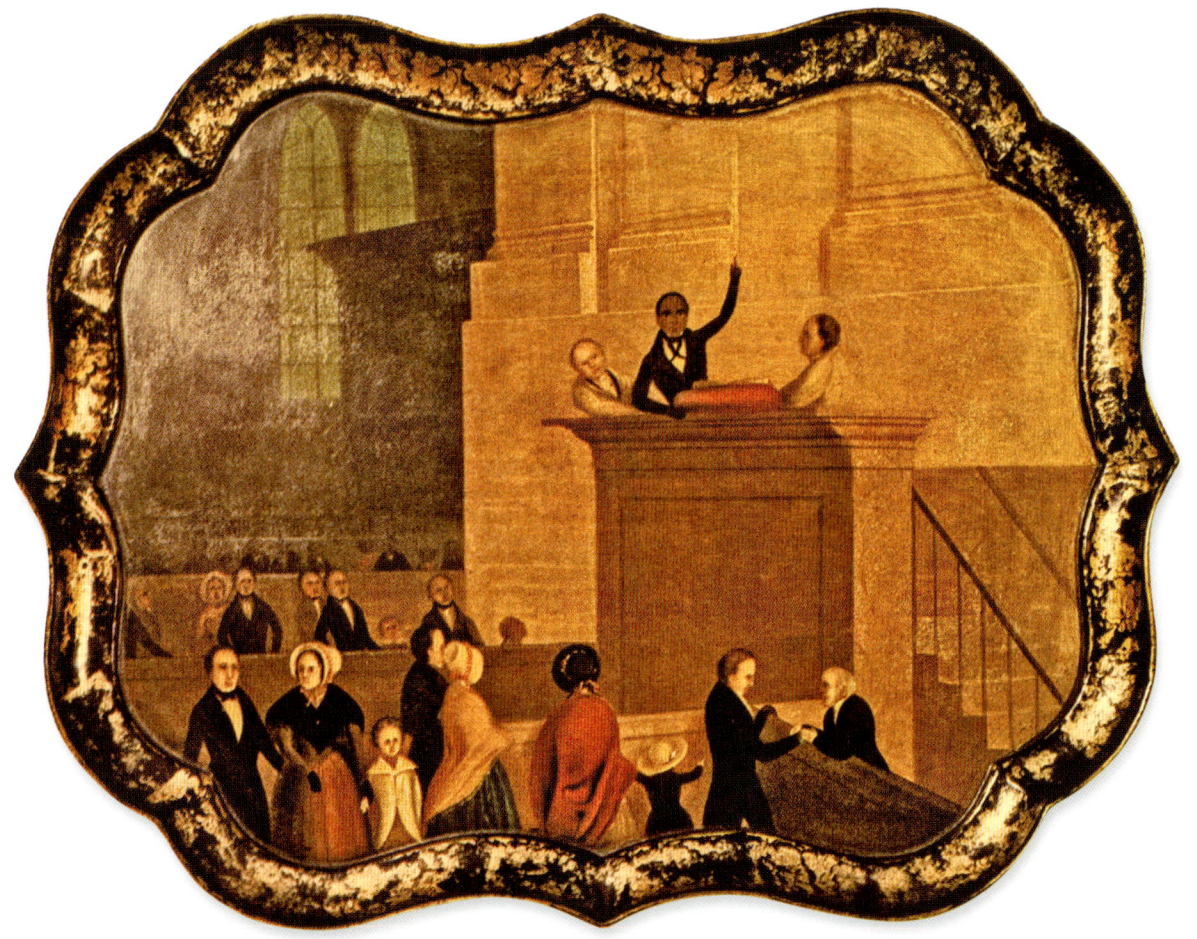

MOTHER BETHEL A poster dating from 1916 shows Mother Bethel AME Church surrounded by portraits of the church's clergy since its founding by Richard Allen (*center*) in a blacksmith's shop in Philadelphia in 1794.

"This land which we have watered with our tears and our blood is now our mother country."

—RICHARD ALLEN, 1827

set the stage for a rebellious plot in 1822, but when enslaved house workers leaked the conspiracy, white authorities hanged Vesey and dozens of others and burned down the AME Church.

In some northern states, white religious denominations had attempted to incorporate free black people, but after the American Revolution, many white congregations began to push them out on the grounds that African Americans would be more comfortable in segregated churches. Mistreated or ousted, the black men and women formed independent denominations that were not only religious, but also abolitionist, benevolent, educational, and reformist. Vesey's AME congregation was an offshoot of the first independent black denomination in the United States, founded by Richard Allen in Philadelphia in 1794 in response to new rules in a local Methodist church that required its African American parishioners to sit in segregated pews in the balcony. Similar racist practices galvanized a group of black Methodists in New York to establish the African Methodist Episcopal Zion

Church in 1796. By 1794, Absalom Jones had created an African American congregation within the Episcopal Church, and several independent black Baptist congregations had also deviated from their predominantly white mother church.

These religious institutions promoted racial solidarity and campaigns to abolish slavery, provided aid for runaway slaves, founded and funded educational institutions, and led efforts to gain political and social equality. Among the most politically active were the African American churches of Philadelphia, which played a major role in garnering signatures for a 1795 petition to the U.S. Congress to repeal the Fugitive Slave Act of 1793, which permitted slaveholders to pursue runaways across state lines. Black churches across the country harbored fugitive slaves and served as stations on the Underground Railroad.

In Ohio in 1856—about twenty years after South Carolina closed Daniel Payne's school for free and enslaved blacks in the wake of the Nat Turner Rebellion of 1831—Payne, by then an AME bishop, helped found Wilberforce University, a church-financed college for African Americans. Two decades on, in 1879, Livingstone College in Salisbury, North Carolina, started out as the Zion Wesley Institute under the authority of the African Methodist Episcopal Zion Church. African American church leaders also encouraged and sponsored literary societies, among them the Bethel Literary and Historical Association, which featured such speakers as journalist and activist Ida B. Wells and Frederick Douglass, at the Metropolitan AME Church in Washington, D.C., and the American Negro Historical Society, which met at a Philadelphia church. From small church sanctuaries that doubled as classrooms during the week to college-level institutions, black churches were in the vanguard of African American education.

Emancipation led to a large-scale expansion of independent churches among African Americans in all parts of the United States. Between 1850 and 1914, a cadre of black clergy emerged who believed that religious commitment involved actions and deeds that made the world a better place for the oppressed and downtrodden. The Social Gospel Movement expressed Christian principles by tackling social ills such as poverty, slums, racial injustice, and unemployment in African American communities throughout the United States. Collaborating with dedicated laypeople, black clergy stimulated and expanded the work of African American religious communities in ministering to the needs of their people.

As increasing numbers of African Americans migrated to cities in the early 1900s, black church membership increased and churches embraced their protective role, effectively becoming their brothers' keepers. Insisting that the church should be "an institution for social betterment," Henry H. Proctor, minister of First Congregational in Atlanta, set up a gymnasium, day nursery, employment bureau, music classes, and a Bible school. William N. DeBerry's congregation in Springfield, Massachusetts, established a home for

WILBERFORCE UNIVERSITY
Students take a typing class at the oldest private black university in the United States. Founded for African Americans by white Methodists in 1856, the college was acquired by the AME Church in 1863.

young working women, a welfare league for women, handicraft clubs for boys and girls, an evening school for domestic training, and an employment bureau. In Chicago in the late 1920s, Samuel Joseph Martin turned St. Edmund's Episcopal Church, a white church that had lost most of its members, into a center of social reform for the African American community. About the same time, Harold Kingsley developed a successful service-oriented parish at Good Shepherd Congregational, also in Chicago. This progressive movement generated black leaders who helped African Americans from rural areas grasp the new opportunities for political participation available in urban areas.

Scattered throughout inner-city black communities were "storefront churches," congregations that met in commercial buildings that had been converted into worship spaces. Still a feature of urban neighborhoods today, these small congregations frequently attract the poor and recent migrants. Often sites of emotional preaching and worship, they are centers of support and hope for struggling people.

Women were a powerful force in religious institutions, some as clergy and many as concerned activists. Journalist Victoria Earle Matthews worked with New York churches and ministers in the 1890s to establish the White Rose Mission, a settlement house for young black migrant women, which helped them find employment and safe living quarters in an effort to protect them from sexual exploitation. Bridget "Biddy" Mason (see page 66), who accumulated a sizeable fortune during the course of her life, financed the building of an AME Church in Los Angeles, the first black church in the city, and was known for her philanthropy to people of all races. Mason was born in slavery in Mississippi but sued and won her freedom in 1856 after being taken to the free state of California by her master.

As church volunteers, fundraisers, and teachers in Sunday schools and church-run academic schools, women contributed immeasurably to the African American community. Because of resistance from male church leaders, few rose to clerical levels in the 1800s, but there were exceptions. Jarena Lee, for example, received authorization from Richard Allen to preach in the AME Church and practiced her ministry in New England and Canada. Her contemporary Rebecca Cox Jackson founded a black Shaker community in Philadelphia in 1859. In the mid-twentieth century, Mary G. Evans became one of black America's most influential pastors while heading a dynamic congregation at Cosmopolitan Community Church in Chicago.

Sometimes social reform emerged from cultlike religious groups whose charismatic leaders claimed to be the embodiment of God. During the Great Depression, George Baker, addressed by his followers as "Father Divine," transformed a small African American church in New York City into a multiracial, international body whose members gathered in meeting places known as "heavens." As well as feeding thousands, Baker's church led a crusade against lynching, called for reparations for descendants of slaves, and instructed his members on ways to strive for economic independence. In the 1920s, Charles Manuel, an evangelist known as "Sweet Daddy Grace," founded the United House of Prayer for All People and established branches in African American communities across the country.

FATHER DIVINE Hand-painted slogans express the optimistic philosophy of religious leader Father Divine (George Baker, 1889–1965). The Peace Mission he founded encouraged racial equality and economic self-sufficiency. Divine actively worked to desegregate America and helped members establish thriving businesses.

TALKING WITH GOD
Rex M. Ellis

Religion and spirituality have served several vital purposes in African American history and culture. Spending time under the sacred roof of prayer and talking with God often delivered enslaved people from earthly pain and heightened their desire for freedom. Prayer for many African Americans was thus a profound act of religious expression throughout the crucible of the black experience.

Jarena Lee, born free in 1783, experienced one of the most significant spiritual conversions in early African American history. She later described her 1807 summons from God to enter the ministry in her autobiography:

An impressive silence fell upon me, and I stood as if someone was about to speak to me ... to my utter surprise there seemed to sound a voice which I thought I distinctly heard, and most certainly understand, which said to me, "Go preach the Gospel!" I immediately replied aloud, "No one will believe me." Again I listened, and again the same voice seemed to say, "Preach the Gospel; I will put words in your mouth, and you will turn your enemies to become your friends."

A Philadelphia resident at the time, Lee shared the experience with Richard Allen, founder of the AME Church and one of the city's most respected religious leaders. But even someone as enlightened as Allen could not bring himself to accept Lee's sanctification. Black religious leaders were exclusively men; they belonged to a privileged male world that could not imagine a twenty-four-year-old female servant such as Jarena Lee hearing directly from God.

Nevertheless, Lee remained courageously steadfast. Even though Bishop Allen and other church elders would not ordain her, she felt that spreading the gospel was her spiritual calling and her responsibility. Her powerful experience of talking with God propelled her to begin preaching without the authority of the church. Eventually, during an AME worship service in 1819, Lee spoke out so passionately—as if by "supernatural impulse," she later wrote—that Allen was moved to finally grant her permission to preach. She became the first black woman preacher in the AME Church.

During the course of a four-year period in the early 1820s, Lee traveled 1,600 miles—more than 200 of them on foot. She spread the gospel to many cities, including Albany, Brooklyn, Buffalo, Philadelphia, Pittsburgh, and Trenton, and small towns throughout the Mid-Atlantic region. Although she occasionally encountered doubters who believed she was "not a woman, but a man dressed in female clothes," she more often preached to congregations that fervently engaged in "shouting and praising of God for what he had done."

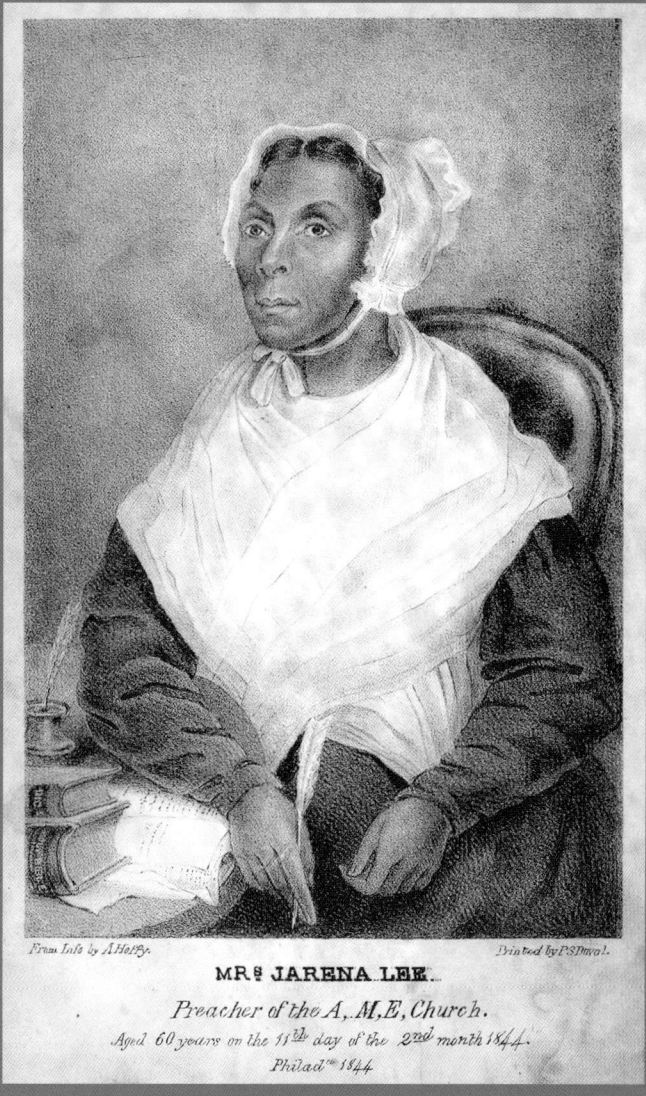

From life by A.Hoffy. Printed by P.S.Duval.
MRS JARENA LEE.
Preacher of the A. M. E. Church.
Aged 60 years on the 11th day of the 2nd month 1844.
Philad.ᵃ 1844

ANSWERING THE CALL Despite the gender restrictions of her time, Jarena Lee persuaded AME Church leader Richard Allen to authorize her to preach. She became the church's first female minister in 1819.

Lee's achievements are still significant in the twenty-first century, when women ministers have become much more common and when the AME Church in 2000 even elected Reverend Vashti Murphy McKenzie as its first female bishop. What Lee achieved some two hundred years ago serves as a spiritual touchstone for individuals—male and female—and for the African American community as a whole. Lee dreamed a world anew, broke free of the shackles of society's restrictions, and used her calling to enhance both her life and the lives of those around her.

Despite discrimination against African Americans in housing, he amassed prime real estate. Critics decried his extravagant lifestyle; nonetheless, he drew hundreds of thousands of followers.

The Nation of Islam (NOI), often called Black Muslims, although it deviated from traditional Islam, emerged in the 1930s and within a few decades became a powerful religious, social, and political force in the African American community. Under the leadership of Elijah Poole, who renamed himself Elijah Muhammad, the NOI promoted moral and social reform. Although controversial and racially polarizing to many people, the reli-

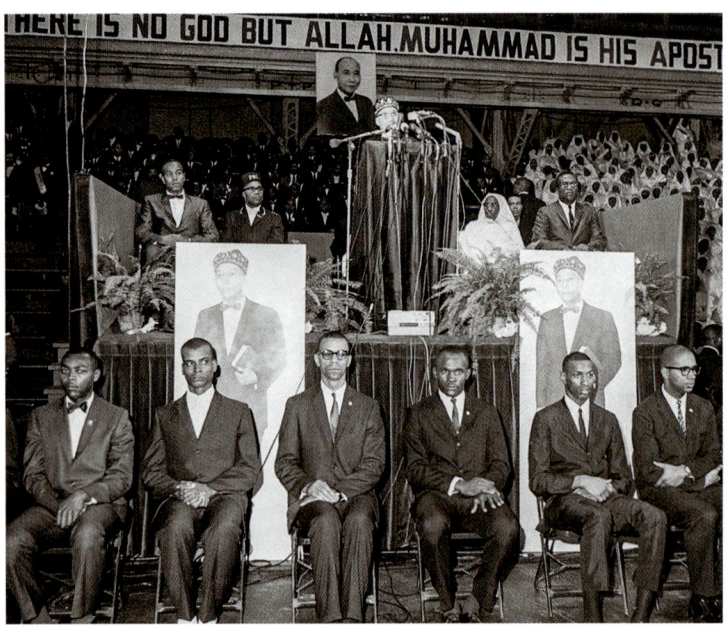

gious group appealed to many alienated African Americans because it gave them a new identity and an empowering worldview. Black Muslims built temples and established schools and clinics. By creating a business empire that included farms, bakeries, supermarkets, and restaurants, the NOI provided employment for its members. By the early 1970s, the movement had grown into a vigorous faith and a self-sufficient black community of nearly one hundred thousand people.

Churches and ministers became key figures in the Civil Rights and Black Power movements of the 1950s, 1960s, and 1970s. Martin Luther King Jr., then minister of the Dexter Avenue Baptist Church in Montgomery, Alabama, made the church the nerve center of the 1955–56 Montgomery bus boycott, which led to the integration of the city's public transportation system. King met with strategists in the church's basement, printed leaflets on the church mimeograph machine, and rallied supporters from the pulpit. Soon after that victory, in January 1957, King gathered sixty ministers at Ebenezer Baptist Church in Atlanta and established the Southern Christian Leadership Conference (SCLC) to coordinate the nonviolent protest movement that would soon sweep the nation. Ralph Abernathy, Fred Shuttlesworth, C. T. Vivian, Jesse Jackson, and Andrew Young were among the

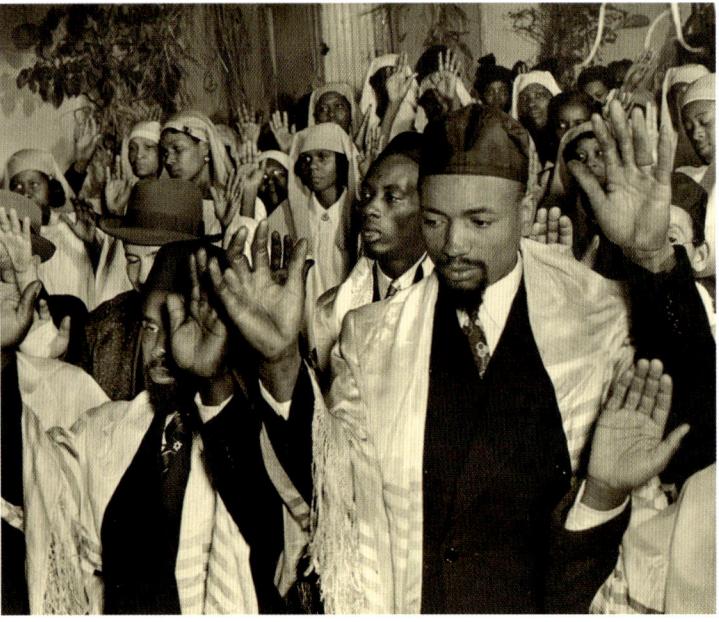

NATION OF ISLAM With his Fruit of Islam guards ringing the podium, Nation of Islam leader Elijah Muhammad speaks at a convention in Chicago in 1966 (*top, left*). Founded in the 1930s, the sect had evolved into an influential social and political force by the 1970s, with tens of thousands of converts.

KEEPING THE FAITH Members of the Commandment Keepers Ethiopian Hebrew Congregation (*left*) raise their hands in prayer during a service in New York City in 1940. Rabbi Wentworth Arthur Matthew, a Garveyite, founded the all-black congregation in 1919, claiming that they were descended from Ethiopian Hebrews.

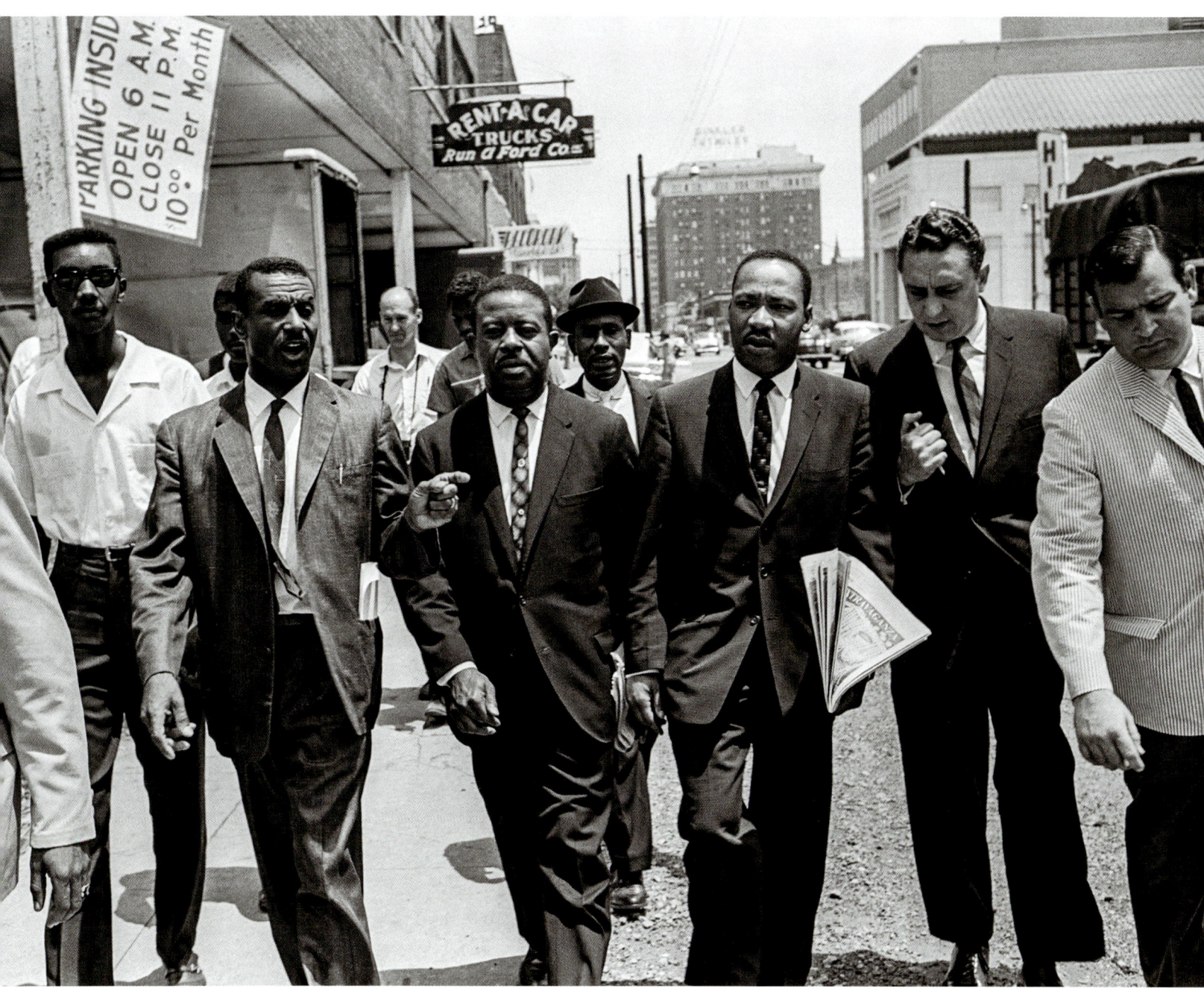

many clergymen who became prominent national figures during this era. Church and clergy spearheaded the struggle for civil rights, from parish basements all the way to the White House.

Although many black churches made politics and activism central to their mission, others followed an apolitical path. The main focus of these more conservative churches continued to be spirituality as expressed in worship, prayer, and leading a moral life.

A small but notable African American religious community is the Black Hebrew Israelites, sometimes referred to as Black Jews, who describe themselves as descendants of

CHRISTIAN SOLDIERS

Many ministers were on the front line of the Civil Rights Movement, including Southern Christian Leadership Conference members (*center, left to right*) Fred Shuttlesworth, Ralph Abernathy, and Martin Luther King Jr., here going to a press briefing in 1963.

the ancient Israelites depicted in the Jewish scriptures. Various branches of the movement sprang up in the United States in the late nineteenth and early twentieth centuries, attracting adherents from the native-born African American and the immigrant West Indian communities. Some combined the theology, piety, and worship practices of Christianity and Judaism; others did not. In Harlem, in 1919, Wentworth Arthur Matthew founded the Commandment Keepers Congregation; he identified the African American experience of exile with that of the ancient Jews.

From the time of origin, the specific beliefs and practices among the various segments of the Black Hebrew Israelite community varied widely. This continues to be true. None of those affiliated with the religious community are recognized as authentic Jews by the members of the Jewish community in the United States, Israel, or other parts of the world. In 1969, the African Hebrew Israelites of Jerusalem, a segment of the religious community, moved to Israel, claiming a right to citizenship under the Law of Return. Ultimately, their claim was denied by the government of Israel.

For My People (excerpt), 1942
Margaret Walker

For my people standing staring trying to fashion a better way
from confusion, from hypocrisy and misunderstanding,
trying to fashion a world that will hold all the people,
all the faces, all the adams and eves and their countless generations;

Let a new earth rise. Let another world be born. Let a
bloody peace be written in the sky. Let a second
generation full of courage issue forth; let a people
loving freedom come to growth. Let a beauty full of
healing and a strength of final clenching be the pulsing
in our spirits and our blood. Let the martial songs
be written, let the dirges disappear. Let a race of men now
rise and take control.

The Press

For much of U.S. history, the mainstream news media ignored the stories and lives of African Americans. Even when the media did acknowledge them, the coverage was often biased and derogatory. In response, African Americans created their own newspapers, magazines, and media outlets to tell their own stories.

African American newspapers appeared in the northern United States decades before the Civil War and never ceased to advocate for the advancement of black people. In 1827, free black men John Russwurm, a journalist, and Samuel Cornish, a Presbyterian minister and editor, published the country's first African American–owned

"The truth must be told.... I will not be silent."
—FREDERICK DOUGLASS, 1847

newspaper, *Freedom's Journal*, in New York City. Like similar publications that followed, the paper crusaded to abolish slavery. Twenty years later, Frederick Douglass launched the *North Star*, the most influential newspaper of the anti-slavery movement.

African American newspapers and magazines were among the most important sources of news and opinion in black communities throughout the United States. Coverage of African Americans and their concerns in the white press was limited, biased, and often disparaging. Prior to the mid-twentieth century Civil Rights Movement, African Americans usually found their "race" newspapers the only trustworthy sources of information and opinion. Black newspapers advocated for equality and justice and provided positive images of African Americans.

After the Civil War and throughout the twentieth century, African American newspapers raised ardent voices demanding social justice, political rights, economic opportunity, and respect for the black community. Editorials and columns reflected a fierce advocacy. "White faces seem to think it their heaven-born right to practice civil war on Negroes, to the extent of bloodshed and death," Mary Cook Parrish wrote in a column for the *South Carolina Tribune* in 1887. "They look upon the life of their brother in black as a bubble to be blown away at their pleasure.… This outrage cannot continue. God still lives, and that which has been sown shall be reaped."

Black newspapers provided a platform for African Americans to vent their anger and frustrations, to affirm the decency and respectability of black Americans, and to issue a call to action. As the editor of the *New York Age* in the 1880s, T. Thomas Fortune established himself as the leading advocate for African American rights by speaking out against discrimination and inequality. One of his editorials denounced a U.S. Supreme Court decision of 1883 that curtailed black civil rights, while another criticized the Republican Party for neglecting African Americans. When the printing press of anti-lynching crusader Ida B. Wells was destroyed in 1892, Fortune invited her to continue her campaign at the *New York Age*. Fortune was a militant, influential voice in the black press for more

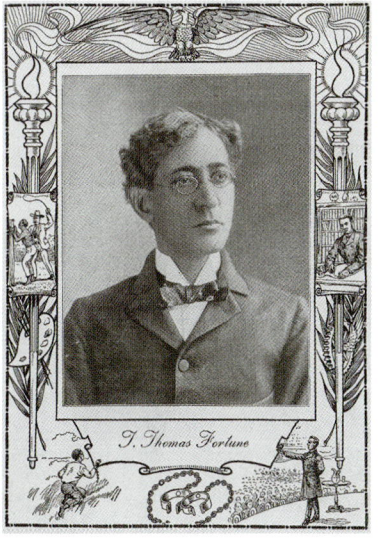

ACTIVIST EDITOR T. Thomas Fortune, born to enslaved parents in 1856, had become a crusading journalist by the late 1800s. During his editorship of the *New York Age*, the publication became the nation's leading newspaper for African Americans.

than twenty years. He also wrote books on economics and race and founded the Afro-American League, an organization devoted to obtaining equal rights for blacks. He spent the last years of his life editing the *Negro World*, the newspaper of Marcus Garvey's black nationalist organization.

The number of African American newspapers proliferated in the early 1900s. By 1979, more than 350 African American newspapers, magazines, and bulletins were publishing on a weekly, monthly, or quarterly basis. The *Atlanta Daily World* and the *Chicago Defender* printed daily; the *New York Amsterdam News*, the *Pittsburgh Courier*, the *Norfolk Journal and Guide*, the *Baltimore Afro-American*, and the *Los Angeles Sentinel* published weekly.

While many of the matters addressed by the black press were similar, individual newspapers often focused on particular issues. At the start of World War I, the *Chicago Defender's* campaign urging African Americans to abandon the South and seek opportunities in northern cities fueled a migration that transformed the African American community. Through editorials and dramatic headlines, the *Defender* decried racial brutality and economic oppression in the South while encouraging black people to trade their meager farm existence for jobs in the booming northern industrial economy. Hundreds of hopeful migrants wrote the paper seeking information about jobs and advice on how to relocate. The *Defender* published train schedules, job listings, advice about schools and housing, and even declared May 15, 1917, the day of the "Great Northern Drive." White authorities in the South, worried about a labor shortage if blacks migrated, confiscated copies of the *Defender*, but black Pullman porters surreptitiously disseminated it on their southern railroad routes, and readers passed it from person to person.

"ONE-SHOT" HARRIS

Photographer Charles "Teenie" Harris rarely needed to take more than one shot to capture his subject. A native of Pittsburgh, where he had a studio and worked for the *Pittsburgh Courier*, Harris took thousands of images documenting African American life from the 1920s to the 1970s.

The *Pittsburgh Courier,* another nationally circulated newspaper, claimed the spotlight during World War II for its "Double Victory" campaign, a call for all Americans to defeat totalitarian forces in Europe and Asia and, equally important, overthrow racism at home. Double V enthusiasm swept the nation as people wrote articles and songs about dual victories and used the symbol in photographs, fashion, and hairstyles. Through columns and editorials, the paper denounced segregation in sports teams and encouraged black voters to shift from the Republican Party to the Democratic Party for a better ally in the effort to achieve justice and equality.

The *Norfolk Journal and Guide*, a politically moderate newspaper headquartered in Virginia, led African American voter registration campaigns and pressed for the integration of the U.S. armed forces. On the West Coast, the *Los Angeles Sentinel* pressed for

THE *AFRO-AMERICAN* NEWSPAPER: REPORTING ON THE MARVELOUS AND THE MUNDANE

Elaine Nichols

Like other black newspapers, the *Baltimore Afro-American* became the voice of the African American community in its city and beyond. In many instances, it was a unifying force that promoted black businesses through advertisements; covered births, marriages, and deaths; and reported on fashion and the outstanding achievements of its readers.

First published as a four-page weekly on August 13, 1892, the *Afro-American* went bankrupt in 1896. John H. Murphy, formerly the manager of the paper's printing department, purchased it at auction for $200, and on March 27, 1897, published the newspaper under his name as owner and business manager, with the aim of campaigning for the rights of African Americans.

In January 1900, Murphy and George F. Bragg merged their newspapers to create the *Afro-American Ledger*, a weekly that continued until Bragg left in 1915. Afterward, it once again became the *Afro-American*.

At the time of Murphy's death in 1922, the *Afro-American* was the largest black newspaper on the East Coast. The paper continued under the guidance of Murphy's sons, with Carl Murphy as president and publisher from 1922 to 1967. His editorial page was a forum for local, national, and international issues that impacted the lives of African Americans, including lynching, discrimination against men and women, and inadequate educational facilities and housing. Before entering the newspaper business, Murphy, a graduate of Howard and Harvard universities, had been a professor of German and chair of the German department at Howard from 1913 to 1918.

In addition to their legacy as the publishers of one of America's major black newspapers, the Murphy family produced leaders in a number of fields. Carl's wife, L. Vashti Turley Murphy, was a campus leader at Howard University and later a respected educator and community activist. In 1913, she and twenty-one other women founded Delta Sigma Theta, a national public service sorority. Two of the couple's daughters, Frances L. Murphy II and Elizabeth Murphy Moss, assumed executive offices at the newspaper after their father's death. Carl and Vashti's granddaughter, Vashti Murphy McKenzie, the first woman bishop in the AME Church, began her career working for the family paper after she graduated from the University of Maryland.

In addition to serving as a vehicle for protest and advocacy, the *Afro-American* provided a place where African American sports figures and entertainers could be recognized and celebrated for their accomplishments. It was also a venue for black journalists to hone their skills. Langston Hughes, William Worthy, and J. Saunders Redding wrote for the newspaper, and from 1935 to 1937 artist Romare Bearden contributed political cartoons. In the late 1930s, the paper was the first African American newspaper to hire a female sportswriter when Lillian Johnson joined the staff.

The *Afro-American*, which has offices in Baltimore and Washington, D.C., was at one time published in more than a dozen markets across the country. It is the longest-running black family-owned newspaper in America and still functions as a guardian voice of the African American community.

A CUT ABOVE This cast-iron paper cutter was one of the machines used to produce the *Baltimore Afro-American*. Purchased in the 1920s, the cutter was used to trim newspapers until 1992.

economic equality, stimulated expansion of African American entrepreneurship, and brought the "Don't Buy Where You Can't Work" campaign of the 1930s from northeastern cities to Los Angeles to fight discriminatory hiring practices.

After World War II, the most significant growth in black publishing was the uptick in monthly or quarterly magazines, many of them produced by the Johnson Publishing Company, founded in 1942 by John H. Johnson. Three years later, the company launched *Ebony* magazine, the most successful publishing venture in the history of African American journalism. Modeled on the popular white-owned news-pictorial *Life* magazine, *Ebony* presented articles and glossy color photographs of African Americans as high-achieving, self-confident, well-mannered people. With a strong emphasis on the lifestyles of educated, financially independent, successful members of the black elite, the magazine conveyed the message that African Americans were significant contributors to the nation and the world. In 1951, Johnson added a new publication called *Jet*, a pocket-size weekly news digest that contained more news than some weekly newspapers but in smaller bites.

Essence, one of the most popular of the new publications, appeared in 1970. Although focused primarily on fashion and beauty, the magazine, under the editorship of Marcia Gillespie in 1971, became an instrument for empowering African American women. Its provocative articles championed the women's liberation movement by attacking sexism and misogyny. Today, its pages include discussions of a range of issues, from racial injustice to work issues and business strategies to family matters. During the 1970s and 1980s, it was one of the fastest-growing women's publications in the United States.

JOHN H. JOHNSON (1918–2005)

When publishing mogul John H. Johnson was a boy, he repeated eighth grade because his rural Arkansas community did not have a high school for African American students. The son of a sawmill worker, Johnson craved education and success, the spurs that eventually transformed him into one of America's most influential publishers. Facing extreme hardship during the Great Depression, Johnson's family migrated to Chicago in 1933. Johnson excelled in high school, becoming editor of his school newspaper. While attending the University of Chicago on a scholarship, he worked part-time at an insurance company, compiling a news digest for its clients. In 1942, with a loan of $500 secured with his mother's furniture, Johnson founded his own publishing company. Three years later, he launched *Ebony*, his flagship magazine, chronicling African Americans' achievements and challenges. Johnson expanded the company, adding a book division and other publications, including the popular weekly magazine *Jet*. With the assistance of his wife, Eunice, the company also launched a line of cosmetics specifically for black women and staged haute couture fashion shows. His many ventures portrayed African Americans living successful middle-class lives. In 1982, Johnson became the first African American to make it onto *Forbes* magazine's list of the four hundred wealthiest Americans.

BLACK VOICES The academic journal *Opportunity* (*above*) first appeared in 1923, publishing discussions of social issues and the works of Harlem Renaissance writers and artists. Editor Charles Spurgeon Johnson ran literary contests to encourage black writers. Winners included Zora Neale Hurston, Langston Hughes, and Countee Cullen. In 1910, W. E. B. Du Bois founded *The Crisis* (*above, right*), the official publication of the National Association for the Advancement of Colored People (NAACP), to crusade against racism. Still publishing today, *The Crisis* covers a broad range of topics, from news and politics to arts and entertainment. *Ebony* magazine (*right*) entered the market in 1945 with inspirational features about African American achievers. Its broad mix of serious news, provocative views, lifestyle features, and celebrity interviews still make it one of the most popular publications aimed at African Americans.

By the 1950s, the African American press had clearly become a major enterprise, generating employment opportunities for black reporters, editors, printers, and businesses at a time when they were denied jobs on white publications. One unusual work arrangement in 1950 was that of black journalist Robert Churchwell Sr., who became the first African American to work for a major newspaper in the South when he was hired by the *Nashville Banner*. Although Churchwell was initially forced to work from home, the quality of his

"The Black press's primary focus was to serve as platforms for the Black abolitionist community and to fight the widespread conception of Black inferiority."

—JOHN HOPE FRANKLIN, historian, 1947

TRAINING GROUND Robert Churchwell Sr. (*lower left*) studied journalism at Fisk before joining the all-white *Nashville Banner* in the 1950s. The class, shown here, was taught by poet Robert Hayden (*standing, in light-colored jacket*).

work eventually brought an end to segregation in the *Banner* newsroom.

In general, the black press denounced white politicians whom it viewed as hostile to African American concerns and lauded those it perceived as allies. The black press usually focused on civil rights in presidential elections and supported candidates it judged to be friends of the freedom struggle. The *Chicago Defender* and the *California Eagle* denounced conservative white Republicans who opposed civil rights legislation, likening them to Nazi leaders. In 1964, the black press was particularly critical of Barry Goldwater, the Republican presidential candidate, and over the next few decades declared the Democratic Party a better ally than the Republican Party to African Americans in their efforts to gain equality.

Some news operations, however, equivocated in the civil rights battle. Although the *Atlanta Daily World* gave the Montgomery bus boycott of 1955 strong support, it was often critical of Martin Luther King Jr.'s massive protest marches, which in its view were too bluntly confrontational to whites, even though they were nonviolent. The *Birmingham World* criticized protesters' direct action as "wasteful and worthless" and accused civil rights organizations of being unwilling to work with white moderates. Consequently, some civil rights demonstrations got little, skewed,

or no local press. In some instances, the documentation of the shocking details of the beatings, water hosings, and dog attacks of that turbulent era fell to major liberal white newspapers such as the *New York Times*. That circumstance turned out to be an odd harbinger of future media coverage of African Americans.

As the United States became more racially integrated, African American press circulation declined. Pioneering newspapers such as the *Pittsburgh Courier* and the *Chicago Defender* could no longer attract a national readership. Local white newspapers increasingly covered matters in the African American community, including weddings, funerals, and church news, diminishing the need for black newspapers. Still, many African American newspapers persevered, as the continued existence of the *Chicago Defender*, Boston's *Bay State Banner*, the *Los Angeles Sentinel*, and other newspapers attests.

The historic black press, which spans nearly two hundred years, was paramount in shaping the African American community. Without it, lives today would be noticeably different. Perhaps the most significant contribution of the black press to the African American community was its function during the decades of slavery and segregation as a medium in which intellectuals, activists, and leaders could give public expression to their own thoughts and their own images. Through their publications, the courageous editors of African American newspapers functioned as guardians of their communities, using the press as a weapon against enemies. Essentially, they turned their newspapers into windows into the world of African Americans, shedding light on a people made invisible by racism.

Stronger Together

From the early days of the republic, African Americans organized to build a cohesive, supportive community as well as to secure political and social rights. Fraternal organizations and benevolent societies—along with churches and religious organizations—were some of the most helpful and constructive groups in the African American community.

As early as 1784, Boston abolitionist Prince Hall petitioned and received a charter from the Grand Lodge of England to establish the first lodge for black Masons. In addition to exemplifying honor, integrity, and friendship, members of the African Grand Lodge of North America sponsored scholarships for promising students, provided charity for the needy, and performed other acts of goodwill. A plethora of fraternal and benevolent societies sprang into existence soon after the Civil War as African Americans faced radical changes in their status and lives.

Although most African Americans had little surplus capital to channel into philanthropic undertakings, they established numerous organizations devoted to helping the less fortunate of their race. It was not uncommon for the better-off to launch social initiatives to uplift the race and combat racism. One of the nation's most influential black women, Mary McLeod Bethune, who was an educator and minority affairs adviser to President Franklin D. Roosevelt, created the National Council of Negro Women (NCNW) in 1935 as an umbrella organization to coordinate the many African American women's groups. Still active today, the council's main goals are to promote the well-being of women and their families through community-based education, mentoring, and support.

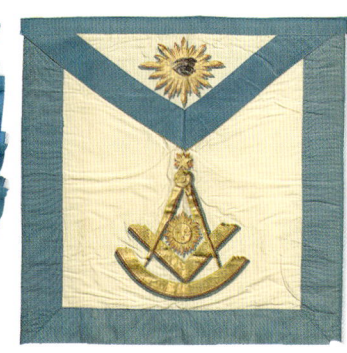

FRATERNAL REGALIA

Freemason Daniel Hendricks (*above*) wears a Masonic apron and collar in an early 1920s photographic postcard. An apron from a historic black Masons organization, Prince Hall Grand Lodge of Massachusetts (*top*), dates from the late eighteenth century.

MARY McLEOD BETHUNE (1875–1955)

"Without faith, nothing is possible. With it, nothing is impossible," Mary McLeod Bethune declared years after overcoming a bleak childhood. One of seventeen children, she picked 250 pounds of cotton a day as a young girl in South Carolina before an opportunity to attend a black missionary school changed her life. After college, she became a devoted educator and civil rights advocate and in 1904 founded a school for black girls in Florida, which later merged with the all-male Cookman Institute to become a college. Bethune served as president of the National Association of Colored Women (NACW) from 1917 until 1925 and in 1935 founded the National Council of Negro Women (NCNW), "a national organization of national organizations" that continues to advocate for female empowerment. As unofficial adviser to President Franklin D. Roosevelt, she had the president's ear on issues affecting African Americans. She also worked with First Lady Eleanor Roosevelt to further black causes, in one instance gaining the admission of African American women to the Women's Army Corps in England during World War II. Bethune's dedication to social causes—from protesting lynchings and poll taxes to supporting tenant farmers—prompted some to call her the "First Lady of the Struggle."

The first African American fraternities were founded in the early twentieth century at Indiana University and Cornell University, primarily as study groups to encourage academic achievement and provide mutual support in coping with racism at predominantly white colleges. Sororities and additional fraternities soon appeared on black college campuses, where their emphasis on leadership and scholarship led to a century of service, charitable work, and social bonding. To this day, some of the most distinguished figures in the African American community belong to black sororities and fraternities.

During the late nineteenth century and the first half of the twentieth century, the number of learned societies and professional organizations swelled as more and more African Americans earned college degrees. In 1897, the Reverend Alexander Crummell established the American Negro Academy (ANA), extending membership to fifty highly educated black men. The ANA was the embodiment of what W. E. B. Du Bois later called "the Talented Tenth"—the "exceptional men" in the African American population who would guide the rest by promoting higher education, literature, art, and science and generally elevate intellectualism.

In 1916, African American historian Carter G. Woodson started the Association for the Study of Negro Life and History (later renamed the Association for the Study of African American Life and History) and published several journals in an effort to preserve, research, and disseminate the history and culture of African Americans. He also initiated Negro History Week, the precursor to Black History Month.

While many organizations bolstered black culture and the welfare of the community, their power and influence are also reflected in African Americans' effort to attain fair treatment at work. In 1886, a group of southern black farmers fought economic exploitation

CALLED TO ACTION

Educated black women established charitable and activist organizations to assist poor African Americans across the country. Suffragette Daisy Lampkin (*above, center*), with activist Dorothy Height (*seated on Lampkin's left*), chairs a meeting of the National Council of Negro Women (NCNW) in 1935.

THE PINK AND GREEN For a century, black fraternities and sororities have worked for the advancement of African Americans. Alpha Kappa Alpha is the oldest Greek letter organization founded by black college women. This Alpha Kappa Alpha flag (*below*) traveled with a 2008 exhibition marking the sorority's centenary. Their pins (*clockwise from far left*)—a circle of pearls belonging to an honorary member, a life membership pin in the shape of an ivy leaf, and a silver pendant—reflect years of service.

EARLY BLACK ENTREPRENEURS

Michèle Gates Moresi

Throughout their history in North America, African Americans with bright ideas and talent have created products and strategies that have made them worthy of the term *entrepreneur*. Nevertheless, during the slavery era, slaveholders invariably exploited enslaved people's innovations, and even when free, African American entrepreneurs faced obstacles that limited their access to capital and consumer markets.

Unjust laws and customs that checked the business activities of African Americans date back to colonial times. After the Civil War, white workers systematically pushed blacks out of many trades, often the very trades that black workers had excelled in during slavery. Stories of African Americans who triumphed in business one hundred to two hundred years ago are, therefore, impressive and instructive.

The tenacious resolve of Henry Boyd, born into slavery in 1802, exemplifies the kind of entrepreneurial spirit celebrated in America. After working in the Kanawha salt works in West Virginia to earn enough money to purchase his freedom, Boyd trained as a carpenter and then migrated to Cincinnati in 1826. However, no carpentry shop would hire Boyd, because white laborers were unwilling to work alongside a black man. Eventually, with the support of a white merchant who learned of Boyd's carpentry skills after employing him as a porter, Boyd was able to set up a business of his own. From 1836 to 1863, his furniture factory in Cincinnati supplied hotels and homes throughout the American South and West with Boyd's Bedsteads, known for their solid yet easy-to-assemble design. While abolitionists celebrated Boyd's achievements and held him up as a model of African American enterprise, his success also sparked resentment from pro-slavery and working-class whites. Although Boyd sought to reduce racial tensions by employing both white and black workers, arsonists repeatedly targeted his factory. He rebuilt the factory twice, but after it burned down a third time in 1863, he was unable to obtain fire insurance and was forced to abandon his business. He continued to work as a carpenter until his death in 1886.

Another early entrepreneur, James Wormley, was born in Washington, D.C., to free parents Mary and Lynch Wormley in 1819. Lynch Wormley ran a successful livery in the city—so successful that he acquired several properties and invested in local businesses, including a hotel. James worked for his father, driving a hackney, and his wife, Anna, ran a confectionery shop. James expanded his skills over the years through a variety of jobs, including working as a steward on a Mississippi riverboat. Using the entrepreneurial instincts learned from his father, he started a catering business in Washington and opened a boardinghouse serving the capital's congressmen and traveling businessmen. In 1871, Wormley opened his own hotel, which became known for its fine accommodations and well-appointed dining room, serving European-style dishes made with fresh ingredients from Wormley's own farm. (Situated a few blocks from the White House, Wormley's Hotel was the site of tense negotiations over the disputed presidential election of 1876, eventually won by Rutherford B. Hayes.)

A community leader as well as a successful hotelier, Wormley led the effort to secure tax funding for the first public school for black children in Washington, D.C. When he died in 1884, he left the hotel to his sons, who continued to operate it until 1893.

Maggie Lena Walker, the daughter of a laundress, developed outstanding organizing skills and business acumen, which she used to nurture a vibrant and robust African American community in Richmond, Virginia. Born in 1864 as the Civil War neared its conclusion, at age fourteen Walker joined the Independent Order of St. Luke, a mutual benefit society that provided insurance and economic support for its members. She quickly rose through the ranks to become a lodge president and then a national deputy. In 1895, she founded St. Luke's juvenile department, which created new leadership positions for women within the organization. In 1899, Walker became Right Worthy Grand Secretary, and over the next twenty-five years she led the order to national prominence through an innovative and successful series of self-help programs. Looking to strengthen economic resources for her local community, she created ventures to employ black residents and provide essential services that white-run businesses denied or made inaccessible to African Americans. The Order of St. Luke launched several ventures: the *St. Luke Herald*, a weekly newspaper written by and for local black residents; the St. Luke Emporium, a department store where African American customers could try on goods before purchasing; and the St. Luke Penny Savings Bank, which issued hundreds of mortgages to African Americans, who were systematically refused services in white-owned banks. Such institutions opened a pathway to economic independence for African Americans in the Jim Crow South.

The twentieth century gave rise to more African American entrepreneurs. Innovators such as inventor and cosmetics magnate Annie Malone, newspaper editor and publisher Robert Sengstacke Abbott, and business tycoon Reginald Lewis continued to build on traditions of ingenuity and enterprise.

BUSINESS VENTURE A black shopkeeper stands in the doorway of a Harlem store, ca. 1940. The name emblazoned over the shop declares the significance of the enterprise to the community as well as the owner.

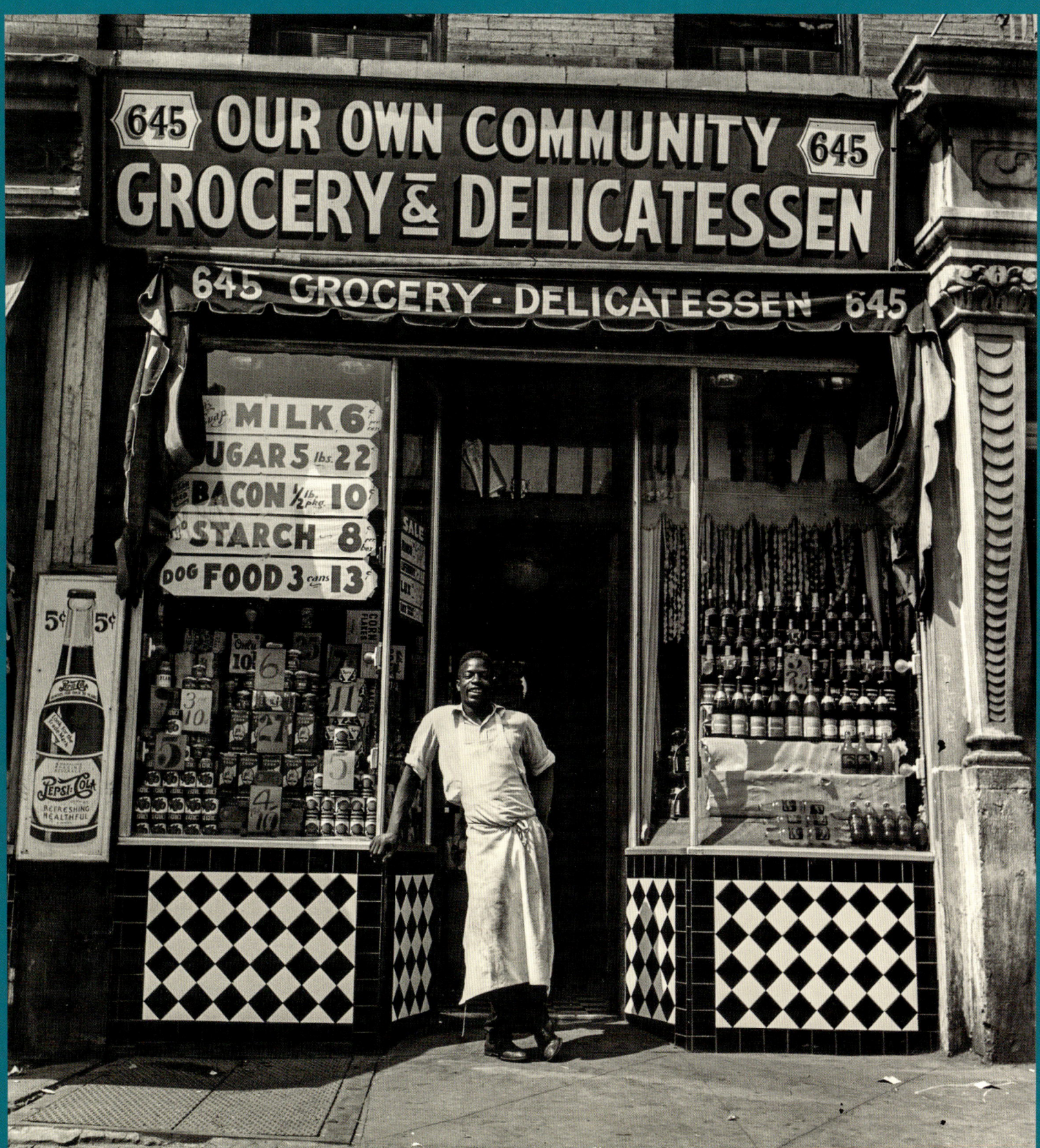

by banding together in the Colored Farmers' National Alliance and Cooperative Union. With more than a million members, the cooperative often allied with white farmers until the groups split over African Americans' demand for higher wages for cotton pickers, a move that eventually led to the demise of the black organization.

The bleak economy of the 1930s hit African Americans particularly hard, sparking a movement among blacks to exercise economic solidarity in the competition for jobs. The National League on Urban Conditions among Negroes (now known as the National Urban League), an interracial organization created in 1910 to help black migrants adjust to urban life, led a black boycott of white-owned stores located in black communities. The movement was dubbed the "Jobs for Negroes Campaign" and quickly spread to cities with sizable black communities. This economic pressure on stores in black communities forced the hiring of many African Americans. The most intensive campaign took place in New York City, where African Americans organized the Citizens' League for Fair Play in 1933 with the motto "Don't Buy Where You Can't Work." Ultimately the action resulted in hundreds of African Americans getting jobs in Harlem stores and with public utilities.

A growing urban population of African Americans working in manufacturing and service jobs gave rise to all-black or predominantly black labor organizations. In 1918, black activists A. Philip Randolph and Chandler Owen founded two labor organizations, the Friends of Negro Freedom and the National Association for the Promotion of Labor Unionism among Negroes, in an attempt to unionize black workers. However, it was Randolph's organization of the Brotherhood of Sleeping Car Porters and Maids

MADAM C. J. WALKER (1867–1919)

Orphaned at age seven, married at fourteen, a mother three years later, and widowed at twenty, Sarah Breedlove took a job as a laundress at her brothers' St. Louis barbershop to support herself and her daughter. She learned the hair-care and cosmetics business while selling Annie Malone's Poro products. In 1905, Breedlove moved to Denver, Colorado, where she developed her own line of beauty merchandise. Under the name Madam C. J. Walker, she set up a business, selling her own hair-care products door to door. "I got my start by giving myself a start," she said. In 1911, she opened the Madam C. J. Walker Manufacturing Company of Indiana, becoming president of what became a thriving beauty and hair products business. She established beauty training schools and a mail-order business and sponsored beauty conferences. Her success made her one of America's first self-made female millionaires.

A badge produced for a Madam C. J. Walker convention in the 1920s

LABOR CHAMPION
A. Philip Randolph addresses the Brotherhood of Sleeping Car Porters and Maids in 1937 (*left*), the black union he organized to improve conditions for Pullman porters. He later helped desegregate defense plants in World War II.

RACE MAN Marcus Garvey (*above*), in a plumed hat, rides in a Universal Negro Improvement Association parade in Harlem, New York City, in 1924. Garvey promoted black pride and urged African Americans to bond with Africans around the globe.

in 1925 that marked the beginning of significant African American participation in labor unions. The Brotherhood struggled for a dozen years but eventually negotiated a contract with the Pullman Company, winning higher wages and improved working conditions for its members.

Around the time Randolph first began trying to unionize African Americans, Marcus Garvey, a charismatic orator and publisher from Jamaica, brought his Universal Negro Improvement Association (UNIA) to New York City in 1916. He urged African Americans to flee the United States, return to Africa, form economic cooperatives with others of African descent throughout the world, and build a prosperous country of their own, with a strong military to defend against racist imperialists. Exalting everything black, he preached that the color black stood for strength and beauty, not inferiority. While the number of those who joined UNIA is unknown, Garvey's organization had seven hundred branches in thirty-eight states by 1920 and claimed to have collected $10 million. The basis of Garvey's wide popularity was his appeal to racial pride at a time when African Americans were routinely denigrated and discriminated against. Garvey's conviction in 1925 on mail fraud, his subsequent imprisonment for two years, and his deportation in 1927 led to the decline and eventual demise of UNIA.

Widespread segregation, lynching and other forms of racial violence, lack of political rights, and limited economic opportunities after the Reconstruction period triggered the creation of new black protest organizations. In 1890, the black journalist T. Thomas Fortune

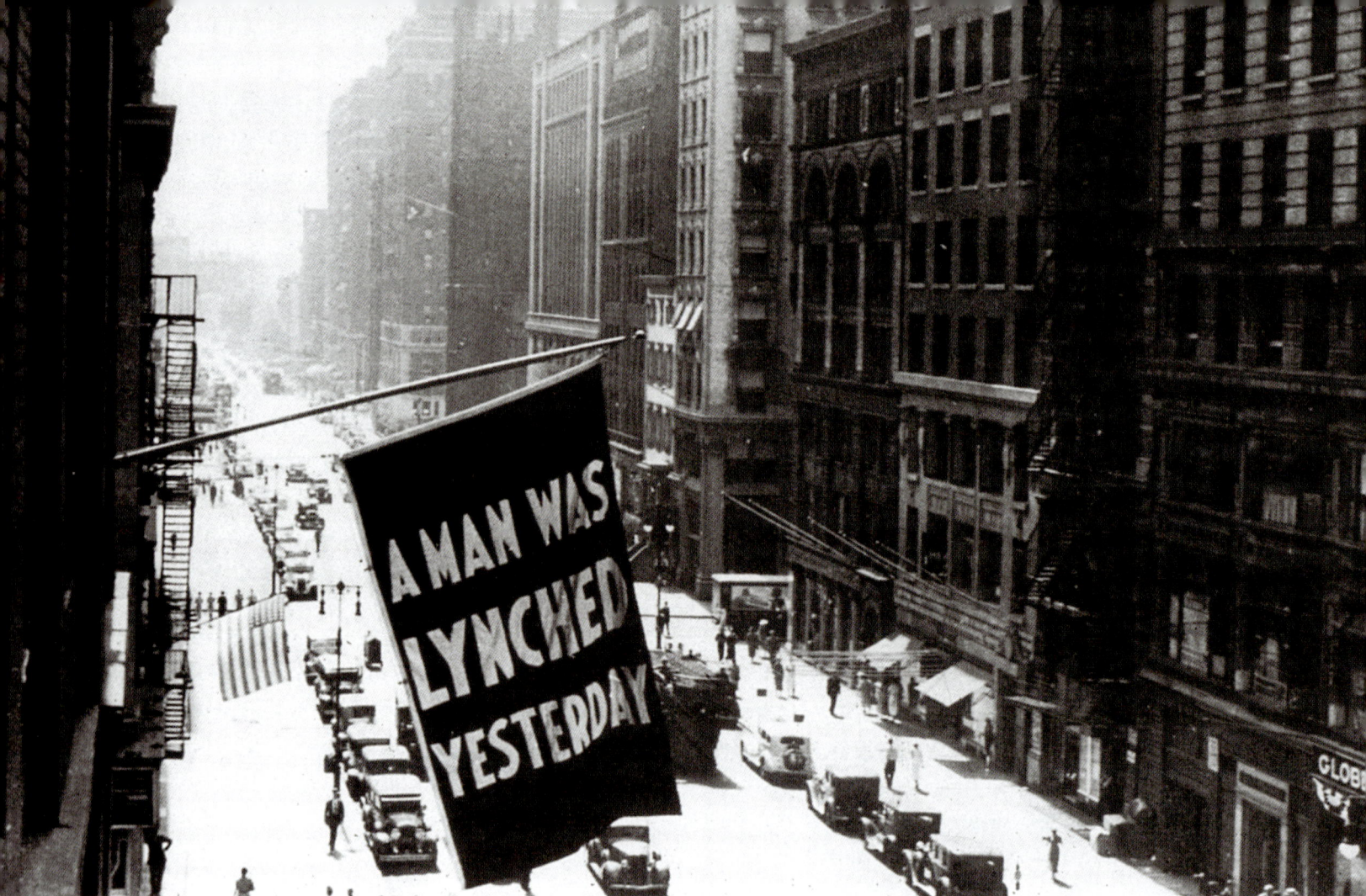

CONSCIENCE RAISING

A banner hangs from the NAACP's New York City headquarters in 1938, announcing the latest reported lynching. The organization displayed the flag regularly for decades as part of its crusade against lynching.

(see pages 177–78) founded the Afro-American League (AAL), a civil rights organization dedicated to fighting segregation and racism and ending lynching. The league successfully challenged discrimination with a number of lawsuits. W. E. B. Du Bois, along with other African American intellectuals and activists, repudiated Booker T. Washington's second-class racial policy in 1905 and formed the Niagara Movement, which endorsed aggressive action to secure full citizenship for African Americans. Niagara was the forerunner of the NAACP, an interracial organization established in 1909 that became one of the most important and effective black civil rights and defense organizations in the nation.

The NAACP and its ally, the NAACP Legal Defense and Educational Fund, were central to bringing about revolutionary legal and social changes. Almost immediately after its founding, the NAACP began an effective legal assault on racist practices. Within fifteen years, the organization's attorneys had won three important decisions before the U.S. Supreme Court. In 1915, in the case of *Guinn v. United States*, the Supreme Court declared that discriminatory voting qualifications clauses in the Maryland and Oklahoma constitutions were a violation of the Fifteenth Amendment. Two years later, in the case of *Buchanan v. Warley*, the Supreme Court declared the Louisville, Kentucky, ordinance requiring African Americans to live in certain sections of the city unconstitutional. In 1923, in the case of *Moore v. Dempsey*, the court ordered a new trial in the Arkansas courts for an African American who had been convicted of murder.

In 1951, the NAACP launched a series of lawsuits to attack segregation in education as unconstitutional and a violation of "basic ethical concepts." One of its greatest and most transforming victories came on May 17, 1954, when a unanimous decision of the U.S. Supreme Court outlawed segregated schools as "inherently unequal." The NAACP laid the groundwork for the Civil Rights and Black Power Movements of the 1950s, 1960s, and 1970s, a turbulent era that transformed race relations in the United States by expanding democracy and discrediting segregation.

In the spring of 1961, the Congress of Racial Equality (CORE), an interracial activist group founded in 1942, sent busloads of Freedom Riders into southern states to challenge the lack of enforcement of a Supreme Court desegregation ruling on interstate transportation. The rides started a chain of events that eventually brought down segregationist "white" and "colored" signs and inspired more activism for civil rights. One of these Freedom Riders was John Lewis, now a member of the U.S. Congress from Georgia, who was subjected to curses, beatings, arrests, and jail. Lewis is proof that in our tortuous, violent march of history, justice prevails.

The Southern Christian Leadership Conference (SCLC), founded by Martin Luther King Jr. in 1957, was a leading organization in the Civil Rights Movement. SCLC brought together African American clergy to coordinate strategies in the nonviolent protest movement that was gathering steam after the

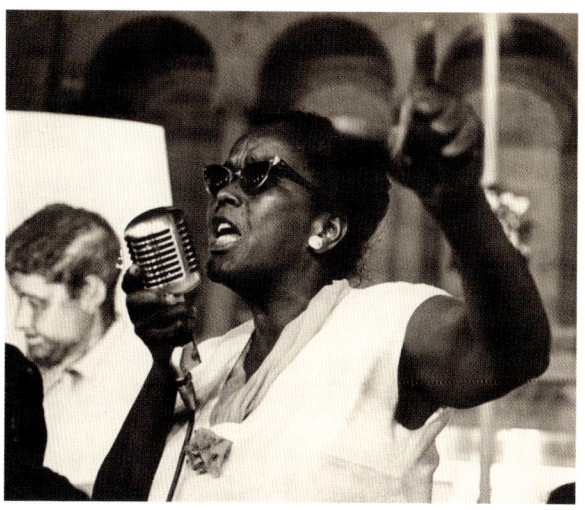

ELLA BAKER The activist and SNCC adviser was a leader of the Mississippi Freedom Democratic Party (MFDP), which moved to replace the official all-white Mississippi delegation at the 1964 Democratic National Convention.

"We who believe in freedom cannot rest until it's won."
—ELLA BAKER, 1964

Montgomery bus boycott. One of SCLC's tireless workers was acting director Ella Baker, who went on to help college students organize a new activist group called the Student Non-Violent Coordinating Committee (SNCC) in 1960. Under Baker's guidance and encouragement, black and white young people joined the Freedom Riders and organized an expansive voter registration drive in the South, where they routinely faced abuse and violent attacks from white hate groups such as the Ku Klux Klan.

The rise of Malcolm X, a charismatic and radical leader, marked the transformation of some African Americans from nonviolent civil rights activists to black power advocates. Malcolm X's political awakening started with his conversion to the Nation of Islam (NOI) teachings, but he broke with the NOI in the mid-1960s to form the Organization of Afro-American Unity, a group that helped shift the focus of many activists from integration to Black Nationalism. Advocating Pan-Africanism, black political and economic independence, and a separation of the races, the group's message resonated with disillusioned civil rights activists. After Malcolm X's assassination in 1965, he remained a powerful symbol

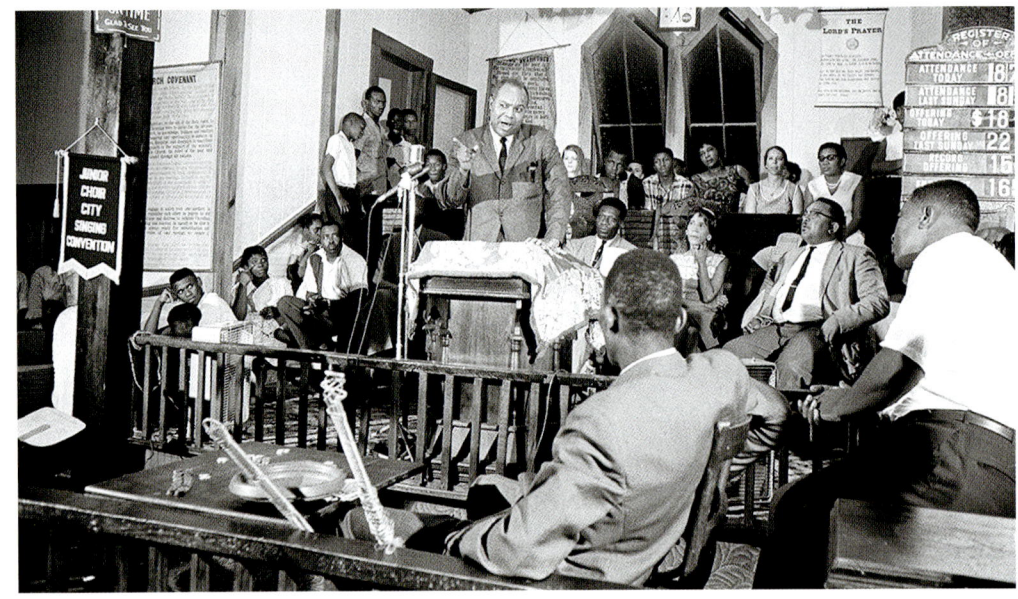

of the vision of Black Nationalism, inspiring radical and controversial organizations such as the Deacons for Defense and Justice and the Black Panther Party for Self-Defense.

As such militant groups declined, mainstream African American political groups ascended. The Congressional Black Caucus, established in 1971, is a powerful and distinguished organization of African American members of the U.S. Congress whose aim is to empower people of color by addressing their particular legislative concerns. The Joint Center for Political and Economic Studies was created in 1970 at the request of a group of black elected officials to be a resource for "intellectual discovery." Today, it is a Washington, D.C., research and public policy institution, or think tank, on issues such as healthcare, economic improvement, and political participation.

African Americans' initiative in creating social bonds and political and religious associations continues to benefit their communities, the United States, and the world. Over the centuries, the black community's advocacy for better education and its outspoken challenge to racism have brought African Americans a long way upon a very rugged path.

Historically, the aim of their institutions was to strengthen the black community and expand and protect political rights. These goals advanced measurably at watershed moments in U.S. history, such as the Reconstruction era and the Civil Rights Movement. In the final decades of the twentieth century, however, the size and influence of many of these institutions and organizations diminished as the black community increasingly split between those who had gained access to mainstream America, which provided better living conditions and educational opportunities, and those left behind in depressed communities with aging housing, poor schools, limited services, and high crime rates. Veteran black organizations continue to try to alleviate the entrenched problems of such communities, and the class divide has stimulated the birth of new organizations, some working in conjunction with government entities, to tackle stubborn problems. These efforts are ushering in a new phase of self-help and cooperation among African Americans.

SPORTING HEROES

HOW AFRICAN AMERICAN ATHLETES BEAT BIGOTRY AND DISCRIMINATION TO WIN JUSTICE AND FREEDOM

WILLIAM C. RHODEN

Every ethnic group in the United States has its cherished sports heroes, and African Americans probably have more than most. Black athletes reflect the very soul of black America. They have landed the punches that African Americans could not throw, won the races they could not run, and earned the victories that seemed beyond their collective reach. Sprinter and hurdler Harrison Dillard, a 1948 and 1952 Olympian, recalled the influence that celebrated African American athletes had on his life and sense of self-worth. "For the most part, we didn't know anything about all of those blacks who were accomplishing things in art, literature, and medicine. You didn't read about them that much. But in the newsreels they had in the movies, you would always see Joe Louis, Jesse Owens, and Henry Armstrong. You'd see the athletes. Those were the people we knew and wanted to emulate."

STAR SPRINTERS Jesse Owens (*near left*) breaks the Olympic record at the 1936 Games in Berlin, where he earned four gold medals in the 100 meters, 200 meters, 100-meter relay, and long jump. These custom-made track shoes (*right*) belonged to Carl Lewis, winner of nine Olympic gold medals and one silver medal in the 1980s and '90s.

Black athletes continue to serve as high-profile symbols of possibility. In 1984, Michael Jordan's first season with the Chicago Bulls, the Nike shoe company honored the basketball great with a line of Air Jordan sneakers. The Gatorade Company followed with the "Be Like Mike" campaign in 1992, in which Jordan was portrayed not just as a superb athlete, but also as a hero and role model. Before Tiger Woods's fall from grace in an adulterous scandal, the management-consulting firm Accenture portrayed the golf superstar as the epitome of concentration, discipline, and dignity.

As their careers flourish, black athletes, many of them from working-class or impoverished families, become

TOP OF THEIR GAME Isaac Murphy is seen in jockey silks (*left*), around 1895. Murphy won three Kentucky Derbies in the late 1800s and hundreds of other horse-racing competitions during his career. Michael Jordan, no. 23, leaping to make a shot in a 1980 game (*below, left*), led the Chicago Bulls to six National Basketball Association (NBA) championships and captured the NBA's Most Valuable Player Award five times. Sports brought both men great wealth and fame.

ISAAC MURPHY

multimillionaires. Jordan, now retired, still earned more than $90 million from corporate sponsors and business ventures in 2013. Boxer Floyd Mayweather, who recalls a time when "seven of us lived in one room," topped *Forbes* magazine's 2014 list of highest-paid athletes with his annual income of $105 million. National Basketball Association (NBA) superstar LeBron James, who never attended college, had a cumulative worth of $450 million in 2014, according to *Forbes*. The astronomic compensation is startling, especially when the humble beginnings of many African American athletes are taken into account.

The genesis of African American involvement in sports can be traced to the plantations of the slavery era, where enslaved people participated in an array of games, ranging from running to rowing. Plantation owners and overseers, however, maintained firm control; slaves were rarely allowed to take part in sporting events without their consent or supervision.

Early in the nation's history, African Americans dominated what became one of the country's greatest pastimes: horse racing. As early as the 1660s, when the British established organized quarter-horse racing in what is now Long Island, New York, African Americans found a route into the sport as groomers, stablehands, trainers, and jockeys. As horse racing became popular in the South, the care, training, and riding of the horses fell to enslaved men on plantations. Two of the most

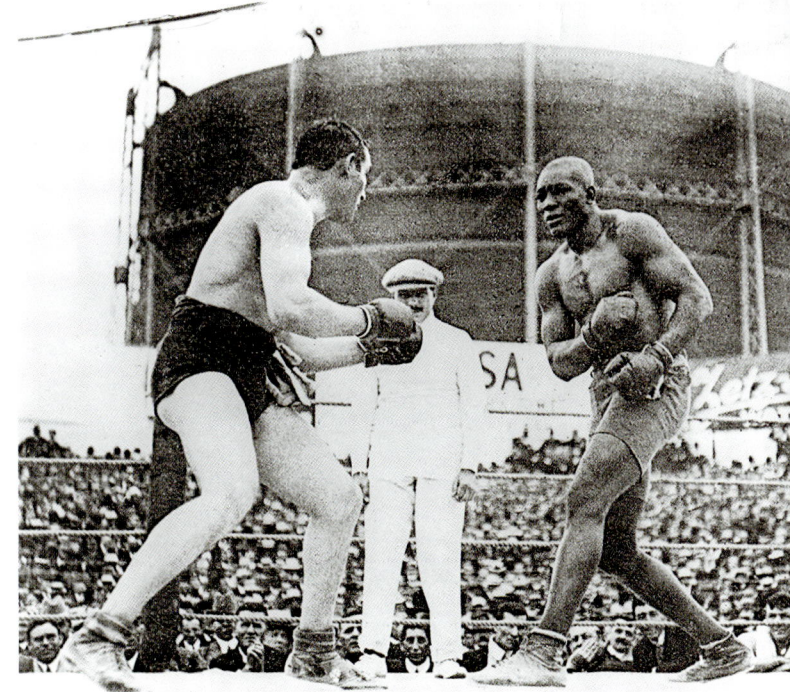

talented jockeys were Austin Curtis, born in Virginia in the 1750s, whose celebrated success won him his freedom, and Abe Hawkins, who distinguished himself by riding first for his Louisiana owner and then as a free man after the Civil War.

The most dynamic African American jockey of the post–Civil War era was Isaac Murphy. Born in Frankfort, Kentucky, in 1861, Murphy rode in eleven Kentucky Derbies, winning titles in 1884, 1890, and 1891. The phenomenal success of Murphy and other black jockeys would be undermined in the late 1800s when Jim Crow laws forced them off the tracks. As legislation mandated the segregation of the races and white jockeys clamored and conspired to grab lucrative riding appointments, the African American presence in racing vanished. With the formation of the all-white Jockey Club in 1894, black jockeys were not relicensed and were systematically squeezed out. Jimmy Winkfield was the last African American jockey to win the Kentucky Derby, in 1901 and 1902.

Boxing was another sport that enslaved men took up to entertain and generate profits for their slave masters. Tom Molineaux, one of the first African American athletes to achieve international acclaim, was born into slavery in Virginia in 1784 and was trained by his father, Zachary, also a bare-knuckle boxer. Molineaux's wealthy owner freed him after the boxer won him a substantial bet in 1801. Molineaux soon moved to England, where he anticipated earning money as a professional fighter. After some success, he fought English champion Tom Cribb for the heavyweight title in December 1810 but lost in the thirty-fifth round. He fought Cribb again in September 1811 and was knocked out in the eleventh round. Less than a decade later, Molineaux died penniless.

When cycling became a popular sport in the United States in the late 1800s, an African American named Marshall "Major" Taylor surfaced as a world champion. He was born in 1878 and raised in the home of the wealthy employers of his coachman father. They gave

AGAINST THE ODDS In 1908, Jack Johnson (*above, right*) knocked out Tommy Burns in the fourteenth round to become the first African American to win the world heavyweight title. A button (ca. 1899) features an image of Marshall "Major" Taylor (*left*), the African American cycling champion who won international acclaim.

him his first bicycle, and when he was fourteen, a bicycle shop in Chicago hired Taylor to perform bike stunts to attract customers. Eventually, Taylor set numerous world records and became the United States' first internationally acclaimed star in the sport by winning the one-mile race in the 1899 cycling world championships in Montreal. In what would become a familiar pattern for African Americans in sports, Taylor succeeded despite repeated attempts by white people to thwart him. White competitors teamed up to box him in and verbally threatened him; the cycling establishment sometimes refused Taylor entry into competitions, especially in the South. Although denied membership to important cycling organizations, such as the League of American Wheelmen, Taylor is regarded as one of the world's all-time greatest cyclists.

Another African American athlete on the ascent at the turn of the twentieth century was boxer Jack Johnson. Like other African Americans in virtually every sector, Johnson's road to fame was filled with racist obstacles.

Despite the hurdles, Johnson defeated Canadian Tommy Burns in Australia in December 1908 to become the world heavyweight champion. His victory created such a maelstrom in the United States that a national cry arose for retired undefeated champion Jim Jeffries to take on Johnson. Answering the call for a Great White Hope, Jeffries said he would come back in deference to "that portion of the white race that has been looking for me to defend its athletic superiority." But after his defeat in 1910, Jeffries admitted, "I never could have whipped Johnson at my best."

However, Johnson, a man of brash confidence, made enemies in high places. Judge Kenesaw Mountain Landis was one of them. Before he became the first commissioner of baseball and played a major role in keeping African Americans out of the sport, Judge Landis was the relentless bloodhound who trailed and ultimately trapped Jack Johnson. When Johnson ran afoul of the 1910 White Slave Traffic Act, designed to stop the proliferation of immigrant prostitution, the government was one foe Johnson could not defeat. In 1913, Landis sentenced Johnson to a year in prison after Johnson dated and then transported a white prostitute across a state border before his marriage to another white woman. Although Johnson fled abroad, he surrendered in 1920 and went to prison. Today, many sports historians regard the incident as racially motivated, spurred partly in retaliation for Johnson's marriages to white women but also for beating his white opponent in the ring. Johnson lost the world heavyweight title to Jess Willard in 1915 while in exile in Cuba. There would not be another black heavyweight champion until Joe Louis nearly twenty years later.

TRAILBLAZERS UCLA's 1939 star football players Woody Strode, Jackie Robinson, and Kenny Washington (*left to right*) later broke racial barriers—Robinson in baseball and Strode and Washington in the National Football League in 1946.

Louis became the hero of a generation of Americans. He was a universally embraced American hero, according to Joe Louis Jr. "What my father did was enable white America to think of him as an American, not as a black. By winning the title, he became white America's first black hero." During World War II, the Brown Bomber, as Louis was known, was portrayed in the press as a clean-cut, all-American young man. His trainers forbade him from being photographed with white women or gloating over fallen opponents.

After Louis defeated Primo Carnera in 1935, a writer for the *Los Angeles Times* raved: "The colored race couldn't have chosen two more remarkable men than Jesse [Owens] and Joe Louis to be its outstanding representatives. Owens is being hailed as the greatest track and field athlete of all time. Same thing goes for 'Dead Pan' Joe Louis, whose decisive defeat of Carnera has sent the scribes scurrying to the dictionaries seeking superlatives of greater scope than any they've used before."

Americans embraced sports stars such as Owens and Louis as American heroes during the Great Depression and World War II, a time when the very survival of African Americans was threatened. The black unemployment rate was nearly three times that of whites; blacks often received less assistance and were sometimes even excluded from soup kitchens.

The most visible gains for African American athletes were won on baseball diamonds. They had been locked out of the country's national pastime for decades. Just as African Americans started businesses such as banks, hotels, and restaurants, Andrew "Rube" Foster, a black pitcher, responded to professional baseball's

ban on African Americans by organizing the Negro National League (NNL) in 1920. Foster's league soon had franchises in cities that included Chicago, Cincinnati, Dayton, Detroit, Indianapolis, Kansas City, and St. Louis. Each team owned its own ballpark and eventually operated its own minor league system. Foster owned the Chicago American Giants.

Jackie Robinson, who played for the Kansas City Monarchs of the Negro Leagues, was handpicked by the Brooklyn Dodgers' Branch Rickey to break Major League Baseball's color barrier in 1947. Robinson's aggressive

base-running style, which included the stealing of home plate, became a hit with fans. His style, as much as his skill, helped define the African American presence in sports. Unfortunately, his performance was not always enough. He still suffered bean balls, death threats, hate mail, insults, and jeers.

NEGRO LEAGUES A button (*above, left*) and a pennant (*above, right*) display insignias of two African American teams during the segregated baseball era. A souvenir program from the first Colored World Series in 1924 features a photograph (*below*) of the Hilldales from Darby, west of Philadelphia, the champions of the Eastern Colored League.

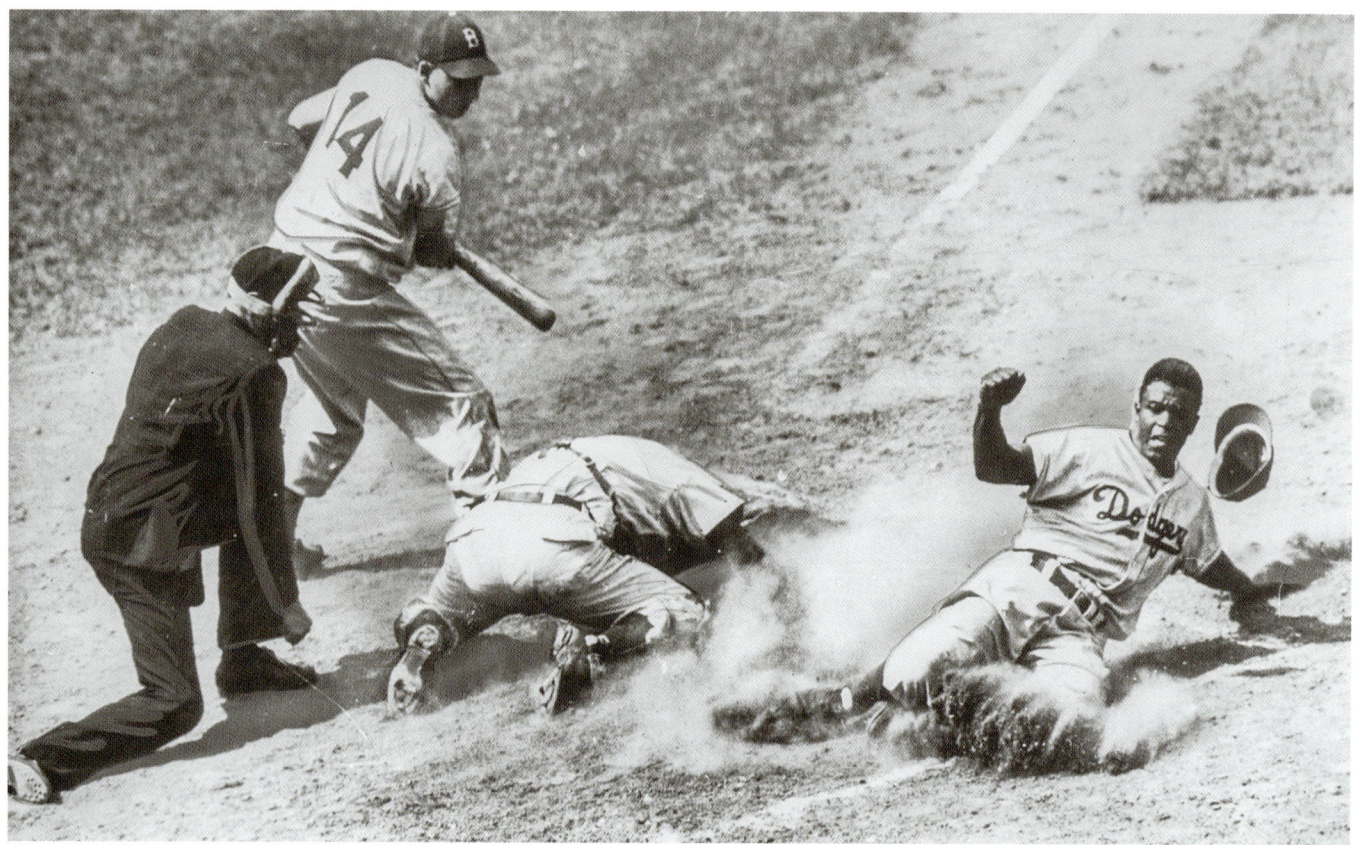

While Robinson's courageous act unfolded in the sports arena, he also loosened the grip of segregation in other areas of life. His strong character, use of nonviolence, and his unquestionable talent challenged the traditional basis of segregation. He made an impact on American culture and contributed significantly to the Civil Rights Movement. Robinson became the first African American television analyst in Major League Baseball and the first black vice president of a major American corporation, the Chock Full o' Nuts coffee company. In the 1960s, Robinson helped establish the Freedom National Bank, an African American–owned financial institution based in Harlem. Ironically, Jackie Robinson's entry into Major League Baseball had a devastating impact on the million-dollar business of the Negro Leagues. However, for many African Americans, this was the price of racial progress.

BREAKING BARRIERS Jackie Robinson (*above, right*), the first African American to play in Major League Baseball, slides into home plate for the Brooklyn Dodgers in 1948. Willie Mays used an Adirondack bat (*below*) in the 1965 Major League Baseball All-Star Game. Both players have been inducted into the National Baseball Hall of Fame.

Willie Mays was another African American player who brought an innovative Negro Leagues style of play to baseball. His speed, daring outfield play, and base stealing would forever change the way Major League Baseball is played. The New York Giants signed Mays in June 1950, the day he graduated from high school. Mays ushered in an era of new horizons for African Americans in the major leagues. Unlike their predecessors, who had been prohibited from having a fair chance, young black players were now given an opportunity to soar in the sport from an early age.

Slam, Dunk, & Hook, 2001

Yusef Komunyakaa

Fast breaks. Lay ups. With Mercury's
Insignia on our sneakers,
We outmaneuvered to footwork
Of bad angels. Nothing but a hot
Swish of strings like silk
Ten feet out. In the roundhouse
Labyrinth our bodies
Created, we could almost
Last forever, poised in midair
Like storybook sea monsters.
A high note hung there
A long second. Off
The rim. We'd corkscrew
Up & dunk balls that exploded
The skullcap of hope & good
Intention. Lanky, all hands
& feet … sprung rhythm.
We were metaphysical when girls
Cheered on the sidelines.
Tangled up in a falling,

Muscles were a bright motor
Double-flashing to the metal hoop
Nailed to our oak.
When Sonny Boy's mama died
He played nonstop all day, so hard
Our backboard splintered.
Glistening with sweat,
We rolled the ball off
Our fingertips. Trouble
Was there slapping a blackjack
Against an open palm.
Dribble, drive to the inside,
& glide like a sparrow hawk.
Lay ups. Fast breaks.
We had moves we didn't know
We had. Our bodies spun
On swivels of bone & faith,
Through a lyric slipknot
Of joy, & we knew we were
Beautiful & dangerous.

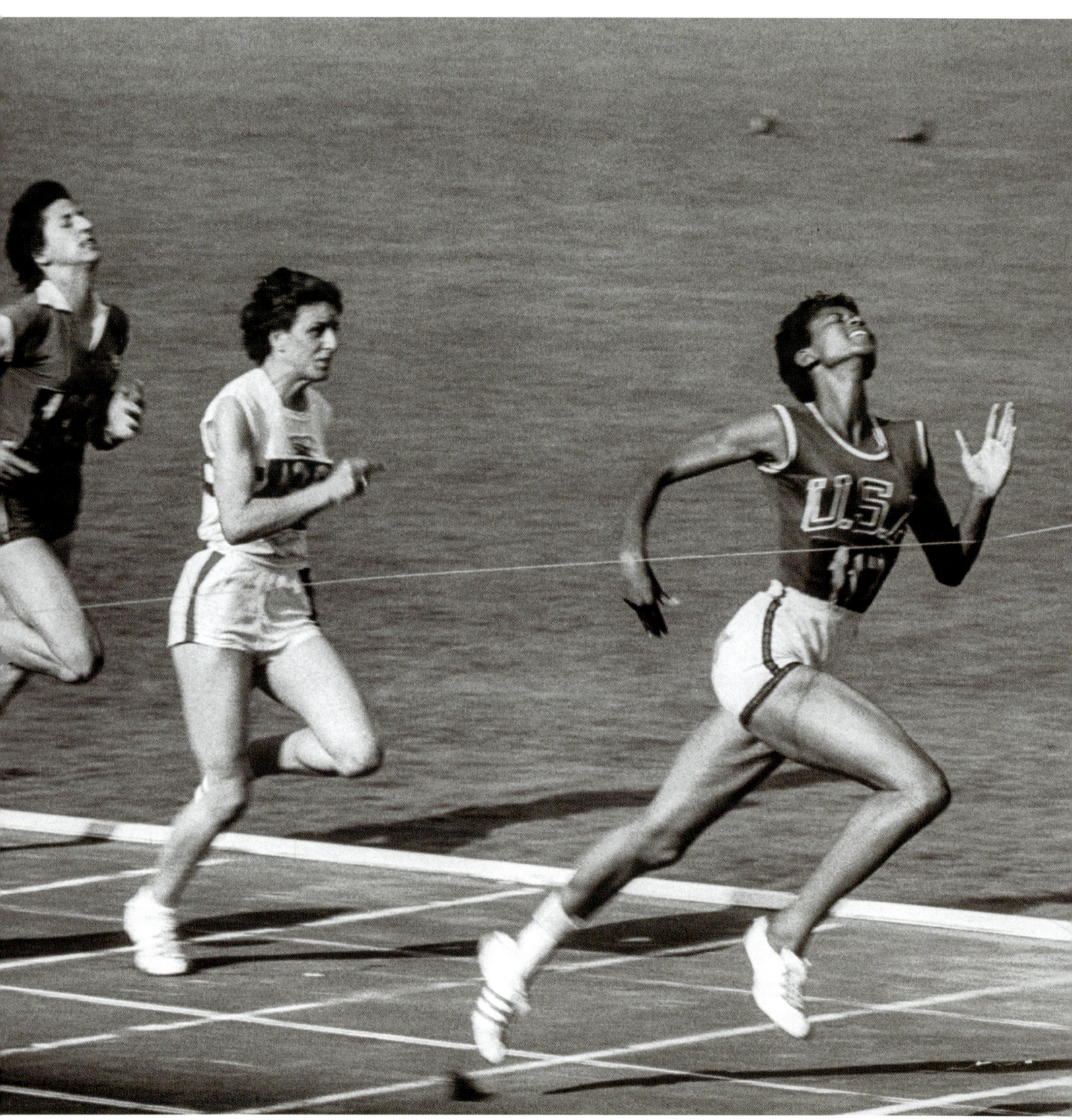

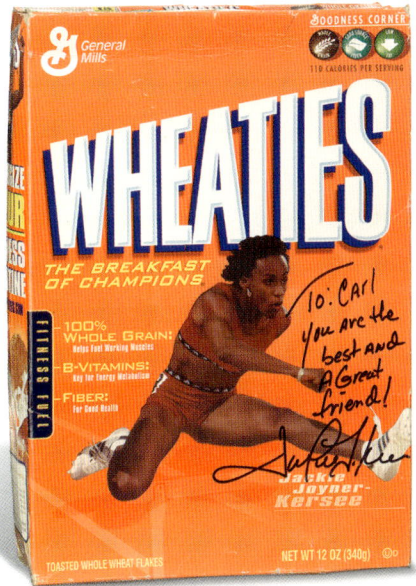

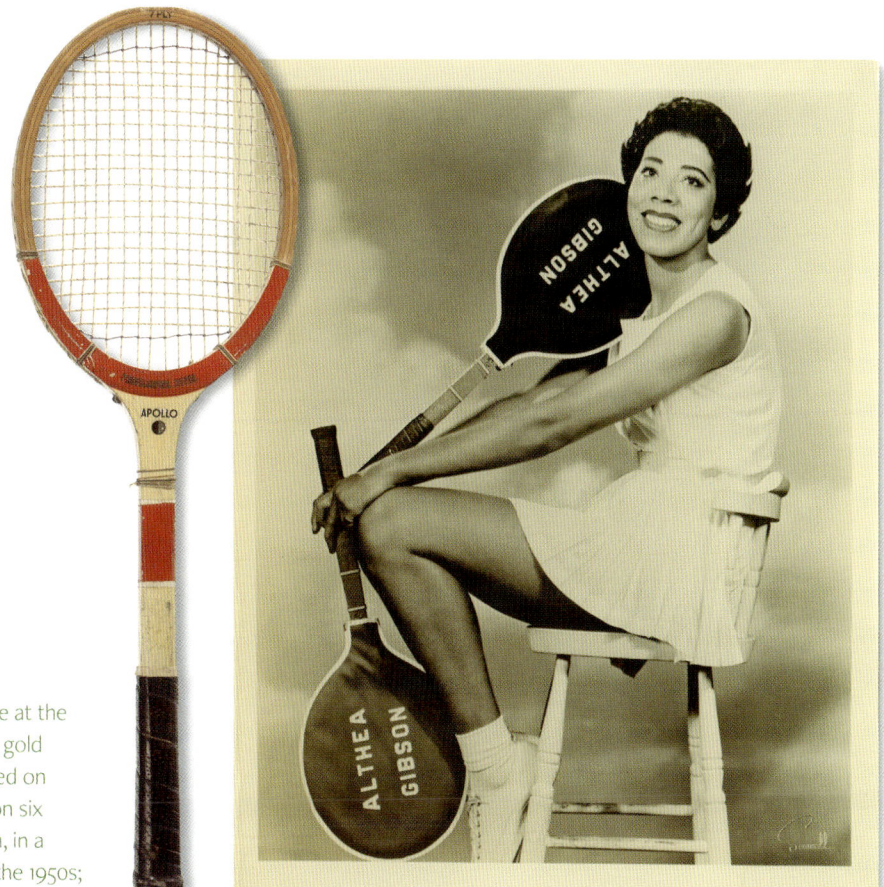

CHAMPIONS Wilma Rudolph crosses the finish line at the 1960 Olympic Games (*opposite*) to win one of three gold medals. Decades later, Jackie Joyner-Kersee, pictured on a cereal box autographed by the athlete (*above*), won six Olympic medals, including three gold. Althea Gibson, in a 1959 photograph (*far right*), led the tennis world in the 1950s; one of Gibson's winning rackets is at right.

A year after Robinson entered Major League Baseball, high jumper Alice Coachman became the first African American woman to win a gold medal at the Olympic Games in London. She set an Olympic record in 1948 and was America's only female gold medalist that year. In London, King George VI presented Coachman with her medal, but her homecoming festivities in Albany, Georgia, were segregated, and the mayor did not shake her hand. Despite these snubs, Coachman, a graduate of Tuskegee Institute, set the stage for female African American success in Olympic track and field events. The illustrious list of medal-winning athletes includes sprinters Wilma Rudolph (1956 and 1960), Wyomia Tyus (1964 and 1968), Evelyn Ashford (1984, 1988, and 1992), and Florence Griffith Joyner (1984 and 1988), and long jumper and heptathlon athlete Jackie Joyner-Kersee (1984, 1988, 1992, and 1996).

Wilma Rudolph, nicknamed the Black Gazelle by the foreign press, exploded on the international athletics scene during the Olympic Games in Rome in 1960. Rudolph became the first American woman to win three gold medals in one Olympiad. Upon returning home to Clarksville, Tennessee, as an Olympic hero, Rudolph refused to participate in the segregated homecoming parade honoring her efforts. Ultimately, Clarksville's mayor, W. W. Barksdale, relented, and the city had its first integrated parade.

Althea Gibson's dominance in tennis and Charles Sifford's determination to make a living in professional golf during the 1950s presented a new view of African Americans to the world as they blazed trails into sports associated with wealth and privilege. In 1956, Gibson became the first African American to win a Grand Slam title when she won the French Open. In 1957 and 1958, Gibson won Wimbledon and the U.S. Nationals and in 1958 was named Female Athlete of the Year by the Associated Press. In 1961, Sifford became the first African American to play on the PGA tour.

In men's tennis, Arthur Ashe emerged as a formidable talent in the late 1960s. After becoming the first African American player to be selected for the Davis Cup team, he went on to win three Grand Slams. Ashe was awarded the Presidential Medal of Freedom in 1993, a few years before the Williams sisters burst onto the world's top tennis courts. Serena Williams, one of the greatest athletes of her generation and arguably the best female tennis player of all time, with a take-no-prisoners approach, avenged the lack of appreciation experienced by Althea Gibson. Once, when asked to describe her style, Gibson said: "Aggressive, dynamic, and mean." Serena Williams would say amen to that.

TENNIS GREATS The first African American man to win a Grand Slam tournament, Arthur Ashe raises the Wimbledon trophy in 1975 (*right*). Serena Williams, multiple gold medalist and Grand Slam winner, reaches for a ball at Wimbledon in 2015 (*below*).

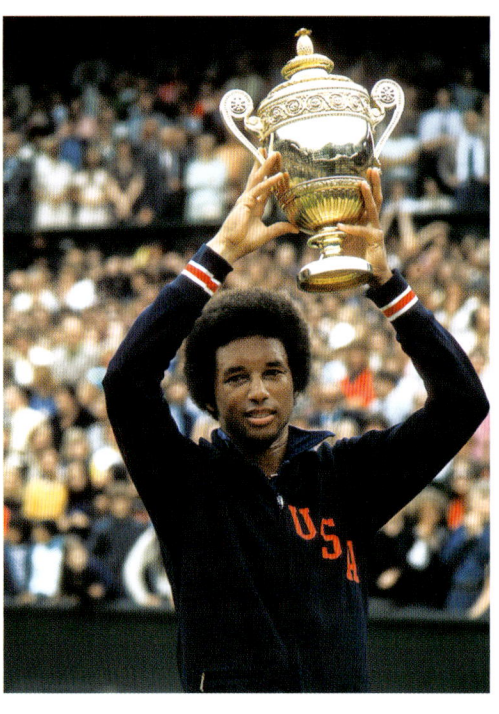

BASKETBALL LEGEND

Lew Alcindor, who later changed his name to Kareem Abdul-Jabbar, was such an accomplished basketball player that some say the NCAA banned slam dunking in 1967 to try to slow him down. Instead, he developed the most unstoppable shot in basketball history—the skyhook. He led UCLA to three national titles and was named player of the year twice. In the NBA, Abdul-Jabbar continued his dominance. He is the league's all-time leading scorer, a six-time Most Valuable Player, and six-time champion, including the title he won with the Milwaukee Bucks in 1971. Off the court, the basketball star has distinguished himself as a writer, filmmaker, and actor.

MASTER AT WORK Kareem Abdul-Jabbar wore this jersey (*right*) while playing for the Milwaukee Bucks. As a Los Angeles Laker (*below*), Abdul-Jabbar executes a skyhook shot at the 1982 NBA finals.

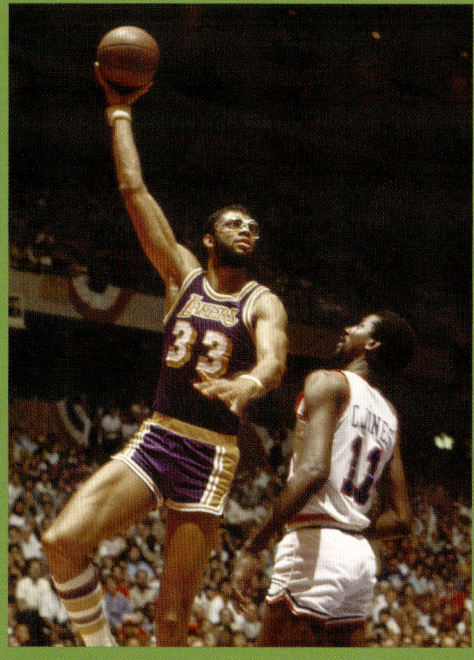

The 1960s saw the influx of unprecedented numbers of African American athletes in college and professional sports. The decade also marked a convergence of athleticism, racial pride, and militancy among black athletes, who showed they were not divorced from the social unrest of the decade.

In 1963, when black comedian and social activist Dick Gregory called for an African American boycott of the 1964 Olympic Games in Tokyo, three-time gold medalist Mal Whitfield tried to fuel the idea by writing an article for *Ebony* titled "Let's Boycott the Olympics." Whitfield suggested that African American athletes should boycott the Games unless first-class citizenship was given at home. "It's time for American Negro athletes to join the

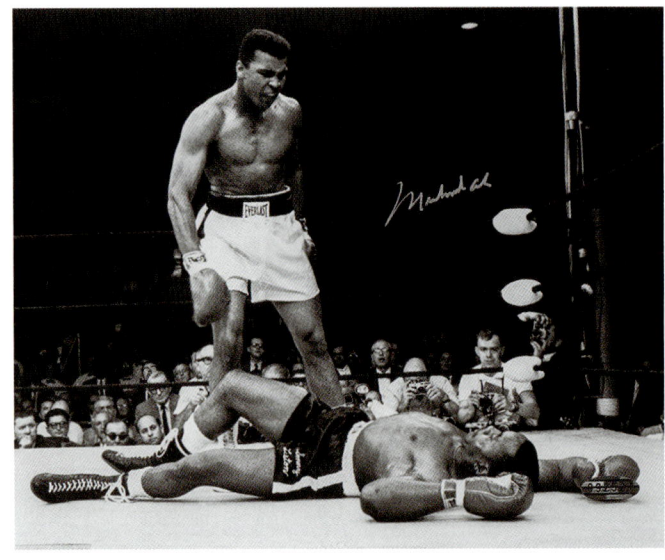

"I AM THE GREATEST" Muhammad Ali lived up to his signature boast in a 1965 rematch with Sonny Liston, knocking him out in the first round (*above*), and in a legendary 1974 match, touted on a pennant (*left*), when he knocked out George Foreman in the eighth round. Ali wore this padded headgear (*below, left*) in 1973 training sessions.

civil rights fight," he wrote. Despite the pleas for black athletes to get involved in the struggle, there was no boycott, but it raised awareness.

Cassius Clay, a talented young boxer who won a gold medal in the 1960 Olympics, gained the world heavyweight championship in 1964 and soon changed his name to Muhammad Ali. He was one of the first African American athletes to take a political stand. In April 1967, he refused to be drafted into the U.S. Army to fight in the Vietnam War. Ali defended his controversial position, explaining that he had no appetite for war. "My conscience won't let me shoot my brother or some darker people," he told reporters. "And shoot them for what? They never called me nigger."

Ali's actions inspired other athletes to speak out against injustice. Shortly after Ali's conviction for draft evasion in 1967, the Cleveland Browns' running back Jim Brown called on some of the most influential black athletes of the era to meet with Ali in Cleveland. Bill

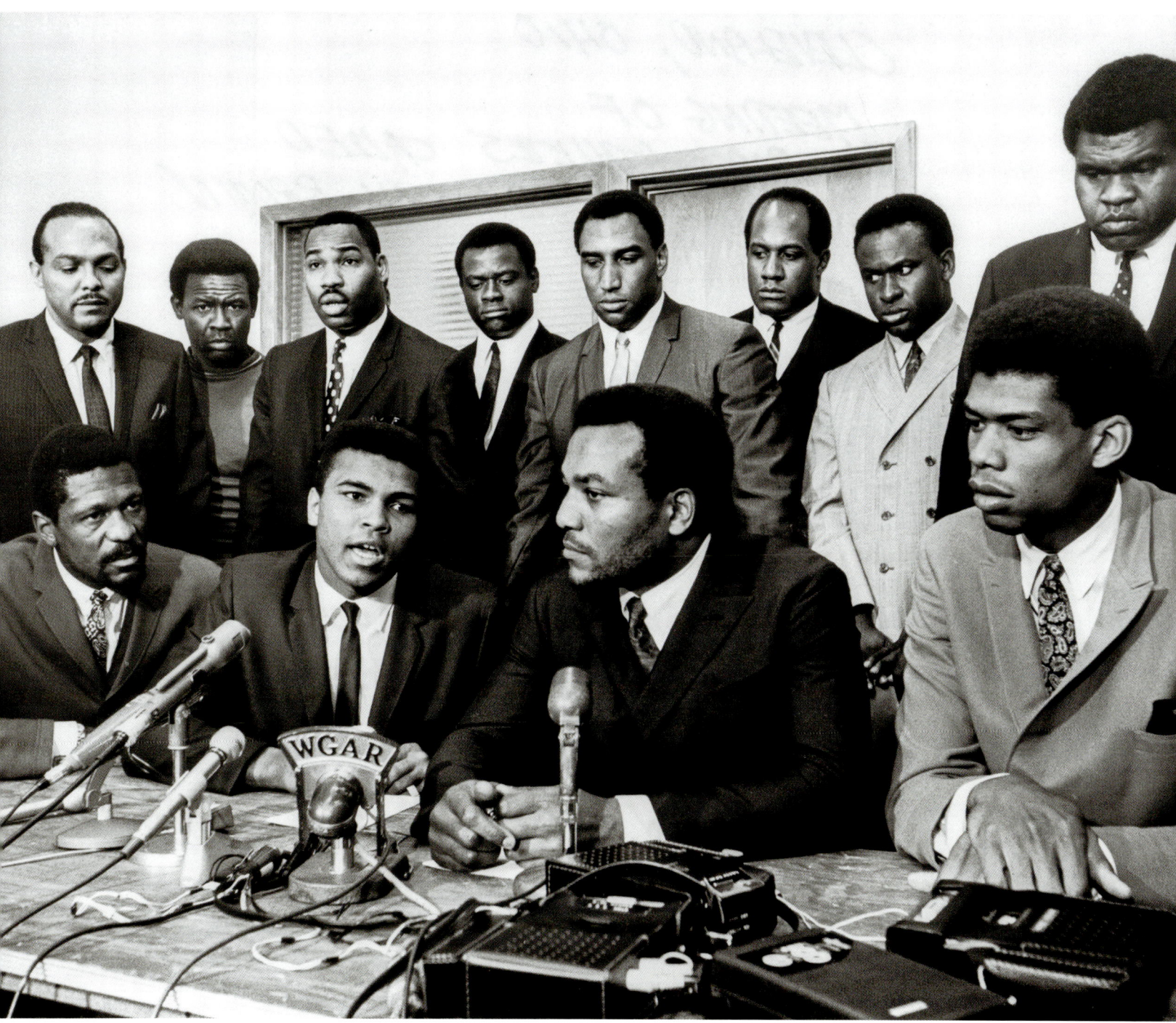

Russell of the Boston Celtics, Willie Davis of the Cleveland Browns, Bobby Mitchell of the Washington Redskins, and a college basketball player from UCLA, Lew Alcindor (later Kareem Abdul-Jabbar) were among those who met with the boxer. Convinced that Ali was sincere, the athletes held a news conference the next day to express their support.

TEAM ALI Former Cleveland Browns running back Jim Brown presides over a meeting of African American athletes in 1967 to show support for boxer Muhammad Ali's refusal to fight in Vietnam. Present are (*left to right, front row*) Bill Russell, Muhammad Ali, Brown, Lew Alcindor (later Kareem Abdul-Jabbar); (*back row*) future Cleveland mayor Carl Stokes, Walter Beach, Bobby Mitchell, Sid Williams, Curtis McClinton, Willie Davis, Jim Shorter, and John Wooten.

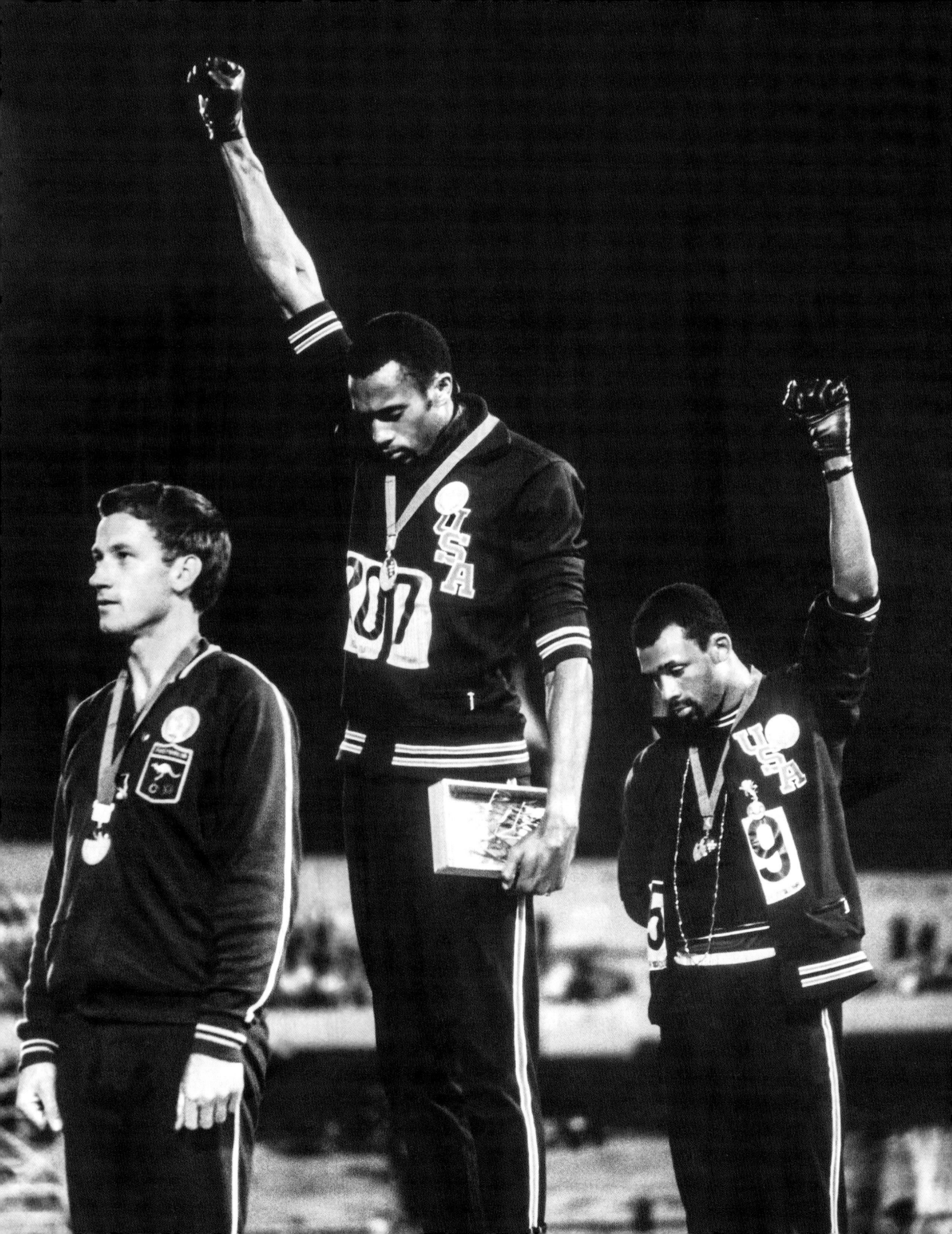

In 1968, during the lead-up to the Olympic Games in Mexico City, social activists at California's San Jose State College proposed that individual black athletes at the Games determine their own method of protest against racial discrimination. In response, San Jose State sprinters John Carlos and Tommie Smith, who had won bronze and gold medals, respectively, in the 200-meter dash, executed a bombshell moment of protest: Standing on the Olympic podium, medals resting around their necks, they raised black-gloved fists and hung their heads during the playing of the U.S. national anthem. Displaying the clenched fist as a gesture of solidarity, the young men wished to call attention to the unjust treatment of people of color in America. The defiant act remains one of the most iconic demonstrations of protest in the history of Olympic competition.

In the following year, Curt Flood, a black All-Star center fielder for the St. Louis Cardinals, daringly took on Major League Baseball's reserve clause by suing the league in a case that went all the way to the U.S. Supreme Court. The reserve clause granted teams the exclusive right to renew the contracts of its professional players automatically, binding those players to teams until their release, retirement, or trade. By not accepting his trade to the Philadelphia Phillies and by taking on the establishment, Flood recognized his career in professional baseball would come to an end. However, he also recognized that players would benefit for years to come. He lost his case, 5 to 3, in 1972. Three years later, arbitrator Pete Seitz ruled in favor of free agency, effectively nullifying the reserve clause after one year without a contract.

For those athletes who took courageous stands, there was a high price to pay: Ali was banned from boxing for three years; Carlos's wife committed suicide; and Flood never played in the majors again.

Each generation had its own method of protest and resistance. During the fall of 2014, the deaths of black men at the hands of police officers inspired a number of collegiate and professional African American athletes to demonstrate their opposition by wearing T-shirts and cleats emblazoned with protest slogans; unlike the

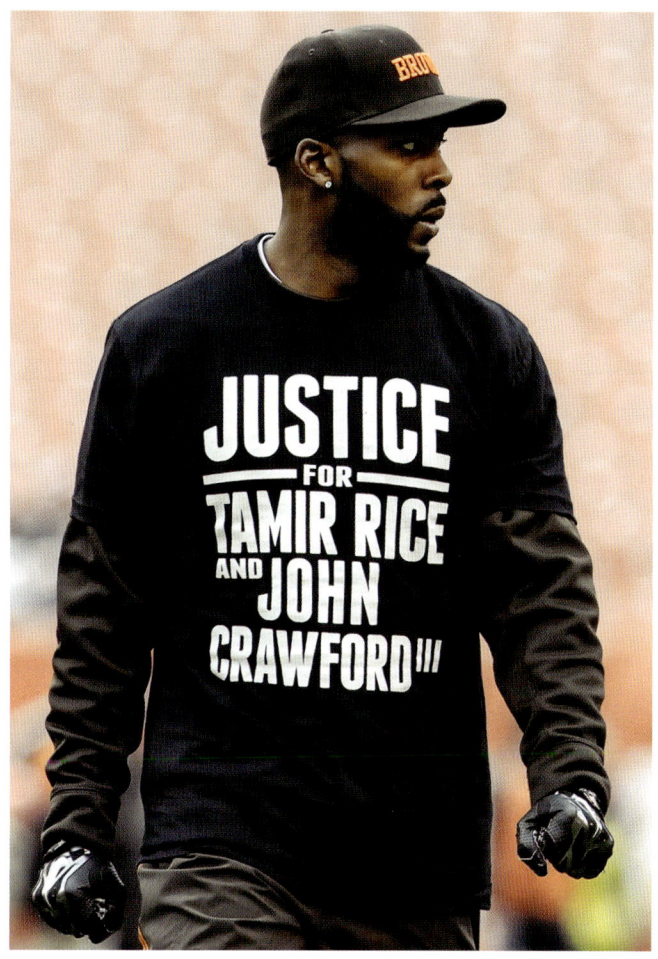

TAKING A STAND Protesting racial discrimination, track and field athletes Tommie Smith and John Carlos (*opposite, center and right*) raise gloved fists in a black power salute at the 1968 Olympic Games. In solidarity, Australian silver medalist Peter Norman (*far left*) wore a human rights badge like those of his fellow winners. Wide receiver Andrew Hawkins (*above*) walks onto a Cleveland football field in 2014 wearing a shirt printed with police brutality references.

outspoken sports stars who had suffered punishment decades previously, the athletes were not penalized.

Today's black athletes are financially compensated at levels their predecessors could not have imagined, making the chasm between them and the underclass from which many of them sprang vast. But these recent acts of protest summon memories, albeit in a limited way, of the courage of Muhammad Ali, Wilma Rudolph, Jackie Robinson, and other athletes who fought for justice as passionately as they strove for excellence in their sports.

THE AFRICAN AMERICAN INFLUENCE ON AMERICAN CULTURE

Mel Watkins

STRIKING A CHORD
Chuck Berry's brilliant licks on
this electric guitar, nicknamed
Maybellene after his 1955
signature hit, captivated teenage
audiences and helped launch
a thrilling musical hybrid called
rock 'n' roll.

"*The nation told Negro jokes, used Negro slang, turns of phrase, and danced Negro comic dances from its very beginning. That is the way this strange country operated.*"

—RALPH ELLISON, "American Humor" speech, 1970

The African American impact on American culture began with the arrival of African slaves during the eighteenth and nineteenth centuries. "Herded together with others with whom they shared only a common condition of servitude and some degree of cultural overlap, enslaved Africans were compelled to create a new language, a new religion, and a precarious new lifestyle," historian Charles Joyner wrote. In time, their precarious but resilient lifestyle would become one of the most formidable influences on American popular culture.

From the outset, the captives aroused and held the attention and curiosity of their captors, who were intrigued by what was perceived as peculiar behavior. The enslaved people's often incomprehensible dialects and uninhibited dances, even their so-called cackling laughter, were a source of amusement and wonder for many white observers.

In the early nineteenth century, writer James Fenimore Cooper described the rapt attention a group of "amused [white] spectators" paid to a festive gathering of black revelers in New York City "singing African songs, drinking, and, worst of all, laughing in a way that seemed to set their hearts rattling within their ribs.... Some were making music by beating on skins drawn over the ends of hollow logs, while others were dancing to it in a manner to show they felt infinite delight."

RALPH ELLISON Famous for his 1952 novel about race and identity, *Invisible Man*, Ellison was an astute critic of American culture.

The journals of visiting Europeans mirrored Cooper's observations. "The slaves frequently dance all night," an Englishman traveling through Maryland wrote in 1833. "Every negro is a musician from birth…. An instrument of music seems necessary to their existence." Another foreigner observed: "Their wild movements, their strange and not unmusical cries, as they kept time with their voices to their quick trampling feet, their dark forms, their contortions, and perfect *abandon*, constitute a *tout ensemble* that must be witnessed to be appreciated."

A slave's musical ability was encouraged, and the image of contented, happy black people was promoted. A jovial bondsman with musical talent and a knack for entertaining was not only a welcome diversion for slaveholders and their guests, but also a valued asset. "Slaves are generally expected to sing as well as to work," Frederick Douglass wrote in *My Bondage and My Freedom*. "A silent slave is not liked by a master or overseer. '*Make a noise, make a noise*,' and '*Bear a hand*,' are the words usually addressed to the slaves when there is silence among them." Solomon Northup, a freeborn black man kidnapped and forced into slavery in 1841, maintained that his musical ability was a crucial factor in mediating the harshness of bondage. As a skilled musician, he was often required to perform at nearby plantations. "Alas! Had it not been for my beloved violin, I scarcely can conceive how I could have endured the long years of bondage," he wrote in his 1853 memoir *Twelve Years a Slave*.

ART OF IMPROVISATION

An eighteenth-century watercolor attributed to South Carolina plantation owner John Rose shows enslaved Africans playing musical instruments that were probably improvisations of African versions. The women shake rattles enclosed in nets, while two men play string and percussive instruments, possibly fashioned from gourds or earthenware.

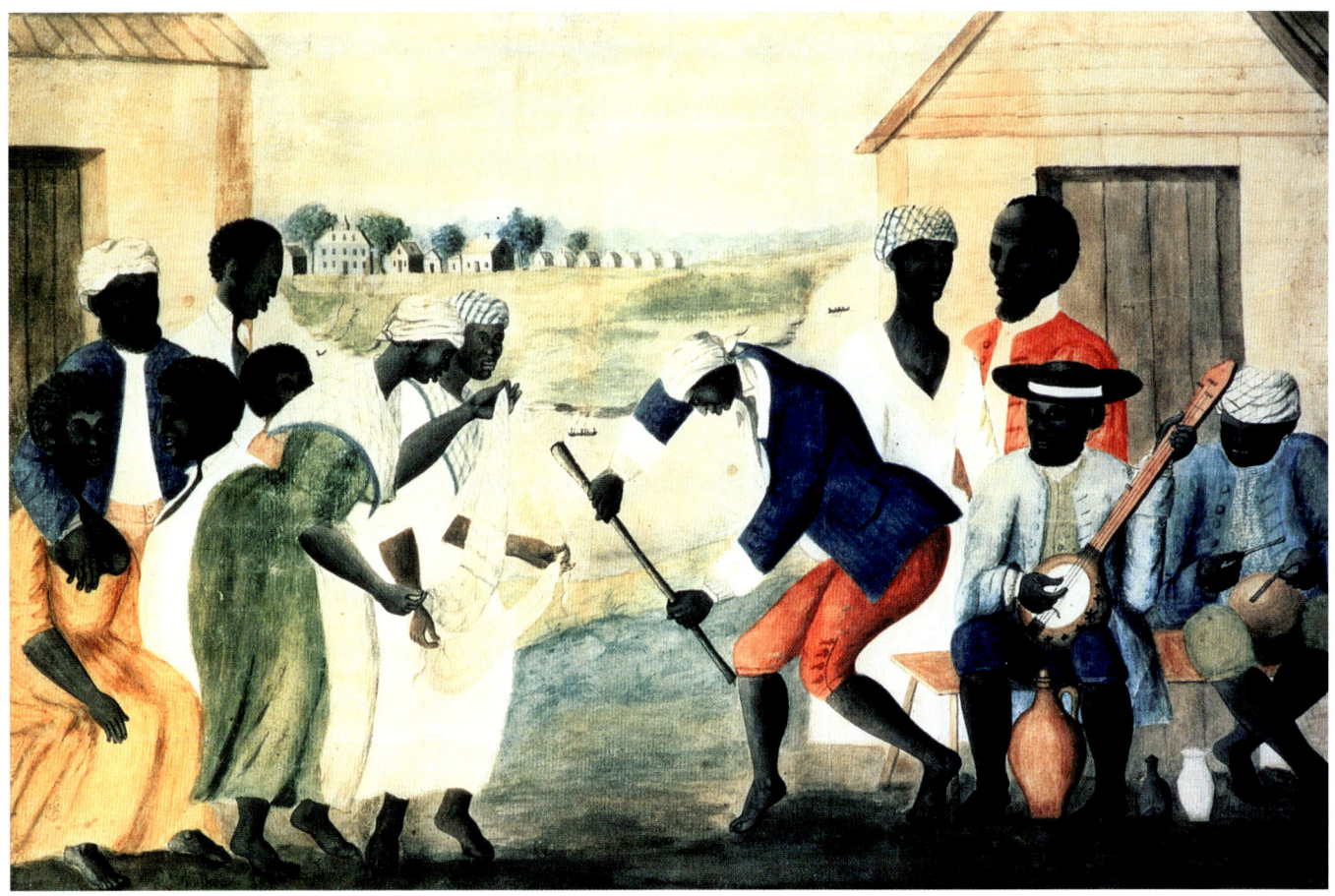

Slave narratives, the diaries of white visitors, and slaveholders' written accounts, as well as articles by contemporary journalists, generally show that in antebellum America, whites perceived enslaved Africans as natural entertainers and happy-go-lucky curiosities. "To the primitive comic sense, to be black was to be funny," anthropologist Constance Rourke wrote in her classic 1931 book *American Humor: A Study of the National Character*, "and many minstrels made the most of this simple circumstance." White entertainer Thomas Rice, one of the most successful of the early Negro impersonators, for instance, introduced the blackface caricature named Jim Crow and began performing a dance and song purportedly copied from a crippled black stablehand in New York City in 1828:

> Come listen all you galls and boys,
> I's jist from Tuckyhoe.
> I'm going to sing a little song,
> My name's Jim Crow.
> Weel about and turn about
> And do jis so.
> Eb'ry time I weel about
> And jump Jim Crow.

The routine made Rice America's most popular comic entertainer, and his success spawned dozens of imitators.

In 1843, the Virginia Minstrels debuted in New York City, offering an entire evening of blackface entertainment and promising a performance that featured the "oddities, peculiarities, eccentricities, and comicalities of the Sable Genus of Humanity." The troupe was an immediate sensation, setting off a national craze and establishing minstrelsy as America's most celebrated form of popular entertainment for decades.

"Minstrelsy's borrowing of Afro-American culture is of great significance because it was the first indication of the powerful influence Afro-American culture would have on the performing arts in America," cultural historian Robert C. Toll wrote in *Blacking Up: The Minstrel Show in Nineteenth-Century America*. "It does not mean that early minstrels accurately portrayed Negro life or even the elements that they used. They did neither. In the process of creating their stage images of Negroes, northern white professional entertainers selectively adapted elements of Afro-American folk culture into caricatures and stereotypes of Negroes."

Even though author Mark Twain raved about minstrelsy's "happy and accurate" portrayal of blacks and Constance Rourke claimed "the Negro minstrel was deeply grounded in reality," most present-day historians agree that minstrel simulations of black song, comedy, and dance were typically grossly distorted in order to comically portray Negroes as foolish, ignorant, and inept. As Toll affirmed, "[Minstrelsy] was the first example of the way

MINSTRELSY An 1843 cover for sheet music popularized by the Virginia Minstrels features the white minstrel troupe in blackface, a racist form of entertainment that swept the nation in the mid-1800s. Minstrelsy, an early means of exploiting black culture, stereotyped African Americans as lazy, ignorant buffoons.

BLIND VIRTUOSO The pianist
Thomas Wiggins Bethune (*left*),
born blind, autistic, and enslaved
in 1849, performed nationwide
at the age of ten and toured
Europe at sixteen. Hired out as
Blind Tom, he had a successful
career but was the lifelong ward
of a white manager.

THE BLACK SWAN Elizabeth
Taylor Greenfield (*below, left*)
became an acclaimed concert
singer. Freed from enslavement
as a child, she reached the height
of her career in the 1850s, even
performing for Queen Victoria.
Greenfield's fans called her the
Black Swan.

American popular culture would exploit and manipulate Afro-Americans and their culture to please and benefit white America."

As was the case with Solomon Northup, numerous enslaved black musicians were called upon to perform for white audiences at plantation gatherings or public venues. A few rose to nationwide prominence as concert artists. Born blind to enslaved parents, Thomas Wiggins Bethune (1849–1908) apparently demonstrated signs of being a musical prodigy from the age of five. Hired out to a concert promoter by his owner and billed as Blind Tom, he earned international recognition as an acclaimed concert pianist—even performing at the White House for President James Buchanan.

Prior to emancipation, some free blacks, among them concert singer Elizabeth Taylor Greenfield (1824–76) and tenor Thomas Bowers (1823–85), established impres-

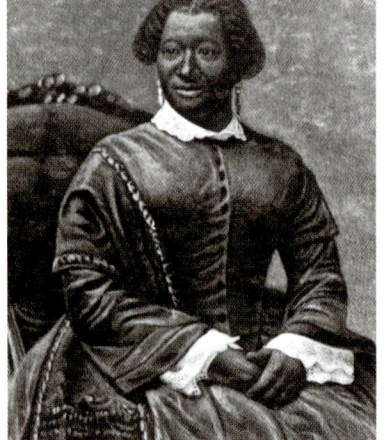

sive reputations on the concert stage. Greenfield was the best-known black concert artist of her era, and Bowers, who studied with her, was known as the Colored Mario because his voice so resembled that of the famous Italian tenor Giovanni Mario. Although perceived as exceptions or curiosities by mainstream society, these performers established themselves as professionals. Against all odds, they demonstrated that African Americans could excel in the classic and fine arts, even though white society thought them incapable of such achievements.

A Distinct Culture Emerges

Black performers did not emerge in large numbers to directly influence American popular culture until emancipation, but a select few had broken through racial barriers and performed with white minstrel troupes decades earlier. They were among the first to introduce more authentic African American performance to the mainstream stage.

William Henry "Juba" Lane (1825–52) was the most famous black artist to appear with white minstrel troupes before the Civil War. He performed with various groups, billing himself as the King of Dance, and thrilled audiences when he traveled to England in 1848 as a member of the Ethiopian Serenaders. Lane apparently combined European

THE AFRICAN AMERICAN PRESENCE IN AMERICAN DANCE

Dwandalyn Reece

Upon their arrival in the Americas, enslaved Africans from diverse cultures created African American dance forms that reflected both African aesthetics and culture and Euro-American influences. In African societies, dance was used in rituals, religious ceremonies, and many facets of daily life that linked the sacred and secular worlds. In large part, African Americans maintained that spiritual and cultural heritage.

Traditional African dance, which has an earthbound orientation in which the body is bent forward and the feet are placed in a wide, solid stance, stood in stark contrast to European dance traditions that emphasized arm and leg movements and upright postures. Fluid movements of the arms, legs, and knees, isolated movements of the shoulders and hips, and shuffling, stamping, and hopping steps are also part of the African aesthetic. An emphasis on percussion and polyrhythms, often executed with handclapping, foot tapping, or body patting, augments the movements. Many dances also feature improvisation, satire, and group participation.

The ring shout, probably the earliest known African American dance form in North America, was often an integral part of religious worship. The fusion of counterclockwise movements, call-and-response singing, hand clapping, and stick beating most likely derived from West African ceremonial circle dances. In the Americas, ring shouts engendered a joyful spiritual connection with God while reinforcing a sense of community by blurring the line between performer and audience.

In the early nineteenth century, enslaved and free blacks in New Orleans performed ring dances as well as Afro-Caribbean dances such as the calenda and the chica in Congo Square on Sundays. Although a tourist attraction for white audiences, the dancing on the square held spiritual meaning for African Americans and facilitated communal sharing. In New York and eastern New Jersey in the eighteenth century, Pinkster Day, a Dutch religious celebration, and Negro Election Day became occasions for African American dancing. On Negro Election Day, blacks in the New England colonies elected their own leaders (whose role often included liaising with the white community) and celebrated with feasting, parades, and dancing.

Such encounters planted the seeds of cultural exchange. Blacks and whites danced in front of each other and picked up performance styles and techniques that they then incorporated into new dances. The buck and wing, pigeon wing, cakewalk, buzzard lope, and other innovative dances spread across the nation. White performers adapted African-influenced dance for the theatrical and minstrel stage but often codified buffoonish stereotypes instead of authentic styles.

In the 1840s, African American William Henry Lane combined his African-inspired skill and technique with Irish jig and reel dances to

DANCING KING AND QUEEN Tap dancer Bill "Bojangles" Robinson (*left*) started performing as a boy, hit his stride in vaudeville, and in the 1930s and 1940s took his elegant steps to Hollywood. Josephine Baker (*right*) began her career in the United States, then headed to Paris in 1924 where she astonished audiences with her flamboyant dancing. She is well known for her role in *Shuffle Along*.

create the earliest known form of American tap dance. Tap dancing would evolve into a new vogue in the next century as the acrobatic skills and rhythmic precision of innovators such as Bill "Bojangles" Robinson, Earl "Snake Hips" Tucker, and John "Bubbles" Sublett imbued the dance with an air of polish and finesse.

In the early twentieth century, the popularity of black vernacular dances such as the Charleston and black bottom, which originated in juke joints, made it to Broadway and launched the careers of breakout stars Florence Mills and Josephine Baker. Mills died young, but Baker made a name for herself in Paris by performing her African-influenced dances. Leggy and beautiful, Baker created signature uninhibited dance moves and performed them in a comic, energetic style that upended cultural conventions about dance.

The Harlem Renaissance took African American dance from the popular stage to the concert hall. In 1931, Hemsley Winfield founded the first black dance company, the New Negro Art Theater Dance Group. He and his peers, including Edna Guy, Randolph Sawyer, Mabel Hart, Lavinia Williams, and Asadata Dafora, worked tirelessly during the early years of the modern dance movement to organize black dance troupes that uplifted the race and acknowledged the African American experience through dance. In the 1940s, the black modern dance movement gained momentum through the work of Katherine Dunham and Pearl Primus, who were trained as anthropologists as well as dancers. Dunham's research in Haiti, Jamaica, Trinidad, and Martinique, where she was both observer and participant, focused on the connections between dance and

continued

culture. The African-derived ritualized movements and gestures that she learned in her fieldwork laid the foundations of her choreography. When Dunham opened her dance school in New York in 1945, she institutionalized the African aesthetic as a legitimate component of modern dance.

As with Dunham, research and study were key to Primus's development. Early in her career, she created social protest dances that challenged the circumstances of black people in America. Her first performance piece, *Strange Fruit*, was based on a poem by Abel Meeropol about the lynching of a black man. As a solo artist, Primus displayed a powerful sense of movement, punctuated with flying leaps and dramatic flourishes. With a strong interest in African themes and subjects, she traveled to Africa in 1948 and studied the dances of thirty ethnic groups. On returning to the United States, she devoted herself solely to African dance.

By the late 1950s, there was greater participation by African American dancers and choreographers in American concert dance; however, racist attitudes still posed obstacles to their joining white dance companies. It took a new generation of pioneers to move things forward. African American choreographer Alvin Ailey started his formal training in California in the 1940s, studying with Lester Horton, a white modern dance choreographer who directed the country's first multiracial troupe.

After Horton's death in 1953, Ailey replaced him as choreographer of the Horton Dance Company before founding the Alvin Ailey American Dance Theater in 1958. Ailey's twin aims were to express black cultural heritage and enrich American dance with a diversity of cultural voices. His choreography drew upon the memories of his childhood in Texas, where blues, spirituals, and gospel music inspired him. References to the rural church of his youth fill his signature work *Revelations*. Later, he would borrow movement and music from the African diaspora to create *Masekela Langage*, featuring the music of South African composer and performer Hugh Masekela. Ailey also employed vernacular dance, modern dance, and jazz dance styles to emphasize dramatic expression and to narrow the distance between audience and performer.

While some dancers were pursuing their own artistic voices in the field of modern dance, others were trying to challenge the rigid wall that stood between African American artists and classical ballet. Janet Collins auditioned for the Ballet Russe de Monte Carlo at the age of fifteen but declined the offer of a place when told she would have to paint her face white to perform. In the 1950s, Collins became the first black prima ballerina with the Metropolitan Opera in New York, dancing in such operas as *Aida* and *Carmen*. Raven

Wilkinson auditioned for the Ballet Russe de Monte Carlo three times before she received a contract to dance with the company full-time in 1955. Similarly, Arthur Mitchell successfully broke barriers in 1956 when he became the only black dancer in the New York City Ballet. He quickly rose to principal and danced all the major roles in the company's repertoire.

Keenly aware of the prejudice against African Americans in ballet, Mitchell wanted to do something that would empower young people to develop their full potential. In 1968, he and his former ballet teacher Karel Shook founded the community-based Dance Theater of Harlem. It has since trained and inspired generations of artists, such as Lauren Anderson, who first saw the company dance as a ten-year-old child. Anderson joined the Houston Ballet in 1983 and in 1990 became the first African American woman to be promoted to the rank of principal at a major American company. Another African American breaking barriers is Misty Copeland, who in 2015 became the first black woman to rise to principal dancer in the renowned American Ballet Theatre.

As artistic visions move dance in new directions, African Americans will continue to shape the landscape of American dance in revolutionary ways. Bill T. Jones, the award-winning African American choreographer of *Last Supper at Uncle Tom's Cabin/The Promised Land* and the Broadway hit *Fela!*, is an artist who constantly pushes the limits of what dance can be. "We wanted to create a company, an environment, reflective of the world we wanted to live in," Jones said. "People would not be limited by their gender, race or ethnicity."

DANCE LEGENDS Judith Jamison (*opposite*) performs the solo role in Alvin Ailey's sixteen-minute ballet *Cry* in 1971. Ailey dedicated the dance, which depicts women's resilience, to "all black women everywhere, especially our mothers." Principal dancers Arthur Mitchell and Diana Adams (*right*) dance a pas de deux in the New York City Ballet's 1957 production of *Agon*.

"The composers, the singers, the musicians, the speakers, the stage performers—the minstrel show got them all."

—W. C. HANDY, *Father of the Blues,* **1941**

steps with juba dancing, a dance with West African origins that involved handclapping, foot-stomping, and slapping or patting hands or sticks against the body. The performance reportedly resembled a fusion of an early form of tap dance with a type of rhythmic hand slapping that later became known as the hand jive or hambone. Lane's innovations may well represent the first appearance of authentic African American dance on the minstrel stage.

With the debut of all-black minstrel troupes in the mid-1860s, many more black performers joined the ranks of professional entertainers. When appearing before white audiences, however, they were expected to reflect the distorted image of African Americans established by their white counterparts. Despite these restrictions, black minstrel performers opened the gates for the emergence of professional black musical and comic artists.

"It goes without saying that minstrels were a disreputable lot in the eyes of a large section of the upper-crust Negroes," African American composer and former minstrel performer W. C. Handy wrote in his autobiography *Father of the Blues.* Not everyone wore blackface, but, as Handy observed, "the best talent of that generation came down the same drain." For many legendary black performers, the minstrel stage was the proving ground on which their reputations were initially established. Among them were Handy, blues singers Bessie Smith and Ma Rainey, ragtime pianists "Jelly" Roll Morton and Eubie Blake, and dancers and comics such as Bert Williams, Moms Mabley, Pigmeat Markham, Bill "Bojangles" Robinson, Josephine Baker, and Stepin Fetchit. For nearly half a century, minstrel shows were practically the only way black performers could achieve mainstream recognition.

The biggest talent to emerge from the early "colored" minstrel troupes was Billy Kersands, who began performing in the 1860s. Much of his popularity came from his raucous onstage clowning, but Kersands was also a renowned hoofer, and his indelible legacy was his dancing. The buck-and-wing and the Virginia essence (a forerunner of the soft-shoe), both rooted in black folk culture, were among his showcase dance routines. Many historians credit him with popularizing these dances; at the very least, he was influential in establishing them as

FATHER OF THE BLUES

The composer and musician W. C. Handy, here making notations on his 1914 hit composition "St. Louis Blues," performed in minstrel shows as a young man.

show business staples, and they were performed in mainstream Broadway productions and Hollywood movies for years.

As pioneering black minstrel performers gradually added more authentic black comic dance and musical elements to their performances, they began to exert increased influence on American popular culture. The impact on comedy was initially not as great because many of the racial stereotypes and caricatures established during minstrelsy's infancy were retained. However, by the late nineteenth century, white Americans were eagerly embracing the African American–inspired music and dance that black performers introduced.

The most acclaimed black artist to emerge during this period was Bert Williams. Early in his career, Williams had teamed with George Walker to form a comedy-dance duo called Two Real Coons. After a Broadway debut in 1896, they became one of the most sought-after acts in show business. The 1901 recordings that Williams and Walker released are among the earliest documented black phonograph recordings; Williams was also the first black performer to star in a motion picture. After Walker's death in 1911, Williams established himself as one of the era's most accomplished solo performers. Eddie Cantor, a white stage and film star who worked with him, wrote: "Whatever sense of timing I have, I learned from him…. He was far superior to any of us who put on burnt cork." When Williams died in 1922, the Broadway impresario Flo Ziegfeld called him "one of the greatest [comedians] in the world," and Booker T. Washington claimed that Williams had "done more for the race than I have."

In addition, the show-stopping rendition of the cakewalk that Williams and Walker spotlighted in their act helped hasten the mainstream acceptance of a dance that originated on plantations. The cakewalk (a shuffling, two-step dance that resembled African ring dances) was thought to be an example of enslaved workers surreptitiously parodying the formal dances and pretentious attitudes of the white slaveholders. The cakewalk began as a circle dance in which couples strutted, sashayed, and pranced to the accompaniment of banjos, sticks or bones, handclapping, and, when permitted, drums.

During the 1890s, it remained a popular dance at black social gatherings and juke joints, where the use of polyrhythms and syncopation often characterized the musical accompaniment. Syncopation involved altering regular rhythmic flow by stressing a normally weaker beat or accentuating an offbeat. The cakewalk and its accompanying syncopated music spread from recreational contests in black communities to stage shows and then to the ballrooms and exclusive cabarets of wealthy whites.

The cakewalk phenomenon was an early example of the interdependent relationship of black music and white

BROADWAY HEADLINERS

Popular entertainers Bert Williams and George Walker, pictured on this 1898 sheet music, subverted traditional minstrel stereotypes to create innovative performances.

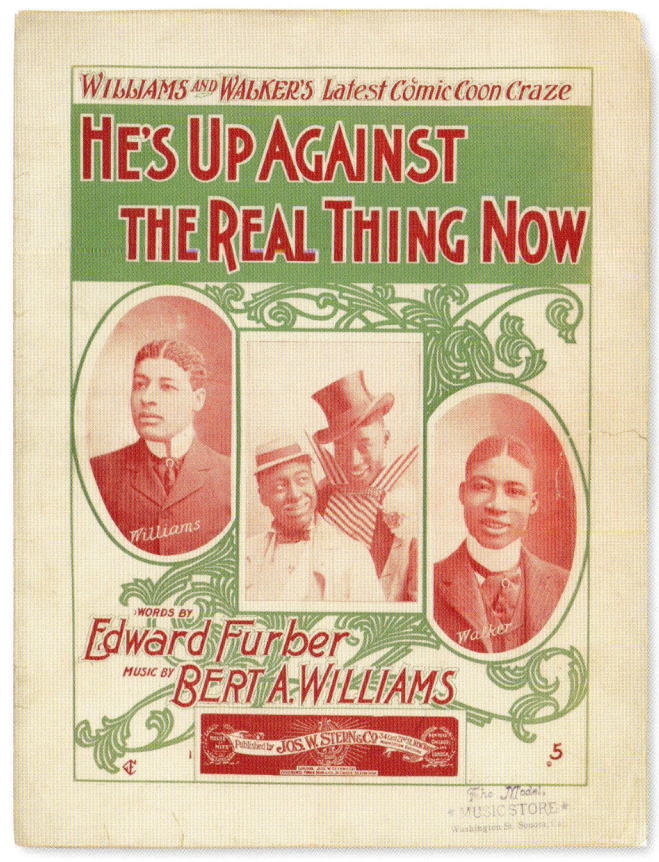

music in America. From the early 1800s to the Civil War, white entertainers had mimicked and parodied black musical styles and customs, showcasing their transformed versions of those styles. With freedom and the advent of black minstrelsy, African American performers began imitating and often satirizing white music. Among the techniques used was "ragging," or adding syncopation to regular musical beats to make them more danceable; black musicians ragged nearly every type of music, including polkas, brass band marches, hymns, classical compositions, and even cakewalks. This mimicking by white and black artists was a give-and-take process from the outset—the beginning of a dialogue and exchange that shaped the evolution of American music. From the 1860s to the turn of the century and beyond, black and white musicians alternately borrowed from one another, then reinterpreted the appropriated elements; the resulting synthesis was then reappropriated and reinterpreted and ultimately syncretized.

Meanwhile, an earthier style of black religious music had started to develop in African American churches. Gospel was characterized by such vocal techniques as growls, slurs, falsetto, and call-and-response, as well as a more insistent syncopated rhythmic approach. At about the same time, gospel's secular counterpart, the blues, began emerging as dance music in juke joints and barrelhouses. Although generally ignored by white mainstream audiences until the twentieth century, the sacred and secular songs of everyday black life were destined to become indispensable features of African American music. Later, they would surface as influential elements in American popular music as well as in jazz.

One of the primary mediums for the transformation of American music was the brass band, which had existed since the 1700s. When creole and black musicians joined or formed brass bands in the late 1800s, elements of African American performance style were added. Brass band music usually depended on written scores, but some black

PAUL ROBESON (1898–1976)

Admirers dubbed actor-singer Paul Robeson "the tallest tree in our forest." Indeed, Robeson, the son of a man who escaped slavery, rose to exceptional heights in an array of pursuits. He excelled in sports and academics at Rutgers University and earned a law degree from Columbia University. Disillusioned with law after facing racial discrimination at a New York firm, Robeson turned to music and theater in the 1920s and was among the first African Americans to be cast in serious acting roles. He won worldwide acclaim for his bass-baritone voice and was celebrated for performances of Negro spirituals and his rendition of "Ol' Man River," which he revised to remove a racial epithet. An award-winning stage and screen actor, he was best known for the title role in a 1943 production of *Othello*, which turned out to be Broadway's longest-running (296 performances) Shakespearean play. Traveling the world, Robeson spoke out against fascism, lynching, and racism. However, his radical views and visits to the Soviet Union led the U.S. State Department to deny him a passport in 1950. He was then systematically blacklisted and defamed for eight years, which nearly destroyed his performing career.

musicians began playing entirely by ear. As Charles B. Hersch pointed out in *Subversive Sounds: Race and the Birth of Jazz in New Orleans*, they performed "hymns and popular songs rather than the complicated 'heavy marches' of traditional white brass bands," combining an earthier, "gutbucket" sound with the established European style. "In a superficial sense," Hersch continued, "black marching bands carried on the European tradition, allowing blacks to integrate themselves into American culture, but they simultaneously commented upon it and changed it. Early brass bands experimented with syncopation, shifting the accent from beats 1 and 3 to 2 and 4, and these innovations were 'absorbed and altered' by ragtime piano players."

Itinerant pianists spread the improvised and spirited syncopated rhythms of ragtime. Its popularity eventually reached Europe when marching bandleader John Philip Sousa (the March King) included cakewalk and ragtime tunes in his 1900 overseas tour. "A pattern was established with the ragtime song that was to recur time and time again in the twentieth century," Charles Hamm wrote in *Yesterdays: Popular Song in America.* "White popular music skimmed off superficial stylistic elements of a type of music originating among black musicians, and used these to give a somewhat different, exotic flavor to white music."

Scott Joplin's 1899 publication of "Maple Leaf Rag" spurred the worldwide ragtime craze, and the African American pianist went on to compose a string of ragtime hits. Although his compositions retained some of the folk patterns that characterize African American performance style, they were more complex and sophisticated than both the earlier folk rags to which African Americans had danced and the popular ragtime tunes churned out in New York City's Tin Pan Alley, the center of the music publishing industry at the time. Joplin set out to establish ragtime as high culture and before his death in 1917 wrote two operas and a ragtime ballet. His classic, formalized compositions reflect a distinctly American music style and are now considered archetypal rags.

By the time Joplin died, ragtime had begun to decline in popularity. Marching bands in New Orleans and elsewhere began developing a more danceable and less stylistically restricted syncopated music form. But ragtime remained an essential part of the new music. According to Hersch, "Musicians took its distinctive syncopation, its ragging, and used it to signify on [mask and reinterpret] American themes and melodies, transforming them into jazz." Ragtime syncopation, the blues, and improvisation were among the tools that effected the transformation.

This new music spread to other cities when musicians joined riverboat bands or vaudeville and minstrel shows in the early twentieth century. The main destinations were New York and Chicago. Creole clarinetist Sidney Bechet arrived in Chicago in 1917. Two years later, he traveled to London, discovered the soprano saxophone, and helped popularize jazz in Europe. Bandleader and cornetist Joe "King" Oliver moved to Chicago in 1918 and established the influential Creole Jazz Band in 1922. Most significantly, Louis Armstrong was called to Chicago by his mentor, Oliver, in 1922 and played second

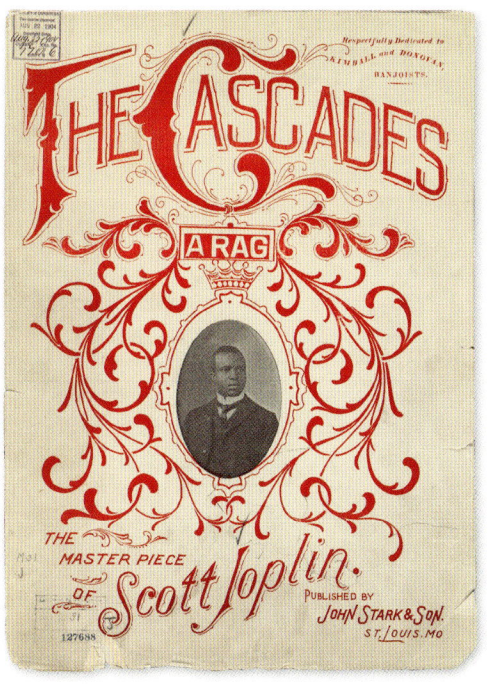

RAGTIME INNOVATOR

In 1899, Scott Joplin, pictured on the cover of this sheet music, published his seminal composition "Maple Leaf Rag," which became a best-selling ragtime song and fueled the genre's popularity.

LOUIS ARMSTRONG (1901–71)

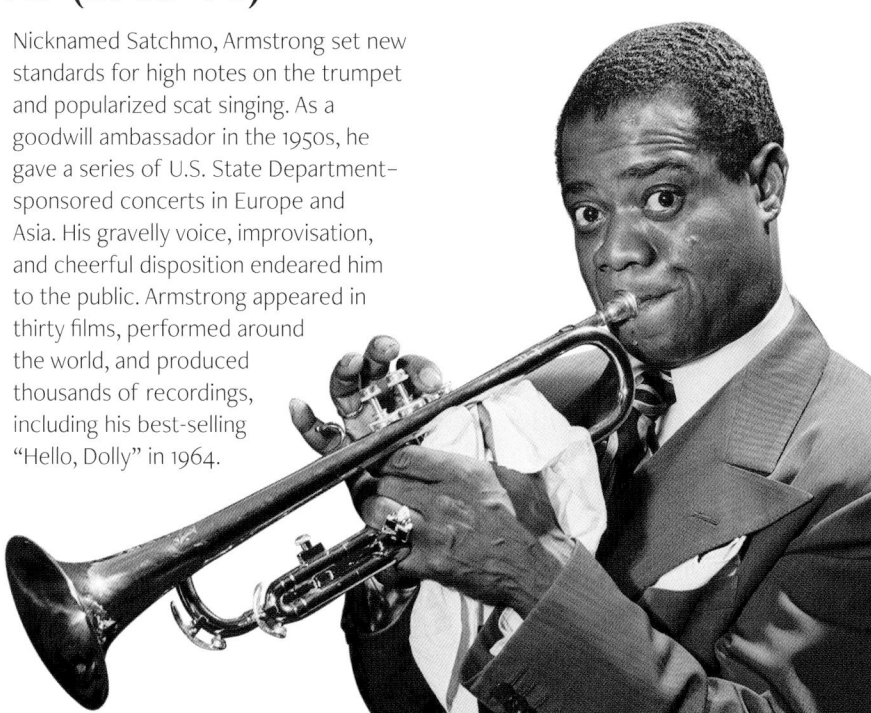

Louis Armstrong was seven or eight when he blew his first note from a battered cornet. Born in a rough, poor section of New Orleans, by age ten Armstrong had landed in a juvenile institution for firing a pistol. During his year and a half in the Colored Waifs Home for Boys, he received his first music lessons and played in the home's brass band. Upon release, Armstrong began playing in local clubs, riverboats, and parades, displaying the facility and versatility that would eventually make his name synonymous with jazz. During the 1920s, he refined his cornet and trumpet abilities with the bands of Joe "King" Oliver and Fletcher Henderson and led his own band called Hot Five. Music scholars deem Armstrong's 1928 solo recording of "West End Blues" a milestone in the evolution of jazz.

Nicknamed Satchmo, Armstrong set new standards for high notes on the trumpet and popularized scat singing. As a goodwill ambassador in the 1950s, he gave a series of U.S. State Department–sponsored concerts in Europe and Asia. His gravelly voice, improvisation, and cheerful disposition endeared him to the public. Armstrong appeared in thirty films, performed around the world, and produced thousands of recordings, including his best-selling "Hello, Dolly" in 1964.

MAESTRO IN EUROPE

Sidney Bechet, shown here in 1950, was deemed "the epitome of Jazz" by Duke Ellington. Revered by peers and critics, he achieved even greater renown when he left the U.S. for Paris.

cornet for Oliver's band before striking out on his own. Armstrong's high notes and unique improvisations would lead to revolutionary developments in jazz soloist performance.

At about the same time, however, a raft of mainstream all-white bands playing diluted or gentrified versions of jazz surfaced. During the 1920s, orchestras led by Ted Lewis, Fred Waring, Rudy Vallée, and Paul Whiteman dominated popular music in America, disseminating a saccharine sound that featured sentimental melodies, string sections, and little or no improvisation. The mainstream cooptation and assimilation of what was essentially a black musical form was reflected in the fact that, despite the innovative achievements of African American musicians such as Morton, Armstrong, and Duke Ellington, publicists and the press dubbed Whiteman the King of Jazz. Notwithstanding this snub, the success and popularity of mainstream dilutions of jazz music were indisputable proof of the growing influence of African American cultural forms on white America's popular culture.

As rhythmic music flooded the nation in the 1920s, freer, less inhibited dances replaced the formal, controlled, patterned movements of nineteenth-century social dancing. African American dances soared in popularity. Mainstream acceptance of such dances as the Charleston and black bottom moved the social critic H. L. Mencken to write in 1927: "No dance invented by white men has been danced at any genuinely high-toned shindig in America since the far-off days of the Wilson administration; the debutantes and their mothers now revolve their hips to coon steps and coon steps only."

The impact of African American culture was palpable in large cities as America transitioned from a rural nation to an urban one in the twentieth century. With rapid urban population growth, accelerated by the post–World War I migration of blacks from the South, conservative rural mores conflicted with new urban values. The African American milieu, especially its music and entertainment, was irresistible to whites seeking adventure or rebelling against traditional values.

In 1921, white and black audiences flocked to see *Shuffle Along*, a groundbreaking musical that ran for nearly five hundred Broadway performances before setting out on a nationwide tour that lasted until 1924. A showcase for African American talent, the musical was written by Flournoy Miller and Aubrey Lyles, with music and lyrics by jazz and ragtime virtuosos Eubie Blake and Noble Sissle. The score of memorable hit tunes—including "Gypsy Blues" and "I'm Just Wild about Harry"—further established ragtime music as a staple of Tin Pan Alley and accelerated the acceptance of blues and jazz in American popular music.

The hit musical's choreography featured routines that were new to Broadway and to most white audiences. An array of dances, including soft-shoe, time steps, acrobatics, rapid-fire tap dancing, shimmies, the buck-and-wing, and the Texas Tommy, electrified the stage and helped propel cast members Josephine Baker and Florence Mills to stardom. *Shuffle Along* set the stage for a string of black-cast Broadway musicals in the 1920s and continued to influence song-and-dance productions in popular American entertainment for decades. A 1922 song from the *Ziegfeld Follies* called "It's Getting Dark on Old Broadway" was a reference to the growing African American presence, which it termed the "latest rage."

SHUFFLE ALONG This hit show featured an African American love story, a taboo in 1921 for black actors. This sheet music for the musical's romantic ballad "Love Will Find a Way" was signed by Eubie Blake, one of the show's creators, and Adelaide Hall, who performed as a chorus girl.

THE BEST OF BROADWAY
Eubie Blake (*left*) and Noble Sissle (*right*), long-time collaborators in vaudeville, wrote the music and lyrics for *Shuffle Along*.

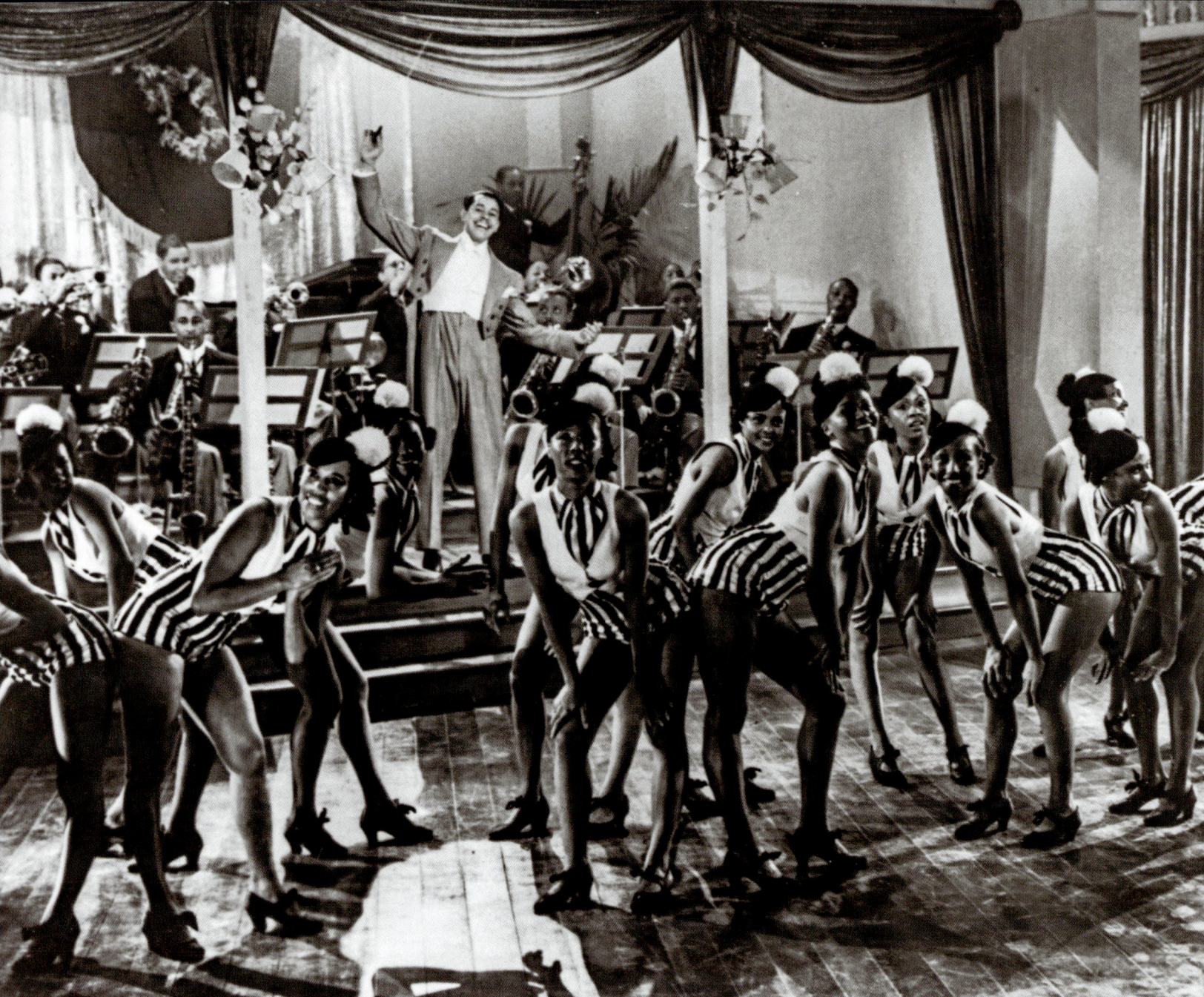

THE COTTON CLUB This famous Harlem club catered only to white patrons, but most of the entertainers were African Americans, including Cab Calloway (*above, center*), performing at the club with black dancers in 1937.

HEAR ALL ABOUT IT
A wooden clapper promoted Ethel Waters's 1933 performance at the Cotton Club.

The Harlem Renaissance

In the 1920s, the appeal of black culture transcended music, dance, and Broadway musicals. The prevailing notion of the African American community as a world of dark, uninhibited revelry and passion lured throngs of white visitors—from ordinary citizens to European royalty—to Harlem as well as to black enclaves in Los Angeles and Chicago. Speakeasies and nightclubs, many mob-owned, provided lavish, sometimes outlandish entertainment. Black waiters danced the Charleston as they served food; beautiful, scantily clad black women gyrated onstage to the music of premier bands headed by Cab Calloway, "Fats" Waller, Fletcher Henderson, Duke Ellington, and other greats who played so-called jungle music in the sumptuous Africanesque decor of the legendary Cotton Club for the whites-only audience.

"At these times, the Negro drags his captors captive," the civil rights leader and novelist James Weldon Johnson wrote. "On occasions, I have been amazed and amused watching white people dancing to a Negro band in a Harlem cabaret … striving to yield to the feel and experience of abandon, seeking to recapture a taste of primitive joy in life and living, trying to work their way back into that Jungle that was the Garden of Eden; in a word, doing their best to pass as colored."

MUSICAL VIRTUOSO Larger than life, "Fats" Waller was a prolific songwriter-musician who transitioned to radio and film. He performed with singer Ada Brown in *Stormy Weather* (*below*), a 1943 film that showcased popular black entertainers.

COVER STORIES: THE FUSION OF ART AND LITERATURE DURING THE HARLEM RENAISSANCE

Tuliza Fleming

A distinctive feature of the Harlem Renaissance was the publication of books with strikingly designed dust jackets, the result of the close relationship between African American writers and artists. In fact, such collaboration wasn't entirely new. Some two hundred fifty years earlier, the enslaved Boston artist and poet Scipio Moorhead was commissioned to execute the portrait of the African American poet Phillis Wheatley for the frontispiece of her book *Poems on Various Subjects, Religious and Moral* (1773). Wheatley so admired Moorhead that she wrote a poem, "To S. M. a young African Painter, on seeing his works," in praise of his accomplishments as an artist and poet and to celebrate the successful union of image and verse.

A cultural and artistic vision shared by artists and writers characterized the Harlem Renaissance, a movement lasting from 1919 through the mid-1930s that sought not only to promote the arts, but also to generate the wider acceptance of African Americans in a white-dominated society. At the forefront of the movement were the writers W. E. B. Du Bois, Jessie Redmon Fauset, Alain Locke, and James Weldon Johnson, and educator Charles Spurgeon Johnson. They nurtured and guided a younger generation of artists and writers, who went on to challenge many conservative values and conventions of the established African American elite, ushering in a new era of black consciousness through the visual and literary arts.

In 1925, Alain Locke edited *The New Negro*, an anthology of fiction, poetry, philosophy, history, sociology, and reviews by and about African Americans. Featuring the work of many young black artists, it was the first major book to seamlessly incorporate visual art and design. It sparked collaborations between artists and writers in two primary areas: the creation of literary journals and graphic illustrations for books.

Prior to the twentieth century, book jackets were used primarily to protect books. By the 1920s, however, publishers regularly commissioned fine as well as graphic artists to design the jackets—expanding their role from mere protection to valuable advertising. Arresting and well-designed dust jackets attracted potential customers and hinted at the book's content. Until then, it had been common for publishing companies to commission an artist who neither knew the author nor had read the book. By contrast, Harlem Renaissance writers typically knew their book designers; in fact, many of them requested specific artists to design their covers.

CREATIVE COLLABORATIONS In the 1920s, publishers began to use dust jackets to market books. Aaron Douglas, one of the era's leading artists and graphic designers, created book jackets for many Harlem Renaissance writers, among them Claude McKay and Rudolph Fisher. White artist Charles Cullen illustrated Countee Cullen's work.

The most prolific of the African American dust jacket designers was Aaron Douglas. After moving from Kansas City to Harlem in 1925, he found himself swept up in the excitement and promise of the New Negro Movement and soon developed a signature graphic style combining elements of art deco, Egyptian imagery, and silhouetted figures within a monochromatic palette. As a talented protégé of the movement's leaders, Douglas forged close relationships with his literary contemporaries. His dust jacket for Claude McKay's novel *Banjo* (1929) shows a small group of people standing on a pier in the Vieux Port of Marseilles; in the center of the illustration is the book's title character, Lincoln Agrippa Daily, known as Banjo, playing his beloved instrument.

Douglas also designed the cover for Rudolph Fisher's *The Walls of Jericho* (1928). Set in late 1920s Harlem, the novel addresses issues of class, color, and racial solidarity through the relationships of Shine, a piano mover, and Linda, a housekeeper. Douglas's illustration places the two main

characters between the stark silhouettes of an African mask and urban skyscrapers, with Shine's piano-moving truck on the ground between his legs.

Douglas's commitment to the ideals of the Harlem Renaissance, his artistic style, and his personal connections made him the most sought-after literary illustrator of the era. Between 1925 and 1940, he designed some twenty-five dust jackets and provided illustrations for four African American magazines—*Opportunity*, *The Crisis*, *Harlem*, and *Fire!!*. As his career advanced, he became best known for his large-scale murals depicting African American life and history.

Other Renaissance writers who partnered with artists to promote their published work include Arna Bontemps and Langston Hughes. They commissioned the Harlem illustrator E. Simms Campbell to create the illustrations and design the dust jacket for their children's book *Popo and Fifina: Children of Haiti* (1932). That same year, Campbell also provided the illustrations and cover for

Sterling Brown's *Southern Road* and for two of his poems, "Glory, Glory" and "A Killer Diller."

Some Harlem writers reached out to nonblack artists to illustrate their publications. Folklorist Zora Neale Hurston, for example, engaged Mexican artist Miguel Covarrubias, who was well known and liked within Harlem's young literary circles, to design the cover and illustrate *Mules and Men* (1935), her collection of stories from African American folklore. *Opportunity* editor Charles S. Johnson and poet Countee Cullen picked Charles Cullen (no relation), an openly gay, white artist known for his erotic images of androgynous men and women, to illustrate their works.

The collaborations between African American writers and artists represented an important period in American publishing history when writers could select specific illustrators to represent their work visually and thematically. Working together, writers and artists produced publications that were creatively independent, socially liberal, culturally inclusive, and aesthetically significant.

Radio Days

During the Roaring Twenties, a new and inventive medium began gaining popularity. Shortly after the debut of radio in November 1920, licensed commercial radio began to influence American society and spread African American culture. Music quickly became an integral part of radio content, and spirituals, jazz, and even some of the early raucous blues tunes were broadcast. "Henderson, Ellington, and others were broadcasting regularly, sometimes every night or even twice a night, from major nightclubs, hotels, and dance halls," James Lincoln Collier wrote in his 1985 biography of Louis Armstrong. "There was more *good* jazz on radio in New York during the twenties than there is today."

In addition, dozens of ersatz "black" voices filled the airways. Whites initially portrayed nearly all of the black characters on radio, just as they had onstage in the 1800s and in early-twentieth-century silent films. By the mid-1920s, many minstrel performers had reestablished their blackface comedy acts on radio, and throughout the 1920s and 1930s the racial ventriloquism of shows featuring Watermelon and Cantaloupe, Molasses 'n' January, and Buck and Wheat ranked high among radio variety programs. These pseudo-black voices were indelibly etched into the American psyche, and the racial caricatures would distort the image of African Americans for decades.

The *Amos 'n' Andy Show*, created by white former minstrel performers Freeman Gosden and Charles Correll, was the most successful and enduring of these shows. After debuting in 1928, it rocketed to the number-one spot in radio rankings and remained near the top until the 1940s. The program remained on the air until 1960 and also became a television series. Some historians contend that it was not only the first great radio show, but also the most popular show ever broadcast. Its success was, in part, due to its pioneering serial format, featuring a continuous storyline with the appeal of latter-day soap operas; its popularity also reflected white America's curiosity about black life—even if it was screened through the imagination of white impersonators.

The continued vocal mimicry of Gosden and Correll notwithstanding, impersonations of blacks on radio began to diminish during the 1940s, and new shows hosted by musical stars such as Nat "King" Cole and Duke Ellington aired. Small local radio stations also targeted black audiences by offering programs hosted by African American DJs who not only brought genuine community patter and black wit to the airways, but also played original blues, rhythm and blues, and other authentic black music that had been mostly ignored by mainstream radio shows. By the late 1950s, these shows, as well as shows hosted by white DJs that imitated them, were increasingly attracting young white audiences. African American voices and influence were key factors in radio's evolution as an entertainment forum.

MODERN MINSTRELSY White actors portrayed the stereotyped characters on the wildly popular *Amos 'n' Andy* radio show. The serial's major sponsor, Pepsodent toothpaste, distributed paper dolls of Amos (*top*) and Andy (*above*) to listeners.

MAKING AN ENTRANCE ON STAGE AND SCREEN

Dwandalyn Reece

Ever since William Brown established the country's first black theater, the African Grove, in New York City in 1821, African Americans in theater—and later in film and television—have struggled to have their creative voices heard. Throughout the nineteenth and early twentieth centuries, black actors fought the racial stereotypes that pervaded minstrel shows and other popular entertainment by creating their own opportunities. *Shuffle Along* (see page 225), a musical revue featuring an all-black cast, with story, music, and lyrics by African Americans, became a Broadway hit in the early 1920s. Although it did not move entirely away from stereotypes, it gave its characters a love story and presented songs with sophisticated themes. A few successes, such as actor Paul Robeson (see page 222), penetrated the upper echelons of theater, but for the most part African Americans performed among their own people. Later generations followed the same strategy as long as the theater remained indifferent to black performers.

In 1940, writer Abram Hill and actor Frederick O'Neal founded the American Negro Theatre (ANT) in Harlem to reflect African American life. Over the course of its nine-year existence, the company mounted nineteen productions. Hill's adaptation of Philip Yordan's *Anna Lucasta*, originally a drama about a Polish family, for an all-black cast, landed on Broadway. ANT's training program welcomed young artists, including Harry Belafonte, Sidney Poitier, and Ruby Dee, who later became celebrated actors.

Although Broadway showed little interest in the work of African American playwrights in the early 1950s, some black actors won awards for outstanding performances in musicals written by whites. Pearl Bailey and Diahann Carroll garnered acclaim, and Juanita Hall was the first African American to win a Tony Award. There were signs of change when Lorraine Hansberry's play *A Raisin in the Sun* opened on Broadway in 1959. The drama, which had a nearly all-black cast, represented a milestone in theater history: Hansberry was the first African American woman to have a play on Broadway and the play's director, Lloyd Richards, was Broadway's first African American. The production told the story of the Youngers, a working-class family in Chicago struggling to better themselves, who face racism when they try to buy a house in a white neighborhood. Groundbreaking in its honest treatment of race, *A Raisin in the Sun* showed that Broadway could deal seriously with racial issues. The play received several Tony Award nominations.

The Civil Rights and Black Power movements of the 1960s and 1970s fueled black artists' interest in their own culture. In 1967, playwright Douglas Turner Ward, theater manager Gerald Krone, and actor Robert Hooks formed the Negro Ensemble Company (NEC) as part of Harlem's Black Arts Repertory Theatre/School. NEC mounted high-end productions that drew interracial audiences, such as Lonne Elder III's *Ceremonies in Dark Old Men*, Joseph A. Walker's *The River Niger*, and Charles Fuller's *A Soldier's*

OSCAR-WINNING PERFORMANCE By refusing demeaning roles, Sidney Poitier broke racial barriers in Hollywood. In 1964, he became the first black person to win the Best Actor award for *Lilies of the Field* (above).

Play. NEC's impressive roster of alumni includes John Amos, Angela Bassett, Laurence Fishburne, Sherman Hemsley, Samuel L. Jackson, Phylicia Rashad, Esther Rolle, Richard Roundtree, and Denzel Washington. Another theater group, the New Federal Theatre, founded by Woodie King Jr. in 1970, worked to bring people of color and women into the mainstream; in 1975, it produced Ntozake Shange's award-winning play *For colored girls who have considered suicide/When the rainbow is enuf*.

August Wilson's *Ma Rainey's Black Bottom*, which opened on Broadway in 1984, was the first in the playwright's cycle of ten plays exploring the black experience in America in each decade of the twentieth century. Wilson brought a lyrical realism to his work while drawing upon African American cultural traditions, collective memories, and a spirit of resilience and survival. He won a Tony and a Pulitzer Prize for his plays, which featured some of Broadway's finest black actors, including Mary Alice, Viola Davis, Laurence Fishburne, James Earl Jones, Ruben Santiago-Hudson, and Denzel Washington.

In the past few decades, the African American presence in theater has expanded in new and vibrant ways as Broadway has embraced black talent. Stephen Byrd, Alia Jones, Kenny Leon, Lynn Nottage, Suzan-Lori Parks, and Anna Deavere Smith are among the playwrights, directors, and producers who have broken new ground with unique voices and points of view. Adaptations of shows with black casts have increased employment opportunities for African Americans and offered contemporary perspectives on traditional stories. The all-black casts of *Cat on a Hot Tin Roof*, *A Trip to Bountiful*, and other classics also attracted more black theatergoers.

continued

Nontraditional casting—the hiring of actors of color or women to play roles in which race, ethnicity, and gender are neutral—is another factor that has engendered a more integrated Broadway. At the dawn of the motion picture industry, African Americans working in film suffered racial bias similar to that felt by early black actors working on the stage. They were cast in mainstream films as maids, butlers, mammies, or worse—criminals and slackers. As early as 1910, independent black filmmakers began working outside Hollywood to make films focusing on nonstereotypical African American characters and themes. In the 1920s, Oscar Micheaux made dozens of films that explored social issues of the time and presented black characters with humanity and diversity.

After World War II, the changing racial climate and the constant pressure exerted on the film industry by the National Association for the Advancement of Colored People (NAACP) led Hollywood to introduce films with serious racial themes and a social message. Films of this period, such as *Pinky* (1949), with Ethel Waters, and *The Defiant Ones* (1958), with Sidney Poitier, featured black actors alongside white actors in plots that addressed the existence of racism and its impact on African American lives. Poitier, who had begun his career in the theater, became a Hollywood star. By eschewing racial caricatures, Poitier expanded the kind of roles open to African American actors. The strength and intelligence he brought to his films resonated with black and white audiences and challenged the racial status quo in Hollywood. In 1964, Poitier became the first African American to win the Academy Award for Best Actor for his role in *Lilies of the Field*, in which he plays a handyman taken in by a community of nuns who believe he has been sent by God.

The 1970s brought controversial new images of blackness to films. The hero in black director Melvin Van Peebles's 1971 *Sweet Sweetback's Baadasssss Song* was a revolutionary avenger of society's wrongs who displayed bravado and sexuality. Targeted at black audiences, *Sweetback* echoed aspects of the Black Power Movement. A plethora of action films, known as blaxploitation movies, soon followed. They featured daring protagonists who took on the establishment and miscreants who committed crimes against the black community: *Shaft*, *Super Fly*, and *Foxy Brown* were popular films of the genre. Along with the depiction of empowered heroes for the masses, however, the films often included graphic sex scenes, violence, and drug use, which many viewers thought stereotyped African Americans in new ways. Others said the films offered authentic portrayals of urban life and provided black heroes. Despite the controversy, such films opened the door for a new type of role for black actors while increasing their numbers in the industry.

Even as Hollywood rolled out blaxploitation movies, some studios produced edifying films, such as *Sounder* in 1972 and *Claudine* in 1974, which focused on black family life. By the 1980s and 1990s, many African American actors had enough leverage to exercise some production control in their films. It was the era of big box-office superstars such as Eddie Murphy and Will Smith, both of whom had creative control and worldwide appeal. Media mogul Oprah Winfrey has acted in several films and has produced even more. A new generation of independent filmmakers, including Spike Lee, with his debut hit *She's Gotta Have It* in 1986; Kasi Lemmons, with *Eve's Bayou* in 1997; and Ava DuVernay, director of the 2014

OSCAR MICHEAUX (1884–1951)

Before Oscar Micheaux made his debut as a filmmaker, he homesteaded a large tract of land in South Dakota. His stint as a farmer was short-lived, but it provided him with the background and inspiration for his first novel, *The Homesteader*, the basis of his first film in 1919, which was also the first feature-length film by an African American. A year later, Micheaux produced *Within Our Gates*, a thoughtful rebuttal to D. W. Griffith's glorification of the Ku Klux Klan in *Birth of a Nation*. Over three decades, Micheaux made

Poster for Micheaux's *The Exile* (1931)

more than forty films, most of them challenging negative portrayals of black people. Because his films depicted complex black characters from different economic classes, examined racial relationships between blacks and whites, and dealt with social problems such as lynching and injustice, they were sometimes banned from white theaters. In advance of the Civil Rights Movement, armed only with an arsenal of films and books, Micheaux used his creativity to fight the racial stereotypes so pervasive during his lifetime.

changing. Prime-time dramas featuring African American actors in prominent, sometimes leading roles include *Law and Order* (S. Epatha Merkerson), *NYPD Blue* (James McDaniel), *The Unit* (Dennis Haysbert), *Scandal* (Kerry Washington), and *How to Get Away with Murder* (Viola Davis).

Today, many African Americans in television exercise creative control as screenwriters and directors with their own production companies, developing shows that respectfully portray the lives of black people. Shonda Rhimes, for instance, is a juggernaut in the business, producing and writing the hit series *Grey's Anatomy* and *Scandal*. The development of cable television and the Internet has led to new opportunities for independent and diverse voices. Concerns about stereotypes and the lack of African American representation in Hollywood continue to surface, but they are met with a steely resolve to make sure black voices are heard, that equal opportunities exist, and that television, like theaters and movies, reflects the fullness of the African American experience.

A NEW TAKE While most blaxploitation films relegated women to supporting and often demeaning roles, a few featured powerful women in leading roles such as *Foxy Brown* (*left*), portrayed by Pam Grier, a nurse-turned-vigilante who takes down a drug gang.

UNFLINCHING VISIONARY Independent filmmaker and cultural icon Spike Lee has dedicated his career to challenging the Hollywood status quo. Through hard-hitting films like *Do the Right Thing* (1989) and *Malcolm X* (1992), Lee has examined issues of race, politics, and the African American experience.

Oscar-nominated *Selma*, have demonstrated the possibilities within independent cinema to tell stories that embody an African American aesthetic and worldview.

In television's earliest days, situation comedies like *Amos 'n' Andy* and *The Beulah Show* gave African Americans opportunities to appear on the small screen but borrowed heavily from minstrel stereotypes. The same social changes experienced by theater and film impacted television as well. As the 1960s came to a close, more opportunities opened up both onscreen and behind the camera. Instead of playing servants, African American actors took roles as doctors, nurses, teachers, and other professionals. Behind the camera, Mark Warren was an early success, becoming the first black director to win an Emmy in 1971 for directing *Rowan & Martin's Laugh-In*.

The last decades of the twentieth century saw a run of comedy shows starring black actors, including *Good Times*, *Sanford and Son*, *What's Happenin'?*, *The Jeffersons*, *The Cosby Show*, *A Different World*, *Frank's Place*, *The Fresh Prince of Bel-Air*, *Martin*, and *Living Single*. There were fewer lead roles for blacks in drama series, suggesting that African Americans were more acceptable in comedy than as complex individuals in serious situations. However, this is slowly

The "Chitlin' Circuit"

America's popular stage entertainment struggled during the Great Depression. The economic crisis exacted a heavy toll on the vaudeville circuit as well as on TOBA (Theater Owners Booking Association), the popular black theatrical circuit that flourished from the early 1900s to the 1930s. Engagements on the vaudeville circuit dwindled and TOBA folded. While a few big-name black performers still had access to integrated venues, by the 1940s, most black entertainers had to work a more loosely organized chain of theaters, cabarets, and clubs that became known as the Chitlin' Circuit. The network of black venues extended across the country; chief among them were the Lincoln Theater in Los Angeles and the Apollo Theater in Harlem.

TOBA and Chitlin' Circuit audiences were primarily African American, and the entertainment presented in the venues generally reflected their tastes. Many of the music, dance, and comedy routines that are now considered classic African American stage acts

FLASH DANCING The Nicholas Brothers, Harold (*left*) and Fayard (*right*), combined acrobatics and tap dancing in their high-energy dance style, which they pioneered in the 1920s. Their daring showmanship made them favorites onstage and in movies.

were developed during this era. The acrobatic dances of Peg Leg Bates and the Nicholas Brothers; the inventive comedy routines of Moms Mabley, Dusty Fletcher ("Open the Door Richard"), and Pigmeat Markham ("Here Come the Judge"); and the song, dance, and salacious patter of Butterbeans and Susie are classic examples of the era's African American stage performances. The black entertainers who created them were often denied wider exposure, so most white audiences were unaware of their origins, even when such performances surfaced in the routines of mainstream films and stage acts.

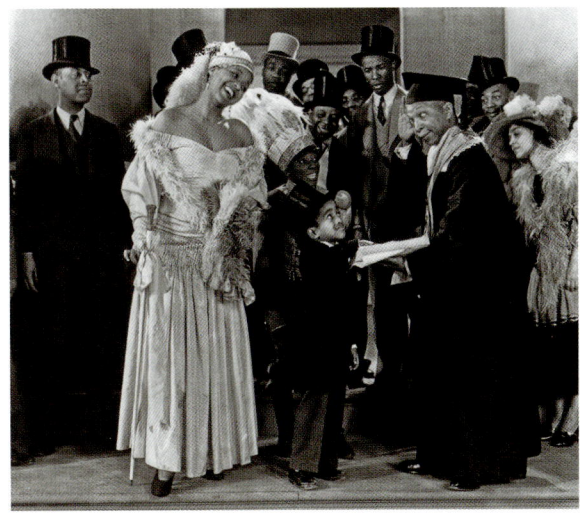

A STAR IS BORN Sammy Davis Jr. (*center*) made his film debut as a child president in the 1933 all-black musical *Rufus Jones for President*. Ethel Waters and comedian Dusty Fletcher flank the young actor.

Popular white comic duos of the period such as Abbott and Costello and (Dean) Martin and (Jerry) Lewis are alleged to have routinely borrowed material from black comic acts. In a 1992 interview, Harold Cromer (Stumpy of the comedy duo Stump and Stumpy) claimed that Martin and Lewis offered to pay to use the black duo's material. Pigmeat Markham recalled Milton Berle (dubbed the Thief of Bad Gags) as "this little white cat hardly out of knee pants" who showed up at the Apollo "with his scratch pad and pencil and started copying down every word I said." Markham also claimed that comedian Joey Adams once ran into him in downtown Manhattan and told a bystander, "Here's a man I ought to give half of my salary to. I stole my first act from him." Bill Cosby humorously lambasted the ongoing pilferage at a commemorative event at the Apollo in 1985, opining that "performers from downtown would come uptown to sit in this theater and copy down what the uptown people were saying so they could take it downtown."

Soundtrack of a Nation

The influence of African American comedy and dance on America's popular culture is rarely disputed; still, its effect is dwarfed by the impact that black music has wielded. With the emergence of "swing" during the 1930s and 1940s, the extent of that influence became even more apparent. The term *swing*—describing another iteration of syncopation characterized by driving, up-tempo, danceable rhythms—surfaced around 1930 and came into vogue with Duke Ellington's 1931 composition "It Don't Mean a Thing (If It Ain't Got That Swing)."

TALENT TRIFECTA
Duke Ellington (*playing piano*) holds court at Pittsburgh's Stanley Theater (ca. 1942–43) as dancer Charles "Honi" Coles (*left*) and Billy Strayhorn, composer and arranger, look on.

Big bands had been playing swing music since the emergence of large ensemble jazz in the early 1920s, and this so-called hot music was immensely popular among African Americans. Mainstream audiences, accustomed to more romantic arrangements, initially resisted this edgier music, with its quick, often erratic tempos and sometimes risqué lyrics. However, by the early 1930s, acceptance of the music was growing steadily. According to many historians, the beginning of the swing era can be dated to August 1935, when the white bandleader Benny Goodman appeared at the Palomar

"Each ... appropriation ... of a Negro style by white America ... has stimulated the Negro community ... to generate a 'new' music that it can call its own."

—CHARLES KEIL, musicologist, *Urban Blues*, 1966

Ballroom in Los Angeles. Goodman's band, which featured arrangements by the African American composer Fletcher Henderson, sparked an upsurge in mainstream interest in jazz that made it the most popular music in America for more than a decade.

Touted as the King of Swing, Goodman remained one of America's most popular musicians until the 1960s. At a time when many white bands turned to more vapid, commercialized forms of swing music, Goodman loomed as one of the musicians who embraced the extemporaneous spirit of the black music tradition with the most fidelity. Readily acknowledging his indebtedness to the African American sources who inspired the music, he evolved as a pioneer in hiring black musicians during the Jim Crow era, when racially mixed music groups were not tolerated.

Even as white musicians subsumed and transformed big band jazz for mass audiences, black communities were giving birth to other musical forms during the 1940s—bebop and rhythm and blues (R & B) were the most notable styles. Bebop was developed by a younger generation of musicians who formed smaller combos and set out to counter the popular big band swing style with a new, non-danceable jazz form that demanded audiences listen. "Beboppers," according to the author and black nationalist leader Amiri Baraka, sought to "restore jazz ... to its original separateness, to drag it outside the mainstream of American culture" and recover the "harshness and asymmetry" that had traditionally characterized it. Jazz legends Thelonious Monk (piano), Charlie Parker (alto saxophone), Dizzy Gillespie (trumpet), and Miles Davis (trumpet) were among the maverick bebop musicians. The predictably bouncy, dance-oriented sound of popular swing was replaced with, among other things, faster tempos, more complex syncopation, increased improvisation, and accentuation of the blues principles that had girded earlier jazz.

When bebop recordings were released in the mid-1940s, they often baffled and disturbed listeners accustomed to the smooth sounds and regular beats associated with popular swing. Art and jazz critic Rudi Blesh of the *New York Herald Tribune* called it "a capricious and neurotically rhapsodic sequence of effects for their own sake, [which] comes perilously close to complete nonsense as musical expression."

If bebop represented a more sophisticated and complex response to the assimilation of African American music, then R & B, with its rhythmic mix of jazz, blues, and amplified guitar, offered a less complicated, more danceable popular alternative. The term R & B was adopted by the record industry to replace *race records* as a designation for music produced by and for African Americans. The music was more upbeat, strident, and risqué than white

JAM SESSION Benny Goodman, playing clarinet at a 1947 rehearsal in New York City (*opposite*), was the first white musician to include African Americans in his band. Here he plays with Teddy Wilson at the piano, Cozy Cole on drums, and Sid Weiss on the double bass.

JAZZ MASTERS Saxophonist Charlie Parker (*below, left*) and trumpeter Miles Davis (*right*) were pioneer collaborators in a lineage that includes Muhal Richard Abrams, Ron Carter, John Coltrane, Herbie Hancock, Bud Powell, Charles Mingus, and Wayne Shorter.

popular music, but singer Louis Jordan, who had begun his career as a big band jazz saxophonist, succeeded in developing its crossover appeal. The infectious, driving music generated by his Tympany Five band (which actually had seven pieces), combined with his vocal style—rapid-fire, sassy, exuberant, and laced with comic asides—was instrumental in popularizing R & B for young white listeners and establishing it as America's dominant postwar dance music.

Fueled by the increasing crossover appeal of Jordan—and by Little Richard and Chuck Berry in the early 1950s—mainstream interest in "race music," or R & B, flourished. The music would soon be absorbed and transformed into the rock 'n' roll sound that dominated popular American music from the mid-1950s to the 1970s. The process was often contentious, but its dynamics reveal the influence R & B wielded in shaping American popular culture as well as the manner in which it assimilated African American music.

Beginning in the early 1950s, the raucous, bluesy sounds of R&B were initially unveiled to most white Americans on radio shows hosted by black DJs and aimed at black audiences or on programs hosted by a few defiant or avant-garde white DJs who embraced black music. Alan Freed was among the latter. With hipsterlike vocal affectations and the sobriquet Moondog, he began airing a steady diet of original black blues, doo-wop, and jump blues recordings, as well as some country songs, instead of diluted covers of R & B (sanitized versions of African American or country and western songs using traditional vocals and instrumentation), on his Cleveland radio show in 1951. The program, which attracted black and white listeners, was an immediate hit, and within the year Freed had begun calling the music rock and roll, in part to disassociate it from its African American source, R&B. The name stuck, and Freed's star continued rising. When WINS, a radio station in New York City, hired Freed, *Life* magazine cited him as the creator of the new musical craze. By the mid-1950s, Freed was dabbling in television and movies as well as radio, more white performers had entered the field, and rock 'n' roll, as it was soon known, had surfaced as the nation's most popular musical form.

The expanding market in rock 'n' roll inspired the owner of Sun Records, Sam Phillips, to initiate a search for a "white man who had the Negro sound and feeling," a quest that resulted in the discovery of Elvis Presley. In 1954, Presley released a note-for-note copy of black bluesman Arthur "Big Boy" Crudup's "That's All Right (Mama)." Two years later, his cover of blues singer Big Mama Thornton's "Hound Dog" propelled him to the

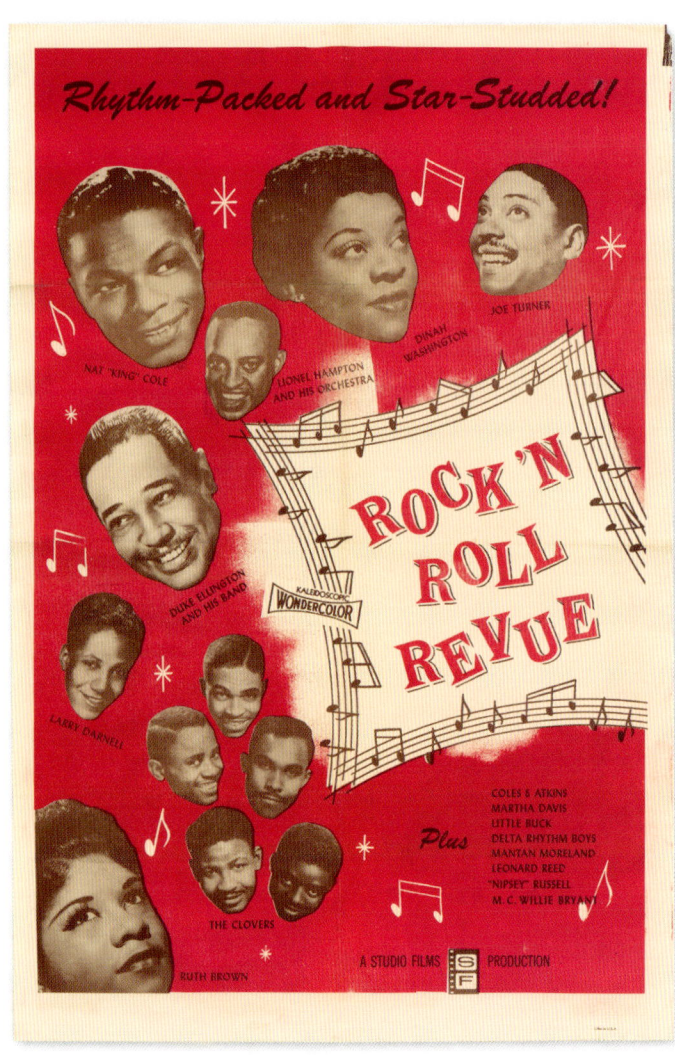

WOP BOP A LOO BOP With screams, wails, and a thumping piano, Little Richard (*above, at piano*) fused black church music and blues to create explosive crossover hits that thrilled diverse audiences.

TRAILBLAZING DJ Alan Freed (*left*), here addressing teenagers in Cleveland, popularized "race music" by playing it on his late-night radio show. He promoted the music to teens as "rock and roll."

"A lot of people call me the architect of rock & roll. I don't call myself that, but I believe it's true.'"

—LITTLE RICHARD

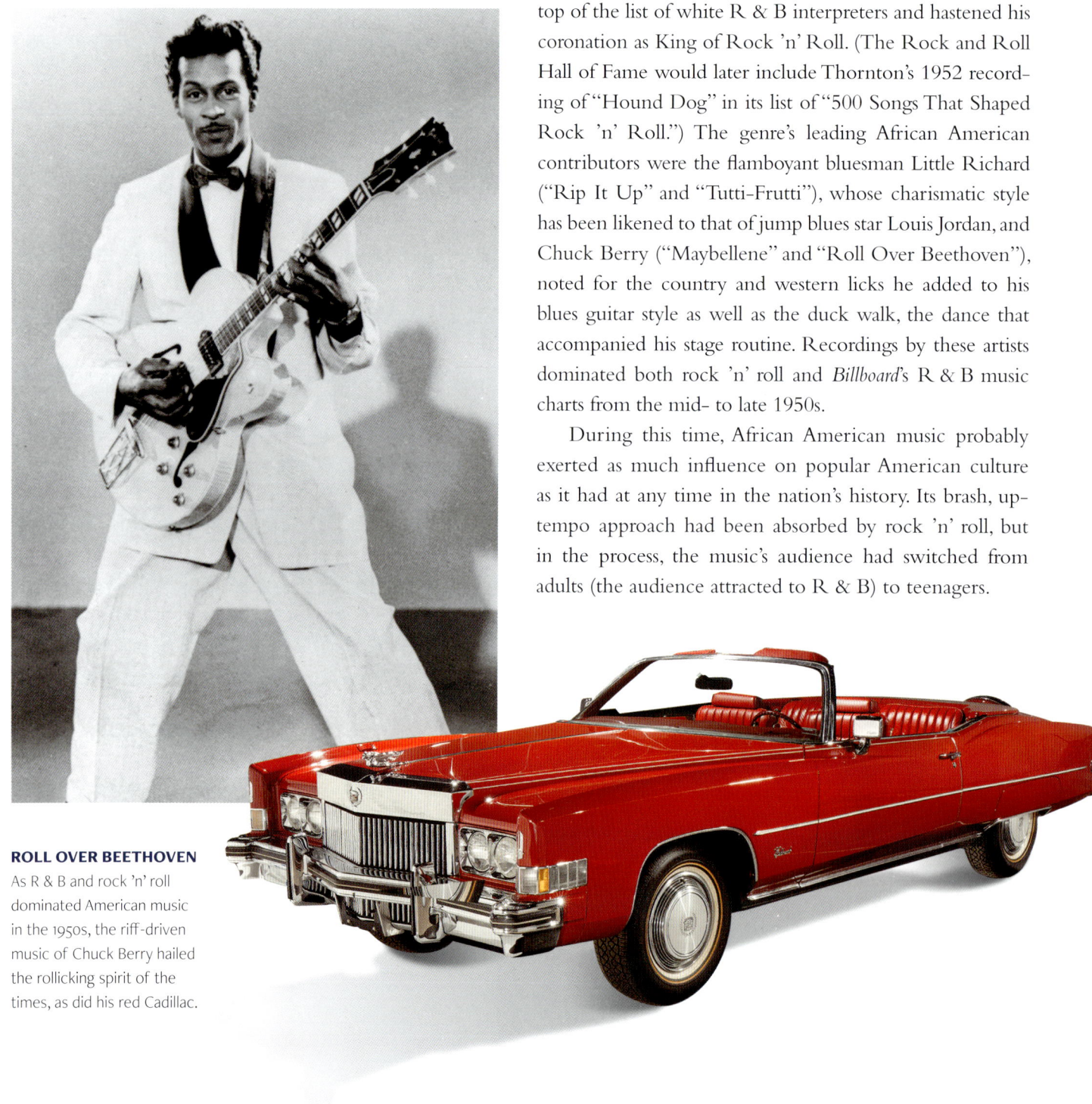

top of the list of white R & B interpreters and hastened his coronation as King of Rock 'n' Roll. (The Rock and Roll Hall of Fame would later include Thornton's 1952 recording of "Hound Dog" in its list of "500 Songs That Shaped Rock 'n' Roll.") The genre's leading African American contributors were the flamboyant bluesman Little Richard ("Rip It Up" and "Tutti-Frutti"), whose charismatic style has been likened to that of jump blues star Louis Jordan, and Chuck Berry ("Maybellene" and "Roll Over Beethoven"), noted for the country and western licks he added to his blues guitar style as well as the duck walk, the dance that accompanied his stage routine. Recordings by these artists dominated both rock 'n' roll and *Billboard*'s R & B music charts from the mid– to late 1950s.

During this time, African American music probably exerted as much influence on popular American culture as it had at any time in the nation's history. Its brash, up-tempo approach had been absorbed by rock 'n' roll, but in the process, the music's audience had switched from adults (the audience attracted to R & B) to teenagers.

ROLL OVER BEETHOVEN

As R & B and rock 'n' roll dominated American music in the 1950s, the riff-driven music of Chuck Berry hailed the rollicking spirit of the times, as did his red Cadillac.

NINA SIMONE (1933–2003)

From an early age, Eunice Kathleen Waymon, who would later rename herself Nina Simone, aspired to be a classical pianist and studied diligently in her hometown, Tryon, North Carolina. After high school, she attended a summer program at Juilliard in New York City, then applied to the Curtis Institute of Music in Philadelphia, which rejected her. Devastated by what she saw as racial discrimination, she supported herself by playing piano and singing at bars and lounges in Atlantic City, New Jersey, transforming standard Gershwin and Porter songs with a voice that could be husky as well as velvety.

Accolades and recording deals poured in. During her fifty-year career, she performed in a range of musical styles, including blues, jazz, folk, and R & B. In the 1960s, Simone was as much a fixture at rallies and fundraisers for civil rights and anti-apartheid causes as in concert halls. Outraged in 1963 by the murders of Medgar Evers in his driveway and of four black girls in a church bombing in Alabama, she wrote "Mississippi Goddam!," a defiant commentary on Jim Crowism and racial violence. Her song "Young, Gifted and Black," a tribute to playwright Lorraine Hansberry, became an anthem of the Civil Rights Movement.

The early rock 'n' roll style, heavily influenced by black R & B artists, had all but disappeared by the beginning of the 1960s. And with its disappearance, much of the African American audience abandoned rock 'n' roll. The arrival of the Beatles and the Rolling Stones did not significantly change their minds, even though R & B and vintage rock 'n' roll had shaped the musical tastes of these British bands. As Nelson George wrote in *The Death of Rhythm and Blues*, many African Americans "saw rock 'n' roll as white boys' music that didn't reflect their musical tastes or cultural experiences." Moreover, while white America embraced the British invasion, a new, exciting sound was stirring in black communities. The sound of soul music was about to erupt and displace R & B.

Hints of the new style had surfaced in the 1950s when Ray Charles began fusing gospel with jazz and R & B in such songs as "Hallelujah" and "I Got a Woman," and a year or so later when former gospel singer Sam Cooke recorded "You Send Me," which topped both the R & B and popular music charts. Despite loud dissent from black church officials and churchgoers, this hybrid approach caught on and was adopted by numerous artists. The musical style, which often combined African American vocal devices such as moans, elisions, and call-and-response with bluesy R & B instrumentation and the sounds of tambourines and hand clapping, was described by publicists for the Rock and Roll Hall of Fame as the "transmutation of gospel and rhythm and blues into a form of funky testifying." Gospel had begun to exert evident influence on America's popular music.

ECLECTIC GENIUS

Ray Charles and back-up singers the Raelettes perform in 1980. Known for his blend of gospel and blues, he expanded his fame with his 1960s country and western hits.

THROUGH BLACK EYES: AFRICAN AMERICAN ARTISTS

Jacquelyn Days Serwer

African American artists have expressed their creativity since the earliest days of the U.S. nation, but racism denied many of them recognition. Even when African Americans were valued as craftsmen, the majority of white Americans did not think them capable of producing fine art such as painting and sculpture. Through the Civil War and beyond, the majority of black artisans remained anonymous.

Nevertheless, a few of these unsung artisans have come to light. John Hemings, enslaved on Thomas Jefferson's Monticello Plantation, made exquisite furniture, surviving examples of which can be seen in the estate's collection. Thomas Day, a free black man in North Carolina, established a lucrative cabinetmaking career in the 1820s, designing and building fine furniture for wealthy whites. The now restored Union Tavern Building in Milton, North Carolina, housed Day's workshop and living quarters.

Among the early African American painters, Joshua Johnson, born ca. 1763, is the first who is known to have made his living as an artist, mainly as a portraitist for wealthy white families in the Baltimore area. The National Museum of African American History and Culture owns his *Portrait of John Westwood*, ca. 1807–08. Cincinnati artist Robert S. Duncanson (1821–72) enjoyed a reputation as one of the best landscape artists of the mid-nineteenth century. He also hand-colored photographs taken by his friend James Presley Ball, the African American owner of a local daguerreotype studio.

Painter Henry Ossawa Tanner (1825–1904) also found success in the 1800s. After studying with realist artist Thomas Eakins at the Pennsylvania Academy of the Fine Arts, he spent most of his career in France. Following the showing of his critically acclaimed painting *The Resurrection of Lazarus* (1896), Tanner became a respected figure in the Parisian art world and served as a supporter for other African American artists living abroad.

Images of artists were not widely available during most of the nineteenth century, which was perhaps a benefit to some artists of color. When landscape artist Edward Bannister (1828–1901) won first prize for his pastoral landscape *Under the Oaks* at the 1876 Philadelphia Centennial Exposition, organizers were surprised to learn that he was a black man. Bannister's approach to landscape painting was characteristic of the prevailing styles of the nineteenth century, in line with the work of other African American artists. While they were always vulnerable to the prejudice of the time, their work was generally not politicized or polemic, despite the troubling racial issues of the day.

The early twentieth century brought more African American artists to public attention, especially in New York City during the Harlem Renaissance of the 1920s and 1930s. Celebrating various aspects of black life and culture, this rich environment nurtured artists such as Aaron Douglas, who painted the renowned mural cycle *Aspects of Negro Life* (1934); sculptor Augusta Savage, most famous for her monumental piece *Lift Every Voice and Sing*, commissioned for the 1939 New York World's Fair; and painters Charles Alston and Jacob Lawrence. Savage and Alston both mentored younger artists, including Lawrence, who achieved great success while still in his early twenties with his highly acclaimed *Migration Series* (1940–41).

Among other artists who settled in New York were Romare Bearden, who became famous for his textured collages evoking African American life, and Edward Clark, a color field artist credited with creating the first shaped canvas. Bob Thompson, a talented migrant from Kentucky, enjoyed a short but celebrated career as an innovative figurative painter.

African American artists found success on the West Coast as well. The Works Projects Administration in San Francisco hired Thelma Johnson Streat, while Sargent Johnson became best known for his African-inspired masks and forms. In the 1950s, the African American–owned Golden State Insurance Company commissioned Charles Alston and Hale Woodruff to create a mural cycle chronicling the history of African Americans in California. The murals would grace its office building, designed by black architect Paul Williams.

Despite producing outstanding work during the twentieth century, African American artists were often relegated to a special racial category. Treated as a homogeneous group, they showed their work largely at all-black exhibitions such as those funded by the Harmon Foundation. The museums at Historically Black Colleges and Universities (HBCUs) were the primary repositories for African

ANTEBELLUM PAINTER Robert Duncanson received international acclaim for his Hudson River School–style landscapes, such as *Robbing the Eagle's Nest*, painted in 1856. Born a free man, he was a housepainter in his father's business before pursing a career as an artist.

CREATIVE EXPRESSION

San Francisco artist Sargent Johnson sculpted the sinuous *Dancer* (*far left*) in the 1930s, a departure from his early portraits and busts with evident African features. Thirty years later, Barbara Jones-Hogu's 1971 screenprint *Unite* (*left*) shows the influence of the Black Power Movement and the political goals of the AfriCOBRA collective.

American art and remain a rich source of cultural patrimony. The tendency to classify all art by African Americans as a separate category persisted far beyond the era of segregation, as demonstrated by the Whitney Museum of American Art's 1971 exhibition, *Contemporary Black Artists in America*.

In 1968, during the Black Arts Movement (1965–75), a few black artists united to form an art collective called AfriCOBRA (African Commune of Bad Relevant Artists). Instead of seeking acceptance in the white art world, the group—which included Jeff Donaldson, Barbara Jones-Hogu, and Wadsworth Jarrell—organized its own exhibitions and created art for a black audience. The artists proudly proclaimed their black identity, their pursuit of artistic excellence, and their commitment to racial uplift and solidarity.

In recent decades, African American artists have become more visible, inspiring other excluded groups to demand more recognition as well. The success of such artists as Lorna Simpson and Kara Walker has helped artists of all backgrounds to find new audiences and greater appreciation by mainstream art institutions. While museums continue to mount some all-black shows, such as the traveling exhibition *30 Americans* (2015), and the Smithsonian American Art Museum's *African American Art: Harlem Renaissance, Civil Rights Era, and Beyond* (2012), that approach is changing. Today's curators often prefer to organize around a theme, like that of the 2015 Venice Biennale (*The Future World*). Such thinking encourages a diverse selection of artists that allows African American artists to be appreciated in the larger context of their peers.

META VAUX WARRICK FULLER (1877–1968)

One of the first prominent women sculptors in the country, Meta Vaux Warrick Fuller was still in high school when one of her pieces was displayed at the 1893 World's Columbian Exposition in Chicago. After attending the Pennsylvania Museum and School for Industrial Art on a scholarship, Fuller continued her studies in Paris, where she was mentored and advised by American sculptor Augustus Saint-Gaudens and the French sculptor Auguste Rodin. On her return to Philadelphia, she began to focus on African themes and black experience rather than those derived from her European training, a direction W. E. B. Du Bois encouraged. Fuller won a prize for her 1907 sculptures depicting the history of African Americans since their arrival in Jamestown, Virginia, in 1619. Her *Spirit of Emancipation*, commemorating the fiftieth anniversary of the Emancipation Proclamation, and *Ethiopia Awakening*, which was in *America's Making Exposition* in 1921, signaled an enduring interest in African and African American history. During the Civil Rights Movement, Fuller's artistic vision and commitment continued with *The Crucifixion*, memorializing four young girls killed in the bombing of a church in Birmingham, Alabama, in 1963. In the twilight of her career, Fuller ardently sustained the black aesthetic and made meaningful contributions to African American culture.

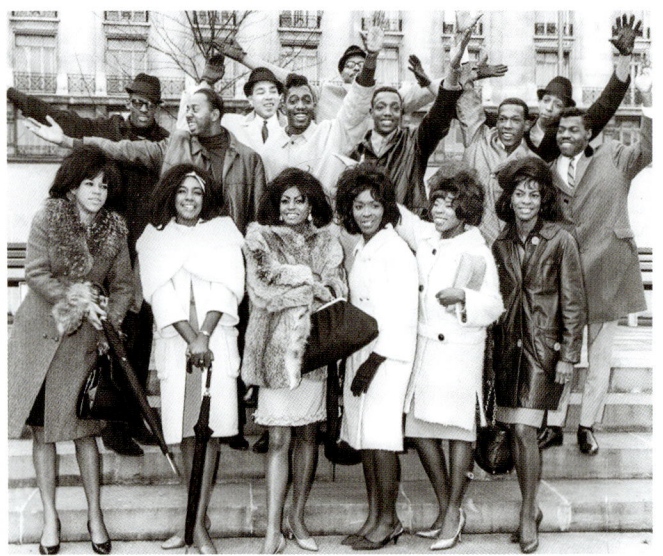

The 1959 release of Ray Charles's "What I Say," with its mixture of sensuality, R & B and Latin rhythms, and gospel-like call-and-response interplay between Charles and his backup singers, the Raelettes, emerged as the catalyst for soul. The music's popularity prompted the launch of several black-owned record companies; Detroit-based Motown, which released its first records in 1960, proved the most successful of these. Attracting mainstream audiences was a primary goal for Motown's founder, Berry Gordy. Consequently, as the singer Smokey Robinson attested, Gordy set out to create "music with a funky beat and great stories that could be crossover, that would *not* be blues." The music's gospel and blues roots were not eliminated, but they were moderated to produce records that easily appealed to white as well as black audiences, and for more than two decades Motown was one of America's most successful independent record companies. The label's stable of artists included many legendary performers, among them Smokey Robinson, the Temptations, Diana Ross and the Supremes, Stevie Wonder, and Marvin Gaye.

Soul music eclipsed nearly every other style of black music during the 1960s. Responding to the flood of soul hits appearing in the pop charts in 1969, *Billboard*'s "Rhythm and Blues" chart designation was changed to "Best Selling Soul Singles." A year later, Don Cornelius's *Soul Train* (a more spirited or boisterous version of Dick Clark's *American Bandstand*) began a thirty-five-year run as a TV variety show featuring contemporary soul artists and a nearly all-black cast of dancers. The show was also popular among young white viewers.

Soul left a lasting imprint on American popular culture. White baby boomers joined blacks to popularize dances such as the Watusi, the mashed potato, the monkey, the Madison, and the twist. Along with Stevie Wonder and Marvin Gaye, inimitable soul vocalists Sam Cooke, Ray Charles, James Brown, and Aretha Franklin not only dominated *Billboard*'s soul charts but frequently topped the pop charts as well.

About this time, *soul* emerged as an umbrella term for nearly all black music. Among its subgenres were funk and disco—two distinctly different forms of dance music. Rhythmic-based funk, combining elements of soul, jazz, and R & B, is probably exemplified by James Brown. It was Brown's seminal 1965 recording "Papa's Got a Brand New Bag" that initially brought mainstream attention to the music. Brown's band deemphasized harmony and melody and accentuated the music's insistent rhythmical base. Even Brown's voice was used like a percussion instrument, frequently incorporating screams and rhythmical grunts that echoed West African polyrhythms and African American work songs and chants, as well as the ecstatic fervor of black churches.

SPREADING THE SOUND
In 1965, the Motown Revue (*above*), featuring Stevie Wonder, Martha and the Vandellas, the Supremes, Smokey Robinson and the Miracles, and other Motown musicians, toured London and twenty other British cities. Motown influenced the Beatles, the Rolling Stones, and other British pop stars.

SOUL TRAIN This neon sign decorated the set of *Soul Train*, a long-running TV dance show featuring R & B, soul, and funk performers, aimed at African American youth.

QUEEN OF SOUL

Aretha Franklin (*above, center*), appearing with backup singers on *The Jonathan Winters Show* in 1968, was one of many African American performers television popularized. She was signed to Atlantic Records.

PLEASE, PLEASE, PLEASE

James Brown (*left*), in Memphis in 1964, drops to his knees in one of his electrifying performances. His signature dance moves and funk and soul sound reverberated across the music industry.

During the 1950s, mainstream popular music had subsumed and synthesized R & B. But while funk and soul music had a significant impact on the nation's popular culture, mainstream musicians rarely appropriated either genre. A few white performers (labeled blue-eyed soul singers), including Joe Cocker, Janis Joplin, the Righteous Brothers, and Tom Jones, adopted the musical style. But in general, as Nelson George concluded, "white musicians had difficulty synthesizing their own version of soul … primarily because white singers just couldn't match the intense vocal style of soul."

Disco, a type of black dance music played by DJs in American and European discotheques, was more easily assimilated. Surfacing in the late 1960s, it combined elements of funk and soul with long musical vamps and lush instrumental backgrounds created by strings, horns, electric pianos, and guitars. Soulful vocals were not necessarily part of the mix. By the early 1970s, the sound had caught on, and soon most large American cities had disco clubs. The music and dance phenomenon was becoming a national craze, and black artists ranging from established funk bands and soul singers to new disco stars Donna Summer and Gloria Gaynor were among its most popular exponents.

From the late 1970s to the mid-1980s, dozens of white pop and rock artists released songs influenced by the disco style—among them Cher, Paul McCartney, the Rolling Stones, the Swedish group ABBA, and even Barbra Streisand. "When disco reached its commercial peak," Charles Hamm wrote, "the cast was largely white."

In the 1970s, rap emerged as part of an underground culture composed of young blacks and Latinos in upper Manhattan and the Bronx. The music was part of a larger hip-hop culture that included breaking—an acrobatic form of street dance—and graffiti, the visual-art expression of rap. According to a 2005 *Journal of African American History*

Black Boys Play the Classics, 1997

Toi Derricotte

The most popular "act" in
Penn Station
is the three black kids in ratty
sneakers & T-shirts playing
two violins and a cello—Brahms.
White men in business suits
have already dug into their pockets
as they pass and they toss in
a dollar or two without stopping.
Brown men in work-soiled khakis
stand with their mouths open,
arms crossed on their bellies
as if they themselves have always
wanted to attempt those bars.
One white boy, three, sits
cross-legged in front of his
idols—in ecstasy—
their slick, dark faces,
their thin, wiry arms,
who must begin to look
like angels!
Why does this trembling
pull us?
A: Beneath the surface we are one.
B: Amazing! I did not think that they could speak this tongue.

article by Derrick P. Aldridge and James B. Stewart, that culture comprised "a style of dress, dialect and language, way of looking at the world, and aesthetic that reflect[ed] the sensibilities of a large population of youth" born after the mid-1960s. Rap was bred from candid engagement with issues of sex and violence that were part of the everyday reality encountered in the too often desolate communities in which the musicians lived.

Initially spurned by record company executives, who questioned whether it was actually legitimate music, rap was confined to inner-city communities. Its appeal began broadening by the early 1980s, and mainstream listeners took notice when the Sugarhill Gang's "Rapper's Delight" was released in 1979. Despite the record's surprisingly high sales figures, rap was regarded as a fleeting novelty. That perception lasted at least until the 1982 release of "The Message" by Grandmaster Flash and the Furious Five. One of the first rap songs to abandon the light, party-time themes that had characterized the music, it attempted to paint a graphic picture of the gritty downside of America's urban slums. Its pulsating, mantralike chorus imprinted its imagery in the mind.

"The Message" was the catalyst of a shift in the content of rap. One of hip-hop's most influential releases, it introduced the political and social commentary that still invigorates much of the music today. Run–DMC's fusion of rap and rock on their single "Rock Box," the first rap video to air on MTV, further expanded the genre's influence on mainstream music.

The exposure on MTV and the success of Run–DMC's 1986 album *Raising Hell* (which included a collaboration with white rock group Aerosmith on "Walk This Way")

DYNAMIC DJ Grandmaster Flash demonstrated his mastery of the turntable at the Rock and Roll Hall of Fame ceremony, when he and the Furious Five were inducted in 2007.

"An explosion of energy and imagination in the late '80s leaves rap today as arguably the most vital new street-oriented sound in pop since the birth of rock in the '50s."

—ROBERT HILBURN, *Los Angeles Times*, 1990

are often credited with ushering in hip-hop's most productive era and broadening its appeal to white audiences. A few years later, *Billboard* editor Paul Grein dubbed 1990 "the year rap exploded," and, in that same year, *Los Angeles Times* columnist Robert Hilburn wrote: "An explosion of energy and imagination in the late '80s leaves rap today as arguably the most vital new street-oriented sound in pop since the birth of rock in the '50s."

Mainstream acceptance of the hip-hop phenomenon increased throughout the decade and into the new millennium, but it was not without criticism. The *New York Daily News* African American columnist and cultural critic Stanley Crouch was among the dissenters who lampooned the music for "encouraging thuggish violence, misogyny, clownish behavior and crude materialism." But neither the negative fallout from gangsta rap vulgarity and sexism nor a violent mid-1990s East Coast–West Coast dispute halted its growth.

HIP-HOP GREATS The first gold album for rap went to Run–DMC in 1984. With co-producer Larry Smith (*above, far left*) and Jason "Jam Master Jay" Mizell (*left to right*), Darryl "DMC" McDaniels, and Joseph "Reverend Run" Simmons, the group became famous for rapping over rock beats. In 2009, Run-DMC was inducted into the Rock and Roll Hall of Fame.

Commercial rap by the likes of M. C. Hammer and the white rapper Vanilla Ice led the sales surge early on. The ascendancy of Queen Latifah and other female rappers, Snoop Dogg's mellow and deliberate style, the hardcore rap content of Wu-Tang Clan, and the overwhelming success of white rapper Eminem (dubbed the King of Hip-Hop by *Rolling Stone* magazine) in the late 1990s also fueled its success. By the end of the decade, hip-hop was the country's top-selling genre.

The edgy music, along with its associated language, fashions, and rebellious attitudes, found advocates not only among black and white youth culture in the United States, but also among young audiences around the globe. An expressive genre that originated in impoverished African American communities had established itself as one of the most commercially successful popular cultural phenomena in American history. The enthusiastic acceptance of hip-hop looms as a continuing reminder of how deeply African American expression has left its imprint on America's mainstream culture.

"Hip-hop, much as the blues and jazz did in past eras, has compelled young people of all races to search for excitement, artistic fulfillment and even a sense of identity by exploring the black underclass."
—CHRISTOPHER JOHN FARLEY, *Hip-Hop Nation*, 1999

That impact is most apparent in popular dance, humor, and music, but as the essays and profiles accompanying this chapter indicate, African Americans and nuanced shades of black culture have surfaced, influenced, and made significant contributions to America's creative heritage in most of the fine arts. In classical music, for example, a few African

Americans gained recognition in the 1800s, and in the twentieth century many concert singers made their mark in spite of racism. Todd Duncan and Anne Brown starred in the 1935 production of George Gershwin's opera *Porgy and Bess*, and concert singer Marian Anderson, who won acclaim in Europe before returning to the United States, became a bellwether of racial change in 1939 when Constitution Hall in Washington, D.C., refused to allow her to sing to an integrated audience. By the 1960s and 1970s, soprano Leontyne Price had become a leading singer at the Metropolitan Opera, while a young Jessye Norman triumphed in *Aida* and Wagnerian operas.

As African Americans gained recognition in classical music, black popular music and culture inspired fine-art disciplines such as symphonic music and modern dance. Johannes Brahms, for instance, began experimenting with ragtime as early as the 1890s. Czech composer Antonín Dvořák came to the United States in 1892, learned black spirituals from Harry Burleigh, whom he encouraged to become a composer, and included the melodies in his *New World Symphony*. Jazz, arguably America's only original art form, not only reigned as the nation's popular music for decades but also inspired classical music compositions. Fascination with syncopated music would lead Igor Stravinsky and Leonard Bernstein to compose jazz-inspired ensemble pieces such as "Ebony Concerto" (1945) and "Prelude, Fugue and Riffs" (1949). Similarly, the influence of African American vernacular dance was not limited to social dance and stage shows; it also impacted the modern dance movement. Katherine Dunham incorporated African aesthetics into classical dance, and Alvin Ailey infused his choreography with gestures from his black church experiences.

In an indirect manner, even the twentieth century modernist art movement was influenced by the culture of black Americans—by way of their ancestral home, Africa. Although initially labeled and dismissed as "primitive," the distinctive features of African art radically influenced visual art in Europe. Modernism and abstract art would eventually dominate the mainstream art world, and during the early twentieth century, American artists gradually adopted aspects of the freer, more imaginative style that European artists such as Picasso and Modigliani had observed in African art and integrated into their own styles. African American artists Hale Woodruff and Lois Mailou Jones also began incorporating traditional African forms with Western art techniques, and Aaron Douglas and Jacob Lawrence would gain national recognition with works that reflected the modernist approach.

The fascination with African American folkways and culture that began in the eighteenth century still persists and, at the dawn of the twenty-first century, remains a significant influence on American culture. While most evident in our popular entertainment, African American culture permeates and helps shape the broad scope of our nation's arts, mainly through the efforts of individual artists who have added resonant highlights that expand and enrich traditional forms. This ongoing phenomenon affirms the intrinsic richness of the African American cultural heritage and the irrepressible appeal that its expression holds for people of all races.

Perhaps more significant, there is little evidence to suggest that either the appeal or influence of African American culture is diminishing—after all, as Ralph Ellison observes in the epigraph that introduces this chapter, that is the way our strange country works.

CREATING DANGEROUSLY: AFRICAN AMERICAN LITERATURE

Joanne Hyppolite and Michelle Joan Wilkinson

In an oft-cited passage from the novel *Sula*, author Toni Morrison says of her title character that "like any artist with no art form, she became dangerous." Without a formal artistic outlet, Sula's curiosity and creativity turn unhealthy and destructive. But even those African Americans who find a way to express themselves artistically are likely to land in perilous territory, especially if they are writers. Writing is a way of pushing against expectations and delivering ideas that empower and enrage. Writing entails risk, suggested Haitian American author Edwidge Danticat in *Create Dangerously*, as both "the creation and the reception, the writing and the reading, are dangerous undertakings, disobedience to a directive." Creating dangerously well describes much of African American writing—from the pre-Revolutionary verse of Lucy Terry Prince to the critical examinations of blackness by contemporary authors such as Ta-Nehisi Coates.

For eighteenth- and nineteenth-century African Americans, the very act of writing was transgressive. When Phillis Wheatley published *Poems on Various Subjects, Religious and Moral* in 1773, the preface contained signed letters from Boston's white intelligentsia verifying that the enslaved Wheatley had indeed authored the work. American slaveholders partially justified slavery on the argument that Africans and their descendants were an inferior race incapable of high achievement. In mastering the forms and finer sentiments of poetry, Wheatley challenged this belief.

Because of prohibitive laws in some states, many enslaved African Americans who learned to read and write did so secretively. Some of those fortunate and daring enough to escape wrote about or dictated to white abolitionist writers their past tribulations, establishing a new genre in American literature: the slave narrative. Solomon Northup's *Twelve Years a Slave* (1853), Harriet Jacobs's *Incidents in the Life of a Slave Girl* (1861), and other personal accounts turned the written word into a weapon for the anti-slavery cause by unveiling the abuses of slavery. Read by thousands, these harrowing narratives went "straight to the heart of man," the formerly enslaved Henry Bibb wrote in his own memoir of 1849.

African Americans' fictional works also denounced slavery and injustice. Abolitionist Frederick Douglass, who was known for his moving 1845 slave narrative, also wrote a novella, *The Heroic Slave*, in 1852, creating a charismatic hero whose bravery and virtues contrasted markedly with white author Harriet Beecher Stowe's passive character Uncle Tom in her novel *Uncle Tom's Cabin*. Harriet Wilson's autobiographical novel *Our Nig* (1859) depicts the discrimination and mistreatment that free African Americans encountered in the North and foreshadows the harsh realities African Americans would face after the Civil War.

Social and political justice continued to be addressed in turn-of-the century African American literature, along with new themes related to black identity. "The pen must be mightier than

LITERARY LION Toni Morrison is one of America's leading authors and a Nobel and Pulitzer prize winner. Notable works include *Song of Solomon* and *Beloved*.

the sword," black novelist Francis Ellen Watkins Harper wrote in 1893. "It is a weapon of civilization and they [African Americans] must use it in their own defense." Her novel *Iola Leroy* explored racial uplift as both the key struggle and goal for postslavery African Americans. Charles Chesnutt, Harper's contemporary, wrote *The Marrow of Tradition* (1901), a novel that exposed the white supremacist agendas underlying the racial violence of the times.

The Harlem Renaissance ushered in a period of creativity as journals and publishers promoted the literary works of the "new Negro." Langston Hughes praised the "honest American Negro literature" that did not simply emulate white writers but looked inward to reveal the beauty, truth, and sometimes ugliness of black life. Expressing oneself without fear or shame exemplified the concept of creating dangerously. Whether reconnecting to a stigmatized African identity in Countee Cullen's poem "Heritage" or championing the black vernacular speech of Zora Neale Hurston's novels, writers pushed against the prevailing and restrictive notions of representing American blackness. Jean Toomer endured the consequences of writing about what moved him when he created controversial depictions of black life in *Cane* (1923). According to Hughes, "white people did not buy" and "colored people did not praise" the image-rich collection of poetry, prose, and drama.

More conventional in her approach, Gwendolyn Brooks used the fourteen-line structure of the sonnet to expose issues of racism and poverty. Her cycle of poems called "The Children of the Poor" imparts 1940s social relevancy to the age-old form.

What shall I give my children? who are poor,
Who are adjudged the leastwise of the land,
Who are my sweetest lepers, who demand
No velvet and no velvety velour

One of Brooks's early supporters was Richard Wright, best known for his indictment of social ills in the fatalistic protest novel *Native Son* (1940). In 1952, Ralph Ellison contributed *Invisible Man*, a

continued

Preface to a Twenty Volume Suicide Note, 1961

Amiri Baraka

Lately, I've become accustomed to the way
The ground opens up and envelopes me
Each time I go out to walk the dog.
Or the broad edged silly music the wind
Makes when I run for a bus . . .

Things have come to that.

And now, each night I count the stars,
And each night I get the same number.
And when they will not come to be counted,
I count the holes they leave.

Nobody sings anymore.

And then last night, I tiptoed up
To my daughter's room and heard her
Talking to someone, and when I opened
The door, there was no one there . . .
Only she on her knees, peeking into

Her own clasped hands.

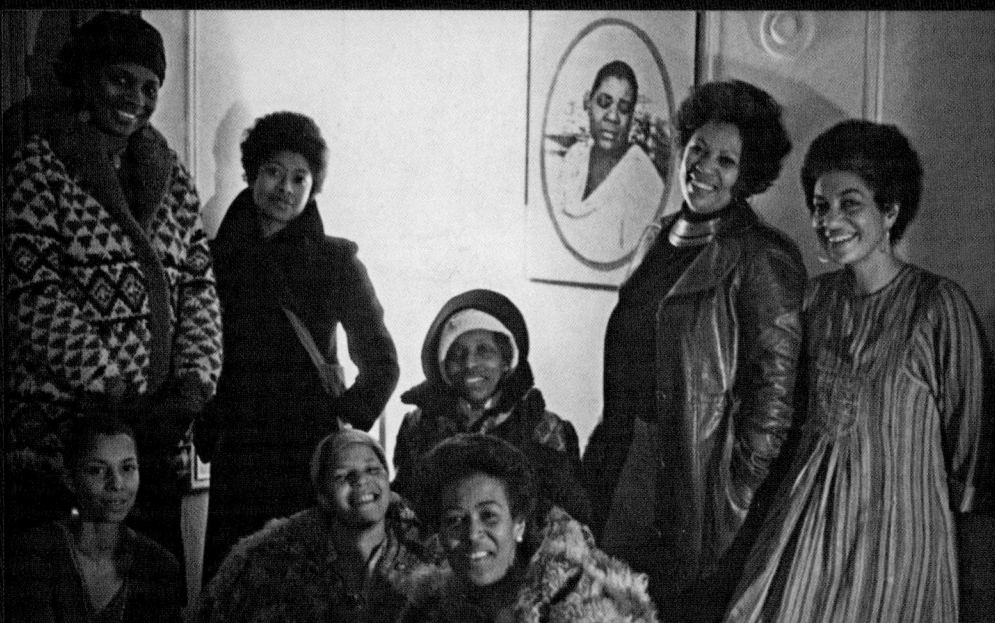

novel about racial hierarchies in America. In his acceptance speech for the 1953 National Book Award, Ellison spoke of his desire for "a fiction which, leaving sociology and case histories to the scientists, can arrive at the truth about the human condition."

In the 1960s, African Americans elevated writing to new levels of activism. The novelist and essayist James Baldwin, a clarion voice in the struggle for black civil rights, observed: "The power of the white world is threatened whenever a black man refuses to accept the white world's definitions." African American poets, playwrights, and novelists of the 1960s Black Arts Movement embodied the

threat when they broke away from Euro-American literature to advocate for a "black aesthetic." Carrying messages of black power and black pride, the writings of Amiri Baraka, Larry Neal, Sonia Sanchez, Nikki Giovanni, Haki Madhubuti, and others summoned the energy of the black liberation movement.

With the rise of the women's movement in the 1970s, new writings by Audre Lorde, Ntozake Shange, Michele Wallace, and Toni Cade Bambara contributed to a chorus of feminist voices. From Toni Morrison's *The Bluest Eye* (1970) to Alice Walker's *The Color Purple* (1982), stories of black girls and women placed issues of race

JAMES BALDWIN (1924–87)

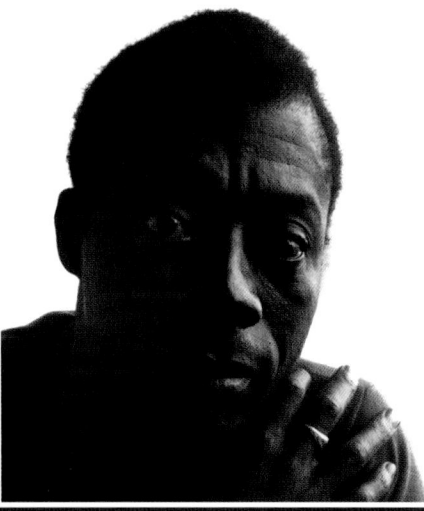

At age thirteen, James Baldwin wrote an essay about the need for "improvement" in his Harlem neighborhood. It was a harbinger of his future literary achievements and the issues that would inform his novels and essays. Baldwin grew up poor under a stern, religious stepfather who tried to suppress his desire to be a writer. After being mentored by Richard Wright, Baldwin relocated to Paris in 1948, where his race and homosexuality did not hinder his literary ambitions. There he wrote his first novel, the acclaimed *Go Tell It on the*

Mountain, a vivid semiautobiographical account of his early years in Harlem, published in 1953. From afar, Baldwin used his writing talent to examine racial issues in America, most notably in *The Fire Next Time*, a compelling 1963 book in which he describes what it is like to live in "the skin of a black man." He returned to America numerous times to engage in protests and raise his voice in the Civil Rights Movement. He was consistent and uncompromising on racial issues during his college-circuit lectures and television appearances as well as in his writing.

THE POWER OF THE PEN
In daring to create stories that express the anguish and triumph of the African American experience, black writers across the decades sparked debate and dialogue that illuminated the human condition. Among them are (*left to right, top row*) poet Gwendolyn Brooks in 1985; novelist Alice Walker in 1989, poet Nikki Giovanni in 2004, and (*left to right, second row*) poet Claudia Rankine in 2014, playwright Suzan-Lori Parks in 2001, and poet Sonia Sanchez in 1997.

and gender side by side. For Morrison, who also worked as an editor at Random House, commissioning and publishing a book like Angela Davis's autobiography in 1974 was its own form of activism. "I thought, 'I will publish these voices instead of marching,'" Morrison recalled in 2014. "I thought it was my responsibility." That sentiment of responsibility was taken up by black-owned presses and journals, which published this new generation of writers and scholars.

The demand for Black Studies courses in universities grew out of the black liberation movement of the 1960s and 1970s and was followed by a rise in the number of African American literature classes. By the 1990s, attempts to shape black writing into a literary canon—a recognized body of work worthy of study and respect—coalesced with classroom-ready publications. Large tomes such as the *Norton Anthology of African American Literature* (1996), *The Oxford Companion to African American Literature* (1997), and *Call and Response: The Riverside Anthology of the African American Literary Tradition* (1998) included an extensive range, from excerpts of slave narratives and social realist novels to spoken-word verses. Unlike in earlier periods, when African Americans had to hide their literacy to protect it, scholars of this era compiled and published African American writing to preserve it.

At the same time, black writers were gaining recognition in the literary world. In 1992, the works of three African American women—Toni Morrison, Alice Walker, and Terry McMillan—appeared on the *New York Times* bestseller list. The commercial success of McMillan's *Waiting to Exhale* led to a publishing boom in popular fiction by black writers. The awarding of the Nobel Prize for Literature to Morrison in 1993 built the momentum for critical recognition through the decade. In the first decade of the new millennium, Suzan-Lori Parks won a Pulitzer Prize for drama and

Natasha Trethewey for poetry. Tretheway was named U.S. poet laureate in 2012, a position held by African American writers Robert Hayden, Gwendolyn Brooks, Rita Dove, and Elizabeth Alexander in previous decades.

In myriad forms of expression, from sparse stanzas to thunderous tomes, African American authors continue to take the risks inherent to writing, thereby challenging political, racial, and literary conventions. Samuel Delany's and Octavia Butler's award-winning contributions to speculative fiction, a genre that encompasses science fiction, fantasy, and Afro-futurism, expanded notions about the range of African American writing. Similarly, novels such as *Hunting in Harlem* (2003) by Mat Johnson and *The Sellout* (2015) by Paul Beatty use satire to take on questions of identity and belonging in black America.

In addition to its history as a deliberately transgressive act, African American writing has been a testament to resiliency. In her 1960s poem "won't you celebrate with me," Lucille Clifton states that "everyday / something has tried to kill me / and has failed." Claudia Rankine's experimental prose poem *Citizen: An American Lyric* (2014) also chronicles daily aggressions and casualties. Questioning what it means to be a citizen if you are black in America, Rankine highlights experiences of devalued humanity and social erasure, reminiscent of Ellison's *Invisible Man* more than half a century ago, as well as of Ta-Nehisi Coates's 2015 *Between the World and Me*, a searing yet contemplative letter to his son.

The fact that black writers continue to grapple with the same issues decade after decade tells us that racism, injustice, and violence persist. It is often through writing that African Americans find outlets for addressing the historically charged nature of their experiences as Americans.

Ego Tripping (there may be a reason why), 1968

Nikki Giovanni

I was born in the congo
I walked to the fertile crescent and built
 the sphinx
I designed a pyramid so tough that a star
 that only glows every one hundred years falls
 into the center giving divine perfect light
I am bad

I sat on the throne
 drinking nectar with allah
I got hot and sent an ice age to europe
 to cool my thirst
My oldest daughter is nefertiti
 the tears from my birth pains
 created the nile
I am a beautiful woman

I gazed on the forest and burned
 out the sahara desert
 with a packet of goat's meat
and a change of clothes
I crossed it in two hours
I am a gazelle so swift
 so swift you can't catch me

 For a birthday present when he was three
I gave my son hannibal an elephant
 He gave me rome for mother's day
My strength flows ever on

My son noah built new/ark and
I stood proudly at the helm
 as we sailed on a soft summer day
I turned myself into myself and was
 jesus
 men intone my loving name
 All praises All praises
I am the one who would save

I sowed diamonds in my back yard
My bowels deliver uranium
 the filings from my fingernails are
 semi-precious jewels
 On a trip north
I caught a cold and blew
My nose giving oil to the arab world
I am so hip even my errors are correct
I sailed west to reach east and had to round off
 the earth as I went
 The hair from my head thinned and gold was laid
 across three continents

I am so perfect so divine so ethereal so surreal
I cannot be comprehended
 except by my permission

I mean . . . I . . . can fly
 like a bird in the sky . . .

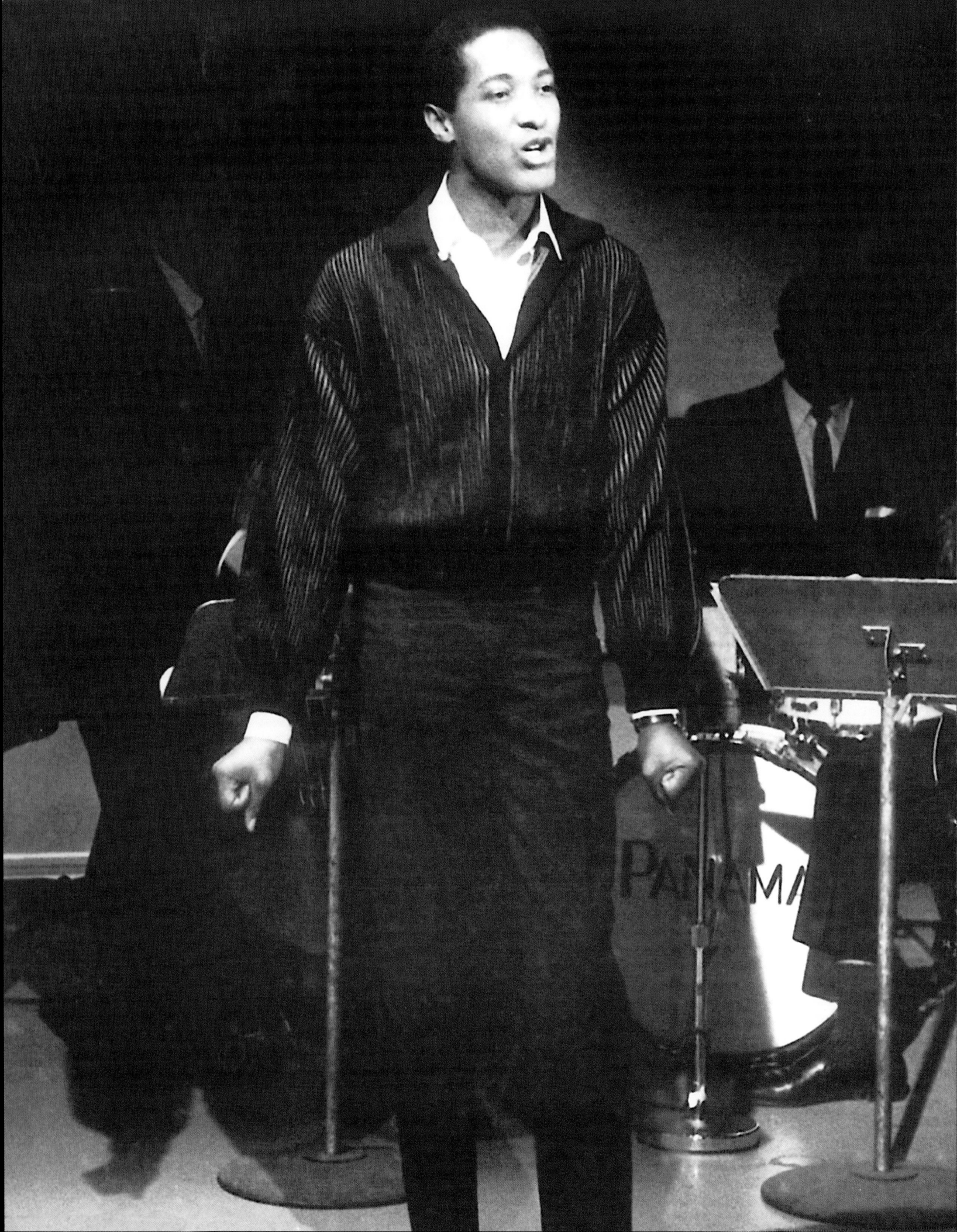

A CHANGE IS GOING TO COME

AFRICAN AMERICAN MUSIC INSPIRES THE WORLD, FROM GOSPEL AND THE BLUES TO JAZZ, SOUL, AND RAP

PORTIA K. MAULTSBY

African American music has influenced American culture for more than two centuries. Indeed, its infectious rhythms, melismatic melodies, and harmonies, along with distinct timbres and improvisational style, give American music its singular identity. African Americans have created a multitude of musical genres, including spirituals, work songs, blues, gospel, ragtime, jazz, rhythm and blues, soul, funk, disco, techno, hip-hop, and protest songs. Improvisation drove some of these forms, but written compositions also played a significant role. Many genres are associated with specific historical periods and functions. The Negro spiritual, for example, originated among enslaved and free blacks after their conversion to Christianity, while gospel evolved as African American congregations created new songs and transformed Old Testament hymns with improvisatory embellishments.

MUSICAL GOLD Sam Cooke (*left*), shown here in 1963, built on his gospel roots to create a highly successful and influential R & B career. Instrument-maker Henri Selmer crafted this brass and gold trumpet (*above*) for Louis Armstrong in 1946.

After the Civil War, classically trained musicians at African American colleges such as Fisk, Hampton, and Tuskegee created choral arrangements of slave spirituals for the concert stage. Usually performed a cappella, these combined European elements, such as four-part harmony, with features of original spirituals. African American composer Harry Burleigh, a pioneer in blending spirituals and classical music, was the first person to arrange the spiritual for solo voice in 1916; he further distinguished the form by adding piano accompaniment. Burleigh's "Deep River" became a standard in the repertoire of black concert singers.

During slavery and after emancipation, African Americans sang while working collectively as field hands, boatmen, dockworkers, and railroad track builders. Singing passed the time, relieved boredom, and regulated the workers' timing. As abolitionist James McKim observed, "When they work in concert, as in rowing or grinding at the mill, their hands keep time to music." Call-and-response and repetitive choruses allowed all workers to participate in the singing. Individuals working at a distance from other workers maintained contact by shouting out improvised phrases. These field hollers and work songs were the precursors of the blues.

The blues, as a discrete musical genre, emerged in the cotton fields of the Mississippi Delta in the 1890s. Many of the first blues singers were plantation sharecroppers whose musical laments reflected the hardships and racism of daily life and expressed hope for better days. Early blues singers were primarily men who also played guitar or harmonica, such as Mississippi bluesmen Charlie Patton, born in the late 1880s, and Robert Johnson, born in 1911. Their pioneering blues recordings in the 1920s helped define the genre.

As the blues moved from their agrarian origins to the minstrel and vaudeville stage, other professional blues singers emerged, including Ma Rainey, probably the first woman to perform the blues. Realizing the music's commercial potential, the cornetist and composer W. C. Handy began standardizing the structure of lyrics and harmonies around 1910. His publication of "Memphis Blues" (1912), "St. Louis Blues" (1914), and

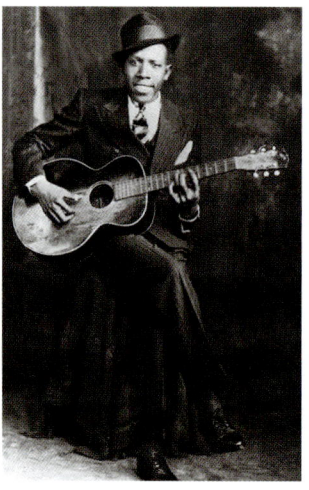

BLUES PIONEER The music of bluesman Robert Johnson, here performing in Memphis in 1935, captured the pathos of many African Americans' hardscrabble lives in the Mississippi Delta during the Great Depression. As the first black blues singer to record in 1920, Mamie Smith (*below, center*) opened the door for other black musicians.

"Beale Street Blues" (1916) spread the genre across cultural and racial boundaries. White vaudeville singers Marion Harris and Sophie Tucker popularized Handy's compositions among white audiences, leading to a flood of blues-flavored popular songs by white songwriters, who simplified the rhythms and altered the lyrics to reflect their own experiences. The songs were made available as sheet music for the masses, especially amateur musicians.

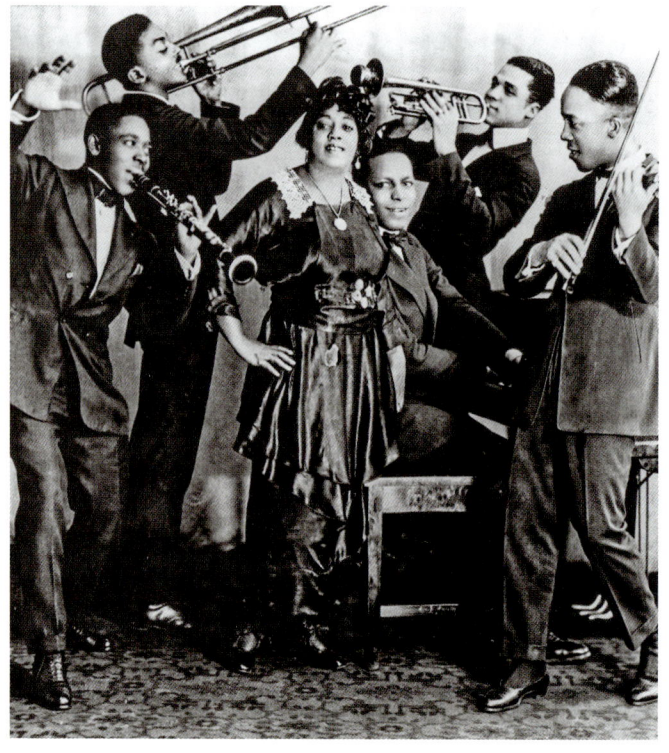

In 1920, vaudeville performer Mamie Smith, the first black blues singer to be recorded, opened the door for other African American musicians to get recording deals. Record companies also capitalized on the popularity of the blues by recording whites singing compositions by black songwriters. While Harris's recording of "St. Louis Blues" became a hit among white fans, Smith's recording of African American songwriter Perry Bradford's "Crazy Blues" soared among black audiences.

From the earliest days of slavery, African American musicians provided entertainment for social and recreational activities in black and white communities. They performed as string bands—banjos, fiddles, and sometimes mandolins, often in combination with drums and other percussion. Syncopated rhythms—the shifting of an accent from a strong to a weak beat—characterized the music. The repertoire, shared by black and white musicians, consisted of African American and European American folk songs from the eighteenth and nineteenth centuries.

African American country musician DeFord Bailey, born in 1899, referred to black string band music as "black hillbilly music." Also known as old-time music, it was the musical choice for rural African Americans in the early 1900s. Bailey's family lived in Tennessee and formed a string band that performed for blacks and whites at barn dances, church gatherings, and country fairs. But as the blues craze took off in the 1920s, blues became the core repertoire of African American string bands. Record companies developed advertising campaigns that labeled music as "race" or "hillbilly." *Race* comprised spirituals, blues, ragtime, and jazz targeting African Americans; *hillbilly* encompassed folk styles of American music intended for southern rural whites. Even though black musicians such as Bailey and the Mississippi Sheiks made at least forty-three hillbilly recordings and black and white musicians collaborated on dozens of similar recordings, African Americans eventually became invisible in the genre, which was relabeled country and western in the 1940s.

In 2005, African American musicians from North Carolina formed the Carolina Chocolate Drops, a band that aimed to restore the black old-time string music of North and South Carolina, as both a heritage and an evolving genre. The group's instrumentation of fiddle, banjo, and guitar often includes jugs, washboard, snare drum, harmonica, and sometimes bones, autoharp, panpipe, and a beatbox. The Carolina Chocolate Drops' fifth album, *Genuine Negro Jig*, won a Grammy in 2010.

BLACK STRING BAND MUSIC The Carolina Chocolate Drops perform at a 2014 New York City concert. Rhiannon Giddens (*center*) beats a tambourine, surrounded by (*left to right*) Malcolm Parson, Jamie Dick, Jason Sypher, and Hubby Jenkins.

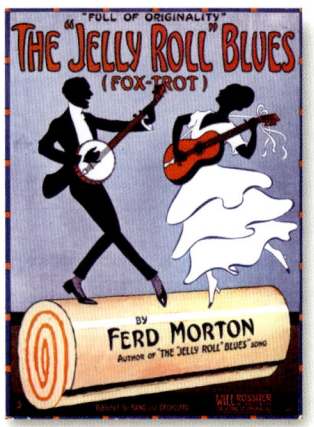

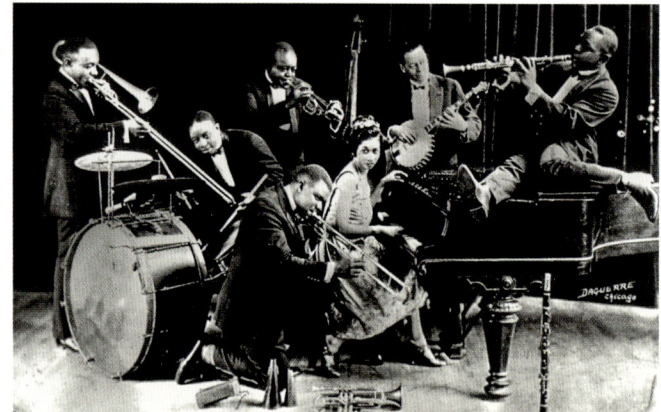

RAGS TO JAZZ Multitalented New Orleans musician "Jelly Roll" Morton, who transformed the rhythms of ragtime into jazz, is credited with composing and publishing the first sheet music for the new genre in 1915 (*far left*). Joe "King" Oliver's Creole Band of the 1920s included a young Louis Armstrong (*left, kneeling*).

Toward the end of the nineteenth century, the syncopated rhythms of old-time string band music led to ragtime, an improvised music with syncopated melodies played over a steady bass line. Its innovators were itinerant African American pianists who played in brothels, saloons, and work camps in the South. In the 1890s, African American pianists Tom Turpin, Scott Joplin, and "Jelly Roll" Morton began composing and publishing ragtime music. As with the blues, the ragtime craze was taken up by white songwriters, who simplified the melodies for consumption by amateur pianists.

African American musicians in New Orleans began applying the ragging style to brass band music and popular song, creating a new musical form later known as early jazz. Charles "Buddy" Bolden, Joe "King" Oliver, and Louis Armstrong created a distinctive ensemble-oriented music that incorporated the ragging style, new rhythmic interpretations, and blues tonalities. They played this music long before its first recording ("Livery Stable Blues," 1917) by a white group called the Original Dixieland Jazz Band. That recording, however, signaled the commercial takeoff of jazz.

During the late 1920s and 1930s, jazz bands increased to fourteen or sixteen musicians, and formal arrangements became standard. African American musicians such as Fletcher Henderson, Don Redman, Duke Ellington, Count Basie, Cab Calloway, and Lionel Hampton pioneered and popularized a big-band sound known as swing, characterized by call-and-response between the brass and reed sections in a

short, recurrent pattern called a riff and a walking or boogie-woogie bass line. Examples of the swing style include Count Basie's "One O'Clock Jump" (1942) and Cab Calloway's "The Calloway Boogie" (1947). Swing bands also featured vocalists, including Billie Holiday, Ella Fitzgerald, Billy Eckstine, Sarah Vaughan, Joe Williams, Dinah Washington, and Betty Carter, who later developed successful solo careers.

In the 1940s, ever-innovative African American musicians formed smaller jazz ensembles and developed a new jazz variant known as bebop. In small clubs in Harlem, Charlie Parker, "Dizzy" Gillespie, Thelonious Monk, and others experimented with harmonic and rhythmic possibilities and extended improvisation. In the 1950s, bebop begat hard bop, which drew from blues and

INIMITABLE VOCALISTS Landing a gig as a featured vocalist for a big band in the 1940s helped launch the solo careers of many African American singers, including Lena Horne (*left*) and Sarah Vaughan (*right*).

JAZZ ROYALTY A fifteen-minute film spotlighting jazz music in 1950 featured Billie Holiday (*above, right*) performing with Count Basie (*at the piano*) and his band. Jazz musicians like virtuoso trumpeter "Dizzy" Gillespie, pictured at a New York City nightclub (*right*), continued to innovate, developing the bebop style in the 1940s.

gospel. It was popularized by the jazz album *Moanin'* (1958) by Art Blakey and the Jazz Messengers. Later came the cool jazz and avant-garde (free jazz) of the 1960s and the fusion of the 1970s. In the 1980s, the jazz became more eclectic as musicians continued to explore new directions—exemplified by Gillespie's collaborations in Afro-Cuban jazz with Chano Pozo and Mano Báuza. While some remained rooted in specific traditions, most crossed the boundaries of musical categories, often juxtaposing multiple styles on a single album.

AVANT-GARDE John Coltrane (*right*) performed with fellow greats, from Duke Ellington and Thelonius Monk to Charles Mingus and Pharoah Sanders.

Meanwhile, the blues had also evolved. During and after the world wars, nearly six million African Americans migrated from the rural South to urban areas, where they transformed rural traditions into urban styles. Musicians amplified their guitars and harmonicas and added a bass, and later horns, to create a modern blues form.

By the 1950s, Chicago had become the center for the blues and home to Chess and Vee-Jay Records, which recorded several Mississippi artists, including Muddy Waters, Howlin' Wolf, and Jimmy Reed. Many blues musicians performed in bars, but others gave up the blues to play for the Lord. In storefront Holiness, Pentecostal, and Baptist churches, the addition of electric guitars, drums, tambourines, and horns gave an urban and secular character to black religious music.

In the 1930s, Thomas A. Dorsey, a former ragtime and blues singer-pianist, combined elements of ragtime, blues, and church music to create a secular-sacred black religious music that became gospel. "This rhythm I had, I brought with me to gospel songs," he once said. "I was a blues singer and I carried that with me into the gospel songs.... I always had rhythm in my bones. I like the solid beat. I like the moaning groaning tone. I like the rock. You know how they rock and shout in the church. I like it."

Dorsey provided the model for gospel songwriters Sally Martin, Roberta Martin, and James Cleveland. Mahalia Jackson and the Dixie Hummingbirds, among others, popularized Dorsey's gospel compositions in live performances, particularly "Precious Lord, Take My Hand" and "Peace in the Valley." In the late 1940s and early 1950s, Clara Ward's female gospel group innovated by alternating leads and performing in a shouting vocal style popularized by male quartets. Percussive timbres, including growls and hollers, pitch variations, and an accelerated tempo, characterized the style. The Clara Ward Singers added new dimensions to gospel music performance by ditching the choir robes and wearing colorful sequined gowns accessorized with towering hats or wigs and glitzy jewelry. They even took gospel performances into nightclubs.

The 1960s ushered in a new era in gospel music when Edwin Hawkins incorporated contemporary elements of black popular music. The danceable beat of soul music and the use of the Fender bass, bongos, and horns in "Oh Happy Day" (1968) resulted in a crossover hit on soul music radio stations. Similarly, the jazz harmonies of the a cappella group Take 6 added another secular sound to gospel, as did rapping and hip-hop rhythms integrated into the Winans' "It's Time" (1987) and Kirk Franklin's "Stomp" (1997). Secular influences on gospel music continue in the twenty-first century, with artists such as Yolanda Adams, Tye Tribbett, and James Hall. Commenting on the ongoing secularization of gospel music, Walter Hawkins said, "[It is] moving in the right direction. I think it moves along with the rest of the world, where current artists try to be relevant to what's going on musically and with situations in the world."

Gospel music helped usher in a new era of African American popular music after World War II, when many swing band musicians scaled down to form smaller bands or combos and added blues and gospel singers. Similarly,

GOSPEL GREATS Talent and marketing propelled acclaimed soloist Clara Ward (*in white*) and the Clara Ward Singers from church venues to Las Vegas nightclubs. Their glamorous style alienated some church audiences, but they became one of the most successful gospel groups in history, performing at Carnegie Hall and touring internationally.

blues musicians created combos by expanding their instrumentation with a rhythm section and horns. Known as rhythm and blues (R & B), the new sounds reflected the pulse and spirit of millions of African American urban dwellers. Several members of gospel quartets switched to singing R & B. "Crossing over from gospel to pop was not hard because it was just a matter of changing words," quipped Lou Rawls, a former gospel singer who found success as an R & B and soul singer.

Stylistically diverse, R & B music attracted a wide audience. Swing band musician Louis Jordan pioneered the blues-jazz hybrid combo sound in the early 1940s, along with the Orioles, an a cappella group, in the late 1940s, and the Dominoes and Clovers, two more vocal groups, in the early 1950s. Romantic songs or ballads dominated the early repertoire of these groups, and record companies added guitar, piano, and drums during studio recordings to increase their commercial appeal. Within a few years, the Spaniels, the Moonglows, the Cadillacs, Frankie Lymon and the Teenagers, and other teenage-oriented groups introduced the syncopated, repeated phrase "doo-doo-wop" to their background harmony, ushering in the era of doo-wop.

MIXING MUSICAL GENRES
Louis Jordan (*above*), pictured on a program from a 1949 show in New Orleans, merged blues and jazz into a danceable precursor to rock 'n' roll. Known for R & B as well as gospel music, BeBe Winans (*near right*), seen here performing at the National Museum of African American History and Culture's Commemorate and Celebrate Freedom event in 2015, has succeeded in both genres. Lou Rawls (*far right*), shown in London in 1990, modified his early gospel sound to become a silky-voiced R & B and soul singer.

New Orleans piano players Fats Domino and Little Richard and Chicago guitarists Bo Diddley and Chuck Berry heralded a new genre that eventually came to be known as rock 'n' roll, a derivative of R & B combos distinguished by a beat reminiscent of the "choo-choo" rhythms of trains. The innovative beat, introduced by Little Richard, combined with reformulations of blues and gospel elements to energize the young postwar generation. These elements distinguished rock 'n' roll from the highly lyrical vocals, lush orchestral arrangements, and simple rhythms of mainstream pop music. White teenagers embraced rock 'n' roll, but their parents detested it, calling it "savage" or "jungle" music. The marketing compromise was to repackage black R & B with cover versions sung by established white artists. David "Panama" Francis, jazz musician and session drummer, recalled how "RCA Victor used to sit up and wait on [black R & B singer] LaVern Baker to record the record [for Atlantic Records]. Then they'd let [white singer] Georgia Gibbs cover it—exactly the same background music in the same song…. They used to do that all the time."

Gibbs covered Baker's "Tweedlee Dee"; the McGuire Sisters covered "Sincerely," originally by the Moonglows; and Jerry Lee Lewis lifted Chuck Berry's "Roll Over Beethoven." Record companies sought out white artists "who had a Negro sound and a Negro feel," according to

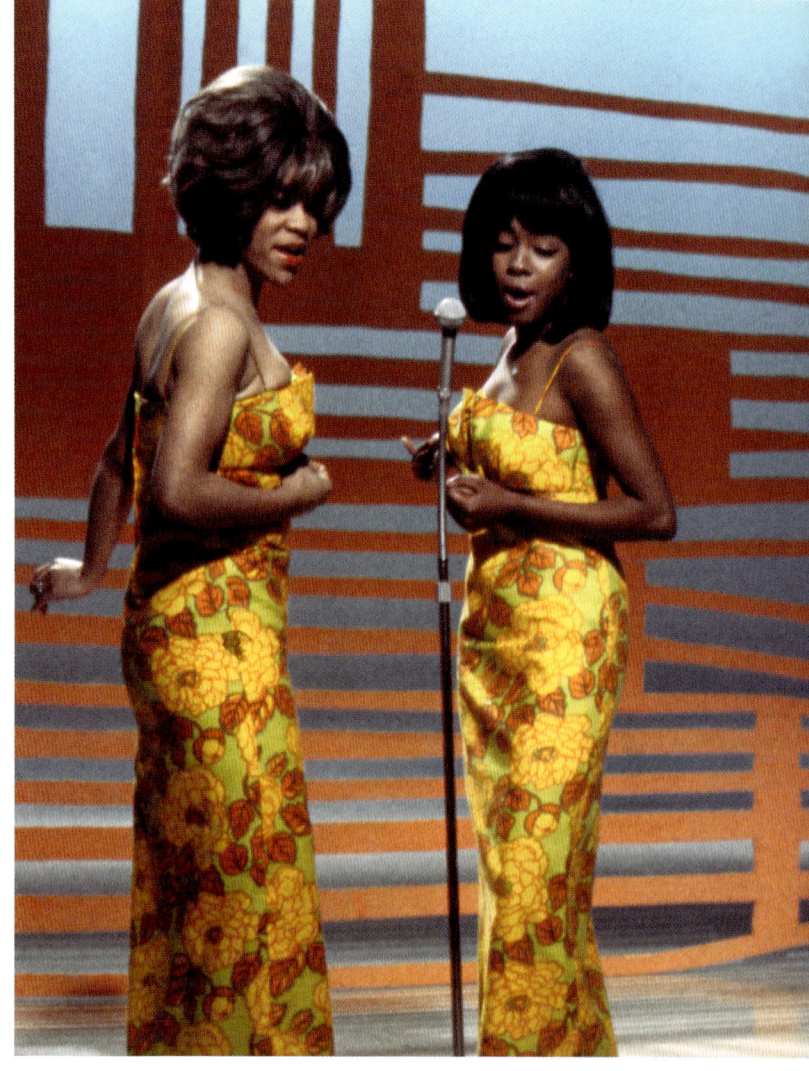

Sam Phillips, the owner of Sun Records. He discovered Elvis Presley, while Ahmet Ertegun, owner of Atlantic Records, found Bobby Darin.

To counter the competition from cover records, independent record labels modified the R & B sound of potential crossover African American artists. Producers added strings and pop vocal arrangements to recordings to sweeten the sound

THE ORIGINATOR Bo Diddley (*far left*) teamed a driving guitar beat with African rhythms in his distinctive rock 'n' roll sound. A medallion bearing his name decorates his trademark hat (*left*).

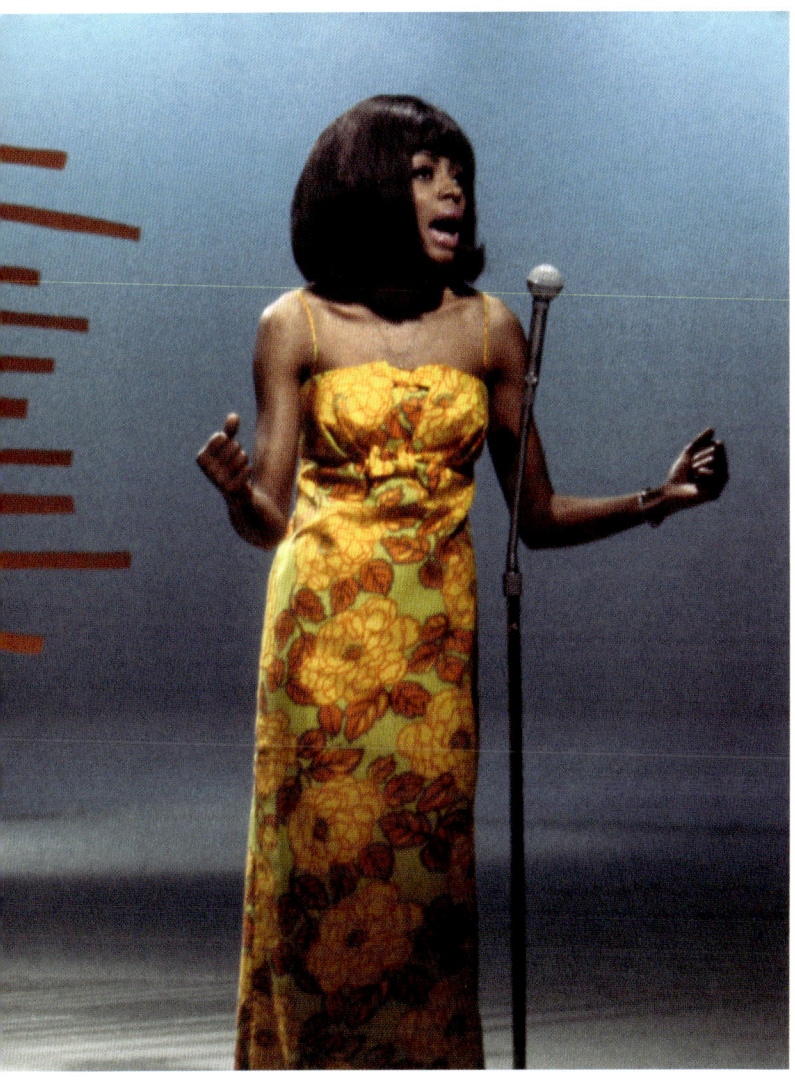

center stage. Soul drew its core elements—rhythms, melodic and harmonic structures, and vocal stylings—from gospel music. This secular iteration, infused with earthy testimonial styling, runs through the music of Ray Charles, James Brown, Curtis Mayfield, Otis Redding, and Aretha Franklin. Their songs often voiced resistance, protest, and social change, and as such also captured the political energy of the times.

"Music has always been integral to the African American struggle for freedom," observed singer and civil rights activist Bernice Johnson Reagon. During slavery, spirituals such as "Steal Away" and "Go Down Moses" had double meanings and contained coded messages about running away. After emancipation in 1863, protest song lyrics were more forthright; a line in "Oh, Freedom" declares "Before I'd be a slave, I'll be buried in my grave, and go home to my Lord and be free." A 1915 folk song decries racial injustice: "If a white man kills a Negro, they hardly carry it to court; if a Negro kills a white man/ they hang him like a goat." In "Levee Camp Holler," blues singer Big Joe Williams sang about the exploitation of levee workers.

BEYOND LABELS The Motown love songs of the Supremes—(*left, left to right*) Florence Ballard, Mary Wilson, and Diana Ross, shown rehearsing in 1965—appealed to diverse audiences. Otis Redding (*below*) was a chart-topping headliner of Stax Records' integrated roster of artists who challenged racial barriers.

of such songs as the Platters' "The Great Pretender" (1955) and LaVern Baker's "I Cried a Tear" (1958). Building on this formula, the Motown Sound, popularized by vocal groups such as Martha and the Vandellas, the Temptations, the Supremes, and the Four Tops, resonated across color lines by the mid-1960s. Motown songwriters wrote teenage-oriented lyrics with catchy tunes; the arrangers used stringsin conjunction with syncopated horns for a lush, rhythmic sound.

While the Motown Sound penetrated the mainstream, the earthy, gospel-styled vocals and blues-derived combo sounds of performers such as James Brown and the Ike & Tina Turner Revue lingered on the racial margins of the music industry until the mid-1960s, when soul music took

The black tradition of protest music experienced a resurgence during the modern Civil Rights Movement, galvanizing African Americans into political action. Original versions and modern adaptations of spirituals, hymns, folk ballads, gospel, R & B, and soul music formed the core repertoire of protesters during demonstrations.

In the 1960s, many jazz artists joined the protest and framed themes of freedom in a pan-African context, creating such works as Max Roach's *We Insist! Freedom Now Suite*, Randy Weston's *Uhuru Afrika*, and Art Blakey's *The Freedom Rider*.

Nina Simone, Sam Cooke, and Curtis Mayfield were among the first nonfolk singers to address issues of racial inequality in commercial recordings. By 1968, when the black power message began to dominate civil rights ideology, some soul singers used their music to show their advocacy of black empowerment. James Brown's "Say It Loud—I'm Black and I'm Proud" became the battle cry of the movement. Motown's The Temptations, Marvin Gaye, Stevie Wonder, and Philadelphia International's O'Jays recorded music focused on issues such as poverty, drugs, and war.

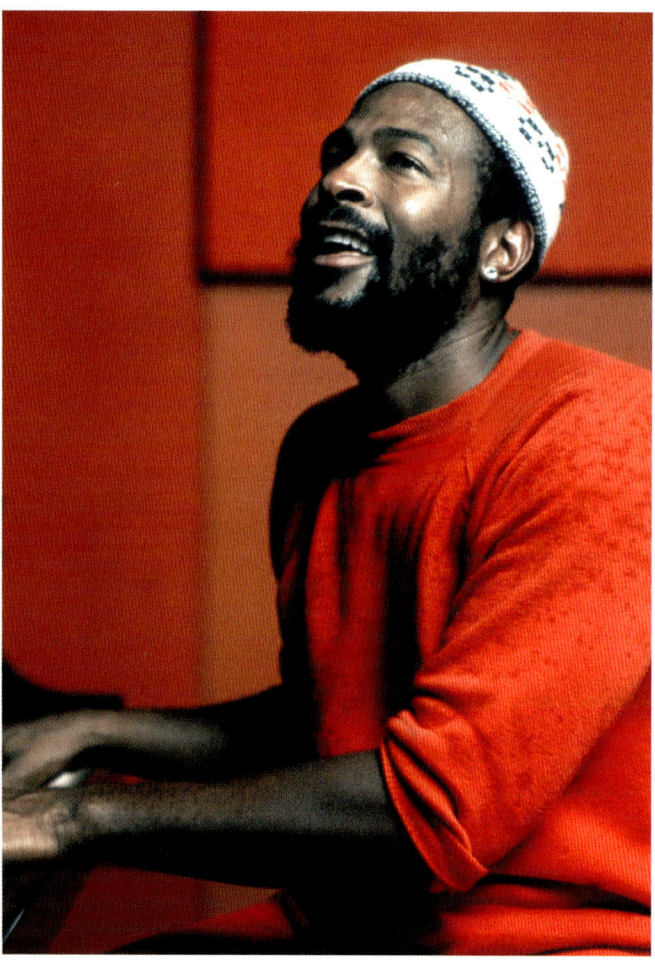

TAKING A STAND During the 1960s and 1970s, many black artists used their talents to protest injustice toward African Americans and other societal ills. Marvin Gaye (*above right*) spoke out against poverty, the Vietnam War, police brutality, and pollution in *What's Going On*, an album that won high praise. Similar themes pervaded the 1970s work of soul singer Curtis Mayfield (*left*).

USA FOR AFRICA The 1985 *We Are the World* album included the single of the same name that brought a group of more than forty racially and musically diverse artists together to record a song for famine relief in Africa. Written by Michael Jackson and Lionel Richie and produced by Quincy Jones, the single raised some $60 million. Soloists for the title track included Paul Simon, Stevie Wonder, Bob Dylan, Diana Ross, Cyndi Lauper, and Ray Charles, among others. Harry Belafonte, Bette Midler, La Toya Jackson, and the Pointer Sisters were in the chorus. Prince, Tina Turner, Bruce Springsteen, Kenny Rogers, and others contributed songs to complete the album.

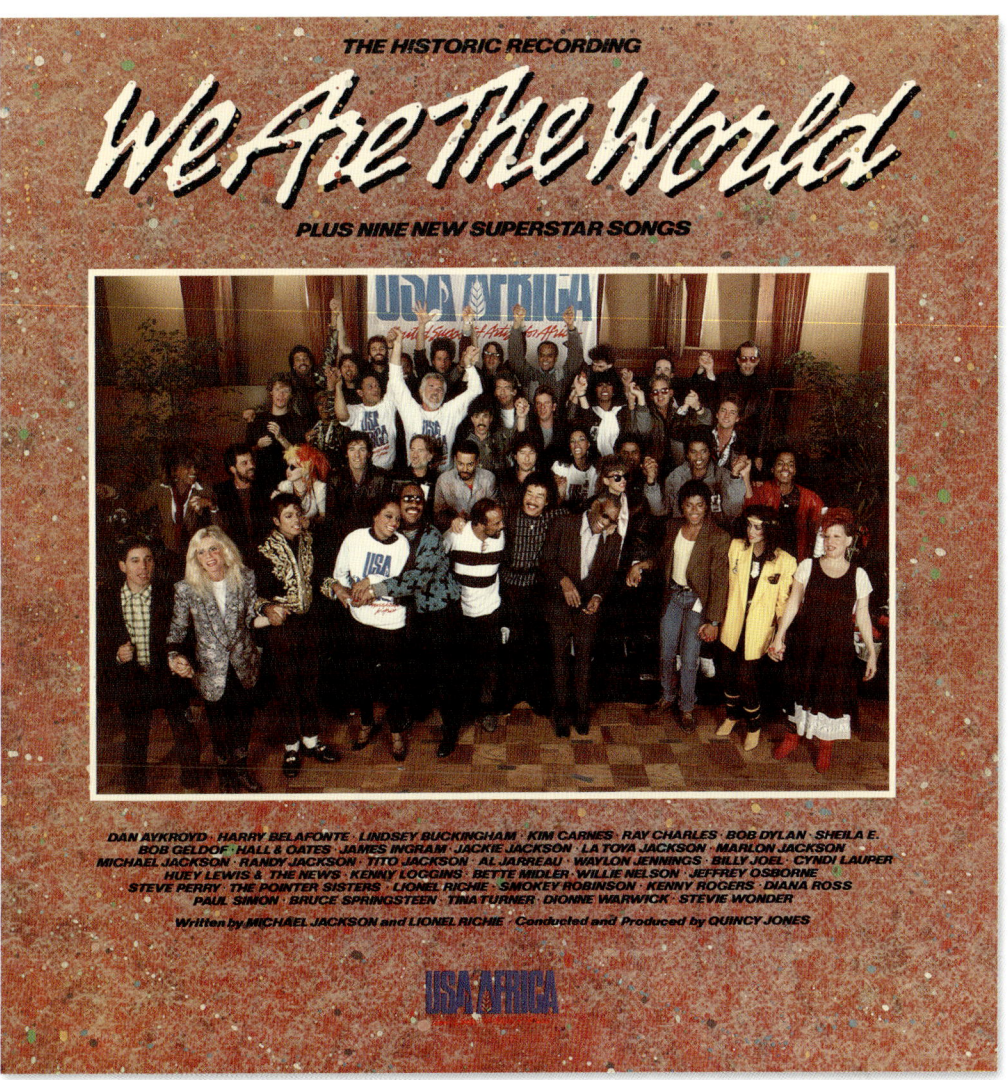

POLITICAL EXPRESSIONS Several jazz musicians supported the Civil Rights Movement: Max Roach's *We Insist!* featured Abbey Lincoln, Coleman Hawkins, and Oscar Brown Jr.; drummer Art Blakey's *The Freedom Rider* featured Lee Morgan and Wayne Shorter; and pianist Randy Weston featured Candido Canero, Yusef Lateef, and Clark Terry in *Uhuru Afrika*.

By the mid-1970s, a new R & B–jazz hybrid had evolved in black music: funk, featuring group singing, prominent horn and percussion sections, jazz-blues-rock-oriented guitar solos, and vocal styles associated with soul music. Earth, Wind, and Fire exemplifies this style. James Brown and Sly Stone were its architects, and George Clinton was the foremost purveyor of P-Funk, which he defined as pure, uncut funk. Promoting his bands Parliament and Funkadelic, whose concerts included a huge spaceship as a stage prop, he espoused a belief that African American communities had become fragmented: In the suburbs and other desegregated spaces, black people were losing their cultural values. With humor and metaphor, Clinton's music sought to boost black identity.

LEGENDS Wearing his black fedora (*left*), Michael Jackson (*below, left*) electrified audiences; his 1982 album *Thriller* is the best-selling album ever. Brilliant and beloved, Prince (*below, right*) created for decades extraordinary music that defied category.

Even as some genres promoted blackness, the popularity of crossover artists such as Prince, Michael Jackson, and Whitney Houston grew, along with the number of interracial duets from the likes of Michael Jackson and Paul McCartney, Patti LaBelle and Michael McDonald, and Aretha Franklin and George Michael. Record companies marketed such acts as "pop" to target different demographics simultaneously. The strategy led to an unprecedented level of national exposure for black singers on Top 40 radio and in other mainstream media, including MTV and Hollywood films.

PARLIAMENT-FUNKADELIC

Inspired by the sights and sounds of the psychedelic era as well as popular science fiction tales, George Clinton was the creative mastermind of Parliament, its sister group Funkadelic, and the musical collective known as P-Funk. Originally formed as a doo-wop quartet, Parliament-Funkadelic has toured and recorded some of funk's greatest hits for more than five decades.

BEAM ME DOWN In the 1970s, during the height of Parliament's popularity, the funk band's live shows included the landing of the metal and glass Mothership (*above*) amid flashing lights and pyrotechnics. Bandleader and producer George Clinton (*right*), an avowed *Star Trek* fan, would then emerge in a swirl of smoke, belting out funk music.

By the late 1980s, rap music—a recitation of rhymed verses over prerecorded tracks that had originated a decade earlier in the South Bronx as part of an urban subculture called hip-hop—began to dominate commercial black music production. A critical element of hip-hop culture, in which urban youths express themselves through innovative DJing, breakdancing, and graffiti, rap music has many diverse styles, including party, socio-political, Afrocentric, gangsta, and Christian. Rappers such as Grandmaster Flash and the Furious Five, Public Enemy, and Run-DMC popularized themes of raucous partying, boasting, and social commentary. On the West Coast, rap songs about gang violence, criminal acts, and conflicts with the police surfaced, giving rise to gangsta rap. Popularized by Ice-T and N.W.A., gangsta rap crossed into the mainstream in the early 1990s.

NO HOLDS BARRED In 1991, Public Enemy (*top*) confirmed their mainstream appeal by performing on *Saturday Night Live*. A few years earlier, in 1989, N.W.A. rappers MC Ren (*above, left*) and Eazy-E (*above, right*) sparked controversy in Detroit when they rolled out an anti-police song during their *Straight Outta Compton* tour.

Women have been part of the hip-hop scene since its beginning. They have distinguished themselves by calling attention to women's issues and bringing feminist perspectives to a range of topics. For instance, early rappers Roxanne Shanté, MC Lyte, Queen Latifah, and the rap trio Salt-N-Pepa challenged stereotypical images of women perpetuated by male rappers and promoted concepts of empowerment and sisterhood. They also addressed issues such as homelessness, apartheid, and black unity.

However, in the mid-1990s, socially conscious female rappers were overshadowed by the gangsta and X-rated themes of a younger group of female rappers such as Da Brat, Eve, Lil' Kim, and Foxy Brown. Lauryn Hill's album *The Miseducation of Lauryn Hill* (1998) reintroduced a feminist view along with religious themes.

DESTINY Janet Jackson shines in a 2011 performance in London. The youngest member of the Jackson family, she started out as a TV child actress before establishing a successful career in the crossover music market with her electronic and R & B fusion sound. She became a top-selling singer, emulated by many younger pop stars, from Britney Spears to Beyoncé.

UNSTOPPABLE Female rappers stormed the hip-hop world with diverse new approaches, including protest and bravado, subverting themes of sex and violence. Lauryn Hill (*top, center*), with comembers of the Fugees Pras Michel (*left*) and Wyclef Jean (*right*) in 1994, gained fame with spiritual, feminist raps. MC Lyte, rapper, producer, actor, and philanthropist (*above*), won acclaim in the 1980s for confronting sexism.

As the suburban white teenage audience for rap increased during the 1990s, record companies catered to a concept of inner-city life that exalted gangs and criminal activities. An article published by the *Los Angeles Times* in 1992 reported: "Ever since the nation's six major music distribution groups entered the lucrative rap market in the late '80s, sales have skyrocketed…. According to a recent Sound Data survey, 74% of all rap music sold in 1992 was purchased by white consumers, especially kids under 18…. What attracts many young white suburbanites to the music is rap's blatant anti-Establishment message."

The 1990s saw the unresolved murders of the two biggest names in gangsta rap. Tupac Shakur, twenty-five, died after a drive-by shooting, and Notorious B.I.G, twenty-four, died in the same manner.

At the dawn of the twenty-first century, a young generation of ethnically diverse rappers and producers expanded the scope of hip-hop, shifting away from the themes of gangsta rap to embrace a wide range of social and political subjects. Rappers with middle-class backgrounds, such as Lupe Fiasco, Common, Kanye West, and Nicki Minaj entered the scene, contributing to the genre's variety.

Despite the dominance of rap music since the mid-1990s, R & B groups and contemporary soul singers have brought diversity and innovations to black popular music by reviving traditions, sampling sounds from earlier recordings, using acoustic and electric instruments, and creatively mixing styles. Boyz II Men, En Vogue,

and other R & B groups reintroduced a 1970s-style vocal harmony, while D'Angelo and Erykah Badu modernized the soul of the 1960s and 1970s as neo-soul, blending elements of soul with jazz, funk, and hip-hop. Pharrell Williams's big hit of 2013, "Happy," evoked vintage Motown.

As the new millennium progresses, eclecticism best describes black popular music and the repertoire of individual artists. Collaborations between R & B and hip-hop artists have become the norm, with the incorporation of hip-hop beats and mixes in tracks and speech in the vocals. A plethora of artists has teamed up to make exciting music. Beyoncé features husband and rapper Jay-Z on her recordings, and Mary J. Blige spotlights Canadian rapper Drake.

For more than five centuries and against the backdrop of political, sociocultural, and technological changes, African American music has evolved into new expressions that are intrinsic to American popular culture. It permeates Hollywood movies, television advertisements, programs, and major sports events; it is part of Muzak's programming for businesses; and it is heard in restaurants, bars, and entertainment venues worldwide. African American music is core to the sound of America.

EAST V. WEST First friends and then archrivals, rap icons Tupac Shakur (*far left*) and Notorious B.I.G. (*left*) remain among the most significant hip-hop artists.

QUEEN BEY Beyoncé (*right*), here at the Grammys in 2015, began her ascent in the music business in the 1990s. A twenty-time Grammy winner, she is one of the most influential entertainers in the world.

DEPTH OF FIELD Rapper and poet Common thrills the crowd at a concert in New York City in 2005 (*top*). Boys II Men perform four-part harmony at the 1993 Rock and Roll Hall of Fame induction ceremony (*center left*). R & B group En Vogue joins the Salt-N-Pepa hip-hop trio on a video shoot (*below, left*) for the 1993 hit single "What a Man." R & B, soul, and hip-hop artist Mary J. Blige (*left*) strikes a pose in New York City in 1992.

On the Pulse of Morning (excerpt), 1993

Maya Angelou

Lift up your hearts
Each new hour holds new chances
For a new beginning.
Do not be wedded forever
To fear, yoked eternally
To brutishness.

The horizon leans forward,
Offering you space
To place new steps of change
Here, on the pulse of this fine day
You may have the courage
To look up and out upon me,
The Rock, the River, the Tree, your country . . .

Here on the pulse of this new day
You may have the grace to look up and out
And into your sister's eyes,
And into your brother's face,
Your country,
And say simply
Very simply
With hope—
Good morning.

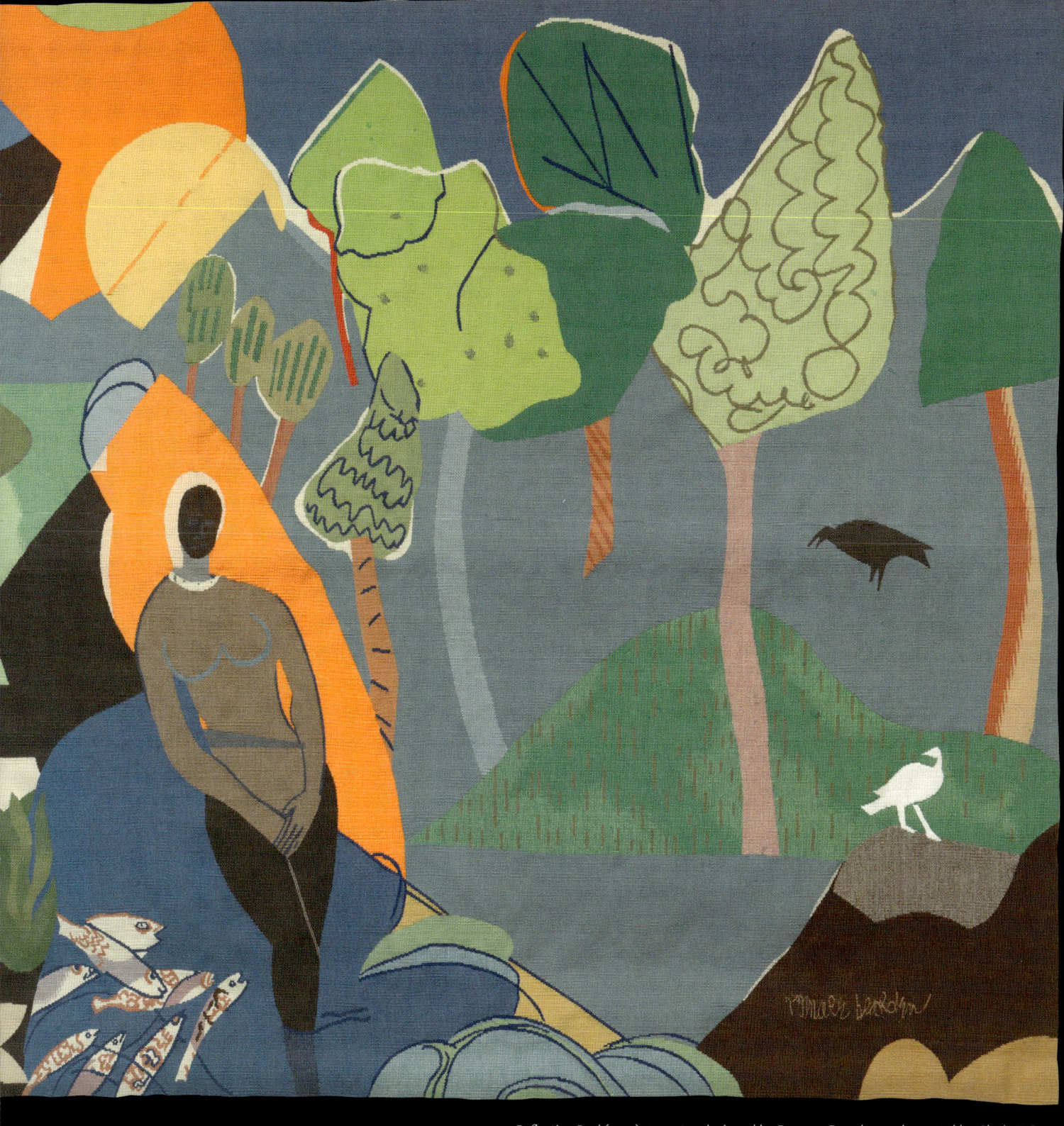

Reflection Pool (1974), tapestry designed by Romare Bearden and created by Gloria F. Ross

INDEX

PICTURE CREDITS

National Museum of African American History and Culture: Front Cover: *2nd from left* 2009.50.2, Gift of Charles L. Blockson **Back Cover:** *r* 2011.20.1, Sedat Pakay © 1964 **4:** *tl* 2011.70.5, © Whitfield Lovell; *tr* 2011.70.10, © Whitfield Lovell; *bl* 2011.70.21, © Whitfield Lovell; *br* 2011.70.22, © Whitfield Lovell **6–7:** 2011.67.2, Gift of the Family of Charles Moore, © Charles Moore **9:** *t* Photography by Alan Karchmer/ NMAAHC **10:** 2014.174.8 **12:** *bl* 2008.15.1, Gift of Dr. Patricia Heaston; *br* 2009.50.33.2, Gift of Charles L. Blockson **13:** *bl* 2010.71.1.1–.11, Gift from the Trumpauer-Mulholland Collection **14–15:** 2009.14.1 **16:** *t* 2011.20.2, Sedat Pakay © 1966 **18:** *b* Data source: Trans-Atlantic Slave Trade Database **21:** *t* 2014.44, Gift of William E. West, Sr. and Family **25:** *t* 2014.312.30, Gift of Oprah Winfrey **26:** *b* 2008.10.3 **28:** *b* 2009.32.1–.4 **29:** *b* 2013.16.1 **30–31:** 2010.21.2 **35:** *b* 2013.46.1 **39:** *b* 2013.46.3 **40:** *l* 2014.312.19.1–.2, Gift of Oprah Winfrey **41:** *t* 2014.262 **41:** *b* 2010.27.1 **43:** *b* 2014.63.31 **44:** *t* 2009.14.2 **47:** *b* 2012.46.46 **48:** *c* 2011.52 **50:** *t* 2013.56.1, Gift of the Bishop Frederick and Mrs. Artishia Jordan Scholarship Fund **51:** *b* 2014.122.2 **55:** *t* 2011.28, Gift of Maurice A. Person and Noah and Brooke Porter; *b* 2012.134.2, Gift of Danny Drain, Walterboro, SC **56:** *t* 2012.46.52ab **57:** *bl* 2008.9.53; *br* 2014.63.17 **58:** 2009.9.7 **59:** *b* 2012.46.1abc **60:** *t* 2014.25, Gift of Elaine E. Thompson in memory of Joseph Trammell on behalf of his direct descendants; *bl* 2014.115.10, Gift of the Garrison Family in memory of George Thompson Garrison; *br* 2014.115.6.1, Gift of the Garrison Family in memory of George Thompson Garrison **61:** *t* 2013.207.1 **62:** *t* 2009.50.39, Gift of Charles L. Blockson; *bl* 2009.50.2, Gift of Charles L. Blockson; *br* 2009.50.25, Gift of Charles L. Blockson **63:** *b* 2014.176.3ab, Gift of Avis, Eugene, and Lowell Robinson; 2014.179.4, Gift of Avis, Eugene, and Lowell Robinson **64:** *t* 2011.69; *b* 2009.34ab **66:** *t* 2011.155.42 **67:** *t* 2011.43.2., Gift of Elizabeth Cassell **68:** *br* 2012.37, Gift of the Family of Irving and Estelle Liss **69:** *t* 2010.77.7 **70:** *t* 2012.133 **72:** *b* 2012.40 **74–75:** 2010.74.147, Gift of Joe Schwartz and Family, © Joe Schwartz **75:** *b* 2015.97.24 **76:** 2011.26.8 **77:** *b* 2011.155.313 **78:** *t* 2011.51.7, Gift from the Liljenquist Family Collection **78–79:** 2014.155.5, Gift of the Garrison Family in memory of George Thompson Garrison **79:** *tl* 2011.155.294ab; *tr* 2011.4.2 **80:** *tl* 2008.2.2; *bl* 2013.196.2; *bc* 2011.108.9.1, Gift of Gina R. McVey, granddaughter; *br* 2011.108.17, Gift of Gina R. McVey, granddaughter **81:** 2012.171.2, In memory of George M. Langellier, Sr. **82:** *b* 2012.43.1, Gift of Lt. Col. Woodrow W. Crockett **83:** *t* 2013.165.1.1ab–.3, Gift of Ray R. and Patricia A.D. Charlton in memory of Cornelius H. Charlton **84:** *t* 2011.155.135; *b* 2013.11.4.3, Gift of James E. Brown **85:** *t* 2014.243.30–.36, Gift of Maj. Gen. Charles F. Bolden Jr., USMC (Ret) **86:** 2009.2, Gift of Billy E. Hodges, © Lorna Simpson **88–89:** 2011.129.63, Gift of Monica Karales and the Estate of James Karales, © Estate of James Karales **91:** *b* 2010.45.11 **96:** 2013.41, Gift of Jacquelyn Days Serwer, from the Collection of the Texas/Dallas History Archives, Division, Dallas Public Library, Image # PA87-1/160-91 **99:** *tr* 2010.2.1ab **101:** *t* 2010.36.9.4 **107:** *t* 2013.117.2, Gift of Mr. and Mrs. Norman and Sandra Lindley **108:** *b* 2010.74.97, Gift of Joe Schwartz and Family, © Joe Schwartz **111:** *br* 2012.102, Gift of the Mamie Till Mobley family **112:** *bl* 2012.107.40, © Time Inc. **116:** *t* 2012.107.16, © Danny Lyon/Magnum Photos **120:** *t* 2011.49.1, © Charles Moore **122:** *b* 2011.17.169, Gift of Elmer J. Whiting, III, © 1964 UPI-Corbis-Bettmann **123:** *c* 2012.107.18, © Danny Lyon/Magnum Photos **124:** *t* 2014.14.12, © 1965 Spider Martin **124:** *b* 2012.107.2, © Estate of James Karales **126:** 2012.83.6, Gift of the Pirkle Jones Foundation, © 2011 Pirkle Jones Foundation **130:** *tl* 2012.107.26, © Gordon Parks Foundation; *bl* 2012.26.5 **131:** *tr* 2012.107.27, © Gordon Parks Foundation **132:** *bl* 2014.167.3, Gifted with pride from Ellen Brooks **134:** *b* 2011.171.16, Gift of Charles C. Adams, © Charles Adams **135:** *tr* 2012.46.69 **137:** *br* 2011.92, © Associated Press/Shephard Fairey **145:** *br* 2012.155.10, Gift of the Lyles Station Historic Preservation Corporation **147:** *tr* 2012.17.2 **148:** *bl* 2007.1.37.1; *br* 2007.1.69.21.77.D, © Smithsonian National Museum of African American History and Culture **151:** 2014.150.1.30, © Estate of Lloyd W. Yearwood **152:** *b* 2011.159.6, Gift from Dawn Simon Spears and Alvin Spears, Sr. **153:** *tl* 2010.6.159, Gift from Mae Reeves and her children, Donna Limerick and William Mincey, Jr.; *tr* 2010.6.158, Gift from Mae Reeves and her children, Donna Limerick and William Mincey, Jr.; *b* 2010.6.46.1, Gift from Mae Reeves and her children, Donna Limerick and William Mincey, Jr. **154:** *t* Courtesy of Shearer Cottage **156–157:** 2010.22.3, Gift of the Hope School Community Center, Pomaria, SC **158–159:** *b* 2013.46.17.1 **161:** *b* 2011.155.171 **163:** *t* 2011.155.205 **164:** *tr* 2015.176.2, Gift from Tulsa Friends and John W. and Karen R. Franklin **165:** *tr* 2011.22.11a-o, Gift of the Hope School Community Center, Pomaria, SC **170:** *t* 2012.46.70 **172:** *l* 2012.46.70 **174:** *b* 2010.38.6, © Alexander Alland, Jr. **179:** *r* 2013.203, Gift of the Afro-American Newspapers **183:** *t* 2013.71.1abc, Gift of Worshipful Prince Hall Grand Lodge of Massachusetts; *b* 2011.72.3, Gift of Robin J. Boozé Miller **185:** *bl* 2013.133.2.7, Gift of the Historical Society of Washington, DC and the Alpha Kappa Alpha Sorority, Inc.; 2013.133.2.5, Gift of the Historical Society of Washington, DC and the Alpha Kappa Alpha Sorority, Inc.; 2013.133.2.6, Gift of the Historical Society of Washington, DC and the Alpha Kappa Alpha Sorority, Inc.; *br* 2013.133.1.3, Gift of the Historical Society of Washington, DC and the Alpha Kappa Alpha Sorority, Inc. **187:** 2011.165.28, Gift of Howard and Ellen Greenberg, © Courtesy The Aaron Siskind Foundation **188:** *bl* 2013.153.8, Gift of A'Lelia Bundles / Madam Walker Family Archives, © A'Lelia Bundles; *br* 2008.15.2, Gift of Dr. Patricia Heaston **191:** *r* 2012.107.2, © 1976 George Ballis **195:** *br* 2012.154.55ab, Gift of Carl Lewis Estate **197:** *c* 2011.159.3.47, Gift from Dawn Simon Spears and Alvin Spears, Sr. **199:** *tl* 2012.3.3; *tr* 2013.171.3; *b* 2014.89.1 **201:** *b* 2013.120.9 **203:** *tl* 2013.126.48, Gift of the Carl Lewis Estate; *tc* 2014.205.2.1, Gift of Donald Felder and family; *tr* 2014.205.17, Gift of Donald Felder and family, © Michael Benabib **205:** *r* 2014.30.4 **206:** *tr* 2012.172.13.3, Gift of Paxton and Rachel Baker, © Neil Leifer; *c* 2012.159.17; *bl* 2010.19.1 **210–211:** 2011.137.2, Donation of Charles E. Berry **216:** *t* 2011.57.26 **217:** *tl* 2013.118.218.2, © Michael Ochs Archives/Getty Images; *tr* 2014.150.1.60.2, © Estate of Lloyd W. Yearwood **218:** 2013.245, Photography by Jack Mitchell © Alvin Ailey Dance Foundation, Inc. and Smithsonian Institution, All rights reserved. **221:** *b* 2014.275.15, Gift of Sylvia Alden Roberts **225:** *t* 2013.118.288 **226:** *t* 2013.237.12, Gift of Cabella Calloway Langsam; *b* 2015.45.3, Gift of Dwandalyn R. Reece in memory of Pauline Watkins Reece **228:** *br* 2015.34.1, Cover art © Aaron Douglas Foundation/Licensed by Visual Artists & Galleries Association, Inc. (VAGA), New York, NY **229:** *bl* 2015.35.2, Cover art © Aaron Douglas Foundation/Licensed by Visual Artists & Galleries Association, Inc. (VAGA), New York, NY; *br* 2010.1.277 **230:** *t* 2014.53.8.2; *b* 2014.53.8.1 **231:** *t* 2012.152.1279, Gift of Dow B. Ellis, © John D. Kisch/Separate Cinema Archive/Getty Images **232:** *br* 2013.118.32 **235:** *br* 2014.302.45, Gift from Charles A. Harris and Beatrice Harris in memory of Charles "Teenie" Harris, © Carnegie Museum of Art, Charles "Teenie" Harris Archive **236:** 2010.53.1, © Time Life Pictures/Getty Images, Inc. **238:** *bl* 2013.46.15 **240:** *r* 2011.137.1, Donation of Charles E. Berry **241:** *tl* 2014.116.27, Gift of Robert and Greta Houston, © Robert Houston; *br* 2011.15.101, Gift of Milton Williams Archives, © Milton Williams **242:** *bl* 2009.13ab **243:** *tl* 2013.164, © Sargent Claude Johnson; *tr* 2008.13, © 1971 Barbara Jones-Hogu **244:** *bl* 2011.50.2, Gift of Soul Train Holdings, LLC, © Soul Train Holdings, LLC **245:** *b* 2009.16.25, © Ernest C. Withers Trust **246:** *tl* 2015.52.3, Gift of Rumal Rackley **249:** *t* 2015.132.57, © Gene Bagnato **250:** *tr* 2015.132.123, © Michael Benabib **254:** *b* 2011.20.1, Sedat Pakay © 1964 **257:** *r* 2013.242.1, Gift of the Fuller Family, © Meta Vaux Warrick Fuller **259:** *b* 2008.16.1–.3 **262:** *bc* 2009.24.9, © Wayne Miller/Magnum Photos; *br* 2010.74.150, Gift of Joe Schwartz and Family, © Joe Schwartz **263:** *br* 2013.66.1, Gift of Nell Draper-Winston, © The Louis Draper Archive **264:** *b* 2014.150.6.1, © Estate of Lloyd W. Yearwood **265:** *tl* 2011.145.2, Henrietta W. Shelton, Chicken Bone Beach Historical Foundation, Inc. **265:** *bl* Leah L. Jones /NMAAHC **266:** *bl* 2012.164.3, Gift of David. D. Spitzer, © David D. Spitzer; *bc* 2009.42.1ab **269:** *bl* 2015.103.3ab, Gift of the Estate of Max Roach; *bc* 2015.195.16ab, © Blue Note Records; *br* 2013.134.1.302ab, © Roulette Records, Inc. **270:** *r* 2009.42.2 **271:** *r* 2011.92.1.1–.9, Gift of Love to the planet; *b* 2013.8.6, Gift of Love to the planet **273:** *t* 2015.132.202, © David Corio; 2015.132.102, © Michael Benabib **274:** 2015.132.132, © Michael Benabib; *bc* 2015.132.71, © Michael Benabib **275:** *bl* 2015.117.11.1, © Michael Benabib **276–277:** 2015.255, Gift of Richard and Laura Parsons, © Romare Bearden Foundation/Licensed by VAGA. **AF Fotografie: 37:** *r* 52: *b* Private Collection/AF Fotografie **Alamy Stock Photo: 110:** *bl* © Keystone Pictures USA/Alamy Stock Photo **138:** *b* © Craig Ruttle/Alamy

Stock Photo **214:** *b* © World History Archive/Alamy Stock Photo **232:** *bl* © Everett Collection Inc/Alamy Stock Photo **244:** *tl* © Daily Mail/Rex/Alamy Stock Photo **260:** *b*; **262:** *tl*; **270:** *br* © Pictorial Press Ltd/Alamy Stock Photo **273:** *bl* © EDB Image Archive/Alamy Stock Photo **Art Resource: 24:** *b* Art Resource: 24: *b* Schomburg Center, NYPL/Art Resource, NY **Clarice Wyatt Bell Church and Clarice Bell-Strayhorn: 149:** *b* Photo courtesy of Clarice Wyatt Bell Church and Clarice Bell-Strayhorn. All rights reserved. **Boxing Hall of Fame: 197:** *tr* Courtesy of the Boxing Hall of Fame **Bridgeman Images: 22:** *tl* Slave traders, Arabic miniature, 12th century/De Agostini Picture Library/Bridgeman Images **23:** *r* Female shrine figure, part of a family of such figures kept in a village shrine, illustrating the continuity of social roles in the world of the living and that of the spirits/Werner Forman Archive/Bridgeman Images **32:** *t* Slave traders tearing man from his wife and family before putting him on board a slave ship. From Ameilia Opie, "The Black Man's Lament: or How to Make Sugar," London, 1826/Universal History Archive/UIG/Bridgeman Images **36:** *l* Nieu Amsterdam (engraving), American School/New York Public Library, USA/Bridgeman Images **53:** *t* A Plantation Burial, 1860 (oil on canvas), Antrobus, John (1837-1907)/The Historic New Orleans Collection/Bridgeman Images **Charlotte Hawkins Brown Museum: 160:** *t* courtesy of the Charlotte Hawkins Brown Museum **Congress of Racial Equality (CORE): 110:** *tl* courtesy of Congress of Racial Equality **Corbis Images: 71:** *t* © CORBIS **125:** *c* © Flip Schulke/CORBIS **144–145:** Image by © Bob Sacha/Corbis **146–147:** *b* Image by © Steve Schapiro/Corbis **204:** *tr* Image by © Michael Cole/Corbis **234:** *b* © Copyright 2007 Corbis **265:** *br* © Brian O'Connor/Heritage Images/Corbis **Delta Haze Corporation: 260:** *t* Robert Johnson Studio Portrait, Hooks Bros., Memphis, circa 1935 © 1989 Delta Haze Corporation. All Rights Reserved. Used by permission. **Duke University: 9:** *b* The John Hope Franklin Center at Duke University **98:** *tl* Portrait of Col. Allen Allensworth from Battles and Victories of Allen Allensworth (1914), David M. Rubenstein Rare Book & Manuscript Library, Duke University **Emory University: 182:** *l* Box 2, Folder 6, Robert Churchwell papers, Stuart A. Rose Manuscript, Archives, and Rare Book Library, Emory University **Everett Collection: 42:** *t* Courtesy Everett Collection **155:** *b* © AGIP/RDA/ Everett Collection **258–259:** ©ABKCO Music/Courtesy Everett Collection **Dr. John L. Fuller: 243:** *br* courtesy Dr. John L. Fuller **Getty Images: Front Cover:** *1st from left* Photo by Stanley Weston/GI; *4th from left* Photo by Howard Sochurek/The LIFE Picture Collection/GI **Back Cover:** *2nd from left* Photo by Steve Granitz/WireImage/GI; *3rd from left* Bettmann Archive/GI **2:** Photo by Thomas D. Mcavoy/The LIFE Picture Collection/GI **19:** *t* Photo by Wolfgang Kaehler/LightRocket via GI **54:** *b* Photo by MPI/GI **85:** *tr* Photo by Larry French/GI for Thurgood Marshall College Fund **104:** *b* Photo by Robert Hunt Library/Windmill books/ UIG via GI **106:** *tl* Photo by Fotosearch/GI **109:** *tr* Photo by Vic Twyman/NY Daily News Archive via GI **111:** *tr* Bettmann Archive/GI **113:** *t* Bettmann Archive/GI **114:** *t* Photo by Donald Uhrbrock/The LIFE Images Collection/GI **116:** *c* Bettmann Archive/GI **118:** *t* Underwood Archives/GI; *b* Bettmann Archive/GI **119:** *t* Bettmann Archive/GI **120–121:** *b* OFF/AFP/GI **122:** *t* Photo by Universal History Archive/UIG via GI **123:** *t* Bettmann Archive/GI **125:** *b* Bettmann Archive/GI **128:** *t* Photo by Lynn Pelham/The LIFE Picture Collection/ GI **129:** *r* Bettmann Archive/GI **130–131:** *b* Photo by Jill Freedman/GI **132:** *tl* Bettmann Archive/GI **136:** *tl* Photo by Jason Kempin/GI for V-Day **137:** *tr* HENNY RAY ABRAMS/AFP/GI **140:** *tl* Photo by Mickey Adair/GI **142–143:** SAUL LOEB/AFP/GI **150:** *b* Photo by Michael Ochs Archives/GI **152:** *t* Bettmann Archive/GI **154:** *b* Photo by Paul Marotta/GI **166:** *b* Photo by Alfred Eisenstaedt/The LIFE Picture Collection/ GI **174:** *t* Bettmann Archive/GI **175:** *t* Bettmann Archive/GI **178:** *l* Photo by Charles "Teenie" Harris/Carnegie Museum of Art/GI **185:** *t* Photo by Afro American Newspapers/Gado/GI **189:** *tl* Photo by Rex Hardy Jr./The LIFE Picture Collection/GI **190:** *t* Photo by MPI/GI **193:** *b* Photo by Scott J. Ferrell/Congressional Quarterly/ GI **194–195:** Photo by Austrian Archives/Imagno/GI **196:** *bl* Photo by Bill Smith/NBAE/GI **198:** *tc* Bettmann Archive/GI **200:** *t* Photo by Afro American Newspapers/Gado/GI **202:** Photo by Mark Kauffman/The LIFE Images Collection/GI **204:** *b* Photo by Julian Finney/GI **205:** *b* Photo by Focus on Sport/GI **207:** Photo by Tony Tomsic/GI **208:** Photo by John Dominis/The LIFE Picture Collection/GI **209:** *tr* Photo by Nick Cammett/ Diamond Images/GI **212:** *t* Photo by David Gahr/GI **220:** *b* Bettmann Archive/GI **224:** *b* Photo by Gerrit Schilp/Redferns/GI **227:** *b* Photo by Photo12/UIG via GI **233:** *tl* Photo by John D. Kisch/Separate Cinema Archive/GI; *br* Photo by Michael Abramson/The LIFE Images Collection/GI **235:** *tr* Photo by Warner Bros/GI **239:** *t, b* Photo by Michael Ochs Archives/GI **245:** *t* Photo by CBS via GI **246:** *tr* Photo by Jeffrey Mayer/ WireImage/GI **248:** *b* Photo by Scott Gries/GI **255:** *tl* Bettmann Archive/GI; *tc* Photo by Anthony Barboza/GI; *tr* Photo by Mike Simons/GI **256:** *bl* Photo by Ricardo DeAratanha/Los Angeles Times via GI; *bc* Photo by Annie Wells/Los Angeles Times via GI; *br* Photo by Anthony Barboza/GI **261:** *b* Photo by Jack Vartoogian/GI **262:** *tr* Photo by JP Garcia/Redfern/Getty Images **263:** *t* Photo by John D. Kisch/Separate Cinema Archive/GI **266–267:** Photo by Donaldson Collection/Michael Ochs Archives/GI **267:** *br* Photo by Michael Ochs Archives/ GI **268:** *bl* Photo by Ron Howard/Redferns/GI; *br* Photo by Jim Britt/Michael Ochs Archives/GI **269:** *t* Photo by Blank Archives/GI **270:** *bl* Photo by Phil Dent/Redferns/GI **272:** *t* Photo by: Raymond Boyd/NBCU Photo Bank/GI; *b* Photo by Raymond Boyd/Michael Ochs Archives/GI **274:** *br* Photo by Robert Gauthier/Los Angeles Times via GI **275:** *cb* Photo by Jeff Kravitz/FilmMagic, Inc/GI **The Granger Collection: 26:** *t* 38: *t* 49: *t* 92: *t* 102: *t* 106: *b* 160: *b* 169: *b* 173: *t* 189: *t* 216: *b* 225: *b* 240: *l* The Granger Collection **252:** *tr* Rue des Archives/The Granger Collection **Harvard University: 254:** *t* Schlesinger Library, Radcliffe Institute, Harvard University **The Image Works: 123:** *b* © 1976 George Ballis/Take Stock/The Image Works **192:** *t* © 1976 Matt Herron/Take Stock/The Image Works **Iziko Museums of South Africa: 33:** *t; lc; rc; bl* **John F. Kennedy Presidential Library and Museum: 121:** *t* Abbie Rowe, White House Photographs, John F. Kennedy Presidential Library and Museum, Boston **Johnson Publishing Company: 181:** *br* Courtesy Johnson Publishing Company, LLC. All rights reserved. **Library of Congress: Front Cover:** *6th from left* 65: *b* 68: *b* 71: *b* 73: *t* 99: *br* 103: *b* 149: *tr* 150: *t* 184: *t* 196: *tr* 222: *b* 223: *t* 224: *t* 237: *b* 263: *bl* **Los Angeles Public Library: 66:** *b* Miriam Matthews Collection, Los Angeles Public Library **Media Punch: 250:** *tl* Photo © Kevin Estrada/ MediaPunch **National Archives and Records Administration: 193:** *t* **National Portrait Gallery: Front Cover:** *3rd row top* NPG.74.75 National Portrait Gallery, Smithsonian Institution; acquired through the generosity of an anonymous donor; *5th from left* NPG.2001.55 Smithsonian National Portrait Gallery/© 2013, Stephen Shames/Polaris Images **Back Cover:** *1st from left* NPG.80.25 National Portrait Gallery, Smithsonian Institution; *4th from left* NPG.79.208 National Portrait Gallery, Smithsonian Institution; *5th from left* NPG.99.57 Smithsonian National Portrait Gallery/© Ida Berman, courtesy Steven Kasher Gallery, NY **98:** *br* NPG.2009.36 National Portrait Gallery, Smithsonian Institution **165:** *tr* NPG.95.89 George Washington Carver by Prentice H. Polk c. 1930, Gelatin silver print, National Portrait Gallery, Smithsonian Institution © Dr. Donald L. Polk **Newscom: 85:** *tc* Dennis Brack/Newscom **The New York Public Library: 177:** *r* From The New York Public Library, Schomburg Center for Research in Black Culture, Manuscripts, Archives and Rare Books Division **215:** *t* From The New York Public Library, Jerome Robbins Dance Division **219:** *b* From The New York Public Library/ Billy Rose Theater Division/Martha Swope Photographs Collection **Ohio History Connection: 171:** *r* **Press Association Images: 133:** *br* Charles Kelly/AP Photo/PA Images **Public Domain: 13:** *br* booking photograph taken by City of Jackson, Mississippi, Police Department, 1961 **95:** *t* from Harper's Weekly, vol. XII, no. 621, November 21, 1868, p. 740 **Ron Riesterer: 133:** *tr* photo by Ron Riesterer ©1973 **The Tennessean: 117:** *b* From The Tennessean, April 19, 1960 © 1960 Gannett-Community Publishing. All rights reserved. Used by permission and protected by the Copyright Laws of the United States. The printing, copying, redistribution, or retransmission of this Content without express written permission is prohibited **UNCF: 167:** *t* courtesy of UNCF **Yale University: 181:** *tl* Beinecke Rare Book and Manuscript Library, Yale University, cover of the magazine Opportunity: A Journal of Negro Life/Art © Heirs of Aaron Douglas/Licensed by VAGA, New York/DACS, London 2016; *tr* Beinecke Rare Book and Manuscript Library, Yale University, cover of the magazine The Crisis: A Record of the Darker Races/Art © Heirs of Aaron Douglas/Licensed by VAGA, New York/DACS, London 2016 **Zuma Press: 180:** *bl* Johnson Publishing Co/TNS/ZUMAPRESS.com **275:** *t* Photo by Aviv Small/ZUMA Press

ACKNOWLEDGMENTS

Dream a World Anew, the lead inaugural publication of the National Museum of African American History and Culture (NMAAHC), was the result of many hands. Invoking a key tenet of the Museum's vision statement, it was, in every way, a collaboration. The engine of the book—that lovely thrumming sound that readers will hear throughout it—is the work of the outstanding writers whose eloquent words grace these pages. We are extraordinarily grateful to the authors of the main text—David W. Blight, Spencer R. Crew, Farah Jasmine Griffin, Peniel E. Joseph, Portia K. Maultsby, Alfred A. Moss Jr., William C. Rhoden, Krewasky A. Salter, and Mel Watkins—for their commanding language and keen insights into the complex and contested history and culture of black America. Thanks are due as well to the deft profile authors, Tonya Bolden, Herb Boyd, and Michel Marriott, whose work animates the larger text. We are enormously grateful to the Museum's entire curatorial team, whose keen intelligence and dedication made the work of this book possible. To the NMAAHC curators who contributed the all-important sidebars to the book, we add very special thanks, as this book was made better by the words of these scholars: Nancy Bercaw, Rex M. Ellis, Tuliza Fleming, Paul Gardullo, Michèle Gates Moresi, Joanne Hyppolite, Elaine Nichols, William S. Pretzer, Dwandalyn R. Reece, Jacquelyn Days Serwer, and Michelle Joan Wilkinson.

We also remember with profound gratitude the late, distinguished historian Clement Alexander Price, a member of the Museum's Scholarly Advisory Committee (SAC), whose early ideas helped guide our work. Clem's SAC colleagues provided essential counsel on the Museum's inaugural exhibitions and in so doing created the bedrock of this publication. We also thank Marie Dutton Brown and Khalil Muhammad, whose advice was integral at critical moments of the book's development.

The Museum's digitization and cataloguing team, under the excellent leadership of Laura Coyle, is irreplaceable. A principal member of the team, Douglas Remley, was tireless in his dedication to the book and an inimitable asset in advising on and identifying images and providing the high-resolution photography, caption information, and a range of metadata. Thanks go to photographer Alexander Jamison for his breathtaking photography of the Museum collection objects included in these pages.

Museum librarian Shauna Collier and her colleague, archivist Ja-Zette Montgomery, were intrepid and invaluable in tracking down subject identities and serving as overall bulwarks to our research efforts. Jim Deutsch once again exhibited his skilled and nuanced touch at critical editorial moments, for which we are grateful. Additional thanks go to Mary Elliot, Michèle Gates Moresi, Elaine Nichols, Dwandalyn R. Reece, Jacquelyn Days Serwer, and Damion Thomas for their close reading of key portions of the final text.

Kevin Mulroy led the book's team of editors and designers, including most notably Ellen Dupont and Marian Smith Holmes, without whom we never could have harnessed such an array of scholarship, information, and design. For their work, we are so very grateful.

Our copublisher, Smithsonian Books, deserves more words of thanks than there is room for here. The leadership of Director Carolyn Gleason and our partnership with Editor Christina Wiginton made all that was accomplished possible. Their brilliance, creativity, and unflagging support of this publication were the essential elements in its realization. No one has done more to bring *Dream a World Anew* to life.

Finally, to NMAAHC Director Lonnie Bunch, I am grateful beyond words. His belief in the book, his own contribution of its introduction, and his counsel and support throughout were priceless. His vision for the Smithsonian's newest museum illuminates the pages of this publication just as it has lighted the path of the Museum's emergence from idea to reality. We are all in his debt.

—**Kinshasha Holman Conwill**

POETRY CREDITS

CONTRIBUTORS

Nancy Bercaw is a co-curator of the inaugural "Slavery and Freedom" exhibition. A cultural historian for thirty years, she specializes in race, gender, and African American political expressions.

David W. Blight is Class of 1954 Professor of American History and director of the Gilder Lehrman Center for the Study of Slavery, Resistance, and Abolition at Yale University. He is the author of *Frederick Douglass: A Life* (2017) and numerous other works on African American history.

Tonya Bolden is the author of *How to Build a Museum: Smithsonian's National Museum of African American History and Culture* (2016) and more than two dozen other books.

Herb Boyd is an activist, journalist, teacher, and the author of *Black Detroit: A People's Struggle for Self-Determination* (2017).

Lonnie G. Bunch III is the founding director of NMAAHC. Before his appointment in 2005, he served as president of the Chicago Historical Society; as supervising curator and assistant director for curatorial affairs for the National Museum of American History; and as curator of history and program manager for the California African American Museum. His widely published writings include subjects ranging from the black military experience to the history of all-black western U.S. towns and diversity in museums, including *Call the Lost Dream Back: Essays on History, Race, and Museums*. He was also co-general editor of *Memories of the Enslaved: Voices from the Slave Narratives*.

Kinshasha Holman Conwill is deputy director of NMAAHC and is the former director of the Studio Museum in Harlem. She has organized more than forty exhibitions and often writes on art, museums, and cultural policy. She is a frequent lecturer and panelist at colleges, universities, conferences, and museums.

Spencer R. Crew is the guest curator of the "Defending Freedom, Defining Freedom: Era of Segregation 1876–1968" exhibition. The Clarence J. Robinson Professor of History at George Mason University, he has published extensively on African American and public history and has served as president of the National Underground Railroad Freedom Center and as director of the Smithsonian's National Museum of American History.

Rex M. Ellis is the Museum's associate director for curatorial affairs. He has been a historian and museum educator for more than thirty years, with specialties in music and early American history.

Tuliza Fleming is an art historian with twenty years of experience in the museum field and has been a curator at NMAAHC since 2007. She is the co-curator of the inaugural exhibition "Visual Art and the American Experience."

Paul Gardullo curated the inaugural "Power of Place" exhibition and is co-director of the NMAAHC-hosted Slave Wrecks Project. He has been a curator at the Museum since 2007, with interests in American cultural and social history, the African Diaspora, memory, and public history.

Michèle Gates Moresi, co-curator of the inaugural "Making a Way Out of No Way" exhibition, is the Museum's supervisory curator of collections. She has been a historian of public history for twelve years and has a special interest in the representation of African Americans in museums.

Farah Jasmine Griffin, the William B. Ransford Professor of English and Comparative Literature and African American Studies at Columbia University, is the author of several books on African American history and culture.

Marian Smith Holmes, a longtime journalist and a former associate editor at *Smithsonian* magazine, is a Washington, D.C.–based writer and editor who specializes in African American history and culture.

Joanne Hyppolite is the curator of the inaugural "Cultural Expressions" and the co-curator of "A Century in the Making: Building the National Museum of African American History and Culture" exhibitions. A curator in the Museum's cultural division with special interests in literature and the African Diaspora, she has more than ten years of professional museum experience.

Peniel E. Joseph, author of *Waiting 'Til the Midnight Hour: A Narrative History of Black Power in America* (2006), holds a joint professorship at the LBJ School of Public Affairs and the History Department at the University of Texas at Austin. He was founding director of the Center for the Study of Race and Democracy at Tufts University.

Michel Marriott is a longtime journalist and author, formerly with the *New York Times* and now an adjunct professor of journalism at Columbia University.

Portia K. Maultsby is Laura Boulton Professor Emerita of Ethnomusicology and professor emerita of folklore and ethnomusicology at Indiana University.

Alfred A. Moss Jr. is a historian and Episcopal priest whose publications include three editions of *From Slavery to Freedom: A History of African Americans*, coauthored with fellow historian John Hope Franklin.

Elaine Nichols is the supervisory curator of culture at NMAAHC, where she also leads the Museum's oral history program. Her research focuses on dress, decorative arts, and African American funeral and mourning customs.

William S. Pretzer is a co-curator of the inaugural "A Changing America: 1968 and Beyond" exhibition. Prior to becoming senior history curator at NMAAHC in 2009, he worked at four other museums since 1980, producing exhibitions and publications on industrial, cultural, and political history.

Dwandalyn R. Reece, curator of the inaugural "Musical Crossroads" exhibition, has been the Museum's curator of music and performing arts since 2009. Her work focuses on how music, theater, dance, and other performance traditions preserve, reflect, and shape our cultural values and social beliefs.

William C. Rhoden has been a sportswriter for the *New York Times* since 1983 and has written the "Sports of the Times" column since 1990. He is the author of *Forty Million Dollar Slaves: The Rise, Fall, and Redemption of the Black Athlete* (2006).

Krewasky A. Salter, guest curator of the inaugural "Double Victory: The African American Military Experience" exhibition, is a retired U.S. Army colonel who commanded at all levels through battalion. Salter has taught and written extensively on the experiences of African Americans in the military.

Jacquelyn Days Serwer is co-curator of the inaugural "Visual Art and the American Experience" exhibition. An art historian, she has been the chief curator at NMAAHC since 2006. Previously she served as chief curator at the Smithsonian American Art Museum and the former Corcoran Gallery of Art.

Mel Watkins, a former staff member at the *New York Times* and NEH Professor of Humanities at Colgate University, has published widely on African American literature and music.

Michelle Joan Wilkinson is a co-curator of the inaugural "A Changing America: 1968 and Beyond" and "A Century in the Making: Building the National Museum of African American History and Culture" exhibitions. A curator at the Museum, she focuses on projects related to contemporary black life and builds the museum's collections in architecture and design.

Copyright © 2016, 2026 Smithsonian Institution
All rights reserved. No part of this publication may be reproduced or transmitted in any form or by any means, electronic or mechanical, including photocopying, recording, or information storage or retrieval system, without permission in writing from the publishers.

Profiles by Tonya Bolden (chapter 1, and George Washington Carver), Michel Marriott (chapters 2 and 3), and Herb Boyd (chapter 4)
Captions by Marian Smith Holmes

Published by Smithsonian Books
PO Box 37012, MRC 513
Washington, DC 20013
smithsonianbooks.com

Director: Carolyn Gleason
Managing Editor: Christina Wiginton
Assistant Editor: Laura Harger
Editorial Assistants: Leah Enser and Jaime Schwender

This book may be purchased for educational, business, or sales promotional use. For information, please write Special Markets at the address or website above.

National Museum of African American History and Culture
Director: Lonnie G. Bunch III
Deputy Director: Kinshasha Holman Conwill
Publications Team: Michèle Gates Moresi, Laura Coyle, Douglas Remley, and Emily Houf
Museum Photographer: Alexander Jamison

Produced by Potomac Global Media in collaboration with Toucan Books, Ltd.
Kevin Mulroy, Publisher, Potomac Global Media, LLC
Ellen Dupont, Managing Director, Toucan Books, Ltd.
Marian Smith Holmes, Editor
Dorothy Stannard, Contributing Editor
Terence Patrick Winch, Marie D. Brown, Consulting Editors
Autumn Green, Editorial Assistant
Dolores York, Proofreader
Marie Lorimer, Indexer
Thomas Keenes, Art Director
Simon Webb, Contributing Designer
Jonathan Halling, Cover Design
Kristin Hanneman, Illustrations Editor, Researcher
Christine Vincent, Picture Manager

Library of Congress Cataloging-in-Publication Data

Names: Conwill, Kinshasha Holman, editor. | National Museum of African American History and Culture (U.S.)
Title: Dream a world anew : the African American experience and the shaping of America / edited by Kinshasha Holman Conwill ; introduction by Lonnie G. Bunch III.
Description: Washington, DC : Smithsonian Books, 2016. | "In association with the National Museum of African American History and Culture." | Includes index.
Identifiers: LCCN 2016015596 | ISBN 9781588345684
Subjects: LCSH: African Americans--History. | United States-Civilization--African American influences.
Classification: LCC E185 .D66 2016 | DDC 973/.0496073--dc23 LC record available at https://lccn.loc.gov/2016015596

Paperback ISBN: 978-1-58834-822-7

Manufactured in China
Not at government expense
30 29 28 27 26 1 2 3 4 5

For permission to reproduce illustrations appearing in this book, please correspond directly with the owners of the works, as seen on p. 285. Smithsonian Books does not retain reproduction rights for these images individually or maintain a file of addresses for sources.

Front Cover (*from left to right*): **1:** Muhammad Ali. Photo by Stanley Weston/Getty Images; **2:** Harriet Tubman. NMAAHC 2009.50.2, Gift of Charles L. Blockson; **3:** Frederick Douglass. National Portrait Gallery, Smithsonian Institution NPG.74.75; acquired through the generosity of an anonymous donor; **4:** Martin Luther King Jr. Photo by Howard Sochurek/The LIFE Picture Collection/Getty Images; **5:** Angela Davis. Smithsonian National Portrait Gallery/© 2013, Stephen Shames/Polaris Images; **6:** Louis Armstrong. Library of Congress.

Back Cover (*from left to right*): **1:** W. E. B. Du Bois. National Portrait Gallery, Smithsonian Institution NPG.80.25; **2:** Oprah Winfrey. Photo by Steve Granitz/WireImage/Getty Images; **3:** Malcolm X. Bettmann Archive/Getty Images; **4:** Booker T. Washington. National Portrait Gallery, Smithsonian Institution NPG.79.208; **5:** Rosa Parks. Smithsonian National Portrait Gallery/© Ida Berman, courtesy Steven Kasher Gallery , NY; **6:** James Baldwin. NMAAHC 2011.20.1, Sedat Pakay © 1964.